PARMIGIANINO

HIS WORKS IN PAINTING

Parmigianino

HIS WORKS IN PAINTING

Sydney J. Freedberg

GREENWOOD PRESS, PUBLISHERS
WESTPORT, CONNECTICUT

TO

WILHELM KOEHLER AND FREDERICK DEKNATEL

Preface to the Reprint Edition

It would be a doubtful compliment to the art historian's profession if this book, published twenty years ago and written some while before that, should still seem satisfactory to its author. In these years, other scholars—in particular A. E. Popham, Augusta Quintavalle, and Konrad Oberhuber—have made additions to our knowledge of Parmigianino's work which, if this were a revision and not merely a reprinting of this book, I should wish to include. Moreover, my own experience has led me to question certain of my judgments on matters of attribution, toward which I now take, in the field of Parmigianino's portraiture especially, a view still more restrictive than I formerly held. Beyond this, the comprehension art historians have attained of the context of Parmigianino's art is sounder than it was two decades ago. We know more about his contemporaries, both in Emilia and in post-Raphaelesque Rome, and we have learned to see Mannerism less as an expressionist adventure and more in the sense of an art like Parmigianino's own.

The results of this change and the deepening of my understanding of Parmigianino appear, at this writing in press, in my *Painting in Italy, 1500-1600,* in the Pelican History of Art series. In a less developed and in an excessively condensed form, they can be found also in my article on Parmigianino in the *Encyclopedia of World Art.* I have indicated there the important differences of opinion on attribution I have come to hold since the initial publication of this book, and supplied some more recent bibliography. I have thus equipped the reader of this reprint with my own antidotes to what I have learned to see as its defects. I hope that, despite these defects, the reader will still find the book substantially of use.

Harvard University
June 8, 1969

Preface

The serious and intermittently intensive investigation of the art-historical phenomenon of Mannerism began some thirty years ago. Since then several authors, conspicuous among them Walter Friedlaender, Nikolaus Pevsner, Friedrich Antal, and most recently Giulio Briganti, have made substantial contributions to the literature of this field. From the work of these men and of others the broad outlines of a solution to the problem of Mannerism have emerged, and found a measure of general acceptance. However, these outlines are still vague; in a generation's research they have not yet assumed precise nor often even satisfactorily comprehensible form. The great bulk of our published knowledge in the field of Mannerism consists of generalizations, many of them acute, but others of remarkable looseness.

The present need in our investigation of Mannerism is to specify these generalizations, and to give them some more concrete substance than the wide sampling of facts, or often fancies, on which they have been based. An inductive method must be applied to our study of this field, of which our precise understanding has been compromised, perhaps more than in any other segment of art history, by the practice of divorcing the study of art history from that of the artists.

This book results from the conviction that the most profitable course to take in our effort to specify our comprehension of Mannerism is to examine in some detail the style of the most important artists who are, by common critical consent, identified as Mannerists. From such an examination we may make, when it is completed, a valid base for generalization. I have undertaken, as my part in this research, to define the style of one such patently major personality of the Mannerist period, Il Parmigianino. He has been selected as a subject partly because the problem he offers is of less complexity than that of other Mannerist artists. The definition of his relatively simple form of Mannerism may provide a basis and point of reference for more difficult researches.

I have deliberately avoided the construction, from this study of Parmigianino's style, of any generalizations which are meant to embrace the whole of Mannerism; such generalization would be in evident violation of the intention of this study and of my deliberately imposed restriction in scope. The generalizations which I have made are meant to apply to Parmigianino, and may be extended to those artists who depend on him in substantial measure; to a less degree they may be applied, tentatively and with

caution, to that major phase of Mannerism of which Parmigianino is admittedly the principal exponent.

Very few general preconceptions about Mannerism were brought to the writing of this book. Among these few, however, was one major premise, which has been proved to the general satisfaction and to my own explicit satisfaction: that of a separate identity, as far as any historical movement has such a separate identity, of Mannerist style. This study has helped to specify and confirm that premise. Otherwise, I have deliberately tried to avoid even that measure of prevention in examination of our artist as would result from the incautious application to him of the very words "Mannerism" and "Mannerist." It will be observed that they occur relatively infrequently in the section of the book devoted to Parmigianino's concepts of style.

This volume is limited to a consideration of Il Parmigianino's works in painting and those drawings which relate, as preparatory studies, to his painting. The paintings contain the fuller and more important information on the problem of the nature of the Mannerist style to which we seek an answer; furthermore, the production in the graphic arts of Parmigianino forms so considerable an *oeuvre* in itself and is of such arresting quality that it merits a separate study. I hope one day, with the accumulation of material already in hand, to undertake this study.

To clear the text as completely as possible for discussion of matters of style, all material which concerns the attribution or dating of the paintings has been inserted into the *catalogue raisonné*. This has been made as full and as exact as possible, not so much as an end in itself, as in the pious hope that I have thus secured all the available evidence which exists for judgment of style in Parmigianino's surviving paintings and that, conversely, I have drawn no conclusions from material which is not his.

This book was begun on the basis of material assembled in Europe in 1936 and 1937, and a first draft was submitted to Harvard University as a doctoral thesis in 1940. After the interruption of the war and military service, work on it was resumed in 1946. Conditions of research have evidently not been auspicious during most of these years and threaten not to be for some years yet. It has seemed best to publish in spite of certain lacks which I can see no surety of repairing for some time to come. One of these is the absence in the catalogue of detailed color information, and a very considerable reluctance to discuss color in the text from notes and from a visual memory that antedate the war. The same conditions have made the acquisition of detail photographs of some important works, especially those in former enemy countries, a matter of major difficulty. I hope, in consideration of their cause, that these defects may be excused.

I wish to express my deepest gratitude to Drs. Rosenberg, Deknatel, and Koehler of Harvard for their patient encouragement and sympathetic criticism of my work. Dr. Deknatel has been particularly generous and kind, and he has demonstrated his

PREFACE

friendship not only in terms of sympathy, but also in many practical ways which have helped toward the writing and publication of this book. Dr. Koehler's scholarly example has always been a major inspiration for me, and to have achieved his good opinion of my work is as much reward as I require.

My particular thanks must go to Miss Edith Standen and Mr. H. S. Leonard who, as Monuments, Fine Arts, and Archives officers in the Military Government in Germany, performed minor miracles to secure photographs for me. In England, the Earl of Normanton, the Earl of Strafford, Sir Robert Witt, Mr. H. C. Kaines-Smith of the Cook Collection at Richmond, Mr. Benedict Nicolson, Deputy Surveyor of the King's Pictures, Mr. Karl T. Parker of the Ashmolean, Mr. Philip Pouncey of the British Museum, Mr. Ellis Waterhouse of Magdelen College, and Miss Rhoda Welsford of the Courtauld have been most helpful in providing photographs and information. So also, in Vienna, have been Drs. F. Klauner and E. Auer of the Kunsthistorisches Museum. In Paris Miss Sirarpie Der Nersessian, now of Dumbarton Oaks and Harvard University, and Mlle. Jacqueline Bouchot-Saupique of the Louvre have given me similar help. In Italy, Miss Marjory Ferguson found photographs for me when this was still a matter that required considerable ingenuity; more recently Director Laurence Roberts of the American Academy in Rome and his Acting Librarian, Mr. P. deDaehn, have given me much assistance to the same end. My thanks are generally due also to a number of museum officials and professional photographers on whose courteous accommodation the bulk of the illustration of this volume depends; specific credits for photographs are listed elsewhere.

Mme. Lili Fröhlich-Bum, author of the handsome monograph on Parmigianino published in 1921, was very generous to me with information and photographs before the war. To her book and to the careful monograph (published in 1932) of the Parmesan scholar, Giovanni Copertini, I owe a considerable debt which I most willingly acknowledge here. So also, like every other American student of sixteenth-century Italian painting, must I acknowledge my debt for inspiration and sage counsel to the dean among the investigators of Mannerism, Professor Walter Friedlaender of New York University.

Mme. Fröhlich has recently written to ask if I was continuing my former project, and with what success. I hope she will not be disappointed in this answer.

Boston, Massachusetts
August 20, 1947

Contents

Plates

Authentic Religious and Mythological Works, Figs. 1-119; *Authentic Portraits*, Figs. 120-147; *Attributed Paintings*, Figs. 148-167

Illustrations

The Authentic Religious and Mythological Paintings

ILLUSTRATIONS

ILLUSTRATIONS

ILLUSTRATIONS

ILLUSTRATIONS

xix

ILLUSTRATIONS

Attributed Paintings

PART I

Parmigianino's Concepts of Style

INTRODUCTORY NOTE

Parmigianino's style in painting is less amenable to generalization than that of many other artists. His activity spanned the two most unsettled decades in the art history of the sixteenth century, and his style in part reflects, as it also in part created, the complex artistic situation of his times.

The extremities of Parmigianino's career, but especially his beginnings, are unsusceptible to generalization. In his early years in Parma he participated fully in what has come to be defined as the crisis of style of c.1520, with its simultaneous triple possibility of resolution: as a continuation of High Renaissance style, as a development into the proto-Baroque, or as a formulation of Mannerism. Parmigianino's predisposition was toward the solution of this crisis in Mannerism. The evidence of this appears in his earliest artistic expressions: Mannerist elements come to assume their dominant place in his style within the first half decade of his career. This solution, though preordained for Parmigianino, could obviously not have been foreseen by him, and it emerged only after investigation of the other possibilities in his artistic environment. He attempted to absorb as much of the style of the High Renaissance as was possible to one of his personality and artistic situation in place and time; and under Correggio's example he experimented profoundly and successfully with the innovations of the proto-Baroque.

The style of Parmigianino's last years is conceived in terms consistent with those of his developed Mannerism, but with certain important qualifications both of form and content that are the result of a further crisis, this one mostly internal to the artist. However, in the decade of maturity (c.1527–c.1537) which intervenes between his early and late work, Parmigianino's painting reveals a remarkable consistency in stylistic intention and achievement. It is in this decade that Parmigianino develops and brings to its fulfillment a major aspect of the Mannerist thesis of style; it is the work of this period which is his most significant and influential contribution to the history of art. This "typical" and art-historically most important phase of Parmigianino's painting is generalizable, and it is from it that the conclusions of our Part I have been drawn.

It is to the works of this same decade that our generalizations are meant mainly to apply; but with the full awareness that this period, though consistent, is not static but a time of continuous development. Each painting will bear the application of a generalization, but with a difference of degree which may be clarified only by the specific analysis (in Part II) of the individual works.

A

THE RELIGIOUS AND MYTHOLOGICAL WORKS

The Canon of Design. For the developed Mannerist the process of artistic creation began at the opposite pole from that of the *quattrocento* realist; it differed also from that of the typical High Renaissance artist. Both these last began the creation of a painting in dependence on the world of visible reality, though with a major difference of degree in this dependence. For the Mannerist the generation of a picture began with an inner image, different from the vision of reality and, so the Mannerist imagined, more nearly perfect. This inner image, named by the late-sixteenth-century critics the *disegno interno*, was justified with arguments derived from Neoplatonic metaphysics, and exalted as the divine source of artistic creation.[1]

To the Mannerist theorist the *disegno interno* was a divine grace, and partook of the archetypal images of God in His own process of creation. The modern historian must account in other ways for the nature of the *disegno interno*. The image in the Mannerist's mind—of man, beast, bird, or landscape more perfect than any in the natural world—was fancied to be perfect from its conformity with an *a priori* canon, both of form and content. Divine grace aside, this canon was formulated in the Mannerist's mind in accordance with the aesthetic and expressive preferences which existed in his personality, which was formed in turn from the interaction of the man with the personality of his time, and of the artist with the natural world and the world of art around him.

The *disegno interno* was in truth a *disegno*, in its most literal sense: a design, or canon of design, which took its shape from the projection into aesthetic terms of the pattern of the artist's personality. For the artist who operates as does the Mannerist, largely from within, this system of design is a primary cause in determining the character of many of the elements of his style.

The High Renaissance artist began in his creation of a painting by consulting nature, but his aesthetic preferences demanded the imposition upon nature's accidental shapes of at least a measure of formal discipline. His canonical shape could be described as generalized in contour, uncomplicated and regular, with a tendency to harmonious equilibrium between horizontal and vertical directions. In certain respects Parmigianino's paradigm of shape could be said to resemble this one, but there are more ways in which it is evidently different. Parmigianino often uses shapes which may be relatively regular, and more often still of generalized contour, but they rarely suggest an effect of balance between directions. One axial direction, generally the vertical, strongly overbalances the

other: Parmigianino expresses as ovals those shapes which tend in nature to be circular; he transforms squarish elements into elongated rectangles. A quality of harmony is retained in such shapes, but it is a harmony much subtler and more attenuated than in the High Renaissance canon.

Shapes of such relatively regular effect occur in Parmigianino's system of design only in part from preference; they are in part a necessary accommodation to the appearance of nature. His more positive preference demands rhythmic activity stronger than that contained in regular shapes. The suggestion of movement, already implied in the emphasis of one direction in Parmigianino's ovals and rectangles, becomes the dominant property of those serpentine shapes which are, in quantity and in aesthetic effect, the most important in his system of design. These are oriented along a continuous direction, generally upward-moving, with such emphasis that little or nothing remains of the High Renaissance effect of balance around opposite axes.

Such serpentine motives may be thought of as quasi-linear: an extension into a lateral dimension of the fluid, warping contours that define them. The very act of comprehension of these shapes demands a sensitive and continuous awareness of their linear contours; an awareness not required in the reading of simple regular shapes, of which the aesthetic effect is immediate. In a sense, Parmigianino's pervasive preference for serpentine motives makes his system of design a kind of monumental calligraphy.[2]

Though the primary property of these serpentine motives is their rhythmic activity they retain, like Parmigianino's more nearly regular shapes, a kind of harmony. Their outline, though active and constantly changing in direction, remains continuous and unbroken; the shapes these outlines enclose have a fluid and eminently graceful continuity. An effect of harmony results also from the fact of the constant repetition through a figuration of serpentine motives of similar shape character. This harmony is perceptibly different from the harmony which emerges from the canon of shape of the High Renaissance, mainly because of the dependence of Parmigianino's system on so assertive a measure of rhythmic activity, but also because of the complication and refinement of the very elements on which the effect of harmony depends. His "harmony" becomes a swift, almost volatile mellifluousness rather than the serene and simply comprehensible balance of the High Renaissance.

The Human Figure: Its Content and Form. There is a remarkable consistency between Parmigianino's conception of the human figure and the character of his canon of design. Both of course take their eventual origin in the same inner disposition of the artist; however, it is usual in most artists that other than purely aesthetic considerations should intrude in their conception of man. A style of representing the human form generally

4

results not only from the aesthetic preferences of the artist but from a complex of ideas about the spiritual and physical functioning of man, of which some may not be in accord with the artist's purely aesthetic concerns.

Parmigianino admits no such intrusion of properties of content in the human being which will not accord with his aesthetic ideals. In his religious and mythological pictures, where he is not obliged to consider either physical or psychological resemblance (as he must in portraits), he projects his human actors as directly as is possible out of his *disegno interno*; the same inner preferences that dictate the aesthetic forms of his canon of design shape not only the forms, but also the content of his figures. They are conceived, both in appearance and in expression, in entire harmony with his aesthetic ideals.

Such an aesthetic conception of the human being is obviously a very limiting one. It excludes from Parmigianino's painting the representation of all that does not accord with his active and subtle harmony of design: neither physical nor emotional force may have any place in his art. The qualities of content he may express are the equivalents in the domain of human feeling and action of the qualities of his aesthetic dogma: mellifluous and subtle grace, and the overtones which may emanate from an extreme refinement of physical beauty. These qualities are so intimately interwoven with the aesthetic texture of the figure, and so intimately in concord with it, that it is impossible to assess the degree to which the human content has been separately infused: content and form harmonize to an exceptional degree and reinforce each other.

This restriction in content was recognized by the sixteenth-century critics, but it did not occur to them as a stricture on Parmigianino's art. They accurately isolated the properties of content in Parmigianino's figures and lauded him for the wondrous aptitude with which he expressed them. Vasari, for example (V, 218), says of Parmigianino: "... he gave to his figures ... a certain loveliness, sweetness, and grace of attitude ... so that his manner has been observed and imitated by an infinitude of painters, for his having given to art so pleasing a light of grace, that his works will always be held in esteem, and himself honored by all students of design."*

The qualities of *venustà* (best translated "loveliness") and *grazia* here distinguished by Vasari, as well as the others he describes, depend in large part on, and are communicated to us through, the physical structure of the body, its attitude and movement. Yet these qualities, as we perceive them in Parmigianino's figures, do not seem to be primarily physical, nor objective, in their effect. We are at least as much aware, when we regard these figures, of the subjective, associative overtones of their loveliness and grace

* "... diede alle sue figure ... una certa venustà, dolcezza e leggiadria nell' attitudini ... intanto che la sua maniera è stata da infiniti pittori immitata ed osservata, per aver egli data all' arte un lume di grazia tanto piacevole, che saranno sempre le sue cose tenute in pregio, ed egli da tutti gli studiosi del disegno onorato."

5

as we are of the physical conformations that underlie these qualities. As Parmigianino interprets them, these qualities require the participation of the spirit: of the spirit of the possessors of this *grazia* and *venustà* in the projection of their subtle overtones, and of that of the observer in his sensitive response to them.

An indication of the unphysical connotation to the sixteenth-century mind of the qualities of *grazia* and *venustà* is given by Dolce's effort to define *venustà*: "... loveliness, which is that I know not what, that is so much wont to please, so in painters as in poets; in such wise that it fills one's spirit with infinite delight, not knowing whence comes that thing, that so pleases us . . ."*3

The quality of *grazia*, the dominant property in content of Parmigianino's figures, is more intangible still. It contained for the contemporary observer almost least of all the connotation of a mere physical attribute: it was by the subjective effect inspired in the spirit of the spectator that the quality of grace took its more important meaning. The usage of the late sixteenth and early seventeenth centuries defined *grazia* as "Beauty . . . which seduces one unto love . . ."†4 As such it was a variant, more positive expression of the effect attributed by Dolce to *venustà*. The very etymology of the word, however, required that the quality of grace have a complex of connotations which, for the scholastically inclined mind of the sixteenth-century critic, extended well into the spiritual and even into the metaphysical realm. Grace was conceived to be a gift which elevated its possessor above the normal material world, and caused him to share in the nature of the Divinity who alone had the power, from His own Grace, to bestow this favor; it was at the same time an index of Divine favor and a means to the favor of others. The *disegno interno*, from which the embodied artistic vision stemmed, was itself described as a Divine grace; what was thus more appropriate than that it should exhibit the quality thereof?5 It was such connotations of the idea of grace as these which tended especially to emerge from Parmigianino's figures, which were themselves of such unmaterial appearance.

The exclusive stress upon these general qualities of intermingled spirituality and aestheticism may banish from Parmigianino's figures all expression of emotion or feeling which is not in harmony with them, but it does not prevent his sensitive exploration of certain types of psychological expression. These, though most subtly transcribed, often with an extraordinary effect of animation, nevertheless remain no more than embellishments or variations on the basic themes of *grazia* and *venustà*. These expressions are of mental states and attitudes—they are not sufficiently profound to be called emotions—which are usually superficial or momentary, or often both.

* "... la venustà, che e quel no so che, che tanto suole aggradire, cosi ne' Pittori, come ne' Poeti; in guisa, che empie l'animo d'altrui d'infinito diletto, non sapendo da qual parte esca quello, che a noi tanto piace..."
† "Bellezza ... che rapisce altrui ad amore ..."

Parmigianino's mature Madonnas are his paradigm of psychological content. Their expressions, so subtly nuanced, reveal among these nuances no more than a shadow of concern with the nominal content of the picture. Their charmingly animated faces are essentially masks. Granted Parmigianino's premises of content in the human figure there is little need for the indication of anything behind these masks. His actors are spiritually constructed in terms of surfaces, just as (as we shall see later) they are physically.

The opinions of two critics, one of the sixteenth and another of the late eighteenth century, aptly summarize between them the nature of Parmigianino's painting of expression. Vasari (IV, 12)[6] underscores the exceptional appearance of animation which Parmigianino infuses into his masks. Vasari observes that in this appearance of vivacity Parmigianino outdistances even Correggio: ". . . as one sees in many of his pictures, in which the faces laugh, and indeed where the eyes glance in most lively fashion, so that one perceives the beating of the pulses, as it best pleased his brush."*

Affò, the later biographer of Parmigianino, with the cooler view of the dawning age of neoclassicism observes, on the other hand, the limited range of Parmigianino's expressions: ". . . that if he did not demonstrate this gift of his in all the aspects of the passions, it resulted from this, that almost never did he paint other than naturally pleasant things."†

This dominance in the content of Parmigianino's figures of effects of *grazia* and its concomitant qualities, only slightly qualified by the psychological animation of the faces, extends from the figures themselves through the content of the entire picture in which they act. The nominal subject matter of the painting, even in the exceptional cases where it depends on positive and potentially dramatic action, is so dominated, and made to subserve Parmigianino's primarily aesthetic ends and their corollary expression in the human actors. In pictures of frankly devotional character, which form the bulk of Parmigianino's mature production, the religious connotation is virtually obscured by the *lume di grazia*. Yet, just as the faces are cleverly animated to give some sharper point of meaning to the graceful forms, so also does Parmigianino conceive, in each of the devotional pictures, some subtlety of incident in his exposition of the iconographic theme which gives some focus, and some appearance of specific and living meaning within the picture's general emanation of grace. Again as within the separate figures, this sharpening and animation of the generic content does not alter its essence, but only lends embellishment thereto.

As with other elements of Parmigianino's style, the reduction of expressive content in his figures has an evident relationship with an aspect of the High Renaissance. In

* ". . . come si vede in molte pitture sue, le quali ridano nel viso, e sì come gli occhi veggono vivacissimamente, così si scorge il batter de' polsi, come più piaque al suo penello."
† (p. 55): ". . . che se in tutti i caratteri di passioni egli non fece conoscere questa sua dote, avenne da questo, che fuori di cose naturalmente gentile altro quasi mai non dipinse."

many of Raphael's devotional pictures the figures have little positive expressive function, either as individual actors or in their connection with the iconographic theme. They are represented in such a way as to stress their beauty as idealized human forms and their decorative value as members in the design. Their expressive content may be reduced to an emanation of mood, only superficially related to the iconographic theme, but perfectly consistent with the aesthetic concepts which underlie Raphael's design of the human form and his design of the picture as a whole. It is essentially this that has occurred in Parmigianino's figures as well; but as in him the aesthetic bases of style have become at once more involved and more exquisite than in Raphael, the content expressed by the figures has become equally more complex and refined.

Parmigianino's conception in aesthetic terms of the human actors in his pictures, and the consequent excision of their religious content, owed less to Raphael's example than to a general cultural phenomenon, which however also had its origin in the High Renaissance. It was made possible by the diffusion among some of Italy's cultural elite of the twenties and thirties of a current of irreligious worldliness which was an extreme product of the humanism of the High Renaissance. In his maintenance of the external formulae, but not the inner content, of religious subject matter and iconography Parmigianino reflects the near-exhaustion in spirit of Catholicism during the period from the later High Renaissance up to the institution of the Counter Reformation.

Unlike his predecessors of the High Renaissance generation who exhibited, in less patent form, an absence of strong religious conviction, Parmigianino at least had in common with the theses of Christianity his highly subjective relation to the material world. This subjectivism, the generation of the work of art out of the *disegno interno*, makes Parmigianino's figures almost eidolon-like in form, almost like figures of pre-Renaissance art. However, in spite of their partial abstraction in appearance, and the vague associations with divinity of his ideal of *grazia*, Parmigianino's eidolons contain nothing of specifically Christian content. Parmigianino's very subjectivism is nevertheless fallow ground on which religious seeds may fall; so they in fact do, and with singular effect, but not until his last years which are beyond the compass of the generalizations we are making here.

Parmigianino's subjective relation to the external world also had an antecedent of a kind in the premises of his High Renaissance predecessors. The High Renaissance process of idealization, which required the elimination from the natural image of unharmonious accidents both of form and content, gave a veneer of subjectivism to that art. This habit of idealization did not, however, alter its essential naturalism. Parmigianino's subjectivism is not the lesser, but the dominant factor in his view of nature: the ratio in which the forms of his painted image are determined by subjective dictates or by consulting nature approaches the inverse of High Renaissance practice.

8

In his construction of the human figure Parmigianino imitates the forms of nature less than those of his *disegno interno*, his inner canon. As Parmigianino conceives and represents it, the figure pertains not to the objective world, but to a subjective sphere elevated above reality, though still parallel to it.[7] Such a concept, which is revolutionary while it only extends the idealistic thesis of the High Renaissance, becomes reactionary by its inversion thereof. This recognition of the ultimate authority of the inner image is by no means the invention of the first generation of Mannerists.

The essentially conventional construction that, in Parmigianino's art, symbolizes rather than represents the human figure differs most evidently from the figure types of the Renaissance in its singular canon of proportion: in Parmigianino's mature works the figure is always at least eight, and may be as much as ten or eleven heads high. This system of proportion is at once different from the canon of the High Renaissance, where such liberties as were taken with the natural appearance of the body tended toward the harmonious regularization rather than the attenuation of its proportions.

Parmigianino's elongation of the body is not motivated solely by notions of certain qualities of content in the human being which may be symbolically expressed by elongation.[8] It results equally from his canon of design, which (as we have observed) depends on fluid, quasi-linear shapes with a continuous and generally upward-moving rhythmic impulse: Parmigianino's figures acquire their specific character not just by elongation, but from the inseparable synthesis of elongation with this rhythmic system of design.[9] His figures are constructed on a long serpentine armature, which is the vertical axis of the body; around this is shaped the physical extension of the form. The outline of the body consists itself of serpentine rhythms, and within it are included rhythmically active shapes which may be oval, urn-shaped, or themselves serpentine.

The female figure is evidently more easily accommodated than the male to Parmigianino's preferences of design. Partly because of this natural concord of form, the dominant population of Parmigianino's pictures, not so much in number as in aesthetic interest, is female. Their preponderance results not only from their physical adaptability to Parmigianino's canon of design, but also from their suitability, so far in excess of that of the male, to the expression of the artist's preferences in content. It might be observed that the very premises of Parmigianino's style are in a way feminine, so that this pictorial matriarchy is inevitable.[10]

The importance of the female form in Parmigianino's paintings requires its analysis in some detail. The most complete, as well as the most developed among his female types is the "Madonna dal Collo Lungo" of *c.*1535, from whom the observations which follow have been mostly drawn (Fig. 80).

The body of the Madonna is at once of infinitely graceful and radically unnatural form. The normal dimensions of the female figure have been altered so that it may be

included in what is generally a long, narrow oval, some six times as high as it is wide. The vertical proportions of the figure have been especially drastically revised: the relation of the size of head to the length of body is some ten or eleven to one. In its general effect alone this figure instantly suggests a conventional construction rather than a reproduction of reality.

The details of anatomy confirm this first effect. Each separate part of the figure appears to have been subjected to a kind of corseting by the contour at its lower part, which forces its shape upward and outward. The feet have become elongated sinuous shapes; the toes are demarcations of the foot into minor curving rhythms. The lower leg is conceived out of two serpentine contours of opposite orientation, which together form the subtly asymmetrical urnlike shape common in Parmigianino's vocabulary of design. Like the foot, the leg is preternaturally long, and swells from the extremely slender ankle into a wide calf, then diminishes again to be rounded off by a rather broad knee. The thighs (obscured in the "Madonna dal Collo Lungo" by her seated posture, but as is evident from other figures) repeat in somewhat more generalized form the shape of the calf. However, the demarcation of the outer line of the thigh from the body is hardly observed, and its curve continues almost without deviation outward to the point of greatest lateral extension of the hips, whence it diminishes into the narrow, improbably high waist. The effect of this long line on the figure as seen from the rear (as in certain of the female figures in the drawings) is even more unnatural than its appearance from the front, for the line from knees to hips makes one virtually continuous sweep, of graceful, but fantastic elongation. This fusion of the lower half of the torso and the upper legs creates, by its complete interpenetration of weighing and supporting parts, a hopeless confusion in the ponderation of the body. There is no perceptible division into a weighing figure and supporting legs, as in a Renaissance figure.

Above the high waist the breasts are even more improbably high. They are very small and far apart, and are often, perversely enough, the only forms in Parmigianino's anatomies which are perfectly hemispherical in shape. They do not depend from any muscular tissue, but swell directly from the chest. The shoulders are molded within the steeply sloping oval outline which confines the upper part of the body, so that their smooth, sharply tapering curve offers no resistance to the fluid progress of the rhythmic contour around the form. The arms continue the shoulder line almost without modification or interruption; their shape is an attenuated repetition of the shape of the legs. The hands suggest the pattern of a slender urn, from which the fingers break into small elongated serpentines.

The neck conforms as well to this system of elongated serpentine shapes, with such remarkable effect that the "Madonna dal Collo Lungo" has taken her name therefrom. The head is an ovoid of almost geometrical purity. This purity of shape gives the head

a classicizing character, though its features are not at all specifically classic. Finally, to the head, as if it were an urn of which the base would be the neck, are attached ears whose shape is a singular approximation of the handles of a vase.

This system of conventional symbols for the human anatomy is highly artificial (in both the literal and figurative senses); and the effect of rarefied loveliness conveyed by the figure is the result of, and in proportion to, its artificiality.

As much as he can, Parmigianino seeks to transform his male figures from nature according to essentially the same principles as he does his female figures. They are given an equal elongation, and they are subjected to his impulse toward rhythmic revision of the natural form. However, if Parmigianino does not respect nature itself he respects the need for observing a parallelism with nature. Since the male body is not so tractable a vehicle for his rhythmic impulses of design he cannot, and would not make of it such an object of large-scale calligraphy as are his female forms. The male figure thus retains, in a general way, the somewhat rectangular structure which it has in nature, but it is an extremely narrow, elongated rectangle. The attenuation of the male figure resembles that of the female: the relation of height to breadth is usually similarly six or more to one. Within this frame Parmigianino exploits every possibility he may, short of evident incongruity, for the exercise of his rhythmic will. The irregularities of male muscular pattern are converted into a complex of rhythmic linear conventions: some broad, some small and nervously calligraphic. These replace, within the male form, the smoothly fluid serpentines of the female figure.

A study (Fig. 147) dating from Parmigianino's later maturity shows his proportions for the male form.[11] In this drawing (as one might perhaps expect from such a study) the proportions are somewhat more restrained and deliberately "correct" than in Parmigianino's other drawings, or than in his paintings. The vertical proportions of the body (considered apart from the head) are here almost academic: as in the most common High Renaissance canon the body is divided into three equal lengths: from foot to knee, knee to upper pelvis, and thence to the base of the neck. However, in strong contrast to the High Renaissance canon the relation of the height of the body to the width of the torso is nearly six to one. The relative size of the head is also less than in Renaissance models, so that it is contained in the torso three times, and in the legs four times. The whole figure is eight heads (or, according to the then more usual system of reckoning, ten faces) high; that is, the chief structural distortions from the High Renaissance type are in the narrowing of the torso and the diminution of the scale of the head.

It is interesting to observe that in spite of what we have described as the "feminine" quality in Parmigianino's style, his process of conventionalization of the male form does not usually transform it into such an androgynous curiosity as appears (for psychological rather than formal reasons) in the work of Correggio and Leonardo. Parmigianino's men

11

do assume as much as is reasonable and proper to the male of the quality of grace, but they remain patently masculine in form and in expression.[12]

The figures thus revised by Parmigianino obviously must "compose" in fashion different from the typical figure of the High Renaissance; and, as we shall see farther on, this in turn qualifies the composition of the picture as a whole. In Parmigianino's figures the bulk of the torso has been so much reduced (in its lateral even more than in its vertical proportion) that the limbs seem more prominent than the torso. Both limbs and torso are subjected to Parmigianino's rhythmic redesign, but the limbs are the more completely transposable into rhythmic terms. They thus tend to determine the compositional effect of the entire figure. Almost in inversion of the normal High Renaissance practice in construction of the body, the trunk is not its static and dominant core, but assumes the lesser role of a connective among the limbs.

A similar inversion of High Renaissance practice in the relative compositional importance of limbs and torso occurs among some of Parmigianino's contemporaries.[13] In their work the effect is often conspicuously different: the limbs may project from the trunk in such a way as to give the effect of the disintegration of the body into nearly separate elements; legs and arms appear as if in a state of centrifugal dislocation from the torso. The result is an almost "Germanic" irregularity of the figure outline; the self-sufficient identity of the human form, postulated by the High Renaissance, is totally destroyed.

In Parmigianino, however, the elements of harmony which persist in his spiritual and aesthetic preferences tend to preserve at least some part of the High Renaissance integrity of the figure. Two characteristics of his system of design operate especially toward this end. The first is the construction of his figures with reference to a continuous and dominating vertical axis. This axis in a sense acts as had the torso of the High Renaissance body, as the "core" of the entire figure: the rhythmic motives in the limbs depend from, and are integrated with, the single dominant rhythmic armature of the form. There results a kind of rhythmic continuity, and thus consistency, in the relation between limbs and torso. Moreover, the limbs do not usually project markedly from the trunk; as we have observed before, the whole figure is more often included within a generalized elongated oval or serpentine scheme. The body as a whole thus tends to be defined (though neither strongly nor consistently) with some effect of identity against its environment.

Parmigianino's distortion of the body in its vertical and lateral senses is not normally accompanied by a like distortion of its extension in depth. The least radically revised property of the human form is its plasticity which remains, at least on superficial examination, relatively natural in effect. However, though separately relatively convincing, this third-dimensional extension is at once deprived of a measure of its con-

gruity by its very association with the highly conventionalized two-dimensional design of the figure. Moreover, there are in Parmigianino's method of indicating the plastic existence of the form certain characteristics which tend further to deprive it of consistency and conviction.

The modeling of form is achieved with the aid of a system of illumination which, though naturally consistent in direction, is not consistent in the intensity with which it falls on the various parts of the figure. Certain portions of the form, arbitrarily selected for compositional or other reasons, receive the modeling light with exceptional strength, while others receive a much diminished light. There is thus no consistent effect of plasticity in the body as a whole, but only an emphatic modeling of certain parts. Parmigianino does not regard the figure as does the High Renaissance artist, as an integral three-dimensional unit, the plastic existence of whose parts must be consistent with the whole. Parmigianino's figures only rarely suggest a completely coherent three-dimensional construction.

There is a second difference from High Renaissance practice in Parmigianino's representation of plastic form. The High Renaissance painter tends somewhat to generalize his modeling of the figure, just as he does its shape. Parmigianino's modeling of form is also generalized, but often to so extreme a degree that it exceeds any High Renaissance standard of idealization and approaches, as is characteristic for Parmigianino, the realm of conventionalized symbol. His forms may in part be affirmatively three-dimensional, but they are so in a geometrical rather than in a naturalistic sense.

This overgeneralization of modeling accords essentially with the conventionalization of the two-dimensional shapes. It often appears that the modeling has been applied to the shapes in such a manner as merely to extend their conventional character from two into three dimensions, and thus to synthesize a conventionalized two-dimensional shape with an almost equally conventional three-dimensional form.

In spite of these qualifications, the three-dimensional representation of Parmigianino's figures still carries relatively more objective conviction than any other formal element in their construction. It would seem that the authority of the High Renaissance persists here more than in other aspects of Parmigianino's style; but this apparent respect for High Renaissance tradition, elsewhere largely contravened, itself requires explanation. As with the medieval artist, Parmigianino's attitude toward the representation of nature contains an element of ambivalence. He seems to feel, probably only partly consciously, how far his representation of the two-dimensional shape of the figure deviates from reality. His affirmation of the three-dimensional extension of the body responds to a need to convince himself, as well as the spectator, of the objective plausibility, or at least the probability, of the mostly unreal vision conjured up on the panel. By endowing an unnatural shape with the chief property that distinguishes the real

from the ideal world, that is, extension into the third dimension, Parmigianino wishes to affirm to the spectator, and also to himself, that his counterfeit is an acceptable substitute for the coin of represented reality.

Like the conventionalization of the shapes of the body, the overgeneralization of its modeling proceeds without reference to any natural anatomical structure. In Parmigianino's male figures, as we observed, the muscular system is converted into a set of near-arbitrary rhythmical conventions; in his female figures the representation of the body glosses over the muscular structure where it does not entirely eliminate it. More important, Parmigianino's figures have no inner structural frame. They are not constructed on a skeletal framework of bones but on a frame of linear rhythms; their apparent plasticity has no organic foundation. Parmigianino's figures are an assemblage of surfaces; nothing is contained within these surfaces, and their modeling is the affirmation not of a solid, but only of a hollow form.

This apparent plasticity is at once different from the concept of the High Renaissance. To the High Renaissance artist plasticity is not merely the representation of a surface extending into three dimensions; it is indissoluble from the sense of the physical mass contained within that surface. High Renaissance plasticity includes the communication of the conviction of this weighing mass of the figure; Parmigianino's "plasticity" is the indication only of the surface of a quasi-abstract volume. That surface is in essence no more than a continuous boundary between the hollowness of the inner body and the surrounding space.

The weightlessness of Parmigianino's forms is a quality not only consistent with, but strongly reinforced by, the numerous devices in his two-dimensional design of the figure that tend to deny the sense of weight. The attenuation of shapes, the dominance of the vertical axis, and the active upward progression of shapes and contours along it all supplement the illusion of weightlessness. Figures thus conceived evidently need not conform to normal considerations of gravity. There is no need for the painter to express the naturalistic effect of ponderation: the pose of the body, the arrangement of its limbs, and its relationship to the ground may be entirely dictated by whatever subjective considerations—compositional, decorative, or other—the artist may choose. The figure may, without discomfort either to its own organization or to the eye of the initiated spectator, occupy naturalistically impossible attitudes which may, in their functional sense, be utterly ambiguous.

Since the activity of the body is a function of its physical structure, it is apparent that the activity of Parmigianino's figures must be regulated by principles consistent not with nature, but only with themselves: their movements may be as artificial as their own structure. A figure may be so disposed as to indicate that it is in performance of an action and it will be understood, with some exceptions, what action is implied.

However, the action remains for the most part implication: no sense of functional conviction emerges from it. It is not accompanied by any expression of physical energy, nor by the idea (necessary to natural motion) of the displacement of any weighing mass, either of the body itself or of any object being acted on. As we have just observed, Parmigianino's pictorial world contains no weighing masses, and it requires no expenditure of energy to move a hollow volume. Even if such energy were required these figures would not possess it, for they have no organic muscular structure through which they may convey the expression of physical force. The only energy which exists in Parmigianino's mature figures is not physical, but an aesthetic energy, which proceeds from the rhythmic activity of their design. What they usually express is not the force of any action, but the effortless grace with which it is accomplished.[14]

Even the representation of such conventionalized action is uncommon in the mature Parmigianino. He seems reluctant to depict his figures in any motion which, in the real world, would require a genuine expenditure of effort. The holding of a flower, a hollow vase, or a scroll of parchment seems to be the most pressing labor to which they condescend. Generally, the body is more or less at rest, and its "energy" is devoted to the maintenance of some decorative pose. Any connotation of movement is so nearly incidental that we may characterize Parmigianino's view of the whole problem of activity of the body as one of concern not with actions, but with attitudes.

The same considerations apply to Parmigianino's representation of gesture, which is also deprived of physical (and thus of most of its expressive) force. His gestures are singularly limited in variety as well as meaning. He uses a few long-established conventions: the hands folded in prayer, the hand laid in pleading or advocacy across the breast, the gesture of pointing, etc. Their connotation is mostly a decorative one of attitude. Like the figures themselves, their gestures communicate a general idea of grace rather than any more specific meaning.[15]

In his method of representing the surface of the body Parmigianino retained, relatively longer than any of his other early Correggiesque habits, some traces of Correggio's sensuous way of indicating skin. In certain paintings from Parmigianino's earlier maturity there is thus a suggestion of sensuous conviction in the surface of the form that the underlying structure does not possess. Its effect on the spectator as to the measure of credibility of the figure is not unlike that which results from Parmigianino's partial assertion of its three-dimensional existence: both qualities help, in the small degree they can, to lend some probability to Parmigianino's improbable image of the human form.

By the middle of his mature period, however, this Correggiesque trait, and with it that measure of Correggiesque handling it required, was laid aside and replaced by a system of representing flesh more congruous with the conventional character of the figure as a whole. In the fully mature works the painting of the flesh does not resemble

any sensuous experience, but rather has the character of a vitreous film, like eggshell-thin porcelain. Its unsensuous, shell-like quality accords with, and accents the fact that it covers not a sensuous solid, but something much more like a hollow volume.

The comparison with porcelain is appropriate in more than one respect, for into this vitreous surface has been fused a complex vibration of color, like the variegated glaze of a porcelain. In spite of its polished smoothness of surface Parmigianino's rendering of the skin thus does not have the static, frigid quality that we associate with the similar unsensuous convention of neoclassic painting. On the contrary, through the sense of vibration imparted by its colored glazes, the skin seems singularly alive. Though unsensuous, it is charged instead with a quality of subtle and exquisitely distilled sensuality. The translation from sensuousness to sensuality—a quality which depends on the psychic overtones of the physical rather than on the physical itself—is characteristic for Parmigianino's interpretation of the human being, and accords with the way in which his other qualities of human content operate.

As with his painting of flesh, Parmigianino's manner of representing drapery is consistently expressed only in his full maturity. The drapery then acquires a quality in texture and in color which is parallel to that in the body surface. It becomes a thin and often transparent film, sometimes with a peculiar brittleness which causes it to resemble a kind of oilskin or cellophane more than cloth. It suggests a sensuous texture to an even less degree than does the flesh.

The form of the garments into which the drapery is composed defies specific description, especially in the more mature works. The garments do not resemble contemporary costume, even of the idealized kind which one observes in the religious works of Raphael. More nearly, they suggest the type of dress with which, in vague imitation of the antique, Raphael was accustomed to clothe his mythological personages. However, while the garments of Raphael's figures have an apparent logic as wearable clothing, the garb of Parmigianino's figures may violate one or the other of the two chief functions of dress in the natural world: that of protecting and concealing the body. The resemblance to wearable clothing is reduced to the borderline of mere probability; the garment is a conventional drapery which may be disposed over the body in any arbitrary way that suits the artist's decorative or expressive will.

In the earlier paintings (and in the latest one as well) the garment may be disposed around the body in such fashion as to weave around it a rhythmic pattern which is partly independent of the body and which may largely conceal it. In the mature pictures the garment tends to adhere closely to the figure; it becomes a partly transparent veil through which the forms of the body are communicated to the spectator. However, the drapery does not just passively subserve the body; it embellishes the basic rhythmic pattern of the figure with a further complex and varied rhythmic pattern of its own.

This adhering, fragile, near-transparent covering of the body sometimes becomes the medium for the transmission of the quality of distilled sensuality which is present in the skin beneath it. Through the drapery is communicated a tenuous suggestion of eroticism: an erotic of half-revelation and prurient half-concealment which is indicative of the complex, oversensitive, and even somewhat morbid reaction of Parmigianino to the physical world.

Composition. The form and content of the human being are so much Parmigianino's dominant concern that, even in the quantitative sense alone, there is small remaining room in his pictures for anything other than the human form. His system of pictorial composition thus depends with exceptional exclusiveness on his figures, and emerges mostly from their character of design. The most common of his mature compositional schemes is in fact one in which the major motive of composition is determined by the arrangement of the principal figure in the picture. Its composition as a single form—rhythmically active and continuous, and arranged upon an undulating vertical armature—becomes the kernel of the composition of the entire work. Such secondary figures as are introduced (constructed, of course, with the same character of design) are arranged on the picture surface in such fashion that their rhythmic movement is intimately integrated into that of the principal form, sometimes so intimately that they read in the design almost like additional parts or limbs thereof. The main and subsidiary figures are threaded together into a continuous rhythmic progression that endows virtually the entire picture surface with a pervasive rhythmic animation.[16]

This rhythmic progression through the picture is directed along a more or less exactly indicated course. Each figure in the design, and especially the major figure, is so arranged that it not only suggests a general impulse of rhythmic direction, but contains as well a fairly specific path which is marked out for the eye to follow. This path is indicated by devices of emphasis or muting, such as variations in the strength of light, manipulation of the drapery rhythms, etc.

Not only is the eye directed in its movement within the compositional progression, but a specific point of entrance at its beginning is marked as well. In the lower region of each picture, where its dominant rising rhythmic impulse begins, one of the extremities of an important figure in the design is almost always clearly isolated in such fashion as to take the spectator's eye. One or both of two devices may be used to achieve this isolation of the starting point: the first is the strong illumination of the extremity against a contrasting ground; the second, more usual device, is the location in space of the starting point so that it is the nearest physical object in the picture to the spectator. Occasionally, indeed, the starting point is so painted as to suggest that it projects for-

ward through the plane of the canvas into the very space in which the spectator stands, and thus provide him with an illusive bridge into the pictorial design.[17]

In certain of the paintings a strong connection with the spectator is effected through the gaze of a figure outward from the panel: it would seem that such a psychological bridge might serve as the avenue of entry into the compositional scheme. As we shall see when we examine specific cases, in the mature works this kind of psychological connective never marks the beginning of the formal compositional construction (though in two instances it acts in subsidiary fashion to reinforce it), but in fact may have an opposite purpose: to afford a termination and place of exit from the progression of design.

Once the entry into the path of composition has been effected the eye ascends swiftly along this path through the undulating, interwoven forms. Generally, its rising movement culminates in the head of the main figure where the rising impulse hesitates, but does not completely stop. However, its swiftness of tempo and its direction change: the head of the main figure (generally a Madonna) invites some sustained interest; the eye turns slowly through the head and then descends (though with little of the speed or sureness of its upward movement) toward the side of the main figure opposite that which it ascended. This suggestion of descent is tentative and brief; it soon intersects, and is caught up in, the dominating upward sweep.

There is not necessarily any period in this rising, curving, and returning compositional line; the spectator may retrace it again and again until he stops by an act of will, or is compelled to do so by a sense of aesthetic saturation. Each retracing of the progression permits the spectator to discover new and more complex embellishments of the main compositional theme. The composition assumes, as we involve ourselves in its detailed reading, more and more the character of an arabesque. It is essentially an extension into larger scale of the linear and quasi-linear motives of Parmigianino's basic system of design.

In certain pictures the artist has provided the spectator with an exit from this kind of compositional maze. Rarely, it may take the form of a minor motive of line, gaze, or gesture which serves as a transition from the involvement of the compositional path into a background space. A more positive device, which we have already observed, is an intense psychological contact with the spectator through the direct gaze out of the picture either of the main figure, or of a secondary figure closely integrated into the main compositional path; this psychological projection outward from the picture space may serve as a bridge out of the involvement of design much as the illusive projection of a physical extremity serves as a bridge into it.

Though arabesque in character, the compositional scheme does not become, as among some of Parmigianino's contemporaries, a free overall pattern conceived without

concern for compositional equilibrium or relation to the picture frame. The undulating vertical axis, normally the core of the design, is usually aligned along the center of the panel, and the main figure (which is the major element in the composition) tends to be fairly evenly disposed around it. The secondary figures may be much less symmetrically arranged on the picture surface, but any effect as of unbalance is resolved in part by the swift and intimate fusion of their rhythmic forms with the major rhythm along the central axis. We should remember that in any case, since Parmigianino's figures rarely contain any connotation of weight, their asymmetrical location need not result, as it would with High Renaissance figures, in the depression of the compositional balance to one side as if it were a scale. A final adjustment into compositional equilibrium results through the manipulation of light and color, and from variations in the energy and tempo of the rhythmic pattern through the figures.

This equilibrium, which is complex, delicate, and hardly stable, is very different from the secure compositional balance, based largely on the distribution of apparently weighing masses, that the High Renaissance artist achieves. The equilibrium of Parmigianino's pictures results mostly from the manipulation of an aesthetic intangible, rhythmic energy; and from the adjustment of the least concrete of physical properties, color and light. It nevertheless retains a quality of harmoniousness, though it is a harmony so tenuous and refined as to be almost unrecognizable by High Renaissance standards.

We have been speaking of Parmigianino's system of composition as if it operated literally in terms of the surface alone. It is obvious that in any representational art this cannot be entirely true. Just as Parmigianino's conventionalized representation of the body has extension into the third dimension, so also does his system of composition have a third-dimensional aspect: the continuous rhythmic progression which adheres to the figures follows them as they move in space. However, such spatial activity is small; the essential aesthetic character of the compositional progression is not altered by the graceful warping and yielding of the figures, though it does receive therefrom a further dimension of complication and interest. The spatial activity of the compositional path remains a minor embellishment of its movement over the surface of the painting.

Construction of Space. The nature of Parmigianino's image of man indicates that his values are primarily subjective ones. As such, it is at once understandable that his interest in the representation of the external physical world of man's environment will be neither profound, nor when it is expressed, objectively logical or correct. The harmonious relation which existed for the High Renaissance artist between man and the world in which he lived and acted, which often attains to an ideal balance, is replaced

in Parmigianino by a virtual dismissal, or at best a relegation to a very minor place, of the representation of the external world. The exclusiveness of Parmigianino's concern with the human being is at once a cause, and by inversion in part an effect, of his unconcern with man's environment.

While this assertive anthropocentrism has a strong and affirmative effect on Parmigianino's system of surface composition, on his handling of space and space composition it has an equally strong, but negative, effect. Because the surface of the picture is so predominantly occupied by representations of the human form the little space that remains around the figures has small opportunity, in quantity alone, to assert itself. As a formal and aesthetic element apart from the figures space has only a secondary role in Parmigianino's mature style.

The space which immediately contains and surrounds the figures themselves appears to depend in its construction more on the manner of construction of the figures than on any separate logic of its own. Its extension is only such as is sufficient to accommodate the figures, and their needs in this respect are limited. We have seen how Parmigianino represents the body as an assemblage of geometrical volumes without consistent plastic extension. The body does not convey the complete conviction of roundness of a High Renaissance figure, nor the feeling which the High Renaissance body suggests that the spectator may continue his inspection of its form around the rear by the exercise of a mental tactile sense. In comparison with High Renaissance figures Parmigianino's bodies do not always convince us of the genuine three-dimensionality even of their hollow volumes; we feel that what exists in the picture is only the modeled surface of the form, which extends as far around as the eye can observe, but not behind. The form may be in relief, but it is rarely convincingly in the round. The space required for the accommodation of such a form is relatively shallow: a narrow plane, like a slab within which a relief may be carved, suffices to contain it.

In none of the mature works are the figures distributed in depth; they uniformly remain within such a narrow, relieflike stratum close behind the surface of the picture. Their movements are expressed with a minimum of divagation from this stratum, either forward or to the rear. This cohesion of the figures in one plane, and the restriction of their spatial activity within it, are necessary to preserve the flowing and continuous character of their rhythmic design, both as individual elements and as a compositional group.

In most of the mature works the relieflike character of the plane of space which contains the figures is immediately apparent, because the space behind it is so little defined as to have no evident identity. It is as if the ample unit of space within which the figures of a High Renaissance picture are disposed had been folded up, accordionwise, toward the surface of the picture. The effect of compression implicit in the simile

is present in the paintings as well, for the figures are usually crowded close up to the plane of the canvas, as near as possible to the boundary between their own and the spectator's space.

In spite of their forward compression, the figures do not violate this boundary. The ideal front plane of the picture (which is physically the plane of the canvas itself) is for the most part kept rigorously intact; the figures stand close against the front plane, but at the same time they are strictly confined behind it. The front plane of the picture space is thus doubly defined: by the compression of the figures up to it, and by their confinement behind it; so that it becomes an almost concretely sensible phenomenon. It strongly marks the boundary between the spectator's space and the space of the painting, and prevents any illusion of continuity between the real world and the artificial world in the picture.

This positive demarcation of the plane of the canvas makes any violation of it particularly apparent. One such violation, or a close approach thereto, occurs in almost every picture: it has a deliberate formal purpose, which we have discussed before. This is the projection toward, or even through the front plane of a part of a figure to serve as a starting point of the compositional progression. That illusive (or equally well "connective") projection of a single form achieves a special emphasis through its (in the literal sense) singularity in the picture.[18]

The demarcation of the rearward boundary of the plane of space which contains the figures is not generally so clear. It is in part only negatively defined: by the compression of the figures toward the plane of the canvas, and by their absence of any assertive projection toward the rear. A sense of the rearward demarcation of the figure plane also results from the neutrality, or only vague definition, of such background as may be indicated in the region which remains visible behind the figures.

At an indeterminate distance behind the figure plane may be indicated a hanging, vague forms of dark foliage, a patch of sky, or even a tone without figuration of any kind. These backgrounds are not intended as reproductions of any specific environment; it would be paradoxical to relate the figures, themselves so distant from objective nature, with an objectively constructed space. An approximate indication of some indefinite milieu, vaguely parallel to an aspect of the physical world, is adequate to define the quasi-abstract sphere in which such figures must exist.

In the mature paintings the background escapes from the category of the neutral or near-neutral only in a few instances. In three cases (the Vienna "Conversion of Saint Paul," the Uffizi "Madonna di San Zaccaria," the Naples "Holy Family with the Young Saint John") landscapes are introduced which are fairly specifically defined, and which have a certain interest apart from the foreground figures. Even these landscapes, however, have characteristics which tend to diminish their spatial logic and inhibit the

sense of free rearward expansion. In the last two of these works the vanishing point of the perspective system has been displaced as far to one side as is possible: the lines of projection are thus partly flattened out into a plane not, as in a normal projection, perpendicular to, but oblique to the front plane of the painting. The background thus gives an effect as of a curtain hung obliquely to the plane of the figures rather than a free opening of space toward the rear. In all three pictures the linear rhythms of the figure composition on the surface intersect and overpower the recessive effect of the lines of projection.

In a fourth picture (the "Madonna dal Collo Lungo") the background contains at least a partial opening into a rearward space. Here Parmigianino uses a system of perspective even more abnormal than that described above. Its effect is, paradoxically, anti-recessive; it in fact increases the sense of forward compression of the figure plane. Partly to intensify the sense of vertical scale in the figures, the vanishing point of the projection has been placed very low. This vanishing point is thus located unnaturally close to the front of the picture, and the progress of the eye inward along the perspective lines which converge on it is effected only with a feeling of artificiality and strain: the perspective lines resist rather than encourage the rearward movement of the eye. Though it operates to some degree with an inward effect, by far the more positive character of this perspective is of a fanwise outward radiation toward the surface of the picture. Other factors in the same picture combine further to deprive the background space of its convincingness, until finally it assumes the character not of a recessive rearward opening, but of a second narrow panel of space slid in behind the figure plane.

Background space in Parmigianino's mature pictures is, then, either virtually non-existent or (in the few cases where it is defined) conveys no more than a tenuous suggestion of independent identity. The rearward space could hardly exist, or could not exist at all, separately from the plane which contains the figures. The backgrounds are conceived essentially in dependence on, and as an embellishment of, the figures.

However, Parmigianino's indifference to the organization of space applies almost as much to his handling of the space of the figure plane as it does to the backgrounds. Considered as a unit of space without its content of figures this plane is only slightly less insecure in its identity than is the background space. It is called into being, is defined, and assumes its perceptible (but simple) organization almost entirely as a result of, and in accordance with the character of, the figures contained therein.[19]

Light and Color. We have already observed of Parmigianino's use of light that it adheres fairly closely to nature in at least one respect, its consistency of direction. Usually, there is one source of light, and the direction of its passage across the objects

in the painting, and the direction of the shadows, accord with normal objective experience. At the same time, the intensity of the light may be most arbitrarily varied to satisfy compositional or other exigencies. We have seen how this distortion of intensities has a very negative effect on the consistent plastic expression of the figures.

In Parmigianino's earlier maturity this distortion of intensities may be quite acute: there are sharp high lights and heavy darks, but practically no middle intensities. This especially effects the use of light for modeling, which becomes somewhat abrupt in its opposition of relief and shade. The effect on the system of composition is still more apparent: the areas of high light are applied to the figures in such a fashion as to coincide almost entirely with the path of the compositional progression, while the areas of dark have a virtually passive role in the compositional scheme. The activity of light and the activity of the design are thus synthesized; the light marks out and reinforces the compositional path. Also, the submergence of the "inactive" parts of the picture in a neutralizing, passive dark helps to stress the dominance of the figures. Their environment is hardly visible, and the rearward extension of space is usually very vague.

In the more mature works this synthesis of light and compositional activity diminishes. The intensities are not so forced, and the lighting becomes much more diffused. Still, a kind of light, less aggressive in character than the forced contrast of light against dark, is employed to help in marking out the compositional progression: this is the coincidence of the active rhythms of drapery and limbs with light (high-value) color.

The lighting of the mature works often differs greatly from that of the earlier pictures, especially from the illusionistic early wall paintings. In these, the illusionism achieved by the apparent penetration of physical forms into the spectator's space is reinforced by the apparent location of the source of light also in his space; the light thus serves as an additional device to intermingle the spectator's and the picture world. As Parmigianino matures, the inhabitants of his paintings retreat more and more strictly into their own quasi-abstract pictorial space. To accord with this isolation of the picture world the lighting of the mature works is also separated from the spectator's space: its source is so located, far on the flank of the picture, that it gives the impression of originating, if not in the visible space of the picture, then in some imaginable sideways extension of it. The light thus becomes part of the picture world, which is separate, with its content, from the objective world of the spectator.

Especially in combination with its content of color, the light (in spite of its literalness of direction) finally assumes a considerable artificiality of effect. It never reproduces clearly the effect of any specific time of day, and especially not of the morning or midday hours. In one or two cases it may be vaguely identifiable as the light of afternoon, but more often it suggests twilight or early evening. The element of time in the environment of Parmigianino's figures is as ambiguous and unspecific as their space.

The active role which light plays in Parmigianino's style, especially in its compositional use, is different from the general practice of the High Renaissance, where light tends to be diffused and placid. However, Parmigianino's use of light is not entirely new in relation to his own regional antecedents, nor is it at all unique in his generation. Since the third quarter of the fifteenth century light had begun to play an increasingly various and active part in the painting of Venice, as well as elsewhere in North Italy. Parmigianino's Emilian predecessor, Correggio, in certain pictures had assigned to light (both as illumination and as high color value) a compositional role very like that which it plays in Parmigianino's work. Among Parmigianino's contemporaries elsewhere than in the North there was a widely manifest tendency to employ light in a similar way.

It seems to be an axiom of the aesthetics of painting that in a style conceived like Parmigianino's, out of fundamentally rhythmic—that is, linear—premises color must be an element of secondary importance. The axiom holds for Parmigianino, but he comes as close to violating it as seems possible. The color in his paintings assumes a formal and aesthetic interest which, though it does not exceed, nevertheless often nearly approaches that of the rhythmic design. His handling of color is as acutely sensitive as his handling of line; it is even more complex, and more difficult to characterize.

This complexity exists in spite of the relatively restricted color range which Parmigianino employs in his mature works. The colors are chosen mostly from the so-called "cool" side of the color circle, in the range between yellow-green and blue, with a dominance both in quantity and aesthetic effect of green and its variants. These colors are rarely clear primaries, except in small fields where they appear as accents; in the larger fields they tend to be a somewhat equivocal mixture between primaries. Further, it is again only in the smaller fields that the colors appear at anything near to full intensity; in larger areas they are reduced in intensity in varying degrees by the admixture of neutrals. Yellow tends toward a pale golden tone, or lower in the scale toward brown; blue is often mixed with white to become a greyish tone, or sometimes a silver-blue suffusion; the dominant greens assume an olive cast.

This limitation in range and intensity evidently results in a kind of harmony. Within the limitation, however, Parmigianino uses every possible device to achieve complexity and variety. When a large field, as of drapery, is painted with single tone it is patterned with light and dark so that its values run through almost the whole possible scale. More often, a large field is painted not in a continuous color, but in a shifting complex of small areas of related colors, which nuance from one into another. A further complication is achieved through a sensitive exploitation of reflected color, not only within the already highly variegated single field, but from adjoining fields as well. The total effect of the color surface may be one of minutely varied, subtly nuanced complexity, like a colored veil shot with prismatic light. Still, because of the limitation

24

of range and intensity in the colors the effect is muted, often even somewhat somber, and sensibly harmonious. What finally emerges from the color surfaces is often not so much a sense of definable color as an effect of shimmering tonality.

Colors from the "warm" side of the color circle are relatively restricted in their use. The draperies of the principal figures, which are usually the largest areas of color in the picture, are only occasionally of a warm color, though they may contain warm accents. The use of warm color in larger fields is more often in a portion of the drapery of a subsidiary figure, or in a part of the background: as in a hanging behind the figures, or the toning in of an undefined rearward space. Except where they are used as accents, the warm tones, like the cooler ones, are muted in value and intensity. Unlike the cooler tones they are usually rather flatly applied, without complex mixture or variation; they tend to have a somewhat passive, recessive effect.

As Parmigianino uses them, the distinction between "warm" and "cool" tones often seems a rather artificial one. The so-called warm tones, at least in the larger areas, may appear rather flat and inert; their warmth seems to have been largely extracted. The so-called cool tones, on the other hand, are often intensely active, and their very activity conveys a kinetic sense of warmth; they seem pervaded with the radiance of a tempered, but living light. Moreover, they often borrow, by reflection from adjoining warmer fields, threads of warm color which are subtly interwoven into their own variegated surface. Sometimes the cool colors assume an almost acidulous quality which in itself contains a suggestion of warmth.

This partial inversion of the usual characteristics of warm and cool color is one of the most subtle of Parmigianino's coloristic devices. With it he is able to introduce a faint, almost indefinable suggestion of dissonance, which however operates within the larger fundamental harmony of color and does not upset it. It is a system more ingenious and sensitive than the frank introduction of dissonant tones used by Parmigianino's most coloristically apt contemporaries (Rosso, for example).

The painting of the flesh surfaces achieves the coloristic vibration which we have remarked before from the same complex system with which Parmigianino colors his larger fields of drapery. The basic tone in the skin of his women and children is an unnaturally pale, cool, porcelain white. Into this are fused subtly variegated glazes: the varying pinks of the skin surface (which sometimes seem quite warm by their contrast against the paleness of the underlying white); the blueish or pale violet tone of shadows; and finally various reflected tones from adjoining surfaces. Occasionally, the coloristic complication of the flesh is such that it acquires a quality like that of mother-of-pearl.[20]

A part of Parmigianino's color surfaces are highly activated by the devices we have described so far but, as we have observed, some color surfaces are relatively passive. The distinction in the use of active or inactive color surfaces depends mainly on the

situation of the color field in relation to the rhythmic compositional design: the active areas of the composition and the most active areas of color largely coincide. As is the case with his use of light, Parmigianino synthesizes the activity of color into the rhythmic progression of the composition.

The relatively passive fields of color are not altogether without an element of compositional meaning, for they may relate to the rest of the picture in such a way as subtly to increase the measure of balance in the usually highly complicated design. Also, in certain instances, the composition may be compensated toward a kind of balance by the few small fields of pure color which serve as accents. However, there is no composition in color which exists apart from the rhythmic design. The compositional function of the flatter tones, or of the few brilliant accents, is entirely subordinate to and dependent from the main rhythmic pattern, to which the active fields of color are applied. The activity of rhythmic composition, light and color are fused: they mutually reinforce one another, but the rhythmic design remains the dominant.

It cannot be determined which element, light or color, takes precedence in the artist's intention. They are in fact probably indissoluble in his conception and painting of them. In any case, the fusion of the active areas of light and color[21] strongly qualifies the character of the latter. The activity of the color is in part a function of its being infused with light: the complex vibration of the active color surfaces results from their partial interpenetration with active light, and their partial dissolution into it. This partial dissolution of substance into light is, consistently with the other basic premises of Parmigianino's style, antimaterial in tendency. The color is only in part a property which pertains to the physical objects, and for the rest is a property of the unphysical, intangible light that is suffused onto their surfaces.

If we should take it apart from its context, Parmigianino's use of light synthesized with color might be considered as a proto-Baroque tendency. This suffusion of the colored surface with light is a characteristic to which Correggio somewhat inclines in his later works (mostly after Parmigianino's departure from Parma; there is no question of influence), and it occurs elsewhere in North Italian painting contemporary with, and subsequent to Parmigianino. In the truly proto-Baroque, and later in the Baroque painters, however, this suffusion proceeds from the naturalistic observation of illuminated atmosphere: it effects not only the surface of the forms, but pervades the entire picture; it is one more objective element in a naturalistic style complex. In Parmigianino the "atmospheric" effect of vibration of color in light is usually confined to certain surfaces arbitrarily selected within the total design. There is no natural "atmosphere" between and around these surfaces; the rest of the picture may be virtually a vacuum.[22] In Parmigianino's paintings the suffusion of color with light is associated not with an otherwise naturalistically convincing representation, but with forms already half-

abstract. His handling of light and color should be read in the context of the rest of his style. In his half-immaterial world this partial dissolution of color into light is a further reduction of materiality; by it his paintings are removed a step still farther from the objective sphere.

Technique. Technique, in the sense of the mechanical application of paint to canvas, offers no special problems in the case of the mature Parmigianino. For an artist of his extreme facility of hand technique comes as a postscript to style rather than as an element in its formation.

The importance of active light and color in his art causes Parmigianino to prefer an oil medium, which he generally applies to a panel support: his minutely varied, shimmering, and somewhat brittle surfaces attain their maximum effect with the aid of reflection from a solid, opaque ground. His use of canvas is rare; even more so is his use of tempera as an exclusive medium. When required to execute a wall decoration, his control over fresco is unusual for an artist who is chiefly an easel painter. In all these media Parmigianino appears to adhere to the conventional technical practices of his contemporaries. He is not an experimenter in the techniques of painting, as he is in the graphic arts.

There is a further aspect of technique which is intellectual rather than mechanical. Technique in this sense consists in the various stages in the generation of an individual painting, from the conception of its aesthetic and expressive idea through its embodiment on the panel.[23] This process is traceable through analysis of the drawings and cartoons made in preparation for the picture, but unfortunately, the actual state of survival of genuine preparatory studies by Parmigianino is such that we cannot construct any reliable case for this "intellectual" aspect of his technique.

One characteristic of Parmigianino's technique deserves special comment. It concerns the actual execution of his paintings, but in fact refers more to the mental attitude of the artist than to the mechanical application of paint. This is his extreme unwillingness, in spite of the authoritative example of Raphael and his school, to admit any assistance in the execution of his pictures. Except in the single case of the Steccata frescoes, where he was most grievously pressed, there is no evidence to indicate that Parmigianino ever delegated any part of the labor of execution to another hand.

This intensely personal concern with the actual execution of his paintings is symptomatic of Parmigianino's strongly subjective attitude toward his art. His visions were entirely personal, and so sensitively conceived that their embodiment could not be left to any but his own hand. Parmigianino alone could control the mechanical agencies of expression so that they would accord perfectly with his inner image.

B

THE PORTRAITS

The basic propositions of style which underlie Parmigianino's religious and mythological works are apparent in his works of portraiture as well. In the portraits, however, these propositions of style are neither so explicitly nor so extremely expressed. Like the actors in his religious paintings, the subjects of Parmigianino's portraits exist in a sphere only parallel to reality, but their remove therefrom is considerably less.

Certain factors inherent in the traditional conception of the portrait compel this closer *rapprochement* with reality. The most important is also the most obvious: the common acceptance by both artist and sitter of the need to achieve a physical resemblance.[24] The second factor grows out of this common thesis, which imposes a different relation between the artist and sitter than that which exists between the artist and the inhabitants of his allegorical picture world. In the painting of a portrait Parmigianino is confronted not merely by the problem of assembling out of his aesthetic preferences a set of shapes which combine into an approximate resemblance to a human body, and into which he may infuse whatever content he pleases. On the contrary, he is confronted by a specific physical form, inhabited by a specific personality. The sitter is the possessor of a "style" just as the artist is. The portrait thus tends to become, in varying measure, a synthetic object in which an accommodation has been effected between the style of the artist and the style of the sitter.

An important element in the "style" of the sitter which helps to effect this accommodation required of Parmigianino is the quality of decorum which attaches to the sixteenth-century personality in increasing measure from the late 1520's onward. The need to observe this controlled continence of spirit and behavior in the sitter immediately imposes not only on the content of the portrait, but also on its formal organization, a similar decorum. The more extreme expressions of Parmigianino's aesthetic will, to which he gives free rein in his devotional and mythological pictures, are much moderated thereby. On the other hand, a related quality in the style of persons of this period, their increasingly self-conscious pretension to, or actual possession of, the appearance of aristocracy and elegance, does not require any special adjustment in Parmigianino's style; this quality accords intimately with a preëxistent basic factor in his own artistic character.

The measure of compromise between the artist and the sitter thus considerably qualifies, but does not fundamentally alter, Parmigianino's basic premises of style.

PORTRAITS

Though both the details and the larger formal structure of each portrait are adapted to the characterization of its subject, this adaptation occurs within a formula that shows a general community throughout most of the mature portraits. There is also a common denominator in the content of the portraits: though without any apparent sacrifice of their individuality, Parmigianino's sitters all conform in some degree to a conception of the human being that partakes at least in some small measure of the painter's imaginative ideations of humanity.

The formal common denominator which exists among Parmigianino's mature portraits is the easier one to define. His predisposition toward the emphasis of the vertical direction causes him generally to adopt a longer format than that used in the portraits of the High Renaissance; he often uses the then relatively new three-quarter length.[25] A few mature portraits are of the conventional bust or waist length, and in these there is no conspicuous distinction in composition from the portraits of the Renaissance.

The figure is usually disposed along a rather rigid vertical axis, and the balance of the picture with respect to this axis is fairly carefully observed, to a greater degree than in the other paintings. The portraits are by no means obvious in their balance, but at the same time none of them is constructed with such an extreme of complicated and tenuous equilibrium as may occur in the religious works of the mature phase.

This simplification in the balance of the composition is accompanied by a restraint of Parmigianino's usual will to achieve a complex, actively rhythmic design. The fundamental compositional structure in most of the portraits consists of a curving arc, formed by the disposition of the arms, which moves across the vertical axis in such fashion that a sense of fusion is effected between the two directions. Each direction contains an impulse of movement, but it is not complicated, nor is the effect of movement at all dominant over the other elements of design. The sense of rhythmic animation in the two intersecting directions is normally contained, and equaled in interest, by the effect of the composition as an arrangement of a fixed silhouette upon the picture surface. Only infrequently does a portrait composition display a touch of the serpentine complication of the religious pictures.

It is in this moderation of his rhythmic impulse that Parmigianino gives the most positive evidence of his adjustment to the special requirements of the portrait. The aesthetic interest of rhythmic pattern, so entirely dominant in his nonportrait paintings, is in the portraits at most only the peer of, and usually quite secondary to, the other qualities of design and content. In fact, what emerges most strongly from some of the portrait compositions is a contrary expression, of a somewhat tight continence, even of a rigidity in design. This effect lies in the intermingled domain of form and content: it proceeds not merely from the marked insistence of the vertical axis, nor from the frequent effect as of a tight interlocking on the surface of the motives of design, but

also from the severity of attitude of the sitters. This rigid continence accords with and reinforces the ideal of decorous self-restraint which, as we have observed, is a frequent property in the personality of the contemporary subject.

The use of color in Parmigianino's portraits is also more moderated than in his religious works. The male portraits of the mature period are particularly restrained: they are mostly painted in neutral tones (for example, black against a ground of brownish gray or grayish blue-green); only rarely is an unassertive note of color introduced into an accessory.[26] The gravity of color in the male portraits again accords with the mood of the subjects. Part of this restraint in color results from the contemporary mode in male dress; the female portraits are less uniform.

The mesh of nuanced color that appears in the religious works, especially of the later maturity, is less evident in the portraits. The animation of their surface is achieved by somewhat different, less highly artificial means, in accordance with the lesser artificiality of the portrait as a whole. The handling in the portraits is much like that of the religious pictures of the corresponding moment. As in them, the highest point of finish is in the head and hands, but this degree of finish tends to be less uniform throughout the portrait than in the religious work. There is a relative relaxation in the rendering of surface texture in the garments, and a greater looseness in the brushing-in of the background. The result is an activity of surface not greater than that in the religious works, but different: this activity depends on the partial simulation of varieties of texture, and a suggestion of an effect of atmosphere. These qualities do more than convey an animation to the picture surface: by their approximation of these aspects of visual appearance they suggest the more nearly genuine sensuous existence of the subject.

However, this difference in physical convincingness of the figures from those in the religious works remains one of degree and not of kind. The more nearly genuine texture of the garment is disposed around a form of which the plasticity (except in the two last, late, portraits) is often even less secure than that of the imaginary figures: in many of the mature portraits the bodies tend to an effect of silhouette. We are much more aware in them of their contours than of their inadequate suggestion of three-dimensional form.

These figures are contained within an environment that is as limited in its extent and its description as in the religious paintings, if not more. The suggestion of atmosphere in the space around the figures, like their texture, conveys only a surface property of sensuous appearance, while its more substantial aspects are less convincingly represented. The narrow plane of space within which the figure exists is not defined beyond the minimum requisite point: within this narrow space the sitter is usually placed at a slight, but unassertive angle to the picture surface, and close up to it. As in the religious works, that surface is carefully respected, and becomes a sensible boundary between

the spectator and the sitter in the picture. This division is intended not only as a device of form, but often helps to emphasize a quality of content: that superior detachment from us that the sitter's aristocracy implies.

The portraits are the one aspect of Parmigianino's art where the interest of the subject matter uniformly at least equals, and generally dominates, the interest of the picture as a formal aesthetic construction. The extreme refinement and sensitivity which the artist applies in his religious works to the perfection of an aesthetic ideal, so slight and subtly fragile in its expressive meaning, becomes, in the mature portraits, his agency for an incisive penetration into, and superlative record of, the psychology and psyche of his sitters. This record often contains qualities of seriousness and intent human concern that are quite at variance with Parmigianino's exalted exploration, in his mature religious works, of the exquisite. By contrast with the *raffiné* content of the religious pictures, the expression of the portraits is at once immediate and vital.

Each of the portrait subjects is highly characterized as an individual. This individuality exists in spite of the elements of conventionalization we have observed in the representation of the physical structure of the sitter, a conventionalization that extends in some degree even to the drawing of the face. This does not affect Parmigianino's sharp rendering of the miniscule details with which, within the larger structure, he is able to convey the high degree of psychological animation of the face. Also, there is ample room within the broad formula of composition for its manipulation into a pattern of which the effect accords with, and complements, the psychological emanation of the sitter.

The examination of the way in which these highly individual characterizations are achieved must be deferred to our study of the specific portraits. In this place we must assess a more general concern: the qualities of content which the subjects of Parmigianino's portraits appear to share in common. These qualities do not exist in the sitters by pure imposition from the artist. They reflect an interpretation by an eminently sensitive contemporary of the collective personality of his time, or rather of the collective personality of the elite thereof. This interpretation takes its character in part at least from the fact that the artist himself belonged to the milieu he was portraying: as one of this milieu he would tend to regard his fellows in basically the same way as they regarded themselves and one another. As the high contemporary esteem of his portraits indicates, Parmigianino's view of his fellow men must have seemed reasonably just in their own eyes.

This generic personality depends most immediately on a degree of consciousness of self in the individual which seems both to exceed, and to be different in its nature from, the self-awareness of the person of the High Renaissance. The self-consciousness of Parmigianino's sitters is more intense, but less inwardly secure. This inward insecurity

may not be betrayed, however; its presence is concealed beneath a mask of extreme self-discipline, appropriate to the contemporary insistence on decorum. This decorum is not the quiet, self-assured reserve of the High Renaissance, but a tense and rigid self-restraint. The more complex and sensitive the man's self-knowledge, and the less his certainty of self, the greater the need for such a fixed outward appearance of control. An evident tension may arise from the imposition of this strict continence on inner feeling.

This conscious discipline of self results in a measure of willed isolation of the person from his fellow men. He presents to them his cool, severely continent exterior, with its fine (and were it not for the artist's subtlety) impenetrable severity of attitude and expression. Whether consciously so intended or not, the whole effect conforms to what we conceive of as an extreme of aristocracy; the conception of aristocratic behavior was, in Parmigianino's time, just in process of acquiring its traditional form. This quality is one which Parmigianino inevitably finds most sympathetic, since it is the nearest counterpart in the realm of manners to his aesthetic ideal of *grazia*.

The effect of aristocracy in the sitter is accentuated by certain externals, as by his decorum in dress; and further by the liberties which Parmigianino's still partially subjective relation to reality, even in the portraits, permits him to take with his sitter's physical forms. These are regularized and refined in most of the portraits so that the sitters conform (in a general way and, as we observed, without trespassing in any evident fashion on individual likenesses) to an ideal of refinement in appearance which, in the physical domain, is parallel to their psychological expression.

Parmigianino is, with Pontormo, among the first of the portrait painters of the post-High Renaissance generation to recognize the changing personality of his time, and to evolve a style for recording it. Parmigianino's generic interpretation of his contemporaries, which we have here described, became a major precedent for the portraitists of the Mannerist period. However, there is a difference, literally vital, between the role which this generic personality plays in Parmigianino's portraits and that which it assumes in the portraits of the subsequent Mannerists. With them, the generic personality tends to absorb that of the individual. To Parmigianino, the generic personality is no more than the common basis among his portraits, upon which he constructs the animate image of a highly individual man.

PART II

The Paintings

A

THE RELIGIOUS AND MYTHOLOGICAL WORKS

*THE FIRST PERIOD IN PARMA.**

1503, January 11: Girolamo Francesco Maria Mazzola, son of the painter Filippo Mazzola, born in Parma. The document in the archives of the Baptistery of Parma reads: *Jeronimus franciscus maria f[i]l[ius] philipi de mazolis natus 11 et bapte[satus] 13 Jan[uarii].*[1]

1505: Death of Filippo Mazzola. Francesco was placed under the guardianship of his uncles Pier Ilario and Michele Mazzola, who were also painters. Francesco displayed an extraordinary precocity in drawing and was encouraged in the study of art by his uncles.[2]

1519: Probable date of Francesco's first essay in painting which survives to us, the "Baptism" in the Kaiser Friedrich Museum.

1521, summer: So that he might be out of danger from the campaign then being conducted by the Papal and Imperial forces against the French in Parma, Francesco's uncles sent him to the small town of Viadana (in Mantuan territory, a few miles to the north across the River Po).[3] Parmigianino was accompanied on this trip by his contemporary, Girolamo Bedoli, who seems to have been a *garzone* or apprentice in the shop of Pier Ilario and Michele.[4] Bedoli later became the husband of Pier Ilario Mazzola's daughter[5] and thus Francesco's cousin by marriage. It is probable that Bedoli was Vasari's source for most of the information in his life of Parmigianino in the second edition of the *Vite*.[6]

1522, early: Francesco returned to Parma.[7]

1522, November 21: Francesco was awarded a contract for the decoration of a chapel in the Cathedral of Parma.[8] The work was never executed, but the award of the contract is significant in that it indicates the high reputation of Parmigianino, in spite of his youth, among contemporary painters in Parma. Other recipients of contracts were Correggio, Anselmi, and Rondani.[9]

1524, late summer or autumn: Parmigianino departed for Rome in company with one of his uncles.[10]

* The discussion of each period is prefaced by a listing of significant dates in Parmigianino's personal history during that period. Those dates which relate specifically to the paintings, rather than to the biography, are to be found in the catalogue.

35

PAINTINGS

In 1519, in his sixteenth year, Francesco Mazzola painted his first recorded work, a "Baptism of Christ" (Kaiser Friedrich Museum, Fig. 1). It is a picture of very limited aesthetic merit, but of great interest as a document: not only for the light it throws on the history of Parmigianino's development, but because it is apparently unique in style for this moment in Emilian painting.

So considerable is the difference between the awkward, provincial appearance of this work and the achievement of the mature Parmigianino that it is difficult to believe, in spite of the secure evidence of the documentation, that he is in fact its author. This difference is, however, not so great as it superficially appears: it results more from a difference of a single one of the elements out of which a style is composed, that is, the surface vocabulary of details, than from a disparity of underlying traits of style. Beneath a vocabulary of detail which, as we should expect in so young an artist, is mostly borrowed, the "Baptism" contains a formal organization essentially consistent with that which appears in Parmigianino's mature work. When this borrowed shell is stripped away the remaining substance testifies to the painter's seemingly innate disposition, in a time and milieu where there were no precedents therefor, toward Mannerist premises of style.

On the whole, Francesco's borrowings in the "Baptism" do not persist beyond this single picture. In his next surviving work they are replaced partly with a vocabulary adapted from Correggio, and partly by the emergence of Francesco's own repertory of detail. However, the borrowed vocabulary of the "Baptism" is not, as is common with an immature painter, a merely automatic effect of his most instantly accessible artistic environment, but the result of a deliberately exercised choice. Like its formal substance, the surface detail of the "Baptism" is indicative of Francesco's early disposition toward a major aspect of his mature preferences of style, and on this account deserves the trouble of tracing it to its source.

It would seem that the influence which should have contributed most to the formation of Francesco's first work should have been that of his immediate teachers, his uncles Pier Ilario and Michele Mazzola. Vasari (V, 218–219) gives an account of Francesco's relation with his uncles which, though somewhat literary, sounds generally convincing:[11] ". . . although they were old men and painters of no great fame, being however of good judgment in matters of art, it being recognized that God and nature were the first masters of that youngster, they took specific care that he should devote himself to drawing under the discipline of excellent masters, so that he might acquire a good manner. And it seeming to them, in continuing, that he was born, one might say, with brushes in hand, on one hand they incited him: and on the other, fearing lest too much study ruin his health, at times they restrained him."*

* ". . . ancorchè essi fussero vecchi e pittori di non molta fama, essendo però di buon giudizio nelle cose dell'arte, conosciuto Dio e la natura essere i primi maestri di quel giovinetto, non mancarono

RELIGIOUS AND MYTHOLOGICAL WORKS

The two uncles seem to have exercised their guardianship in admirable fashion, particularly in that they recognized their inability to communicate anything to Francesco other than the mere mechanics of their craft. When we seek in their paintings for elements which might suggest those found in Parmigianino's first essay we find that the "Baptism" has preserved little, if anything, from these retarded imitators of the Venetians.[12]

As Vasari notes, Pier Ilario and Michele "took specific care that he should devote himself to drawing under the discipline of excellent masters." It is impossible to know how literally this statement can be taken.[13] The other members of the company of painters in Parma during these years were in fact hardly *eccellenti maestri*; at best their merit did not much exceed that of the two elder Mazzola.[14] Comparison of the "Baptism" with the productions of other native painters then working in Parma indicates that their influence, if any, is as inconsequential and as dubious as that of Parmigianino's uncles.[15]

In 1519 Correggio had not yet established himself as a dominant force in the Parmesan artistic scene. By then he had executed only a single work in Parma, the Camera in the Convento di San Paolo; in 1519 he was mostly absent from the city.[16] The "Baptism" indicates that Parmigianino had nevertheless acquired some minimum experience of Correggio's art, for it would appear that at least the *putti* and the facial types in Francesco's picture depend with fair certainty on that master. The *putti* in the "Baptism" may have been suggested by those of the Camera di San Paolo, but there is an alternative precedent for them in the "Saint Francis" altar in Correggio's native town. That this is the more likely source is indicated by the suggestively Leonardesque flavor of the heads of Francesco's two large figures: the most convincingly Leonardesque type then existing in the neighborhood of Parma was the Saint John in this same Correggio altar.[17]

It thus seems that the young Francesco must have visited the town of Correggio between 1515 and 1519, and there examined this publicly visible example of the older painter's art. The visit must have been relatively brief, and Francesco's opportunity to examine other works by the master relatively limited, for there is no other evidence in the "Baptism" beyond the details just discussed to indicate a more profound exposure of the young Parmigianino to Correggio's painting of his pre-Parmesan period. In all the works of Francesco's first period in Parma subsequent to the "Baptism" Correggio's influence was to become pervasive, in fact nearly exclusive; but in Parmigianino's first essay this influence is just perceptible.[18]

con ogni accuratezza di farlo attendere a disegnare sotto la disciplina d'eccellenti maestri, acciò pigliasse buona maniera. E parendo loro, nel continuare, che fusse nato, si può dire, con i pennelli in mano, da un canto lo sollecitavano: e dall'altro, dubitando non forse i troppo studi gli guastassero la complessione, alcuna volta lo ritiravano."

Though the amount of Parmigianino's derivation in the "Baptism" from Correggio's "Saint Francis" altar is of minor importance, it is nevertheless indicative of the young artist's disposition to pass over the products of the contemporary school of Parma and to seek in works of more accomplished, non-Parmesan, painters for models for his style. It was such a questing beyond the limits of his local school that led Parmigianino to the main source for the vocabulary of his first work. From the moment when he had acquired the mechanics of his craft Francesco was beyond inspiration by the second-rate painters of his native milieu. Had Correggio's works been more conveniently accessible Francesco might have turned more completely to him for this inspiration. More immediately at hand, however, was an acceptable source: those imported pictures, by "foreign" masters more consequent than those of Parma, which were exposed in the churches of the city. One of these imported paintings, a "Deposition" by Francia (in Parmigianino's time in the Convent of the Annunziata, now in the Parma Gallery; Fig. 4), Francesco seems virtually to have made his school.[19]

The dependence of the "Baptism" on the Francia "Deposition" is immediately apparent in Francesco's figure types. Francesco's Christ and the Christ of the "Deposition" are alike in their graceful elongation of shape and in their gently rounded outlines; the modeling of their bodies is smooth and generalizing, with little perceptible indication of anatomical structure. In Francesco's Christ (and somewhat in his Saint John as well) these characteristics are exaggerated beyond the degree to which they appear in the Francia; these exaggerations are indicative of tendencies which will be confirmed in Francesco's mature style.

Francesco's drawing of certain specific anatomical details, as the hands and feet, is also apparently derivative from the "Deposition";[20] while the heads in Francesco's painting, in spite of their eventual dependence on Leonardo (by way of Correggio), might still be conceived instead as related to, and perhaps dependent on, Francia's facial types. Further, the landscape in the "Baptism" derives most of its details from the "Deposition": compare the shapes of the trees, the cloud forms, and the indication of a path into the landscape along a zigzag road.[21]

In Francesco's time the churches of Parma contained paintings by other foreign masters of importance than Francia,[22] but Francesco did not accept them as models. His rejection of the others, and his selection of Francia, is significant. Certainly, this selection was not based on a sense in the young artist of any deep spiritual kinship with Francia. It would be hard to find two artistic personalities, even when we consider Parmigianino only as a youth of sixteen, who better summarize the opposition between the placid accomplishment of provincial painting of the early 1500's and the experimental spirit of the new sixteenth-century generation.

The source of Francia's attraction for the younger man lay in the former's impo-

sition of a canon of refined and idealized beauty on his forms, however weak those forms; among the works of art then accessible in Parma only Francia's pictures contained this quality of the ideal. Francia's work was, for Parmigianino, the best available approximation of High Renaissance style. More specifically, it was an approximation of that Central Italian High Renaissance style to which, as it was perfectly embodied in the art of Raphael, Francesco was later to be so much drawn, and which was to be a major fundament in the construction of his own mature Mannerism. Francia shared with Raphael not only certain similarities in artistic disposition, but also certain cross influences in their styles: Timoteo Viti, Raphael's second teacher, had been a Francia pupil, while Raphael's third master, Perugino, had exercised a strong influence on Francia. In forming himself on Francia, who had these communities with Raphael in the formation of his style, Parmigianino was thus in a sense, already in his first work, a Raphaelesque painter at second hand.[23]

Not all of the vocabulary of detail in the "Baptism" is borrowed. A few details are tentative expressions of Parmigianino's nascent individuality, and especially of the calligraphic tendency which was to become so strong a factor in his more developed style. It is most apparent in passages such as the edges of John Baptist's garment and the intricate curling of his hair. The ears are also calligraphic conventions, which persist in more or less this form well into Francesco's later manner. In the legs of the Saint John a pattern of sinuous lines, rather than effects of modeling, is used to indicate the muscles; and in the larger forms of the body there is also a rhythmic element, greater than in the Francia model, in the stress on the smooth and graceful movement of the contour.

However, it is beneath the vocabulary of detail, in the formal organization of the "Baptism," that Parmigianino's identity asserts itself most strongly. In formal character the "Baptism" deviates significantly from the style of Francesco's Renaissance model, and this deviation is consistently toward the expression, however incomplete or awkward, of concepts of style recognizably akin to those in his developed work.

There is at least a partial indication in the "Baptism" of Parmigianino's future system of representing the human figure. The figures have an apparent elongation, which results from the arbitrary diminution of the size of the head in relation to the length of the body. The modeling, especially of the Christ, is as excessively generalized as in Parmigianino's mature figures and (as we have remarked) gives no evidence of an inner anatomical structure. Both forms are Francesco's habitual weightless volumes, and their seeming weightlessness is increased by the balletlike attitude of their legs, and the resultant unclarity in relation of the figures to the ground.

The spatial construction of the "Baptism" is also basically consistent with the premises of Francesco's mature style. The two protagonists are confined within a single

shallow plane of space, and they adhere closely to the front plane of the picture. In the space behind the figures Parmigianino has attempted to create a comprehensible landscape, but like later backgrounds it is compounded out of elements which diminish its convincingness. A measure of recession is suggested by the winding road at the right rear (borrowed, we recall, from Francia), which is linked to the figure plane by the rearward extension of John's left leg and by the train of drapery which falls behind him. However, the falsity of the perspective system, with its overhigh horizon, partly contradicts this recession; moreover, the largest area of the background is occupied not by an opened space, but by such a screen of foliage, of rather indeterminate rearward location, as occurs often in the later works.

The compositional system of the picture is at once its most interesting and most difficult aspect. More than is apparent at first glance, it differs from any conventional High Renaissance system of composition; but at the same time it resembles Francesco's mature method only in certain special, though at the same time highly characteristic, ways.

At the moment which proceeded the depicted action, the two figures may be conceived to have been symmetrically disposed on both sides of the picture, leaving the central vertical axis empty. At the moment shown, Saint John has moved his head, his arm, and the dish with which he is to perform the baptism on to the central axis: the action in which Saint John is engaged, and the dish which is the instrument thereof, contain the essential interest of the particular moment of the story which Parmigianino has chosen to represent. Christ, in this same moment the more passive figurant, remains off center. However, to demonstrate His essential greater importance in the drama, He is more brightly illumined than the Baptist: He retains, as it were, the spotlight. To indicate further that the action in which the Saint John is engaged is directed at the Christ, the long curving line made by the Baptist's body as he bends leads into Christ's face.

The relationship between design and content has thus been carefully considered, and the iconographic interpretation of the theme is, to the best of my knowledge, novel. The composition displays a remarkable intellectual originality for so young an artist; nevertheless, in spite of its novelty and originality, the expressive meaning of the picture, characteristically for Francesco, is small.

The arrangement of the figures on the picture surface has been curiously dislocated away from a conventional High Renaissance balance. The basic pattern still depends on the disposition of the bodies on either side of the central axis. However, equally prominent, and existing in an unresolved and somewhat ambivalent relationship with this approximate balance is the asymmetrical pattern formed by the long vertical line of Christ's figure on the left, and the leftward, upward curving arc through Saint John's

body which abuts in His head. A further compositional complication, intended apparently to compensate somewhat for this latter asymmetry, is the succession of diagonal motives that incline rightward through the figure of Saint John.

These larger motives in the compositional structure are accompanied by a pattern of smaller units of design, which result mainly from the arrangement of the limbs. The effect of this pattern of the limbs is not subordinate to the larger pattern established by the placing of the figures: it makes an overlay upon it of equal aesthetic interest, and adds yet another quasi-independent part to the already complicated compositional scheme. The pattern created by the limbs depends on the arbitrary stopping of the figures in the middle of their action. The Baptist is arrested as he stoops to take the baptismal water in his dish; the Christ is "caught" as he walks toward Saint John and begins to bend slightly to receive His baptism. Neither figure conveys any sense of physical motion. They are fixed and frigid in effect; the artist is evidently indifferent to the empathic or expressive connotations of their action. He has set the figures into motion, and then deliberately arrested that motion, in order to achieve a compositional design of greater complexity than would be possible to derive from figures at rest.

The pattern of the limbs creates a series of fragmentary but strong accents over the surface of the panel. Some accents are vigorous repetitions of parallel motives while others are of converging direction; but the same accent, in a different combination, may be read in the opposite sense. The aesthetic effect of this play of accents is highly complex and ambiguous; it instills an angular, nervously shuttling movement into the design. This kind of movement could hardly be more different from the rhythmic fluidity of Parmigianino's mature compositions, but it is nevertheless indicative of his innate will to create a system of composition in which, unlike that of the High Renaissance, the aesthetic quality of movement (quite apart from physical motion) shall play a dominating role.

It is interesting to observe that Francesco's use of such shuttling accents to animate his composition is very like the device employed (much more aptly) by his most important Florentine contemporary, Pontormo, when the latter first began to develop his personal deviation from High Renaissance style. Pontormo's first evidently Mannerist picture, the San Michele Visdomini Altar, is closely contemporary with Parmigianino's "Baptism."[24] These two pictures are together the earliest examples of a characteristic Mannerist compositional system, of which the appearance in Parmigianino, an artist of sixteen painting his first work in a relatively isolated provincial capital, is certainly the more unexpected and remarkable.[25]

In the early development of an artist of Parmigianino's unusual precocity, two years can accomplish a major change. Francesco's next surviving work after the "Baptism,"

an altar with the "Marriage of Saint Catherine" (Canonica di Bardi, near Parma, painted in 1521, probably during Francesco's sojourn in Viadana; Fig. 5) is, unlike the "Baptism," instantly associable with his characteristic style. The Francia-esque vocabulary has almost entirely yielded in the Bardi Altar to a vocabulary formed mostly on Correggio, who by this time had assumed his dominant place in the Parma school. At the same time, Francesco's dependence on Correggio is not at all as literal as his former dependence on Francia. Simultaneously with his exposure to Correggio's manner Francesco has begun to develop a very evident individuality in his vocabulary of detail: his maturing artistic will is beginning to mold even the lesser pictorial forms to accord with its own intentions.

Francesco's calligraphic instinct, so imperfectly expressed in the "Baptism," has emerged positively in the Bardi Altar. The human form, as a whole and in its parts, including its garments, has been recast into rhythmically active shapes. These figures do not have the suavity or the fluid elegance of the later forms, but they are recognizably akin to them. The types, though related to Correggio, are even more apparently peculiar to Francesco: they are juvenile approximations of his mature types, with a still more pointed preciosity of feature and expression.

The emergence of Francesco's rhythmic instinct in the Bardi Altar certainly owes much to Correggio. In the "Baptism," such rhythmic intention as Francesco had was inhibited by the example of the essentially static styles of painting of which he then had visual experience, and by the inflexible system of handling he had acquired from his teachers, and then imitated from Francia. The animation of Correggio's figures, and the relatively free, loose handling with which he painted them, emancipated Parmigianino's mind and hand from the restrictive conventions to which he had been educated.

As in the "Baptism," the basis for the compositional scheme of the Bardi Altar is a Renaissance one, but (less awkwardly than in the "Baptism") it has been complicated and asymmetrized away from the High Renaissance norm. The general scheme might have been derived from any one of a number of North Italian late quattrocento or early cinquecento altars; several of this type, with a Madonna enthroned among saints, existed in Parma in Francesco's time.[26] Unlike these prototypes, in Francesco's picture the disposition of the figures around the Madonna's throne is not symmetrical; further, the main iconographic motive of the picture, and thus its center of interest, has been displaced toward the left. However, this asymmetry has been compensated in various ways back into an adequate effect of balance.[27]

The animation of the composition, achieved in the "Baptism" by the awkward overlay of shuttling accents, has here been effected with fluid rhythmic devices. The rhythmic character of design in the individual figures is extended through the entire

compositional scheme: a continuous movement passes through each figure, and connects with the adjoining one. This is the first tentative appearance of the compositional method which Parmigianino will maintain and develop through the rest of his career. However, though this rhythmic character is markedly present in the Bardi Altar, it is not yet its dominant compositional effect. The High Renaissance elements in the design are of at least equal prominence. The rhythmic movement through the picture is itself so disposed that it assists almost as much in the equilibrium as in the animation of the design. It follows a more or less continuous oval scheme, about equally distributed on both sides of the central axis; unlike the single continuity of direction in the later pictures, it diverges from its starting point into opposite and approximately equally balancing branches of the oval scheme. In the somewhat ambiguous space made by the step at the lower edge of the painting, the form of Saint Catherine's wheel, seemingly half projecting into the spectator's space, serves as the place of introduction to the movement through the design.[28] From the wheel, two suggestions of direction are implied: an immediately obvious movement, which sweeps up Catherine's ascending drapery toward her outward-gazing face, and into the area where the nominal action of the picture (the bestowal of the ring) takes place; and a secondary, longer, movement which turns through the body of the Baptist, the left arm of the Virgin, and the squirming figure of the Christ child, and thus also into the iconographic center of the painting, where it intersects the first compositional path. Both paths lead into, and mingle in, the asymmetrically located area which contains the narrative point of the scene.

As in the "Baptism," the relation between design and content has been carefully considered. In addition to the synthesis of the two branches of the rhythmic pattern in the area of the main iconographic motive, other devices as well have been employed to stress this motive's interest. Catherine invites the attention of the spectator to this area by her outward gaze, accompanied by the inward turning of her upper body, and the head of John Evangelist also attracts the eye thereto. The light spots of their heads and hands, with the body of the Christ child, form a pattern of shifting accents which interlaces and still further animates the two large compositional rhythms as they meet in the neighborhood of the giving of the ring. In spite of these devices, the expression of the content in the picture still remains indifferent. The spectator is less aware of these devices, which are primarily matters of aesthetic organization, than of the facial expressions of the actors, with their somewhat childish preciosity and their apparent lack of concern for deeper implications of the scene. The subject has been handled with a high degree of aesthetic sensitivity and considerable cleverness, but with only superficial regard for its expressive meaning: this is a characteristic we shall meet repeatedly in succeeding works.

PAINTINGS

As the Bardi Altar indicates, Parmigianino's efforts at this time were directed to a considerable extent toward the absorption of the style of the High Renaissance, as it was represented by its principal exponent in the sphere of Parma, Correggio. However, this *rapprochement* was not such as to inhibit the increasing expression of Parmigianino's personal tendencies of style, nor in particular his will toward greater animation of the composition. The works which succeed the Bardi Altar show a simultaneous development of traits adapted from Correggio and of Parmigianino's own latent characteristics of Mannerism.

On Parmigianino's return from Viadana early in 1522 his renewed contact with Correggio resulted in an apparent increase of the impulse, already evident in the Bardi Altar, toward the assimilation of the latter's principles of style. The original of Francesco's first production after his return, a "Madonna with Saint Jerome and the Beato Bernardino da Feltre," has been lost, but surviving copies (Figs. 6, 7) have preserved at least something of its appearance. This work seems to have reflected, in increased degree, the situation we have described above. It suggests the Correggiesque High Renaissance style in the appearance of amplitude in its figures, which conform to a High Renaissance canon considerably more than do the somewhat preciously constructed forms of the Bardi Altar. The basis of the compositional scheme is a pyramidal group such as occurs frequently in Roman and Florentine High Renaissance works, though rarely in Correggio.

On the side of Parmigianino's simultaneously developing individuality, in the "Madonna with Saint Jerome and the Beato Bernardino," is the fusion into its basically High Renaissance scheme of a rhythmic activity more positive than in the Bardi Altar; this rhythmic movement has also acquired a pronounced serpentine character which results from the postures of the figures which carry it. Though, as in the Bardi work, an effect of balance has been maintained, this composition has been even more asymmetrized. Comparison with a characteristic High Renaissance design of a similar triangular type, for example, Raphael's "Holy Family" of the Casa Canigiani, reveals the measure of Parmigianino's deviation from the High Renaissance norm.

This simultaneous process of development of his own stylistic concepts and absorption of Correggio's style arrived at its apogee in Parmigianino's frescoes in the church of San Giovanni Evangelista in Parma (Figs. 8–13), executed probably just after the lost "Madonna with Saint Jerome." In these works, which are an exercise in the special problem of wall decoration, the *rapprochement* with Correggio involved not only the adaptation of the High Renaissance postulates of the latter's style; it required as well that Correggio be followed into the realm he had explored in mural painting, as the

44

first to this degree, beyond High Renaissance style into the proto-Baroque. Later on the proto-Baroque and the Mannerism of which Parmigianino was to become a principal exponent were to develop into the stylistic antitheses of the sixteenth century; but in 1522, with Francesco's personality not yet fully formed and his Mannerism no more than nascent, Correggio's proto-Baroque was a dominantly authoritative, and highly interesting, experimental course on which to embark. Both the proto-Baroque and Parmigianino's personal impulses of style shared a difference from the High Renaissance in their mutual concern to infuse an animation into that style: Correggio's proto-Baroque thus had at least one strong stylistic claim to sympathy from Parmigianino. The latter had not yet achieved the major premise which would soon cause him to diverge in a nearly opposite direction: his rejection of the naturalistic theses of the High Renaissance, which the proto-Baroque not only retained, but intensified.

The extent of Correggio's influence on Francesco's San Giovanni frescoes is immediately understandable from the fact that Correggio too was working in San Giovanni at this time. Francesco had every opportunity for contact with Correggio's painting, as well as, presumably, opportunity for personal contact with the painter himself.[29] In his frescoes Parmigianino adapted from Correggio a concept of the body, and a concept of space as well, which were essentially antithetic to the principles of the mature style which he would develop. The partial convergence with Correggio in these respects is temporary; after the San Giovanni frescoes these Correggiesque properties of style gradually disappear. Correggio's influence on Parmigianino's conception of the figures is apparent not only from their amplitude of proportion, but also from their relatively convincing three-dimensionality of form. Exceptionally for Parmigianino, his figures at San Giovanni seem capable of genuine physical action which, in two of the four frescoes, they vigorously express. Even certain details of the figures approach Correggio more closely than before: as, for example, the heads and the hands, of which the drawing is for once more functional than decorative.

Parmigianino's handling of space is equally inspired from Correggio. It has its origin in Correggio's decoration of the pendentives in the same church.[30] In these, as in the cupola, the boundary between the spectator's space and the picture space is eradicated. Unlike that in the cupola, however, the space in the pendentives is not conceived primarily as a continuous opening from the spectator's space into and beyond the wall, but rather as a projection in front of it: the figures are built outward from the wall into the space occupied by the spectator. Francesco is obsessed with the conquest of this one aspect, the projective aspect, of Correggio's system of illusionism; so much so that the order of execution of his work in San Giovanni can be judged from the successive greater facility shown by the individual frescoes in the solution of this problem.

45

While he masters the problem of Correggiesque illusionism, Francesco's individual stylistic premises also develop and assert themselves more strongly as he proceeds from wall to wall. His tendency toward verticalization emerges positively for the first time in San Giovanni, and his rhythmic bias in composition becomes more apparent than ever before. The latter is synthesized with the borrowed Correggiesque concepts of body and space by giving to the rhythmic armature on which the figures, and their combination into a composition, are constructed a strong activity in space. This armature is converted from the undulation on the surface which it had been before into a spiraling torque, which turns through and around the plastic forms and outward into the spectator's space.

Parmigianino's illusionism is thus achieved in part with the collusion of a characteristic rhythmic device; but his solution of the illusionistic problem is different from Correggio's in other ways as well. Correggio is able to create an illusion of spatial projection virtually independently of any terms of reference outside of the figures themselves: he projects his figures, so to speak, into thin air. Possibly because Francesco is less secure in his mastery of illusionistic techniques[31] he depends considerably, in indicating his projections, on the spatial relation of the figures to the terms of reference afforded by a more or less tangible painted architectural framework. This framework attempts to define the plane of the wall, and in the successive frescoes the figures overlap increasingly upon it.

In his use of light Francesco also adapts his method from Correggio's pendentives, but he makes the light assume a much more active role than does Correggio in helping to create the projective illusion. The illumination is forced by contrasts of chiaroscuro, with the projecting parts in strong light; more important, the light in each fresco is identical in direction with the light source which, entering through its north wall, illumines the chapel itself. The illusion of the presence of the painted figures in the same space as the spectator is intensified by the fact that they both share a common illumination.

The evolution of Parmigianino's control over illusionism, and the fusion with it of his simultaneously developing personal principles of style, becomes clear from an examination of the individual frescoes. The composition of the right wall of the first chapel (the "Saints Lucy and Apollonia [?]"; Fig. 8) is entirely dependent on Francesco's source of inspiration, the Saints in Correggio's pendentives.[32] As in the pendentives, Francesco's two figures form a rather compact unit with an almost continuous rounded contour, which is repeated by the semidome of their painted architectural frame. The forward figure sits parallel to the plane of the wall, but her relation to it in space is somewhat ambiguous. A part of her drapery, and the legs of the second figure, appear definitely in front of the painted architectural frame which (from intellectual and con-

structive reasons both) should logically be in the same plane as the wall surface. The platform on which the figures sit must thus be intended to obtrude, with the figures which it carries, across the wall into the spectator's space. However, the actual result obtained is not of a convincing projection, but of an ambiguous limbo between the space of the wall and the space of the spectator, which is neither securely one nor the other.[33]

On the left wall of the first chapel (the "Saint Agatha," Fig. 9) the figures are less compactly arranged. The composition contains a pronounced rhythmic movement, which extends in a vertical direction. At the same time the rhythm is no longer, as in the first fresco, an essentially superficial movement but clearly an active torsion in space. The architectural frame, including its basis, is consistently in the plane of the wall surface. The shallow, unclear space of the painted niche is inadequate to contain the ample figures, and appears to compress them outward toward the spectator. The lower part of the saint is parallel to the wall but her upper body, and the upper part of the body of her executioner, turn, with the spiraling movement of the composition, outward in front of the plane of the architecture, and thus through the wall into the space of the spectator. In the lower part of the fresco, an interpenetration is created between the two spaces by the obtrusion of part of Agatha's drapery across the front of the niche, and by the oblique turning of the block on which she is seated.

On the left wall of the second chapel (the two deacon saints, Fig. 10) the architectural frame, as before, appears to mark the plane of the wall. Both figures now stand clearly in front of this frame, as if on a platform which extends outward from it. The effect of compression of the figures outward from the architecture is intensified by its exaggerated perspective, which seems to open outward fanwise rather than to move inward into the wall. In the lower part of the fresco the foot of the foremost saint projects boldly over the already projecting platform; and to permit a further interpenetration with the space of the spectator the form of the seat has been changed from the solid block of the previous pictures to an open frame. The effect of space in the fresco, seen from the point of view of the spectator on the floor of the chapel, is strongly like that of an elevated stage, with the actors on it and the scenery behind. The spiraling movement of the design is less aggressive here than in the "Saint Agatha," perhaps because of the less dramatic nature of the subject; however, it is still apparent. More obvious than in the "Saint Agatha" is the upward extension of the composition.

The outward-spiraling compositional torque is a stronger factor in the illusionistic effectiveness of the "Saint Isidore" (or "Saint Secundus" [?], on the right wall of the second chapel; Fig. 11) than in any of the three previous frescoes. The compositional movement begins in the turning attitude of the saint and swells upward and powerfully outward along the form of the horse. There is no element of ambiguity in the illusion

of this fresco: it is nearly as accomplished an illusionistic *tour de force* as are Correggio's pendentives. This illusionism is expressed with a fine rhythmic suavity of design, but also with a power and directness that, regrettably, Parmigianino achieves only rarely in his mature works.[34]

The daring and dramatic motive of the horse plunging outward into the spectator's space is not Parmigianino's own. It seems to have been an invention of Giovanni Antonio Pordenone, and was used several times by him: once in a fresco series executed just before Francesco's paintings at San Giovanni, and in a reasonably accessible place, the Duomo in Cremona (Fig. 16).[35] Through his expression of this motive in the terms of his personal system of design Parmigianino has given it a very different aesthetic quality than that which it conveys in Pordenone. The derivation from Pordenone nevertheless remains evident; it appears certain that Francesco must have known the work at Cremona.[36] The importance of this lies not so much in Francesco's derivation of a motive as in the fact that by his contact with Pordenone Francesco had a second powerful stimulus, in addition to that of Correggio, toward an interest in illusionistic painting.

Pordenone's decoration of the nave walls at Cremona is not constructed with a primarily illusionistic purpose, though it contains a large repertory of illusionistic devices. However, one of Pordenone's frescoes in the Duomo, a "Deposition" (Fig. 15),[37] is conceived entirely with illusionistic intention, and the method by which this illusionism is achieved in one important respect resembles that used by Parmigianino. In the "Deposition" a painted niche is constructed into the wall, using as its architectural frame on the wall surface partly the actual architecture, and partly a painted continuation of it. In front of this niche projects a painted platform on which the figures stand; some are perceptibly contained within the niche while others appear in front of the architectural framework, on the painted platform. This fresco is somewhat later in date than Pordenone's remaining decoration in the Duomo; it was paid for on December 30, 1522.[38] It is possible that it was executed enough earlier in the year so that Parmigianino might have seen it before undertaking his own series at San Giovanni.[39] If this was so, it is probable that Francesco's way of using an architectural framework as an important aid in achieving illusionistic projection is dependent at least in part on Pordenone's example.

The secondary decoration of Francesco's two chapels at San Giovanni is of considerable interest, and not merely as pure decoration. The *putti* who form the main motives of the inner arch faces of the first chapel (Fig. 12a, b) are of Correggiesque inspiration, and at once resemble the *putti* of San Paolo and those executed by Correggio's assistants beneath the pendentives in San Giovanni.[40] However, Francesco has enriched and enlivened the movement of his infant forms beyond that of any of his

models. Francesco's *putti* are constructed on the same torquelike armature that appears in the "Agatha" and the "Isidore," but they display a torsion of plastic form even more vigorous than in the larger figures. More than Correggio's *putti*, those of Parmigianino suggest a kinship in style with the heavy, turning forms of Michelangelo's *putti* of the Sistine: indeed, the stylistic concept of plastic forms turning in a constricted space, which appears throughout the San Giovanni series, is more closely parallel to the later parts of the Sistine Ceiling than to anything of this date in Correggio. There is no available external evidence to explain this likeness; we must accept the assumption that Parmigianino, handling a not dissimilar problem, fortuitously arrived at a similar solution. However, the vexed problem of the Correggio-Michelangelo relationship here has yet another ramification.

The inner arch faces of the second chapel contain no figures, but are decorated with a frieze of a classicizing character which repeats that of the dress of the military saint on the right wall. Though Francesco's manner of drawing the various objects gives them an appearance in common with that of designs by contemporary Roman decorators (for example, Polidoro), it is more likely that his sources were the ornament prints of North Italian engravers working in the Mantegnesque tradition.[41]

The ceiling of the second chapel is a compromise between the motives of the arch faces in both chapels. It contains a loose, asymmetrical arrangement of *putti* at play with various objects, some military, some horticultural, some animal. The theme was to recur, though in rather different form, at Fontanellato.

All the incidental decoration, and to a somewhat lesser extent the four main frescoes as well, are distinguished by a brilliantly confident, loose handling. The emancipation of Francesco's handling had begun, as we observed, in the Bardi Altar as a result of Correggio's example, but there are passages in Parmigianino's work in San Giovanni where he seems even to exceed Correggio's virtuosity with the brush. Once thus mastered, this loose manner of handling persists in varying degrees through Francesco's early career and even somewhat into his maturity, until he finds it necessary to discard it because this handling comes to be at variance with his conception of the physical world.

When we consider the proximity and impressiveness of Correggio's proto-Baroque example, and also Francesco's success in his initial attempt to assimilate it, it seems remarkable that he did not continue farther in the direction into which he had been momentarily drawn. It is an indication of the exceptional strength of his disposition toward Mannerism that Parmigianino was able to enter into Correggio's proto-Baroque orbit, master certain important essentials of this style, fuse them into his own preëxisting and developing artistic tendencies, and then diverge from the proto-Baroque to continue his own different personal development.

PAINTINGS

None of the easel paintings executed about contemporaneously with San Giovanni shows any concern with the illusionistic problem which absorbed Francesco in his wall designs. Of these easel works, only one survives in the original ("Saint Barbara," Prado; Fig. 17), but we have copies which suggest the style of the others ("Circumcision," Detroit, Figs. 18, 19; "Marriage of Saint Catherine," Parma no. 192, Fig. 20). Only the "Circumcision" attempts to deal with the problem of spatial organization in any form. In this picture Francesco adapts the rhythmic compositional armature of the San Giovanni frescoes to the purpose of achieving a spatial recession rather than a forward projection; a tightly crowded group of figures is threaded through by a continuous serpentine path which inclines backward into the canvas. If the evidence of the copy is dependable it would appear that the recessive effect of the compositional path was much less pronounced than its character of surface ornament.

In the two other easel works of 1522 the adherence of the compositional scheme to the picture surface is entirely unequivocal. In the larger of these, the "Marriage of Saint Catherine," the figures are mostly compressed into a shallow plane of space close behind the picture surface, in a way suggestive of the characteristic arrangement of Francesco's mature works. In both the "Marriage of Saint Catherine" and the "Circumcision" there is an insistent assertion of the serpentine basis of design.

From the evidence of these paintings it would appear that Francesco's interest in Correggio's proto-Baroque illusionism was confined to the field of wall decoration, for the illusionistic devices of San Giovanni have left no perceptible mark on the contemporary easel works. In this respect Parmigianino resembles Correggio himself, whose easel pictures exhibit little or no intrusion of the principles of illusionistic style he was so strongly developing from 1520 onward in his frescoes.

It is difficult to tell securely from the two copies, and almost equally from the inconsequential small original of the "Saint Barbara," to what degree Francesco preserved in these pictures the other elements of Correggiesque style which he appropriated at San Giovanni. They appear to deviate not only from Correggio's convincing representation of space but also from his plastic modeling of the body. In handling, however, and in other ways as well there is evidence in them of Correggio's example. In the "Circumcision" copy there is an attemptedly dramatic manipulation of light and dark which suggests certain of Correggio's easel pictures of the early 1520's.[42] The Christ child of the "Circumcision" appears to radiate a flickering illumination, and the fragment of landscape at the rear is lit by the moon. There is an analogy between these unusual devices of lighting and those in Correggio's "Notte," but that picture evidently postdates Francesco's "Circumcision" in execution, though not in its design.[43]

The "Marriage of Saint Catherine" is an obvious compound of Correggiesque motives. The precedent for the arrangement of the principal figures in profile occurs in

Correggio's treatment of the same theme.[44] The location of the scene in a heavenly sphere, with the Madonna seated on clouds supported by *putti*, is derivative from the familiar pendentives of San Giovanni, while the multiplication of saintly and angelic heads in the background appears in Correggio's apsidal decoration of the same church.

In both the "Circumcision" and the "Marriage" Parmigianino seems to have been overly ambitious: stimulated probably by Correggio's densely populated compositions at San Giovanni (as especially in the apse) he has packed his pictures tight with figures, or rather with a fussy density of heads and gesticulating hands. The compositions contain a multitude of accents which, though they are connected on a common rhythmic thread, still seem overcomplex and agitated. This overcomplexity in design is a labored, immature manifestation of Francesco's almost excessive nervous sensibility; it occurs in instances throughout his first Parma period. It is not until after his experience of another aspect of High Renaissance art than that represented by Correggio—the Raphaelesque High Renaissance of Rome—that this sensitivity of Francesco's is transmuted into the highly refined, yet harmonious aesthetic complication which appears in his mature works.

In 1523, the year following the execution of the San Giovanni frescoes, Parmigianino undertook a second fresco decoration. This commission, at the Rocca di Fontanellato near Parma, seat of the Counts Sanvitale, was a secular one: it involved the decoration of the upper part of a small room with the story of Diana and Acteon (Figs. 21–29). No documentation of any kind survives for this work, so it is impossible to trace the responsibility for its somewhat exceptional iconographic program. Certain liberties have been taken with the Ovidian legend; these liberties have no evident relationship to a known literary source. The chief deviation from the legend is the introduction on one wall of a scene of two hunters (Acteon and a companion?) pursuing a nymph. A second wall is occupied by a female figure who has no apparent direct connection with the narrative, and who does not participate in it. All the principal figures are framed by a painted arbor; around this arbor is depicted a series of *putti*, most of whom carry garlands of vegetables of fruit.

These various elements of subject matter—the Acteon story, the separate female figure and the *putti*—are more closely allied in theme than may at first appear. The Acteon story itself is an allegory of the onset of the height of summer, with its "dog days."[45] The single female figure holds in her left hand two strands of ripened grain, and in her right an urnlike cup, within which there may still be discerned the faded shapes of fruit; both attributes are symbols of the mature summer season.[46] The floral and vegetable trophies which the *putti* bear, and the rich vegetation on the arbor, are

PAINTINGS

further products of these same late July and August days. The whole room thus has a
common iconographic burden: it is a pictorial ode on the midsummer season, spun out
of the ideal core of the Acteon theme.

As in his decoration of San Giovanni, Parmigianino's starting point for the Fonta-
nellato decoration is in Correggio, in this case in the Camera di San Paolo. Almost all
the major components of Correggio's scheme for the Camera reappear at Fontanellato
(the lattice against the sky, the *putti*, the lunettes with figures) but Francesco has
recombined them into a markedly different ensemble.[47]

The illusionistic problem which obsessed Parmigianino in San Giovanni is now no
longer either a problem or an obsession. As a result of his experience in San Giovanni
illusionism is now a completely mastered and easily manipulated part of Francesco's
artistic vocabulary. He uses an illusionistic system as the basis for organizing the com-
plicated arrangement of wall surfaces with which he is presented, but this system is not
the dominating motive of the whole. The illusionistic devices operate with an accom-
plished ease, quite without the aggressive obviousness of effect of San Giovanni; they
retreat to a place more nearly in balance in relation to the other formal elements of
the decorative scheme.

As presented to Parmigianino's brush the space he was to decorate offered one
vertical surface (the lunettes), an oblique or partly spherical surface (the cove of the
ceiling) and two separate horizontal surfaces (the tops of the lunettes and the ceiling
of the room). In the lunettes he painted the main narrative; on the ceiling cove (and
projecting by foreshortening partly above it onto the upper ceiling) he painted the
"architectural" frame of the narrative: a latticework arbor against which, in the spand-
rels, stand the *putti*. The ceilings of the lunettes were decorated with a painted mosaic,
through which openings were "cut" looking through to the "sky" above. This painted
"sky" also occupies the center of the horizontal surface of the ceiling.

This succession of painted wall surfaces, intersecting on different vertical and
horizontal planes, complicates the boundary between the spectator's space and the
space of the painted walls almost out of existence. The spectator's space and the space
of the frescoes are intimately interpenetrated: the *putti* against the latticework appear
to exist within the space of the spectator, while the main narrative appears to take
place just beyond an open loggia which seems a continuation of that space. The whole
scene occurs beneath a painted sky which at once covers the onlooker and the painted
actors. Only the tangible architectural feature of the cornice affirms a division between
the real and the artificial world.

The figures in the lunettes, unlike those at San Giovanni, make no attempt to
intrude upon the spectator across this one tangible boundary. They are arranged close
behind the wall surface and on a plane parallel to it; they do not radically trespass

52

beyond this plane either forward or backward. Behind them is an open view of foliage, water, and sky, sufficiently defined to suggest the free continuity of space outward from the room and behind the figures, but too summary in its construction to seem habitable.

Unlike the figures in the lunettes the *putti* of the spandrels project easily into the space of the spectator. They stand on platformlike supports in front of the latticework frame which marks the plane of the wall along the ceiling cove; with a twisting motion of their bodies they turn outward in varying degrees into the space of the room. Their projection is achieved by the same devices which are employed in the San Giovanni figures, but by comparison it seems graceful and effortless.

Though a continuous space seems to include both the spectator and the painted world this illusion is not intensified, as it is at San Giovanni, by a forceful illusionistic use of light. As in the San Giovanni chapels, there is one main source of actual light (here a window in the wall beneath the nymph with the attributes of summer), but this actual light source is not assertively exploited. Rather, the light within these frescoes is handled as if to reinforce the intended effect of out-of-doors: it is somewhat diffused, and appears to fall, at a low oblique angle, from the sky behind the wall that contains the "Summer" figure. This system, though not forced, is consistently enough observed to suggest to the spectator that the light, too, operates as part of the same spatial unity within which he, under the painted sky, is included with the painted figures.

The illusionism of Fontanellato is formally and aesthetically an important part of the whole decorative scheme but it has not been conceived, as is nearly true at San Giovanni, as an end in itself. It is intimately integrated with the other formal elements of design, and operates in unassertive and harmonious association with them.

On the wall where the narrative begins, that leftward from the "Summer," a continuous undulating movement starts which moves around all four walls, threading through the figure elements in the lunettes: this movement forms the core of the compositional scheme. Though all four walls are connected by this continuous path, at the same time each wall is so composed within this scheme as to have a satisfactory balance in itself.

More remarkable than this extension through the several picture fields of the rhythmic continuity of composition is the way in which the main sequence of the lunettes and the sequence of *putti* in the spandrels have been integrated into a unity of design. The range of *putti* is evidently subordinate to the figures of the lunettes. The *putti* are posed within their spandrels in such fashion as simultaneously to fulfill a double function: they complement the design of the lunette between them and rectify its balance, both by the disposition of their mass and by the direction and energy of their movement; at the same time the *putti* form a complete rhythmic continuity among themselves.

53

The lunettes partly depend on the *putti* for the completion of their compositional sense, and the *putti* are designed to function in association with the lunettes, yet either range of figures may be experienced by itself as an aesthetically satisfactory integer. The compositional concept can best be described in the musical terms of two contrapuntal lines, each an adequate whole, interacting to effect a harmonious unity. If one excepts the Sistine Ceiling, which Parmigianino had not seen in 1523, this idea is without precedent in the history of wall painting.[48] If, as would appear, this contrapuntal scheme of decoration is Francesco's invention, it indicates a high degree of originality and confirms the capacity we have already observed in him for the intellectual organization of design.

For the casual spectator, interested in enjoyment rather than analysis, this intellectual substructure is only intuitively felt. The main effect achieved within this room is that of a most pleasureable illusion. Regardless of season, we are as if half out-of-doors, in a world agreeably compounded of reality and allegory. We stand within a leafy pergola, which shields us in its coolness while we look up into it, and beyond it, at a recreation of an August day. Parmigianino's illusionism, and his calculation of design, become the handmaids of an Arcadian poetry.

The whole of the Fontanellato scheme, as Parmigianino has conceived and shaped it, assumes the character of an art-historical novelty. In one respect only, it has a contemporary analogy.

The early development of Parmigianino and of Pontormo, both important personalities in the invention of the Mannerist style, is similar in several ways: one of these similarities is in the appearance of the particular "Arcadian" mood embodied by Parmigianino at Fontanellato, and by Pontormo in his nearly contemporary work at Poggio a Cajano. In North Italy, a precedent of a kind existed in the Giorgionesque Arcadianism of Venice, but it is improbable that Francesco had any direct experience of it. In any case even such a precedent would not account for the special mood of Fontanellato: unlike the rather lush atmosphere of the Giorgionesque Arcady, the mood of Fontanellato has a coolness which we have come to recognize as characteristic of the temper of the Mannerist in his rare excursions into the bucolic world.[49]

The graceful lyric mood of Fontanellato and its accomplished fluency of design appear also in two very small easel pictures which Francesco executed about the same time as the frescoes. In these pictures the mechanics of style are no longer so labored and obvious as they were in the easel works contemporary with San Giovanni. The ease in dealing with problems of composition has brought with it, as at Fontanellato, a relaxation from the former intensity of mood: these panels share an emanation of

faintly precious grace which is beginning recognizably to resemble that of the mature works.

Probably the earlier of the two easel paintings of the Fontanellato phase, and possibly antecedent to the frescoes, is a "Rest on the Flight" (Cook Collection, Fig. 30) which in its horizontal form recalls the "Marriage of Saint Catherine" of 1522. This is the last instance (except in wall paintings) of Francesco's use of a horizontal composition: as his system of design matures, his preference for the vertical compositional direction becomes exclusive. In the Cook panel, the horizontal armature winds through the design with a slight trace still of the complexity, but not the obviousness, of the preceding phase. The bland outdoor lighting, the vine-grown architecture and the vaguely indicated landscape background suggest something of the Arcadian atmosphere of Fontanellato, but it is here more intimate and genrelike.

The second panel, a so-called "Saint Catherine" (Frankfort, Fig. 31), is a patent recollection of a model by Correggio of only some years earlier, the "Zingarella."[50] The "Zingarella" must have been a particularly sympathetic picture to Francesco, for it is the single work of Correggio in which he experiments with a definitely serpentine compositional scheme. Francesco has adapted the convoluted pose of Correggio's figure, as well as his motive of the *putti* bearing the palms of martyrdom.[51] However, in his picture Francesco has combined these elements into an essentially different design. He has displaced the main figure away from the central axis, and created a swift rhythmic undulation, much more positive than Correggio's, which sweeps over and around the panel in an involved continuous oval movement.

After the San Giovanni frescoes, Parmigianino's development proceeds not by radical steps, but rather by an intimate and very gradual evolution. During the first half of the year 1524, as a demonstration piece for the Roman world of artists and connoisseurs to whom he would shortly be introduced, Parmigianino painted a "Holy Family" (Prado, Fig. 35). The distinctions which we observe between this painting and the works of the Fontanellato phase are not profound, but they are nevertheless of some significance for the history of Francesco's development. This painting marks the point in the succession of gradual and intimate changes in Francesco's manner where his vocabulary of detail and his technique begin clearly, rather than merely approximately, to resemble his mature works. In the more fundamental aspects of style, Parmigianino had already moved a considerable distance along a personal path quite divergent from that of Correggio. However, up to 1524 Parmigianino's types and technique had evolved in evident dependence on the older master. In the Prado "Holy Family" Francesco's divergence from Correggio in these respects as well has begun to crystallize;

this picture is the beginning of Francesco's full emancipation from his model. From this work on, Parmigianino can no longer be considered a satellite, however innately original, of the school of Correggio; he is an imminently independent artistic personality.

The most important deviation in the Prado "Holy Family" from the Fontanellato group is its change in handling. Francesco has preserved only one obvious element from his previous Correggiesque technique: this is the soft and imprecise indication of many of the contours of the forms. Otherwise, the handling is perceptibly different from that in San Giovanni and in Fontanellato. The brushwork does not have the free calligraphic immediacy of, for example, the "Saint Catherine" panel; the relative scale of the stroking has diminished and its softness has been somewhat lost. The brush strokes are more closely interwoven and the rendering of detail and the application of modeling light and dark are much more careful than before. This more intimate and careful technique is the beginning of a slow process of crystallization in handling which will end in the mature period in the porcelain-smooth surfaces of the "Madonna dal Collo Lungo."

As we have observed, this technical change was later to be confirmed by Francesco's realization of the disparity between the sensuous richness of a Correggiesque handling and the increasing unmateriality of his own conception of physical form. However, this latter characteristic has not yet been defined in the Prado "Holy Family." The change in handling in that picture probably had a less profound motivation. This work was intended as a showpiece for the Roman audience before whom Francesco intended to appear. He probably wished to make in it the greatest possible capital out of his extra-ordinary manual competence. The conventional technical *tour de force* of the time was in the counterfeit of reality by the highly specific reproduction of detail, and to this end Francesco accordingly applied his virtuosity of hand.

The difference in the types of the Prado "Holy Family" from those in the previous paintings depends in a measure on the change in technique. The type of the Madonna is not radically different from earlier Madonnas, but her facial structure and features have been much more exactly indicated: she thus acquires something of the precise, pointed refinement of Francesco's later female types. The Joseph is a much sharper and more specifically rendered image of a male model basically like those in Fontanellato; he has come to resemble closely the recurrent type of older male of Francesco's later pictures. In the children the degree of difference from the earlier works is somewhat less apparent.

Something of the tightness which characterizes the handling of the Prado "Holy Family" has entered into its larger aspects as well. A sense of strain and overcomplexity appears in its design. This is a recurrence of the fault of the labored, striving panel paintings of two years before, of the time of San Giovanni. The active elements of the

compositional scheme are relieved in light, and the pattern of these light areas is nervous and somewhat staccato in effect, with an excessive variety of directions. There is a sense of compression of this tightly active pattern within a picture surface, and within a plane of space,[52] too small to contain it comfortably.

The nervous complexity (and ambiguity) of the composition is reinforced by a similar character in the expression of content. There is a disturbing multiplicity of psychological states and directions of gaze. The iconographic motive of the picture counts for almost nothing: the Christ child's act of taking fruit from the angel's basket interests none except the angel; the Christ child himself, apparently in response to the fluttering gesture of the bodiless hands toward the right, has turned his rather vacant regard on some object beyond the vision of the spectator. Only the bearded Joseph in a measure fixes our attention.

This is the last of Francesco's surviving works which reflects an incomplete control over his excessive nervous sensibility. With his imminent emergence into maturity he acquires an entire discipline over that sensibility, and is able to control its expression within the subtle harmony that becomes a major principle of his artistic system. For the moment, however, in the Prado "Holy Family," the shuttling, nervous quality in design and content resembles that which appears frequently in the contemporary pictures of the Florentine Mannerists, but is exceptional in Francesco's own expression of that style.

It appears that Parmigianino's departure for Rome interrupted his painting of a pair of monumental wings for the organ of the church of the Steccata (Figs. 36, 37). As they stand today, not much more than the design of the central part of the wings is securely his. The completion of their execution was entrusted, many years afterwards, to Francesco's cousin, Bedoli. They were further repainted and restored, a generation after Parmigianino's death, by the Italo-Fleming, Giovanni Sons. Parmigianino's intention in these paintings has been much obscured not only by damage and repaint, but by liberal later additions made around his central figures; in particular by the elaborate painted construction that has been imposed on and around his original simple painted architectural frame. One panel is, in fact, in a state so much disfigured that it is hardly possible to discuss.

One of these wings represents Saint Cecilia, and the other, more damaged one, the musician king from the Old Testament, David. Though on canvas, both wings are of the character and dimension of wall paintings. To decorate these "wall" spaces, in shape much like those in San Giovanni, Francesco has revived that basic scheme: the figures appear to stand on a platformlike structure in front of a shallow painted niche; they

overlap its architectural frame, and elements in the lower part of the composition project outward over the front of the painted platform. The illusionistic intention, and the means used to achieve it, are identical with those at San Giovanni but the effect is attained with unassertive ease.

This ease of effect results, as at Fontanellato, from the high degree of rhythmic suavity in the compositional scheme. The "Saint Cecilia" wing especially contains a free, sweeping rhythmic movement, so arranged upon the canvas that it conforms in pattern to a huge, serpentine figure eight. This pattern has a more perceptible impulse of verticality than does either of the antecedent fresco works. The vertical extension is also evident in the figures: in the "Cecilia" we observe the first obvious emergence of what will become Parmigianino's characteristic mature canon of proportion.

The effect of the figures in decorative attitude and design is equaled, as at San Giovanni, by Parmigianino's expression in them of a functional meaning. In the "Cecilia" wing this meaning assumes the role of the saint as the inspirant and leader of the music of the Church. She is attended to her niche, from which she is to lead the music, by a youth who bears the instruments. As Cecilia passes on to the platform the youth moves leftward to make way for her. As she steps forward, she grasps her viol and begins to turn with bowing arm raised, conductorlike, to signal the beginning of the music. As her arm descends she would, in a continuation of the same sweeping movement in which the painter has caught her, complete her turning toward the spectator and fully fill the niche, from which the youth meanwhile would have disappeared. This is the last instance but one in Parmigianino's work where it may be said that the pictorial scheme depends upon a vigorous and specific physical action.[53] As such, it is a last definite occurence (until his late period) of a principle associable with proto-Baroque style rather than with the rapidly developing Mannerism into which Parmigianino was growing.

An analogy of style with Michelangelo's later portions of the Sistine Chapel is presented in the device used here of an active composition so conceived that its central area would be filled should the action of the figure be completed. As with the other similarities to Michelangelo's experiments that we have mentioned earlier, this device as well must have been independently conceived. Parmigianino's experience of Michelangelo's art, as well as of the whole vast artistic realm of Rome of the mid-1520's, was still, though imminently, to come.

ROME AND BOLOGNA.

1524 (late summer, or autumn?): In his twenty-second year, with one of his uncles[1] Francesco arrived in Rome from Parma. Vasari's story of the move is as follows: ". . .

having conceived a desire to see Rome, as one who was on the way to doing well and [who] heard the works of good masters much praised, and particularly those of Raphael and Michelangelo, he told his mind and wish to his old uncles, to whom it seeming that such a desire was nothing if not praiseworthy, they said they were content; but that it would be well that he should carry with him something from his hand, which should provide him with an entry to those gentlemen and to the practitioners of the profession . . . he made three pictures . . . These works finished, which were held rare not only by his old (uncles), but amazing and marvelous by many others who knew about art, and the paintings having been packed . . . accompanied by one of his uncles he betook himself to Rome; where the Datary[2] having seen the pictures and estimated them that which they were, the youth and the uncle were instantly introduced to Pope Clement, who having seen the paintings, and Francesco so young, was stupified, and with him the entire court."*

Francesco gave his "samples" to Clement, who promised him that he should receive the commission to complete the decoration (probably already initiated by Giovanni da Udine and Pierino del Vaga[3]) of the Sala dei Pontefici; the promise was not kept.

It had been generally accepted, but mistakenly, that Francesco came to Rome in 1523. Three considerations require that we advance this date to 1524.[4] The first of these is the evidence of a passage in Vasari's life of Giovanni Antonio Lappoli: ". . . Giovanni Antonio . . . the plague at Rome having passed entirely . . . resolved to go there . . . having come to Arezzo Messer Paolo Valdambrini secretary of Pope Clement VII, who [Valdambrini] returning from France by the post, passed through Arezzo . . . Having gone thus with this Messer Paolo to Rome, there he found Pierino, Il Rosso, and other friends of his; and furthermore, by means of Messer Paolo, it came to him to know Giulio Romano, Bastiano Veneziano, and Francesco Mazzuoli from Parma, who in these days arrived in Rome."†

* (V, 221-222): ". . . venuto in desiderio di veder Roma, come quello che era in sull'acquistare e sentiva molto lodar l'opere de' maestri buoni, e particolarmente quelle di Raffaello e di Michelagnolo, disse l'amimo e disiderio suo ai vecchi zii, ai quali parendo che non fusse cotal desiderio se non lodevole, dissero esser contenti; ma che sarebbe ben fatto che egli avesse portato seco qualche cose di sua mano, che gli facesse entratura a que' signori ed agli artefici della professione . . . fece tre quadri . . . Finite queste opere, che furono nei pure dai suoi vecchi tenute rare, ma da molti altri che s'intendevano dell'arte stupende e maravigliose, ed incassato i quadri . . . accompagnato da uno de'suoi zii si condusse a Roma; dove avendo il datario veduti i quadri e stimatigli quello che erano, furono subito il giovane ed il zio introdotti a papa Clemente, il quale vedute l'opere, e Francesco così giovane, restò stupefatto, e con esso tutta la corte."
†(VI, 10): ". . . Giovanni Antonio . . . passata del tutto la peste a Roma . . . deliberò andarsene la . . . venuto in Arezzo Messer Paolo Valdambrini segretario di papa Clemente settimo, che tornando di Francia in poste, passò per Arezzo . . . Andato dunque con esso messer Paolo a Roma, vi trovò Pierino, il Rosso, ed altri amici suoi; ed oltre ciò gli venne fatto, per mezzo di messer Paolo, di conoscere Giulio Romano, Bastiano Viniziano, e Francesco Mazzuoli da Parma, che in quei giorni capitò a Roma."

According to this passage Francesco's arrival would have occurred not only a while after Clement's election (December 19, 1523) but also after the last in the series of outbreaks of plague by which Rome was visited from 1522 into 1524; the last outbreak occurred during the summer of the latter year.[5]

The likelihood of Francesco's arrival after Clement's election, that is, after December 1523, is increased by Vasari's report that it was Clement who received Francesco in audience. It should also be considered that Francesco would have had some diffidence about presenting himself in Rome during Adrian's papacy, when even the established Roman masters were suffering the effects of Adrian's puritan policies toward the arts.

A third argument, less secure, results from the date (not necessarily in Francesco's own hand) on the rear of Francesco's portrait of Count Galeazzo Sanvitale of Fontanellato: that date, 1524, implies the artist's presence in Parma during at least a portion of that year.

1527, May: Francesco's career in Rome interrupted by the Sack. Vasari relates the traditional story of Francesco's adventure with the invaders:

". . . at the beginning of the Sack he was so intent at work, that when the soldiers entered the houses, and some Germans were already in his own, he did not move from his work [in spite of] the clamor they made, so that they, coming upon him, and seeing him work, they were stupified by that painting, so that, like the gentlemen they must have been, they let him continue. Thus while the most impious cruelty of those barbarous people ruined the poor city, sacred and secular things alike, with respect neither unto God nor men; he was provided for and highly esteemed by these Germans, and defended from any injury. As much discomfort as he then had was that, one of them being a great lover of painting, he was compelled to make an infinite number of drawings in water color and pen, which were the payment of his ransom. But when the soldiers were afterwards changed, Francesco was close to meeting with bad fortune: because going to look for some friends, he was made prisoner by other soldiers, and had to pay some few *scudi* that he had, as ransom: wherefore his uncle lamenting this, and [lamenting] the hope of Francesco's acquiring knowledge, honor, and wealth that this disaster had cut off; he resolved, seeing Rome hardly less than ruined, and the Pope prisoner of the Spaniards, to take him back to Parma: and thus having sent him on towards his native land, he (the uncle) remained for some days in Rome . . ."*

* (V, 225): ". . . in sul principio del sacco era egli sì intento a lavorare, che quando i soldati entravano per le case, e già nella sua erano alcuni Tedeschi, egli per rumore che facessero non si moveva dal lavoro, perchè sopragiugnendogli essi, e vedendolo lavorare, restarono in modo stupefatti di quell' opera, che, come galantuomini che dovèno essere, lo lasciarono seguitare. E così mentre che l'impiissima crudeltà di quelle genti barbare rovinava la povera città e parimente le profane e sacre cose, senza aver rispetto nè a Dio nè agli uomini; egli fu da que' Tedeschi proveduto e grandemente stimato, e da ogni inguria difeso. Quanto disagio ebbe per allora si fu, che essendo un di

RELIGIOUS AND MYTHOLOGICAL WORKS

1527, late May or June: Parmigianino's arrival in Bologna.[6] He settled in Bologna, and resided there, apparently continuously, until his final return to Parma.

1531, early: Parmigianino's departure from Bologna to return to Parma. He had been in contact with his native city before his return: in 1529 he may have received from the Parmesan Confraternity of the Steccata a payment for his work on their organ wings (which he had left unfinished in 1524)[7] and in 1530 he was contracting for further work in their church.[8]

Parmigianino's production of paintings during his residence in Rome appears to have been relatively limited: it seems that during this time he was at least in part concerned with the acquisition of the then rare technique of etching, and with the practice of the graphic arts, both directly and as a designer. Of the pictures he did paint, only five rather disparate examples remain. There is thus insufficient material from Parmigianino's time in Rome to enable us to assess his development in detail, as we could do in the previous period; nor can we completely trace his assimilation, in its successive stages, of the art of High Renaissance and contemporary Rome. However, one of the surviving paintings, the "Vision of Saint Jerome," produced at the end of his stay, serves as a summary of his Roman experience; and we can supplement the evidence which this work offers of Francesco's Roman studies by examination of his drawings and graphic art.

Vasari informs us, though in somewhat stylized fashion, of the way in which Parmigianino went about his study of art in Rome: ". . . studying in Rome, he wished to see all the ancient and modern things, both sculpture and painting, which were in that city; but in the highest veneration he held particularly those of Michelangelo Buonarotti and of Raphael of Urbino: they said afterwards the spirit of that Raphael had passed into the body of Francesco, seeing that young man rare in art and amiable and gracious in deportment, as was Raphael; and, what is more, it being perceived how much he tried to imitate him in all things, but above all in painting."*

loro molto amatore delle cose di pittura, fu forzato a fare un numero infinito di disegni d'aquerello e di penna, i quali furono il pagamento della sua taglia. Ma nel mutarsi poi i soldati, fu Francesco vicino a capitar male: perchè andando a cercar d'alcuni amici, fu da altri soldati fatto prigione, e bisognò che pagasse certi pochi scudi, che aveva, di taglia: onde il zio dolendosi di ciò, e della speranza che quella rovina avea tronca a Francesco di acquistarsi scienza, onore e roba; deliberò, vedendo Roma poco meno che rovinata, ed il papa prigione degli Spagnuoli, ricondurlo a Parma: e così inviatolo verso la patria, si rimase egli per alcuni giorni in Roma . . ."

* (V, 223-4): ". . . egli studiando in Roma volle vedere tutte le cose antiche e moderne, così di scultura come di pittura, che erano in quella città; ma in somma venerazione ebbe particolarmente quelle di Michelagnolo Buonarotti e di Raffaello di Urbino: lo spirito del qual Raffaello si diceva poi esser passato nel corpo di Francesco, per vedersi quel giovane nell'arte raro e ne'costumi gentile e grazioso, come fu Raffaello; e, che è più, sentendosi quanto egli s'ingegnava d'imitarlo in tutte le cose, ma sopra tutto nella pittura."

PAINTINGS

According to Vasari's report, Francesco's reactions to his new milieu were no different from those of most of his contemporaries. He profoundly admired Michelangelo and Raphael both, but particularly the latter, whom he strove to imitate *in tutte le cose, ma sopra tutto nella pittura*. This adherence to Raphael implies a less exclusively partisan attitude than it would have a decade earlier. The conflict between the two great masters had been in part resolved, not merely by the death of Raphael, but by his acceptance, during his own later lifetime, of many of Michelangelo's principles. The defection from pure High Renaissance standards of Raphael's surviving school was more considerable still.

The evidence of Parmigianino's drawings is not necessarily a true index of his allegiances, because their survival depends so much on accident; but from the drawings and graphic work of the Roman period it would appear that Francesco was as much absorbed in the study of the Sistine as in the Loggie, Tapestries, and Stanze. In the "Saint Jerome" altar the influence of Michelangelo is as visible as that of Raphael. This partition of Francesco's interest persists throughout his stay in Rome, but after his departure the balance changes rapidly. In the drawings, prints, and paintings of the post-Roman periods the reminiscences of Michelangelo diminish, while not only Raphaelesque motives, but an underlying temper of style analogous to that of Raphael, increase.[9]

Francesco's concern with Michelangelo is chiefly with certain formal problems of the latter's art; as we have observed, Francesco had already independently achieved, in his experimentally minded wall paintings of his earlier time in Parma, similar solutions to some formal problems of the movement of the body and of composition. Michelangelo's spirit was essentially foreign to Parmigianino: there is an unbridgeable gap between the heroic and aesthetic conceptions of man. Nevertheless, in the "Vision of Saint Jerome" (and for a time afterward in the paintings of Francesco's Bolognese period as well) there are reflections of Michelangelo's handsome amplitude of pose and movement, and even something of the grandeur of his figures and types.

We have seen how, in his first venture in painting, Francesco had selected as his model a work of Francia, the best available provincial exponent of a style akin to that of Raphael. Francesco's orientation toward Raphael in Rome, and the increasing exclusiveness of his later sympathy with him, are a recrudescence in more positive form of his original intuitive inclination toward an artist who, in the terms of his own generation, was of like spiritual disposition. Like Parmigianino's painting, that of Raphael is rarely urgent in expression; especial y the easel paintings of his pure High Renaissance phase are essentially agreeable in mood. Their expression is of the qualities of gentleness and grace which Vasari (see above) observed that Raphael and Francesco, as persons, had in common. Led to Raphael by this kinship in spirit, Parmigianino

acquired from his art certain properties of style that he had not found in his earlier contact with the High Renaissance style of Correggio.

Francesco adapted the characteristics which he assimilated from Raphael within the frame of reference of his own, mostly different, principles of style, but these Raphaelesque characteristics remain clearly recognizable; they persist in Parmigianino's art through the rest of his career. Most important among them are a sense for monumentality, and a more apparent (though not on that account less internally complex) harmony of composition. The latter is accompanied by an increased suavity in the use of compositional devices; Francesco's excess of sensibility is disciplined so that it may no longer complicate the composition into a nervous pattern. Under Raphael's influence, Francesco's ideal of beauty of the human face also becomes more harmoniously regular, and thus somewhat classicizing, so that the infantile preciosity of his early types gives place to a more mature and rather purer canon.

Parmigianino's contact with the art of Raphael, and to a lesser extent with that of Michelangelo, constitutes the second, and more important, phase of his education in High Renaissance style. The impress on him of Correggio's style comes in great part to be replaced, during the sojourn in Rome, by that of Roman, and especially of Raphaelesque, High Renaissance models; Parmigianino's mature style clearly shows its Roman High Renaissance antecedents. It is their transmutation into and synthesis with his preëxistent and developing Mannerist style that give the latter its specific mold.

It must not be forgotten, however, that Francesco's contact with the art of Raphael and Michelangelo was not exclusively a discipline in High Renaissance style. Michelangelo in particular, from the Sistine onward, was reaching out simultaneously toward proto-Baroque and Mannerist types of expression. The later Raphael, both in his frescoes and his easel paintings, reveals important tendencies toward disintegration of pure High Renaissance style, partly through Michelangelo's influence; such affirmative aspects as this disintegration shows tend mostly in a Mannerist direction. Parmigianino's experience of the two monumental artistic personalities of the Roman world would thus have given him a dual lesson: one, derived from their earlier works, would have been an exposition of relatively pure High Renaissance style; the other, derived from their later art, would have confirmed Francesco in his own Mannerist direction.

Parmigianino's contacts with contemporary artists working in Rome would have tended further to confirm his Mannerism. By the middle 1520's some among them were in a stylistic situation which, in varying degrees, approached Francesco's own. Conspicuously, Rosso was in Rome from 1524 through 1527; he had developed a distinctly Mannerist style before his arrival. Sebastiano del Piombo, the chief Roman representative of Michelangelo's coterie, was working in a style which combined evident Mannerist characteristics with the monumental and idealizing ambitions of the High Renais-

sance. Among Raphael's entourage, Penni and Peruzzi remained mostly within the limits of High Renaissance style; but some among the Raphael school had exploited farther the Mannerist direction that their master had indicated in his later works. In Romano, for example, some Mannerist elements were considerably developed. Pierino del Vaga adhered less than Romano to the outward canons of the High Renaissance, and was practicing a style in which the evolution of recognizable Mannerist characteristics was at least in step with Parmigianino.

Francesco knew not only the works of the more prominent among his Roman contemporaries, but knew the artists as well. He would thus have participated in the intellectual and artistic atmosphere in which the new style (of which he was the youngest, but an important, exponent) was being generated, and there would have been ample opportunity for the exchange of ideas and influences between Parmigianino and his fellow practitioners. The key figure in Francesco's circle of Roman acquaintances was Giovanni Antonio Lappoli, the minor Aretine artist whom we have met before (p. 59). Lappoli was a close intimate of Francesco's; according to Vasari[10] (VI, 10) they had met originally through Pope Clement's secretary, Paolo Valdambrini, with whom Lappoli had traveled to Rome. Lappoli was also a good friend of Pierino del Vaga: they had lived in the same house in Florence, that of Ser Raffaello di Sandro, chaplain in San Lorenzo and an enthusiastic amateur of music and the arts (Vasari VI, 7 and V, 607, 608). Rosso, too, had been a habitué of Ser Raffaello's salon, and was *amicissimo* to Lappoli (VI, 7 and 9). Through Lappoli, Parmigianino would thus have come to know, probably quite well, the two most advanced among the Mannerist artists in Rome.

Friendship with Pierino del Vaga presumed at least an acquaintance with the Romano-Penni partnership, for Pierino became the latter's brother-in-law in 1525 (Vasari V, 609, 610). An acquaintance with Romano, however, would have been terminated by his departure for Mantua late in the year of Parmigianino's arrival in Rome.[11] At Valdambrini's house Parmigianino probably met still others among the artistic notables of Rome, among them the dean of the contemporary Roman school, Sebastiano. Through Rosso or Penni, or both, Francesco could also have known Cellini,[12] but the acute opposition of their personalities would have made such a contact hardly sympathetic to either.

In spite of this precise knowledge of Francesco's personal associations, it is difficult to find explicit evidence of the artistic influence of these Roman contemporaries on him, or of his (considering his youth, less to be expected) influence on them. Among the contemporary group, Pierino del Vaga was the closest to Francesco in the character and intention of his style. By the mid–1520's Pierino had developed a manner in his wall paintings (his easel works were more conservative) which was like Francesco's in its fluent rhythmic animation of the composition, and also somewhat like in its rhythmic

redesign of the human form. Pierino's example probably served to impress Francesco with the reassuring conviction that he was not pursuing an isolated course, but one in which he had the company of one of the most esteemed artists in the capital; however, no evidence survives to show that Francesco appropriated anything specific from Pierino.

Though Rosso's Mannerism, at once expressive and bizarre, is the antithesis within the Mannerist style of Parmigianino's variant thereof, he nevertheless appears to have concerned Francesco more than did Pierino del Vaga. Beyond their common experimentation with the premises of Mannerism, the cause of Francesco's greater interest in Rosso may have been the latter's reflection of two qualities which Francesco himself possessed in high degree: a strong impulse toward originality, and an intense intellectuality in the organization of his pictures. It was especially this last characteristic that Pierino del Vaga did not share. It may have been on this account that Francesco felt, in spite of the closer community of their styles, that Pierino was not a source in whom he could find inspiration. By comparison with the cerebral and expressive Rosso, and the cerebral and aesthetic Parmigianino himself, Pierino remains more nearly on the level of a mere decorative painter.

There are two positive instances among Parmigianino's Roman drawings which reveal his study of Rosso. While in Rome, both Francesco and Il Rosso were employed by Baviera, the entrepreneur of engravings. One of Baviera's publications, a "Marriage of the Virgin," by Caraglio (Fig. 39; Bartsch XV, p. 66, no. 1), is after a design by Parmigianino, of which the lower half (or a study therefor) survives among the drawings of the Morgan Collection (Fig. 40).[13] This design, in its composition and in many specific motives, clearly derives from Rosso's painting in San Lorenzo in Florence (Fig. 38).[14] It is possible that Francesco had seen this picture on his journey to Rome from Parma, and had been sufficiently impressed by its novelty of style to make a careful study from it. It is much more likely that Rosso, in Rome, gave Francesco a drawing from his album, which he permitted him to rework for Baviera; Rosso is known to have been generous in such matters with his friends (Vasari VI, 9). Such an action would have been a gesture of amity on Rosso's part, while Francesco's acceptance of this gesture would have been a demonstration of esteem for the older artist. It does not seem reasonable that Francesco should have undertaken such an obvious plagiarism without Rosso's sanction. Another drawing by Parmigianino, a "Creation of Eve" (British Museum 1865-7-8-147; Fig. 41),[15] shows a less exact, but still evident dependence on a fresco by Rosso in Santa Maria della Pace (Fig. 42).[16]

It is more difficult to determine to what extent Francesco was influenced by his study of Rosso in the more fundamental aspects of style. It has been advanced[17] that Parmigianino's tendencies toward verticality, and also his system of composition in space, were inspired by Florentine examples, communicated to him in Rome through

Rosso's agency. It is undeniable that the earliest positive appearances in sixteenth-century painting both of verticalism and the compression of space occur in Florence, in the work first of Pontormo and then of Rosso. However, we have observed both characteristics in Francesco's early style, before his contact with Rosso, and equally before any brief contact with the art of Florence which Francesco may have had in the course of his journey to Rome. It is further true that these same characteristics are less evident in the work of Rosso's Roman period than in his earlier paintings, possibly because of the restraining influence on him of Roman High Renaissance models. There is, in fact, a visible lessening of the extremism of Rosso's Mannerism between 1524 and and 1527, while Parmigianino's Mannerism becomes more assertive.[18]

During these years, after Raphael's death and during Michelangelo's absence from Rome, Sebastiano del Piombo enjoyed a higher reputation than any other living painter in the city.[19] His style in portraiture, for which he was particularly esteemed, seems to have left an unspecific, but still perceptible impress on Parmigianino. The somewhat Venetian look of Parmigianino's portraits, as well as their simplicity in design, restriction in color, and grave dignity of mood have a precedent in the portraits of Sebastiano. It is probably from the example of Sebastiano that some of these qualities in Francesco's portrait style originate. They emerge in the single portrait known to have been done in Rome, and persist after his departure when, in Bologna, he begins the active practice of portraiture. One post-Roman painting of Francesco's which is not a portrait (the Naples "Holy Family") also contains a specific reminiscence of a work by Sebastiano.

Giulio Romano seems to have impressed Francesco more in his guise of Raphael's executant than for his own inventions. One of Francesco's Roman paintings, a "Marriage of Saint Catherine," is based in part on compilation from Raphael designs presumably executed by Romano. Otherwise, Giulio's influence tends to emerge, though in less significant respects, only later in Parmigianino's career. In Francesco's rare landscape backgrounds, for example, there is some relationship with the landscapes in those devotional pictures of the later Raphael school of which the execution is generally attributed to Romano.[20]

Francesco's study during his Roman years of classic art itself seems to have been quite superficial. A few Roman drawings exist which surely derive from antique models; among them is a study (Uffizi, no. 743; Fig. 43) of the head of the youth at the right of the (then) most popular of classic sculptures, the Laocoön group.[21] Francesco used this study as the model for the head of a very minor figure in his etching of the "Entombment." In a drawing of a "Presentation in the Temple" (Victoria and Albert Museum; Fig. 45 and Part III, p. 237), the form of the architectural background is apparently derived from the Pantheon. In works subsequent to his residence in Rome, in addition

to some details of classic Roman architecture, there are (more in drawings than in the paintings) some reminiscences of antique statuary.[22]

Francesco's experience of antique art gave him a taste for a somewhat more classicizing, but still far from archaeologically exact appearance of costume in his mythological subjects and in his few saintly legends which take place in a classic setting. This taste Francesco shared with most of his contemporaries; it presumed no special sympathy with or understanding of classic art, but only an acquiescence in the current mode.

In general, Francesco's response to the world of antiquity, in its purely visual forms, seems to have been somewhat casual, perhaps understandably in an artist of his essentially unclassical disposition. However, he was genuinely responsive to the content and atmosphere of antique mythology: this literary heritage of antiquity, as distinguished from its visual survivals, had a persistent effect upon Francesco. Its results are barely evident in his Roman and post-Roman commissions in painting, which are so predominantly religious, but they emerge repeatedly in the subject matter of his more intimate production in drawing.

Except on the ground of convenience of nomenclature there is no valid reason for describing the products of Parmigianino's stay in Rome as constituting a "period"; this is equally true of his works produced in Bologna. Of the pictures which survive from his painted work in Rome the two earlier ones are still closely related to the manner of his antecedent work in Parma. On the other hand, the last Roman work, the "Saint Jerome" altar, develops and completes such tendencies toward maturity as had been tentatively expressed in the last pictures of the first Parma period: this altar marks Parmigianino's full emergence to mature and independent artistic personality. Once thus achieved in the "Saint Jerome" altar, a logical development of this mature style is initiated which continues through, and beyond, Francesco's years in Bologna and culminates in the "Madonna dal Collo Lungo," painted about 1535, well after his return to Parma.

The logic of this development is almost singular among the Mannerist painters. With only minor deviations the propositions of style embodied in the "Vision of Saint Jerome" are gradually refined, from picture to successive picture, to the end of the achievement of a stylistic whole completely consistent within itself. Our appreciation of this logic of development is of course a posteriori, for we have in view as we characterize it its two termini, the "Saint Jerome" and the Pitti altars. When we abjure our historical advantage and put ourselves in the position of the artist, who conceives his present work in relation only to the past and without any definable idea of his eventual accomplishment, we realize of Parmigianino how strong an ideal of style he

must have borne within him, and with what single-mindedness he strove toward its ultimate expression. Except for an expected human minimum of aberration, Parmigianino's stylistic progress during these mature years, from the last Roman work to the "Collo Lungo," assumes an almost mathematical character. It is like the solution of an equation with multiple unknowns: with each step the investigator gains a clearer apprehension of the final solution, yet each step itself remains a satisfactory entity, consistent within itself.

Two small panels in the Doria Collection, a painting of a "Marriage of Saint Catherine," and the London "Vision of Saint Jerome" are all that survives to us of Parmigianino's production of religious works during his time in Rome. The situation in the Roman period of the two Doria panels (an "Adoration of the Shepherds" and a "Madonna and Child," Figs. 46 and 49) depends on considerations of internal evidence. Though mostly convincing,[23] these considerations seem almost overshadowed by the strong sense of community in style that the panels afford with the later works of the first Parma period, and in particular by the persistence in them of the influence of Francesco's exemplar of that period, Correggio. Their execution must relatively shortly postdate Francesco's arrival in Rome, before his thorough absorption of his Roman studies, for they show more continuity from his old environment than influence of the new.

This is particularly true in the handling of both panels, which is in Parmigianino's personal, calligraphic transposition of his most Correggiesque vein. The relatively tight brushwork of the Prado "Holy Family," the highly finished demonstration piece Francesco had prepared for his debut in Rome, has here been relaxed from its "demonstration" standard. Both panels are loosely painted and soft in surface; their analogy is with Correggio rather than with any model of the contemporary Roman school. However, their relaxation in finish from the Prado "Holy Family" makes them no less virtuoso works: their virtuosity (especially that of the "Adoration") is of a swift, almost bravura handling, which is doubly remarkable on so small a scale. This manner of painting was a novelty in Rome of the 1520's, and Parmigianino's brilliant demonstration of it, seemingly even more accomplished than in any of his previous performances during his years in Parma, must have astonished his Roman contemporaries, though it may not have gained their approval. Later in his Roman stay, when the influence of his new milieu had grown on Francesco, he mostly put this way of handling aside.

The Doria panel of the "Madonna and Child" reveals, in contrast to its Correggiesque surface, the instant effect on Francesco in Rome of the model who was to have the most persistent influence in the shaping of his mature style. The generally Raphaelesque

basis of the picture is evident, though Francesco has not imitated any specific work of the master. Nor has he accepted literally even the general Raphaelesque scheme. Parmigianino's composition seems at once more archaic in the conventional attitude of the Madonna, and more complex in its use of a series of diagonal motives which interlace into a zigzag pattern. In deference to his model Parmigianino has imposed a momentary discipline on his instinct for serpentine rhythms, but these interlacing diagonals are a substitute for them in their complication and animation of the design. The mood of the picture (both of its persons and its setting) is veiled and subtle, as that of Raphael's devotional works is not; the complication of the nascent Mannerist mentality here intrudes with a strong sense of its difference from the almost obvious clarity of Raphael's art.[24]

The middle term of Parmigianino's Roman experience, between the Doria panels and the "Saint Jerome" altar, is preserved to us in a "Marriage of Saint Catherine," once in the Borghese Collection in Rome, hitherto known only through copies (for example, in the Wellington Collection, London), but now rediscovered in the collection of the Earl of Normanton at Somerley (Figs. 50–52). In this picture the tentative inclination toward Raphael which Francesco demonstrated in the Doria "Madonna" has become a considerable dependence, in a sense almost discipleship.

The Raphaelesque antecedents of the two main motives of this design, the Madonna and the Saint Catherine, are immediately apparent. The former has been inspired from the "Madonna della Sedia," and probably as well from the similar "Madonna della Tenda," where there would also have been a suggestion for the *contrapposto* movement of Parmigianino's infant Christ. The "Tenda Madonna" was probably executed by Romano; another Raphaelesque work probably of Romano's execution, the so-called "Cinque Santi,"[25] contains the Saint Catherine from which Francesco's figure was derived. Neither derivation is a literal one. A tapering attenuation of proportion, symptomatic of that which is to be further developed in the figures of the National Gallery altar, has much transformed the ample Raphaelesque models. Especially the pose in profile of the Madonna has been rhythmically refined, and the elegance which this pose permits accentuated.

The subtlety of rhythmic modulation in the contour of the Madonna's breast, neck, and head has been further increased by turning her into *profil perdu*: for this time an exceptional, if not unique, situation for a major figure in the composition. The lost profile achieves not only an extreme of refinement in the movement of its contour, but conveys a refinement of psychological effect as well. The Madonna's expression is only half perceptible and her loveliness (an important part of her "content") is veiled; we

69

comprehend it only obliquely, and with a rather romanticizing sense of mystery. With a far more sophisticated device than in the Doria Madonna Francesco has here effected a similar, but more nearly complete, transposition of his eventual Raphaelesque model into Mannerist psychological terms.

In its composition, the "Marriage of Saint Catherine" again demonstrates Parmigianino's simultaneous acquisition of an element of Raphael's High Renaissance discipline and his adjustment of it to his Mannerist predispositions. The organization of the profile figures on a serpentine scheme, laid parallel to the picture plane, is one which Francesco had employed in other works before, among them his own earlier version of this same theme.[26] Nearer in date to the Roman version of the "Marriage of Saint Catherine," the Doria "Adoration" had been similarly composed. The difference in their compositional effect is the result of Francesco's study of Roman models; each figure has acquired a clarity and deliberateness in its rhythmic articulation, and a degree of identity in its situation within the design, that the figures in the preceding pictures do not have. This sense of identity in the figures is in part reinforced by some degree of change in the artist's manner of handling: their surfaces are less atmospheric and their contours more clear; there is a beginning approximation, at least in these effects of surface, of the ideal of plastic clarity of the Roman school.

The motives in this picture are by no means all Raphaelesque derivations. A number of them have been adapted from that aspect of Francesco's art which occupied so much of his attention at this time, his graphic work. Among the adaptations from his prints is the motive of the male saint in the lower foreground, who is meant to (but who does not quite effectively) serve as a psychological and physical intermediary between the spectator and the principal actors in the painting.[27] This device is a transposition, into the terms of a hardly more than intellectual symbol, of Parmigianino's vigorous, illusionistic motives of his first Parma phase. In more sophisticated and effective form, the device will occur again, in the "Saint Zachary Madonna" of a half-decade later.

Even after three years of contact with the art of Rome the authority of Correggio was not entirely supplanted. In Francesco's "Vision of Saint Jerome" (London, National Gallery; 1526–May 1527; Figs. 57–60) the basic compositional idea, though ultimately derived from Raphael's "Madonna di Foligno,"[28] is qualified by the recollection of Correggio's "Madonna with Saint Sebastian" (Dresden), which, however, itself apparently had been inspired, at least in part, from the Foligno altar.[29] In Correggio's painting, done between 1523 and 1525 (but apparently early enough for Francesco to have seen it before his departure for Rome),[30] the Raphaelesque idea had been vastly animated. This animation is particularly evident in the Correggio work in the figure of the saint who fulfills the role of communicant between the spectator and the Madonna:

he performs his function in a fashion far more active and expressive than does Raphael's Saint John. Parmigianino, in designing the Baptist in his picture as an active figure on a continuous central axis with the Virgin, has modified the precedent of the Foligno altar (by then a rather old-fashioned painting) in the light of Correggio's more stimulating, nearly contemporary translation thereof.

From the same Correggio altar Parmigianino recalled a subsidiary figure: that of the sleeping Saint Roch. He combined the pose of this figure with an even more exact recollection from a second picture by Correggio of about the same time, the "Sleeping Antiope";[31] from the combination Francesco evolved the pose of the title saint of his own painting. Correggio's influence was thus still sufficient to condition Francesco's choice of motives of composition and of pose, but in other respects that former ascendancy had been virtually completely replaced. Francesco's altar depends in substance on elements derived from Raphael and Michelangelo, which he has integrated into a stylistically Mannerist whole.

Though the placing of Parmigianino's Saint John does in fact suggest Correggio's Dresden altar, it is probable that Francesco again consulted the work of Raphael when developing the specific arrangement of the Baptist's pose. In Raphael's "Madonna dell'Impannata" (Pitti)[32] there is a young John Baptist with a comparable, though less emphatic, action of arms, legs, and head, who fulfills a similar connective function between the spectator and the Madonna as does Francesco's saint. However, in Parmigianino's John this pose has been complicated into a positive spiral torsion: a formal device which, as we have previously observed, Francesco had evolved independently of Michelangelo, but which he shares with him. Parmigianino's use of this torsion in the pose of the Saint John suggests that his interest in the device had been confirmed by his study of the Sistine, and also of such Michelangelo works as the "Christ" of Santa Maria sopra Minerva.[33]

A similar compound of Raphael and Michelangelo exists in Parmigianino's "Madonna" group. Its situation in the composition derives from the "Madonna di Foligno," but the arrangement of the figures is dependent on Michelangelo's Bruges "Madonna."[34] The drapery of the Madonna, and especially the high-girdled dress she wears, is of Michelangelesque inspiration though Raphael, in dependence on Michelangelo, had also used such dress in his figures on the ceiling of the Stanza della Segnatura. The form and proportion of the Madonna figure, and to a lesser extent those of the Saint John, recall the figure canon of Michelangelo as he embodied it in the last phases of the Sistine. Their heads, however, are more suggestive of Raphael in their regularity of feature and their pleasant superficiality of expression.

The Michelangelesque infusion in the "Vision of Saint Jerome" is considerable, but the picture nevertheless conforms more nearly to the Raphaelesque than to the Michel-

angelesque ideal. It preserves a considerable measure of High Renaissance harmony; though the design may have a quality of drama, the temper of the picture remains controlled and suave. It holds no trace of Michelangelo's spiritual *terribilità*.

In a sense, the "Saint Jerome" altar makes almost plausible the legend reported by Vasari (see p. 61) of the transmigration of Raphael's spirit into Parmigianino's body. Parmigianino's feat of synthesizing various influences into a stylistically consistent and essentially original whole is itself a Raphaelesque characteristic. More important: when we observe the influence of Michelangelo on Raphael's late style, and the latter's late inclination toward Mannerist forms of expression, the "Saint Jerome" altar might almost be considered as the logical continuation of Raphael's prematurely interrupted development.

It is not as a reflection of Parmigianino's High Renaissance models that the "Saint Jerome" altar is important. The significance of the work lies first in its evidence of Parmigianino's achievement of maturity. Then, though it is not an isolated stylistic phenomenon in the Roman school of the immediate post-Renaissance, the "Saint Jerome" altar is the first painting to embody with such completeness and certainty the principles of style which were being generated in that milieu and time. The maturity here displayed marks not only the artistic emergence of an individual, but the crystallization of the tenets, not till then so clearly and convincingly expressed, of Mannerist style.

The most immediately apparent among the novel qualities of the "Saint Jerome" altar is its extreme emphasis on verticality, not only in the elongation of the figures, but in the picture format as well. The height of the panel is two and one-quarter times its width: this proportion is revolutionary. The only previous approach to it was in Rosso's "Descent from the Cross" in Volterra;[35] and more closely in Francesco's own unfinished organ wings of 1524. The vertical axis of the picture has achieved an exclusive predominance, and the principal interest of the composition is in the winding ascension up this vertical axis of Parmigianino's usual continuous, undulant rhythmic progression. The equilibrium of composition is also effected mainly in terms of vertical, and only incidentally of horizontal, relationships; it consists of an approximate balance of the picture's upper and lower halves.

As in certain of the earlier pictures, but in more pronounced fashion, the main compositional progression follows a path which has been isolated in high light. This path, and the figures which lie on it, adhere closely to the picture surface. In the figure of the Saint John the compositional line turns, in a torquelike manner reminiscent of the San Giovanni frescoes, beyond the front plane of the picture into the spectator's space, as

if to seek intimate contact with him and to intrude upon his attention the starting point of the design. This projective connection is strongly reinforced by John's psychological contact with the spectator.

As the eye follows the spiraling gesture of the Baptist's pointing arm it becomes aware of the figure of the Saint Jerome. The way in which his figure has been disposed does not contradict the essential adherence of the composition to the surface; in spite of the provision of a shallow nook of space for him to lie in, and in spite of the foreshortened drawing of his body, the Saint Jerome conveys no positive suggestion of extension into depth. More than as a recessive motive he tells as part of the surface complex of design; his pose is an echo to, and reinforcement of, the curving arm of the Saint John.

Though seemingly somewhat behind the figure of Saint John, the Madonna group is still close to the picture surface, so much so that the Christ child's extended foot acts almost as a second projection through it. The foot takes up the direction pointed by the finger of the Baptist; the rhythmic movement of design proceeds through the body of the Child into his head. There the progression diverges on two paths: one branch moves across the Christ's arm into the Book which contains the words of prophecy of which He is childishly unaware; the other turns through the lovely head of the Virgin, and follows her veiled glance downward back to the same prophetic text. The compositional line thus twice intersects what could be called the iconographic "key" of the picture.

Characteristically for Parmigianino, the Virgin shows none of the tragic content of her Michelangelesque antecedent. In his rehandling of the Michelangelesque group Parmigianino has transposed its expressive and its aesthetic values. He has displayed the beauty of rhythmical form of both the Madonna and the Child, and most sensitively recorded their extreme refinement of physiognomy. With equal sensitivity he has recorded their psychological states, but these, though subtle and alive, are reflections merely of surface states of spirit. Neither the surface beauty of the figures nor their equally superficial psychological expression has anything to do either with religiosity or with spiritual feeling.

We have observed that the figures in the "Saint Jerome" altar reflect the Michelangelesque canon, but the reflection is in more ways than one without the content of the original. Parmigianino has elongated his bodies beyond any Michelangelesque precedent available to him in painting, even beyond the late pendentives of the Sistine.[36] What has been adapted from Michelangelo's figure canon is mainly its rhythmic quality of shapes (to which Parmigianino would obviously be sympathetically disposed) and secondly something of its appearance of muscular amplitude. However, almost nothing remains of the sense of physical power of Michelangelo's forms, and less of their heroic content. In place of these superhuman qualities Parmigianino has substituted a suave,

73

decorative grace. It is true that Parmigianino's figures too are superhuman, but only in their artificiality. It is curious, and in a way revealing for the nature of the Mannerist mentality, that these artificial beings, who are iconographically but the creatures of a vision, are represented by the artist as if they were nevertheless nearer to reality than the saint in whom their visionary images originate.

The first painting executed by Parmigianino after his arrival in Bologna was a "Saint Roch and Donor" (Figs. 64, 66), which still exists in the chapel in San Petronio for which it was commissioned. This painting is most intimately associated with the "Saint Jerome" altar in style; in fact, it may be regarded as a recombination into a new compositional scheme of the main motives of the lower half of the Roman painting. The Saint Roch and the Saint John Baptist of the Roman picture are nearly interchangeable models, and the bearded donor with Saint Roch (fortuitously, of course) suggests the Saint Jerome. The action in both pictures takes place against a screen of foliage, similarly spatially indeterminate.

The attitude of the Saint Roch, the chief element in the compositional scheme, is a further experiment with the problem of torsion propounded in the figure of the National Gallery Baptist.[37] An explicit physical action determines the complex arrangement of his limbs: the conditions of this action are designed to introduce a complicated turning movement in Roch's figure. A moment before that shown in the painting the saint had been sitting on the rock in the foreground, in a position parallel to the front plane (see his right leg) and facing the donor. At the represented moment Roch, having heard the donor's prayer, has begun to recommend him to the Divinity who appears, in answer to Roch's intervention, in the form of a burst of light in the sky behind the saint, over his right shoulder. Making the gesture of advocacy (the hand on the breast), and placing his left hand on the shoulder of the donor for whom he intercedes, Roch rises from his seat and turns, his drapery swelling out behind him, toward the Light. The head of Roch's dog echoes this turning, and so also does the head of the donor; but the bodies of both remain, like the saint's left leg, in their original position parallel to the front plane. The turning action of Roch's body has been caught at the moment of its greatest complexity: he is halfway between sitting and standing, at the point where his limbs have the maximum variety of directions.

More than in the John Baptist, the intention of this action is primarily aesthetic. In a manner reminiscent of the early "Baptism" of eight years before Francesco has set the figure into motion, and then arrested that motion for the sake of the complex decorative pattern which results therefrom. This intention in the Saint Roch is so extreme that his figure has little other than a purely decorative effect, and almost no expressive physical meaning.

Comparison with the Roman Saint John reveals a factor which would seem partly to be the result of Parmigianino's lesser interest in the functional meaning of the action of Saint Roch, and reciprocally partly the cause thereof: this is the lesser clarity in the Roch of the disposition of his limbs in space. The spatial implications of his turning movement are almost indifferently, certainly unclearly expressed. Francesco seems to have been more concerned with the pattern Roch's body makes along an arabesque-like path, which adheres to the surface more strictly than before.

In its compositional arrangement the "Saint Roch" panel again suggests a further complication on the lower half of the National Gallery altar. As in that work, the composition in the "Saint Roch" is initiated by the leg of the saint, which obtrudes itself upon the eye of the spectator on the lower central axis of the picture. From there the high-lighted areas which carry the design lie mostly to the left of the central axis. The leftward deviation is more complete than in the case of the John Baptist; though the latter's body is to the left of center his torsion is rightward in direction, and his right arm turns across the axis; in the Saint Roch, the torsion is entirely leftward. To restore an equilibrium against this rising diagonal unbalance, the figure of the donor has been assigned a considerable place in the lower right half of the panel; this device achieves a partial equilibrium between the upper and lower parts of a leftward diagonal direction. To further adjust this equilibrium, and simultaneously to complicate it, a series of rightward (and partly rearward) diagonal motives of design intersect the main movement toward the left.

The monumental harmoniousness of his High Renaissance models, of which there is an evident reflection in the "Saint Jerome" altar, was seemingly in some measure antipathetic to Francesco. No sooner had he removed himself from Rome than, liberated from the restraint imposed by the authority of these models, he attempted in the "Saint Roch" to replace their system of compositional harmony with an excessively complex and tenuous equilibrium of his own. In the "Saint Roch" none of the devices used to maintain the equilibrium of the picture conforms to a rational or measurable diagrammatic pattern; they are the result of involved adjustments and counteradjustments of rhythmic direction, suggestions of space, and light. No work among the subsequent paintings of the Bologna phase verges so perilously on compositional disharmony as does the "Saint Roch."

The completion of the "Saint Jerome" altar had brought with it not only the first positive exposition of Parmigianino's mature premises of style, but also the artist's own recognition of the stylistic novelty he had introduced into contemporary Italian painting. Parmigianino's discovery for himself of the nature of these new concepts must have stimulated in him a strong experimental curiosity. The design of the "Saint Roch,"

singular and in a way extreme as it is, is conceived as if to investigate experimentally some of the possibilities of these concepts; the work which succeeds it pushes this experimental exploitation of the new ideas so far that it passes from the singular almost into the extravagant.

The "Conversion of Saint Paul" (Vienna, Kunsthistorisches Museum; late 1527–1528; Figs. 65, 67, 68) is dominated by the form of Paul's rearing horse: a horse such as has never before or since been seen. Francesco has practiced an aesthetic vivisection on this animal; before attempting the drastic revisions of the human anatomy which will appear in his later works, he has experimented on the equine form, torturing it into conformity with a pattern of sweeping, curving rhythms that are of singular elegance, yet powerful—and utterly beyond belief. The arbitrary swelling and attenuation of anatomical shapes, and the excessive diminution in the size of the horse's head, make him an anticipation in the equine world of what the "Madonna dal Collo Lungo" is to be among Francesco's humans some years later.

This form, so rhythmically active, has been disposed across the upper two thirds of the canvas in a great ascending serpentine, to which the figure of Saint Paul seems almost the introductory appendage. Paul's attitude has been conceived exactly as was that of the Saint Roch: he is a variation on the same theme of content, action, and design. As in the Roch, though less aggressively, Paul's pose is based on the decorative complication which results from the interruption of a turning movement. Paul, prostrate on the ground a moment before, has just started to raise himself and simultaneously to turn toward the miraculous burst of light in the sky above. His turning, more subtly and gracefully articulated than that of Saint Roch, describes a virtual spiral, to which the upward and rearward direction of his (unseeing ?) gaze provides a kind of finial. Paul's gaze, however, does not carry us with it to its divine object; it catches his horse full in the flank, and we are irresistibly swept away through that astonishing form. The miraculously constructed animal completely distracts us from the biblical miracle which is the nominal subject matter of the picture.

As we recall, Parmigianino had employed the motive of the rearing horse once before, in his San Giovanni frescoes of five or six years past. There the motive was equally bold and equally sensational in effect, and also unequivocally dominant over any consideration of human subject matter. However, there is an important difference in the stylistic intention with which the motive was used at San Giovanni. There it was a powerful proto-Baroque demonstration of interaction between the spectator's and the picture space. Here the animal rears, not through the picture surface, but in a disciplined parallel to it. Parmigianino's mature Mannerist point of view no longer admits the proto-Baroque purpose of intermingling the artificial and real worlds. The great rearing steed is not now a vehicle for illusion, but for a rhythmically decorative arabesque.

The inspiration of this motive at San Giovanni had come from Pordenone. In the "Saint Paul" picture it reflects another influence, that of Francesco's Roman experience of Raphael. The group at the right of the Heliodorus fresco in the Stanze is comparable to Parmigianino's painting both in the pose of the horse and of the half-prostrate man. Raphael's group, however, composes in significantly different fashion as a closed, plastic form, while in Francesco's composition its elements have been rearranged in an open, rhythmically continuous, serpentine Mannerist pattern.[38]

In discussing the "Saint Roch" altar, Vasari had commented on Francesco's excellence in the painting of landscape. In the "Saint Roch" the background is hardly evident, but in the "Conversion" we see fully the first one among the rare examples of Parmigianino's developed landscapes, and can understand from it the enthusiasm of Vasari's judgment. This landscape is peculiarly picturesque, in a way different from that of the contemporary Venetians; in spite of its picturesqueness, it remains much closer to nature than do the figures disposed before it. The handling of detail within the landscape is most delicate, in places so much so that some details, like the buildings, seem half transparent. The effect of this handling is curious: it at once suggests an increased reality in its effect as that of atmosphere, and yet makes these details seem strangely intangible, and thus less real.

For all its interest, this landscape occupies only a fraction of the picture surface, which is filled, as in all Parmigianino's mature works, so largely with the figure composition; and there is no sense of continuity between the figures and the landscape. As he will again in his few subsequent landscapes, Parmigianino has here arranged that the effect of rearward opening is entirely secondary. There is no perspective device which aids our retreat into the distance; on the contrary, the landscape is constructed of successive layers laid parallel to the picture surface one behind the other. The landscape is compelled to a subservient participation in the larger surface design: it is so formed that the sloping line of the mountains at once repeats the curve of the belly and off leg of the horse and the line of Saint Paul's left leg.

The "Conversion," like the "Saint Roch," is (perhaps happily) a somewhat exceptional picture in Parmigianino's *oeuvre*. More even than the antecedent "Saint Roch" it indicates the lengths to which Parmigianino was willing to go in his transposition of the work of art into terms that should accord entirely with his aesthetic point of view. Vasari estimated the "Conversion" *cosa rarissima*. His judgment was already a generation after the event; it is difficult to conceive of the effect of this picture on the minds of Parmigianino's immediate contemporaries, to whom it must have appeared of quite revolutionary novelty, and infinitely more sensational than it seems still to us today.

There is an evident relaxation in the "Saint Margaret" altar (Bologna, *c.*1528, Figs. 71, 72) from the overcomplicated experimental mechanics of the "Saint Roch," and from the extravagance of form and content of the "Saint Paul." This work exhibits a new dimension of Parmigianino's maturity: it is designed with superb ease and mastery, and similarly executed. Parmigianino's assurance in the "Margaret" altar is apparent, among other ways, in his assurance of hand. The technical virtuosity of this picture is at a level beyond any he had hitherto attained. There is a variety in the interest and tempo of his brushwork which parallels the variety with which he handles the linear rhythms of the design. In places in this painting, as for example in the garment of the Saint Margaret, there is a singular breadth of stroking, almost prophetic of Tintoretto in its quality; in other parts, as in the head of the Madonna, there is an extreme of fineness in the handling.

However (as we observed in Part I), Parmigianino exhibits as he matures a tendency toward increasing hardness of effect in his painted surfaces. Even in the broadly handled areas of the "Margaret" altar the visual recombination of the brush strokes from a little distance singularly gives an effect of surface texture which is hard and smooth.[39] In the tightly brushed-in portions there is a closer approach than in any previous work to the ideal of smooth, porcelain-like surface which is completely attained in the "Madonna dal Collo Lungo."

The composition of the "Saint Margaret" is the most fluent expression so far of Francesco's rhythmic system of design. The compositional line is initiated by the lowest edge of Margaret's drapery, on the central axis of the panel; this is like a grace note to the swift serpentine movement which winds through her convoluted form. The initial passage of drapery, and indeed the whole of Margaret's figure, are very close to the front plane of the picture, but there is no assertive projective device. There is no need here of an illusionistic detail to effect the transition of the spectator into the quasi-abstract pictorial world; the swiftness and intensity of the rhythmic pattern, operating through the figures in a plane as close as possible to the spectator's space, is enough to compel that transition immediately.

The sweeping movement which traverses the figure of the Saint Margaret turns through her head, and then through the body of the Christ child, which is an inverse repetition in miniature of her own. The arm of the Madonna takes the upward sweep of rhythm into her head; as usual, the Madonna's face creates a retard in the tempo of the compositional line as we observe her beauty, now more pure and regular than in earlier types. The main phrase of the progression ends in the head of the Madonna, but a secondary phrase, more suggested than precise, but still apparent, starts there: it weaves across the panel in the pattern of a horizontal figure eight, leading the eye through the heads of the attendant figures.

Though so fluidly rhythmic in character the composition contains strong elements of harmony. There is an approximate balance of figure areas on either side of the central axis, and a corresponding balance in the disposition around the vertical axis of the main compositional path. The curving, but generally balancing near-isocephaly of the upper row of heads contributes a further measure of equilibrium.[40] This equilibrium remains distinct from High Renaissance balance, not only because of its secondary place in the compositional scheme beside the rhythmic design. The composition conspicuously does not have, as it would in the High Renaissance, a stable base. The slight suggestion of a triangular, High Renaissance-like frame that it contains proves, on examination, to be an inverted triangle: its base is in the upper row of heads, and it stands balanced, like a top, on its apex in Saint Margaret's knee.

The aesthetic interest of the composition, as usual, is dominant over its expression of content. However, such content as exists in the "Saint Margaret" altar is of a rather unusual kind for Parmigianino, and it is expressed with particular ingenuity within the design. Generally the personalities in Francesco's religious paintings remain curiously without interest in one another. Often, the only psychological interchange occurs between a figure in the picture and the spectator; and sometimes even that is absent. The angel in the Margaret altar fulfills this function, but his psychological activity is secondary. The main center of psychological interest is in the interplay of feeling between Saint Margaret and the Christ child.

The motives of design are so arranged as to intensify this interplay. It takes place in the center of the picture, where the ascending sweep of the main serpentine rhythm breaks abruptly in direction at Margaret's head. The energy of this upward movement is, so to speak, concentrated in her head. The branch of the serpentine which convolutes through the body of the Child, and up the arm of the Virgin into her face has, as is often the case in Francesco's design, a dual character of direction. In the quick reading of the whole design its direction is continuous with that of the ascending rhythm through the body of Saint Margaret, but in our rereading of the composition, following the inclination of the head of the Madonna, we are impelled to turn back along her arm and through the Christ child in the reverse direction. In actuality, the eye schooled in the complex mechanics of Parmigianino's design simultaneously appreciates both possibilities of direction.

The downward energy in this movement, opposing the ascending rhythm which culminates in the head of Margaret, is gathered up through the body of the Child (where the rhythm is compressed as in a coiled spring) and into His head. Out of the energies of the two opposing movements an aesthetic tension is created. This tension is discharged across the narrow interval that separates the two heads as across a spark gap. It is not by spiritually meaningful expression of the faces that Parmigianino has chosen

to convey this emotional exchange, but by the manipulation of an aesthetic device.[41]

By contrast with Francesco's next surviving devotional picture, the "Madonna della Rosa" (Dresden, 1528–1530, Fig. 73), the "Saint Margaret" altar is made to appear a work of genuine religious depth. In no Christian painting previous to the "Madonna della Rosa" had the Madonna theme been represented in a manner so essentially un-Christian. Beyond the iconographic convention by which we are accustomed to recognize the association of a clothed female and a more or less clothed infant as a representation of the Virgin and her Child, there is little which convinces us of the sacred character of Parmigianino's figures. The picture does contain an explicit religious symbolism (the red rose, symbol of Christ's sacrifice, through which he achieves salvation of and dominion over the globe), but this has been so suavely absorbed into the elegance of decorative effect, and of feeling, that its interest is almost altogether tangential.[42]

In this picture the actors have been shaped almost wholly in conformity with the dictates only of Parmigianino's special personal aesthetic, from which religious sentiment or even its more general counterpart, profound spiritual feeling, seems to be excluded. He has thus fused into his "Madonna and Child" certain qualities which are actually contradictory to their Christian character: the chief of these is their degree of sensual interest. This sensuality is exceedingly refined, but that does not diminish its irreligiousness.[43]

Observers have long been conscious of the irreligious conception of the "Madonna della Rosa," and the earlier critical literature contains a legend inspired by it. According to Vasari (V, 227) the "Madonna della Rosa" was originally commissioned for Aretino, but when Pope Clement came to Bologna in 1530 it was given to him instead. Affò (pp. 71–72) suggests that Aretino had commissioned not a "Virgin and Child," but a "Venus and Cupid." When the recipient of the picture became not Italy's Great Libertine, but the Pope, Francesco would have adapted his painting somewhat and, secondarily, renamed its characters.[44]

This story is not necessary to explain the un-Christian quality of Francesco's picture. We have observed the evolution of his Madonna type, with its increasing refinement of surface beauty and increasing quality of sensual interest; we have also observed the absence of meaningful religious content in his previous devotional pictures. Such a conception as the "Madonna della Rosa" could logically have evolved of itself as a consequence of Francesco's dominantly aesthetic point of view. It is interesting not only for the artistic personality of the painter, but also for the historical personality of the contemporary Pope, that he should be thought a fit, and presumably appreciative, audience for a painting of the Virgin and Child so conceived.

It may be that the character of Aretino, allegedly the original patron for the picture, may have played some part in the extreme sensuality and worldliness of conception of

the "Madonna della Rosa." It is also possible that a pagan model may have been present in Francesco's mind when he conceived the image of his Virgin, and that it in part dictated her appearance. In the pose of her arms the Virgin recalls a common classical type, the Venus Pudique, of which the most famous examples are the "Cnidian Venus" and her derivatives, including the "Venus de' Medici." Several antique examples of the type were known in Parmigianino's time. The pose of his Madonna, though it makes decorative sense of a high order, has so little reason functionally that it may in fact owe its origin to the imitation of the attitude of an antique. If the Virgin was inspired by a classic statue it then becomes more understandable that Francesco was reluctant to obscure the physical beauty of his model with the traditional opaque garments of the Christian Madonna.[45]

The distilled sensuality of the "Madonna della Rosa" is both novel and extreme, but it can be said to have developed as a logical extension of an authoritative High Renaissance precedent. In many of Raphael's pictures the religious content of the actors is hardly more than nominal. The figures are idealized, but not with a primarily spiritual purpose; their idealization is imposed upon a basis of sensuous naturalism. With one step in Parmigianino's stylistic direction Raphael's precedent is easily transformed from a figure of idealized sensuousness into one of abstracting sensuality.

The sensual emanation of the "Madonna della Rosa" is strongly reinforced by the artist's handling of brushwork and color. The technical virtuosity of the "Saint Margaret" altar has here gone into reverse: the "Madonna della Rosa" shows an equal virtuosity, but in this case of uniform extreme finish and specificity of handling. All the figure surfaces, and the half-transparent garment of the Madonna, are most minutely brushed in; and into this intimate tissue of brushwork has been woven a variety of small touches of changing color. As we have observed in Part I, the skin surfaces are unsensuously smooth and even vitreous, but the coloristic vibration within these porcelain surfaces endows them with fictitious life. This refined and subtle vibration titillates and excites the eye; it is a visual parallel to the psychological experience of sensuality.

The exquisite surfaces of the "Madonna della Rosa" are but one expression of an increased refinement evident throughout the picture. The types of the Madonna and Child are distinguished beyond their previous counterparts by an even greater delicacy of feature (accompanied in the Madonna by a further regularization) and by a purer rhythmical refinement in the design of the torso, limbs, and hands. The same quality is evident in the extreme grace of effortless, and virtually unfunctional, gesture and in the complete rhythmic fluency of composition. The ideality of Francesco's pictorial world has been refined, in the "Madonna della Rosa," a step farther in the direction of abstraction; that sphere parallel to reality within which Parmigianino constructs his paintings has here withdrawn one stage more beyond the objective world.[46]

If not more refined than the "Madonna della Rosa," the feminine types of Francesco's "Madonna with Saint Zachary" (Uffizi, *c.*1530, Figs. 74–78) are of a more nearly abstract and more regular beauty. This regularization of the shapes of the features and head had been proceeding continuously since the National Gallery altar, and could have attained the form apparent in the Uffizi picture without any outside example. However, the Madonna and the Magdalen of this painting recall the types of Raphael: it is possible that, in a measure, they were inspired by him. Raphael's "Saint Cecilia" altar was then in Bologna, exposed in the church of San Giovanni al Monte.[47] The Magdalen in Raphael's painting may have served as a point of departure for both the feminine heads in Parmigianino's work, but particularly for the face and attitude of the saint. However, both heads in Parmigianino's painting reveal a difference from the Raphael model which results from its translation into Francesco's personal terms: they have a cool perfection of modeling and expression which makes them, in contrast to the evident sensuous reality of Raphael's type, seem like statuary.[48]

There is also a Raphaelesque (or perhaps rather a Giulio Romano-esque) reminiscence in the landscape, not only in its exceptional importance in relation to the figures, but also in its mélange of classic and contemporary details. The classical elements of architecture are a specific recollection from Francesco's time in Rome: they are certainly derived (though not literally) from the Arch of Constantine and from the great narrative sculptured columns. These classical derivations are, however, interpreted most unclassically, for they share in the romantic atmosphere of the rest of the landscape with its tangled trees, craggy mountains, cloud-shot sky, and its ghostly, half-transparent indication of a city. In spite of the quantitative importance of this landscape and its interest of mood, we have already observed (Part I) how its spatial construction has been so conceived as to conform essentially with Francesco's unsympathetic attitude toward the logical representation of environment.

In the foreground there is also an unusual amplitude in the space within which the figures are disposed, but this space too has no more than Parmigianino's accustomed minimum of spatial logic. Each figure occupies an element of space which is dependent only on the extension of that figure, and which is not defined except in relation to it; there is no logical objective relation between these separate elements of space. Each of them is situated at a different level, dictated by the demands of the surface design. The significant difference between the spatial arrangement of this figure plane and that in previous paintings is in its lesser compression toward the picture surface. It is as if the figure plane had been somewhat drawn open, accordionwise, in an oblique direction.

As if to compensate for the absence of the customary compression of the figures toward the picture surface, the foremost plane of the picture, which contains the Saint Zachary, has been pushed farther toward the spectator than in any previous instance

among the mature works. The result recalls the device employed, in much less adroit fashion, in the Roman "Marriage of Saint Catherine."

By the scale of the Zachary in relation to the Madonna group, and by the extraordinary interruption of his body by the frame at the waist and side, the artist approaches as near as is possible with pictorial devices to giving the spectator the psychological impression of the saint's existence within the spectator's own space. For, measured in terms of the very considerable nearness to the front plane of the Madonna group, the size and position of the Zachary in relation to that group can be logically resolved only through the idea of his existence in front of the picture, rather than in it. This impression is intensified by the fact that the level at which the saint stands does not have any rational connection with the main group: the ground level on which he stands is approximately the same as that of the spectator.[49] Zachary's scale and perspective relationship make sense in relation to the Madonna group only if one conceives of him as another spectator, who partially interrupts our view as we regard the painting over his shoulder.[50]

This deduction, which we may make in logic, does not operate according to its intellectual premise either as a visual or psychological fact. The ineradicable boundary of the frame remains to mark the Zachary off from participation in our world. This effort of illusionism is Parmigianino's one positive reassertion during the decade of his maturity of the one-time preoccupation of his early years. However, this effort is constructed on an idea so abstruse, and is so curiously tangential in its effect, that it may no longer conceivably be confused with the powerful, physically assertive, proto-Baroque devices of the first period in Parma.

The form of the Zachary initiates the movement through the composition. The undulant progression which begins in him is simultaneously the core both of the picture's surface design and its design in space: this identity is to the advantage of the former. This would not be so if (as in similar instances of identity of space and surface pattern in a Baroque picture) the spatial disposition of the figures and the logic of construction of the landscape were more objectively convincing than in the present work. Because they are not, the decorative, superficial effect of the compositional arabesque tends to absorb its spatial meaning.[51]

Like the "Madonna della Rosa," the Uffizi picture contains a quality of coloristic vibration, but it has been extended beyond the figures and their garments into every portion of the picture surface. The seemingly frigid flesh, the draperies, and the thinly painted landscape all shimmer with a silver-blue suffusion of mingled light and color. The effect resembles that of atmosphere: not of any atmosphere in the objective world, but such an ethereal atmosphere as we should expect would pervade the realm in which Parmigianino's figures might live.

THE SECOND PERIOD IN PARMA.

1531, May 10: On this date appears the earliest definite notice that Parmigianino had again taken up residence in Parma. The source of information is the initial contract for Francesco's decoration of the Steccata. An informal agreement for the Steccata project appears to antedate the contract of May 10; it is therefore probable that Francesco was in Parma for a brief, but undeterminable, time before that date.[1] On May 10 Parmigianino's address is given as his late father's house near San Paolo, where his cousin by marriage, Bedoli, and Bedoli's family, were also living. Other documents of successive years indicate that Francesco changed his residence at least once each year from 1531 to 1534. His last recorded residence in Parma (December 1534) was in the relatively isolated district of Santa Cecilia.[2]

Francesco's execution of the Steccata frescoes was extremely dilatory. The contract was twice renewed but on *December 19, 1539,* he was finally relieved of his commission.

1539, between August and December: to escape from his legal difficulties with the Confraternity of the Steccata, Francesco left Parma (accompanied apparently by his apprentices and/or servants) and settled in the town of Casalmaggiore, nearby but out of Parmesan territory. Here he worked until taken mortally ill.

1540, August 21: Francesco signed his will,[3] and three days later,

1540, August 24: Parmigianino died, ". . . assailed . . . by a severe fever and by a cruel flux."* He was buried in the Chiesa della Fontana near Casalmaggiore.

Francesco's return to Parma was probably motivated chiefly by the prospect of new commissions from the Confraternity of the Steccata, and in particular that for the decoration in fresco of their church.[4] His decision to return would have taken substantial encouragement from the fact that Correggio, so long the dominant painter in Parma, had retired in 1530 to his native town.[5] The field in Parma was thus open; with his considerable reputation and his background of "foreign" experience Francesco was certain to take over the leadership in Parma which had been Correggio's.

In view of Parmigianino's early affinity for Correggio it might be expected that renewed exposure to that master's work would bring with it a reassertion of his influence. In his earlier career Francesco had absorbed much from Correggio: as we have observed, the latter's influence had persisted to some degree even through Parmigianino's Roman years. However, there is no positive survival of this influence in Francesco's Bolognese pictures. In spite of the early *rapprochement* of the younger with the older artist, since Parmigianino's departure for Rome the two had been exploring largely divergent paths: one mainly in the direction of the proto-Baroque, while the other had achieved a nearly pure formulation of Mannerist style.

* ". . . assalito . . . da una febre grave e da un flusso crudele" (Vasari, V, 233).

Nevertheless, on Francesco's return to Parma the former authority of Correggio somewhat reasserted itself, but not in such fashion as to alter the essential character of Francesco's developed style to any perceptible degree. This reasserted influence seems to be confined to the suggestion of figure motives and, to a lesser extent, of decorative motives. Francesco's "Amor," painted during the earlier part of his renewed residence in Parma, is related to Correggiesque motives of pose, and is touched with a Correggiesque overtone in expression. In the design of the Steccata decoration, prepared in the first days after Francesco's return, there are also derivations from Correggio's unavoidable example in wall painting. However, no other element in these works, nor in others of the second Parma period, suggests that Francesco had reverted to his earlier dependence.

By the time of his return to Parma Francesco had not only positively formulated his own concepts of style, but he was absorbed in the problem of their successively more complete and consistent expression. The first half of his second stay in Parma is devoted to the refinement, to its logical extreme, of the style postulated in the works painted in Bologna. This end Francesco achieved in the "Madonna dal Collo Lungo."

It is obviously impossible to carry the evolution of Parmigianino's premises of style beyond this picture. In it we are already beyond the realm of what we commonly understand as idealization, and have ventured into a realm of quasi-abstraction almost as reactionary, from the point of view of the High Renaissance, as that of a medieval work. To take a further step in the same direction would have required a radical desertion of the world of appearances, and would have resulted in an essentially abstract (and, lacking a better word) "Byzantinesque" style. Parmigianino was an original, and in the extremism of the "Collo Lungo," even a bizarre personality, but he was still a heritor of the Renaissance. No artist in Italy, from the mid-fifteenth through the nineteenth century, approached so near abstraction as Parmigianino did in the "Collo Lungo"; but Parmigianino was no more capable of the perilous step beyond this point than was any other artist immersed in a tradition dependent on the Renaissance.

Having achieved this culminating expression of his Mannerist style Parmigianino was not content only to mark time and repeat himself with variations within the same formula. He was himself in the situation in which Vasari, in his conclusion of Francesco's life in the first edition, puts other artists who would wish to imitate his style: ". . . who should imitate him, would make no more than an augmentation in his style."* Francesco was therefore impelled to seek a new orientation of style. In fact, certain items of evidence suggest that such a reorientation may have been generating within him simultaneously with the ultimate embodiment in the "Collo Lungo" of his previous ideal.

The purely rhythmic basis of the style of the "Collo Lungo," there developed to its extreme, had all but eradicated the quality of monumentality from Francesco's

* ". . . qui quella imitasse, altro che augumento nella maniera non si farebbe" (p. 852).

painting. The first element of his reorientation consisted in a reassertion of monumentality, in greater measure than had been present in his art before, even in the single great altar of the Roman period. The achievement of this quality was, naturally, a synthetic process. Francesco could not, and surely did not wish to, discard completely the basic principles of style he had already evolved. He could modify them in considerable measure and considerably alter their effect, but he would not wholly deny them.

Parmigianino revised his concept of design so that the rhythmic element is no longer unopposedly dominant, but synthesized with a profound gravity of forms and composition. The same gravity invades the spiritual atmosphere of his few later paintings; his new monumentality is not merely a formal device, but the manifestation of a new seriousness of mind and feeling. His previous almost exclusively aesthetic point of view, both toward his art and toward the human beings represented therein, is qualified by the imposition on it of a new dimension of spiritual meaning.

This late tendency toward monumental gravity in form and spirit hardly had time to affirm itself completely before Parmigianino's premature death. It is fully expressed only in his last work, the "Madonna with Saints John and Stephen" (Dresden), where it attains a very high level of nobility and beauty. This altar marks the integration into Parmigianino's art, which had before been chiefly impressive for its "style" (almost in the colloquial sense), of a deeper spiritual value. In contrast to the exquisite aestheticism of the "Collo Lungo," the Dresden altar is austere, hieratic, and spiritually transcendent. It marks Parmigianino's conversion from a creed of personal aesthetic subjectivism to a spiritual subjectivism which, expressed as it is in this case through the symbols of Christianity, appears genuinely religious. This "conversion" antedates the official institution of the Counter Reformation, yet the nature of the change it presents is like that from the "late Renaissance" to the Counter Reformation in the historical personality of sixteenth-century Italy. Parmigianino's personal conversion is thus of more than personal meaning; it is symptomatic of the general redirection toward religion which was then in generation, and which in two years' time would bring the convocation of the Council of Trent.[6]

From the sparse biographical evidence that is left us it would seem that such a change in fact occurred in Parmigianino's personality during the last half decade of his life as would help to motivate this redirection in his art. It is fairly certain that during these late years Francesco was absorbed in alchemy, to that extent where he considerably neglected the practice of his painting. Vasari thus describes his alchemistic activities: "because having begun to study alchemy, he had neglected his painting altogether, thinking to grow rich soon, in the congelation of mercury . . . he wasted all the day in messing with coals, firewood, glass bowls, and other similar household trumpery . . . thus he went consuming himself bit by bit with these chemist's furnaces of his . . . "*[7]

* (V, 231): "perchè avendo cominciato a studiare le cose dell'alchimia, aveva tralasciato del tutto

Such an absorption in alchemy would seem not altogether unexpected in a person already so far removed from interest in objective reality as Francesco was.[8] However, to comprehend the full meaning of this alchemistic concern and its significance for the re-direction of Parmigianino's personality, we must realize how alchemy was regarded by contemporary practitioners in the "science." To the initiate of Parmigianino's time alchemistic research was not either merely pseudoscientific dillettantism or a royal road to riches. It was instead a kind of mystic-philosophical activity. In alchemy "we are called upon to deal, not with chemical experiments as such, but with something resembling psychic processes expressed in pseudochemical language."[9] The philosopher's stone which was the object of the alchemist's research had, since the fourteenth century, been identified with the idea of Christ, and the whole alchemistic practice was profoundly interpenetrated with Christian theological symbolism. The researcher had to "cleanse his mind through God,"[10] and "cast aside all such insignificant cares as food and clothing, and so appear to himself as if he were born anew . . . chemistry excites the artifex to meditation on the good things of heaven."[11] This last injunction Francesco must have obeyed well for Vasari notes that "having his mind always on this alchemy of his . . . and from one [who was] refined and amiable, become, with his beard and hair long and ill-kept, almost a wild man and another from that which he had been[12] . . . and become melancholic and strange . . ."*

Parmigianino's concern with alchemy may thus be considered ultimately religious in its intent, though it was admittedly a bizarre and highly unorthodox form for the expression of religious feeling to take. His direction of his spiritual energies into this singular channel is nevertheless entirely comprehensible. Francesco had matured in that generation when the Church, the official vehicle for the expression of man's spiritual concerns, was less authoritative than ever in its history before. Francesco's "religious" pictures through the "Collo Lungo" amply demonstrate his attitude toward the dogma of the Church: a casual acceptance of its conventions, without the least response to their meaning. His spirit had expressed itself in terms not merely disassociated from the intent of the Church, but even often at variance with its teaching; these terms were further highly individual, so much so that they border often on anarchic fantasy.

When his crisis of artistic style and personal psyche (as cause and effect they are indissoluble) came upon Francesco in the middle 1530's he was hardly disposed to satisfy his need for deeper spiritual values through the institutional means at hand, the Church.

le cose della pittura, pensando di dover tosto arricchire, congelando mercurio . . . perdeva tutto il giorno in tramenare carboni, legne, boccie di vetro, ed altre simila bazzicature . . . si veniva così consumando con questi suoi fornelli a poco a poco . . ."
* (V, 233): "avendo pur sempre l'animo a quella sua alchimia . . . ed essendo di delicato e gentile, fatto con la barba e chiome lunghe e malconce, quasi un uomo salvatico ed un altro da quello che era stato . . . e fatto malinconico e strano . . ."

This would have been particularly true because, in spite of the general symptoms of revival of religion then current, and the beginning efforts of the Church to reconstruct itself, it had not yet reëstablished the authority it was later in the century to have. Even in his spiritual need the Church was no refuge for Parmigianino, at once because it lacked the authority to claim him, and from the very fact that it was an institution, and thus no fit place for Francesco's extreme development of individuality.

Francesco's late expression of religion thus took its bizarre and personal form, rather than the channel offered by the Church. However, his ultimate Christianity was never in doubt. Vasari (V, 234) reports that he was buried, as he asked to be, naked, with a cross of cypress on his breast.

The first work Francesco executed after his return to Parma, the "Amor" (Vienna, Kunsthistorisches Museum; c.1532–1533; Fig. 79), clearly shows the evidence of his renewed contact with Correggio. The "Amor" appears to have been evolved by Parmigianino out of suggestions gathered from four among Correggio's approximately contemporary works: the nude youths on the painted balustrade of the cupola of the Duomo, the "Ganymede," the "Io," and the "Allegory of Vice."[13] From the two latter paintings Parmigianino adapted two more or less specific motives: the unconventional rearward exposure of the nude, and the head of the grinning infant in the lower part of the panel. The inspiration of the two former works is less precise but in a sense more important, for in them lay the origin of the expressive idea of the "Amor": the representation of physical attractiveness in the youthful male form.

Though the moral (or immoral) idea stems from Correggio, its expression in the "Amor" has been transposed into terms which are peculiar to Francesco and, more generally, to the Mannerist mentality he represents. Correggio's "Ganymede" deals with a subject of overtly homosexual connotation, but by comparison with the "Amor" the "Ganymede" seems a relatively normal, almost healthy work. The "Ganymede," even with its rich sensuousness, remains an essentially objective picture which we may contemplate in detached fashion, without any necessary psychological involvement therein. The reaction imposed upon the spectator by the "Amor" is quite different: it demands an intense immediacy of contact and an intimate psychological response.

The Amor's body, modeled with as much of statuary roundness as Parmigianino can achieve, is projected against a completely neutral background. It occupies the entire picture field, and at the same time approaches as closely as it can to the very foremost limit of the picture space. The sense of compression toward the spectator is accentuated by the tight constriction of the frame. The figure seems even more than normally to be compelled toward us: its impact on us is exceptionally instant and direct. Moreover, once this contact with the entire form is thus established, the eye is then required, by the rhythmic movement of design, to traverse the body in detail. This imposition on

the spectator of the Amor's physical form is accompanied by his compulsion from us of a psychological relationship, through his sly, intent, malicious gaze.

The physical form of the Amor, so bold and fluent in its design, is the core of the formal structure of the picture, but it is only a point of departure for the picture's content. As a sensuous object, the body is merely the vehicle from which that content, a complex of irritant psychological overtones, proceeds. The chief among these overtones is the extreme effect of sensuality in the figure, which is achieved by the infusion into its surface of fine, nacreous glazes like those used in the "Madonna della Rosa." However, the subtle flavor of her sensuality has here become, through its association with the abnormal theme, strangely acid in effect.

This content of the "Amor" could operate within the frame of any number of possible iconographic schemes. The particular one chosen here, however, appears basically to be a "Triumph of Love," as traditionally conceived in the conventional Renaissance "triumph" series. The Amor steps on two great books, so symbolizing his conquest over science and knowledge, while to indicate his victory over strength he carves a bow out of the club of Hercules.[14] The two struggling *putti* who appear below the Amor are not a part of the traditional iconographic scheme but Vasari (V, 230) has explained convincingly enough the action in which they are represented: ". . . one takes the other by an arm, and laughing wishes that he touch Cupid with a finger; and that one who does not wish to touch him, cries, showing that he is afraid lest he cook himself in the fire of Love."* It has further been suggested that the shrinking *putto* symbolizes the reticent female, the bold one the male.[15] However, whatever symbolic or specific narrative meaning the picture contains, it is certainly but a minor aspect of its content; that emerges rather from the aesthetic and psychological elements in Parmigianino's representation of the chief actor in this humanistic charade.

The "Madonna dal Collo Lungo" (Florence, Pitti; *c.*1535; Figs. 80–85) is less complex in content than the "Amor." Its mood maintains a kind of harmony, at least within Parmigianino's elastic concept of that term. That concept, however, can be stretched no farther than it has been here, where its expression is precious and exquisite in the extreme. No pretense to harmony could be maintained beyond this highly tenuous point: with one step farther in this same direction we should fall either into vapidity or hysteria.

This extreme in expression of the "Collo Lungo" is accompanied by an equal extremism in matters of form. The "Collo Lungo" contains the ultimate development of the principles of style first formulated in the "Vision of Saint Jerome," eight years before; as we have remarked, there is no way beyond this extreme of style except into

*(V, 230): ". . . uno piglia l'altro per un braccio, e ridendo vuol che tocchi Cupido con un dito; e quegli che non vuol toccarlo, piange, mostrando aver paura di non cuocersi al fuoco d'Amore."

Byzantinesque abstraction, where no heritor of the Renaissance would find it possible to venture.

The "Madonna dal Collo Lungo" was never quite finished. Though begun in 1535 with strict assurances of quick delivery, it appears never to have left the artist's studio, and to have been taken thence only after his death.[16] According to Vasari (V, 231) Parmigianino never completed the picture *perchè non se ne contentava molto.* The statement may contain a deeper truth than superficially appears. We have described the transformation of Parmigianino's style after he had, so to speak, embalmed one whole set of values in the "Collo Lungo." Symptoms of this change may have appeared even as he was giving ultimate expression in this picture to his aesthetic of the years 1527–1535. His (in the literal sense) revulsion from the manner of the "Collo Lungo" may have matured while he was still engaged in the laborious process of completion of the painting, so that he found himself unwilling and unable in conscience to apply those few final touches which would have permitted his patrons to remove the altar from hiding in his studio and expose it to the public.

In Francesco's later years, as the documents of the affair with the Confraternity of the Steccata sufficiently show, he was an intensely self-critical and independent person. That he allowed the "Collo Lungo" to rest five years overdue without finishing a few minor passages could hardly have had any valid basis other than a psychological one.[17] This extreme example of self-critical dissatisfaction singularly distinguishes Parmigianino from most High Renaissance painters, with their essentially craftsmanly attitude toward their work.

A full analysis of the "Collo Lungo" would demand the repetition of a large section of Part I of this book, since almost every major principle of style there described is embodied to a superlative degree in this painting. Such an extreme is at once evident, for example, in the system of proportion of the figures. All the figures, and the Madonna in particular, exceed not only natural probability, but even Francesco's previous revisions thereof, in their elongation and in the rhythmic distortion of their forms.[18] Conceive of the shape which would be presented to us if the Madonna should rise: she remains within even the remoter sphere of credibility only by remaining seated.

Her "seated" pose, however, is in itself illogical. In Francesco's successive representations of the Madonna the articulation of her seated figure had become less and less clear, until in this work the Virgin more than casually resembles the production of some fourteenth-century North European sculptor; she is supported less by some objective logic in her body than by the ascending impulses of linear rhythm which traverse her form. She does somehow rest, in her half-seated, half-standing pose, against an invisible support; but her relation to it suggests the way in which a Gothic architectural sculpture may be hung pendant against the wall. This ambiguous posture seems to result in part

from Parmigianino's assertive will to impose upon the representational elements of the picture a complete conformity with his developed principles of design: he will not permit the intrusion, into his aesthetic preference for vertically moving rhythms, of the ponderative associations which emerge from a properly articulated seated form.

Another aesthetic predisposition, for compressing the figure forward into the shallowest possible plane of space, also conditions the Madonna's pose: she has been flattened simultaneously forward and upward in the picture. The accessory figures are subjected to a similar, but not so extreme a compression. They, however, are even more arbitrarily articulated than the Madonna. Only the urn-bearing angel shows a part of a coherent physical structure; the rest are mere heads, with no indication of the bodies that sustain them.

The narrow plane of space within which the figures are compressed is almost without definition apart from the figure elements themselves. A clear, but intangible, boundary does exist, as is usual, in the plane of the canvas itself. Further, in the upper left quadrant, at an indeterminate distance, but evidently close behind the surface, a curtain[19] contains the figure plane from the left rear. However, the entire picture is not confined within this plane. In the narrow strip not occupied by figures, at the right, a background space is indicated.[20] This is constructed on a continuation of the same perspective projection as that on which (as much as is defined of) the figure plane is built,[21] but this common projection does not either convey an intelligible connection between the rearward space and the foreground plane, nor does it give the rearward space an objective logic within itself. The relation of ground levels between the foreground and background[22] is utterly ambiguous and so creates a strong uncertainty about the distance from the foreground of the rearward space. This ambiguity of distance in turn makes ambiguous the effect of the difference in scale between the tiny male figure at the right (the so-called "prophet") and the principal figures; his scale suggests a strange and arbitrary diminution of size rather than a natural result of perspective vision.

Only the few lines which define the right side of the base of the colonnade communicate a positive idea of recession. Their effect, however, is strongly outweighed by the much more evident repetition in the architecture of rectilinear motives laid parallel to the picture surface.[23] The landscape and sky in the rearmost distance behind the architecture are indicated, as usual, in summary and spatially unemphatic terms.[24] The whole background, but especially that part of it which contains the architecture, assumes the character of a rather shallow panel of space, of somewhat imprecise limits, inserted at an ambiguous distance behind the figure plane.

Parmigianino's intention in creating the opening of space into the background is not merely the simple one of providing the spectator with a relief from, and contrast to, the forward compression of the figure plane. It does in fact serve this purpose in limited

fashion; but like many motives in Francesco's work, this one is ambivalent in function, and is impressed to serve another and apparently contradictory purpose. When the spectator enters the rearward space he becomes aware not only of its ambiguities, but also of its limited, unpositive character. It becomes evident that the background is not intended only as a recession from and contrast to the foreground, but that it is essentially subordinate thereto and serves further to affirm the character of design of the figure plane.

The two principal elements in the rear area are supplements to the composition of the forward plane and are meant to be "read" in dependence upon that composition. The figure of the "prophet" is the almost exact pendant, at the bottom corner of a roughly triangular scheme, of the lower leg of the urn-bearing angel; the right arm of the same figure makes an almost uninterrupted continuation of the smaller rightward projection of the Virgin's garment. The single executed column repeats in inverse, and balances, in relation both to the horizontal and vertical axes, the light area of the angel's entire leg; the column further contributes to the equilibrium of the design by its chaste, rigid vertical echo of the undulating vertical armature of the Madonna.

The perspective projection serves also as a device to reinforce the effect of the foreground figures. The opening of the picture toward the rear makes more evident the extremely low placing of the vanishing point, and this in turn accentuates the extraordinary impression of height and verticality in the figures. Finally, because of the abnormal fanwise opening toward the spectator of the lines of projection (a result of the low vanishing point) the perspective system aids as well in the sense of propulsion toward the spectator of the figure plane.

The forward compression of the figures does not have the emphasis (effected through the constriction of surface area) of the "Amor," nor does it employ the exceptional illusionistic device of the "Saint Zachary Madonna." The actors in the "Collo Lungo" keep their distance from the spectator not only in mood, but physically. They are entirely contained behind the plane of the canvas; there is only the customary extension toward (and almost across) this plane of the initial point of the serpentine design: the right foot of the Madonna.[25]

Introduced into the painting by this detail, the spectator's eye follows the swift impulse of the rising rhythm through the Virgin's body to her head. The eye reads not only the main rhythmic path (along the right leg of the Virgin, the body of the Child, and the Virgin's left arm) but simultaneously, as in counterpoint, observes the accessory rhythms (in the lower area the leg of the urn-bearing angel, the left leg of the Virgin, and the left arm of the Child) which stream upward in the same vertical direction. This movement culminates in the partly isolated head of the Madonna, where a combination of devices is employed to arrest our attention and the tempo of movement of the design.

The gaze of the Madonna and the slight turning of her head suggest a countermovement downward through the same path as that of the ascent: the eye follows the body of the Christ child leftward to the area where his legs interlace with the upper half of the figure of the angel. Here the movement again ascends, following the gaze of the angel across the group of strangely truncated adolescent heads[26] into the ineffably graceful posture of the Virgin's right hand and arm, where we are caught up again in the original compositional path. After the first swift upward serpentine movement, then, the eye descends in a counterrhythm and describes a clockwise oval movement which threads through the main elements of psychological interest in the picture.

Unlike the "Amor" or the two previous Madonna pictures, there is no point in the "Collo Lungo" where the energy of the rhythmic movement is concentrated, there to be discharged in the form of a psychological interplay with the spectator. Nor is there such an intense psychological connection between any of the actors in the "Collo Lungo" as we have observed between the Margaret and the Christ child in the Bologna altar. The enraptured gaze of the urn-bearing angel is too precious to be meaningful, and the expression of the Madonna is more precious still; in neither gaze is there the sense of a genuine psychic discharge toward its object.[27] The Antea-like girl (compare portrait, Fig. 144) in the background looks out in the general direction of the spectator, but her eyes evade our search for contact. These background heads especially manifest the psychological detachment of Parmigianino's figures from one another.

If there is any place in which the design may be felt to concentrate a measure of its energy it is in the head of the Madonna, which in a sense contains such expressive point as the picture may have. Though the opposite of profound or spiritually moving, this is in its own way superlative: the fragile, eminently refined, exquisite beauty of form and expression which she offers us. The Madonna is Francesco's ultimate statement of his ideal of *grazia* and *venustà*; and in spite of her singular distance from the physical world in mood and in appearance, she still emanates the most subtle, volatile perfume of sensuality.

It is the embodiment of this quasi-abstract canon of beauty which summarizes such expressive purpose as exists in the "Collo Lungo" altar. The spiritual content of the picture results from, and is confined to, the overtones of Parmigianino's reshaping, into primarily aesthetic terms, of the human being and his content. The iconographic and religious meaning of the subject have been almost entirely submerged in this aesthetic intention of the figures and design.[28]

Parmigianino's commission for the decoration in fresco of the church of the Steccata in Parma (Figs. 87–112) antedated by three and a half years his commission for the

"Collo Lungo." However, his execution of the Steccata project was laggard in the extreme. It is clear from the documents that what little of the project he did complete postdates the autumn of 1535, and may be later still.[29] The initial scheme included the painting of the east vault, its arch faces, and the semidome of the apse; of this only the vault was executed by Francesco, or under his direction. His certain personal contribution was more limited still: only the north wall of the vault and its arch faces are unquestionably by his own hand.

Though later in execution, the decoration conforms in its essential scheme to that conceived by Francesco in 1531. Among the various authentic preparatory drawings which survive is one (British Museum, Cracherode Ff. 1.86; Fig. 104) which gives a fairly complete indication of the scheme he selected for the east vault, probably in its initial statement. The basic compositional idea, that of three draped female figures standing, arms outstretched, between the cofferings of the vault, is much as executed. For the arch faces a more complex decoration exists in the drawing than that which was finally painted, and there are such numerous variations in detail as we should expect between a compositional sketch and the executed work. These variations, however, are of less importance than the evidence of a change in style which has occurred between the drawing and the fresco: a change which does not result alone from the difference in scale and medium.

The female figures in the study of about 1531 conform to a system of extreme attenuation in proportion which accords with the ideal finally embodied in the "Collo Lungo." The painted figures (those on the north wall, from Francesco's own hand, Fig. 88), which are subsequent to 1535, embody a perceptibly different canon. In them the previously elegant, slender forms have been modified in the direction of a greater gravity and amplitude. Their bodies convey a certain breadth and massiveness and even a measure of convincing weight; the parts within the body reflect a corresponding change. The somewhat arbitrary distortions of relationships of size and shape of the elements of anatomy remain, so that the effect of the whole figure is not at all that of a reasserted naturalism; however, instead of the improbable grace of the "Madonna dal Collo Lungo," the Steccata Maidens (though they retain a measure of that grace) have a more sober and monumental, nearly a classical beauty.[30]

In fact, in these figures Parmigianino more nearly manifests the influence of the antique than in any other work. The classicizing regularity of feature (especially of the heads in profile), the headdresses, the style of the garments,[31] and even the considerable measure of statuesque gravity of the figures, all recall the characteristics of antique art. For these same reasons, the Steccata Maidens also show a degree of relationship, however slight, with High Renaissance art from which, between 1527 and 1535, Francesco had so much grown away. The very notion of the urn-bearing maidens is almost certainly

a High Renaissance reminiscence: of Raphael's famous figure in the "Incendio del Borgo."[32]

The breach between Francesco's style and that of his High Renaissance antecedents is slightly less here than before, but it has not been at all significantly closed. The entire predominance of decorative over representational and narrative purpose which appears in Parmigianino's frieze of figures distinguishes them from most recognizably High Renaissance schemes.[33] This predominance of decorative over representational values is evident not only in the totality of the scheme but, in spite of the partial reassertion of a monumentality of form, within the individual figures as well.

These continue to be composed in such fashion as to express a rhythmic continuity. Each figure is constructed on a serpentine armature which is, however, much less rhythmically active than formerly; this vertical core is intersected, furthermore, by a roughly horizontal rhythm, of deliberate tempo, formed by the heavily modeled outstretched arms. The figures are covered by garments which are to some degree rhythmically convoluted, but these convolutions do not have an effect of swift, unopposed movement as in the "Collo Lungo"; they act in heavier and slower fashion. This is partly due to the linear design of the arabesques of drapery, and in certain passages is partly also the result of a change in the character of the garments. A quality of gravity is evident in the drapery of the Maidens even, for example, in the half-transparent dress of the Maiden at the right: the way in which her drapery hangs and is related to the body beneath indicates a concern for the weight, and perhaps even the texture of the material. The garment is perceptibly less than in the "Collo Lungo" a quasi-abstract surface which entirely subserves an impulse to rhythmic patterning.

The greater gravity of the separate figures is reflected in the way in which the three Maidens have been related into a composition. As in earlier compositions, they are connected in a rhythmic scheme, but this scheme is now grave, deliberate, and harmoniously balanced. A continuous horizontal path descends from the left arm of the leftward Maiden, undulates toward the apse across the line of horizontally extended arms, and ends in the raised arm of the Maiden on the right. The vertical axes of the three figures intersect this horizontal path and are synthesized with it; the horizontal and vertical movements, thus intersecting and partly fused, approximately balance each other in the interest of their directions. This effort of modulation and balance is unlike that found in the preparatory study of 1531, where the artist has indulged his earlier characteristic dominance of the upward direction, there hardly impeded by the motive of the Maidens' outstretched arms.[34]

For this scheme of wall decoration Parmigianino has not only in part recalled his own early experience at San Giovanni, but has also studied Correggio's subsequent achievements in illusionism in the Duomo. It was Francesco's intention to represent his Maidens

as standing upon the projecting cornice, in front of the wall and within the very space of the church. The idea is essentially dependent on Correggio's Apostles, who stand in front of the painted balustrade of the cupola in the Duomo.[35] However, there is no reflection in Parmigianino's Maidens of Correggio's proto-Baroque vehemence of inter-action between the space of the spectator and the painted space, nor of the similar quality which Francesco had himself developed at San Giovanni. Francesco now employs this illusionism with a restraint and gravity which accord with the restrained gravity of the structure of the figures and their composition. He has accepted from the proto-Baroque vocabulary only its device of obliteration of the physical front plane of the painting; but he has rigorously maintained an ideal boundary between the figures and the spectator: this is established by the continence in pose and movement of the Maidens and by their strong ideality of form.

The accessory figures of the Moses and the Adam on the north wall, and those of the Aaron and the Eve on the south wall are less restrained in their illusionistic conception. Parmigianino's source for the illusionistic motive is again Correggio: the figures of the prophets, framed in painted oval niches, on the faces of the pendentive pilasters of the San Giovanni cupola.[36] Parmigianino's monochrome figures emerge only partly from the niches into which, statue-like, they have been inserted, but a sense of interaction with the spectator's space arises from their activity of pose, and from the feeling of their compression outward by the constricted space excavated in the wall for them by the painter.

The idea of the four nudes (or quasi-nudes) disposed in complex poses around the main subject seems distantly to recollect the "Ignudi" of the Sistine ceiling. In Francesco's figure of the Moses the Michelangelesque derivation is explicit; it is the one such instance in Parmigianino's painting since 1527.[37] Francesco's Moses is shown as if about to dash the tablets of the Law with a sweeping, turning gesture to the pavement far below. His action contains a distant echo of Michelangelo's *terribilità*, and his type and anatomical structure as well retain something of the nobility and power of the Michelangelesque model. The modeling of his form is at once nervous and vigorous, and his illusionistic activity into space aggressive, genuinely in the manner of the proto-Baroque. A quality as evident as all these together, however, is the persistence in the Moses (even in this moment, which marks the beginning of a reorientation in Francesco's style) of the artist's exceptional will to rhythmic elegance, expressed in the drawing of the figure and in its fluency of pose.[38]

The purely decorative ornament of the vault seems to have been a matter of con-siderable concern to Parmigianino; indeed, if we may judge from the documents which record his activity in the Steccata, it would appear that he devoted a disproportionate amount of labor to its execution, or at least to its supervision. The installation of the

great metal *rosoni* in the coffering of the vault may have been a preëxistent condition to the decoration, but their actual design is Francesco's,[39] as is that of the elaborate grotesque decoration which frames the coffers, and of the latticework motive on the arch faces. The decorative scheme is a splendid elaboration of existing traditions, rather than an invention. In its general character, it develops from the Roman grotesquerie of Giovanni da Udine, and among its details it includes not only motives of such Roman origin, but also elements from the common stock of ornament of the late twenties and early thirties in North Italy.[40]

Whether invention or elaboration, the ensemble conveys a particular effect of ornamental richness which perhaps exceeds that of any antecedent decorative scheme. Even so, the scheme as executed was the less luxurious of two possibilities evolved by Parmigianino in his preparatory studies for the vault. The discarded scheme, of which evidence survives in a large drawing in the British Museum (1918-6-15-3; Fig. 111) would have consisted of an arrangement of figured medallions along the center and side axes of the vault, between and at either side of the *rosoni*; these medallions to be interspersed with rich garlands, and to be supported by sinuous, contorted nudes in attitudes of Michelangelesque complexity. This scheme was at once a homage to, and perversion of, the Sistine. Like the Roman "Vision of Saint Jerome," it betrays Francesco's characteristic response to the inspiration of Michelangelo: in both, Michelangelo's heroic model is converted to a suave and splendid, but very differently beautiful decorative end.

An iconographic justification for Parmigianino's decoration of the vault of the Steccata hardly exists. The semidome of the apse was to have contained a "Coronation of the Virgin";[41] this was finally executed, after Parmigianino's discharge, by Anselmi on a design supplied by Giulio Romano. The Maidens of the vault, presumably, are the Wise Virgins of the lamps,[42] though they do not agree in number with the Virgins of the Biblical tale. It is significant for Francesco's point of view toward iconographic content when he originally designed the scheme that the Maidens then had no such Christian identity. In neither the early Cracherode conception nor in any of the other surviving preparatory drawings which we consider authentic do the Maidens have their attribute. However, as the Virgins of the lamps that they became, they may be considered as a court of attendants upon the Madonna in the half dome, while they are at the same time the brides of Christ who crowns her. The Adam and Eve as creators of Original Sin, and the Aaron and Moses as prophets of the Redeemer of that Sin, associate with the central theme no more loosely than in many medieval portals, which this iconographic group in fact suggests. In this scheme the iconographic thread is as slender as in the antecedent religious pictures: Parmigianino's consideration of the iconographic and expressive matter of the Steccata as quite secondary to its decorative import is entirely characteristic.

PAINTINGS

The beginning reorientation of style which is taking place in the Steccata is as yet confined to matters of formal organization. The purpose of the partial change in style is to achieve a more harmonious and monumental kind of decoration; its primary intention is still decorative, and thus confined within Francesco's essentially aesthetic premise. It must be remembered that the scheme of the Steccata had been conceived before Parmigianino felt the impulse toward reorientation of his style. Once fixed, the scheme would admit of some change in form, through the course of its long execution, but not of substantial change in its meaning. The gravity of form which has been imposed on this work has thus not been joined with a corresponding gravity of content. Such an integration does not fully occur until the "Saint Stephen" altar. It is only in this last one of Francesco's paintings that the reorientation of style, in part manifest in the Steccata, becomes complete.

The phase of Parmigianino's style which is represented by the Steccata seems to be the one with which his "Holy Family" in Naples (Fig. 113; one of his rare works in tempera on canvas) most convincingly associates itself. In the Naples picture, as in the Steccata Maidens, the modeling of the exposed parts of the figures is heavily plastic, and the anatomical forms are less sveltely calligraphic than in the antecedent phase. Not only is the rhythmic character of the drawing of the figure less apparent than before, but the rhythmic basis of the composition as a whole is neither so dominant nor so active: its movement has something of the gravity and deliberateness of the design of the Steccata.

Beside its rhythmic scheme, the composition of the Naples "Holy Family" contains several strong, even massive, units of design which are so disposed as to secure an effect of compositional equilibrium. This effect superficially resembles that of a High Renaissance picture; in fact, the "Holy Family" even suggests certain traceable Raphaelesque antecedents: the "Madonna del Velo" or the "Madonna di Loreto,"[43] or more clearly Sebastiano del Piombo's compound of these two in his "Holy Family" (also Naples) of about 1525.[44] However, Parmigianino's picture differs from its High Renaissance antecedents in one conspicuous quality of design: its equilibrium is not one which is established by the harmonious distribution of masses along the horizontal base of the picture; Francesco has avoided the definition of such a stable base. Instead, the equilibrium is secured by the adjustment of opposing counterweights of mass and direction, suspended on either side of the vertical axis and operating as if by leverage against it. In one of the two such major adjustments (between the body of the Christ child at the left and the tree trunk at the lower right) the "counterweights" form two branches of a shallow V whose point is in the knee of the Madonna at the lower end of the vertical axis. The picture is "balanced" upon this precarious base: as in the "Saint Margaret" altar, but to a far greater extent, this is an inversion of the familiar High Renaissance solid triangle of composition. A similar equilibrium of counterweights suspended in tension against

one another results from the redress of the leftward inclination of the Madonna's move-
ment, gesture, and gaze by the tree trunk behind her. Elsewhere in the painting are
further lesser adjustments of mass and direction which simultaneously complicate and
compensate the equilibrium of design.

The system of balance in the composition of the Naples "Holy Family" depends in
greater measure than before on the distribution of units of weight, and thus (with the
Steccata) differs from Francesco's usual method of assuring an equilibrium in composition.
Though the presence of these counterbalanced elements of weight offers what is in one
sense an analogy to a High Renaissance system of composition, we have observed that the
manner of their balance is not that of a High Renaissance scheme. The compositional
effect of Francesco's picture is far from a secure and unequivocal High Renaissance
harmony; it offers instead a highly artificial, even disturbing, equilibrium of tensions in
suspension. There is perhaps the evidence in the "Holy Family" of a conflict between
Francesco's desire to adjust his style toward a more stable basis, and his by now un-
shakably Mannerist premises of thought and feeling.

Without the "Saint Stephen" altar (Dresden, 1540, Fig. 117) the tentative steps
toward a reorientation of style made in the Steccata and the Naples "Holy Family"
would have remained incomplete. In this last work Parmigianino achieves a final synthetic
formulation of a conception of style different in certain important premises from that
embodied, and entombed, in the "Collo Lungo."

It could have been assumed that the symmetry in composition of the Steccata had
been imposed by, or at least accepted from, preëxisting architectural conditions, that is,
the coffering of the vault. No such condition existed for the Dresden altar; its symmetrical
design must be the result of deliberate aesthetic preference. This symmetry is accom-
panied by an effect of compositional stability which is definitely greater than in the
Steccata vault, and which far exceeds that in the Naples picture. The two Dresden
saints sit close together in the lower half of the panel, where they rest on a defined
horizontal basis. Their life-size forms, amply draped, make an impressive bulk in the
lower portion of the painting. Each figure weighs equally on either side of the vertical
axis, and both fill the lower corners of a regular triangular shape of which the apex
contains the figure of the Madonna. There is a secure and obvious balance among the
major elements of composition, and accessory motives of design are employed to stabilize
it still further.[45] Finally, as if to establish clearly a point of reference from which the
eye may measure the equal balances in the picture, its central point is marked by Saint
Stephen's stone.[46]

In contrast to the Steccata and the Naples "Holy Family," the Dresden altar is in
Francesco's usual oil medium. He has executed the surface with that extreme degree of
finish which is a constant characteristic of his later maturity. This glazed smoothness

of surface does not permit the modeled forms to achieve such an effect of massive plasticity as was evident in the exposed parts of the bodies of the frescoed Maidens of the Steccata, or in the tempera "Holy Family" in Naples. Nevertheless, an effect of gravity in the anatomies of the Dresden figures exists, and was certainly intended, for the modeling of the exposed flesh is at least as strongly contrasting and emphasized as in the Steccata, or perhaps more. The anatomical shapes also reveal such an intention of gravity: the previous weight-negating calligraphic activity of their contours has been to a considerable extent suppressed.

It is in the ample drapery of the two saints that there is the strongest expression of the intention to achieve an effect of gravity. This is not attained by the simulation of material texture; in fact, the drapery surfaces are hardly less highly polished and asensuous than the surfaces of flesh. Like the flesh, the draperies are emphatically modeled in light and dark, but this is not the main factor in establishing their seeming ponderousness. Elsewhere in the picture Parmigianino has deliberately suppressed calligraphic effects where they would negate the weighing character of certain forms. However, he still persists strongly in his aesthetic predisposition to achieve stylistic ends through the manipulation of linear rhythms. In the "Collo Lungo" and in antecedent works Parmigianino had employed linear rhythms in a swift, ascending pattern which deprived the drapery of weight. In the Dresden altar, extending the device which had first appeared at the Steccata, Parmigianino has changed the linear rhythms into which the draperies are arranged into a slow, deliberate movement, and thus (in combination with the plastic emphasis of their modeling) has imparted to the garments a profound gravity of effect.

The almost ponderous linear movement in the lower areas of the drapery initiates a slow and powerful rhythmic convolution that winds through and across the compositional structure of static, symmetrically disposed figures. This convolution begins (as in the earlier pictures) in a forward projection, here of the Baptist's leg at the lower right, and follows the great lobe of drapery across his lap; it then descends into the drapery across the knees of the Stephen and turns upward through his torso. Stephen's arm continues the upward movement toward the Virgin; as the rhythm ascends into and through her it becomes swifter and less grave, as if to express by the quality of its movement the idea of emancipation into a more exalted visionary sphere, or as if to resolve the energy of the compositional rhythm in the figure who is the picture's iconographic climax.

In its compositional structure, then, the Dresden altar, like the antecedent Steccata and the Naples work, is a compound of massive elements arranged in balance, and of a continuous rhythmic scheme. More than in the Naples "Holy Family," the symmetry and obvious geometrical logic of the Dresden composition suggest a relationship with High Renaissance principles of design, but here too there is a critical, though less easily definable difference from High Renaissance style. In spite of its evident effects of

balance there does not emerge from the "Saint Stephen" altar such a sense of serene relaxation in harmony as conspicuously proceeds from a High Renaissance work comparable in theme and in basic design: as for example, from Raphael's "Sistine Madonna." Parmigianino's composition, in comparison, at once conveys the sense of extreme artificiality and of arbitrary rigidity; the rigid framework of this composition itself contains, like the somewhat different system of design of the Naples "Holy Family," an element of tension. Not only the composition as a whole but the individual figures within it seem unnaturally, hieratically, constrained.[47]

The manner in which the rhythmic scheme has been compounded into this rigid compositional framework adds a further positive element of aesthetic tension to the design. The rhythmic and static schemes have about equal formal importance; neither is perceptibly subordinate to the other.[48] Their coexistence in the design is not a synthesis but a forced marriage of aesthetic opposites, in which the contrast of one intensifies the character of the other. This aesthetic tension between rigid stasis and powerful rhythmic activity is a principal factor in generating the intense expressiveness of the picture.[49]

Exceptionally among Parmigianino's works, perhaps uniquely, the Dresden altar does contain an extraordinary expressive power; it has a gravity in content which accompanies and reflects Parmigianino's change in formal style. It is not that the artist's "aesthetic" vision of humanity has been transformed entirely; on the contrary, the persistent elegance and refinement of the figures, and their quality of being elevated above the normal material sphere do much to establish the special character of this picture. Their elegance and refinement, however, are here joined with a new austerity and gravity, and charged from within with the great aesthetic and emotional tension which emerges from the design. The result is an intensely controlled, yet deeply moving, religious vision. The picture is, in a way, an icon, of singular sophistication.

The Dresden altar antedates the official institution of the Counter Reformation, but it embodies a spiritual attitude symptomatic of that phase in the cultural history of the sixteenth century. The individual elements of form in Parmigianino's picture have been chastened and purified, and a strict discipline has been imposed upon the organization of the whole. A powerfully active aesthetic and spiritual force operates within this total discipline, by which the force is constrained and controlled. Out of the tension between them is created an intense exaltation, outwardly chaste but inwardly almost febrile, here expressed through the terms of a traditional religious image.

This theme of the visionary walking of the Madonna in the heavens, with the two holy figures interceding between her and the spectator, is essentially the same as in Raphael's "Sistine Madonna."[50] To compare the two great Dresden pictures may confirm our awareness of how great a distance Parmigianino has moved, in his two short decades of artistic life, away from the world of his High Renaissance predecessors toward a more subjective and here transcendental world of his own creation.

B

THE PORTRAITS

The sources of Parmigianino's portrait style cannot be precisely defined. It is clear that the school of Bologna, from which he drew so largely for his first work in religious painting, had no influence on his first essays in the portrait field. We have virtually no knowledge of Correggio's activity as a portraitist, but such speculative material as we have indicates that (except for matters of handling and technique) the work of the older master was not a source for Francesco's beginnings in portraiture.[1] Exact proof is impossible, but the appearance of the three surviving portraits of the first period in Parma seems to depend (as far as they may be said to be dependent) on Venetian models of the decade 1510–1520; by 1520 such works had apparently achieved a more or less general diffusion through the northeast of Italy. Even in these earliest portraits, however, there is a very high degree of originality. It is difficult to invent in the field of portraiture, but we can find no convincing antecedents, or even contemporary parallels, for the Vienna self-portrait or for the "Galeazzo Sanvitale."

As we have observed elsewhere, contact in Rome with Sebastiano del Piombo, at that time the principal portraitist of the Roman school and one of the most authoritative painters in Italy, seems to have left a more or less tangible and persistent mark on Parmigianino's portrait style. Parmigianino's portrait of Lorenzo Cybo, painted in Rome, reflects characteristics not before present in his portraits, but which had appeared in Sebastiano's work since the end of the second decade of the century: these include the somewhat excessive sense of scale of the figure, a tendency to largeness and simplicity in composition, and an atmosphere of almost somber gravity.

There was a Venetian element in the influence of Sebastiano; after Parmigianino's departure from Rome this predisposition toward Venetian models (already evident in his first portraits, and certainly understandable in a North Italian painter) seems to have persisted. Francesco's portrait style in his Bologna period is entirely formed and strongly individual, but if it is possible that any further influence was exerted from outside sources on his portraiture it was that of Titian.[2] However, this possible contact with Venetian work of the later 1520's would have effected only surface modifications in Parmigianino's style in portraiture, for, unlike the contemporary Venetians, Parmigianino's portraits of his Bolognese years and later are unequivocally Mannerist: Titian does not arrive at a comparable phase in portrait style until the 1540's, after Francesco's death.

The earliest surviving one of Parmigianino's portraits is preserved in the collection of the Earl of Strafford at Wrotham Park in Hertfordshire (Fig. 120). It represents a gentleman vaguely identified, on the authority of an old inventory,[3] as a priest: this identification would seem to depend on the form of beret the sitter wears. The other attributes are less specifically priestly: an "antique" relief of Venus, Cupid, and Mars, a classical figurine, some coins, and a handsomely bound book. This presumed cleric would seem to have affected strong humanistic interests, but this is a combination not by any means improbable for the time.

This portrait appears to have been executed about 1523, when Francesco was twenty years old. Like other pictures of this moment, this one reflects the influence of Correggio in technique; also Correggiesque in origin is the rather dramatic effect of exaggerated chiaroscuro in an outdoor setting. The portrait seems, however, to suggest a knowledge not only of Correggio's art, but some acquaintance as well with the style of portraiture of the Giorgione-early Titian milieu. The amplitude of the figure and its arrangement in the picture recall, though vaguely, this phase of Venetian art.

Any precedent we seek for the Strafford portrait, other than the obvious technical one in Correggio, will be similarly vague. This picture presupposes some visual experience of the current Italian, and in particular of the Venetian portrait mode, but on this conventional foundation Parmigianino has imposed some singular novelties. The portrait contains at least as much invention as it does derivation.

The most striking innovation results from the intrusion into the picture of a measure of Francesco's then current interest in illusionism: the succeeding work in portraiture, the self-portrait in Vienna, partakes to a far greater degree in this same problem. A construction in perspective has been introduced into the foreground of which the intention is to create a bridge between the space of the picture and that of the spectator. The sitter rests his arm on a table top, which slopes forward, intersecting the plane of the panel as if to provide our eye with a continuous surface upon which it may travel inward toward the figure; the effect of this device is supplemented by the foreshortening of the "antique" figurine. This effort to establish a continuous transition into the picture space is only moderately successful, but it is nevertheless interesting for its intention, so markedly different from the intent of the parapet in Giorgionesque portraits, which defines the boundary between reality and the ideal space inhabited by the sitter.

The priest is himself seated on a pronounced bias to the front plane of the picture. To the left, behind his shoulder, the perspective direction of the table is repeated in the painted relief. The landscape, however, as is common in Francesco's pictures, does not continue and extend the perspective space: it is not the space of the rearward environment, but only that which pertains to the figure plane and its connection with the spectator that concerns Parmigianino.

The lines of projection on which the perspective is constructed are used not only in Parmigianino's somewhat deficient effort to create an illusive space; they also function in an original way in the compositional construction. The shape of the priest's figure and his attitude strongly suggest the simple triangular composition of the conventional High Renaissance portrait. Parmigianino attempts to complicate this by appending the system of perspective lines to the pyramid of the sitter's form. The figure is thus imbedded in a scheme of zigzag lines, which operate simultaneously on the surface and in space. By displacing the body somewhat to the left and by raising the priest's left arm, a further complication of design, an evident diagonal, is introduced.

In spite of this effort toward complication of design, and in spite also of its measure of illusionistic intent, the Strafford portrait still remains, in its formal organization, basically akin to the portraits of the High Renaissance. The expression of the sitter, however, does not accord with the High Renaissance ideal. His face does not exhibit the harmonious composure of the subjects of the early Titian or of Raphael: his expression is more sharply intent and perhaps even somewhat hostile. In contrast to Francesco's conception of himself in his self-portrait in Vienna, but in a manner which foretells that of Francesco's later sitters (though with far less suavity), the priest seems to be on guard against the spectator. There is some possibility of the misanthrope in him, and for this there is no precedent in the pictorial world of the High Renaissance.

It would appear that Francesco's self-portrait (Vienna, early 1524, Fig. 122), like the slightly subsequent Prado "Holy Family," was painted as a demonstration piece with which to *épater* the audience he was imminently to confront in Rome. Stimulated by this intent, Francesco made of his self-portrait an extraordinary virtuoso performance, not only of technique but of intellectual invention.

He exploited in it an extreme of his illusionistic capacity, of which only a suggestion had appeared in the previous portrait of a priest. In one sense, the self-portrait goes beyond the limits of illusionism of the kind we have defined in San Giovanni and at Fontanellato, and enters into the realm of *trompe-l'oeil*. The panel is contrived in the shape of a convex mirror, on the surface of which the artist has represented his image as the mirror reflected it, with the curious distortions that such a mirror makes. Evidently, the intention was to create in the spectator's mind the idea of looking at more than just a painting: we are meant to accept the illusion, if only for the briefest initial moment, of seeing an actual reflected image in an actual mirror. The deception, as with all *trompe-l'oeil*, can be of only the most momentary kind, but it is enough to create the response of astonishment in the spectator and the sense of wondering admiration at the technical brilliance with which the illusion has been achieved. The conceit is both precocious

and piquant in its exploitation of the special psychological response stimulated by an ingenious, and pleasurable, deception.

The picture is without precedent in its extreme and consistent reliance on the device of *trompe-l'oeil*; in particular it has no comparable antecedent in the field of portraiture. The mechanical agency through which a self-portrait is achieved, the mirror, had never before been openly confessed, nor indeed exploited as it is here, nor had it been used as the vehicle for the formal structure of a portrait.[4] Partly from the accidental fact of the shape of the simulated mirror, the self-portrait acquires yet another aspect of novelty: it is the earliest (surviving) Italian example of a portrait in tondo form. It also precedes Holbein's first exercise in this format by some years.[5]

In order to achieve even the momentary conviction of illusion it is necessary that the visual (but not indeed the intellectual) comprehension of the picture by the spectator be almost instantaneous. To aid in this immediacy of effect Francesco has made his image as uncomplicated as is possible: pose and composition are most direct and simple. The hand, distortedly large as it would in fact appear in such a mirror, looms in the very foremost plane and instantly catches the spectator's eye, but does not hold it: the hand serves as a bridge into the depth of the picture where the head is placed. Details of clothing, background, etc. are reduced to quite summary terms; this reduction is the equivalent of the visual suppression in a quickly-seen image of details which are incidental to the main object on which the eye is focused. The brushwork adds to the quality of illusion with its imitation of the naturalistic qualification of surfaces and contours by atmosphere and light.

These are the means of Francesco's illusionism, but what is its end? Vasari has commented elaborately on the self-portrait,[6] in more illuminating fashion than is his habit. Vasari insists (as always when he is being complimentary) on the success of the self-portrait as an achievement of technical realism. His insistence is justified: an important part of Parmigianino's intention in its execution certainly was to demonstrate, on a virtuoso level, the extent of his capacity to reproduce visual reality. In this sense, the self-portrait is a demonstration of a problem in scientific realism. However, its purpose is by no means this alone; such an end, acceptable in itself to a *quattrocento* experimenter, is not sufficient to the more complicated sixteenth-century personality.

Into this demonstration of illusionistic realism, and actually dominating its effect, are intermingled other motives, characteristic for Parmigianino's special personality and stylistic tendencies. There is the very fact that he has chosen, as the basis for this scientific demonstration, an extreme complication of a problem in realistic representation. This extremism in itself involves a kind of precious intellectuality, an excess of scientific cleverness, which at once separates us from the usual. Francesco undertook this problem

"to investigate the subleties of art . . ."* says Vasari, but Francesco's wish was not to investigate these subtleties in a detached scientific spirit; he wished through them to impart the sense of novelty and amazement to the spectator.

In another respect the self-portrait contains a still more provoking departure from common experience. It is true that Francesco has counterfeited a real image on his panel, and that he has done so with remarkable scientific truth. But though the counterfeit is visually exact as a rendering of a thing seen, the thing seen is not in itself an ordinary image, but a singular distortion of objective normalcy. ". . . seeing these eccentricities . . . the wish came to him to imitate [all this] for his caprice . . ."† says Vasari: Francesco's realism has been employed to create an effect which is capricious and bizarre. Realism in this portrait no longer produces an objective truth, but a *bizarria*.[7]

The character of this *bizarria* is important, for it is symptomatic of Francesco's attitude toward an important aspect of High Renaissance style. He has chosen to paint a capricious and psychologically piquant image, which is to a considerable extent distorted. It violates the fundamental High Renaissance principle of representation of an idealized norm; however, its distortion does not create a feeling of disharmony. Further, again despite their degree of distortion, the forms retain a strong measure of ideal beauty. The hand is disproportionate, but of exceptional sensitiveness and grace, while the face is still, as Vasari observes "of most beautiful aspect . . . and rather more of angel than of man . . ."†† Francesco here admits elements which are visually abnormal, and which are, because of this visual abnormality, also in part of abnormal psychological effect. Nevertheless, this early portrait preserves much of the High Renaissance qualities of harmony and ideality which (though they diminish in his succeeding work) Francesco will never entirely discard.[8]

There is no trace of the bizarre in the expression of the sitter's face. He emanates a gentleness and an unaffected grace which makes Vasari's judgment of *più tosto d'angelo che d'uomo* seem not far exaggerated. In spite of the Mannerist elements in the intellectual premise of this portrait, the fully Mannerist nature of the sitter's spirit has not yet recognizably emerged. Within Francesco's gentleness there is a visible sharpening of self-awareness and a subtlety in expression that are prerequisite to the developed Mannerist personality, but there is yet no evidence in the young Parmigianino's representation of himself of the sharpening of this self-awareness into the later characteristic Mannerist tension. The personality which Francesco shows us here is that which underlies the expression, not so much of his portraits, as of his religious and mythological works, which are in a sense a counterreflection of the reflected image shown here, with its high degree of refined beauty of form and its air of grace.

* "per investigare le sottigliezze d'arte . . ."
† ". . . vedendo quelle bizarrie . . . gli venne voglia di contrafare per suo capriccio . . ."
†† "di bellissima aria . . . e più tosto d'angelo che d'uomo . . ."

The portrait of Galeazzo Sanvitale, Count of Fontanellato (Naples, 1524, Fig. 123), occupies a situation in Francesco's portrait style exactly like that which the Prado "Holy Family" holds among his religious paintings.[9] Among the portraits the "Sanvitale" is the first which manifests a more evident community with the style of the mature works than with the earlier ones. An important factor in this impression is the awkward, but evident stress of verticality. This portrait shows the figure downward to the knees (a format then still highly novel)[10] while it extends the proportion of the panel also in the upward sense. The vertical impulse is evident in the swift upward diminution of the lines of the arms and shoulders into the singularly elongated head; and by the extension above the head of the long axis in the architectural feature at the corner of the wall. This stress of verticality, for all its awkwardness, is positive and marks the "Sanvitale" off from the earlier "Priest," as well as from the mirror portrait, with their relatively Correggiesque amplitude of form and compositional scheme.

However, the design conspicuously does not yet show that easy synthesis of horizontal motives into the vertical axis that characterizes the portraits of Parmigianino's maturity. The horizontal motives (the arm of the chair, the edge of the table, and in part the arms of the sitter) intersect the dominant direction in a rigid and unassimilable fashion; their interlocked opposing directions create a sense of tense rigidity in the design. Within this frame of rigid oppositions are a multiplicity of nervous, shuttling accents, created by the almost "Germanic" outline of certain of the accessories, by the metallic and literal rendering of some details, and by the numerous small contrasting areas of light and dark. These recall the staccato activity of surface in the contemporary Prado "Holy Family," and similarly suggest an effect of tension in design.

The pose and expression of the sitter accord with and reinforce this effect. The Count's chair is placed parallel to, and at the very forward edge of the picture plane. While his lower body faces to the left, his head twists full-face to the spectator. Because his bust and shoulders are not quite plastically convincing they do not suggest an easy turning of the figure; like the head, the trunk seems twisted at a singular right angle to the arm of the chair and to the lower body. The pose contains just such a rigid (and in this case organically disquieting) opposition of directions as does the larger design.

The Count's expression also contains an element of rigid contrast. His wide-eyed stare straight outward from the picture makes immediate contact with the spectator; and he directly offers us a medal which he wishes us to see.[11] Yet, in spite of the direct nature and apparent urgency of this contact, he seems quite unwilling to carry this communication any farther. His invitation is extended, and instantly denied. In this portrait of an aristocrat Francesco apparently has sought to indicate a quality that had no place in the boyish self-portrait: the sense of aristocratic constraint and separateness of the sitter. This is Francesco's first, and rather painfully assertive, attempt to define what he later comes to recognize as a characteristic attribute of the elite of his time.

The only work in portraiture which survives from Francesco's residence in Rome is his portrait of the Marquis Lorenzo Cybo, Captain of Pope Clement's guard (Copenhagen, Fig. 124). This work is probably not more than a year subsequent to the "Sanvitale"; but there have been eliminated from it at least the major awkwardnesses that the previous portrait still displayed. The "Cybo" retains something of the rigidity in pose and in expression of the "Sanvitale," and still more of its tendency toward excessive particularization of accessories and detail, but in the "Cybo" both these qualities have been absorbed within a new breadth and fluency of design. Like the "Saint Jerome" altar, but in more obvious fashion, the "Cybo" reflects Parmigianino's comprehension of the lesson of monumentality taught by contact with the Roman High Renaissance.

In place of the nervous oppositions of the "Sanvitale," the "Cybo" shows an essentially harmonious organization of design. Though Cybo stands upright in three-quarter length, there is no sense of such insistent stress on the vertical direction as in the "Sanvitale." The figure itself has an amplitude of silhouette; and behind it is defined the clear, broad horizontal of the balustrade, which intersects the vertical direction with an effect of balancing accord. Upon this harmonious intersection of horizontal and vertical directions is laid an ample and continuous oval path, which moves along the shoulders and the arms of Cybo and through the figure of his page. This oval is laid upon a diagonal ascending to the right; its rhythmic rightward sweep is counterbalanced by the strong, straight leftward direction of the great ceremonial sword.

The balancing adjustment of directions in the "Cybo," and its harmonious combination of rhythmic and static motives, give its composition a more positive effect of stability than exists in any other of Francesco's paintings. Though this work exhibits Francesco's Mannerist predisposition in many ways (as especially in the construction of its space) it nevertheless depends as well to a considerable extent on principles peculiar to the Roman High Renaissance style. This portrait, painted shortly after Francesco's advent in Rome, shows his absorption of the discipline of the High Renaissance more clearly than does any of his surviving Roman religious works.

The combination in the "Cybo" of High Renaissance and certain Mannerist traits has an analogy in the contemporary work in Rome of Sebastiano del Piombo. As we have observed, Francesco knew Sebastiano's work, and must have studied it with the respect due Piombo's then prodigious reputation. The breadth and grave dignity in the composition of the "Cybo," and in the attitude of the sitter, suggest similar qualities in the portraits of Sebastiano; even more suggestive of the latter's style is the monumental, yet curiously hollow-seeming bigness of the figure. The surface of the portrait, with its somber richness in tone and texture, also may reflect Sebastiano's influence.

Two elements in the content of the "Cybo," however, are utterly foreign to Piombo's habits of mind. The introduction of the smiling infant page who holds the broadsword

is a relieving touch, impossible to the humorless Sebastiano. Further, the intent directness with which Cybo regards the spectator is quite unlike the majestic, and rather vague, abstraction of Sebastiano's sitters. Cybo's proud and here still somewhat frigid continence of expression is visibly a result of Francesco's developing conception of aristocratic bearing, related to that so awkwardly stated in the "Sanvitale," but soon to be so admirably expressed in the mature portraits.

Parmigianino's attainment of full maturity in his portrait style occurs in his first Bolognese portrait, traditionally, but only doubtfully, called a self-portrait (Uffizi, 1527–1528, Figs. 125–127).[12] The evidences of this maturity are in one way unlike those in his religious paintings. In the "Vision of Saint Jerome," the first mature religious work, its maturity was evidenced in part by the artist's proof of his capacity to create a refinedly harmonious arrangement of a complicated design. Once achieved in the "Saint Jerome" altar, this junction of refinement and complexity continues, with a simultaneous increase of each, throughout the mature religious works. In the Uffizi portrait Francesco's achievement of a refinement comparable to that of the "Saint Jerome," and an equal suavity both of content and design, is fully evident. However, this refinement is accompanied, not by the complex organization which appears in the mature religious pictures, but by the assertion of a relative simplicity of design which contrasts both with the contemporary religious works and with the antecedent portraits. By comparison with this portrait, the "Sanvitale" seems a fussy, complicated picture, and to a less degree so also does the "Cybo"; only the self-portrait in Vienna suggests the present work in its appearance of simplicity. Once thus attained in the Uffizi portrait, this simplicity persists substantially in the succeeding portrait works. Only the frankly quasi-allegorical painting of Charles V departs from it.[13]

Though so different in its suave simplicity of effect, the Uffizi portrait is in fact constructed on a basis of expression and design related to that first embodied in the "Sanvitale" of three years before. The vertical axis of the Uffizi portrait is marked (but not, as in the "Sanvitale," overstressed) by the succession of the light areas of hand, collar, and head, and the vertical direction is extended by the free space above the head of the sitter.[14] The aggressive horizontals of the "Sanvitale" have been eliminated, so that there is no opposition to the dominant direction; however, a harmonious equilibrium has been effected between horizontal and vertical by the wide, swinging oval of the shoulders and arms, and by the echo of a segment of this oval in the curving shape of the hat. The line of the sloping shoulders tapers toward the head and there intersects, and is absorbed into, the vertical direction. Instead of the agitating opposition of directions in the "Sanvitale," or the (by comparison) rigid framework of balancing directions of

the "Cybo," the Uffizi portrait displays a suave equilibrium of two ample, fluid movements, synthetically interpenetrated with one another.

As compared with the "Sanvitale," there is not only a major simplification of the compositional scheme, but also a considerable reduction of the number of active elements in it. A similar reduction and simplification occurs also in the spatial system of the Uffizi portrait. The figure is seated close to the picture surface, with his hand nearly impinging on it; his body is disposed on a slight but evident bias to the spectator. As in the "Cybo," but unlike the "Sanvitale," there is no sense of the aggressive in the forward compression of the form. The background has been reduced to a summary indication, at an indeterminate distance, of a wall which has almost the quasi-abstract character of a screen. On it hangs a lightly-sketched grisaille whose elongated oval shape repeats, parallel to and to the rightward of the vertical axis, the oval shape of the head and torso of the sitter.[15]

The simplicity of design and directness of aesthetic and expressive effect in the Uffizi portrait are in part the result of simplification of the represented "scene." The accessories which encumbered all the previous portraits but the Vienna one are absent from this work. There are no impedimenta to indicate the sitter's function or his exact station in society. He is presented to us with only his most intimate externals: his clothes (of an almost Spanish discretion) and his rings; his environment is barely defined. The subject achieves his impression on us through his unadorned person and his personality.

Both elements, which make up what we referred to in Part I as the "style" of the sitter, have visibly been accommodated in some degree to the preferences of the artist. The face and hands have been subjected to an attenuation which suggests, though it does not equal, that of the improvised types of Francesco's religious works; and the features have been endowed with an exceptional, yet not in the least unmasculine, delicacy and refinement. The hands strongly reinforce the impression of the kind of physical beauty and personality with which the artist (and nature, in combination) have endowed the sitter. In no previous or contemporary portrait by an Italian artist[16] have the hands been assigned so considerable an expressive role in the definition of the sitter's character and station. This item in the portrait painter's repertory of effects may be considered Parmigianino's invention.

This type of portraiture, with its absence of complex accessories, affords a far more immediate contact with the sitter, and is much more concentrated in its expressive effect. However, in spite of this immediacy of contact, the sitter of the Uffizi portrait does not permit a psychological examination much more intimate than do the "Sanvitale" or the "Cybo." He retains their discipline over the expression of any inner feeling. The rigid staring of Sanvitale, and the somewhat hostile rejection of our curiosity by Cybo, have here taken a more subtle form. The Uffizi gentleman's face is a carefully controlled,

deliberately austere, even somewhat severe mask. He does not invite our probing; our inquiring gaze into his inward self is immediately rejected. The usual role of sitter and spectator is here reversed: the spectator feels that he, and not the sitter, is being inspected. There is a presumption of superiority in this look that will accept no question from the outside world, nor admit our curiosity.

However, this austerity of expression is by no means the frigid, hollow shell of an indifferent or negative personality. Within the controlled mask the eyes are most subtly animated, and seem vividly alive. We sense, in the Uffizi man, the heightened potential for emotional, and perhaps intellectual, response of a complex kind that characterized the eminently civilized, but often insecure and self-questioning personality of the second quarter of the sixteenth century. His control over the outward expression of this capacity for feeling, and for doubt, is positively willed; it is the sitter's means to achieve for himself, and present to the outer world, the appearance of an equilibrium of personality. This equilibrium is calculated and highly self-conscious, and quite unlike the amiable self-assurance of the men depicted in the portraits of the High Renaissance.[17]

The conception of the Uffizi portrait is aristocratic in more than the obvious sense of its assertion of the subject's superior social station. It portrays a person superior in sensitivity and complexity of spirit, in self-control, and in continence of dress and manners; and these qualities are contained within a physical shell of singular refinement. The elevation above and distance from the spectator of the Uffizi gentleman—who may be Francesco himself—in some degree approaches that which separates the avowedly ideal persons of the religious pictures from the spectator's world.

The young prelate represented by Francesco in the small portrait in the Borghese (1528–1529, Fig. 131) is less insistently the gentleman than the sitter of the Uffizi work. The prelate was not endowed by nature with the former's exceptional refinement and regularity of feature; nor had he assumed the Uffizi gentleman's aristocratic extreme of decorum. Francesco could not, even if he wished, make this subject approach so nearly to an ideal type without sacrificing both physical and psychological resemblance.

The lesser approach in nature of the sitter to an ideal results in a more intimate, and in one sense more animated, portrayal than in the Uffizi picture. As Parmigianino has recorded it, the prelate's psychic state is fundamentally like that of the Uffizi subject: a self-awareness, here visibly more acute, and a cautious defense against the probing of the spectator. Here, however, there is not the deliberate rejection of our curiosity that the Uffizi gentleman makes us feel. The priest is more accessible. He admits that we should seek him, but before he permits a deeper contact he examines us as keenly, and more cautiously, than we do him. His face is imminently mobile: we feel that he is prepared to, but may not, offer us a welcoming smile. The equilibrium between feeling

and its outward expression in this work is still more subtle than in the Uffizi gentleman. There are few portraits which convey, with such a quality of life, the sense of a sceptical psychic fencing between the sitter and observer.

The prelate's directness of effect is increased by the restricted format of his portrait (of course the result of the terms of the commission). The manner in which his head is constricted within the limited picture surface compels a more than normal compression toward the spectator; this further increases the immediacy with which the subject is presented to us.

This portrait reflects, through Parmigianino's sensitivity of mind and skill of hand, another characteristic type among the personalities of the high civilization of the second quarter of that century, here not so much the type of aristocracy as that of sceptical intelligence and subtle spirit: a member of the elite of mind rather than the elite of birth. Such a portrait could not have been painted before the first Mannerist generation; and it could have only exceptionally recurred among the second Mannerist generation, where there was rarely so sensitive an adjustment as was here achieved between the painter's and the sitter's styles.

Probably next in chronological sequence among the portraits is a work that remains in the portrait category mostly by courtesy. In November 1530 the Emperor Charles V arrived in Bologna for his coronation. Parmigianino saw Charles once at dinner;[18] on the basis of this limited study, and quite without the authority of a commission, Francesco composed an allegory, of which the central feature is the person of the Emperor. The original of this picture, in Vasari's time in the Ducal Collection in Mantua, has been lost, but a copy exists in the Cook Collection (Fig. 132).

There could be no pretense to the qualities of a studied portrait, in the sense of the Uffizi and Borghese works, in Parmigianino's representation of Charles. The artist has been content to achieve a general resemblance to the Emperor's striking head; as far as the evidence of the copy shows, there has been no attempt to investigate or display him as an individual personality.[19] In both form and content the work is conceived as are the nonportrait paintings. The simplicity of design and the intensity of psychological expression of the two previous mature portraits have not been intended here.

Charles is formally clad in full armor. He is attended by the infant Hercules, who offers him a globe, the symbol of his Imperial dominion over the earth. A winged Fama hovers beside the Emperor: with one hand she presents him with a laurel, symbol of his material conquests; in the other hand she bears a palm, the indication of his spiritual triumphs. This association of an earthly person and of classical divinities, classically garbed, is among the first such large-scale allegorical portraits in Italian art.[20] Its early appearance in Parmigianino's *oeuvre* is more easily comprehensible than in the work of

others, for Francesco's personal preference in his conception of human types had long been one which might permit them to consort as near-equals with mythological beings.

As in Francesco's religious or purely allegorical works, his fluid, rhythmic compositional system here asserts itself strongly. Wide curving motives thread along the extended arms of the figures and interlace, pinwheel fashion, into a complex serpentine design. This design, as usual, operates within a limited plane of space. Toward the rear the picture is closed by a curtain; toward the front most of the elements are turned in a direction more or less parallel with the picture surface. Only the young Hercules tends to violate the forward plane: by his outward-leaning attitude and by the direction of his gaze he makes both a physical and psychological connective with the spectator. What he introduces us into, however, is less a work of portraiture than an allegorical and decorative conceit, an ideal demonstration of Charles's Imperial Majesty.

The portrait called "Giovanni Battista Castaldi" (Naples, Fig. 135) must have been closely contemporary in execution with the original one of Charles V. The "Castaldi" demonstrates by contrast the extent to which the allegorical work is an aberration in the portrait style of Parmigianino; and it resumes Francesco's development of the maturity he achieved in the Uffizi portrait. The broad communities in design and expression between these two is instantly apparent. However, while it retains the basic formula of the Uffizi portrait, the "Castaldi" is remarkably different in its specific effect. Since no other work of Parmigianino in this period reveals the special character of form and content of the "Castaldi," it is to be presumed that the source of this difference lies in the personality of the sitter, and in the artist's consequent response to him.

As Francesco shows him to us, Castaldi appears not to have the fine suavity of the Uffizi gentleman. Castaldi seems the more intense personality of these two, both in reaction and in his discipline of self. His control is utterly precise; the equilibrium of his personality seems adjusted to a razor's edge. There is implicit, in so fine an equilibrium, a quality of almost brittle tension, the expression of which is not confined just to Castaldi's face. As the design of the Uffizi portrait accords with the suave gravity of its sitter, so does the design of the "Castaldi" reflect his strict adjustment into equilibrium of tensions within himself.

Instead of the fluid synthesis of the two main directions of design which occurs in the Uffizi portrait, the "Castaldi" shows a rigid interlocking of the broad oval of the body into the vertical axis of the head, collar, and hands. Both these major motives are more symmetrically disposed than in the Uffizi work: the vertical axis of the head and body coincides exactly with the axis of the panel, and the oval area of the trunk and arms is nearly equally arranged on both sides of this axis. This symmetry is not meant to and does not create an effect of balance. It serves to contain and hold in check certain motives

which operate against it: the opposition of these motives to the symmetry effects a sense of tension.

The principal one among these elements of tension is the diagonal direction which arises from the disposition of the arms in a diagonal oval scheme. This diagonal is reinforced by the inclination of the right hand, the slash of the white shirt front across the central axis, the angle of the hat, and in part by the slanting of the book. The symmetrical silhouette of the body does not itself have enough authority to contain this rightward direction; to reëstablish the equilibrium of the design there is inserted into the left background the strong fixed vertical of the pilaster.[21] To the effect of tension arising from these opposing motives is added the nervous effect of the irregular, brittle contour of the figure, sharply relieved against the light wall behind.

The disposition of the figure in space is such as to create a similar sense of tension. The lower part of the body is placed on a slight angle to the front plane. The upper part of the figure, however, tends to turn back into a plane parallel with the surface. A subtle, but positive effect of torsion results from the reaching forward of Castaldi's right arm to the very front of the chair, while his left arm is gathered back against his body.[22]

The compositional tensions in this work recall the character of design in the Sanvitale portrait of a half decade earlier. The measure of Parmigianino's maturity emerges from a contrast of the nervous awkwardness of the earlier portrait with the far more powerfully expressive, yet most finely disciplined equilibrium of the "Castaldi."

This equilibrium is shown here not as a continuing state, but as the result of a specific act of spirit and body, accomplished at the moment of interchange of glances between the sitter and spectator. To indicate this, Francesco has departed somewhat from the very generalizing character of pose and environment of the Uffizi portrait and introduced more suggestions than usual of specific time and place; however, he has not permitted these to diminish a similar end effect of extreme formality. Castaldi is seen as if interrupted during his reading. He has lowered his open book into his lap, then composed himself to regard the spectator. This suggestion of the momentary is a slight one; we do not see the action but rather the state that follows it. Corresponding to this partial specification of the moment is a partial specification of environment. At a seemingly measurable distance behind the sitter is a clearly defined wall, of which the texture and material are indicated. Upon this wall is cast the sitter's shadow—which occurs in no other portrait by Parmigianino—thus further implying certain specific conditions of light, air, and space. To the left rear of the sitter is the elliptical indication of the figure of a servant,[23] caught in the momentary act of passing through a door into the (implied, but not defined) space beyond.

As with the specification of Castaldi's pose, the specification of environment is only partial. Though their intellectual implications are clear to the observer, these specifica-

tions are made in terms so summary that they remain still on the border of generalization. They thus qualify, but do not deny, the general effect of a removal somewhat toward ideality of the sphere within which Francesco's portrait subjects are projected.

In strong contrast to Castaldi the young man who is the sitter of the portrait at Hampton Court (1530–1531, Fig. 136) seems the least complex among Francesco's male subjects. In this youth neither the physical structure of the face nor its content seems so sharply defined as in the other sitters; by comparison he seems still unformed, boyish, and immature. He projects a kind of adolescent melancholy, of which the effect is increased by his extreme severity of dress, by the total absence of accessories, and by the dark, vacant space behind him. The bilious humor of this youth becomes, for Parmigianino, the motive spring of an effect of tension in his personality. This tension, which Francesco expresses in the sitter's pose and in the design, in this case seems as if it might be more an imposition of the artist's preferences of form and feeling on the sitter than an actual property of the latter's nature. In any case, in accord with the lesser complexity of that nature, the expression of tension is far less complex than in the "Castaldi": it is as if the multiple rigid oppositions of the "Castaldi" had been resolved into a simple antithesis.

A sense of strain is manifested first in the attitude of the sitter, whose body seems to strain and slightly twist in a rightward sense; an impression of torsion is reinforced by the folds of the young man's cloak, which is wound rightward and upward around his form. This turning is not free, but countered and opposed: the head turns back in the opposite direction from the twisting of the body, and the right arm reaches forward and to (our) left. The youth's hand strains upon the table as if seeking an anchor and a firm hold against his own turning. Such a pose has no reasonable physical explanation: it can be only the outward expression of some strain of inner spirit.

The composition communicates a tension yet more positive, though even simpler. The oval of the arms here moves on a frank diagonal. The bold clockwise sweep of this oval is brought into compositional equilibrium by clamping upon it, so to speak, the static right angle of the doorframe. The placing of this architectural feature, as in the Castaldi with its accent toward the left, is such as exactly to counter and control the rightward rhythm of the oval. Each of these main motives of design is simple and affirmative; the complex adjustment into equilibrium of the Castaldi is here replaced by a direct and comparatively elastic opposition.

In most of Francesco's portrait compositions the arc of the arms and the vertical central axis synthesize in the head. In this picture the central axis has no function; its suppression is one of the factors that eliminates the usual sense of rigidity from this design. However, the two present main motives of design (the moving oval of the arms

and the fixed frame of the door) still intersect in the head; there, where these two oppos-
ing elements interlock, one rhythmic and one static, the aesthetic energy of their opposi-
tion is resolved and discharged through the sitter's gaze.

The sitter in the fantastically titled "Schiava Turca" of the Parma Gallery (1530–
1531, Fig. 137) is less mature still than the subject of the Hampton Court portrait. The
so-called "Schiava" is in fact a very young married lady of quality, so excessively young
as to seem a child bride by modern standards. Francesco has compounded in her expres-
sion something of the alert shyness of the children of his religious pictures and something
of the awareness of womanly attraction of his Madonnas. But the degree of her vitality
is greater than that of any of Francesco's ideal types: she veritably sparkles. She has a
touch of most immediately human coquetry, and a quality of sensual attraction even
more piquant than that of the mature Madonnas. Though the Schiava resembles the
ideal personalities of Francesco's religious world, and though she seems even in some
respects to have been modified to resemble them in physical form,[24] her assimilation
toward the ideal has proceeded only far enough to enhance her charm, without compro-
mising her immediacy or her individuality.

The young Schiava has a still lesser consciousness of problems than the Hampton Court
youth. Though the expression she wears may seem more complex, it is a complexity of
the pleasurable, surface aspects of a feminine personality. She feels no trace of the inner
malaise which afflicts even the least mature among Francesco's male subjects. The design
of her portrait accords with her depicted character: it is a freely flowing, uncomplicated,
curving movement; this weaves across a vertical axis which is not rigidly marked, but
diffused into the whole suave rhythmic flow.

Though the sitter is unmistakably an Italian type, Francesco's presentation of her
mingled qualities of sensual attraction and childish charm suggests comparison with what
we usually consider a specialty of French artists, particularly of the Rococo. However,
Parmigianino's characterization of the Schiava has both greater vitality and sensitive-
ness than is usually displayed in French eighteenth-century work of similar theme.
Further, she exhibits none of the later school's patent stress of sexual overtones; and
Parmigianino's subtlety and vivacity in the description of his sitter keep him from the
pitfall of sentimentality into which the eighteenth-century French, in their use of this
formula of mixed sensuality and adolescence, too often fall.

A fragment, only partly finished, remains of a second female portrait of this time:
that of the Bolognese Countess Gozzadini (Vienna, Kunsthistorisches Museum, Fig.
138). This lady possesses neither the physical attraction nor the charm of spirit of the
Schiava. She is more mature, not in the sense of a greater refinement or complexity of
thought or feeling, but only in her possession of an adult composure that the Schiava

lacks. The Countess is alert, but untroubled and unreflecting. Presumably an unemancipated woman, she seems to have enjoyed at least the security of her bondage: the problems that beset the contemporary males whom Parmigianino painted do not exist for her any more than they do for the "Schiava Turca."

Parmigianino's activity as a portraitist seems to have been at its maximum during his few years in Bologna. The much longer span of time after his return to Parma yielded relatively few portrait commissions. The cause may have been the economic one of the lesser wealth and more provincial character of society in Parma, but more probably it had to do with the lesser rate of productivity, even the strange dilatoriness, that seems to have overcome Francesco not very long after his return. Only four portraits are definitely assignable to the second Parma period.

Two of these are pendants, the portraits in the Prado of the Count and Countess San Secondo (c.1533–1535, Figs. 139, 143), and of this pair the latter is not entirely by Francesco. However, the portrait of the Count compensates in its quality for the deficiencies, inflicted by another hand, in the portrait of the Countess. He is the counterpart in portraiture of what the approximately contemporary "Madonna dal Collo Lungo" represents in the religious paintings: an extreme in the possible development of Francesco's style within its genre. The meeting of Pier Maria Rossi, the Count, as subject and of Parmigianino as artist was a fortunate conjunction: the Count was, as a subsequent biographer described him, bel'uomo; he required the minimum of adjustment in Francesco's almost excessive tendency of this time (so much manifest in the "Collo Lungo") toward the expression of an ultimate refinement of physical form.

Rossi's handsome regularity of countenance is approached among previous subjects only by the Uffizi gentleman. Even more than in the latter Francesco has exercised upon the Count his tendency to stress the refinement of the structure of the face; his features seem thinner and even more elegantly attenuated. This attenuation is pervasive; it has been extended to the body; and the pose, composition, and format of the portrait are more positively vertical than ever before. The Count is represented in a standing position, visible downward almost to the knees;[25] his elongated form extends through the whole length of the panel. There is a dominant sense of vertical extension. The motives of design subsidiary to this vertical are arranged in a connected movement of serpentine character, suggestive of Francesco's system in his religious paintings, but much less assertive in effect.[26]

The vertical direction is reinforced by the relief of the edge of the brocade behind the Count against the strip of landscape at the right.[27] Even the landscape curiously shares in the vertical impulse of the picture; it does not recede so much as it is piled up, layer

on successive layer, almost to the upper frame. Though equally abstract as a construction of space, this is an inversion of the arbitrary trick of perspective used in the "Collo Lungo," where the vanishing point has been lowered out of all normal relation to the figure group. However, much like a device in that painting is the way in which the statuette (of Mars?) is used to contrast in scale with the figure of the Count and thus accent his impression of extreme height. The "prophet" in the rear of the "Collo Lungo" stands in a similar relation of contrasting scale to, and indeterminate distance from, the main figures.

As in the Pitti altar, the extreme elegance in Rossi's portrait has been achieved at the expense of a considerable sacrifice in the seriousness of content of the subject. More than any other sitter, male or female, the Count depends for the impression he makes on us upon the graces of his outward form: decorative and superbly elegant, though fully masculine. The essence of this man, as Francesco has chosen to indicate it, is in his expression of distant, utterly assured aristocratic superiority: he seeks no contact with us but blandly deigns to be admired.[28]

The Count's easy accommodation to Francesco's predisposition was in inverse proportion to the problem offered by the portrait of his Countess. It is probable that her portrait was left unfinished, and was completed by another hand. The portions which are surely by Francesco are of his accustomed quality, but this commission offered difficulties of content and design which the artist apparently could not bring himself to face. The Countess San Secondo, like the Gozzadini, was a mature and not particularly handsome woman; however, Francesco seems to have achieved a moderately satisfactory compromise in depicting her. More perplexing was the question of including her three sons within the same design. Francesco executed the head of one, with such a sensitivity as we should expect from our experience of the children in his religious works; but seemingly he then balked at the others. This contract for an omnibus portrait was not in Francesco's specialized and highly refined line; it is not unlikely that he may have refused to finish it. As we have long since observed, Francesco did not have a craftsman's attitude. His difficult and inflexible behavior in the matter both of the Steccata and the "Collo Lungo" altar[29] make such an action in this case eminently possible to him.

Again inverted, this time to the opposite pole, was Francesco's situation when confronted by the sitter of his portrait in Naples, fancifully titled with the name of the notorious Roman courtesan, Antea (1535–1537, Fig. 144). "Antea" far exceeded even Count San Secondo in the degree to which her actual person accorded with the artist's predisposed ideal. The structure of her face must in reality have much resembled that of Francesco's invented female type. So easy was its translation into ideal terms that he

in fact used it, or at least a face most closely modeled on it, in the group attendant upon the "Madonna dal Collo Lungo" in her ideal realm.

Even in Antea's case the artist was not content to let her special beauty, so singularly created by nature in harmony with Parmigianino's design, speak entirely in its own terms. Antea's image on the canvas is, as in all Francesco's portraits, a synthetic one, subject to the artist's passion of this time for an ultimate refinement. The contour of her face is a long oval more perfect than any that nature could have devised;[30] the proportions of her features are artificially reworked: her eyes impossibly large, her nose impossibly long and straight, the mouth too exquisitely small, the ear set on at the strange angle that Francesco preferred because he could thus exaggerate its perfection of calligraphic shape.

The proportion between Antea's head and body is also modified to suit Francesco's artificial canon. He could not, without violating the proprieties of resemblance demanded in a portrait, endow her with the extreme of elegant attenuation of the "Collo Lungo" Madonna, but he achieved a comparable effect by an arbitrary diminution of the scale of the head against that of the body.[31] What is perceptible of Antea's figure beneath her ample dress suggests also that the proportions within her form, and its shapes, have been somewhat arbitrarily adjusted: her tapering shoulders, high waist, and wide hips recall, more than is physically probable, the appearance of the Madonnas. Her body conveys a sense of suave maturity (and with its garments, even of largeness) that subtly contradicts the almost childish delicacy of her head. From this contrast comes a suggestive overtone stronger even than that in the "Schiava Turca."

This relative amplitude of the figure serves an important function in the design of the portrait. Though there is an element of rhythmic connection among the parts of the standing form, this is less evident than in the previous portrait of Count San Secondo. There is an apparent emphasis of rectilinear motives in Antea's figure: the shape of her garment, the placing of her arm, and the panel of her dress suggest a rectilinear framework of design rather than a rhythmic one. Her body seems disposed within a rectangle which, though elongated and of great elegance of effect, seems grave and static by comparison with the fluid design of earlier portraits. The difference in this portrait composition, perhaps more one of inflection than of kind, suggests comparison with the change which became apparent in the later religious works in their increasing sense of gravity in design. The "Antea" accords in date with the appearance of the tendency toward such compositional change in Francesco's religious style.

Other factors, the handling of light and the treatment of surface texture, add to the effect of gravity conveyed by Antea's form. The light here models not just the exposed flesh but the entire figure; the body is projected against a neutral background in strong, three-dimensional relief and communicates a sense of consistent tactile existence more

convincing than in earlier portraits.[32] In spite of its carefully executed detail the surface is less vitreous and shell-like than before; the use of a canvas rather than a panel[33] perhaps has helped Francesco to give to the dress a quality of materially convincing, weight-communicating texture. To the contrast between body and head in scale, and to their contrast between maturity and girlishness is added yet another element of difference: that between the conviction of physical plausibility in the mass and surface of the body (in spite of its distortions of proportion) and the almost improbably ideal, half-fictive-seeming beauty of the head.

This refinement into a nearly fabulous ideal loveliness of Antea's face has not brought with it any lessening of the living immediacy of her expression; her look conveys an individuality and actuality almost more intense than in any other sitter. Like most of Parmigianino's subjects, she seeks instant contact with the spectator through her gaze. All her inner self is focused in that gaze; her concentration on us is such that she stands tense, unmoving, rigid with attention. There is something wonderfully feline (and thus feminine) in this look, like the waiting stare of a cat. Her face is perfectly composed, yet imminently mobile in its faint suggestion of a smile. Like the Borghese "Priest," Antea is engaged with the spectator in a cautious, penetrating mutual assessment of intentions before she will admit less formal communication. Here, however, the burden of that assessment is not the wit or the politics, worldly or churchly, of the spectator, but matters more intimate than these.

An old tradition, apparently as false as the sitter's traditional name, identifies her as the artist's mistress. There is a kind of sense, though not historical sense in this, in the same way that there is a kind of logic in the tradition that identifies the painting in the Uffizi as a self-portrait of Francesco. Antea is the human, individual, feminine counter-part of Francesco's ideal conception of the male. In a realm where idea and matter perfectly coincide the Uffizi gentleman could have been Parmigianino; in that same realm Antea would be the woman of whom Francesco could have been the lover. Her portrait certainly has been painted *con amore*.

The indices of Francesco's change in style during the second half of the thirties are only in part evident in the "Antea." In many respects, both of form and content, she conforms still to the characteristics of that phase of Parmigianino's maturity which culminates and ends in the "Collo Lungo." From the subsequent phase of Parmigianino's late style, we have only one work in portraiture, the painting in Naples doubtfully identified as of Girolamo de' Vincenti (Fig. 146).

This portrait shows a much more positive affirmation of the "Antea's" grave and rectilinear character in design. This character proceeds only in part from the relative squareness of the picture format as compared to the "Antea"; portraits of similar format,

but of very different effect, occur in Francesco's earlier work. Within the picture area the body, itself of squarish shape, bulks assertively large. Though posed on a bias, its general accord with the rectangular shape of the frame has been preserved. As in the "Antea," the sense of physical gravity resulting from the amplitude of the body is somewhat reinforced, not in this case so much by modeling with light, but by the indication of its materially convincing surface texture. Much more than the body, Vincenti's head and hands are weightily and most powerfully modeled.

This gravity, both of physical form and composition, accords with Parmigianino's latest phase of style, but differs in one important respect in its means of expression. The tendency toward a lesser activity of rhythmic devices apparent throughout the portraits, in contrast to the religious works, has achieved entire fulfillment here. This portrait is not only grave, but almost static in design.

The mood of the sitter is different in a singular way from that of previous sitters. Like the Count of San Secondo, Vincenti is exceptional in that he seeks no contact with the spectator. However, he displays nothing of the languidly aristocratic, faintly vacuous remoteness of the former. Vincenti's face is finely composed and subtly aware: this awareness includes both the spectator's presence, obliquely, and more evidently his own inner self. His inward regard does not find such tensions as those which existed in Castaldi or the Uffizi gentleman of ten-odd years before. Vincenti does not wear their tense, fixed look; his composure, though deliberate and self-conscious, seems by comparison genuine, not the product of constraint.

Vincenti's own specific personality doubtless counts for much in this interpretation, but the kind and measure of its difference from that of the earlier sitters must depend in some measure on the customary mutual accommodation between the sitter and the artist. Parmigianino's search in his late years into a graver and profounder realm than that of his earlier aesthetic ideal had, as a major motive spring, the need for values more secure than those tenuous and exquisite ones. We know from his late "Saint Stephen" altar that he finally achieved a capacity for grave and noble exaltation based on, and conceived in terms of, Christian faith. Perhaps the grave, calm surety of the "Vincenti," instilled there partly from the artist, indicates that Francesco achieved as well some measure of the serenity of spirit, for himself and in his view of his fellow men, that accompanies the grasp of faith.

POSTSCRIPT

PARMIGIANINO'S PLACE IN SIXTEENTH-CENTURY STYLE

PARMIGIANINO'S PLACE IN SIXTEENTH-CENTURY STYLE

The way beyond the Renaissance in some respects significantly resembles the way into it. Certain major premises of Parmigianino's style are like those of the late-Gothic artists, especially of the early fifteenth century's so-called "International School." These similarities are no more than the sharing of a lowest common denominator; in Parmigianino, obviously, his premises are expressed with vastly greater complexity and sophistication. Beneath the considerable difference of degree, the likenesses nevertheless remain apparent: in their habits of constructing space, and in their manner of representing the human form, where the similarity extends beyond the physical dimension of the figure into its content. Both practice a common calligraphic exercise upon the body and its garments, and extend its rhythmic character throughout the larger compositional scheme. There is a common stress on grace of attitude and prettiness of face, and the emanation of the person tends to be more that of grace than any more substantial human property. Both share the qualities of preciousness and elegance, and the resultant character as of a courtly style. Ultimately, both styles stand in a similar place between the opposite poles of external reality and subjectivism.

Among the artists of the Early Renaissance, Parmigianino shows communities only with those who are not entire converts to the realist cause, but in whom the principles of late-Gothic style tend to persist. The least distant analogy to Parmigianino among the painters of the *quattrocento* style—and it is an anology which extends regrettably to form alone—is Botticelli who, beneath a realist discipline, maintains an arbitrary attitude toward space, and carries the calligraphic impulse of the late-Gothic painters into a new dimension; Botticelli too, in a sense, is the practitioner of a courtly style. Among Parmigianino's more nearly regional antecedents he has counterparts, each of a separate aspect of his art, in Tura and Crivelli.

These communities of style are not induced in Parmigianino, but innate; there is no question of influence in the generation of his art from any of these precedents. His evolution of a style analogous in certain basic premises to that of the late Gothic is a consequence of a common state of mind. This is no intentional revival, but a spontaneous reëmergence of a Gothicizing point of view, which had been latent beneath, and was in part amalgamated into, the Renaissance. This artistic occurrence in Parmigianino is

125

a consequence of what has for some while been recognized as the general cultural situation of his time.

It should by no means be made to appear, however, that Parmigianino's style was generated in despite of, or in reaction to, that of the High Renaissance. On the contrary, as we have tried to demonstrate throughout this book, his style absolutely presupposes the experience of the High Renaissance; and we believe that it was probably conceived by Parmigianino to be a logical extension thereof. Parmigianino's attitude toward the High Renaissance was not like that of his contemporary Pontormo, in the formation of whose style a measure of antipathy, perhaps partly conscious, to the style of the High Renaissance appears to have played some part. Parmigianino's relation to the High Renaissance is one of sympathy to its ideals, and in particular to its ideality. The critics of the sixteenth century recognized this sympathy in their invention of the legend of the transmigration of Raphael's spirit into Parmigianino. Like that of Raphael, Parmigianino's art was dominated by the will to the attainment of an ideal of beauty achieved in large part through the manipulation of aesthetic means. We have explained how Raphael's ideality in Parmigianino comes closer to abstraction, and how Parmigianino's ideals of beauty, and of harmony, so change from those of the High Renaissance that, in spite of the broad identity of aim, they are no longer comprehensible within one concept of style. Nevertheless, the basic link is still patent and undeniable.

Parmigianino was, as we have observed from his earliest works, as if by innate disposition a Mannerist. However, without his experience of the High Renaissance his mature Mannerism would never have assumed the art-historically significant form that eventually it did. Parmigianino's style would otherwise have remained a naïve and personal, or even provincial Mannerism, of which the exact nature is not conjecturable, but the case history of which would have resembled that of such painters as Gaudenzio Ferrari, Aspertini, Mazzolino, or still others. Such provincial forms of Mannerism are in a way more a continuity from the strain of Gothic that persisted through the Renaissance than a new invention in style.

Mannerism, as an art-historically significant style, had to include within its visual experience, and to some extent in its intellectual understanding, the art of the High Renaissance. This comprehension was not necessarily extended into the spiritual domain, though in Parmigianino's case it was in some measure. The relation of Mannerism to the High Renaissance was like that of the Early Renaissance to classicism: without the experience of the latter the Early Renaissance would never have acquired its specific outward character of style. Equally, Mannerism bore a relation not unlike that of the Early Renaissance to the Gothic, to which (though in the case of Mannerism without any presumption of experience thereof) both may trace certain of their major motive springs of content.

PARMIGIANINO'S PLACE IN SIXTEENTH-CENTURY STYLE

The style developed by Parmigianino is the first, and at the same time most complete and consistent, exposition of one of the two major aspects within the Mannerist style, that which might be loosely called its "decorative" aspect: this becomes as well the dominant aspect of Mannerism. The other, quite as loosely nameable the "expressive" aspect of Mannerism, of which the development is due to Pontormo more than any other single personality, and indirectly to Michelangelo beyond him, had much less general currency. The wide dissemination of Parmigianino's brand of Mannerism would have occurred even without his particular example, because it is at once the more widely palatable, and more easily practicable, manner of the two.

Further, not even the invention of this kind of Mannerism required Parmigianino's specific effort. As we have observed, a similar manner was in process of development in Rome in the middle 1520's by Pierino del Vaga, and one not altogether different by Beccafumi at the same time in Siena. There are even elements in the style of Pontormo which could be transposed, by an artist of opposite disposition to him, into a manner analogous to that of Parmigianino.

It nevertheless remains that though not literally or entirely the inventor of this "decorative" Mannerism, it was Parmigianino who gave its earliest, and then its ultimate demonstration; and it was his precedent and example that was the source of its specific form in the practice of a considerable number among sixteenth-century painters. It is not only this substance of his achievement, but also its entire preëminence in quality, that give Parmigianino his primacy among the painters of his aspect of Mannerist style.

Though Parmigianino's style is thus the place of origin for much in the art of many painters of his own, and more still of the subsequent, generation, he may not be taxed with the conspicuous deficiencies of the *maniera*, that frigid and uninventive art of formulas rather than of inspiration, which degraded Parmigianino's example through much of the second half of the sixteenth century. Parmigianino's imitators fell into the very pitfall he himself avoided, and which was noted as early as 1550 by Vasari: ". . . who should imitate him, would make no more than an augmentation in his style." There was no possibility for invention in this aspect of Mannerism beyond that which Parmigianino had himself already invented.

The spread of Parmigianino's example not only throughout Italy, but beyond her borders, has been amply commented upon by other authors, and needs no further exposition here.[1] Parmigianino's influence was vast, probably greater than that of any other Mannerist painter. This legacy, however, was one which Parmigianino did not necessarily choose to leave. This influence was derived from a manner which Parmigianino himself recognized, after he had attained it, offered no prospects beyond those he had fulfilled, and from which he had turned, in his last years, into another, at once more profound and exalted path.

NOTES
PARTS I AND II

Affò: Padre Ireneo Affò, *Vita del graziosissimo pittore Francesco Mazzola detto il Parmigianino* (Parma: Filippo Carmignani, 1784).

Berenson (*Lists*): Bernard Berenson, *Italian Pictures of the Renaissance* (Oxford: Clarendon Press, 1932).

Campori: Giuseppe Campori, *Raccolta di cataloghi ed inventarii inediti di quadri . . . dal secolo XV al secolo XIX* (Modena: Carlo Vincenzi, 1870).

Copertini: Giovanni Copertini, *Il Parmigianino* (Parma: Mario Fresching, 1932).

Fröhlich-Bum: Lili Fröhlich-Bum, *Parmigianino und der Manierismus* (Vienna: Anton Schroll, 1921).

Vasari: References to Vasari throughout this volume are to the edition of Gaetano Milanesi (Florence: Sansoni, 1878-1885), except where the first edition of 1550 is cited, when the page references are according to the original.

Venturi: Adolfo Venturi, *Storia dell'arte italiana* (Milan: Ulrico Hoepli, 1901—).

NOTES

PART I—PARMIGIANINO'S CONCEPTS OF STYLE

1. See E. Panofsky, *Idea* (Leipzig: Teubner, 1924), pp. 39-56; J. von Schlosser, *Die Kunstliteratur* (Vienna: Schroll, 1924), book VI.

2. Here we might remark an analogy with Ingres, in whom the preferences for flowing, "melodious" linear rhythms have been attributed to his exceptional musical gift (*le violon d'Ingres*). Parmigianino was also an exceptional musician: Vasari (V, 234) describes him, on the evidence of a mutual Aretine friend (Giovanni Antonio Lappoli) with whom Parmigianino used to play in Rome, as a performer on the lute *non manco eccellente che nella pittura*.

3. Ludovico Dolce, *L'Aretino, ovvero Dialogo della Pittura* (Milan: Daelli, 1873, ed. Téoli; original ed. 1557). The speech is placed by Dolce in the mouth of Aretino.

4. *Vocabolario della Crusca* (Venice: Alberti, 1612).

5. See Panofsky, *Idea*; A. Blunt, *Artistic Theory in Italy* (Oxford: Clarendon, 1940), pp. 97 ff.; Castiglione, *Il Cortigiano*, tr. Hoby (London: Dent, Everyman ed., 1937), pp. 45 ff.; Catholic Encyclopedia, (New York: Appleton, 1909).

6. In the preface to his part III.

7. Affò (p. 44) makes the understanding comment on Parmigianino's figures that we might expect of a critic of the beginning of the neoclassic period: "pose il Parmigianino tutto lo studio nel dare alle sue figure tutte quelle proprietà che in esse avrebbe posto natura, quando piacuto le fosse di perfettamente produrle."

8. See the later sixteenth-century theorists. Zuccaro (von Schlosser, *Die Kunstliteratur*, book VI, p. 398) defines the content which he associates with bodies of different proportion: a figure seven heads high, for example, appropriately characterizes Cybele and the Sybils in their sublimity; Juno and the Madonna should, however, be eight heads high. This canon, he says, connotes *celeste belezza*, while Diana, as the embodiment of the ideal of *grazia*, must be nine heads high.

9. Juxtaposition with the Renaissance use of elongation makes this immediately apparent. Compare the completely different character, both in design and expression, of such a *quattrocento* example as Ercole Roberti's "St. John" (Kaiser Friedrich Museum). Comparison with occasional figures in Botticelli, however, suggests at least a partial analogy with Parmigianino, because in the former the elongation of form is also combined with a fluid linear pattern.

10. Is an analogy with Ingres again in order? It cannot be assumed that, reversely, it is the feminine population of Parmigianino's pictures which gives his style its somewhat feminine quality. Compare the marked difference in the style of those Renaissance painters who show a more or less equal absorption in the female: for example, Raphael, Correggio, Giorgione.

11. Parma, Galleria, no. 510/4.

12. The following are the chief relationships of vertical proportion in this same figure. They illustrate the complex harmony in Parmigianino's design of the human form.

body (including head) upward from crotch (vertical center of body): body below crotch = 1:1

lower legs: upper legs: torso = 1:1:1

supporting parts of the body: weighing torso = 2:1

torso: neck and head = 2:1

supporting parts: torso: neck and head = 2:1:½

Observe that there are two major relations of balancing or equal intervals, but that they are overlapped by a diminishing progression of intervals in the *upward* direction. (The reader may compare the elaborate analysis of the "harmonies" of proportion in an identical canon described by Lomazzo in his *Trattato, libro primo, cap.* v [*ed. princeps*, 1584], pp. 40-43. Lomazzo there employs to characterize these "harmonies" the musical terminology first appropriated to this purpose by Alberti in his *De Re Aedificatoria*.) The blocklike units of measure indicated on the right of the figure in Parmigianino's

drawing are lengths of the face, used in accordance with the traditional Vitruvian prescription (Vitruvius, III, 1, 2; see trans. M. H. Morgan, Cambridge, Harvard University Press, 1914, pp. 72-73). The evident intent of academic conformity in this drawing is indicated by the fact that the vertical measure of the body accords with that specified by Vitruvius. In admitting, in this study, the Vitruvian stipulation that the figure be ten faces high Parmigianino has, in his readiness to find sanction for his tendency to elongation, accepted a proposition that his Renaissance antecedents, from Ghiberti onward, had preferred to reject. (The Renaissance canons appear to have been related rather to one attributed to Varro, in which the height of the body was 9 1/3 faces.) The canons of Ghiberti, Filarete, and Guaricus, as well as Dürer's normal canon, are all 9½ faces or less. Vasari and Armenini also accept a canon of 9 faces. (See J. von Schlosser, *Lorenzo Ghibertis Denkwürdigkeiten*, Berlin, Bard, 1912, pp. 33-38.) Lomazzo, however, advocates a "normal" canon which, as we have observed, is like that of Parmigianino (and thus also like the canon of Vitruvius).

In support of our view that Parmigianino's figures retain a strong masculinity of form and expression Lomazzo (*Trattato, cap.* vi, p. 43) asserts that the canon of ten faces which he prescribes, and which Parmigianino has employed in the drawing under discussion, is "regolata . . . ad imitatione de la forma del corpo di Marte Dio de le battaglie" and speaks of this type of figure as appropriate to "gl'impetuosi, colerici, crudeli, bellicosi, discordi, audaci, termerarii, e pronti all'ira, i quali tutti sono gagliardi, e forti."

13. As especially in Pontormo in the early 1520's; also in certain works of Rosso, Romano, and Beccafumi.

14. The only important exception is the Steccata "Moses," of which the execution falls into the late period.

15. An especially pointed illustration is afforded by the juxtaposition of the "gesture" of the right hand of the "Madonna dal Collo Lungo" and the nearly identical gesture of the right hand of Bernini's "St. Teresa."

16. In the earlier and in the latest works the figures may be less closely interwoven, and may even have a considerable independence from one another. In these works as well, however, a continuous, undulating progression flows through and connects the figures, though its continuity need not depend, as in the mature paintings, on the actual interpenetration of parts of the bodies or their draperies. The progression may have caesuras in it, across which the eye is carried by the suggestion of direction in limbs or garments, or even by the direction of gaze or gesture.

17. Occasionally, more than one lower extremity of a figure or figures will be thus marked out, with a resulting apparent ambiguity in the starting point of the design. In such cases, however, the paths into which the separate starting points lead are sufficiently near to one another to be read simultaneously, like musical counterpoint; usually, they are both soon synthesized into one main compositional movement.

18. In Parmigianino's wall paintings (which are products of his early period and of his late style) his use of illusionistic intrusion of forms across the front plane into the spectator's space goes far beyond the mere connective purpose described above. In the wall paintings Parmigianino employs his command over illusionistic painting as an end in itself, rather than as an incidental device subordinate to the composition. These works reflect Parmigianino's experience in Correggio's proto-Baroque school.

19. Max Dvořák once stated the proposition that the figures in Mannerist pictures "create their own space." This states the situation well, but too strongly. Dvořák's characterization evidently cannot apply to the organization of background space, in which there are most often no figures. A more important qualification concerns the space of the figure plane: once this space has been "erected" it assumes (in Parmigianino's painting at least) a certain limited independence, and may then react upon the figures and determine the character of certain minor forms. So as not to violate the relieflike shape of the narrow panel of figure space certain minor figures in a compositional group, which should logically occupy a more forward or rearward situation with respect to the main element of the group, are constricted in a very artificial way behind the front and rear boundaries of the figure space: the figures thus constricted may be reduced to fragments of virtually two-dimensional shape.

20. In the flesh of his adult males Parmigianino often tends to a darker basic tone. Into this he may fuse earthen or reddish-orange glazes which may have a darkish, warm effect.

21. As we have observed, in the later, more diffusely lighted works the light is not so much illumination as light in the form of high value of the color.

22. But in one case among the mature religious

pictures (the Uffizi "Madonna di San Zaccaria") the coloristic vibration of surface extends nearly over the entire picture. The tonality of this surface is not that of any naturalistically recognizable atmosphere.

23. "Intellectual" technique, in this sense, has been much theorized about by sixteenth-century writers, and commented upon by our contemporary critics. See von Schlosser, *Die Kunstliteratur,* books IV-VI, and Panofsky, *Idea, passim.*

24. Vasari (IV, 463, in the life of Domenico Puligo) thus expresses the accepted point of view toward the portrait: ". . . molti eccellenti maestri hanno fatto pitture e ritratti di tutta perfezione in quanto all'arte, ma non somigliano nè poco nè assai colui, per cui sono stati fatti. E per dir il vero, chi fa ritratti dee ingegnarsi, senza guardare a quello che si richiede in una perfetta figura, fare che somigliano colui, per cui si fanno; ma quando somigliano e sono anco belli, allora si possono dir opere singolari, e gli artifici loro eccellentissimi."

25. Raphael, for example, uses the three-quarter-length seated form as early as 1510 ("Julius II"); Titian the three-quarter-length standing figure apparently only *c.*1522 ("Laura de' Dianti"). Fröhlich-Bum wrongly considers Parmigianino the inventor of the three-quarter-length format.

26. As notably in the servant in the left background of the Castaldi portrait in Naples, whose costume is a pale rose.

PART II—THE FIRST PERIOD IN PARMA

1. Register of baptisms from 1487 to 1504, p. 253 verso, lines 11-12; transcribed by Copertini (I, 49, n. 1).

2. Vasari V, 218-219.

3. The "war" was declared by Charles V on July 12, 1521. See F. Guicciardini, *Storia d'Italia,* book XIV, *passim;* Umberto Benassi, *Storia di Parma* (Parma: Battei, 1899), vol. III, chap. ix; U. Benassi, *Francesco Guicciardini, Governatore di Parma* (Parma: Battei, 1899), *passim.*

4. Vasari V, 220: *anch' egli putto e pittore.*

5. Vasari V, 235 and n. 1.

6. See Vasari VI, 487, where personal contact between the author and Bedoli is specified.

7. Parma was in fact a center of disturbance from June 1521 until late in December of that year. With the new year Parmigianino would have been free to return to the city with reasonable assurance of safety. See works cited in note 3 above.

8. Affò, pp. 31-34; Copertini I, 54, n. 20.

9. See Thieme-Becker, under the article "Anselmi."

10. See below, introduction to the Rome-Bologna period, pp. 59 and 136, note 1.

11. Since it does not appear in the first, but only in the second edition, this report would have been derived from Bedoli, and would therefore be reasonably well founded. More important, Vasari's description of Parmigianino's education seems borne out by our analysis of the "Baptism."

12. See Copertini, *tav.* IIb. Possibly the folds of Christ's severe, rather wooden drapery are a survival of the formulas used by Francesco's uncles; so also the inclined, smiling head of Christ may be, in part, a reflection of their manner. Their archaic system of perspective, with its overhigh vanishing point, may have left its effect in the landscape background of the "Baptism." However, not even the derivation of these details can be proved.

13. Milanesi (V, 219, n. 2) assumes this to refer to a supposed training of Parmigianino under Correggio. There is no evidence to support this interpretation.

14. For a discussion of painting in the fifteenth- and early sixteenth-century school of Parma see Copertini I, chap. i; L. Testi, "Pierilario e Michele Mazzola (Notizie sulla pittura parmigiana del 1250 c. alla fine del secolo XV)," *Bollettino d'arte del Ministero della Pubblica Istruzione,* IV (March 1910), 49 ff. and 81 ff.; A. Venturi, "Pittori parmigiani del Quattrocento," *L'Arte,* III (1900), 375 ff.; A. Venturi, *Storia dell' Arte Italiana,* VII, part 3, pp. 1102-1128.

15. As good, if not better in quality than the work of any current Parmesan, and naturally of interest to the young Parmigianino, were the works of his father, Filippo. One in particular, a "Baptism of Christ" (1493, now in the Cathedral; in Parmigianino's time in the Church of San Francesco del Prato; Fig. 2) should presumably have had some influence on the young artist when he set out to paint a similar theme. However, the comparison offers no satisfaction if we are looking for similarities. The thing we remark most strongly is the difference of generation; there are not even suggestive similarities of detail. Indeed, the iconography itself has been altered. A juxtaposition of this kind

serves to underline the essential novelty of Francesco's painting and to emphasize how, underneath the seemingly "primitive" aspect of the "Baptism," there is a markedly *cinquecento* character of style.

16. Corrado Ricci, *Correggio* (London and New York: Warne, 1930), pp. 47 and 131, dates the Camera di San Paolo between April and December of 1518, and confirms that during 1519 Correggio was mostly in his native town.

17. Certainly not a source for the Leonardesque types of Parmigianino's picture is a work by the Parmesan painter, Alessandro Araldi, who about 1515 executed (also in the Convento di San Paolo) a copy of Leonardo's "Last Supper" (Photo Direzione Generale delle Belle Arti, E-27607). The basis from which Araldi drew his copy seems to have been one of the several engravings published shortly after Leonardo's completion of his painting. See P. Kristeller, *Die Lombardische Graphik der Renaissance* (Berlin: Cassirer, 1913), and Delaborde, *La Gravure en Italie avant Marc-Antoine* (Paris and London: Librairie d'Art, 1883). It is known that Leonardo was in, or more probably near Parma for a brief visit in 1514. A note in his Codex E(80 r), Paris, Institut de France (quoted Beltrami, *Documenti e Memorie riguardanti La Vita e Le Opere di Leonardo da Vinci*, Milan, 1919) reads: "a Parma alla Campana a di 25 di settembre 1514." It is unlikely that this visit had any artistic consequence, and certain that it had none on Parmigianino, then eleven years old.

18. In spite of the evidence of Parmigianino's only limited contact with Correggio's pre-Parmesan productions there seem nevertheless to be certain broad communities between Correggio's earlier style and Francesco's "Baptism." These communities are very indefinite, but nevertheless present, and it may puzzle us to explain them until we recall the circumstances of Correggio's education. As Parmigianino in the "Baptism" is (as we shall see) dependent through Francia on the school of Bologna, so also did the early Correggio have a connection with the school of Bologna-Ferrara. By the time of his arrival in Parma Correggio had largely outgrown this aspect of his education, but this common factor in their backgrounds explains the vague kinship in style between the pre-Parmesan work of Correggio and Francesco's first painting.

19. The Francia "Deposition" is dated not later than 1510 by G. Lipparini, *Francesco Francia* (Bergamo: Istituto Italiano d'Arti Grafiche, 1913), p. 98, ill. p. 97. Venturi (VII/3, p. 918) dates it between 1506 and 1509. For the location of the picture in

Parmigianino's time see Copertini I, 12. Francia painted at least two versions of the "Baptism" subject, but it is very unlikely that Parmigianino knew them. One "Baptism" by Francia, dated 1509, is now in the Dresden Gallery (ill. Venturi VII/3, fig. 696, p. 938); it is thought to have been painted for export to Modena. Another, earlier, version (Fig. 3) is now at Hampton Court; of this picture it is alleged, but not definitely known, that it was acquired in Mantua. However, Parmigianino may have known a print by Marcantonio (Bartsch XIV, p. 28, no. 22; no. 14 in Delaborde, *Marcantoine,* ill. p. 97) after the Hampton Court painting. The print only roughly approximates Francia's style in painting, and so could not have served as a source for Francesco's borrowings. However, he may have derived from the print the starting point for the iconographic treatment of his own "Baptism," for the print similarly represents not the actual moment of baptism, but the previous moment in which St. John bends to fill his vessel with water.

20. Compare, for example, Francia's slender, long-fingered hands, with their marked separation of the fingers, with what is evident of the hands in Parmigianino's picture. The feet of Francia's figures seem to have served perhaps even as exact models for those in the "Baptism."

21. The single architectural detail in the "Baptism," however, derives from quite another source than Francia. A casual examination of this detail indicates its eventual origin in Dürer, but its more direct source for Francesco may have been a print by Giulio Campagnola, or by another of the printmakers who introduced such rustic buildings into their backgrounds: for example, Robetta, IB with the Bird, etc.

22. As well as two other works by Francia himself: a "Madonna with Saints" dated 1515, originally in the church of San Giovanni, now Parma Gallery (ill. Venturi VII/3, fig. 708, p. 950); and a "Madonna with Two Angels," said to have been also in San Giovanni, but now in a Viennese private collection (ill. A. Venturi, *Studi dal Vero;* Milan, Hoepli, 1927; fig. 111, p. 185). These pictures represent the duller (and more characteristic) aspect of Francia's art, which explains why the oversensitive young Parmigianino found them less interesting as models. Paintings by other foreign masters included work by Francesco Zaganelli, then in the church of the Annunziata; Cima (Annunziata and Cappella Monti, Duomo); Jacopo and Giulio Francia (San Giovanni); Bianchi-Ferrari(?) (San Quintino). See Ricci, *La R. Galleria di Parma* (Parma: Battei,

1896), *passim*; *Inventario degli oggetti d'Arte d'Italia*, III, Provincia di Parma (Rome: Libreria dello Stato, 1934), *passim*; Copertini I, chap. i.

23. At the time of the "Deposition" Francia had not yet come, as he was to come later, under the direct influence of Raphael. Though Voss seems not to have been aware of the specific source in Francia of Parmigianino's apparent early Raphaelism, he nevertheless characterized its significance most aptly in his publication of the "Baptism" ("Ein Wiedergefundenes Gemälde von *Parmigianino*," *Jahrbuch der Preussischen Kunstsammlungen*, vol. LIV, heft 1, 1933, pp. 33-37): "So sehr er sich später von diesem provinziellen Raffaellismus aus zweiter Hand durch selbständige Verarbeitung der originalen römischen Raffaeleindrücke befreit hat, so bleibt es doch von Bedeutung, dass schon der Sechzehnjährige, wenn auch zaghaften, ungewissen Schrittes, jene Richtung einzuschlagen versucht hat, die später im Schaffen des reifen Meisters—trotz aller Anregungen durch Correggio—die eigentliche Dominante bleiben sollte."

24. The San Michele Visdomini "Madonna" is dated 1518-1519. See F. M. Clapp, *Pontormo* (New Haven: Yale, 1916), p. 127.

25. The evolution of this system in each artist is certainly completely independent.

26. Including Francia's altar of 1515, see note 22 above. Correggio's "Madonna of St. Francis," referred to in our discussion of the "Baptism," is another example of the type. One detail in the Bardi altar suggests that Correggio's picture may in fact have been among Parmigianino's prototypes: this is the attitude of the name saint in each picture. There is also some possibility that Parmigianino may have studied, and in remote fashion depended upon, Correggio's "Marriage of St. Catherine" formerly in the Frizzoni Collection (now Kress). It may have been in this early Correggio that Parmigianino found the suggestion for his motive of the steplike transition into the space of the painting, and for the placing on the step of the fragment of the Catherine's wheel.

27. Mainly by the concentration of light areas in the figure of the Baptist, by the considerable width of his form, and by his more forward location in space. The architectural framework of the picture also helps its balance and stability.

28. Hung as an altarpiece, the lower edge of the picture would be near eye level.

29. See note 13 above. Such a contact still does not make Parmigianino a "pupil" of Correggio, in the usual sense in which we use the word.

30. The pendentives and cupola seem to have been the earliest part of Correggio's decoration, and were completed by 1521. In mid-1522 Correggio was receiving payments for his decoration of the apse. G. Gronau, *Correggio* (Stuttgart and Leipzig: Deutsche Verlags-Anstalt, Klassiker der Kunst, 1907), p. 160.

31. But see below for a possible influence from Pordenone.

32. Compare especially the Mark and Gregory (Fig. 14).

33. Part of the ambiguity of effect in the relation to the wall of the architectural framework results from the slightly curving surface of the wall: when seen from the angle from which it is necessary to take photographs the architectural frame appears illogically to curve outward and forward in its lower part.

34. On extremely superficial grounds, Copertini (I, 36-40) inverts the order of execution of the frescoes which we have set forth here.

35. See G. Fiocco, *Giovanni Antonio Pordenone* (Udine: La Panaria, 1939), pl. 82-83. The frescoes on the *arconi* of the Duomo were finished by October 8, 1521 (Sacchi, *Notizie dei Pittori Cremonesi*, 1872, quoted Fiocco, p. 124). For other examples of this motive in Pordenone see Fiocco, pl. 8, 118, 130, 137. The motive is related to that in the Heliodorus fresco of Raphael, where it is used without any illusionistic intention. Note, however, that its appearance in the Spilimberg Castello fresco, attributed by Fiocco to Pordenone, is antecedent to the Raphael by some seven years.

36. A derivation which was observed independently also by C. Gamba, "Il Parmigianino," *Emporium*, vol. XCII, no. 549 (Sept. 1940), p. 109. A. Sorrentino, in *Bollettino d'Arte*, vol. 25, ser. 3 (1931), p. 183, had earlier remarked that the San Giovanni series in general *fanno pensare al Pordenone*. Parmigianino may also have imitated another motive, though not so much an illusionistic one, from Pordenone's fresco of the Crucifixion at Cremona: this is the attitude of the executioner who breaks the legs of the thief (ill. Fiocco, *Pordenone*, pl. 90-91), which resembles the pose of the executioner in Parmigianino's "St. Agatha" fresco.

37. On the inner wall of the façade of the Duomo, to the right of the "Crucifixion" fresco.

38. See Maniago, *Storia delle belle arti Friulane* (Udine, 1819 and 1823), pp. 322-324.

39. A possible indication that Parmigianino may in fact have seen the "Deposition" is the resemblance which exists between the head of his St. Agatha

and that of the Magdalen in Pordenone's fresco.

40. The latter attributed by Ricci to Rondani. Ill. Venturi, IX/2, fig. 434, p. 536. There here may be a further connection with Pordenone, whose decoration of the nave pilasters at Cremona resembles that of Parmigianino's arch faces in the use of *putti* motives as well as of trophies, garlands, etc. Pordenone may have been indebted in turn to Correggio for these motives, so any dependence of Parmigianino in this matter on Pordenone would in any case imply an eventual dependence on Correggio.

41. Compare Fra Antonio da Monza's "Candalieri" series (Berliner, *Ornamental Vorlage-Blätter des 15 bis 18 Jahrhunderts*, Leipzig, Klinkhardt und Biermann, 1925-1926, pl. 17) or Giovanni Antonio da Brescia's friezes (ill. *ibid.*, pl. 26). A less likely, though nearer source of classical motives is Araldi's grotesque decoration in fresco of a room in the Convent of San Paolo (ill. Copertini, I, *tav.* VIIIa), which in turn appears also to arrive from similar Mantegnesque prints.

42. For example, his Budapest "Madonna" (ill. Gronau, *Correggio*, p. 130); the "Madonna Adoring the Christ Child" (Uffizi, ill. *ibid.*, p. 89), etc.

43. The design for the "Notte" may have been seen by Parmigianino in 1522, for the contract therefor was awarded on October 14, after the patron's approval of the design (Ricci, *Correggio*, pp. 90-91).

44. See the example in Naples, ill. Gronau, *Correggio*, p. 50; dated 1518-1519.

45. See W. H. Roscher, *Ausfürliches Lexikon Griechischen und Römischen Mythologie* (Leipzig: Teubner, 1884-1891), vol. I, under "Aktaion."

46. See Ripa, *Iconologia* (Padua: Pasquardi, 1630), under his descriptions of Summer (III, 99), the Summer Solstice (III, 79), July and August (469, 470, 473).

47. There is a resemblance to Parmigianino's scheme at Fontanellato in a fragment of a so-called "Allegory of Autumn" executed, according to G. M. Richter (*Giorgione da Castelfranco*, University of Chicago Press, 1937, p. 221, ill. pl. LIV) by Giorgione and Giovanni da Udine *c.*1500 for the

Palazzo Grimani in Venice (now Kingston Lacy, Bankes Collection). This fragment shows *putti*, seen in vertical perspective against an arbor, picking fruits, etc. However, it cannot be reasonably assumed, from the general comparison of motives, that Parmigianino was acquainted with this precedent.

48. There are, of course, precedents for the suggestion of a rhythmical continuity along a single range of figures in a decorative scheme; one of these is very close to home, in the *putti* of Correggio's *Camera*. The degree of rhythmic connection is, however, very far indeed from that effected by Parmigianino; the High Renaissance isolation of each picture unit is far stronger than any continuity between them.

49. Venturi (IX/2, p. 652) feels something of this coolness in the color scheme. "Dall 'aurora del Correggio," he says, "si passa al crepuscolo lunare."

50. The "St. Catherine" is a much damaged and restored work. For a discussion of its status as copy or original see the catalogue, p. 166. The "Zingarella" dates about 1518-1519; its presence in Parma in the next decade is probable though not certain. It has been traced as far back as 1587 to the Parmesan collection of Ranuccio Farnese. See Gronau, *Correggio*, p. 159. In the so-called Sezione Iconografica of the Mostra del Correggio held in Parma in 1936 there was exposed a copy, very doubtfully ascribed to Parmigianino, after the "Zingarella." See *Manifestazioni Parmensi nel IV. Centenario della Morte del Correggio* (Parma: Bodoni, 1936), p. 74, n. 2. It is likely that this copy was once in the Casa Boscoli in Parma: see Part III, catalogue of lost pictures, under the date 1690.

51. Parmigianino has made the latter motive the rather ingenious theme of the picture: the *putti* help the saint in her depicted action of plucking her palms of martyrdom.

52. The sense of the nearness to the spectator of the figures is more acute than in previous works where there is a somewhat similar forward compression, because of the psychological connotation of nearness afforded by the clarity of detail.

53. The only later example is the Steccata "Moses."

PART II—ROME AND BOLOGNA

1. Traditionally (Affò, p. 39) Michele Mazzola, but his presence in Parma in 1526 is documented, and Vasari (V, 225) implies that the uncle (whichever one he may have been) was with Francesco continuously during his residence in Rome. Copertini (I, 93, n. 1) considers it equally unlikely that the other uncle, Pier Ilario, would have passed so long a period away from his large family. Copertini

suggests that Francesco's companion may have been some other relative. A very doubtful clue to the identity of such another relation is the name scratched on the walls of the Domus Aurea of Nero in Rome (see Fr. Weege, "Das goldene Haus des Nero," *Jahrbuch der Kaiserlich Deutsch. Arch. Inst.,* vol. XXIII, 1913, p. 144) in a sixteenth-century hand: ZACARIA MAZOLO DA PARMA. Weege suggests a possible relationship with Francesco Mazzola. However, the name Zacaria does not appear in any available genealogical table of the Mazzola (see that in L. Testi, *Bollettino d'Arte,* vol. IV, 1910, facing p. 104).

2. Milanesi's note (V, 222): "Cioè Matteo Giberti, che fu datario di Clemente VII, e poi di Paolo III."

3. See Vasari V, 561, in the life of Giovanni da Udine.

4. The date was first correctly established by Copertini (I, 63, 64).

5. See Fr. Guicciardini, *Storia d'Italia,* books XIV and XV; Cellini, *Vita* (Florence: Piatti, 1829, ed. Tassi), p. 109, n. 3; Copertini I, 63, 64.

6. In the first edition, Vasari (p. 848) reports that Parmigianino went home to Parma for a short while, whence he returned to Bologna: ". . . Francesco ritornò a Parma per alcuni mesi, et non stette molte, che se n'andò a Bologna a far lavori." That the correction of the second edition is deliberate is indicated by the following sentence from it, describing Parmigianino's final return to Parma (in 1531): "Dopo esser stato Francesco, come si è detto, tanti anni fuor della patria . . . se ne tornò finalmente, per sodisfare a molti amici e parenti, a Parma . . ." (V, 229).

7. See our catalogue, Part III, p. 168.

8. According to documents in the Archives of the Steccata, cited by Copertini I, 134, and 150, n. 1. The subjects of the pictures contracted for, but apparently never executed, were to have been a St. John Baptist and a St. Joseph.

9. The Raphaelesque and Michelangelesque motives which appear in the paintings will be discussed in the subsequent text. Motives derived from these artists appear as well in many of the drawings and etchings of Parmigianino, and in some of the graphic works by other executants after Parmigianino's designs. There is evidence in such graphic material of Parmigianino's study of the following details of the Sistine Ceiling: the Jonas, the Sybils (especially the Delfica), the Daniel, the Isaiah, the Ignudi, "God Dividing the Waters"; there is also a possible indication of Parmigianino's knowledge of some of Michelangelo's "Resurrection" drawings.

The graphic material also shows Parmigianino's study of Raphael's Stanze, Loggie, and tapestry designs (including a direct copy after the "Curing of the Lame"). Albani, in an unfinished *Trattato,* published by Malvasia in the *Felsina Pittrice* (II, 4) and reported by Affò (p. 52), states that Francesco copied drawings by Raphael which were then in the Chigi Collection.

10. Vasari, a fellow Aretine, knew Lappoli well (VI, 14-15).

11. Though in a letter to Romano written in 1540 (quoted p. 192), Parmigianino uses the phrase (sixteen years after their meeting): "Io non so che dir se non ch'io penso che quela [ella] mi ama come io amo lei."

12. See Cellini, *Vita,* pp. 102, 122, 124.

13. No. I, 48; see *A Selection from the Collection of Drawings by the Old Masters Formed by C. Fairfax Murray* (London, 1905), pl. 48.

14. As observed by Antal, "Un Capolavoro inedito del Parmigianino," *Pinacoteca,* I (1928), 49-56.

15. No. 1865-7-8-147, red chalk, 16.8 x 10.2 cm.

16. See Kurt Kusenberg, *Le Rosso* (Paris: Michel, 1931), p. 129. The fresco 1524. It is of interest for the rapport between Rosso and Parmigianino that the owner of this chapel, Agnolo Cesis, was the same person for whom Parmigianino painted an "Annunciation," now lost (Vasari, V, 224; see below, p. 238).

17. See W. Friedlaender, "Die Entstehung der antiklassischen Stiles in der italienischen Malerei um 1520," *Repertorium für Kunstwissenscaft,* vol. XLVI, *heft,* 2 (1925), pp. 49-86.

18. Friedlaender (ibid.) also asserts a community between the "heroic" female type who appears in Parmigianino's "St. Jerome" altar and the similar type in Rosso's Città di Castello "Transfiguration"; both were painted for the same city, and were produced in successive years (1527 and 1528 respectively). The community of types is not so striking as is the fact of their evident common source in Michelangelo. A possible, though unlikely instrument for the transmission to Parmigianino of elements of Florentine Mannerist style was Lappoli. He had been for some months a pupil of Pontormo, apparently soon after 1520, but quickly lost interest in serious study (Vasari VI, 6, 7).

19. See Vasari V, 571, and Michelangelo, letter of March 1525 to Sebastiano, quoted in Milanesi, *Lettere di Michelangelo Buonarotti* (Florence, 1875), letter CCCXCVII.

20. There is a single instance of a derivation from Peruzzi: compare the resemblance in composition

between Peruzzi's "Augustus and the Sybil" (Siena, Church of the Fontegiusta) and Trento's chiaroscuro print after Parmigianino of the same subject (Bartsch XII, p. 90, no. 7).

21. Black chalk, 11.5 x 13.5 cm. Ill. Copertini II, *tav.* CXII, as a copy.

22. See Uffizi drawing no. 1525 (ill. Copertini II, *tav.* CVIIa) where one figure resembles the classic semidraped Venus type, and another the Apollo Belvedere. See also our discussion of the possible relationship of the Cnidian Venus type to Parmigianino's "Madonna della Rosa" (p. 81).

23. See Part III, pp. 170-172.

24. Parmigianino's personal habits of mind are visible also in the incorporation into the Madonna of certain motives of North Italian, rather than Roman flavor; these are also an index of the closeness in time of the picture to the first Parma period. Note the North Italian form of the mantle and headdress of the Madonna, and the strongly marked parapet. The motive of the Child holding the bird is Francesco's, and is not derived from Raphael's "Cardellino." Francesco had used it in 1522 in his "Madonna with St. Jerome and Beato Bernardino da Feltre."

25. Now Parma Gallery; formerly in the church of San Paolo, Parma. Ill. A. Rosenberg, *Raffael* (Stuttgart and Leipzig: Deutsche Verlags-Anstalt, Klassiker der Kunst, 1909), p. 209. The date of the departure from Rome of this picture is uncertain. The earliest record of its presence in Parma does not antedate the seventeenth century. *Ibid.*, p. 251.

26. Parma Gallery 192. The present version, like the earlier one, ultimately recalls Correggio's "Marriage of St. Catherine." See p. 136, note 44.

27. Compare the shepherd in the foreground of Parmigianino's etching of the "Adoration of the Shepherds" (Bartsch XVI, p. 7, no. 3; ill. Copertini, *tav.* CXVI). Note that Bonasone's engraving of this "Marriage of St. Catherine" (Bartsch XV, p. 121, no. 47) contains what is in effect a critique of the motive of the saint in the foreground. Bonasone has enlarged the figure downward so that his location in space, and his function as an intermediary, become more apparent; the figure as Bonasone interprets it comes more nearly to approximate the corresponding figure in the "Adoration" etching mentioned above. It is not impossible that the painting has been to some extent cut down, but it is unlikely, since all the copies show the foreground saint in the same dimension as in the Normanton original.

28. Then visible in Rome. It had been painted for Sigismondo Conti, secretary to Julius II. After Conti's death the picture was housed in the Aracoeli. See Rosenberg, *Raffael,* pp. 234-235; ill. p. 97.

29. In its upper half; probably through the agency of Marcantonio's print (Bartsch XIV, p. 53, no. 52) after a drawing by Raphael for the altar.

30. The "St. Sebastian" altar (ill. Gronau, *Correggio,* p. 94) was sent to Modena on its completion. For its dating see Ricci, *Correggio,* pp. 87 and 169. Parmigianino may have seen it, if not finished, either in design or in course of execution.

31. See Ricci, *Correggio,* pp. 87 and 170; ill. pl. CLIV; also ill. Gronau, *Correggio,* p. 92. Parmigianino's evident adaptation of the "Antiope" is, incidentally, a counterproof for Ricci's early dating of that picture, as against those critics who place it as late as 1530. It should, however, be observed that in the earliest of the certain preparatory drawings (British Museum 1882-8-12-488) the group of the Madonna and Child is still essentially dependent on its counterpart in the "Madonna di Foligno." In both recto and verso of this sheet Parmigianino's Madonna and Child seem more than casually resemble not only the figures of Raphael's painting, but even those of the drawing (Frankfort, Staedel-Institut) which Fischel describes as Raphael's first thought for the Madonna group of the Foligno altar. (The drawing ill. O. Fischel, *Raphaels Zeichnungen,* G. Grote Verlag, Berlin, 1913-1941, vol. XI, text fig. 271).

32. Then in the Palazzo Altoviti, Rome. See Rosenberg, *Raffael,* p. 236, ill. p. 102.

33. Unveiled in 1521. See F. Knapp, *Michelangelo* (Stuttgart and Leipzig: Deutsche Verlags-Anstalt, Klassiker der Kunst, 1906), p. 167, ill. p. 98.

34. Through a contemporary drawing (?). The statue itself was sent to Bruges in 1506, and we know no engraving antecedent to 1527. For a history of Michelangelo's statue and its antecedents and iconographic parallels, see Tolnay, *The Youth of Michelangelo* (Princeton: Princeton University Press, 1943), pp. 156-159.

35. Ill. Kusenberg, *Le Rosso,* pl. VIII.

36. But significantly, the elongation is not beyond that evident in the contemporary work in sculpture of Michelangelo then being executed in Florence; compare especially the "Victory" statue.

37. It is possible that the attitude and expression of the saint are a distant reminiscence of Raphael: compare the "St. Catherine of Alexandria," now in the National Gallery (London), in Parmigianino's time perhaps in the Borghese Collections in Rome. See Rosenberg, *Raffael,* p. 225.

38. Other evidences of Raphaelesque influence, beyond that from the Heliodorus group, may exist in the "Conversion of St. Paul." The horse, in its pose and in the deliberate accentuation of its elegance of form, resembles the foremost horse in the right front plane of the "Leo and Attila" in the same Stanza (ill. Rosenberg, *Raffael*, p. 93), and perhaps recalls even more the rearing steed in the left center foreground of the "Battle of Constantine" (ill. *ibid.*, p. 196). However, as Walter Friedlaender has observed (in the course of a discussion of the antecedents of Caravaggio's "Conversion" in the Cerasi Chapel, in an amendment to his article, "Der antimanieristische Stil um 1590," which appears in a mimeographed translation, "The Anti-Mannerist Style around 1590 and its Relation to the Supernatural," New York University Institute of Fine Arts, 1941), the iconography of Parmigianino's picture does not conform to the Raphaelesque precedent available in the Vatican tapestry of the "Conversion of St. Paul" (ill. Rosenberg, *Raffael*, p. 136), but accords instead with a peculiarly North Italian iconography which omits the image of Christ and shows only the divine illumination in the sky described in Acts 9:3. According to Friedlaender this iconography is earliest found in Pordenone and Moretto: in Pordenone's organ wing in Spilimberg (1524, ill. Fiocco, *Pordenone*, pl. 118), and in Moretto's painting in Santa Maria presso San Celso in Milan (Fig. 69), which Friedlaender suggests may be about the same time as the Pordenone. Accepting the then current attribution of the Vienna "Conversion of St. Paul" to Abbate, and its consequent dating in the decade 1540-1550, Friedlaender assumes the derivation of the Vienna painting not only in iconography but in composition from the Moretto.

There is in fact a very considerable resemblance in both respects between the Moretto "Conversion of St. Paul" and the painting in Vienna. Now, however, that the Vienna "Conversion" may be established as a work of Parmigianino, dateable with some certainty in 1527-1528, the question of precedence between the two paintings must be reconsidered; especially since Friedlaender's dating for the Moretto is only a general suggestion, and cannot be confirmed from any internal or external evidence. It is notorious how difficult the problem of dating in Moretto's *oeuvre* may be when documentation is lacking: Gombosi, in his recent monograph on Moretto (G. Gombosi, *Moretto da Brescia*, Basel, Holbein-Verlag, 1943, p. 109) is unwilling to hazard an estimate even of a period for the Milan

"Conversion"; he describes its time of origin simply as *unbestimmt*. The picture may perhaps, as Friedlaender suggests, be as early as the middle 1520's, but it could with equal probability be dated as late as the 1540's. The only possible item of external evidence for dating that may be connected, however vaguely, with Moretto's painting is a letter of December 1530 (reproduced in Gombosi, *Moretto da Brescia*, p. 84) in which the artist notes that he had recently been in Milan (*mi occoreva andar per mie facende a Milano*). This is the sole document for any connection of Moretto with Milan, where his "Conversion" has been at least since it was described in Vasari's edition of 1568 (VI, 506); but this visit may by no means be certainly associated with this painting. The question of precedence in time and in compositional idea thus remains in doubt, but even more uncertain is the way in which either artist, Parmigianino or Moretto, could have come to know the other's painting of the "Conversion." However, if such a personal knowledge of one painting by the other master must be assumed (and there are in fact similarities between the two pictures which might perhaps make such an assumption necessary) it would seem more in accord with the logical probabilities of the case to suggest that Moretto's painting was the dependent one: because, though its *terminus post* may conceivably antedate that of the Parmigianino, its *terminus ante* may be extended far beyond that of Parmigianino's painting, as much as ten or fifteen years later.

I suggest that the similarities between the two paintings, as well as the question of their relative precedence in invention, may be otherwise explained than by the assumption of direct derivation one from the other. The earliest dated Italian example known to me of what Friedlaender calls the North Italian iconography for the "Conversion of St. Paul" is the above-mentioned organ wing at Spilimberg. This iconographic scheme was combined by Pordenone, perhaps even earlier than 1524, with his obsessive motive of the outward-plunging horse, which probably first appears, in another context, in the frescoes of the Duomo at Cremona (1520-1522). A "Conversion of St. Paul," in 1939 at the Bachstitz Galleries at The Hague (earlier in a private collection in Vienna; published by Fröhlich-Bum in *Münchner Jahrbuch der Bildenden Kunst*, N. F. II, 1925, pp. 87-90; in the judgment of Fröhlich-Bum and Schwarzweller an original Pordenone, in that of Fiocco a school piece, and in my judgment a copy after a lost original) illustrates this combination (Fig. 70). In its principal elements this picture

shows perhaps a stricter kinship with Moretto's painting than does the Moretto with the Parmigianino. The particular evidence of Moretto's dependence on Pordenone is his retention of the proto-Baroque outward plunge of the horse; other points of similarity between the Moretto and the Bachstitz picture are in the direction of the composition and in the armored costume of St. Paul. It need not have been from this specific Bachstitz picture (or rather from its lost original) that Moretto derived his "Conversion." Ridolfi records other versions by Pordenone of the subject which are now lost; one of these may have afforded a comparison still more convincing. In any case, as between the Moretto and the Pordenone there can be no question of precedence, since the motive of the plunging horse is beyond dispute Pordenone's peculiar property (though, as we observed in our discussion of Parmigianino's "San Isidoro," it may not in itself be Pordenone's actual invention, but an elaboration on Raphael's horse in the Heliodorus fresco).

Whether Parmigianino may have known a "Conversion of St. Paul" of this type by Pordenone is uncertain. After his initial experience of Pordenone at Cremona c.1522, Parmigianino was, from 1524 to the time of execution of the Vienna picture, more geographically separated than was Moretto from Pordenone's area of activity. However, as far as we may judge from the Bachstitz painting, the lost original thereof may very possibly have been contemporaneous with the Cremona frescoes; in that case it could have been seen by Parmigianino when he visited Cremona. Parmigianino's "Conversion of St. Paul" could then, both in composition and in its (for its date) highly novel iconography, result from a memory of the same painting, or one similar to that from which we assume Moretto's picture to have derived. Even should this not be the case, Parmigianino's work must still admit to an eventual descent, at least in the motive of the horse, from Pordenone, through the intermediary of San Isidoro's mount in Parmigianino's fresco at San Giovanni Evangelista. As is always true in such cases, where there are so few fixed terms with which to work, this hypothesis of a common origin in Pordenone of the similar works by Moretto and Parmigianino remains no more than a hypothesis. There are a half-dozen further logical gambits which may be performed with the available data: they include the possibility of Parmigianino's quite independent invention of both the compositional scheme and the iconography of his "Conversion of

St. Paul." Of the alternative hypotheses, however, all seem less plausible than that suggested above.

39. This characteristic in the technique of the "Madonna of St. Margaret" is commented on by Affò (p. 74): "Certi luoghi, che non sembran finiti, mostrano que' gran colpi maestri, cui ci fece poc'anzi avvertire l'Albano; e il loro effetto maraviglioso ben si conosce allontanandosi alquanto dalla pittura, perchè svaniscono all'occhio quei colpi, e sembri il tutto finito coll'ultimi più scrupolosi degradazioni."

40. The unusual isocephaly may have been suggested by Raphael's "St. Cecilia" altar, then in Bologna. The type of the Madonna also somewhat suggests Parmigianino's study of Raphael's picture. See our discussion (following) of the "Madonna with St. Zachary."

41. The discharge of this tension across the gap is aided by the gestures of Margaret's hand and of the arm of the Christ child. The "Madonna of St. Margaret" seems to be entirely original with, and characteristic of, Parmigianino in every respect. Nevertheless, one cannot dismiss a sense of association with this work of another picture. Investigation of Correggio with this association in mind yields a curious result: certain of the motives of the "St. Margaret" are like corresponding motives in Correggio's "Giorno" (for example, the attitude of the Magdalen in comparison with the St. Margaret, the presence of the angel, the monster attribute in the corner, the St. Jerome type, etc.). Granted the total stylistic difference between the two pictures, these likenesses nevertheless suggest Parmigianino's reminiscence of Correggio's altar when he approached a similar problem of his own. Proof of this suggestion is impossible from the tenuous character of the internal evidence, however, and the external evidence would tend neither to disprove nor confirm that Parmigianino could have known Correggio's "Giorno." When Parmigianino left Parma in 1524, Correggio's altar had already been commissioned, but it is not known whether it was either designed or even partly executed. It was set up only in 1528. (Ricci, Correggio, pp. 171-172). In any case, it never left Parma, and no evidence can be adduced for Parmigianino's revisiting that city before he painted his "Madonna with St. Margaret." This particular question, then, must be left hovering in the limbo between coincidence and influence until we have more definite information.

42. For the iconography of the rose see W. Menzel, Christliche Symbolik (Regensburg: Manz, 1854), II, 279-285. Besides the obvious iconographic interpretation here suggested by the juxtaposition of the

rose and the globe, there are accessory interpretations which the many associations of the rose alone permit. This very diversity of meanings for the rose tends to diminish its effectiveness as a specific symbol. More of these associations are with the Virgin, in her various characters, than with the sacrifice of the Saviour. This is recognized in the picture, where there is some question implied, in the ambiguity of gesture between giving and taking, as to which of the two actors the rose more properly pertains; this ambiguity serves further to diffuse the point of the symbol, though it enriches it. Finally, the religious symbolism of the rose by no means excludes nor, especially in a picture such as this, does it replace the ultimate secular symbolism of the rose as *Uralte Sinnbild der Liebe* (Menzel, *loc. cit.*), and of the red rose in particular as the symbol of physical love. For the Christ child with the globe, as *Salvator-Imperator Mundi,* compare the earlier examples in Mantegna (Mond Collection, ill. Venturi, VII/3, fig. 162, p. 277) and Andrea del Sarto (Metropolitan Museum, New York).

43. N. Pevsner, *Barockmalerei in den Romanischen Ländern* (Potsdam: Athenaion, Handbuch der Kunstwissenschaft, 1928), pp. 50-51: "Ein wenig lüstern . . . umspielt die schleierdünne Gewand die Brust und lässt die Knospen durchschimmern. . ."

44. Affò (p. 72) quotes his contemporary, the engraver Bossi, in evidence for such a proposition. Bossi, who had studied the "Madonna della Rosa" in Dresden, was accustomed to say that pentimenti were visible in the painting which revealed its original pagan character: "si raffigurano ancora le ali alle spalle del Putto, e si comprendono certi smanigli alle braccia, e certi ornamenti al capo della Vergine, che sanno pienissima fede del pentimento del dipintore, che di una Venere fece una Nostra Donna, e di un Cupido formò un Gesù bambino." No one since, however, has presumed a declaration similar to Affò's retailing of Bossi's story.

45. S. Reinach, *Repertorium de la Statuaire Greque et Romaine* (2nd. ed., Paris, 1908), vol. II, part I, illustrates some fifty variants of the Venus Pudique. Among those visible to Parmigianino would probably have been the "Venus de' Medici" itself which (see A. Michaelis, in *Arch. Zeitung,* vol. XXXVIII, 1880, pp. 13-14, and in *Kunstchronik* N.F. I, 1890, pp. 297-301) was in the del Valle Collection in Rome from the early years of the sixteenth century (according to Michaelis, since at least 1513), though this is contested by L. Correra, in *Mitteilungen des Deutschen Archaeologischen Instituts,* XIX (1904),

267-275. It should be stressed, however, that the "Venus de' Medici" was then missing her lower arms, which were not restored until her installation in Florence in the later seventeenth century. A complete and very beautiful variant of the same Cnidian derivation as the "Venus de' Medici" existed in Florence at least from the middle of the sixteenth century, and probably since the Middle Ages. (L. A. Milani, "Il Motivo e il tipo della Venere de' Medici," in *Strena Helbigiana,* Leipzig, 1900, pp. 188-197.) It is probably this same statute that was recorded in a Dante commentary of the end of the fourteenth century by Benvenuto Ramboldi da Imola (*Comentum super Dantis Aldighieri Comoediam,* ed. Lacaita, Florence, 1887, II, 280; noted by J. Mesnil in "Masaccio and the Antique," Burlington Magazine, February, 1926, where Mesnil, in a discussion of the pose of the Brancacci Eve, notes also that the Prudence of Giovanni Pisano's Pisa pulpit is a copy of the Venus Pudique). Ghiberti, in his *Commentaries* (ed. Schlosser, Berlin, 1912; II, 90), recorded a figure of the Venus Pudique type which was discovered in Siena and which for a brief time decorated the fountain of the town. A translation into a Madonna by Bronzino of a variant of the Cnidian Venus in the Vatican Collection occurs in that painter's "Holy Family" in the Pitti. Bronzino's picture is variously dated 1535 or 1547-1548. See B. Schweitzer, "Zum Antikenstudien des Angelo Bronzino," in *Mitteilungen des Deutschen Arch. Inst.,* XXXIII (1918), 45-63. Another contemporary use of the Venus Pudique motive in painting was by Daniele da Volterra in his frescoes of *c.*1540 in the Palazzo Massimo alle Colonne, Rome; Volterra's Venus is closely imitated from a statuary model, even to its monochrome (bronzelike) statuary tone. (Ill. Venturi, IX/6, fig. 140, p. 250). Mrs. Jameson (*Legends of the Madonna,* London, Hutchinson, n.d., p. 22) has a characteristic comment to make on this sixteenth-century habit of interchangeability between the classical and Christian worlds: ". . . the same artist who painted a Leda, or a Psyche, or a Venus one day, painted for the same patron a Virgin of Mercy, or a 'Mater Purissima' on the morrow. Here, the votary told his beads, and recited his Aves, before the blessed Mother of the Redeemer; there, she was invoked in the purest Latin by titles which the classical mythology had far otherwise consecrated."

46. As in the "Madonna of St. Margaret," there is a concentration of the energy of the rhythmic motives of the composition in the psychological center of the picture, which is in this case the head of

the Christ child. He looks out at the spectator in a way so striking and direct that it moved Vasari (V, 227; see below, Part III, p. 181) to special comment on Parmigianino's capacity to represent the *spiriti acuti e maliziosi che hanno ben spesso i fanciulli*. Also as in the "St. Margaret," the concentration of the energy of design in the Child's head is transmuted into an intensification of His expression; in this case thus intensifying His gaze at the spectator.

47. Ill. Rosenberg, *Raffael*, p. 109. See note 40 above. Other Raphaelesque motives are suggested in the Uffizi painting but they are not, like the relationship in type, traceable to a source immediately available to Parmigianino. The pose of the Madonna compares with the "Madonna d'Alba," then in Nocera dei Pagani; the motive of St. John embracing the Christ child recalls the Raphael school piece, the "Madonna del Paesaggio" (ill. Rosenberg, *Raffael*, p. 206); the attitudes of the two children suggest "La Perla" (executed by Romano, ill. *ibid.*, p. 160), then in Verona. The head of the "Madonna del Cardellino," then in the Nasi Collection in Florence, bears a close resemblance to that of Parmigianino's Madonna.

48. This characteristic is accented in the head of Parmigianino's Magdalen by her pose in profile and her classicizing headdress. She suggests, beyond the influence of Raphael's model, the specific influence of an antique sculpture. H. Bodmer (*Correggio und die Malerei der Emilia*, Vienna, Deuticke, 1942, p. xxv) improperly considers the Roman elements in the landscape a justification for dating the picture in the Roman period.

49. The picture is therefore hung too low in the gallery today. This is generally true of most of Parmigianino's devotional pictures, which were mostly intended to be hung over altars. When the lower edge of the picture is at eye level the "introductory" devices in the lower region of the

design are much more immediately apparent. Copertini (I, 120) suggests that the fact that St. Zachary "non participa materialmente alla scena, ma solo con lo spirito" might justify calling the picture a "Visione di San Zaccaria." This idea of a vision may indeed have motivated the singular placing of the saint, and might in part explain it. It is curious to note, however, that the relation of the Zachary to his (possibly) visionary image is the reverse of that of the St. Jerome in the London picture.

50. Both the St. Zachary and his earlier parallel in the Roman "Marriage of St. Catherine" differ significantly in their "illusionism" from the figure who appears in the foreground of the etching of the "Adoration," to which we referred in our discussion of the Roman "Marriage" (p. 70). In the etching there is a logical reason advanced for the difference in level between the foreground and rear figures, as well as a logical relation in scale between them. This qualification applies also to comparable devices used by earlier painters with an illusionistic bent: compare Mantegna's "Crucifixion" predella from the San Zeno altar, or his Louvre "St. Sebastian"; also Ghirlandaio's fresco in the Sassetti chapel. In all the *quattrocento* instances I can recall, as in Parmigianino's "Adoration" etching, there is a reasonable excuse adduced for the placing of the figures and a logical relation in their scale.

51. A kind of caudal appendage is tacked to the compositional progression through the figures. It moves rightward from the Magdalen's head and forward along the curving axis of the landscape, behind the Virgin, over the road and bridge in the right middle distance, and into the head of the Zachary, in which the composition begins. This forward-moving motive through the landscape is one of the factors which help to counteract any normal sense of rearward expansion.

PART II—THE SECOND PERIOD IN PARMA

1. The authorities for the documentary sources are given in the section of our catalogue which treats of the Steccata, Part III, pp. 189-197.

2. Documents in the Archivio Notarile of Parma; see Copertini I, 136, and I, 150, n. 2-6.

3. Reproduced in transcribed form in Copertini I, 194, n. 46. Parmigianino's principal heirs were his three *servitores* (so named in the testament) and his

sister Ginevra. It is likely that at least two of the *servitores* were Francesco's apprentices from the Steccata because persons with similar Christian names appear in the Steccata documents (where only Christian names are mentioned) as such.

4. See p. 61 for Parmigianino's communications with the Steccata from 1529 onward.

5. After the unveiling of the cupola in the

Duomo. See Venturi IX/2, pp. 472-473; Ricci, *Correggio*, p. 116.

6. The bull of convocation was issued May 22, 1542. The stylistic character of this change in Parmigianino's art to a "Counter Reformation" style from a free Mannerism suggests an analogy with the history of sixteenth-century music. Parmigianino's synthesis of a grave and monumental character, and of a deeply religious feeling into the previous framework of his style seems to have a parallel in the "reform" of church music from secular influences, signalized by the austerity of Palestrina's Mass of Marcellus, composed c.1560.

7. This exposition of Francesco's possession by alchemy appears also in the first edition (which dates only a decade after Francesco's death); Vasari's information on this point may have been gathered during a visit to Parma in 1544. See letter of Vasari to Aretino, VIII, 283. The retention of the story in the second edition indicates that it must have been confirmed by Bedoli. Other later sources report Francesco's mania similarly: as Armenini (*De veri precetti della pittura,* Ravenna, 1587), and da Erba ("Compendio dell'origine . . . della città di Parma," MS of 1572 in the Palatine Library, Parma). Dolce (*L'Aretino,* 1557), on the authority of one Battista di Parma (a sculptor described as the *creato* of Parmigianino) denies the imputation of Parmigianino's devotion to alchemy.

8. It is less unexpected still when we recall that, from his experience as an etcher, he already had some small knowledge of "chemical" processes. It should also be observed that the preparation of certain mineral colors was described in the sixteenth century as an "alchemistic" function. Vasari (I, 183): "E toglievano . . . i colori che erano di miniere, i quali son fatti parte dagli alchemisti, e parti trovati nelle cave."

9. C. Jung, *The Integration of the Personality* (New York and Toronto: Farrar and Rinehart, 1939), chapter v: "The Idea of Redemption in Alchemy," p. 210.

10. The alchemistic author Alfidius, quoted Jung, *op. cit.,* p. 217.

11. Michael Majer, quoted Jung, *op. cit.,* p. 219. For further information on the Christian symbolism of alchemistic processes see Rev. J. B. Craven, *Count Michael Maier, Life and Writings* (Kirkwall: Peace, 1910), esp. pp. 15-30; A. E. Waite, *Lives of the Alchemystical Philosophers* (London: Redway, 1888), esp. pp. 10-37; also a recent publication of Jung, *Psychologie und Alchemie* (Zurich: Rescher, 1944).

12. With his *volto più tosto d'angelo che d'uomo* (V, 222).

13. W. Friedlaender, "The Anti-Mannerist Style," p. 83, n. 1, suggests a relationship between the Amor and the angel at the left of Pontormo's Santa Felicità "Deposition," which Parmigianino might possibly have seen on his journey from Rome to Bologna in 1527. The relationship is more than dubious from the visual evidence, as well as from the chronology: Pontormo's picture may not have been painted until 1528.

14. As analyzed by Voss in his review of Fröhlich-Bum's book, in *Deutsche Literaturzeitung,* Vol. XLIII, no. 26 (1922), p. 566.

15. Copertini, I, 138. Such a distinction in sex is probably justified by the difference in coiffure of the two *putti:* the headdress of the "female" seems a variant of that worn by Parmigianino's adult females. It is barely possible that a stricter ideal connection than is indicated by Vasari (or by Copertini) exists between the *putti* and the Cupid. In antique mythology, besides Amor, there existed two other *putto*-deities: Anteros and Lyseros. These three gods divided among themselves the supervision of the various aspects of an affair of the heart. (Panofsky, "Der Gefesselte Eros," *Oud Holland,* L (1923), 193ff.) Cupid inspired the lover, while Anteros inspired an answering passion in the heart of the loved one. Lyseros, the third deity, was the extinguisher of love. It is barely possible that we may identify the two *putti* with the Amor as the struggling Anteros and Lyseros. The myth of Anteros and Lyseros seems to have been known to the Renaissance chiefly through a corrupted text (the Vergil Commentary of Servius), in which the personalities of Anteros and Lyseros are confused, so that Anteros is identified as the inspirer of resistance to love.

16. See Part III, p. 187.

17. There can be no question of arrears in pay. The whole sum was paid, in gold, in advance. See Part III, p. 186.

18. One result of this rhythmic elongation of proportion is, of course, the detail from which the picture derives its current name. It seems certain that the length of the Madonna's neck is the result of an aesthetic proposition entirely, yet there are a number of curious evidences which seem iconographically to justify Parmigianino's distortion of this detail. I doubt, however, that these could have occurred to him.

The Parma catalogue of 1896 contains (p. 313-314, Ricci's note to a copy of the "Collo Lungo")

the following tale: "Ottaviano Gambi scrivendo nel 1660 la biografia del pittore Savonazzi, dice che un giorno parlando con lui e rimproverandolo di aver fatto il collo troppo lungo alla Madonna ed 'oltre al prescritto termine della simmetria' il Savonazzi replicò che 'sarebbe stato errore considerabile il formarlo diversamente, perchè il collo lungo è contrassegno della verginità nelle donne.' " Apparently the association of a long neck with virginity, and therefore with the Virgin, was no new idea to Savonazzi's time. A medieval hymn of unknown authorship (quoted in H. O. Taylor, *The Medieval Mind,* II, 240) speaks of the neck of the Virgin thus: "Collum tuum ut columna, turris et eburnea." Pagan times also echo the association of virginity and the long neck. A poem of Catullus (Argonautica [64] lines 376-377) contains the idea of such a relation. Finally, a modern medical authority offers substantiation thereof, but of course in merely relative terms (Thompson, in the British Medical Journal, January 7, 1922). For the three references immediately above I am indebted to Messrs. Charles Niver and Bernard Peebles.

Dolce (*L'Aretino,* p. 35) has an archaeologically interesting, and very critical comment in connection with the Mannerist habit of elongation of the neck: "Altri si sono messi a fare alle teste (massimamente delle donne) il collo lungo; tra perchè hanno veduto per la maggior parte nelli imagini delle antiche Romane i colli lunghi, e perchè i corti non hanno gratia: ma sono ancora essi passati nel troppo, e la piacevolezza hanno rivolta in disgratia."

19. Like the other elements in the picture this one is ambiguous in its objective function. It may be the drawn-back side of a pavilion in which the Madonna may be sitting. Is it distantly related to the Raphael-Fra Bartolommeo theme of the "Madonna del Baldacchino"?

20. See the summary discussion of the space construction of the "Collo Lungo" in Part I.

21. Note the continuation of the same perspective line from the base of the Madonna's seat into the stylobate of the colonnade behind.

22. Note the area to the lower right of the Madonna's seat.

23. The extended vertical of the single finished column and the horizontals of the steps. The pose of the "prophet" figure is also parallel to the surface. It may be that Parmigianino left the upper parts of the remaining columns unfinished because he was disturbed by the more positive effect of recession which might have resulted if they had been drawn in. It is more likely that he may have been em-barrassed by the effect on the size of the columns of the singular system of perspective applied to this picture. The vanishing point for the base of the colonnade (as for the foreground plane) is just over the left shoulder of the "prophet." If Parmigianino had chosen to conform to this projection in drawing the columns it would have been necessary to make them diminish absurdly quickly in height as they receded.

24. Further, the perspective projection does not continue beyond the architecture into the landscape. What exists of the landscape is thus seen from a second, quite arbitrarily taken, point of view.

25. With the picture hung high up, as an altar, this detail would be near the level of the eye. See p. 142, note 49.

26. One of whom seems to be identical with the subject of the so-called Antea portrait. There is no way of identifying either her or the others (all of which may be portrait heads) beyond the vague and unprovable suggestion that they may possibly be children of the patron's family. See our discussion of "Antea's" identity in Part III.

27. Venturi (IX/2, p. 670) thus expresses in his liquid prose the character of the Virgin's expression: "l'agghindata dama carezza con lo sguardo il bambino come un oggetto raro che ella abbia distesa tra sue ginocchia per ammirarne il contorno elegante."

28. The traditional explanation for the iconography (which only doubtfully corresponds with Parmigianino's intention) regards the reading figure in the "antique" background as a prophet (or as Vergil) who foretells the Redeemer pictured in front. It was Parmigianino's original intention to insert a second figure behind the "prophet" (see the pentimento of the foot of this figure) to whom he would be reading his scroll. This second figure, in monastic dress, appears in certain of the preparatory drawings, *q.v.* Neither figure can be positively identified, though the monk in the drawings carries as an attribute, somewhat uninformatively, a cross.

29. See Part III, pp. 189 ff., a detailed analysis of the documents pertaining to the dating of the Steccata.

30. Venturi (IX/2, p. 663) compares the preparatory drawings for these figures to Tanagra figurines.

31. And in the right-hand Maiden the relation between garment and body.

32. Ill. Rosenberg, *Raffael,* p. 113. The attitude of the Maiden on the left also recalls, but probably fortuitously, the Eve in the "Temptation" in

Raphael's Loggie (ill. *ibid.*, p. 169). A further comparison may be made with the Caryatid figures on the "Allocutio" wall, by Giulio Romano, of the Sala di Costantino.

33. Compare, for example, Raphael's decoration of the Farnesina.

34. Note how the effects of balance and of deliberateness in rhythm in the fresco are aided by the obvious equal disposition of masses around a central axis, by the measure of monumental identity allowed each of the separate figures, and by the introduction of caesuras (the lamps) in the horizontal path.

35. Ill. Gronau, *Correggio*, p. 102 ff., and Venturi IX/2, pp. 566-567.

36. Ill. Gronau, *Correggio*, pp. 80-82.

37. Gamba, in *Emporium* (Sept., 1940; p. 114), improbably suggests Raphael's "Vision of Ezekiel" (then in Bologna) as Parmigianino's source for the pose of the Moses.

38. Pevsner, *Barockmalerei*, p. 65, remarks that the loose handling of the figures on the arch faces may be considered an antecedent of the Tintorettesque mode of brushwork.

39. Adapted, says Copertini (I, 182) from the rosettes on the main doors of the Duomo, which he illustrates (I, *tav*. Xa).

40. Compare the numerous similar patterns illustrated in Berliner, *Ornamental Vorlage-Blätter*, vol. I.

41. Preparatory drawings for two different schemes for the "Coronation of the Virgin" are preserved: see Part III, p. 196 and note 172.

42. The tradition for calling them such is at least as old as Vasari. See Part III, note 171.

43. Ill. Rosenberg, *Raffael*, pp. 76 and 206.

44. Ill. L. Duessler, *Sebastiano del Piombo* (Basel: Holbein-Verlag, 1942), fig. 52. This painting originally belonged to the Farnese Collections in Rome.

45. Among them are: the horizontal balustrade, the intersection of the upper part of the triangle by the oval of the clouds, the suggestion of an inverted triangle which locks into the upright triangle of the design.

46. This is the actual central point on the horizontal axis, and almost equally exactly central point in the vertical direction, if one discounts the step of the platform.

47. The rigidity of effect is accentuated by the manner in which the accessory motives of design mentioned in note 45 serve to "lock" the parts of the composition together.

48. As occurs with the secondary role of rhythm in the generally stable totality of a High Renaissance composition; compare again the "Sistine Madonna."

49. A similar, but lesser effect of tension is created by the manner of handling color in the Dresden altar: in particular by the borrowing of reflected color from a large adjoining field and using it as an overcast on the local tone. See the color in the garments of the two saints. H. Maenz, in *Die Farbegebung der italienischen Malerei des Protobarock und Manierismus* (Berlin: P. Brandel, 1934), p. 113, further notes the contrast between the quiet of the large symmetrically disposed forms and the "mysterious, uncontrollable activity" of color and the "restless metamorphoses of tone."

50. It is not certain, but highly probable, that Parmigianino knew the "Sistine Madonna," in his time in Piacenza. The relation between the two works is not sufficient to justify a suggestion of a derivation by Parmigianino from the Raphael.

PART II—PORTRAITS

1. Amadore Porcella, in *Manifestazioni Parmensi nel IV Centenario della Morte del Correggio* (Parma: Bodoni, 1936), p. 134, suggests two new tentative attributions to Correggio; both are portraits which he identifies as members of the Sanvitale family of Fontanellato, where Parmigianino had two commissions in 1523-1524.

2. This problematical influence may have been reinforced by an even more problematical personal contact between the two artists. It is presumed, but not universally credited, that Titian visited Bologna in 1530, at the time of Charles V's coronation. Another possible, but highly uncertain opportunity for contact is indicated by a letter from Alfonso d'Avalos, written November 2, 1532 to Aretino, asking him to induce Titian to come to Correggio, where the Marquis then was (*Manifestazioni Parmensi*, p. 107). According to Marco Boschini's *Carta del Navegar Pittoresco* (published 1660) Titian was in Parma during the later twenties; but at this time Parmigianino was in Bologna. We have no knowledge of any visit by Parmigianino either to Venice, Ferrara, or Mantua, where he would have been able to see excellent examples of Titian's work.

3. The inventory of the Palazzo del Giardino in Parma, c.1680. For the full entry see Part III, p. 199.

4. Leonardo had investigated the scientific problem of images in a mirror, but never applied it artistically. See O. Werner, *Zur Physik Leonardo da Vincis* (Erlangen, 1910). Reflected images had previously appeared only in mirrors shown *within* the picture; as in Van Eyck's double portrait in London, in Christus' "St. Eloi," in one of Giorgione's destroyed figures (a "San Giorgio tra specchi") on the Fondaco dei Tedeschi.

5. For a brief discussion of the historical place of the Parmigianino self-portrait see O. Goetz, "Holbeins Bildnis des Simon George of Quocoute," *Städel Jahrbuch*, VII-VIII (1932), 147.

6. V, 221-222. See Part III, p. 201, for the full quotation.

7. This is the first example of the sixteenth-century employment of perspective distortion in portraits for novelty of effect; compare the famous "Edward VI" of the National Portrait Gallery. Perspective for the sixteenth-century artist was no longer merely an agency for scientifically correct vision, but also a toy to play with.

8. While Vasari admits the bizarreness of this painting, he does not condemn Parmigianino for it, as he so strongly condemns Pontormo for his *bizzarrie*. The reason may lie in Vasari's recognition of what we have exposed above: that Parmigianino retains his ideal sense of beauty in spite of the bizarreness, while Pontormo's bizarreness is permitted to destroy the "beauty" of the represented forms. This latter is therefore foreign to Italian taste, in fact "Germanic," as Vasari calls it.

9. Both must have been executed within a very narrow interval of time.

10. See p. 133, note 25.

11. What he wishes to communicate may concern at least in part the medal he holds, but its meaning has never been deciphered. See Part III, note 190.

12. For a discussion of the identity of the sitter, see Part III, p. 204-205.

13. As with the Vienna self-portrait, the Uffizi portrait suggests a community with the portrait style of Venice. Francesco had already had some experience of that style, though apparently for the most part at second-hand, through the paintings of Sebastiano in Rome. Francesco's return to Emilia would have brought him at least geographically nearer to the Venetian milieu; it is conceivable, though not necessary, that the simplicity of his mature portrait style, as embodied in the Uffizi

gentleman, may have been in part influenced by contact with Titianesque examples. However, there is no available record of the existence in Bologna of a portrait by any major Venetian at this time.

14. This effect was somewhat exaggerated by a piece which had been added to the top of the panel, and which is shown in most older reproductions; see Part III, note 201.

15. Possibly intended to represent a sculptured relief in a niche rather than a painting. The subject matter represents an antique sacrifice: a kneeling woman presents an urn to a bearded figure standing at an altar.

16. Except perhaps for Leonardo's "Mona Lisa," and, to a lesser extent, Titian's "Man with a Glove."

17. A highly interesting contrast with the High Renaissance solution of a closely similar problem may be made with Raphael's "Castiglione."

18. It is probable that he did not even take a sketch. See the account by Vasari, Part III, p. 207.

19. Contrast Titian's representations of this monarch, based on proper sittings. The portrait of Charles standing with his dog (Prado), is sometimes (doubtfully) considered to have been executed during the Imperial stay in Bologna.

20. Titian's "Alfonso d'Avalos" (Louvre), for example, is apparently later (c.1533). For an excellent brief discussion of the allegorical portrait in the fifteenth and sixteenth centuries, especially in Northern Europe, see H. W. Janson, "A Mythological Portrait of the Emperor Charles V," *Worcester Art Museum Annual*, I (1935-1936), 19-31.

21. The pilaster would seem to have been inserted after the completion of the figure of the sitter. Note how the extreme left edge of the hat is cut off by the edge of the architectural feature.

22. The book Castaldi holds in his left hand inclines outward toward the edge of the picture surface, and thus plays the part of the usual connective into the design.

23. From the salver which the figure carries.

24. See how she resembles Parmigianino's purely ideal projections of women in a more than probable measure in the elongation of her head and the falsification of its proportions; in the shape of her long, straight nose, the location of her ear, the drawing of her eyes; the character of her hands, the slope of her shoulders.

25. The three-quarter standing posture has occurred once before in Parmigianino's portraits, in the "Cybo" of the Roman period, but neither the figure, pose, nor design of the "Cybo" reflect the vertical emphasis of the Rossi portrait.

26. This path starts in the left leg, runs through the codpiece and the right arm to the head, then descends the left side of the body into the hand on the sword.

27. The details of the landscape are brushed in quite as they are in the Uffizi "Madonna" of *c.*1530 and in the later Naples "Holy Family." The architectural elements recall the archaeological overtone of the former picture.

28. There may be an external reason for the absence of visual contact with the spectator in the fact that the direction of the Count's gaze is, though only generally, toward his wife in the pendant portrait.

29. See Part III, pp. 186 ff.

30. "Il Cinquecento Italiano non conosce contorno più sintetico e preciso di quello che circoscrive l'ovoide purissimo del volto . . ." (Venturi IX/2, p. 674).

31. Antea would stand at least seven heads high if her portrait were full length.

32. In its original state the "San Secondo" would probably also present an effect of clear plasticity more like that of the "Antea" than it now does. See the evidence offered by the Vivian-Neal copy (fig. 142), which has been cleaned; in it the background brocade is quite light in tone, and the figure stands out in bold relief against it.

33. A presumably deliberate choice. Note that canvas recurs as the support in the next (and last) portrait, that of Vincenti.

POSTSCRIPT

1. Compare Fröhlich-Bum, Part II, which is devoted entirely to an exposition of Parmigianino's influence: an exposition which assigns to Parmigianino a role greater than he deserves. Copertini II, 90-126, gives a valuable summary of Parmigianino's influence especially within the Italian local schools.

Catalogue Raisonné

A

CHRONOLOGICAL CATALOGUE OF THE AUTHENTIC WORKS

The authentic works have been arranged in the catalogue according to what I believe to be, as nearly as it can be determined, the chronological order of their production. Each entry is discussed in a scheme which is generally as follows:

Title of the work, and place. Date. Category of attribution (see below).

Medium, support, dimension (height, then width, in meters).

Necessary remarks on the condition of the painting.

History of the work; its documentation; critical opinion on its authorship or dating where these may be in dispute.

Analysis and comparison of the morphology and technique, and of such elements of style of the work as are necessary to establish its authorship and date.

List of preparatory studies; material reflecting lost preparatory studies.

List of copies.

Of the above headings only the one which refers to "category of attribution" requires special explanation. In this place is inserted a Roman numeral (I, II, or III) which symbolizes the character of the external evidence available for judging the authenticity of the work. The nu-meral I indicates that the external evidence is totally certain and that the picture has an uninterrupted documentation from a source at least within the sixteenth century. Works in this category are without exception so patently authentic in style, as well as from external evidence, that their inclusion in the catalogue of authentic pictures only exceptionally requires a supporting explanation.

The numeral II indicates that the external evidence available for attribution of the painting is either incomplete or in some way untrustworthy; the numeral III means that no external evidence of any reputable kind can be found. In the case of the first of these latter categories it is assumed that a certain amount of careful comparison with the works of category I is required; in the case of category III, such comparison (either directly with works of category I or with already established works of category II) must be even more carefully and fully made. The reader may therefore often find that the amount of discussion devoted to an attribution is in inverse proportion to the quality or interest of the picture; this may be in a sense regrettable, but it is necessary to the critical soundness of the catalogue.

Bibliographical abbreviations are listed on p. 130.

THE AUTHENTIC RELIGIOUS AND MYTHOLOGICAL PAINTINGS

BAPTISM OF CHRIST (Berlin, Kaiser Friedrich Museum), *c.*1519. I. Tempera (?) on panel, 1.93 x 1.27 m. Fig. 1.

Parmigianino's earliest surviving painting has had a very complicated history. It was lost to sight during the later years of the nineteenth century and the first two decades of our own, and first reappeared in the critical literature only in 1922, when Voss[1] mentioned it as existing in

[1] In a review of Fröhlich-Bum's book, " 'Verschollene' Werk des Parmigianino," in *Kunstchronik und Kunstmarkt*, N. F. 34/2 (1923), pp. 635 ff.

the Protestant Church of Rederitz in East Prussia, where it had been loaned—and practically forgotten—by its owners, the Kaiser Friedrich Museum. After ten years of wrangling subsequent to Voss's rediscovery, the church authorities finally consented to return the painting to Berlin.[2] Immediately thereafter, Copertini published a photograph with a brief notice as an insertion in his book (*tav.* XII bis), and Voss followed with a full publication of the work.[3]

The history of the picture, unraveled from numerous and often conflicting sources, would seem to be as follows. The painting was first mentioned by Vasari (V, 219): "essendo all'età di sedici anni pervenuto, dopo aver fatto miracoli nel disegno, fece in una tavola di suo capriccio un San Giovanni che battezza Cristo; il quale condusse di maniera, che ancora chi la vede resta maravigliato che da un putto fusse condotta si bene una simil cosa. Fu posta questa tavola in Parma alla Nunziata, dove stanno i frati de' Zoccoli." Affò (p. 19) informs us that the commission came from the family Garbazza. When the Church of the Annunziata was destroyed in 1546, Parmigianino's work was set up in a new church of the same name at Capo di Ponte.[4] The chapel in which the picture was kept passed into the hands of the Counts of Coenzo, and then to the family of the Counts of Montechiarugolo. These latter had a Latin verse inscribed in the chapel (which at Affò's time was still in place) praising this achievement in a child of fourteen (*sic*). The inscription, as reported by Affò, read:

> Annum fluentum tunc tener Masoleus
> Bis numerabat septimum
> Has dum lepores inserens coloribus
> Imagines effingeret.
> Miraris hospes munus artis integrae
> Aequasse mollem dexteram?
> Manum forebat qui optimum Baptismati
> Semen salutis credidit.

[2] Where it was still at the last information, early 1947.
[3] "Ein wiedergefundenes Gemälde von Parmigianino: Taufe Christi," *Jahrbuch der Preussischen Kunstsammlungen*, vol. LIV, heft 1 (1933), pp. 33-37.
[4] C. Ricci, *La Reale Galleria di Parma* (Parma: Battei, 1896), p. 133.

On the fifteenth of November, 1706, the "Baptism" was sold by the Montechiarugolo to Count Carlo Sanvitale (together with a painting by Cima, for 4200 lire).[5]

While in the Sanvitale Collection the picture was seen by Affò and carefully described (p. 18): "Le due figure di Gesù Cristo, e di San Gioanni veggonsi svelte, ben disegnate, ottimamente colorite, e piene di affetto. L'aria specialmente del volto di Cristo è amabilissima, e la modesta attitudine sua rapisce chi la rimira. Sono ambidue nell'acqua limpidissima e trasparente sino a mezza gamba; e il Precursore sta in atto di piegarsi per coglier l'onda con un vasetto di porcellana. Di alto scende lo Spirito Santo in forma di colomba, e guatanno in giù tre graziosi Angioletti. Vedesi in lontananza un paesino, e due figurine rappresentanti il Salvatore, e S. Gioanni nell' atto di venire al Giordano: il qual difetto di far vedere in più luoghi dello stesso Quadro le figure medesime in azioni diverse, fu comune in quella età anche a' Pittori, che avrebbero dovuto dimostrar senno migliore; laonde non è maraviglia che vi cadesse un putto di quattordici anni."

This description leaves no doubt as to the identity of the present work with the picture seen by Affò. When, however, in 1834 the pictures of the Sanvitale Collection passed into the Parma Gallery the "Baptism" was not among them.[6] Count Luigi Sanvitale, in his book on the paintings at Fontanellato, informs us that Parmigianino's "Baptism" had been sold to an English collection.[7]

Count Sanvitale's report of the sale of the picture to England was correct, for it was acquired by the Berlin Museum in 1821 from the English collector Solly. The "Baptism" was published in Waagen's catalogue of 1830 with the descriptions of Vasari and of Affò, and the indi-

[5] *Ibid.*
[6] A painting of the same subject by an anonymous sixteenth-century Parmesan was for some years wrongly identified as Parmigianino's early "Baptism," but the identification was completely disproved by Ricci, *ibid.*, p. 133, no. 66.
[7] *Memorie intorno alla Rocca di Fontanellato ed alle pitture che vi fece Francesco Mazzola detto il Parmigianino* (Parma: Grazioli, 1857).

cation of an eventual provenance in Parma. In 1884 the painting was loaned to the Church at Rederitz, where it was for a time lost to critical notice.

The picture we know today thus has a continuous history, and is traceable in documentary and critical literature as Parmigianino's earliest work back as far as Vasari's edition of 1568. By the circumstantial evidence of its presence in the Church of the Annunziata (in which, according to Vasari and others, it was originally set up) its historical pedigree extends back beyond 1546 (the date of the destruction of the old church and the transfer of its contents into the newer one of the same name).

One minor circumstance only, on the documentary side, remains unclear. This is the successive notation of the age of the author of the painting as sixteen (Vasari) and later as fourteen (Affò). Reasonable caution alone would incline us to accept Vasari's later limit.

The morphological system of the "Baptism" is anomalous in Parmigianino's *oeuvre*. However, close correspondences of detail can be found in some number in his next earliest surviving painting, though not in later, more developed works. Summarily presented, the morphological correspondences with the Bardi altar are as follows:

The *putti* of the "Baptism" considerably resemble the Christ child of the Bardi picture. The correspondence here is mostly due to the (otherwise exceptional) infiltration of Correggiesque influence into the *putti* of the "Baptism." The John Baptist type shows a fundamental similarity in both pictures, though in the Bardi work he has become more svelte and rather more doll-like than his earlier counterpart. The general shape of the face and features of the Virgin in the Bardi picture are not unlike those of the Christ in the "Baptism," as are her contained and inward smile and her downcast eyes.

In the handling of anatomy there is a marked similarity in the hands and feet of the Christ in the "Baptism" and the St. John Evangelist of the Bardi painting. The reason for the similarity here is the reverse of that which accounted for the likeness of the child figures in the two paintings. While the *putti* in the "Baptism" are

an anticipation of the Correggiesque vocabulary of the Bardi work, the hands and feet of the Bardi John Evangelist are still executed in the angular, primitive way of like details in the "Baptism," and have not been transformed into the calligraphic rendering evident in details of the other figures in the painting.

The manner of handling of the areas of nude flesh of the John Baptist figures in both pictures is very similar. The skin is dark toned and covered with soft hair. The peculiar way of indicating the demarcations between the muscles of the legs appears in both figures, though it is less pronounced in the Bardi St. John than in the "Baptism": the muscles are not indicated so much by modeling as by a quite abstract linear demarcation; this is particularly evident around the knees.

One cannot push the catalogue of likeness beyond this point, for the penetration of a new vocabulary of detail in the Bardi altar prevents further close comparisons. However, the likenesses are enough to show that there is no discord between the apparently incontestable external evidence for Parmigianino's authorship of the "Baptism" and the visual evidence supplied by the picture itself.[8]

[8] A. O. Quintavalle ("Falsi e veri del Parmigianino giovane," *Le Arti*, Anno V. *fasc.* 6, 1943, pp. 237-240) admits, in connection with the Berlin "Baptism," "Una tradizione . . . ed una identificazione di carattere storico . . .", but insists that these have been attached to the wrong picture. Quintavalle asserts that the Berlin picture does not accord in style with the other early works of Parmigianino (as we have, in general, also indicated); however, Quintavalle has not at all considered such positive evidence for Parmigianino's authorship as we have been able to adduce above. Quintavalle would assign the Berlin "Baptism" to a Flemish Romanist. In Quintavalle's own opinion, his most forceful argument against the authenticity of the "Baptism" is the presence in it of an elongation which exceeds that of later works of the first Parma period. Quintavalle apparently (mistakenly) considers that such elongation of form is a characteristic only of a developed, or at least developing, Mannerist style. It is in fact, in the case of the Berlin "Baptism," quite as much a survival, or revival, of a Gothic habit. We have indicated the precedent in Francia's almost contemporary "Pieta" for a nearly equal elongation to that found in the "Baptism"; dozens of other late *quat-*

CATALOGUE

MARRIAGE OF ST. CATHERINE, WITH SS. JOHN EVANGELIST AND JOHN BAPTIST (Canonica di Bardi near Parma, Chiesa Arcipretale di Santa Maria), 1521. III. Tempera on panel, 2.03 x 1.30 m. Fig. 5.

At the time of its recent rediscovery the painting was somewhat damaged by flaking of paint, mainly in the lower draperies of St. Catherine and the Madonna.

The first notice which may be definitely attached to this picture dates only from 1860. In that year, it was the object of a report by the Accademia Parmense di Belle Arti,[9] to which the painting had been submitted for consideration. According to this report, the ". . . professori presenti . . . non hanno incertezza nel giudicarlo unanimi opera del Parmigianino, benche giovanile e certamente non delle più insigni . . ."; it was recommended that the picture be purchased for the Parma Gallery. This recommendation was not followed. The picture remained in the Canonica di Bardi and, after its brief notice by the Academy, was again forgotten for seventy years.

The existence of the Bardi panel was recalled only in 1934, when it was recorded in the *Inventario degli oggetti d'arte d'Italia*[10] as "opera di ignoto del secolo XVI . . . Databile intorno

agli ultimi anni del primo ventennio del Cinquecento." Copertini recognized this picture as an early work of Parmigianino, and so published it in 1935.[11] The panel was repaired in that year, and brought to Parma for exhibition in the Mostra del Correggio.[12] A. O. Quintavalle[13] accepted Copertini's attribution, and further recalled the (previously forgotten) attribution of the picture to Parmigianino by the Parma Academy. Berenson (*Lists*, Italian ed., 1936) also has accepted the Bardi "Marriage of St. Catherine" for Parmigianino.

In spite of the penetration of a Correggiesque vocabulary into the Bardi "Marriage" and the simultaneous development of Francesco's own vocabulary of detail, there are (as we demonstrated in our discussion of the "Baptism," above) enough morphological correspondences between the two pictures to establish their common authorship. However, we have not yet secured Parmigianino's authorship of the Bardi altar; we must now do this by indicating the coincidences between it and subsequent paintings in which Francesco's hand is unquestioned.

In the Bardi altar we are no longer confronted with the paucity of comparative material presented by the "Baptism." The evolution of Parmigianino's individual vocabulary has here progressed to the point where the peculiarly Parmigianinesque character of details is amply evident, and we need only summarily indicate them. In the "Marriage of St. Catherine" Francesco has made his first statement (surviving to us) of the very individual female type whose basic facial construction and expression are to serve him, with only surface modifications and refinements, throughout his career. The St. Catherine differs from the later female type of Parmigianino only in that she is younger and less self-consciously

trocento, as well as early *cinquecento*, examples (especially in North Italy) might be adduced. Quintavalle also, in using this argument, neglects the evidence of the conspicuous elongation of form that appears in the Bardi altar, which he, like ourselves, places in the Viadana period, admitting it, with its elongation, as antecedent to the more ample figures of Parmigianino's subsequent, Correggiesque (High Renaissance and proto-Baroque) phase. Quintavalle's entire conception of Parmigianino's beginnings, as he indicates it in the article cited, is badly distorted as a consequence of his erroneous rejection of the "Baptism." See discussion below in catalogue of attributed paintings, under Parma, San Giovanni Evangelista, fourth and sixth chapels on the left, of the material which he attempts to substitute as productions of Parmigianino's earliest phase.

[9] August 3, 1860, preserved in the records of that society, I, 222; transcribed by A. O. Quintavalle, "Falsi e veri del Parmigianino giovane," *op. cit.,* p. 238, n. 10.

[10] III, *Prov. di Parma* (Rome: Libreria dello Stato, 1934), p. 170.

[11] "Un opera sconosciuta del Parmigianino: Lo Sposalizio di S. Caterina in Bardi," *Aurea Parma, Anno* XIX, *fasc.* 2 (1935), pp. 58-59. The article contains a photograph taken before restoration.

[12] *Mostra del Correggio, Catalogo* (Parma: Fresching, 1935), ill. p. 84.

[13] "Falsi e veri del Parmigianino giovane," pp. 238-239, and in his review of the Mostra del Correggio (*Emporium*, vol. LXXXI, 1935, p. 358).

exquisite.[14] The Madonna, who in her features conforms a little less to the later types, is particularly like them in her affectation of their veiled downward glance. The type of the St. John Baptist persists throughout the first Parma period and even somewhat later. A substantially similar anatomical and facial construction is given to the Acteon at Fontanellato and to the Joseph of the early Roman Doria "Holy Family." Similarly, the infant Christ, who recalls the Correggiesque *putti* of the "Baptism," reappears in only slightly altered form throughout the first Parma period (compare the San Giovanni arch faces, Fontanellato, the Cook Collection "Holy Family"). As we have observed, only the St. John Evangelist seems to preserve something of the primitive morphology of the "Baptism" in the rather brittle articulation of his fingers, and in the careful, literal modeling of his feet.

The drapery passages are not yet consistently expressed in a single formula. As in the subsequent works of the first Parma period they reveal the parallel use of two formulas. The first of these appears in the garment of the St. Catherine, where the drapery is described by heavy folds arranged in a rhythmic, upward-moving pattern; this formula is related to Correggio in its interest in texture. The second formula appears in the passages of drapery over the left leg of the Virgin, and across John's breast. Here the folds are compressed into an involved, zigzag linear pattern. This occurs repeatedly through the first Parma period, as at Fontanellato, in the San Giovanni Evangelista frescoes, etc.

More markedly than in other details, the hands and feet in the Bardi picture have undergone a calligraphic transformation that causes them especially to suggest similarities with subsequent works. Particular coincidences are afforded by juxtaposition with the Doria "Nativity" of *c.* 1524-1525, where the outstretched hand of the Madonna closely resembles the left hand of John Baptist here. Also, compare the drawing of John Baptist's feet with those of the Joseph in the Doria picture.

Since the Bardi altar is evidently of more developed character than the "Baptism" of *c.*1519, but is the only surviving painting which retains certain morphological characteristics in common with it, we can safely assume that it is broadly datable between 1519 and 1522. There is a record in Vasari of a painting by Parmigianino of the "Marriage of St. Catherine" done during his sojourn in Viadana (second half of 1521):[15] "dipinse Francesco due tavole a tempera: (una . . .) e l'altra, nella quale è uno Sposalizio di Santa Caterina con molte figure, fu posta in San Piero. Nè creda niuno che queste siano opere da principiante e giovane, ma da maestro e vecchio" (V, 220).

Not only the morphology, but also the formal organization of this painting (see text, p. 42) require a date in, or very close to, the Viadana period. We may therefore tentatively identify this painting with the "Marriage of St. Catherine" recorded by Vasari.[16]

According to Campori,[17] the Viadana "Marriage" was "Trafugato e venduto a Parma al tempo dell'assedio di Mantova del 1629." Between that date and 1860, when the presence of our presumed Viadana picture in the Canonica di Bardi was first noticed, there is no record of its history.

Until Copertini's publication of this work a painting of the same subject, No. 192 in the Parma Gallery,[18] had been identified as the Viadana "Marriage of St. Catherine." On a purely stylistic basis, as well as on the evidence afforded by Vasari's text, this identification is entirely less plausible than the one we suggest above.

Copy: Milan, Collection Bonomi.[19]

[14] Note particularly the appearance in the St. Catherine of his characteristic early formula for the drawing of the ear: it is conceived with a rather thick, curved stroke of the brush, and is set on too far forward.

[15] See p. 35, above.
[16] A. O. Quintavalle ("Falsi e veri del Parmigianino giovane," p. 238) agrees with this identification of the Bardi "Marriage."
[17] *Lettere Artistiche Inedite* (Modena, 1866), pp. 101-102.
[18] Which I regard as a copy; see below, p. 160.
[19] The photograph of this copy, as well as photographs of several other copies of works by Parmigianino, was very kindly shown to me by Dr. W. Suida from his files. According to A. O. Quinta-

MADONNA AND CHILD, WITH ST. JEROME AND THE BEATO BERNARDINO DA FELTRE (Parma, Galleria, no. 76). Copy of the lost original of 1522. Oil on canvas, 1.85 x 1.27 m. Fig. 6.

Vasari informs us (V, 221): "Finita la guerra, e tornato Francesco col cugino a Parma, primamente finì alcuni quadri che alla sua partità aveva lasciati imperfetti, che sono appresso varie persone; e dopo fece in una tavola a olio la Nostra Donna col Figliuolo in collo, San Ieronimo da un lato, e il beato Bernardino da Feltro nell'altro; e nella testa d'uno dei detti ritrasse il padrone della tavola tanto bene, che non gli manca se non lo spirito . . ." The program of work here described would (according to Vasari's indication) have been accomplished early in 1522.[20]

The original of the only painting identifiable from this passage, the "Madonna with St. Jerome and the Beato Bernardino da Feltre," has disappeared, but we have evidence with which to reconstruct it in considerable measure.

This evidence consists of a copy in oil, no. 76 in the Parma Gallery, and a print which is with fair certainty after the lost original. This print, by Bonasone (Bartsch XV, p. 125, no. 57; Fig. 7), was executed during the second quarter of the sixteenth century; it carries the legend *F. Parmisanino Inventore*. The print is not only earlier in date than the painted copy evidently is, but also accords far more closely with what we know (from other surviving early works) must have been the style of the original. The print further includes one important detail that the

painted copy does not: the head of an old man, presumably St. Joseph, which appears above the head of the Beato on the left. The painting and print also differ in format and relative scale of the figures; in both respects the print is aesthetically more satisfactory (although not for that reason necessarily the more faithful).

For the best part of the nineteenth century the painted copy was accepted as Francesco's original. The responsibility for the error lay with Affò who in 1784 identified it as such in his book (p. 24). Affò's identification was made despite Vasari's statement, twice repeated in his text, that the picture was on panel, and (more important) despite the evident grossness, inferiority, and later date of the painting.

In Affò's time the copy was in the Convent of the Annunziata; his text (p. 26) indicates that it had been there for some thirty years previous, but not necessarily before that. By 1828 at the latest the copy was in the Parma Gallery, and was there being exhibited as Parmigianino's original.[21] Ricci, in his catalogue of the Parma Gallery,[22] destroyed the legend which had been created by Affò with the judgment that "la tela della Galleria appare lavoro d'artifice tardo e grossolano . . . Potrebbe tutto al più concedere che fosse una copia."[23]

[21] As indicated by the legend on the print by Dalcò; see note 23. In 1880 Milanesi (V, 221, n. 2) still indicated Parma 76 as Parmigianino's original, but his opinion was apparently based only on the legend on Dalcò's print.

[22] (1896), pp. 139-140.

[23] Ratti, in *Notizie Storiche sincere intorno la vita e le opere del celebre pittore Antonio Allegri da Correggio* (1781), p. 136, had, earlier than Affò, attempted to identify as Parmigianino's lost original a painting of the same subject which still exists in the Church of San Bartolommeo in Parma. This picture has since been universally rejected as a work by Parmigianino, and is usually considered to be by Rondani. Two further prints of the subject exist, but neither can be used as evidence for the reconstruction of the original. One is by A. Dalcò, published in L. Ronchini, *Fiore della Ducale Galleria Parmense* (Parma, 1826); it is derived from the copy in oils here discussed, then in the Parma Gallery. The second print, by Fr. Rosaspina, is after a drawing by Francesco del Vieira. It was published in *Le più insigni pitture parmensi indicate agli amatori delle Belle Arti* (Parma: Bodoni, 1819).

valle ("Falsi e veri del Parmigianino giovane," p. 238, n. 10) the Bonomi picture is assigned to Greco. Quintavalle notes also that he has seen a nearly identical composition in the magazine of the Naples Museum.

[20] Vasari's text continues: ". . . e tutte quest' opere condusse innanzi che fusse di età d'anni dicianove." This appears to be a contradiction of the statement that these works were executed *after* the conclusion of the "wars" and Francesco's subsequent return to Parma, for by mid-January 1522 Francesco would already have reached his nineteenth birthday. The contradiction is resolved when we recall that Vasari placed Parmigianino's birth date in 1504. For the dating of the "war," see p. 133, n. 3.

FRESCOES (Parma, Church of San Giovanni Evangelista), 1522. II. Figs. 8-12.

First chapel on the left:
right wall—"SS. Lucy and Apollonia [?]" (A)[24]
left wall—"Execution of St. Agatha" (B)
inner arch faces—*putti* with garlands
Second chapel on the left:
left wall—"Two Deacon Saints" (C)

This latter print has the square format of the painted copy, but includes several details, especially the head of St. Joseph, which also appear in the Bonasone engraving. The drawing of the Rosaspina print is looser and somewhat more Correggiesque in feeling than the Bonasone, and the types handsomer and in a way more convincingly like Parmigianino. The publication in which the Rosaspina print appeared contained information to the effect that the original painting was on panel, and that it once was (*esisteva*) in the Convent of the Nunziata. The appearance of the Rosaspina print, and the information which accompanies it tend to convince the critic (as in Copertini's case, I, 34) that it, or rather, the del Vieira drawing which it reproduces, was made after the original painting. I consider that the Rosaspina print is instead a clever compilation from the painted copy and from the Bonasone engraving, and that the information which appeared with it was compiled from critical sources such as Vasari and Affò. My reason therefor is that del Vieira, the author of the drawing used by Rosaspina, was in Parma only between 1791 and 1794 (see article on del Vieira in Thieme-Becker); the diligent Affò, a native Parmesan (writing in 1784), did not know the authentic original but only the picture which had been for a generation (or more) in the Convent of the Nunziata and which we know now to be a copy. It is doubtful that the true original could have been discovered between Affò's time and the early years of the nineteenth century; if it had been it is not likely that the bad copy would have entered the Parma Gallery in its stead. It is not impossible, but hardly probable, that del Vieira should somehow have known Francesco's lost original.

[24] For the iconographic identifications, see the evidence adduced by Copertini (I, 39 and I, 53, n. 16). In subsequent references to the San Giovanni paintings the letters (A, B, C, and D) which here follow the titles may be used in place of those titles. A summary note on the last restoration of these frescoes, undertaken in 1930, appears in A. Sorrentino, "Parma: Restauro di affreschi e di quadri," *Bollettino d'Arte,* vol. XXV, ser. 3 (1931), pp. 182-183. They proved, after cleaning, to be in fair condition.

right wall—"St. Isidore Martyr [or St. Secundus?]" (D)
inner arch faces—vases, trophies, etc.
ceiling—*putti*

Vasari's contribution to the critical history of Francesco's work in San Giovanni Evangelista is a confusing rather than a helpful one: he stated (V, 220)[25] that Francesco was the author of seven chapels in this church. Later critical history has been unanimous in its refusal of Vasari's report. Affò (p. 27) indicated that the chapels of Parmigianino's authorship are *realmente le due prime*. With this limitation subsequent critics, including myself, have been generally in agreement. There have been certain attempts, in my opinion unconvincing, to assign additional chapels to Parmigianino. In 1739 Clemente Ruta[26] very tentatively attributed the third chapel on the left to Francesco; Copertini has assigned him the sixth chapel, and Quintavalle the fourth chapel on the left.[27]

There is no completely trustworthy external evidence for the dating of the San Giovanni frescoes. No documents exist which certainly refer to them.[28] In the early critical literature,

[25] There is no mention of the San Giovanni frescoes in the first edition of Vasari.

[26] *Guida ed esatta notizie a' forestieri delle più eccellenti pitture che sono in molte chiese della città di Parma* (Parma, 1739).

[27] Copertini's and Quintavalle's attributions are discussed in the catalogue of attributed works, below, pp. 223-224.

[28] It is somewhat curious that neither Copertini nor other Parmesan archivists have found Parmigianino's name in the "Libro dei Debitori e Creditori" of San Giovanni, which covers the years 1519-1525, or in the other surviving records of the church. Copertini (I, 54, n. 18) suggests that the reason therefor is that Parmigianino was still a minor at the time of his work in San Giovanni, and that he would thus not have been able to act in his own behalf, but would have been represented by his uncles. Copertini adduces two documents, dating from 1519 and 1522 respectively, which contain the names of Francesco's uncles and suggests that they may refer to work done by Parmigianino under his uncles' guardianship. The pertinence of these documents is more than dubious; further, neither makes any mention whatever of Francesco, which would be exceptional even if he were a minor. It should be observed that Francesco's

Vasari inserted his tale of the "seven" chapels done by Francesco for San Giovanni immediately before his mention of the war of 1521 which drove Francesco from Parma. From this we might conclude that they antedate Viadana. Such a conclusion, however, is untenable. If we admit the presumed identity of the Bardi altar with the "Marriage of St. Catherine" painted by Parmigianino in Viadana, it would then follow that the San Giovanni chapels (or rather the only two chapels in which we see his hand) should demonstrate (a) a less thorough absorption of Correggio's style than the Bardi altar (whereas the reverse is true) and (b) more points of community of morphology and technique with the early "Baptism" than does the Bardi altar (where no such communities are evident). A pre-Viadana dating for Parmigianino's authentic work at San Giovanni is thus excluded.

Affò discusses the two chapels which we mutually assign to Parmigianino immediately after the picture we have identified as the copy, Parma 76, and immediately before Francesco's contract for the (unexecuted) frescoes in the Duomo (November, 1522), thus intimating a dating in 1522. All subsequent authorities (at least in reference to these two chapels) accept Affò's revision of Vasari's chronology. Not merely on grounds of morphology or technique, but on larger grounds of style resulting from the extent of Parmigianino's experience of Cor-

reggio which is manifest in the San Giovanni frescoes (see the discussion in the text, pp. 44-49), it emerges that this dating in 1522 should be correct.

Preparatory drawings: Berlin, Print Room. Study for the SS. Lucy and Apollonia. Red chalk, 25 x 14 cm. (Fig. 13).

London, British Museum, 1948-10-9-126. Study for left wall of second chapel. Pen and bister on pink-tinted paper, 20.1 x 11.4 cm. Two saints seated: at left, St. Lawrence(?) with his gridiron; at right, a female figure.

Copies: Parma Gallery, nos. 622, 623, 624, 625. The main subjects of all four walls. By Toschi, Raimondi, and Marchesi; 1839-1843.

ST. BARBARA (Madrid, Prado, no. 282), 1522. II. Oil on panel, .48 x .39 m. Fig. 17.

The earliest reference which may apply to this panel dates from 1624 when "una Sta. Barbara in tavola del Parmigiano" was listed among the pictures bequeathed to the Principessa Guilia d'Este by the Cardinal Alessandro d'Este.[29] A more definite citation is found in the inventory of the Muselli Collection in Verona (1662):[30] "Sta. Barbara in profilo con una torre in mano ben finite e conservata, al gusto mio delle più ben dipinte cose del Parmigianino, di lunghezza d'un braccio." There is no further reference to such a picture until the present painting (possibly the same one) appears in early-nineteenth-century catalogues of the Prado Museum.

Fröhlich-Bum overlooked this picture in her book, and the oversight was called to her attention by Baldass in a review.[31] With the exception of Venturi, who does not discuss the "St. Barbara" in his account of Parmigianino, all the authorities agree in accepting the picture as an authentic work.[32] This acceptance is in spite of certain evident weaknesses, as the drawing of

minority did not interfere with the insertion of his name into the contract drawn up November 21, 1522, for his (unexecuted) work in the Duomo, i.e. the same year as that in which we date the San Giovanni frescoes. See Affò, pp. 32-33. The documents of 1519 and 1522 referred to above have more recently been resurrected by Quintavalle to justify his further attributions to Parmigianino in San Giovanni. See the catalogue of attributed works, below, p. 223. Documentary evidence does exist for Correggio's work in the same church, and for Pordenone's work in the Duomo at Cremona, on both of which series Francesco's paintings in San Giovanni depend in various ways (see above, pp. 45 and 48). I have attempted to adduce evidence for at least a *terminus post quem* for Francesco's frescoes from the Correggio and Pordenone material, but such a terminus goes back to before the Viadana sojourn, and therefore is not relevant to our dating in 1522.

[29] Campori, p. 62.
[30] Campori, p. 191.
[31] *Graphische Künste,* vol. XLIV (1921), "Mitteilungen," p. 64.
[32] Copertini (I, 42); Berenson (*Lists*); Fröhlich-Bum in the article on Parmigianino in Thieme-Becker, 1930.

the thumb, the drawing of the lower eyelid, the rather vacuous expression, the false perspective of the breast. The work as a whole, however, is of such a sensitive and nervous execution as is proper to even the early Parmigianino; further, at least the last three of the above faults recur in other early works, so that they become a kind of guarantee for, rather than cause for suspicion of, this painting.

Copies:

Chatsworth, Collection the Duke of Devonshire, no. 508.

(formerly) Rome, Collection Cardinal Alessandro d'Este. Bequeathed 1624 to Emanuel Sbaigher Todeschino (Campori, p. 72).

CIRCUMCISION (Detroit, Institute of Arts). Copy of the lost original of 1522. Oil on panel, .42 x .31 m. Fig. 18.

This work came to the Detroit Institute in 1930 as the gift of Axel Bestow. According to the catalogue of the Institute (1936) the picture had previously been in the collection of the Prince Leuchtenberg in St. Petersburg. The Leuchtenberg Collection had its chief seat in the family palace in Munich; the catalogue of that collection (1851) lists this painting and illustrates it with an engraving which corresponds entirely satisfactorily.[33] An earlier catalogue of the same collection (1835, p. 32, no. 42) mentions the same painting, with the apparently mistaken indication that the picture is on copper. The Detroit picture cannot be traced farther back in documentary sources than this date.

On immediate qualitative judgment it is certain that this work cannot be an original painting by Parmigianino, but at the best only a copy after him. There are most pronounced weaknesses of drawing which are below Francesco's lowest standard, even during his immaturity (the hands, the heads in the background, etc.);

[33] Catalogue by Passavant, engravings by J. N. Muxel. It is there described as a panel of 15″ x 11 9/12″, but such slight variation in measurement (vs. the actual 16½″ x 12⅜″), which is very frequent in old catalogues, is not adequate cause to doubt the identity.

there are also just such variations in quality of execution in separate parts of the picture (compare the background figures on the left with the central group) as usually betray the copyist's hand.[34]

This subject matter in Parmigianino has an excellent pedigree. A painting of the "Circumcision" by Parmigianino is most intimately described by Vasari (V, 223): "fece un bellissimo quadro d'una Circoncisione, del quale fu tenuta cosa rarissima la invenzione, per tre lumi fantastichi che a quella pittura servivano; perchè le prime figure erano alluminate dalla vampa del volto di Cristo; le seconde ricevevano lume da certi che, portando doni al sacrifizio, caminavano per certe scale con torce accese in mano; e l'ultime erano scoperte ed illuminate dall'aurora, che mostrava un leggiadrissimo paese con infiniti casamenti . . ."

This work, according to Vasari, was painted in Rome, and presented by Francesco to the Pope (Clement VII). Later (says Vasari) "si stima che poi col tempo l'avesse l'imperatore . . ." All trace of this picture of distinguished pedigree has long been lost; there is no mention of it in any source after Vasari.

We have no way of checking the credibility of Vasari's description, but his enumeration of details would lead us to believe that he had actually seen the "Circumcision" of which he speaks. If, as we perforce assume, Vasari's description is correct, then—even if quality permitted—the Detroit picture could not be the painting which Vasari describes, because it deviates in numerous details from his specifica-

[34] A. O. Quintavalle ("Falsi e veri del Parmigianino giovane," pp. 243-244) accords with our estimate of this picture. I see no justification whatsoever for Copertini's acceptance (I, 42) of this work as an original, especially when he chooses at the same time to deny the originality of Parma 192. Both, to my mind, are equally copies, but Parma 192 is at a level of achievement clearly higher than that of the Detroit picture. If Copertini wished to preserve the status as an original of one of these two works, he has selected the less deserving. Berenson (*Lists*) also accepts this Detroit copy as an early original by Parmigianino. It was unknown to Fröhlich-Bum, who however knew the "Crozat" engraving mentioned in note 36.

tions.[35] These deviations are not only of details specified by Vasari as existing in the "Circumcision" painting he describes, but, equally important, there is a difference in the presumable date of each. Vasari's picture was executed after Francesco's arrival in Rome, while the Detroit picture reflects, with entire consistency, the vocabulary of detail and the character of design of a moment somewhat earlier in Parmigianino's career: the time of the San Giovanni frescoes. Certain details of the frescoes are repeated in the Detroit copy; so also is the type of the St. Barbara of the Prado panel, with almost literal exactitude.

The Detroit work thus preserves for us the forms, though not the quality, of an original painting by Parmigianino of the "Circumcision" subject executed not about 1525 (as was the picture described by Vasari) but about 1522.[36]

[35] This is recognized by the museum authorities, who have invented the very doubtful hypothesis that this is a "study" for the picture owned by Clement VII. This is contrary to the general early sixteenth-century practice; the artist was not then normally in the habit of making "studies" in oil for a larger work.

[36] There is further evidence as to the character of the probable original of the Detroit picture. An engraving exists, tentatively attributed to Crozat (ill. Fröhlich-Bum, fig. 118) which, though it shows basically the same composition as the Detroit copy, yet deviates considerably from it in many details. A drawing also exists in the Louvre (inv. no. 6390, pen and wash with white heightening, 19.6 x 14.2 cm., Fig. 19), attributed to Parmigianino (but of doubtful authenticity), which shows differences from the Detroit picture in the same senses as the "Crozat" engraving; but which (it is of superior quality and reverse direction) is not surely related to it. A second, similar, drawing, in the Uffizi (no. 9279, red chalk, 29 x 20.5 cm.) has been published by A. O. Quintavalle ("Falsi e veri del Parmigianino giovane," p. 244 and note 22; also with an attribution to Parmigianino). None of these objects agrees any more closely with Vasari's description than the Detroit painting does. It is unlikely that we are, as might be assumed in the case of the Detroit picture, in the presence of a reconstruction in Parmigianino's manner, based on a drawing or a print related to Parmigianino such as those described immediately above. The pasticheur only very rarely is able to approximate as closely and as consistently as does this painting the morphology of a specific moment in the artist's development.

MARRIAGE OF ST. CATHERINE (Parma, Galleria, no. 192). Copy of the lost original of 1522. Oil on canvas, .74 x 1.17 m. Fig. 20. Parma 192 has been considerably repainted.[37] This picture is described in the 1896 catalogue of the gallery as having been acquired in 1839 from the Quadreria Callani. A painting which is probably identical with it is recorded as being left in legacy to the Church of San Giovanni Evangelista in 1590. The description of that work fits the present picture exactly: "Un altro quadro senza ornamento di larghezza di br. 2 once 2 di alteza un brazo et once 4, dove è una gloria in cielo con una Madonna et il Putino che spossa Sta. Catherina et il San Giovanni et altre due teste di un Puto et una Puta che basia nostro signore con duoi vecchi San Pietro e San Giuseppe. Viene dal Parmeggiano fatto da lui a guazzo, ma è di buona mano fatto a oleo, vi è ancora duoi putini da basso a esso quadro."[38] It should be observed that the document says of the painting in question: "Viene dal Parmeggiano fatto da lui a guazzo, ma è di buona mano fatto a oleo" clearly indicating not only a copy, but a copy executed in a medium different from that of the original.

Until their almost simultaneous notices to the contrary were published by Copertini and Berenson, Parma 192 had been regarded as Parmigianino's original.[39] However, even when we make the most liberal allowances for repainting, the fundamentally un-Parmigianinesque character of this picture is apparent. Because of the repainting, we can base no judgments on the handling and textures, but there are very disturbing per-

[37] Copertini (I, 32) suggests that one of the former owners of the picture, the painter and art dealer Gaetano Callani, or his painter son (from whom the picture was purchased) may have been responsible for the radical repainting.
[38] Quoted, Copertini I, 51, n. 11.
[39] Copertini I, 32; Berenson (Lists). In subsequent literature Gamba ("Il Parmigianino," Emporium, vol. XCII, no. 549, September 1940, p. 110) and A. O. Quintavalle (Parma catalogue, 1939, pp. 116-117, and "Falsi e veri del Parmigianino giovane," p. 241) continue to regard the picture as an original. In his remarks in the Parma catalogue, however, Quintavalle appears to admit the force of the arguments to the contrary.

versions of form, of a kind which usually indicate a defective copy. The most evident of these are: the arbitrary variation in the sizes of the heads in the group at the right; the strange relationship between the back of the Christ child's head and the contour of the cheek of the angel behind Him; the omission of the back of St. Peter's head. Also, it seems unlikely that repainting alone could account for the shapes of the ugly, turniplike hands and their clawlike fingers.

These circumstances, and the coincidence of this painting in medium and measurement with those in the document quoted above, compel our agreement with the judgments of Copertini and Berenson about the originality of Parma 192.[40]

The material with which we work in trying to clarify the dating of the group of paintings in the vicinity of San Giovanni Evangelista creates a difficult problem: in three out of four cases (Parma 76, Parma 192, and the Detroit "Circumcision") we must draw our conclusions from copies of varying dependability. On such evidence it is impossible to specify an exact chronological sequence, nor can we indicate the exact

[40] There is a remote possibility that underneath the present repainted surface may exist, not the copy described in the document of 1590, but Parmigianino's original. Though I doubt the possibility, it would be very desirable to have the painting X-rayed. Before the "rediscovery" of the Bardi altar, Parma 192 had been regarded by certain critics (e.g., Fröhlich-Bum) as that "Marriage of St. Catherine" *con molte figure* reported by Vasari to have been painted by Parmigianino during his stay in Viadana. Copertini was the first to demonstrate his lack of satisfaction with this thesis. He felt clearly that the painting could not be dated earlier than the San Giovanni frescoes, and that assignment of the picture to a date prior to 1522 (even by a year) inflicted a considerable strain on the logic of the early Parmigianino's development of style. He solved this difficulty by the ingenious intellectual legerdemain of having Francesco paint the work in Parma after his return from Viadana; from Parma he would have sent it back to the smaller town. Since the rediscovery of the obviously earlier Bardi picture of the same subject this logical acrobatic is no longer necessary, and the lost original of Parma 192 can comfortably take its place among the works of 1522.

relationship in time of this group of paintings to the frescoes in San Giovanni.

However, about the three works which we have just catalogued (the "St. Barbara," the Detroit "Circumcision," Parma 192) we are able to make certain general propositions. First, it is certain that these three paintings (or at least the originals thereof) are all very closely contemporary in time. This is apparent chiefly from their morphological identity, and also from the strongly similar compositional system used in the two larger pictures. Secondly, the common morphology of these pictures is very close to that employed in San Giovanni Evangelista. One should observe the close relationship between the principal feminine type of any of these three paintings and the profile of St. Lucy in San Giovanni *A*. Other types in the two larger pictures also appear in San Giovanni: for example, the *putto* type, and the type of young boy. Further, there is a close parallel in many of the drapery formulas (for example, the broad sweep of drapery over the lap of the Madonna of Parma 192 and the corresponding detail of the Saint Lucy in *A*, etc.). At least one of the incidental motives from one painting of this group, the rabbit in the wicker basket in the "Circumcision," has its exact parallel on the arch faces of San Giovanni. If all these coincidences are called in evidence, we must assign to the present group the same date that we have given to the San Giovanni frescoes: 1522.

We may arrive by another route at the same conclusion for the dating of this group of paintings. Aside from any question of identities or differences between their morphology and that of San Giovanni, it is evident that the vocabulary of detail in these three pictures is transitional between the Bardi altar of the second half of 1521 and the frescoes of Fontanellato (1523). Characteristics which are only suggested in the Bardi picture, and which are emphatic at Fontanellato, appear in an intermediate stage in this group (for example, the flat S-fold motif of drapery, the formulation of the feminine type, etc.). On this basis as well, then, we should have to assign these works to 1522. Conversely, because of the coincidences with San Giovanni described

above, the conclusion thus arrived at gives us counterproof for our dating of those frescoes.

(Further) copy: Naples, Pinacoteca del Museo Nazionale, no. 199. Canvas, .67 x 1.20 m. See Naples catalogue (ed. 1911), pp. 282-283. Probably the picture referred to in the Farnese catalogue of 1680 as "Un quadro alto br. 1, on. 3 e 1/2, largo br. 2, on. 3. La Madonna Santissima a sedere sopra le nubi con presso il Bambino che sposa S. Caterina, con altre figure che in tutto sono dieci et una gloria d'angelini di Michele Angelo Sanese."

FRESCOED ROOM WITH THE LEGEND OF DIANA AND ACTEON (Rocca di Fontanellato, near Parma), 1523. II. Figs. 21-28.

In the lunettes: "A Nymph Pursued by Acteon and a Companion" (*A*); "Acteon Changed into a Stag" (*B*); "Acteon Devoured by His Dogs" (*C*); "Nymph with the Attributes of Summer" (*D*).

On the spandrels: *Putti* with fruit, vegetables, etc. against a trellis open above to a painted "sky" on the ceiling.[41]

The frieze running continuously beneath the lunettes bears the following legend: *Ad Dianam: Dic Dea si miserum sors huc Acteona duxit a te cur canibus traditur esca suis? non nisi mortales aliquo pro crimine penas ferre licet: talis nec decet ira deas.* The center of wall *D* formerly bore the inscription *Respice finem.*[42]

In 1836 certain restorations were made by the Parmesan painter, G. B. Borghese. Count Luigi

[41] References to individual lunettes or to separate *putti* may hereafter be made in terms of the diagram herewith. The Roman numerals refer to the lunettes; the Arabic numbers refer to the *putti* in the spandrels above and between them.

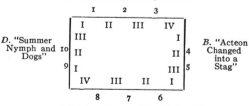

A. "Nymph Pursued by Acteon"

D. "Summer Nymph and Dogs" / *B.* "Acteon Changed into a Stag"

C. "Acteon Devoured by His Dogs"

[42] See Copertini I, 55, n. 24.

Sanvitale[43] described these restorations as affecting a head of a stag, the head of a dog, and the figure of a nymph.

It is singular that a work as important as this for Francesco's history should be without notice in any early source. The first mention in critical literature dates only from 1689, when the frescoes were attributed to Parmigianino in the book of Gian Carlo Giuseppe Fontana, *Pallade Segretaria.*[44] Ratti, in his volume on Correggio,[45] seems to have considered them as by Parmigianino. Affò (pp. 79-80) quoted Ratti's description at length and confirmed his suggestion of Parmigianino's authorship. From the late eighteenth century onward, critical notice of Francesco's authorship is frequent, and without any dissenting voice.

Indeed, no discussion is possible after even a superficial examination of the Fontanellato frescoes. There are so many correspondences in morphology between them and San Giovanni, as well as with the easel paintings of 1522,[46] that we must assume not only common authorship but a close relation in time. However, it also appears that the morphological system at Fontanellato shows, to a slight degree, a tendency toward more fluid and graceful forms than are usual in the San Giovanni group: for example, the bodies of the *putti* and the attitudes of the larger figures are, in comparison with San Giovanni, more svelte and more easily rhythmical in their design. These differences, which reveal a slightly greater maturity in the artist, are not

[43] *Memorie intorno alla Rocca di Fontanellato,* op. cit., 1857.

[44] Parma: Pazzoni e Monti, 1689. An earlier, but only an indirect connection between Parmigianino's name and the Fontanellato frescoes results from two engravings (ill. Copertini I, *tav.* XXXV) executed in 1637 by H. Van der Borcht. Both engravings carry the legend *F. Parm. in,* and represent studies of *putti* fairly closely related to nos. 3 and 10 at Fontanellato. The source of these engravings was not the paintings but the drawing now in the Morgan Collection (see under *preparatory drawing,* below).

[45] *Notizie Storiche sincere* (1781), p. 354.

[46] Compare the male and female facial and figure types, the *putti,* the drapery formulas; even the dogs suggest a relationship with San Giovanni *D.*

yet so pronounced, nor so suggestive of Parmigianino's mature style as in the next certainly datable picture in his *oeuvre,* the Prado "Holy Family" (which may be located in the first half of the year of 1524). One can, therefore, securely assign the Fontanellato series to a time between San Giovanni Evangelista and the Madrid picture: that is, to 1523.

There was a considerable time before the obviousness of this dating was recognized. It had been assumed (Affò, Ricci, Fröhlich-Bum, etc.) that the Fontanellato series was executed during Francesco's second Parma period.[47] Francesco's comparatively meager production during the years when he was under contract to work on the Steccata (1531-1539) encouraged such a view; Ricci,[48] following the lead of Affò, and of Count Luigi Sanvitale, as well as of other nineteenth-century critics, suggested that Parmigianino's work at Fontanellato had been done between disputes with the Confraternity of the Steccata, while operations in the church were suspended pending the signing of a new agreement in 1535.

There is no external evidence to support the dating of the Fontanellato frescoes;[49] our judgment is thus necessarily based on internal comparisons. Comparison of Fontanellato with the Steccata works makes it amply evident that there is no possible chronological association between them: they stand at nearly opposite poles of Parmigianino's development. The anatomical

[47] Not only Fröhlich-Bum, but also Berenson and Venturi mistakenly assigned the Fontanellato series to the Parma II period. Pevsner was (to my knowledge) the first to contradict this dating in print (*Barockmalerei in den Romanischen Ländern,* Potsdam, Athenaion, 1928, p. 50; he assigned them correctly to the Parma I period: Copertini is definite in his early dating, and assigns the work to 1522-1524. Only Gamba (*Emporium, op. cit.,* p. 114) and H. Bodmer (*Correggio und die Malerei der Emilia,* Vienna, Deuticke, 1942 p. xxvi; in Italian as *Il Correggio e gli Emiliani,* Novara, De Agostini, 1942), still persist in the late dating. Gamba further alleges a resemblance in the scheme of lunettes and spandrels to Raphael's Farnesina and to the Loggie.

[48] Parma catalogue (1896), p. 308.

[49] Except for one item, more suggestive than conclusive. The site of Parmigianino's model, the Convento di San Paolo, had been generally open to the public under the Abbess Giovanna Piacenza's libertarian regime. When she died in 1524 the convent was strictly closed, and would thus probably not have been accessible to Parmigianino during his later residence in Parma to serve him as a source of inspiration for his work at Fontanellato. Correggio's decoration seems, after this closure, to have been virtually forgotten until at least the end of the sixteenth century. See A. Barilli, *L'Allegoria della Vita Dipinta dal Correggio nella Camera di San Paolo* (2nd ed.; Parma: Battei, 1934), p. 1. A letter discovered by A. Ronchini (published in Count Luigi Sanvitale, *Memorie intorno alla Rocca di Fontanellato, op. cit.,* part 2, pp. 14-15) was entirely misconstrued in such fashion as to lend a measure of support to the thesis of a late date for Fontanellato. This letter, sent by the Confraternity of the Steccata to Count Galeazzo Sanvitale, the lord of Fontanellato, on June 23, 1533, in fact contains no reference which can be regarded as referring to Francesco or to any work by him. We quote the letter (as translated in Ch. Nisard, *Correspondance inédite du Comte de Caylus avec le Père Paciaudi, Théatin, etc.;* Paris: Pougin, 1877; p. 364, n. 3): "Illustre et très-honoré Seigneur, la confrérie de la Madone de la Steccata envoie le respectable D. Geronimo Piazza, pour communiquer à votre Illustre Seigneurie certaines choses concernant les interets de ladite confrérie, et prie Votre Illustrissime Seigneurie de vouloir bien prêter au dit Messer Geronimo la même foi qu'elle prêterait à la confrérie elle-même. La dite confrérie récommande ses raisons à Votre Illustrissime Seigneurie que Dieu et sa Très-Sainte Mère gardent en santé et bonheur. De Parme le 23 Juin 1533. Le très-dévoués prieur et officiers de la confrérie de la Madone de la Steccata." The only points of contact with Parmigianino's history afforded by this letter are the circumstance of its passing between two parties who were known to be his patrons, and that it mentions the name of Geronimo Piazza, with whom Francesco had various dealings during the long execution of the Steccata contract. If the evidence of the Fontanellato frescoes were such as to suggest a late date, this document might then (still arbitrarily, however) be presumed to have some connection with the case, but the evidence of the style of the frescoes is in direct contradiction thereof. If the mention in the letter of the name of Galeazzo Sanvitale, the patron of the Fontanellato series, is thought to bear any weight in this matter, it may be observed that Parmigianino's most certainly datable contact with him, his portrait of Sanvitale (which accords with the Fontanellato frescoes in general style) was almost positively done in 1524.

conceptions (compare the Acteon of *A*-II with the Moses, or the Diana of *C*-II with any of the Steccata maidens) are radically different; so also are the drapery formulas, and even the mere mechanical aptitude in the handling of detail. Particularly different are the soft, Correggiesque outline and modeling of the Fontanellato figures from the clarity and smoothness of outline and modeling of the Steccata maidens.[50]

Preparatory drawing: New York, Morgan Library (no. I, 49). 15.4 x 15.3 cm. From the Fairfax Murray and Spencer Collections. Fig. 29. Recto, study of two *putti*. Pen, bister,[51] and red chalk. Engraved as two separate sheets by H. van der Borcht in 1637. Verso, study for the "Diana Splashing Acteon" (the latter here posed by a draped female figure), for the head of a dog, and for the decoration of the "mosaic" underside of a lunette. Black chalk, with a few touches of red chalk.

Copies: Parma Gallery 841-852. By Felice Boselli. Copies in oil of the whole series; on separate panels and in rectangular format.

HOLY FAMILY: REST ON THE FLIGHT INTO EGYPT (Richmond, Cook Collection), 1523. III. Oil on panel, .355 x .415 m. Fig. 30.

The Cook "Rest on the Flight" can be traced through the most important of its various changes in ownership as far back as the late eighteenth century, to the collection of the Graf Moriz von Fries in Vienna.[52] From the Graf Fries the picture passed to the Collection Speck-Sternberg, thence to the Lawrence Gallery (sold 1820), to a Miss Rogers (sold 1856), and finally to the Cook Collection by 1868.[53] No early documentation exists for this work. An inscription on the rear of the painting reads *Das Hand von Parmizon*.

The Cook painting was "rediscovered" by Berenson, and first published in 1913 in Borenius' catalogue of the Italian pictures in the Cook Collection. Considered a work of Parmigianino by Berenson (*Lists*), by Frizzoni, and also by Venturi,[54] critics of authority in the field have since doubted Parmigianino's authorship.[55] Though it has not been so specified in the literature, this doubt is probably based first on the somewhat dry and overprecious execution of the picture and the lack in its handling of much of the sense of rhythmic activity that is normal to Parmigianino. It could also be objected that, while it is true that the expression of content in Francesco's works is often rather indifferent, in this picture the content borders on vacuity. However, these admitted facts do not constitute a difference in kind from Francesco's authentic works, but only a difference in degree; nor are these differences so pronounced as to make it impossible that the picture should be by Parmigianino. When we consider the very small size of the figures in the Cook panel (they are little more than half the size of those in Francesco's already very small Doria "Nativity") it becomes possible to consider its "deficiencies" as the result of (unaccustomed) working in a nearly miniature scale.

[50] The extent of dependence at Fontanellato on Correggio, which (at least in morphology) is almost equal to that evident in the San Giovanni frescoes, is in itself a strong argument for a date in the early period. Compare, for example, the Diana of wall *B* with Correggio's Diana above the fireplace of the Camera, and any of the nude females with the smaller nude feminine figures in the San Paolo lunettes, as the Three Graces, or the "Giunone Pentita."

[51] The term "bister" is used hereafter, in accordance with common practice, to describe either true bister or iron-gall (brown) ink.

[52] For the history of the Fries Collection see F. Lugt, *Marques de Collections* (Amsterdam: Vereenigde Drukkerijen, 1921), p. 515 under no. 2903. The picture was engraved, probably while in this collection, by Agricola (ill. Fröhlich-Bum, fig. 121, p. 99).

[53] See *A Catalogue of the Paintings at Doughty House, Richmond, etc.,* ed. Herbert Cook (London: Heinemann, 1913-1914), vol. I, *Italian Schools,* by T. Borenius, p. 112.

[54] Frizzoni in "Dipinti italiani alla galleria Cook di Richmond," *Rassegna d'Arte,* XIV (1914), 127-128; Venturi IX/2, p. 652.

[55] Copertini (II, 99): Bertoia; Voss (*Kunstchronik und Kunstmarkt,* 34/2, 1923, p. 637): a clever imitator of Parmigianino such as Bertoia; Suida (quoted in *Abridged Catalogue of the Pictures at Doughty House, etc.,* London, Heinemann, 1932, ed. M. W. Brockwell, p. 52): "a later adaptation"; Fröhlich-Bum (*Burlington Magazine,* vol. XLVI, 1925, p. 88): a later adaptation of a drawing, painting, or etching by Parmigianino.

I am inclined to accept the Cook picture, with its deficiencies, as a work by Parmigianino, though it would perhaps be more comfortable to reject it either as a copy or as a later pastiche. However, for the first of these possibilities the painting itself offers no sustaining evidence. It does not exhibit to a recognizable degree any of the normally identifiable characteristics of a copy, and certainly has nothing in common with the other copies (either those after lost paintings, or others) that we have included as such in this catalogue.

The critics who dissent from Parmigianino's authorship seem to have been thinking not of a copy, but rather in terms of an "imitation" or "adaptation" of Parmigianino. We find this thesis harder still to justify, for the picture itself offers almost indisputable internal evidence against it. This evidence consists of the morphological system used in the picture: it is not only Parmigianesque in a merely general way, as is usual for an imitation, but exhibits throughout, with complete consistency, the system of morphology used by Parmigianino during a narrow span of time in his development, centering closely on Fontanellato; this complete morphological consistency of a short phase is a characteristic the imitator (unlike the copyist) is able only very abnormally to achieve.[56]

[56] It must be remembered that we should be dealing here with an eighteenth-century (or earlier) imitator, not with the art-historically learned modern forger. The imitator will usually betray his difference from the inventor by the synthetic character of his morphological system: in painting a detail for which the imitator has no model among the accessible works of the master from the special phase of style he is imitating, he (the imitator) is likely to go farther afield in the master's work, that is, into another phase of style, in search of a precedent. The imitator's painting is thus likely to contain morphological forms from various periods of the master's art, rather than forms consistently representative of a single moment in the master's style. Further, the imitator will not usually be so scrupulous in confining himself to the morphology of the master; such conscientious fidelity is too exacting and he will in some places insert some detail of telltale personal style. In the case of the Cook picture, the observations above apply even to the imitator who would make his fabrication in direct contact with early originals by Parmigianino, as would Bertoia. For any artist outside of Parma, or to whom the works of the first period were not accessible, it would be incredibly difficult to achieve an imitation successful enough to deceive. An artist working (as has been suggested for this picture) after a lost drawing or a lost print (*sic!*) might be able to reproduce approximately the morphology of an early painting by Parmigianino, but hardly the exact morphology of the Fontanellato phase, which appears here. From these remarks it must be apparent that even though set on our guard, and made suspicious by the weight of previous critical opinion, our examination of this picture has not betrayed such flaws as suggest the imitator, or the copyist.

In spite of the great differences in scale most of the morphology of the Cook picture can be duplicated in Fontanellato, while a few details find coincidences in paintings which vary in date from Fontanellato by not much more than a year or two. For example, the head of the Virgin compares with the feminine heads of wall *B* at Fontanellato, down to and including such details as the insertion of the rather too sharply V-shaped eye, and the rather fat, curving loop used to define the edge of the ear. The Joseph compares with the Acteon of Fontanellato *A*-II, and even more closely with the bearded male heads of the early Roman "Nativity," in the Doria Collection.

The children of course suggest the Fontanellato *putti*. For a more exact correspondence we may juxtapose the Christ child with *putto* 9, and the angel with the left *putto* of no. 7. We may also compare the round face of the Christ child with the face (in a similar pose) of the infant Christ in the Doria "Nativity." Even the animal types suggest a correspondence with the animals at Fontanellato.

The drapery on which the Christ child leans is like the drapery to the left of Diana in Fontanellato *B*-II. The drapery of the Virgin's arm and shoulder suggests the similar detail in *A*-III at Fontanellato, while the garment of the Joseph is like the formula used in *A* of San Giovanni, but with slightly increased fluidity of movement.

The pose of the Joseph compares closely with the Lucy of San Giovanni *A*. Also compare the extension of his arm and the gesture of his hand with the Virgin in the Doria "Nativity."

CATALOGUE

The attitude of the Virgin's hand in this picture is identical with that of the left hand of the foremost maiden in Fontanellato B-III; the disposition of the legs of the Christ child may be compared with the Doria "Nativity" and the copy, Parma 76.

In the background the column on a high base at the left recurs in the Detroit "Circumcision." The artificiality of perspective effect in the "receding" niche brings to mind the niches of San Giovanni. The handling of foliage is exactly as in the backgrounds of Fontanellato. As for the reliefs on the wall on which Joseph sits, one may call to mind A and B of San Giovanni, while the vague extension of landscape space at the left is like that in the Doria pictures.

Copy: Milan, Collection Avvocato Giolioli.[57]

FEMALE MARTYR WITH TWO *PUTTI,* CALLED ST. CATHERINE (Frankfort, Städelsches Kunstinstitut), 1523-1524 (possibly a copy after a lost original). II. Panel, .26 x .19 m. Fig. 31.

It is probable that this panel has lost a fraction of its original width on the right side, where the body of one of the *putti* is cut off more abruptly than in the (other) copies. The paint surface is badly abraded in some places, and dubiously restored in others.

This painting has a very curious history. When it was acquired by the Städel in 1913 from the Baroness Beaulieu-Marçonnay this panel looked like just one more in the series of paintings variously described as replicas, or copies, after what was then considered an original work by Parmigianino in Vienna. The Frankfort picture had obviously been much repainted, and differed considerably in appearance from the other paintings of the same theme; it was generally regarded as the least worthwhile of the number of Parmigianinesque representations of St. Catherine. In 1932 a radiographic investigation of the picture was made.[58] The radio-

graph (Fig. 32) revealed, beneath the disfiguring overpaint, what we consider to be almost certainly an autographic production by Parmigianino. The painting was then cleaned, but unfortunately the original paint surface proved to be much damaged, so that it is impossible to assert positively that this St. Catherine is in fact Parmigianino's original, rather than merely the closest to Parmigianino's style of the existing copies.

The Frankfort picture has a compositional scheme and morphology which indicate a phase in Parmigianino's development between the Fontanellato frescoes and the earliest productions of the Roman period. The attitude of the figure in the Frankfort picture has a close analogue in the "Summer" nymph at Fontanellato. Both show a similar convolution of body and legs, a similar turning of the head, and a not unlike extension of the arms. The type of garment is closely comparable in the two figures, and the drapery formula, with its parallel repetition of soft calligraphic folds, is almost identical. The *putti* who accompany the "Catherine" are evidently of a common family with the *putti* of Fontanellato, both in their morphology and their poses.

The correspondences with the two Doria panels of 1524-1525 are still closer. The Catherine head intimately resembles the head of the Doria Madonna; if we discount the exaggeration of contrast in the values which results from the rubbed state of the Frankfort head the resemblance becomes a near identity. Catherine's drapery compares closely with that of the Virgin in the Doria "Adoration." Certain characteristic Parmigianinesque idiosyncrasies of drawing in the latter work, such as are exhibited in the feet, are nearly exactly repeated in the former.

If the evidence of the damaged surface of the Frankfurt picture is supplemented by that of the radiograph, the painting not only assumes a close quantitive resemblance to the two Doria panels, but an intimate qualitative comparison may be made as well: its soft and fluent brushwork is equally sensitive and as rhythmically spontaneous (as is not normally true of a copy).

It is possible that an iconographic singularity has emerged with the cleaning of the Frankfort panel. The St. Catherine's wheel, which appears

[57] A photograph exists in the files of Dr. W. Suida, New York.

[58] K. Wehlte, "Roöntgenologische Gemäldeuntersuchungen in Städelschen Kunstinstitut," *Städel Jahrbuch,* VII-VIII (1932), 220-223.

uniformly in all the copies, and which appeared also in the repainted surface of the Städel picture, (according to the original investigator, Wehlte[59]) does not exist in its original paint structure. The iconography of the Frankfort picture in its repainted condition, and that of the copies, though permissible, was hardly very meaningful. However, it is more difficult still to make positive iconographic sense of the subject without the attribute of the wheel.

It should be observed that Wehlte's reading of the radiograph so as to exclude the wheel from the paint structure of the Frankfort picture is by no means beyond question. The opinion of other radiographic experts, to whom I have submitted the X-ray, was, in substance, that it would be very difficult to make a judgment as to the existence or nonexistence of the attribute from the evidence of the radiograph. It would seem, granted this permissible doubt, and granted the appearance of the wheel in all the other versions, that the Frankfort panel, in its original (and presumably autographic) state, in fact represented a St. Catherine.[60]

(Further) copies:

Parma Gallery, no. 363. Fig. 33. .27 x .205 m. Probably identical with the painting, called a copy after Parmigianino, which is mentioned in the Farnese inventory of 1680 (Campori, p. 304), and which in turn may be the same as the painting described in the inventory of the Boscoli Collection in Parma (1690; Campori, p. 404). This latter work apparently subsequently passed to the Sanvitale, and thence to the Gallery. Engraved by Bossi while in the Sanvitale Collection. See Parma catalogue (1896), p. 315.

Parma, Collection Bocchialini.

Vienna, Kunsthistorisches Museum, no. 57. Fig. 34. Canvas, .28 x .25 m. (enlarged from .28 x .215 m.). Acquired from the collection of Charles I. Dropped from the catalogue in the latest edition (1938). It had previously been considered Parmigianino's original.[61]

[59] *Ibid.*

[60] The diadem of pearls might represent the crown of Catherine as a princess; can the minuscule streamlet symbolize the Egyptian Nile?

[61] First recognized as a copy by Baldass (*Graph-*

HOLY FAMILY (Madrid, Prado, no. 283), first half 1524. II. Oil on panel, 1.10 x .89 m. Fig. 35.

Just before Francesco's departure from Parma in mid-1524 he painted three pictures which he took with him to Rome to be his "entratura a que' signori ed agli artifici della professione" (Vasari V, 221). Since the beginning of the present century the Madrid "Holy Family" has been universally certified by the critics[62] as the one of these three pictures which Vasari describes in detail (*ibid.*): "fece tre quadri, due piccoli ed uno assai grande: nel quale [that is, in the larger picture] fece la Nostra Donna col Figliuolo in collo, che toglie di grembo a un Angelo alcuni frutti, ed un vecchio con le braccia piene di peli, fatto con arte e giudizio, e vagamente colorito." After Francesco's arrival in Rome this picture, with the others mentioned,

ische Künste, XLIV, 1921, "Mitteilungen," p. 65), and withdrawn from the latest catalogue, evidently in acceptance of that judgment. Copertini (I, 80) and I agree therewith. Fröhlich-Bum, Berenson, and Venturi, in their last mentions of the Vienna picture (1921, 1932, and 1926 respectively) maintained its originality. Baldass, it should be noted, with extraordinary acumen judged the Frankfort panel—in spite of its repaint—as *das bedeutend bessere.* Count Luigi Sanvitale, in his *Memorie intorno alla Rocca di Fontanellato* (*op. cit.*) recorded "replicas" in the Vatican, in the Palazzo Borrommeo (Lago Maggiore), in the collection of the Cardinal Fesch in Rome, and in London. This last, London, version of the "St. Catherine" would seem to have only a mythological existence. Affò (p. 81, n. 2) speaks of a William Peters, an English painter, who remarked of the "St. Catherine" which he saw at Sanvitale's that "un quadro simile grande al naturale, conservasi nella galleria del Re d'Inghilterra." If such a picture existed it would presumably, in view of its larger size, be the original of the surviving St. Catherines. No sign of it occurs in any available royal inventory, nor does it exist in the royal collections today. We should note that the possibility of the existence of a larger original is discounted by the close agreement in their dimensions of all the surviving versions.

[62] C. Ricci, "Di alcuni quadri del Parmigianino già esistenti in Parma," *Archivio storico per le provincie Parmensi,* IV (1895; printed 1903), 18; Gronau in his Vasari translation, p. 336, n. 11; Berenson, *Lists,* 1907 and 1932; Baldass, *Graphische Künste,* XLIV (1921), "Mitteilungen," 63; Fröhlich-Bum in the Parmigianino article in Thieme-Becker (1930); Copertini I, 60.

was given to Pope Clement; Clement in turn gave the "Holy Family" painting to his nephew, Ippolito de' Medici.[63]

From the time of Vasari's mention of the picture, and his location of it in Ippolito's collection, there is no further definite notice of the present painting until its appearance in the Prado catalogues.[64] In spite of this long hiatus in the history of the picture, no serious doubt has ever been entertained as to its authorship. In fact, to the critic who has no special acquaintance with Francesco's early work his hand is more immediately recognizable here than in the paintings we have so far discussed, for (as we observe in the discussion in the text, p. 55) the manner of this work marks a perceptible step nearer Parmigianino's more widely known mature style. Numerous correspondences of morphology and technique, too obvious to catalogue here, can be found in this painting not only with the earlier pictures of the first Parma period but also with the "St. Jerome" altar of 1527.

Copies:

London, Buckingham Palace. By Henry Bone.

Rocca di Fontanellato, near Parma. Possibly identical with the picture said formerly to have been in the parish church of San Quintino.[65]

[63] Vasari was in the employ of Ippolito de' Medici in 1531-1532; it is probable that he saw the picture then. The picture is the subject of a certain confusion in the first edition. There it is, so to speak, "stirred into" a picture in the collection of the Gaddi family, executed by Francesco during the Roman period: ". . . lavorò un quadro di una Madonna con un Christo; con alcuni angioletti, et un S. Giuseppo: mirabilmente finiti d'aria di teste, di colorito, di grazia, e di diligenza. Nel quale fece a S. Giuseppo sopra un braccio ignudo molti peli come al vivo spesse volte veggiamo. La quale opera rimase appresso Luigi Gaddi, et da' suoi figliuoli et da chi la vede, e in vita di lui et dopo la morte, è stimato pregio grandissimo" (1st ed., p. 847). This running together of the two pictures is clarified in the second edition, where each (the present Madrid picture and the lost "Madonna . . . con alcuni angioletti") is separately described.

[64] The earliest available catalogue which lists the picture is that of 1858. There is no information on how the "Holy Family" came to Spain.

[65] The publication *Le più insigni pitture Parmensi, etc.* (Parma, 1819), reproduces a painting practically

(FORMER) WINGS OF THE STECCATA ORGAN (Parma, Church of Santa Maria della Steccata), first half 1524. I. Figs. 36, 37. "St. Cecilia" and "David." Oil on canvas, each wing originally 2.75 x 1.20 m.; later additions by other hands bring the overall dimensions of each wing to 5.00 x 2.80 m. The central sections which contain the main figures are on rough canvas; the outer parts with the additions are on fine canvas. There is a visible seam between them. The wings are very badly damaged and almost entirely overpainted; the "David" in particular is virtually a ruin.

The organ wings have existed continuously in the Steccata since their painting. In 1761 they were placed in the choir; in 1908 they were moved to their present position on either side of the west end of the nave.

It is reported that the archives of the Steccata contain a document, dating from 1529, which records a payment made to Parmigianino for work on these organ wings.[66] The date of this document has not necessarily to do with the date of execution of the painting; to the best of our knowledge Francesco was not in Parma in 1529. The reason for the date emerges by implication from the later documents concerning these pictures; from these documents it is apparent that Parmigianino had left the wings unfinished, presumably (if our dating of them is correct) on his departure for Rome. The delay till 1529 in payment for such efforts as he had expended on the pictures would have resulted from his having left the job undone. Conversely, the making

identical with the Madrid picture, except that the given proportions differ, being wider and less high. The work reproduced bears the legend "esisteva nella chiesa parrocchiale di S. Quintino". Copertini (I, 93, n. 5) suggests the identification of the Quintino work with the copy now preserved at the Rocca di Fontanellato. A not very reliable source, D'Argenville, in his *Abrégé de la Vie des Plus Fameux Peintres* (Paris, 1762), II, 30, lists a picture of identical description with that of the Madrid "Holy Family" in the Vatican collection.

[66] I have not seen this document either in original or in quotation. It is reported in the *Inventario degli oggetti d'Arte d'Italia*, III (Provincia di Parma), 68, where the other documentary evidence is also recorded briefly.

of this tardy payment by the Confraternity of the Steccata would result from their interest at this time in securing Parmigianino's services for new work in their church; as we know (see text p. 61 and p. 137, n. 8) he did in fact contract with the Steccata for an (unexecuted) commission in 1530.

In 1542, two years after Parmigianino's death, his cousin Girolamo Mazzola-Bedoli received a payment for some work on these wings.[67] However, thirty-seven years later, in 1579, they were not yet entirely finished. A letter of that year[68] reveals that the Fabbricieri of the Steccata had been considering without success the problem of an artist of sufficient merit to complete the wings, "havuta considerazione all' eccellenza delle figure di quel famoso nostro Parmigianino che le fece." It would appear from the quoted phrase that, whatever the degree of completion of the wings as a whole in 1579, it was then considered that the main figures were substantially the work of Francesco. In 1580 payment was made to Giovanni Sons, a Fleming resident in Parma, for "la sua mercede di ritoccare le figure del Parmigianino delle portelle dell'organo dell' oratorio della compagnia, quali figure erano guaste in molti luoghi."[69] Sons's restoration was apparently a very liberal one; also, it probably included some original work on the large extensions of canvas which had been added around Parmigianino's central figures.

Parmigianino's responsibility for at least the design, and probably much of the original execution of the central figures in both wings seems, from the evidence of the documents above, to be reasonably certain.[70] The extent of Bedoli's contribution to the execution of these figures is unclear. It seems that the principal task with which he was confronted was that of enlarging the wings and decorating the added surface of canvas. This enlargement was required by the fact that Parmigianino's original wings had been painted for an old organ, which at that time was not in the church itself but in the old oratory of the structure which existed before the rebuilding of the Steccata. This old organ was brought into the new church in December 1541, but the Confraternity of the Steccata decided it was not adequate. On October 21, 1541, a new and larger organ was commissioned; this required the enlarging (by Bedoli, in 1542) of Parmigianino's painted wings, which were apparently transferred to the new instrument.[71]

The efforts of Bedoli and Giovanni Sons have made the question of the presence of Parmigianino's actual hand in the organ wings a purely academic one. As they stand, the picture surfaces offer hardly any visible trace of the original execution. Though the valuable evidence of

[67] Ibid. The document of 1542 (referring to payment made to Bedoli) has sometimes been considered the definitive argument for the attribution of these pictures. The organ wings therefore not infrequently appear in the critical literature as works of Bedoli: see L. Testi, "Una grande pala di Girolamo Mazzola alias Bedoli detto anche Mazzolino," Bollettino d'Arte, II (1908), 384; Fröhlich-Bum, p. 110; Venturi IX/2, p. 729. For a complete bibliography of critical opinion see Inventario degli oggetti d'arte, III, 69. It should be observed that Vasari does not record these wings in his account of Bedoli's work in the Steccata (V, 236-237) though he was conducted through that church by Bedoli himself (VI, 487) and though he mentions the organ wings which Bedoli had done for San Giovanni Evangelista.

[68] January 9, from the Fabbricieri of the Steccata to the Duke of Parma; quoted Copertini I, 55, n. 23.

[69] Quoted L. Testi, "Una grande pala," p. 384, n. 1.

[70] Copertini (I, 42) and the Inventario agree with our attribution to Parmigianino, and Testi, in a book subsequent to his 1908 article cited above (S. M. della Steccata in Parma, Florence, Battistelli, 1922, p. 178, n. 171; p. 179; p. 212) also admits the original conception and execution by Parmigianino. Testi's judgment (ibid., p. 212) in this matter seems to be as well founded as is possible in so speculative a matter. We quote him: "Abbiamo in ognuno di queste due sportelli l'intervento di tre artisti successivi: Francesco Mazzola detto Il Parmigianino; Gerolamo Mazzola-Bedoli e Giovanni Sons. Al primo spetta l'ideazione e la dipintura della parte centrale, ossia la grande figura e la nicchia circostante; il Bedoli aggiunse tutto quanto è a di fuori della nicchia, e ritoccò in modo di imprimervi i caratteri dell'arte propria, tuttora ben visibili e determinati, nonostante i restauri e qualche aggiunta del Sons nel 1580."

[71] See Testi, S. M. della Steccata in Parma, pp. 73-77, where are reproduced documents concerning the organ from the archives of the Steccata: Libro VII, 10 December 1541 and 28 October 1541.

handling and texture has been destroyed, the drawing (at least of the "St. Cecilia") has fortunately been left essentially undistorted, and the basic design of the figures remains as well. These supply enough visual evidence to confirm the conclusion of Parmigianino's original authorship which is afforded by the documents.

In the "St. Cecilia," a comparison of morphology suggests as close as possible a chronological identity with the Madrid "Holy Family." Correspondences include: the same feminine type; like the "Holy Family" Madonna, the face of the St. Cecilia is distinguished from earlier female types by its more specific articulation. There is a close correspondence in the shapes of hands, as between the left hand of the Cecilia and the right hand of the Madrid Virgin. Further, the drawing of the drapery folds gathered up beneath Cecilia's arm is as if in amplification of the similar passage in the garment of the Madrid Madonna.

NATIVITY: ADORATION OF THE SHEPHERDS (Rome, Galleria Doria-Pamphili, no. 279), 1524-1525. III. Oil on panel, .58 x .34 m. Fig. 46.

There is no certain mention either of this painting, or of its companion in the Doria Collection, in critical literature before the last years of the eighteenth century. Both Doria pictures were then recorded in a *Descrizione ragionata della Galleria Doria,* by Salvatore Tonci (Rome, 1794), pp. 163-164. The paragraph in the *Descrizione* which contains this account includes as well a mention of a Carracci painting which hung between them, which we omit from our quotation: "Il primo dei tre quadri, che seguono, abbasso, è un'opera condotta con gran franchezza dal Parmigianino. La testa soprattutto della Madonna è d'una forma elegante all' estremo, e ripiena di quella grazia, che è propria di questo Autore. L'effetto del quadro è rilevato, e grandioso. . . . Il terzo rappresentante il Presepe è del suddetto Parmigianino; e veramente, tanto nell' aggruppamento delle figure, quanto nelle loro mosse, e respettive forme, e ripieno di grazia Correggesca. Le teste sono tutte animate, e sublime è la forma del giovinetto Pastore, colle braccia sollevate in aria verso il graziosissimo Puttino volante. L'effetto del chiaroscuro è parimente Correggesco, e per la grandiosità delle sue masse, e per la sua perfetta degradazione."

Apparently more from oversight than from any other cause neither Doria picture was mentioned in Fröhlich-Bum's book, though Berenson had included both in his 1907 *Lists.* Voss, in his article in *Kunstchronik und Kunstmarkt,*[72] corrected Fröhlich-Bum's omission, describing the Doria paintings as being in *Erfindung . . . Malweise und Formensprache durchaus . . . Parmigianino.* Copertini (I, 79) accepted both paintings with equal confidence; so too does Venturi (IX/2, p. 655).

In connection with the "Nativity," Voss offers the suggestion that it is possibly identical with the picture described by Vasari (V, 224) as follows: "Dipinse similmente in un quadro la Madonna con Cristo, alcuni Angioletti, ed un San Giuseppo, che sono belli in estremo per l'aria delle teste, per il colorito, e per la grazia e diligenza con che si vede esser stati dipinti: la quale opera era già appresso Luigi Gaddi, ed oggi dee essere appresso gli eredi." This identification becomes fully acceptable only if we are willing to multiply into *alcuni Angioletti* the single winged infant who hovers at the top of the picture.

Voss's suggested identification depends on the assimilation of the Doria "Nativity" into the Roman period, in which Vasari includes the Gaddi picture described above. Copertini also suggests a Roman dating; he finds in the Nativity the . . . *ricordi parmensi . . . ancora più tenui.* The dating of this work in the early part of Francesco's residence in Rome is most probable, but this probability does not result from any evidence of a significant change in style from the first Parma period. The "Nativity" is, in fact, in spite of its great difference in scale and the difference in medium, comparable in morphology and technique to the Fontanellato frescoes, and intimately comparable in some details to the "Rest on the Flight" of the Cook Collection, which we have assigned to the same time as Fontanellato. It should be observed, however, that the reduction in scale of the Doria panel

[72] p. 637.

has not, as in the Cook picture, cramped Parmigianino's calligraphic fluency of handling; indeed, it would seem that the rhythmic activity of the brush is greater in the small "Adoration" than in the frescoes. This increase in facility may be adduced as one of the arguments for a later, Roman, date.

It is significant that the "Nativity," to an extent equaling that in the Fontanellato frescoes, shows the pervasive evidence of Correggio's influence. However, in spite of this Correggiesque quality, and in spite of the communities with Fontanellato, there are stronger arguments for situating the panel in the early part of Francesco's time in Rome rather than in the last years of the first Parma period. The chief of these depends on evidence supplied by comparison, not with paintings, but with Parmigianino's graphic work. The theme of the "Nativity" (or "Adoration of the Shepherds") was a favorite with Francesco in his graphic art of the time following his arrival in Rome: it occurs in one etching from his own hand (Bartsch XVI, p. 7, no. 3) of about 1525, in an engraving by an unknown artist (generally called Caraglio; Bartsch XV, p. 68, no. 4) after a drawing by Parmigianino, and in a number of Parmigianino's own drawings. These drawings and prints all show considerable resemblances in types and in many details with the Doria "Nativity." The type of the Christ Child and of the old man with the windblown hair recurs in these graphic works, as does that of the Virgin. Certain poses and attitudes, though not identical, are comparable. One drawing in particular, now in the Metropolitan Museum in New York (Fig. 47),[73] shows similarities in certain poses, as in that of the Joseph; also like the Metropolitan drawing are the upper part of the body of the Virgin and the motive of the *putto* (an angel in the drawing) who flies in at the top of the picture. The figure of the young shepherd with arms raised at the left of the painting recurs at the left of a

drawing in the Uffizi (Fig. 48).[74] Neither of these drawings is sufficiently like in its entire composition to be considered a preparatory drawing for the Doria picture, but they suggest a closely contemporaneous working out of the same theme.[75]

MADONNA AND CHILD (Rome, Galleria Doria-Pamphili, no. 281), 1524-1525. III. Oil on panel, .58 x .34 m. Fig. 49. See also the previous entry in this catalogue.

The critical history of this painting is the same as that of its companion in the Doria Collection, the "Nativity" (no. 279), with which it is identical in measurement, shape, and medium.[76] This picture demonstrates the closest similarities, material, technical, and morphological, with its companion piece. Among them are:

The very similar handling of the brush, with its almost feathery stroking, and its consequent suggestion of softness and "atmospheric" blurring of form and contour. The loose brushing-in of the landscape background, and the similar soft diffusion in the effect of light. The time connoted by the light is as unspecific as it is in the "Nativity," but the suggestion here is one of twilight rather than night.

The similar soft-textured yet calligraphic

[73] No. 46.80.3. Pen and wash, white heightening, 21.6 x 14.8 cm. The Metropolitan drawing is the final stage in a series of studies which include Chatsworth 787D; British Museum 1853-10-8-3; Louvre 6385; Ecole des Beaux-Arts, Coll. Armance 37849.

[74] No. 747. Pen and wash, white heightening, 27.3 x 19.9 cm.

[75] As do also the other authentic Roman drawings of the same theme, conspicuously those at Windsor (0535) and Christ Church, Oxford (M 14B), both preparatory to the etching Bartsch 3.

[76] As with Doria no. 279 there is no available information on provenance. Because of the sketch-like quality of handling Copertini (I, 79) describes the picture as unfinished. Voss (*Kunstchronik*, p. 637) very tentatively suggests the possible identification of this "sketch" with a "Madonna" once owned by Vasari and thus described by him (V, 228-229): "Abbozzò anco un quadro d'una Madonna, il quale fu poi venduto in Bologna a Giorgio Vasari aretino, che l'ha in Arezzo nelle sue case nuove . . ." However, this work is mentioned in Vasari's sequence of pictures as if it were a production of the Bologna period; the Doria picture certainly is not that. The different scale of figures in the two Doria pictures, as well as their lack of iconographical connection, suggests that they are not actually a pair, but this is no argument against their close chronological community.

handling of drapery. (See especially the gauze-like bands on the Virgin's arm with the covering on the left arm of the Virgin in the "Nativity.") Compare also the details of hands, and the calligraphic rendering of the foot of the Christ child with the right foot of the Virgin in the "Nativity." The facial types in the two Doria pictures have a generic likeness, but do not correspond exactly. In the Virgin of no. 281 the face is rather more elongated, her chin more sharply defined, and her nose longer and straighter. She, and to a somewhat less obvious degree the Christ child, tend to a resemblance with the corresponding types of the Madrid "Holy Family" (which just antedates Francesco's arrival in Rome).[77]

The intimate association between this picture and the Doria "Nativity" requires that they be similarly dated. As in the "Nativity," there is no significant change from the manner practiced by Francesco during his last year or so in Parma; but also as in the "Nativity" there is stronger reason to indicate a time of origin in Rome: the motive and the general scheme of composition seem to require some direct experience of the art of Raphael.[78]

MARRIAGE OF ST. CATHERINE (Somerley, Ringwood, Hants., collection of the Earl of Normanton), 1525-1526. II. Panel, .64 x .56 m. Figs. 50-52.

The paint structure has been damaged in a few places nearly to the point of disfigurement. The most obvious damages are in the central area of the panel, where the modeling, and some of the drawing, in the head, torso, arm, and hand of the Christ child have been scrubbed away. The Child's hand has been further damaged by clumsy retouching. The modeling in Catherine's right hand is in part effaced, and the form of her right wrist has been almost altogether obliterated. There is evidence of repaint especially in the high-lighted areas of the face

of the Catherine and in the neck and shoulder of the Virgin. The outline of the Virgin's profile may have been gone over by a later hand. The background shows evidence of uneven cleaning. A film of heavy varnish, thick enough to have developed its own crackle, overlays the whole panel.

The earliest authority for the attribution to Parmigianino of this design is an engraving by Bonasone (Fig. 53; Bartsch XVI, p. 121, no. 47), which bears the legend *FRANC PARM IV*.[79] In 1586, a second record occurs of Parmigianino's authorship of such a "Marriage of St. Catherine," which is, by this record, specifiable as a painting (rather than a drawing, from which Bonasone might conceivably have derived his print). In that year a copy of Parmigianino's painting was bequeathed to the church of San Giovanni Evangelista in Parma, and so described: "Un altro [quadro] di una Madonna et il Putino che sposa Sta. Caterina con un vecchione abaso e duoi teste in prospettiva lontane. Viene dal Parmigianino ma è di buona mano; è di larghezza br. uno et circa on. 2, di altezza un brazzo et circa on. cinque e meggio."[80] Of Parmigianino's original itself there is no direct sixteenth-century notice.

In the seventeenth century there is a further record, in Charles I's collection, of a picture of which the description accords with this design. Parmigianino's name was not connected with this picture; it was described only as a work of the Raphael school. In the eighteenth century, notices of four further versions of this "Marriage of St. Catherine" appear. One of these (inventoried in the Farnese Collection in Parma in 1708) is explicitly described as a copy, but the other three all laid claim to the status of originals. Two of these (one recently in the Westminster Collection, but in 1786, when first recorded, in the Palais Royale in Paris; the other in the Wellington Collection, but earlier, in 1789, in the Royal Palace in Madrid) have since been recognized as unequivocal copies. In the case of

[77] Note that the infant Christ in the Doria "Madonna" seems to have Francesco's own features, and even something of his expression: compare the Vienna self-portrait.

[78] Copertini (I, 79) also dates the picture early in the Roman period.

[79] The print differs from the painting in its omission of the *oeil-de-boeuf* above the door, and in the inclusion of the bust and hand of the male saint in the foreground.

[80] Quoted Copertini I, 95 n. 27.

the Westminster picture there is no possible question, and in that of the Wellington picture hardly less, of their merit of this status.[81]

The third of these pictures which, in the eighteenth century, was claimed to be Parmigianino's original, was in the Borghese Collection in Rome. In 1771 it was engraved in that collection by Camillo Tinti, with the legend *Francesco Mazzola detto il Parmegianino pinxit.* Hitherto the Borghese picture had been thought lost, but it is now possible for us to trace its history.

Sometime before 1814 the Borghese panel was sold from the collection, and made its way to England. In 1814 it was engraved by J. S. Agar in the collection of W. Morland, M.P.[82] On May 19, 1832, this painting appeared in the sale of property of Sir F. Morland, Bart., at Christie's. It was described in the sale catalogue, under lot 102, as "Parmegiano . . . the Marriage of Saint Catherine—the celebrated Picture from the Borghese Palace." The picture was bought at the sale by Seguier, acting for Welbore Ellis, second Earl Normanton. It was removed to the Normanton estate at Somerley where, some twenty-five years later, it was seen by Waagen and described in his supplement as follows: "Parmigianino—The Marriage of St. Catherine. The Child is looking at the Virgin, a slender figure, seen in profile. St. Catherine is also in profile. In the foreground on the left is the powerful old head of a male saint; in a window two other aged heads. One of the most beautiful pictures I know by the master . . . The drawing is delicate, the color blooming and yet harmonious, and the execution very careful in a good impasto."[83]

The picture remains at Somerley. Its identity with the panel which in 1771 was in the Borghese is not only indicated by this history, but proved by its coincidence in precise details as well as in general design with Tinti's engraving (Fig. 54).[84]

Now that it has been rediscovered, the eighteenth-century claim of the Borghese panel to be Parmigianino's original can be examined. The simple fact of the superiority in quality of this painting to the acknowledged copies is striking but not conclusive evidence; more convincing argument is afforded by the qualitative comparisons that can be entirely satisfactorily made with Parmigianino's authentic productions of the same period.

That period is fairly easily determinable. The time of origin of the Borghese "Marriage of St. Catherine" is certainly Parmigianino's Roman phase. In general, the Borghese picture manifests a much closer study of Raphael than is evident in Doria no. 281; however, it does not yet reveal that degree of absorption of Raphael's models into a completely Mannerist synthesis that is evident in the "St. Jerome" altar. In specific motives and details there are numerous analogies both with the pair of pictures in the Doria and with the "St. Jerome" altar, sufficient to confirm the situation of the Borghese painting between them. Where quantitative differences appear in the Borghese panel, they are neatly interpolable between the terms of the Doria and National Gallery works. Some of the more conspicuous likenesses are indicated below.

In the Doria "Madonna" there are generic resemblances with the Borghese picture in the anatomy of the Christ child, in the attenuation of the Madonna's features, and in the manner of disposing the drapery at the right of the figures, in the second plane. In the Doria "Adoration," the male types are considerably like those in the Borghese design; there is a particular resemblance among the heads of the old men toward the rear of both pictures. Further, the right foot of the Borghese Virgin is painted from a formula identical with that used in the Madonna of the "Adoration."

The Madonna in the "St. Jerome" altar more nearly approaches Parmigianino's mature Madonna type than her counterpart in the Borghese

[81] Cf. Copertini I, 78-79.
[82] The drawing for the engraving by W. W. Hodgson.
[83] *Galleries and Cabinets of Art in Great Britain* (London: Murray, 1857), p. 367.
[84] This degree of precise coincidence is demonstrated neither by the Westminster or Wellington

versions, nor by any of the other copies now traceable. For such further copies, of pedigree later than the eighteenth century or of no pedigree at all, see the listing of copies, below.

panel, but some of the characteristics of the former are already manifest in incipient form in the earlier figure. Among these are the exaggeration of the lower proportion of the body, and the tapering diminution of its upper parts. The Madonnas of both pictures, as well as the St. Catherine, wear a similar high-girdled dress, which accents the improbable form and location of the breasts.[85] The headdress of the women in the Borghese "Marriage" anticipates the style, and the calculated rhythmical abandon, of the coiffure of the Madonna of St. Jerome.

These analogies with the surviving works in painting of Parmigianino's Roman period may be supplemented by others, equally convincing, among his graphic production from his time in Rome. The most conspicuous of these analogies is with the etching of the "Adoration of the Shepherds" (Bartsch XVI, p. 7, no. 3; ill. Copertini II, tav. CXVI), where the conception of the composition in general is not dissimilar, and where there is a specific resemblance in the location of a figure in the foremost plane at a lower level. In this same etching the type of older man in a Phrygian cap, who appears in the background of the Borghese panel, recurs.

The profile pose of the Borghese Virgin appears in an etching of a "Madonna and Child" (Bartsch XVI, p. 7, no. 4; ill. Copertini II, tav. CXVIIIa), where there is also a very similar arrangement of drapery over the Madonna's back and shoulders. The profil perdu of the Borghese picture occurs also in Parmigianino's contemporary Roman drawings: in the head at the upper left of the disegno del topo morto (Parma 510/16 recto; Fig. 56), in the figure at the right of the study (Morgan Library) for the Sposalizio engraving (Fig. 40), and in a drawing in the British Museum (1905-11-10-46 verso), from life, of a woman at a taboret.

The quantitative resemblances we have indicated above confirm the dating of this "Marriage of St. Catherine" about 1525-1526.[86] This evi-

dence is supported further by the handling of the Borghese panel, which is intermediate in character between the Correggiesque stroking of the Doria panels and the harder Roman surfaces of the "Vision of St. Jerome." The handling suggests qualitative as well as quantitative comparisons. Where it is not obscured by loss or repaint,[87] the drawing with the brush shows the same swift yet sure and sensitive calligraphy that Parmigianino demonstrates in other near-contemporary works. The painting of the hair and headdresses of both Catherine and the Virgin has the same brilliance as in the Madonna of the "St. Jerome" altar. The brushing of the draperies, especially those of the Catherine, has the same quick and subtle rhythmic movement, and even more variety of textural suggestion, than in the Doria panels. The head of the male saint at the lower left is comparable in its handling of the hair and beard, and in its convincingness of modeling, to the head of the name saint of the National Gallery altar, or to the slightly subsequent head of the donor in the "St. Roch" altar.

Together with the qualitative comparisons we have made above, a further observation takes the apparent originality of the Borghese panel beyond dispute: this is the contrast of its whole pictorial effect with that of the copies. Even with its damages, the Borghese picture escapes the characteristic effect of schematization which betrays the copies. In the Wellington copy this schematization takes the form of what might be described almost as a denial of form, a flattening of all the figures into a pale planarity. In an equally meritorious copy in the New York art market the copyist's schematization has proceeded in the opposite sense, that of an awkward exaggeration of contrasts of spatial relationships within and among the figures. No trace of these copyist's habits of eye and hand mars the fluid, consistent, and aesthetically satisfying organiza-

[85] In Parmigianino's Judith etching (Bartsch XVI, p. 6, no. 1; ill. Copertini II, tav. CXVIIIb) there is the same distortion in the shape and location of the breasts as occurs in the Catherine figure.

[86] There is a vague mention in Vasari (V, 227)

of a painting of ". . . una Nostra Donna volta per fianco con bell'attitudine, e parrecchie altre figure" done for the saddler friend with whom Parmigianino lived in Bologna. Affò (p. 67) had (improperly, in view of the evidence we present) suggested the possible identification of this lost Bolognese work with the Borghese design.

[87] See the summary of damage, above.

tion, on the surface and in space, of the Borghese "Marriage of St. Catherine."

Copies:

Bologna, Museo Davia Bargellini. Recorded in the Museum as "Sacra Famiglia e Santi, imitazione dal Parmigianino." See F. Malaguzzi Valeri, *Il Museo d'Arte Industriale e La Galleria Davia Bargellini* (Reggio Emilia, 1928), p. 16.

Bologna, Pinacoteca. Oil on canvas, .68 x .55 m. Described in the museum catalogue (1935), p. 61) as a seventeenth-century copy. See also E. Mauceri, "Dipinti inediti nella R. Pinacoteca di Bologna," in *Comune di Bologna*, no. 6 (1934), p. 7.

(formerly) London, Collection of Charles I. *c.* .66 x .53 m. Recorded in Vanderdoort's inventory of Charles' collection (London: Bathoe, 1757; p. 10, no. 38). There listed as "A Mantua piece, said to be done by some of Raphael's school . . . being our Lady and Christ sitting sidelong and Saint Catherine kneeling before him, also sidelong . . . in a bright yellow habit, in some part of her upper garment light blew . . . 2 feet 2 inches by 1 foot nine inches." Probably, though not certainly, identifiable with this same design.

London, Collection of the Duke of Wellington. Canvas, .72 x .55 m. Fig. 55. Inventoried in the Royal Palace, Madrid, in 1789. Captured at Vitoria by the first Duke, 1813.

(formerly) London, Collection the Duke of Westminster. Copper, .22 x .17 m. In the Palais Royal, Paris, 1786; to the Westminster Collection, 1820. Sold July 4, 1924, at Christie's. Later in the Collection Charles Brunner, Paris, and in the Collection Agosti. Sold with the Collections Agosti and Mendoza at the Galleria Pesaro, Milan, January 25-29, 1937, no. 253. Ill. in the catalogue of that sale, pl. XLI.

New York, art market. Oil on panel, .74 x .58 m. From the de Cleves Collection.

(formerly) Paris, Musée Napoléon. Engraved by Godefroi in the Galerie du Musée Napoleon, 1813, as by "Niccolo."

(formerly) Parma, Church of San Giovanni Evangelista. *c.* .79 x .64 m. Left to the church by Tiberio Delfini in 1586. This copy was still in the church in the late eighteenth century, and was then described by Affò (p. 67), in contradiction of the evidence of Delfini's testament (see p. 172 above), as an original.

(formerly) Parma, Collection Farnese. *c.* .73 x .68 m. By Sisto Badalocchio. Recorded in the inventory of 1708 (Campori, p. 477).

(formerly) Stuttgart, Collection d'Abel. Canvas, .85 x .62 m. Sold April 1920.[88]

VISION OF ST. JEROME (London, National Gallery, no. 33), 1526-May 1527. I. Oil on panel, 3.50 x 1.53 m. Figs. 57-60.

The National Gallery altar is documented without hiatus from the mid-sixteenth century. It is mentioned in Vasari's first edition, and thus described in the second (V, 224): "Essendogli poi dato a fare per madonna Maria Bufolina da città di Castello una tavola, che dovea porsi in San Salvatore del Lauro in una cappella vicina alla porta, fece in essa Francesco una Nostra Donna in aria che legge, ed ha un fanciullo fra le gambe; ed in terra con straordinaria e bella attitudine ginocchioni con un piè fece un San Giovanni, che torcendo il torso accenna Cristo fanciullo, ed in terra a giacere in iscorto è un San Girolamo in penitenza che dorme." Vasari continues with the report that ". . . quest'opera non gli lasciò condurre a perfezione la rovina ed il sacco di Roma del 1527"; the painting was, by this account, "on the easel" during the first half of 1527.[89]

[88] Sir Robert Witt has kindly communicated to me his partial record of copies from his file of reproductions. Sir Robert owns a copy in drawing after Tinti's engraving (no. 1829 in the Witt Collection; exhibited in the Mostra del Correggio in 1935 as Parmigianino's original preparatory study. The Uffizi owns two further copies in drawing: no. 9203 (described as a copy in the catalogue of the Mostra del Correggio, p. 139) and no. 9284 (a late copy after the Bonasone engraving).

[89] Vasari tells in detail (V, 225; quoted in text above, p. 60) the story of Francesco's experiences with his captors, who interrupted him while he was painting, presumably (though not necessarily, the wording being unclear) at this picture. In spite of Vasari's testimony that Francesco was unable to finish the "Vision" it today seems as finished as one could wish. We believe that Vasari is probably in

When Francesco left for the north, the uncle who had stayed with him during his residence in Rome "si rimase egli per alcuni giorni in Roma dove dipositò la tavola fatta per madonna Maria Bufolina ne'frati della Pace; nel refettorio de'quali essendo stata molti anni, fu poi da messer Giulio Bufolini condotta nella lor chiesa a Città di Castello" (V, 225). The picture was seen by Michelangelo Biondo while still in Santa Maria della Pace, and reported in his *Della Nobilissima Pittura*.[90]

Affò (p. 62) informs us that after its transfer to Città di Castello the painting was removed from San Salvatore del Lauro by the Buffalini, and set up in their palace, "in cui al giorno d'oggi alquanto guasto e scrostato conservasi con gelosía," while a copy was substituted in the church.[91]

After an earthquake in 1790 (whether out of fear for the safety of the work, or because the family required the money for other repairs) the picture was sold to the English painter, Durno. He sold it shortly afterwards for 1500 guineas to the Marquess of Abercorn, from whom it came into the hands of the Messrs. Davis and Taylor. These last sold the painting to the Watson Tyler Collection, which disposed of it (1823) to the governors of the British Institute for 3030 guineas. The Institute finally presented the altar in 1826 to the National Gallery, where it was set up in 1838.[92]

error on this point; a minor one, but which has a certain pertinence in fixing of the picture's date. Because she could see no evidence of an unfinished state in the altar, Fröhlich-Bum (p. 18) rejected all of Vasari's evidence, and quite improbably dated the work at the very beginning of the Roman period. Among all the critics, Fröhlich-Bum is the only one who dissents from a dating in 1527.

[90] *Della Nobilissima Pittura, e della Dottrina, di conseguirla agevolmente et presto* (Venice, 1549), chap. 19; Biondo's reference thus antedates that of Vasari's first edition by a year. A further relatively early sixteenth-century document for the altar is Bonasone's engraving (Bartsch XV, p. 127, no. 62). The engraving carries the legend *F. P. I. V.*

[91] Affò apparently did not see the picture, since he mentions as his informant the Abate Luigi Rondinelli of Città di Castello.

[92] *National Gallery, Catalogue of the Pictures* (London: H. M. Stationery Office, 1921), p. 224.

Preparatory drawings:

London, British Museum, no. Ff. 2.131 verso. Three studies for a St. Jerome. Chalk, pen, and wash, 20 x 14.2 cm. Two of the studies apparently conceived more or less independently of the function and position of the saint in the finished picture; the third study evolving toward the pose of the St. Jerome in British Museum 1882-8-12-488 and 1905-11-10-32.

London, British Museum, no. 1882-8-12-488, recto and verso. Studies for the entire composition. 26 x 15.8 cm. Recto (Fig. 61), pen and brown ink and wash, heightened with white, over red chalk; verso (ill. Fröhlich-Bum fig. 8, p. 20.), red chalk. A stage in the development of the composition antecedent to Parma 510/16 (see p. 138, note 31).

London, British Museum, no. 1905-11-10-32, recto, study for the St. Jerome. Fig. 63. Pen and brown ink and wash with some corrections in white. 11.1 x 11.1 cm. The figure is related in pose especially to that shown on the verso of the drawing above.[93]

Parma, Galleria, no. 510/16, verso (of the *disegno del topo morto;* Fig. 62). Study for entire composition, but with its upper and lower halves disposed side by side. Pen, 19.2 x 13.7 cm. The final stage in the evolution of the design.

(Copy after lost) preparatory drawing. Fran-

[93] The British Museum drawings recorded here are not mentioned by Copertini. Closely related in pose and in general style to the upper half of both recto and verso of British Museum drawing 1882-8-12-488 is a drawing of a "Madonna and Child" in the Louvre (inv. no. 6379, pen and brown wash, 15.9 x 9.2 cm.). This is considered by Fröhlich-Bum (p. 21) to be an authentic preparatory study for the "Vision of St. Jerome," but I find the sheet so badly damaged as to make positive judgment of its authenticity difficult. Also possibly authentic, but not certainly so, is a further drawing for a "Madonna and Child" in the British Museum (Cracherode Ff. 1.94, pen, 21.7 x 11.5 cm.; ill. Fröhlich-Bum, fig. 9, p. 21.) This drawing is cruder, and more summary in its style, than B. M. 1882-8-12-488. A drawing in the Hermitage considered by Fröhlich-Bum to be a preparatory study for the Madonna in the "Vision of St. Jerome" (ill. fig. 10, p. 21) is almost certainly an eighteenth-century drawing, only generally imitative of Parmigianino, and not even specifically of the National Gallery altar.

cesco Rosaspina, print. Two studies for the figure of the St. John, one for the St. Jerome; on a single sheet (ill. Copertini I, *tav.* XLVIa).

Copies:

(formerly?) Leigh Court (near Bristol), Collection of Mr. Miles. Recorded by Waagen (*Treasures of Art in Great Britain,* 1854; III, 185) as a "small version".

(formerly) London, Collection Duke of Westminster, sold Christie's, July 4, 1924. Copper, 31 x 20 inches. Brought from Spain *c.*1760. Once called a "study" for the National Gallery picture. Mentioned in Waagen (*Treasures of Art,* II, 170). Photo Braun no. 29235.

Lovere, Galleria Tadini. A copy of the Madonna and Child only. Described as an original in the Gallery.

ST. ROCH AND DONOR (Bologna, San Petronio, Cappella Gamba),[94] second half 1527. I. Oil on panel, 2.70 x 1.97 m. Figs. 64, 66.

There are three citations of the "St. Roch" in the critical literature of the sixteenth century. The first, by Michelangelo Biondo in 1549, antedates Vasari; this citation considered the painting to be *degna di suprema lode*.[95] In 1550 Vasari described the painting explicitly in his first edition, and again in 1568 in his second edition (V, 226-227), as being the first work of Parmigianino's residence in Bologna: "la prima pittura che fusse in Bologna veduta di sua mano, fu in San Petronio, alla cappella de' Monsignori, un San Rocco, di molta grandezza: al quale diede bellissima aria, e fecelo in tutte le parti bellissimo, imaginandoselo alquanto sollevato dal dolore che gli dava la peste nella coscia; il che dimostra guardando con la testa alta il cielo, in atto di ringraziarne Dio, come i buoni fanno eziandio delle avversità che loro addivengono: la quale opera fece per un Fabrizio da Milano, il quale ritrasse dal mezzo in su in quel quadro, a man giunte, che par vivo; come pare anche naturale un cane che vi è, e certi paesi che sono bellissimi, essendo in ciò particolarmente Francesco eccellente."

[94] Eighth chapel on the left.
[95] Biondo, *Della Nobilissima Pittura,* chapter 19. Biondo mistakenly gives the church as San Pietro.

In 1560 Lamo, in his *Graticola di Bologna,*[96] spoke of the "San Rocco." Lamo described the donor as Baldassare, rather than Fabrizio, da Milano. The "San Rocco" still remains in the chapel for which it was commissioned.[97]

In spite of the sure external evidence of Parmigianino's authorship (which is further confirmed by repeated references in seventeenth- and eighteenth-century sources) the "San Rocco" was practically lost to sight for contemporary critics —in a very literal way. Until relatively recently the picture was almost totally obscured by dirt, and almost impossible to investigate closely on account of its position and lighting. Therefore, though universally accepted as an authentic work,[98] it figured only in brief mention in various contemporary articles on Parmigianino. Its fuller recall to modern notice was in an illustrated article by Antal.[99] It was subsequently cleaned, and exposed in the Mostra del Correggio at Parma (1935).

Copies:

(formerly) Bologna, Galleria Boschi. An inventory of 1777 (Campori, p. 633) mentions a "San Rocco" attributed to Parmigianino which was probably a copy. Now lost.

(formerly) Bologna, Collection Galli. According to Affò (p. 70) a "study" for the head of the "San Rocco" was in his time in this collection.

(formerly) Bologna, Collection Tanasi. By L. Carracci. According to Affò (p. 71) a full-size copy in pastel by Carracci was in his time in this collection.

(formerly) Parma, Collection Maria Garimberti. An inventory of 1627 (quoted Affò, pp.

[96] Quoted from the MS by Milanesi (V, 226, n. 5) and earlier by Affò (p. 70). An additional sixteenth-century documentation of the "San Rocco" is an engraving by Bonasone (Bartsch XV, p. 130, no. 70).
[97] The chapel passed from the hands of the Monsignori family, who owned it in Vasari's time, to a Ravennese noble family, the Gamba-Ghiselli.
[98] Fröhlich-Bum, p. 39; Venturi IX/2, p. 624; Berenson (*Lists*); Copertini I, 100-104.
[99] "Un capolavoro inedito del Parmigianino," *Pinacoteca,* I (1928), 48-53. Antal makes what seem to me some rather extravagant deductions as to the Mannerist spirit expressed in the picture.

CATALOGUE

93-94, n. 2) mentions a *San Rocco del Parmigianino*.

(formerly) Parma, Palazzo del Giardino. A small painting of St. Roch was attributed to Parmigianino in the inventory of 1680 (see Campori, p. 218). The same picture had been cited earlier as a work by Parmigianino by Giacomo Barri, in his *Viaggio pittoresco* of 1671 (English ed., 1679, p. 129).

CONVERSION OF ST. PAUL (Vienna, Kunsthistorisches Museum, no. 68A), late 1527-1528. II. Tempera (?) on canvas, 1.775 x 1.25 m. Figs. 65, 67, 68.

This painting, attributed in the Kunsthistorisches Museum to Niccolo dell'Abbate, was found in the deposit of the gallery and placed on exhibition in 1912.[100] No information is available on its history in the gallery before that date. The picture is not listed in any of the accessible nineteenth-century catalogues of the Imperial Collections in Vienna, nor does it appear in Mechel's catalogue of 1784.[101] It is to be presumed that the painting was in the Imperial Collection earlier than that date, and that it was relegated to the deposit either at the time of the major rearrangement of the galleries in 1781, or before.

The attribution this canvas now bears in the Vienna catalogue was made by J. Wilde.[102] It would appear to have been based on no more than a general resemblance in style with the work of dell'Abbate. Such a resemblance is admitted, but it cannot be confirmed in specific detail, as is necessary to justify a convincing attribution. A careful search of Niccolo's work, both among authentic and attributed pictures, reveals no analogies which are more than superficial. The general resemblance to Niccolo results in fact from the reflection throughout the work of that artist of the style of the actual author of this picture, Parmigianino.

The earliest record of Parmigianino's authorship of this picture, until now considered lost, occurs in Vasari's first edition. There, immediately after his description of the "St. Roch," Vasari says (p. 848): "Poi fece un quadro con un S. Paolo per l'Albio medico Parmigiano, con un paese et molte figure."[103] In his second edition Vasari's mention (V, 227) is substantially the same, but he further specifies the subject as a *conversione di S. Paolo,* and estimates the picture as *cosa rarissima.* In 1560 Lamo, in his *Graticola di Bologna,*[104] mentions the same work: " . . . un quadro in tela, dove dipinto la conversione di S. Paolo di mano del raro Parmigianino." Lamo also gives the owner as Gian Andrea Albio Parmigiano. The support, subject, and presence of the landscape in the Vienna picture are all as documented in these early references. Only Vasari's reference to *molte figure* gives cause for hesitation. His reference was not altogether mistaken: the *figure* in fact exist, but his summary description has omitted to say that they are of miniscule size and in the middle distance of the landscape, and that further only some are men, and others animals. The landscape contains a caravan of camels with three human attendants; a group of bathing lions; and on the left a pack of dogs bringing down a stag.[105]

This identification from sources in the early literature provides us with the first documentation of Parmigianino's authorship and with the history of the picture from the time of its commission to the 1560's. Since there is no subsequent notice of the painting as a work by Parmigianino, this identification must be secured with

[100] *Katalog der Gemäldegalerie* (2nd. ed.; Vienna: Kunsthistorisches Museum, 1938), p. 1. There is no record of the picture in the catalogues of 1928 and 1907.
[101] *Catalogue des Tableaux de la Galerie Impériale et Royale de Vienne* (Basle: *chez l'auteur,* 1784).
[102] *Catalogue* (1938), p. 1. The painting has been published, also as by dell'Abbate, in a brief mention by H. Bodmer in *Correggio und die Malerei der Emilia,* p. xxv and pl. 89.

[103] Albio is identified by Milanesi (V, 227, n. 1) as "Giovannandrea Bianchi, latinamente detto Janus Andreas Albius. Fu archiatro di Papa Pio IV, e morì in Roma nel 1560."
[104] Bologna: Guidi, 1844; p. 22.
[105] A drawing in the Louvre (Donation His de la Salle, black chalk, 9.3 x 7.7 cm., Archives photo 3627) attributed to Parmigianino by Fröhlich-Bum (but which I consider doubtful) may reflect a study for this scene within the landscape.

particular caution from the visual evidence afforded by the picture itself.

The earliest analogy with the "Conversion" in Parmigianino's authentic *oeuvre* dates as far back as his San Giovanni Evangelista frescoes of 1522. The motive of the rearing horse, which here seems so astonishing, appears there in the San Isidoro fresco in a conception quite as sensational. The singular distortions of form are far more evident in St. Paul's horse than in the earlier animal, but Isidoro's horse is conceived with a rhythmical urgency that also does violence to his natural appearance. The connection here is a general one of motive rather than an exact connection; only the drawing of the horse's dilated eye suggests a coincidence in detail.

Much nearer in time to the "St. Paul" is the "St. Jerome" altar, where specific coincidences appear in considerable number. The anatomies of the Baptist and the St. Jerome are conceived on the same pattern as that of St. Paul. The drawing of the heads, and even more of the hands, is strongly similar. The pose and drawing of the foreshortened legs of St. Jerome, but especially of his left leg, intimately resemble those of St. Paul, while the left leg and foot of the Baptist and the right leg of the Paul are of virtually identical construction. Among the other details, the foliage in the foreground of both pictures is drawn in the same calligraphic, lively fashion; further, the manner of indicating the clouds around the Madonna in the National Gallery altar, as darkened areas surrounded by a thin calligraphic edge of light, is the same in the upper left of the "Conversion."

Vasari enters the "St. Paul" in his record as if it had been executed in immediate succession to the "St. Roch" altar. The correspondences between the two paintings are so many that we incline to accept Vasari's word literally. Beside the similarity in the turning motive of the main figure (which we discuss in the text, see above, p. 76) there is the virtual anatomical identity of the St. Roch and the St. Paul: this identity extends from the general shape of the body (with its attenuation of the hips and lower torso and its breadth of shoulder) into all the details of drawing: legs, feet, the forearms with their rhythmical bulge of muscle, and the hands with their excessively elongated, tapering fingers. Paul's head is a slightly more mature variant of that of St. Roch: except for the indicated difference in age they are very alike in the construction of their features and in their expression. Both have the same upturned eyes, with a squarish eyebrow and a line of high light across the lower lid; they have the same slightly opened mouth. The costumes are much alike: each is dressed in a manner reminiscent of Roman military garb, and wears a mantle of which the draping across their shoulders shows a similar pattern of folds. The painting of foliage in both pictures shares a common character with that in the "St. Jerome" altar. The burst of light and the clouds which surround it, similarly placed in both works, is executed on an almost identical formula.

The manner of painting in the "Conversion" seems a little thinner than in the "St. Roch," and the modeling in certain forms (as in the face of St. Paul) less strong. At least two good reasons may be advanced to account for this difference. The first is the less contrasting lighting of the "Conversion": part of the force of modeling in the "St. Roch" emerges from its strongly contrasting illumination. Secondly, we recall that this picture is, in Vasari's sequence, subsequent to the "St. Roch": as we have observed, Parmigianino's tendency as he matures through the Bologna period is increasingly to refine his treatment of surfaces. The head of the title saint in the "St. Zachary" altar of *c*.1530 shows the same fineness and relative thinness, as well as the same exquisite execution of detail, that are evident in the head of St. Paul; in the "Madonna della Rosa" (*c*.1529) there is duplicated not only much of the quality of texture of Paul's drapery, but even its actual linear pattern.[106]

[106] A further reason for the difference in effect of surface and modeling from the "St. Roch" may be the nature of the support: in the "St. Paul" Parmigianino is using the (for him) relatively unaccustomed support of canvas, into which the contrasts tend more than on panel to be somewhat absorbed and diminished. The fine and somewhat linear manner of painting used in St. Paul's head

The "St. Zachary" picture contains a further analogy with the "Conversion" quite as convincing even as that just mentioned of the two heads. The landscape background of the "Conversion," a rare occurrence in Parmigianino's work, here reappears with some change in its contents, but with almost no alteration in its manner of painting. The geology and the flora of these backgrounds are the same in general form and in detail; their handling is identical. The buildings in the landscape are also alike nearly to the point of identity: they are picked out with an edge of light against the background in which their bulk remains half submerged.[107]

The coincidences we have remarked are so specific that they permit us not only to confirm Parmigianino's authorship, but to date the painting exactly as Vasari implied it should be. Our identification of the Vienna "Conversion of St. Paul" with that described by Vasari, but until now lost, thus seems positive.[108]

MADONNA WITH ST. MARGARET AND OTHER SAINTS (Bologna, Pinacoteca), late 1527-August, 1529. I. Oil on panel, 2.04 x 1.49 m. Figs. 71, 72.

Other than St. Margaret the saints are Jerome, a bishop saint who is identified by Vasari as St. Petronius and by Affò as San Benedetto, and an angel (called Michael by Vasari, but simply denominated *un angelo* by Affò, p. 73).[109]

Vasari (V, 228) describes this picture briefly: "fece . . . alle monache di Santa Margherita in Bologna, in una tavola, una Nostra Donna, Santa Margherita, San Petronio, San Girolamo e San Michele, tenuta in somma venerazione, si come merita, per esser nell'aria delle teste e in tutte l'altre parti, come le cose di questo pittore sono tutte quante."[110] Affò (pp. 73ff.) informs us on the basis of documents furnished him by one Signor Marcello Oretti that the painting was set up in the church for which it was commissioned in August, 1529. In 1536, the picture was removed within the church to the chapel of the family Giusti. The Giusti later took the painting out of the church and installed it in their house, where it was seen by Affò in 1782. It was taken by the French in 1796, and returned in 1815 not to the family, but to the Gallery in Bologna.

There has never been any serious question of the chronological situation of the "Madonna with St. Margaret." The documentary evidence provides us with a *terminus ante quem* in August of 1529, and an approximate *terminus post quem* is implied in Vasari's evidence of the prior execution, after Francesco's arrival in Bologna, of the "San Rocco" altar.[111]

(Copies after lost) preparatory drawings:

Florence, Galleria degli Uffizi, no. 1517. The best among a number of copies after a lost study for the entire composition.

Bonasone, in engraving (Bartsch XV, p. 126,

gives a faint suggestion of transparency to the canvas that would not be evident in a work on panel.

[107] In the "St. Margaret" altar, which by our account next succeeds the "St. Paul" in execution, there is one correspondence of detail too remarkable to result from accident: this is the etching of a nearly identical faint pattern, as of a brocade, in the cloak of St. Margaret and the mantle of St. Paul.

[108] Copertini (I, *tav.* LIV) illustrates a drawing of a "Conversion of St. Paul" (in the Biblioteca Palatina, Parma, no. 18200) which he attributes to Parmigianino's Bologna period. The drawing is in our opinion not by Parmigianino, but by a considerably later hand; nor does it recognizably reflect either Parmigianino's manner of draftsmanship or his habits of composition.

[109] According to Copertini (I, 111) an old legal document, cited by Affò's informant Oretti, establishes the correctness of Affò's identifications.

[110] A garbled reference in Biondo (*Della Nobilissima Pittura*) may have been intended to describe this painting. See below in the catalogue of lost paintings under the date 1549, p. 236.

[111] Only one critic, Baldass (*Graphische Künste,* 1921), considers this painting, on the basis of what he feels is its "Correggiesque" character, to be a work of an earlier period. That the "St. Margaret," "St. Roch," and "St. Paul" are in fact closely related in time is evident from the intimate morphological correspondences they exhibit. The heads of the male saints in the "St. Margaret" picture (and particularly the St. Jerome) strongly resemble the portrait head of the donor in the "San Rocco" altar. The head of the angel seems to be a more youthful and more individualized variant of Rocco's own type. The hands of the St. Benedict almost exactly

no. 61). Derived probably from a drawing such as that listed above rather than from the painting.[112]

Copies:

(formerly) Bologna, Casa Sampieri. The inventory of this collection (1743, Campori, p. 600) lists a copy of the "St. Margaret" altar.

(formerly?) Blaise Castle (near Bristol), Collection Harford. Recorded by Waagen (*Treasures of Art*, III, 189) as "An original repetition on a small scale."

Milan, Pinacoteca di Brera (deposit). By Lorenzo Sabbatini (?). See C. Ricci, *Pinacoteca di Brera* (Bergamo, 1907), pp. 141-142.

Paris, Louvre. .46 x .35 m. Possibly that recorded (as an original) by d'Argenville (*Abrégé de la Vie des Plus Fameux Peintres*, Paris, 1762, II, 31; ill. Fröhlich-Bum, fig. 33, p. 43).

Parma, Collection Molinari. Canvas.

Rome, Galleria Colonna. Described as an original in Titi, *Descrizione delle Pitture, Sculture, etc., esposte al pubblico in Roma* (1763), p. 482; entered in the current catalogue of the Gallery ("Holy Family," no. 122). The ascription to Parmigianino was already quite discounted in Affò's time (p. 74).

Vienna, Akademie der Bildenden Künste, no. 272. Oil on panel, .87 x .70 m. See the catalogue of the Akademie (1927), p. 287.

Novellara (?), formerly collection of the Cardinal Gonzaga di Novellara. Campori (p. 659) lists a copy after the head of the Madonna in the Bologna altar as existing in this collection in the eighteenth century.

MADONNA DELLA ROSA (Dresden, Gemäldegalerie, no. 161),[113] 1528-April 1530. I. Oil on panel, 1.09 x .885 m. Fig. 73.

Vasari relates (V, 227) that after Antonio da Trento's theft of his drawings Francesco "Perchè mezzo disperato tornando a dipingere, ritrasse per aver danari non so che conte bolognese; e dope fece un quadro di Nostra Donna con un Cristo che tiene una palla di mappamondo: ha la Madonna bellissima aria, ed il putto è similmente molto naturale; perciochè egli usò di far sempre nel volto de' putti una vivacità propriamente puerile, che fa conoscere certi spiriti acuti o maliziosi che hanno bene spesso i fanciulli. Abbigliò ancora la Nostra Donna con modi straordinari, vestendola d'un abito che avea le maniche di veli gialletti e quasi vergati d'oro; che nel vero avea bellissima grazia, facendo parere le carni vere e delicatissime: oltra che non si possono vedere capegli dipinti, meglio lavorati. Questo quadro fu dipinto per messer Pietro Aretino; ma venendo in quel tempo papa Clemente a Bologna, Francesco glielo donò. Poi, comunche s'andasse la cosa, egli capitò alle mani di messer Dionigi Gianni, ed oggi l'ha messer Bartolomeo suo figliuolo..."

We know the subsequent history of this painting. Gianni (or Zani, in the Bolognese) had acquired the painting in legacy from Clement VII; it remained in the family until 1752, when a descendant, Paolo Zani, sold it (for 1350 *zecchini*) to Augustus III of Poland and Saxony for his gallery in Dresden.[114]

The papal sojourn in Bologna, during which Clement was given the "Madonna della Rosa," lasted from December 1529 to April 1530; our *terminus ante quem* for the picture is therefore

repeat the donor's hands. Further comparisons, hardly necessary to enumerate, may similarly be made with the "St. Paul." See Note 107 above.

[112] The chiaroscuro woodcut of uncertain authorship reworked by Andreani (Bartsch XII, p. 64, no. 24) is based explicitly on such a drawing. A chiaroscuro cut by G. N. Vicentino (Bartsch XII, p. 3, no. 23), which bears the legend *F.P.*, is possibly after a subsequent reworking of the altar design specifically for publication in chiaroscuro, rather than after a drawing preparatory to the painting. This reworked design may not have been by Parmigianino himself, in spite of the attribution indicated in the legend.

[113] The location of the Dresden pictures at the moment of writing is uncertain.

[114] See *Die Staatliche Gemäldegalerie zu Dresden, 1ste abt.,* "Die Romanischen Länder" (Dresden, Baensch, and Berlin: Bard, 1929), p. 79. The "Madonna della Rosa" also appears in Vasari's first edition (p. 849), rather similarly described, but without notice of its ownership previous to Zani. A further sixteenth-century source, Lamo (*Graticola di Bologna*, p. 12), described the painting as existing in the Casa Zani. Another early document is the late sixteenth-century engraving of the picture by Domenico Tibaldi (Bartsch XVIII, p. 13, no. 3).

the latter date. The *terminus post* cannot be defined from external evidence. The strong morphological similarities between the "Madonna della Rosa" and the "St. Margaret" indicate that they are close together in time of origin, but certain stylistic features (see text above, p. 81) imply that the "Rosa" should be somewhat the later painting of the two.[115] The later *terminus ante* gives a certain probability, though not necessarily any logical certainty, to this view.

(Copy after lost) preparatory drawing: A. M. Zanetti, in chiaroscuro (Bartsch XII, p. 163, no. 5). Ill. M. Pittaluga, *Incisione Italiana nel Cinquecento* (Milan: Hoepli, 1928), fig. 198, p. 259.[116]
Copies (according to Vasari V, 228, over fifty copies existed in his time):

(formerly) Bologna, Palazzo Malvezzi. Campori (p. 677) notes that the inventory of this collection contained a copy of the "Madonna della Rosa."

(formerly) Bologna, Palazzo Zani. Mentioned in *Pitture, scolture, e architetture delle chiese e luoghi pubblici, etc., di Bologna* (1792), p. 334. Apparently painted to replace the original, sold by the family in 1752.

Hampton Court, no. 155. Canvas, 1.16 x 91.4 m. Called a copy in the catalogue (1923); confirmed as such by Benedict Nicolson (letter of June 9, 1939). Formerly in the collections of Charles I and James II.

—————————, by Giambatista Bolognini. Mentioned without indication of place by Affò (p. 73).

MADONNA WITH ST. ZACHARY, THE MAGDALEN, AND THE YOUNG ST. JOHN (Florence, Galleria degli Uffizi), *c*.1530. I. Oil on panel, .73 x .62 m. Figs. 74-78. Long cracks extend through the entire length of the

panel, but the paint surface is generally in good condition.

Among the papers preserved in the Parma Library which once belonged to Affò, Copertini discovered and published[117] three documents which virtually certainly refer to this painting. The documents date from 1533 to 1538, during Francesco's second period of residence in Parma. All have to do with the artist's attempts to secure from Bonifazio Gozzadini of Bologna[118] payment overdue for "un quadro ov'è depinta l'Imagine della B.V. col Bambino e l'imagine di S Zaccaria e l'Imagine di S Maria Maddalena" (October 27, 1533). A later document (October 19, 1535) again describes the painting: "un quadro con l'Immagine della B. Vergine, che tiene in braccio il Bambino, S. Giov. Batt., S. Zaccarria e S. M. Maddalena."

In 1543, three years after Francesco's death, the picture was engraved by Bonasone.[119] It would appear that probably in the forties, but possibly even earlier, the picture changed hands[120] for in 1560 Lamo (*Graticola di Bologna*, MS quoted by

[115] Vasari mentions the "St. Margaret" altar after the "Madonna della Rosa," but without any necessary chronological implication.
[116] The two drawings in Budapest (EIV 12*a* and *b*) ill. by Fröhlich-Bum (figs. 31 and 32, p. 41) as preparatory drawings are probably of the eighteenth century, and are derivative either from Zanetti's chiaroscuro or from its lost original.

[117] Archivio Notarile di Parma, rogiti di Andrea Cerati, October 27, 1533, and October 19, 1535; rogito di Luigi Amidano, January 11, 1538. These documents were reproduced in part (and in Italian translation, as here quoted) in Copertini I, 116-118; previously reproduced in an article by the same author: "Il capolavoro del Parmigianino, 'La Madonna di San Zaccaria,'" *Aurea Parma, Anno* XI, *fasc.* 6, 1927, pp. 261-269.
[118] Of whom, and of whose wife, Parmigianino had also painted the portraits during his Bolognese period. See Vasari V, 228.
[119] Bartsch XV, p. 124, no. 54. The date was wrongly reported by Ricci (*Arch. Storico per le provincie Parmensi*, p. 3) as 1527. This engraving does not carry any indication of Parmigianino's "invention," but a subsequent (undated) repetition by Bonasone, in the reverse sense (Bartsch XV, p. 124, no. 55) bears the legend *Fra. Parm. F.* This reversed version turned the Zachary into a St. Joseph. The identification of this saint has given some trouble in the past, for he has been variously described as Joseph or Josiah.
[120] Possibly for some reason connected with Gozzadini's nonpayment. An alternative line of reasoning is that there were two versions by Parmigianino of the "Madonna with St. Zachary": I am reluctant to accept this possibility in view of the nonexistence not only of any other authentic replica by Parmigianino, but even of any record of one.

Affò, p. 69) described: "nel palacio delli man-gioli nobili gentilomini e conti quello raro quadro del Parmigianino con la Mᵃ. e il putto che fa festa a S. Gioaino la madalena e san giacera."[121] Ten years before, in his first edition (p. 848) Vasari had made a most elliptical mention of *un quadro* painted by Parmigianino for Count Giorgio Manzuoli; in the second edition (V, 227) the same elliptical mention occurs. Lamo's description is the key for Vasari's cryptic cita-tion: before 1550 Parmigianino's "Madonna di San Zaccaria" was in the house of the Manzuoli; Vasari assumed that it had been commissioned by them.

There is no record of the "Madonna di San Zaccaria" from Vasari's second edition until 1605 (June 19). It then appears, as a work of Parmi-gianino, in an Uffizi inventory of the paintings exhibited in the Tribuna. The picture is men-tioned again in an Uffizi inventory of 1704, and appears in all subsequent inventories and cata-logues of the Gallery.[122]

The dating of the "Madonna di San Zaccaria" offers no difficulty. Since the picture was com-missioned by a Bolognese, it is logical to consider that it was begun before Francesco's departure from Bologna. The internal evidence indicates a time of execution in the vicinity of, but cer-tainly subsequent to, the "Madonna della Rosa." The chief argument for such a dating lies in the degree to which the types in the "Madonna di San Zaccaria" show characteristics in common with the types of Francesco's second period in Parma. For example, the head of the Madonna in the Uffizi picture shows an oval regularity which is comparable to that of the "Madonna dal Collo

Lungo"; and within this oval the features (and especially the nose) have been given a more regular form than in other Bolognese works. The almost statuary profile of the Magdalene anticipates the Virgins of the Steccata; the Zachary suggests the Steccata Moses; the Giovan-nino resembles the child who, in the "Collo Lungo," leans on the shoulder of the foremost angel.[123]

Copies:
(formerly) Boston, Mass., Collection Castano. A free copy in tondo form, omitting the Zachary.
(formerly) London, Collection Lord Over-stone. Canvas .63 x .53 m. Recorded by Waagen (supplement, 1857, p. 147).
Loreto, Sacristy of the Santa Casa. Partial copy, omitting the Zachary.
(formerly) Milan, Collection Agosti or Men-doza. Oil on panel, .83 x .67 m. From the Erle Drax Collection. Sold Milan, Galleria Pesaro, January 25-29, 1937, no. 254.
(formerly) Parma, Collection Boscoli. c. .82 m. high. The inventory of this collection (1690, Campori no. XXIX) records a version of this painting as *di mano del Parmigianino.*
(formerly) Parma, Collection Farnese. c. .82 x .64 m. Listed in the inventory of the Palazzo del Giardino (c.1680) and in the *Cento Quadri più famosi, etc.* (1725). It was claimed for this work and the picture listed in the Boscoli Collection above that they were replicas by Parmigianino.
Rome, Palazzo Corsini (deposit). Panel, .83 x .60 m. Identified as the original by Affò (pp. 58 and 69); established as a copy by C. Ricci (*Archivio storico per le provincie Parmensi, op. cit.,* p. 3).

[121] Affò apparently did not know the Uffizi paint-ing, for he identified (p. 69) as the work described by Lamo a picture in the Corsini Gallery in Rome, which has long since been relegated to the deposit as a copy (see list below). Affò was followed in this erroneous identification by Milanesi (V, 227, n. 2).

[122] A late inventory of paintings by Parmigianino in Bologna, taken in 1686 by Malvasia, does not mention the "Madonna of St. Zachary." I think we may discount the unsubstantiated tradition that the "Madonna di San Zaccaria" is one of the paintings left to the Uffizi by Ippolito de' Medici. Compare Milanesi, V, 224, n. 1.

[123] In spite of the internal evidence Fröhlich-Bum (p. 22; she did not know the documents) wrongly identified the Uffizi picture with a painting of the "Madonna con Christo, alcuni Angioletti, ed un San Giuseppo," described by Vasari (V, 224) as a work of the Roman period. Venturi (IX/2, p. 630) and Berenson (*Lists*), apparently on the basis of Fröhlich-Bum's erroneous identification, also ac-cepted a Roman dating. It was Voss (*Kunstchronik und Kunstmarkt,* p. 636) who first published the correct identification of the Uffizi picture with the Lamo and Vasari texts, and provided the external evidence for a dating in the Bolognese period.

(formerly) Versailles, Collection Lt.-Gen. Despinoy. See Copertini (I, 128, n. 44), who suggests that this was a copy after the Uffizi painting.

(formerly) Vienna, Lichtenstein Gallery. Described in the catalogue of the gallery for 1767 (V. Fanti, *Descrizione completa di tutto ciò che ritrovasi nella galleria . . . di S. A. di Lichtenstein,* Vienna, 1767, p. 38; quoted Affò p. 89). A partial copy only? This work does not appear in modern catalogues of the gallery.

AMOR (Vienna, Kunsthistorisches Museum, no. 62), 1531-1534. I. Oil on panel, 1.35 x .65 m.[124] Fig. 79.

In the case of the Vienna "Amor," Vasari is at once a source of truth and of error. In his edition of 1550 (p. 851) he mentions the "Amor" among Francesco's works of the second Parma period: "Fece . . . a un gentilhuomo Parmigiano a punti di Luna un Cupido, che fabbricava uno arco di legno, la qual pittura fu tenuta bellissima. . ." The second edition (V, 230) elaborates this description considerably: "In questo medesimo tempo [i.e., the time of his work on the Steccata] fece al cavalier Baiardo, gentiluomo parmigiano e suo molto familiare amico,[125] in un quadro un Cupido che fabrica di sua mano un arco; a piè del quale fece due putti, che sedendo, uno piglia l'altro per un braccio, e ridendo vuol che tocchi Cupido con un dito; e quegli che non vuol toccarlo, piange, mostrando aver paura di non cuocersi al fuoco d'Amore. Questa pittura, che è vaga per colorito, ingegnosa per invenzione, e graziosa per quella sua maniera, che è stata ed è dagli artefici e da chi si diletta dell' arte imitata ed osservata molto, è oggi nello studio del signor Marc'Antonio Cavalca, erede del cavalier Baiardo. . ."

This description of the "Amor" should have fixed the painting and its authorship sufficiently in Vasari's mind. However, in his life of Girolamo da Carpi (VI, 477) Vasari mentions a copy

by Girolamo of the "Amor"; Vasari there attributes the original to Correggio, and asserts that he had seen it in the cell of the Vicar of the Certosa di Pavia:[126] the error is adequately set right not merely by Vasari's own account in Parmigianino's life, but also by other contemporary evidence. A letter from one Anton Francesco Doni, dated 1552, contains the following: "Andando a Parma fate di vedere il Cupido del Parmigianino, il quale è in mano del cav. Bajardo."[127] A further sixteenth-century source, da Erba, mentions the "Amor," by Parmigianino, as existing in Parma (1572).[128]

The "Amor" was left by Baiardo to his heir, Cavalca, but did not long remain in his hands. Before 1585, it had been acquired by Antonio Perez, state secretary in Madrid. In that year Perez fell into disgrace and fled the country; his pictures were confiscated by the Crown. Count Khevenhueller, ambassador and picture agent for Rudolf II, wished to acquire Perez' "Amor" for his master's collection, but negotiation with Perez, then in exile, came to nothing. Rudolf's agent then brought pressure to bear on the Spanish royal house. However, it was not until 1603 that Philip III (the successor of the Philip who had disgraced Perez) consented to part with the picture.[129]

[124] The Vienna catalogue of 1938 notes that 7 cm. at the top, 4 cm. at the bottom, and 2 cm. left and right have been added. The width in all earlier catalogues had been given as .56 m.

[125] Baiardo was guarantor for Parmigianino during his troubles with the Confraternity of the Steccata.

[126] As Copertini (I, 150, n. 11) remarks: "Curiosa invero ed amena amnesia, non certo avantaggiosa per la buona memoria dell'onesto prelato!"

[127] Published in Bottari-Ticozzi, *Raccolta di Lettere sulla pittura, scultura, ed archittetura* (Rome, 1754), III, 238.

[128] E. da Erba, "Compendio dell'origine, antichità, successi e nobiltà della città di Parma," MS of 1572, no. 419 in the Parma Library; quoted Affò, p. 3.

[129] See L. Ulrichs, *Beiträge zur Geschichte der Kunstbestrebungen und Sammlungen Rudolphs II,* 1870 (no. 831 in Battaglia, *Correggio Bibliografia;* Rome, Palombi, 1934). See also the catalogue of the Kunsthistorisches Museum, 1907, pp. 19-20, under no. 62, and the same number in the latest edition of the catalogue (1938). The establishment of the exact date of transfer in 1603 clears up the confusion caused Copertini (I, 151, n. 12) by the poet Tassoni's description of the "original," which he claimed to have seen on his trip to Spain during the *primi anni* of the seventeenth century. Since the "Amor" was in Spain till 1603, Tassoni's notice fits in entirely consistently with the history of the painting. (Compare Copertini, *loc. cit.*) In substantiation

The "Amor" was accompanied in its transfer from the Spanish Royal Collections to Rudolf's galleries in Prague by a fitting companion piece, Correggio's "Ganymede," which at that time was also believed to be a work of Parmigianino.[130] The "Amor" remained in Prague till 1631, when it was transferred to the Schatzkammer in Vienna. Under Joseph II (1765-1790) it was taken to the Belvedere, whence it came with the remainder of the Imperial picture collection to its present place.

As if in retaliation for the imposition of Parmigianino's name upon the Correggio "Ganymede," the error of attribution made by Vasari in the life of Carpi was later revived. The earliest published recurrence of the attribution of the "Amor" to Correggio seems to occur in 1702,[131] and it persisted largely through the eighteenth century (even, in many quarters, till late in the nineteenth). Most eighteenth-century engravings after the "Amor," as well as most of the numerous copies, bore this false ascription. Even in the eighteenth century, however, the attribution to Correggio did not go entirely unchallenged: in the 1740's Zanetti and Mariette were among those who insisted on Parmigianino's authorship. The attribution to Correggio remains in Mechel's Vienna catalogue of 1784 (the first thorough catalogue of the gallery) but was subsequently corrected.[132]

The dating of the "Amor" is less specifically determinable than is the case with many others of Francesco's works.[133] As the early terminus we necessarily establish the time of Parmigianino's arrival in Parma (that is, early 1531);

this terminus may be somewhat advanced, probably into 1532, by the presence in the picture of motives apparently derived from works by Correggio of which the date is generally set in that year. The later terminus can be established only in relative stylistic terms. In all respects of content and form, the "Amor" is not as advanced within Francesco's development as the "Collo Lungo," and should therefore somewhat precede it chronologically. The treatment of surface texture in the "Amor" shows an increase in vitreous character and in minuteness of brushwork beyond the most specific passages in the Uffizi Madonna; at the same time the picture is not quite equal to the "Collo Lungo" in its degree of "finish." More obviously, the canon of proportion has not been refined to the extreme of the Pitti painting: one has only to compare the anatomy of the "Amor" with the not dissimilar figure of the urn-bearing angel in the "Collo Lungo." The chronological distance which separates the "Amor" and the Pitti altar cannot, however, be much, for in both above respects of handling and proportion (and in certain morphological details as well: compare, for example, the *putti* between the Cupid's legs with the *putto* who peers over the urn-bearing angel's shoulder in the "Collo Lungo") the "Amor" stands definitely nearer to the "Collo Lungo" than to the last painting of the Bologna period.

Copies:

(formerly) Brussels, Collection Archduke Leopold William. Noted in the inventory of 1659, no. 412, as by one "Eykens," after Parmigianino.

Copenhagen, Collection G. Nilson. Wrongly published by the owner (1914) as an original. Compare entry no. 584 in Battaglia, *Correggio Bibliografia.*

Dresden, Gemäldegalerie. Panel, 1.35 x .64 m. From the Tuscan Granducal Collections in the early eighteenth century. Ascribed to Correggio as late as 1856.

(formerly) Florence, Collection Cerretani. Until the earlier part of the eighteenth century in the collection of the Cerretani in Siena. Wrongly published in 1882 by A. Wolynski as the original by Parmigianino.

of the departure of the original from Spain before the end of the first decade of the seventeenth century, the Spanish royal inventory of 1611 makes no mention of the "Amor."

[130] See Ulrichs, *op. cit.*

[131] Tolner, *Erinnerung der seltenheiten in und um Wien,* II, 204. No. 834 in Battaglia, *Correggio Bibliografia.*

[132] For a complete documentation of the critical history of the "Amor" as an object of controversy between Correggio and Parmigianino, see Battaglia, *op. cit.,* nos. 27, 76, 78, 80, 108, 221, 305, 834, 836.

[133] Venturi (IX/2, p. 625) mistakenly gives the date of the second Steccata contract as the date of the commission for the "Amor."

(formerly) Florence, Collection Contini.[134]

(formerly) Florence, private collection. Mentioned 1784 by D. M. Manni, in *Osservazioni historiche, etc.* (see Battaglia, *op. cit.*, p. 33, no. 83).

Hampton Court, no. 902. Formerly in the Collection of James II (inventory of James' collection, p. 27, no. 306) as by Parmigianino.

London, Bridgewater House. Formerly in the Collection of the Duke of Orleans in the Palais Royal, where it was attributed first to Correggio, then subsequently to Parmigianino (see Battaglia, *op. cit.*, nos. 48, 49, 865). Acquired by Orleans from the Odescalchi family in Rome in 1722 (see catalogue of the Vienna Museum, 1882, p. 241); previously in the collection of Christina of Sweden in Rome (Campori, p. 342). Described by Waagen (*Treasures of Art*, II, 30) as "a moderate example."

Madrid, Prado, no. 281. Panel, 1.48 x .65 m. In the collection of Philip IV in the Alcazar in 1636. Entered in the inventory of 1666 as by Correggio. The Prado catalogues of 1933 (p. 531) and 1945 (p. 445) describe this as a replica of the Vienna painting.

(formerly) Munich, Collection Leuchtenberg. A free copy by Galanino (d. 1638). Ill. plate 86 in the catalogue of the Collection (1851).

Parma, Collection Pietro Bortesi. Mentioned by Copertini I, 151, n. 13.

(formerly) Parma, Collection Farnese. Two copies, each *c.* 1.31 x .70 m., were mentioned in the inventory of the Palazzo del Giardino (*c.* 1680). One of these was ascribed to Bedoli (Campori, p. 257).

(formerly) Parma, Collection Taccoli-Canacci. Described in the eighteenth century by the engraver Giarré as the original sketch for the finished picture.

Schleissheim, Gemälde-Galerie, no. 1013. Canvas, 1.425 x 1.08 m. By Peter Paul Rubens, signed and dated 1614. A free copy probably after a print or another painted copy. See catalogue of the Gallery (1905). Ill. R. Oldenbourg, *P. P. Rubens* (Munich and Berlin: Oldenbourg, 1922), p. 109.

[134] A photograph is in the files of Dr. W. Suida, New York.

Vienna, Akademie der Bildenden Künste, no. 526. See the catalogue of the collection (1900).

Vienna, Kunsthistorisches Museum. By Josef Heinz. See Vienna catalogue (1938), p. 76, no. 1523.

(formerly) Collection of the Duke of Brescianino. Indicated by Copertini I, 151, n. 13.

————————————, by Girolamo da Carpi. See Vasari (VI, 477) in his life of Carpi, where Vasari mistakenly attributes the original to Correggio.[135]

MADONNA DAL COLLO LUNGO (Florence, Galleria di Palazzo Pitti, no. 230), *c.*1535. I. Oil on panel, 2.14 x 1.33 m.[136] Figs. 80-83.

The picture known as the "Madonna dal Collo Lungo" was commissioned from Parmigianino December 23, 1534, by Elena Baiardi, wife of Francesco Tagliaferri, and relative of the Francesco Baiardo for whom the "Amor" was painted. The payment for the picture (303 gold *scudi*) was made in advance. Parmigianino guaranteed to have the work completed in five months from the date of the contract, failing which he was to restore the sum paid, with interest.[137]

Vasari briefly mentions the "Collo Lungo" in his first edition (p. 851): ". . . et alla sorella del Cavalier Bajardo dipinse una ancona che fu molto stimata." The description in the second edition is considerably more detailed (V, 231): "Alla chiesa di Santa Maria de'Servi fece in una

[135] Copertini (II, *tav.* 3) illustrates as by Parmigianino a drawing of a nude youth seen from the rear (Parma Gallery, no. 510/14, red chalk, 19.6 x 8.7 cm.) which in its pose suggests that it might be a preparatory study, from life, for the "Amor."

[136] Though Fröhlich-Bum (p. 52, n. 1) speaks of the condition of the painting as being ruinous, no other critic has made such an observation. There are numerous minor abrasions, and the left foot of the Madonna is repainted, but there is no major damage.

[137] The document, in the Archivio Notarile di Parma, is published by C. Ricci in *Archivio Storico per le provincie Parmensi*, p. 24. As guaranty for his execution of the contract Parmigianino offered the house which he had inherited from his father in the neighborhood of the church of San Paolo. See Venturi IX/2, p. 625, and Copertini I, 140-141. The architect Damiano da Pleta was selected to decorate the chapel in the Church of the Servi for which the painting was intended.

tavola la Nostra Donna col Figliuolo in braccio che dorme, e da un lato certi Angeli, uno de'quali ha in braccio un' urna di cristallo, dentro la quale riluce una croce contemplata dalla Nostra Donna: la quale opera, perchè non se ne contentava molto, rimase imperfetta; ma nondimeno è cosa molto lodata in quella sua maniera piena di grazia e di bellezza."[138]

From Vasari's note we observe that the painting *rimase imperfetta*. Though almost the entire picture surface has been brought to an exquisite degree of finish, certain small passages are in fact incomplete. The most obvious of these is the head of the Christ child, where the detail of the hair has not been indicated. In the range of columns at the right rear the upper part of only the foremost column has been drawn in, and there is a pentimento of an unfinished foot beside the figure of the man with a scroll (the so-called "prophet") at the lower right edge of the panel.

Parmigianino thus violated the provision of the contract by which he promised to complete and deliver this picture within five months. Unlike the Confraternity of the Steccata, however, the indulgent Elena Baiardi seems not to have harassed the painter; he was never required to make restitution nor compelled to make good his guarantee. Exactly when the picture was delivered we do not know. It probably remained in the artist's studio until his death and the disposition of his property, for it was not set up in the Church of the Servites until 1542.[139] Presumably

after Francesco's death, and before the picture was set up in its chapel, the following legend was inscribed on the second step of the colonnade in the background: *Fato preventus F. Mazzoli Parmensis absolvere nequivit.*

The "Madonna dal Collo Lungo" remained on its altar in the Chiesa dei Servi in Parma until 1698. It was then sold (through the agency of a Count Calvi) to Ferdinando de' Medici, who installed it in the Pitti.[140]

Preparatory drawings:

Chatsworth, Collection of the Duke of Devonshire, no. 790B. Fragment, with parts of three studies for the "prophet." Pen and wash, 10.3 x 7.4 cm. The drawing shows two lower halves of the prophet figure (one striding forward, the other moving obliquely to the left) and, at the bottom of the sheet, the upper half of a study for the same figure.

London, British Museum. 1905-11-10-52. Study for the "prophet." Fig. 84c. Pen and brown ink with wash, 7.7 x 2.8 cm.

London, British Museum. 1905-11-10-61 (Fig. 84a) and 1905-11-10-62, recto and verso. Studies for the drapery of the Madonna's torso. Pen and brown ink on pink tinted paper, 8.5 x 6.2 cm.

Oxford, Ashmolean Museum. A single sheet with three studies for the figure of the "prophet," accompanied by a priestly figure to whom he

[138] Vasari's mention of a cross painted in the urn is mistaken. What the origin of this notion may have been we do not know. It is curious to note that an engraving by Ant. Lorenzino (first half of the eighteenth century) shows such a cross; possibly out of deference to Vasari. The undated nineteenth-century *Galerie des Peintres Célèbres*, in pl. 23 of the volume devoted to Correggio and Parmigianino, reproduces an engraving by Reveil of a "Madonna and Child" subject with the legend *Parmigianino inv*. In this composition the child (but not an angel, as Vasari notes in his description) bears an urn, within which is reflected a cross. It is impossible to tell from the print whether the original of this composition was actually a (now lost) work by Parmigianino or not.

[139] Affò (p. 84) records the inscription formerly

in the chapel: *Tabulam praestantissimae artis — sacellumque a fundamentis erectum—helena Bajardi—uxor Equitis Francisci Talliaferri—honori beatissimae Virginis — . . . anno MDXLII.*

[140] A previous effort, in 1674, to sell the altar to Leopoldo de' Medici had failed. The actual sale of 1698 brought a law action in its trail, for the owner of the rights to the former Baiardi chapel, one Count Cerati, disputed the right of the monks to sell what he considered his property. In spite of a verdict by a doctor of laws in Cerati's favor the case was settled against Cerati in the simplest way: Ferdinando de' Medici requested the Duke of Parma to put pressure on Cerati to drop his suit. In 1717 Parmigianino's picture was replaced in the chapel by a copy (attributed by Ratti, *Notizie Storiche*, to Cesare Aretusi), and the replacement celebrated by a tablet. The copy has also since been removed. See Affò (pp. 84-85), Ricci (Parma catalogue, 1896, p. 309), and Copertini (I, 152, n. 18). The last reference contains the most complete account.

reads his scroll. Fig. 85*a*. Pen, 14.0 x 17.7 cm. From the Arundel, Zanetti, Vivant-Denon, and Lawrence Collections.[141]

Paris, Louvre, inv. no. 6384. Madonna and Child seated, the seat on a low basis; the Madonna extends her hand in blessing over the heads of a bearded man and a boy. At the right, lightly sketched and partly washed over, the full-length figure of a draped male, with head bent as in meditation. Fig. 86. Pen, chalk, bister, and wash, 24 x 19.5 cm. Either the earliest of the surviving *pensieri* for the "Madonna dal Collo Lungo" or, less probably, an independent *concetto* precedent to the commission of the "Collo Lungo" from which the idea of that picture evolved.[142]

Parma, Galleria, no. 510/8. Study for the "prophet." Fig. 85*b*. Pen, 17.5 x 7.9 cm.[143]

[141] Engraved in part while in Arundel's collection by Lanière; then by Zanetti in 1723. The Zanetti engraving ill. Copertini I, *tav*. LVII. Subsequent collections in which the drawing was owned after the Lawrence Collection were the French collections of Count Nils Barck, Galichon, and Thibaudeau. The drawing was published and illustrated by J. Isaacs, "The Collector of Drawings," in *Apropos* (London: Pilot Press, n.d. [1945?]), pp. 1-8, ill. fig. 3, p. 4.
[142] Published by Fröhlich-Bum (in "Studien zu Handzeichnungen der italienschen Renaissance," *Jahrbuch der Kunsthistorischen Sammlungen in Wien*, NF II, 1928, pp. 173-183) as a design for a "Holy Family."
[143] Brandi, in the Mostra del Correggio catalogue (p. 147, n. 39), prefers to consider Parma 510/8 as a drawing for a St. John Baptist rather than a study for the "prophet" of the "Collo Lungo."
Uffizi no. 13620 (a male nude, reading from a book to a second figure with him, pen, 6.7 x 6 cm.; Fig. 84*b*) does not seem to be a preparatory drawing, in the strict sense, for the "Collo Lungo," but it is related in its motive to that of the prophet and his companion, and it is comparable to the preparatory drawings in style. This drawing differs from the other "prophet" drawings in the direction of the figures, and in the seeming youthfulness of its types. It may be either an anticipation, or a later recollection and reworking by Parmigianino, in some other context, of the motive in the "Collo Lungo."
Among the drawings which Fröhlich-Bum illustrates as preparatory studies for the "Collo Lungo" are two in the Louvre (no. 0577 and 6378, fig. 44 and 45) which show the Madonna and Child with attendant figures in an architectural setting. Neither of these drawings is, in my opinion, authentic; they

Copies:
Chatsworth, Collection of the Duke of Devonshire. A partial copy.
Hampton Court, no. 106. Called in the catalogue of 1914 "Holy Family with Four Angels, after Parmigianino."

conspicuously do not bear comparison with the style of the authentic Louvre drawing 6384. Both seem to be examples of later imitations. Fröhlich-Bum's fig. 44 seems to be derived from the painting, but it is possible that the drawing in her fig. 45 may be based on a lost preparatory study actually by Parmigianino. Should this be true, this drawing would be evidence of a stage in the development of the composition subsequent to Louvre 6384. A chiaroscuro print by A. M. Zanetti (Bartsch XII, p. 174, no. 34) would also appear to have derived from such a (presumable) lost stage among Parmigianino's preparatory studies.
Fröhlich-Bum's fig. 48 (p. 54; Louvre inv. no. 6381) strongly suggests the hand of Bedoli. The same skilled but nevertheless derivative hand may be responsible for the drawing (also alleged to be a study for the "Collo Lungo") in the Morgan Library (red chalk, 19.1 by 13.2 cm.). A drawing of the Madonna and Child, in Parma (510/26), is by a far less able hand.
Two further drawings considered by Fröhlich-Bum (in *Jahrbuch der Kunsthistorischen Sammlungen in Wien*, 1928), to be preparatory studies for the "Collo Lungo" are, in my estimation, not such. Louvre 6469 (a "Holy Family" [?], ill. *ibid.*, fig. 235, p. 173) though an authentic drawing, is of the Roman period; Louvre 6387 ("Madonna and Child with the Infant St. John"; ill. *ibid.*, fig. 236, p. 174) is not surely by Parmigianino, and may be related in its authorship to Louvre 6381 cited above.
Many drawings of the "prophet" are improperly attributed, in particular that in the Uffizi (no. 1484) which shows five studies of a draped male form in an attitude only remotely comparable to that of the figure in the painting. Considerably closer to Parmigianino in its style, but in our opinion yet not certainly authentic, is a small drawing for the "prophet" and his companion, one of five drawings on a Mariette mount in the Louvre (R. F. 584; published by Fröhlich-Bum, "Unpublished Drawings by Parmigianino," *Old Master Drawings*, vol. IX, no. 36, 1935, p. 56; ill. pl. 60). Very sketchily indicated beside the leg of the "prophet" in this drawing is the head of an animal, seemingly a lion; this may have been intended as an identifying attribute. If this drawing were certainly by Parmigianino, and the prophet figure in fact a St. Jerome, an iconographic interpretation for the picture could be suggested which would relate it to the "visionary" theme of the altar in the National Gallery.

New York, Collection of Frederick Freund. Canvas, 2.05 x 1.63 m.

Parma, Galleria, no. 62. Oil on canvas, 2.10 x 1.28 m.

(formerly) Parma, Collection Farnese. The inventory of the Palazzo del Giardino (c.1680) lists a copy by Cesare Aretusi.

Parma, Collection Giuseppe Magawli-Cerati. This is apparently the copy which was substituted for the original when Parmigianino's painting was sold. It was removed from the Cerati chapel in the Church of the Servi di Maria by the family before the middle of the eighteenth century (see Ratti, *Notizie del Correggio, op. cit.*, p. 150; and Affò, p. 85, n. 1). Ratti considered the copy as by Aretusi. Compare the entry above.

(formerly) Parma, Collection Sanvitale.

(formerly) Parma, Collection Scutellari.

(formerly) Parma, Collection Smitti.

(formerly) Parma, Collection Taccoli-Canacci. According to Ricci (Parma catalogue, 1896, p. 314) the old inventories of these four collections listed copies after the "Collo Lungo."

Rome, Galleria Borghese, no. 109. Canvas, .78 x .56 m. A free copy in which the Madonna has been transformed into a St. Catherine (see catalogue of the Gallery, 1893, p. 88).

FRESCO DECORATION (Parma, Church of Santa Maria della Steccata), 1531-1539, but mostly after 1535. I. Figs. 87-103.

North (left) wall of the vault preceding the apse:

"Moses," "Three Virgins Bearing Lamps," "Adam." Decorative latticework, garlands, etc.

South (right) wall:

"Aaron," "Three Virgins Bearing Lamps," "Eve."

While the North wall is entirely from Parmigianino's own hand, the South wall is for the most part the work of an assistant following Parmigianino's design.

Thanks to the careful investigations of Amadio Ronchini in the middle of the last century, and of Laudadeo Testi in this, the archives of the Steccata have yielded almost an embarrassment of riches in the way of documentary material on Parmigianino's activity in that church.[144] Among these documents is an informal agreement by Parmigianino to undertake the Steccata commission; it is apparently preliminary to the regular contract. This agreement describes in some detail the project on which the artist and the Confraternity of the Steccata have determined in accord, and indicates that designs therefor had already been submitted. Parmigianino's letter of acceptance reads: "Io, Francesco Mazollo pictor, prometto alli spectabili Signori Fabricanti de la Chiesa de Santa Maria della Steccata, pingere la nicchia cioè el cubo ovvero volta de la detta Cappella grande e farvi come hanno propuose una Incoronazioni et observando la metta del disegno qual hanno visto, mettendo li colori così d'azzuro fino come d'altre sorte et nelle rose de li lacunari et nel campo di esse rose e questo a spese di me maestro Francesco.

"Item la fascia delli lacunari insieme con quelle due fascette piccole e a dipingere insieme con il fregio il cornisone et architrave eccettuando fora li ori, i quali ci entreranno in li detti corni-

[144] As well as in the Steccata archives, much documentary material of importance for the history of Parmigianino's experiences in the Steccata has been found in the Archivio Notarile of Parma. While the first profound and systematic search of the documentary sources is due to Ronchini (published under the title "La Steccata di Parma," in *Atti e Memorie della Deputazione di Storia Patria per le provincie modensi e parmensi, Anno 1863*), the work of Testi has been still more thorough, and it is on the material he discovered (published and interpreted in *S. M. della Steccata in Parma*, Florence, Battistelli, 1922, especially pp. 117-142) that our conclusions are largely based. The documentary material adduced by Copertini in his section "Gli affreschi della Steccata" (I, 157-186) also depends mostly on Testi. The documents are reasonably complete and for the most part unequivocal; Testi, Copertini, and myself agree fundamentally in our interpretation of most of the documents, especially with regard to their implication for the dating of the frescoes. The Steccata documents appear in the MS volume in the Steccata archives: "Storia dell' Ordine Constantino—Pitture ed. architetture nella Chiesa Magistrale—Anno 1531-1547," vol. VI, and in the file of the notary Benedetto del Bono in the Archivio Notarile of Parma.

soni, che circondano la ditta capella; etiam se in le ditte fascie entrerà oro, li detti Signori Fabbricanti siano obbligati a darlo e pagare la mettitura del detto oro.

"Item che li Signori Fabbricanti me diano le rose, che vanno alli lacunari insieme con l'oro che gli anderà e pagar la mettitura, che anderà a mettere dite rose de oro.

"Item che li detti Signori Fabbricanti siano obbligati a darmi li ponti fatti, armati, con la comodità che vanno a tale opera, a tutte sue spese, et etiam che siano obbligati a farmi smaltare a mia comodità per il pingere.

"Item li infrascritti patti si intendono dal trave inclusive in su, il quale lega da torno la detta Capella.

"Item il prezzo della soprascritta opera sia di quattrocento scudi d'oro del sole, cioè che li detti fabbricanti danno a me detto Francesco Mazollo per la mia manifattura.

"Item sia obbligato a dar l'opera fornita intra il termine di mesi diciotto prossimi che verranno."[145]

This document bears no date, but it evidently served as an informal statement of the terms and conditions which were stabilized in the contract of May 10, 1531.[146] As the informal agreement and the regular contract indicate, the payment for the Steccata enterprise was to be four hundred gold *scudi*, and it was stipulated that the work was to be completed within eighteen months. Until November 6, 1532, there are records of

[145] In the Steccata archives, vol. VI, doc. A. Here quoted as transcribed by Copertini (I, 158-159) with its spelling in part modernized. Testi transcribes the same document (*S. M. della Steccata*, pp. 265-266) in its original spelling. Copertini considers the document an autograph, while Testi considers it a contemporary copy.

[146] The original contract, drawn up by the notary Benedetto del Bono, was not found by Ronchini among the papers in the Steccata. It was discovered by Testi among del Bono's files in the Archivio Notarile, and was published (in part) by him (*S. M. della Steccata*, p. 118). The terms of the original contract are repeated in a renewal made December 27, 1535, and in a document of September 19, 1544 connected with litigation against the Steccata by Francesco's heirs. Both these later documents were also drawn up by del Bono, and exist among his papers in the Archivio Notarile.

various payments made to Parmigianino, but the work was clearly not progressing satisfactorily. On that date (four days before the expiration of the original contract) Francesco had collected only up to one-half of his total fee: it had been specified in the contract that payment should reach this amount on the completion of the cartoons and the *beginning* of the work of painting.[147] From November 1532 until June 9, 1534, the Steccata documents make no mention of any payment to Parmigianino. However, on the latter date, and until February 13, 1535, the records indicate the delivery to Parmigianino of considerable quantities of gold leaf for the gilding of cornices and architrave.[148]

It would seem that by mid-1535, more than four years after the award of the commission, Parmigianino had progressed so little in the execution of his project that the patience of the Confraternity was exhausted, and they asked the artist to forfeit the sums which had already been paid him. Certain of Francesco's *amici boni e nobili*[149] intervened, and were able to induce the Confraternity to reëntrust Francesco with their commission. On September 27, 1535, a new contract was signed;[150] it quite specifically indicated the new terms, in money and in time, on which Parmigianino must work. This contract gave Parmigianino two years ". . . da compiere l'opera, cioè l'anno prima abbia a dipinger la Fascia grande con i lacunari e Fregio e sottofascia di fuori a detta cappella e nell'altr'anno seguente tutta l'opera della nicchia."[151] It is clear from this document that Parmigianino had executed next to nothing of his intended original project. That he had at least started on it is indicated by ". . . abbia da compiere l'opera," but the "abbia a dipinger la Fascia grande, etc." indicates that he had yet to paint at least the greater part of

[147] See Testi, *S. M. della Steccata*, p. 121, and Copertini I, 159.
[148] See Testi, *Steccata*, p. 122 and n. 12.
[149] They are so referred to in the document of September 19, 1544.
[150] In which we are informed of the previous action for restitution. For this contract see Testi, *Steccata*, p. 126, and Copertini I, 162-165.
[151] As translated from the Latin contract by Copertini I, 163.

the vault; "nell'altr'anno seguente tutta l'opera della nicchia" indicates that he had not yet touched the semidome of the apse.

What, then, had Francesco actually executed up to the time of the signing of the new contract in September 1535? In the beginning, there seems to have been difficulty with the preparation of the scaffoldings.[152] This may have provided the excuse for the Confraternity's original leniency with Parmigianino's delay. Once the scaffoldings were up he may have spent such time as he chose to give to the church in the execution of the decorative ornament: he certainly closely supervised, if he did not himself execute, much of the gilding.[153] The terms of the new contract are not specific enough to enable us to tell whether or not any of the figures had by then been executed, but their wording gives one the impression that in September 1535 Parmigianino was confronted in the Steccata largely by bare wall.

In October and November of 1535 payments were being carefully doled out to Parmigianino in accordance with the terms of the second contract.[154] In April 1536, a single small consignment of gold leaf was sent to Francesco.[155] But by June 3, 1536, he had apparently advanced his work very little beyond the state in which the contract of the year before had found it, for on that day a legal notice—an *intimazione podestarile*—was sent him and his guarantors by the Confraternity. This informed him that "dovesse recarsi sopra la stessa opera, ed insistervi e non desistere da essa fino a che non l'avesse finita, come avesse promesso, e che non dovesse trascurare quell'opera, nè differirla, come l'aveva differita e trascurata fino a quel giorno." Nor did it seem to the Confraternity, when they sent this note, that "lo stesso maestro Francesco potesse adempiere alla sua promessa per la brevità del tempo."[156]

By the twenty-sixth of February, 1538—five months after the expiration of the second contract, and almost seven years after beginning the work—Francesco had still not executed the first half of his project. A document of that date informs us that "passarono li detti due anni, e non perfezionò nè la fascia, nè lacunari, nè il friso e sottofascia."[157] The Confraternity therefore took action for restitution of their money, but Francesco's guarantors[158] achieved a seemingly miraculous extension of time for the artist until August 26, 1539, in which he might attempt to finish his job.

From June of 1538 to the twelfth of April 1539, Francesco is recorded as working at (or supervising) the decorative gilding, especially of the recently installed metal *rosoni* which fill the coffers of the ceiling,[159] but there is no documentary mention of his being engaged specifically in painting. At any rate, whatever Francesco did during this extremely indulgent extension was not enough to discharge his obligations to the Confraternity, and he was finally dismissed. The first documentary notice of his dismissal is the record of a proposal voted December 19, 1539, by the Confraternity of the Steccata; it virtually excommunicates Parmigianino from any further participation in the decoration of the church, and indicates the resolution of the Confraternity to replace Francesco by another artist. The document concludes:

"A chi piace de le S. V. che conclusivamente si ordina et statuisce che magistro franco mazolo pictore non si habbia più per modo alcuno intromettersi nè impacciarsi della pictura della cappella grande della giesa nova della Madonna della Steccata: immo che per il presente partito sia escluso et excomiato da detta opera et che si ponga perpetuo silenzio de confirmarlo più

[152] Francesco's heirs accused the Confraternity of delay in erecting the scaffoldings (document of September 19, 1544).

[153] See Testi, *Steccata*, pp. 122-125.

[154] See Testi, *Steccata*, pp. 126-129 and n. 21 and 22.

[155] See Testi, *Steccata*, p. 122, n. 12.

[156] Arch. Steccata, vol. VI, document H, as trans-

lated from the Latin by Copertini I, 166. Francesco's lawyer was able successfully to protest the legality, if not the content, of this *intimazione*. See Testi, *Steccata*, p. 130.

[157] Rogito del Bono, February 26, 1538, quoted Copertini I, 190, n. 10.

[158] Francesco Baiardo, who commissioned the "Amor," and Damiano da Pleta, architect of the chapel for the "Collo Lungo."

[159] See Testi, *Steccata*, p. 122, n. 12, and p. 130.

nella detta opera: immo chel si proveda de uno altro pictore da esser condutto per la Compagnia da parte d'essi officiali, a chi si darà la facultade, et questo per la inobservantia sua delle cose promesse tante volte per lui circa ciò dia la fava. Obtentum fuit nemine discrepante."[160]

Sometime between the expiration of the third contract and the above declaration Francesco was confined to prison for a brief time on account of his breach of contract.[161] After his release, and possibly before the date of his final dismissal, he fled from Parma to Casalmaggiore, accompanied apparently by a few of his dependents.[162] The measure of hostility which had grown up between Parmigianino and his employers in the Confraternity may be judged from the fact that before his flight the artist inflicted certain spiteful, though seemingly insignificant, damages on his own work.[163]

Certain general facts emerge clearly from the documentary history of the Steccata. Progress on Parmigianino's commission was painfully slow:

[160] Arch. Steccata, vol. VI, document M; as reproduced in Testi, *Steccata*, p. 137, n. 35.

[161] The clearest and seemingly most positive evidence of Francesco's confinement is the document of September 19, 1544, which contains the information that after he had done the "faxiam et subfaxiam cum lacunaris, non autem nichiam et postea cessasse, et post carcerationem de eo factam dicta de causa non perfecti operis praedicti, et eius relaxationem, obiesse" (quoted Testi, *op. cit.*, p. 137). Other evidences, though less definite, confirm the fact of Francesco's imprisonment. There is the phrase in Parmigianino's letter to Giulio Romano (see below): ". . . m'è parso col più bel modo levarme da le sue forze . . ." i.e., of the Confraternity; also the statement of Vasari in his first edition (p. 851): ". . . fu preso, et messo in prigione," which is however replaced in the second edition by the ambiguous ". . . gli mossero lite. Onde egli per lo migliore si ritirò . . ." Finally, there is the late report of Armenini (1587): ". . . fu perciò con poco suo honore posto prigione . . ."

[162] As appears from the wording of Francesco's letter to Romano (see below), Francesco may not have been in Parma when he was finally relieved of his commission; his departure for Casalmaggiore would seem to postdate the end of August and predate the 19th of December 1539.

[163] See the document of September 19, 1544. The same document repeats in three places the statement that Francesco had damaged his own work. See Testi, *Steccata*, p. 137, n. 34.

virtually nothing of the work in fresco seems to have been done before the second contract of 1535; after that date the painting seems still to have but crept along. The total project was so far from completion by the end of the period of extension granted beyond the second contract (eight years and three months after beginning) that the Confraternity was moved to prosecute and irrevocably dismiss the painter.

At the time of Francesco's flight from Parma the semidome of the apse (the major part of the project) was still utterly innocent of paint. After his departure, the Confraternity of the Steccata determined to seek another artist to provide the design and cartoons for the "Coronation of the Virgin" which was to occupy that place; their choice fell on Giulio Romano as designer, with Michelangelo Anselmi as executant.[164] On April 4, 1540, Francesco wrote to Giulio from Casalmaggiore pleading that he refuse the Confraternity's commission. The letter is of interest not only biographically, but for the archaeological conclusions we may draw from it:

"Molto magnifico maestro Julio salute.

"Per esser nato a dì passati più de uno po' de discordia fra una certa Compagnia e io d'una mia opra nela Steccata de Parma m'è parso col più bel modo levarme da le sue forze e non però dall'opra la quale potrò fare così fenire in Casalmaggiore come la faceva in Parma e non lì manca da fare se non una certa Nichia e da me non manca ogni volta che io sapia d'havere il mio premio; la causa del mio scrivere ala S. V. è stato che si dice per Parma che parte de questi de la Compagnia se sono acordati con la S. V. e che quelo li fa li desegnij et lorj se la fanno mettere in opra a chi li piacerà. Questo me tornaria danno de trecento scudi quela se dignarà scrivermi e darmi aviso a cercha di questo perchè Io non so che dir se non ch'io penso che quela mi ama come io ama lei.

"Ancora quela se potrà chiarire del presente mio Amicissimo; De Casalmaggiore ali 4 de Aprile MDXXXX.

[164] Giulio's contribution was in fact eventually confined to a water-color design, from which Anselmi drew his cartoons. See Rogito del Bono, May 8, 1541, in the Archivio Notarile, reproduced Testi, *Steccata*, pp. 276-277.

D.v.s.

Franco Mausolo

"Al molto Mag.co Sig.r. M.r. Giulio Romano pittor Dignissimo e zentilomo del Ill.mo Ducha di Mantua in Mantua."[165]

In this autograph Francesco states that he had yet to do the half-dome, but that the vault had been finished. This statement is accurate; it appears again in the document of September 19, 1544: "[perfecit] . . . faxiam et subfaxiam cum lacunaris, non autem nichiam . . ."[166] However, it also appears from Francesco's words that it was not he personally who had finished the entire vault, for he states that he would be able to have the work in the apse done while he himself remained in Casalmaggiore: "come la faceva in Parma," as he was doing in Parma, which could be only by leaving the execution to others.[167]

In 1566, Vasari inspected the Steccata at length under the guidance of Francesco's cousin and contemporary, Bedoli.[168] Vasari described Parmigianino's work in the church as consisting of "sei figure, due colorite e quattro di chiaroscuro molto belle, e fra l'una e l'altra alcuni molto belli ornamenti" (V, 229-230).[169] Whether or not his numeration of the figures done by Francesco is correct, Vasari at least leaves no doubt that, on information furnished him at the site by Bedoli, Francesco had in fact not himself executed all ten of the figures on the east vault.

The visual evidence is as unequivocal on this point as is the external evidence: the decoration on the south wall of the vault appears to be for the most part the work of a conscientious but limited assistant, who evidently used the same cartoons, without variation, that Francesco had drawn for the north wall. Francesco's share at most in the actual execution of the south wall seems to have consisted of the painting of the Eve in chiaroscuro, a part in the painting of the right-hand one of the three Maidens, and less possibly, the painting of the Aaron.[170] The difference in quality from the north wall cannot be explained by the assumption of work done by Francesco in great haste, to satisfy the insistent demands of the Confraternity as time drew toward the expiration of the last contract: the technique in the Maidens of the south wall is, if anything, more labored and detailed than in the north wall. It is not the same hand, working at a lesser level of quality, but for the most part simply another and lesser hand.[171]

[165] From the Arch. Steccata, vol. VI. Originally published by Michelangelo Gualandi, *Nuova Raccolta di lettere sulla pittura, etc.* (Bologna, 1845). Reproduced in Testi, *Steccata*, pp. 270-271; Fröhlich-Bum, p. 58; Copertini I, 177-178. For Romano's reply see Testi, *Steccata*, pp. 271-272. Testi also gives in considerable detail, and with excellent documentation, the subsequent history of the decoration of the semidome and of the other vaults in the Steccata.

[166] See n. 161, above.

[167] Copertini (I, 191, n. 26) will not admit that this passage implies the use of assistants, but insists that Parmigianino would have had the half-dome done by others "as well" (i.e., in quality) as he had himself done the part of the commission already executed. Copertini's interpretation would be permissible only if the document were regarded separately from the visual evidence.

[168] See Vasari VI, 487.

[169] More fully, the phrase is preceded by: ". . . gli fu subito dato a lavorare in fresco nella chiesa di Santa Maria della Steccata una volta assai grande; ma perchè inanzi alla volta era un arco piano che girava secondo la volta a uso di faccia, si mise a lavorare prima quello, como più facile; e vi fece sei figure, etc. . . ." The Steccata frescoes are less accurately described by Vasari in the first edition (p. 850): ". . . poi tolse a fare alla Madonna della Steccata una opera grandissima a fresco, nella quale andavano alcuni rosoni per tramezi in ornamento: i quali egli si mise a lavorare in rame, et fece in essi grandissime fatiche. Et lavorando questa opera fece alcuni profeti e sibille di terretta e poche cose in essa a colori, nascendo ciò dal non contentarsi."

[170] This is in substance the estimate of Testi (*Steccata*, p. 224, and in his *Parma*, Italia Artistica series, vol. XIX, 1905, p. 86). We quote from the former: (the figures on the south wall) "debbono ritenersi disegnate pure da Francesco Mazzola e ritoccato in fresco da lui, ma forse preparate dagli aiuti." Fröhlich-Bum (p. 61) agrees essentially with this opinion. Only Copertini (I, 191, n. 26) specifically rejects the idea of any assistance or collaboration.

[171] The use of Francesco's own cartoons for the Maidens on the right (south) wall is on the whole very literal; this lack of inventive freedom would in itself suggest the practice of the assistant or imitator. In spite of the careful attempt to reproduce Parmigianino's forms and manner there are acutely evident differences in quality between the Maidens

CATALOGUE

Preparatory drawings:

Budapest, Museum, no. EIV, 35a. Study for one of the female figures, holding garlands (in the frieze along the side of the vault). Pen and wash, 14.4 x 8.5 cm. (ill. Fröhlich-Bum, fig. 106, p. 88).

Florence, Uffizi, no. 1982. Study for the Adam. Fig. 108c. Pen and wash, 8.9 x 3.2 cm. Compare Uffizi 1984, of which this is evidently a companion study. See also the studies for the Adam, British Museum 1895-9-15-754, 5 and 6, recto.

Florence, Uffizi, no. 1984. Study for the Eve. Fig. 108d. Pen and wash, 8.5 x 3.7 cm. Compare the study for Adam, Uffizi 1982, and the studies for Eve, Windsor 0575, 6 and 7, as well as the print by Rosaspina, listed below, after a similar lost drawing.

Florence, Uffizi, no. 9226. Study for the Adam. Fig. 108a. Pen, 9.5 x 4 cm. Based on an imprecise recollection of the Adam in Michelangelo's "Temptation" in the Sistine. A very early *pensiero* for the figure, probably antecedent to the

of the left wall and those on the right. The elements which most obviously show such differences are as follows. In the drapery, particularly of the center and left-hand Maidens of the south wall, the labored rendering of the folds, which are drawn in a manner which schematizes and makes frigid Parmigianino's own suavely rhythmical handling of drapery. The drawing of drapery in the left figure is painfully meticulous and hard. That of the center Maiden, though somewhat less hard, is equally fussy: in the drapery of this figure a kind of nervous squiggling (note especially the drapery of the lower torso and legs) has replaced Parmigianino's fluent calligraphy. These faults are qualitatively impossible to Parmigianino in any phase of his later career, either that contemporary with the (late) Maidens of the left wall, or with the antecedent "Madonna dal Collo Lungo" (compare the drapery of that Madonna with the drapery of the center Virgin).

Though the individual portions of Parmigianino's anatomies may be distorted and implausible, the assembly of the parts of the figure into a whole always gives the illusion of organic coherence. This is not true of the Maidens of the south wall: again the center and left-hand Maidens especially are disjointed and incoherent in their anatomical assembly. See the upper torso of both these figures, and also the legs of the center Virgin. These contrast most unfavorably with the Maidens of the left wall, and also may not be compared even with the "Madonna dal Collo Lungo," the least organically reasonable among Parmigianino's figures. As contrasted with the heads of the Virgins on the left wall, the heads of the center and left-hand Maidens of the south wall are much less plastically convincing. Their drawing is weak, and vacillates between flaccid curves and meaningless angular accents that are not to be found in the heads of the left wall. Further, the expressions of the heads of the center and left Virgins of the south wall are of a singular vacuity, impossible to Parmigianino even at his worst.

The Maiden on the right of the south wall reveals the defects of her two companions to a con-

siderably less degree. Her drapery, anatomy, and especially her head are more securely constructed and more fluently drawn, and her expression is far more convincing. She may reflect the considerable intervention of Parmigianino's own hand in her execution. So, surely, does the chiaroscuro Eve, and less certainly, the Aaron of the south wall. Both are boldly drawn and modeled, and the Eve exhibits, together with this boldness, a considerable sensitivity in execution.

The Steccata documents, otherwise so informative, fail us in our effort to specify the identity of Francesco's assistant or assistants. One is definitely mentioned by name in the Steccata papers: he is a *Isepe gargiò de maestro Francesco,* who occurs in a document of March 30, 1538 (Arch. Steccata, vol. VI). (Unless, as Copertini I, 190, n. 21 suggests, there has been an error of transcription) another assistant, one *zà franco* (Gian Francesco) is recorded in a document of January 22, 1540 (Arch. Steccata, vol. VI, reproduced Testi, *Steccata,* p. 125, n. 12). Both *garzoni* appear in connection with the decorative incidentals of the scheme, especially in the gilding. There is no mention of any assistant working specifically at painting. "Giuseppe" cannot be identified at all; "Gian Francesco" may be the Gianfrancesco Strabuco (or Strabecchi) who appears in Francesco's will as an heir and one of *ipsius testatoris servitores;* or less possibly he might be Gianfrancesco Rondani. Testi has other speculations about the possible identity of the assistants *loc. cit.* and p. 142, n. 46.

A passage in Vasari's life of Anselmi (VI, 485-486) makes a statement which may be completely incorrect, and which seems to take its meaning from an error in terms, that Anselmi did "nel *medesimo* arco piano, come si disse nella Vita del Mazzuoli, le Vergini prudenti e lo spartimento de' rosoni di rame" (my italics). Anselmi's work in the Steccata is fairly extensively documented; he did decorate the vault *opposite* Parmigianino's, but there is no evidence among the documents that he worked on any Maidens in the *"medesimo* arco piano" as did Francesco.

other surviving studies therefor. See British Museum 1905-11-10-50.

London, British Museum, Cracherode Ff.1.86. Pen and brown ink, brown and yellow wash, white heightening, 21 x 17.9 cm. Recto, design for the three Maidens, in their architectural setting of coffered *rosoni,* and for a frieze of accessory figures along the face of the arch to the left of the Maidens (Fig. 104). Verso, part of an arch, and a seated figure. Probably the earliest surviving sketch for the project in the form in which, approximately, it was executed.

London, British Museum, 1895-9-15-754, 755, 756. Recto, three studies for the Adam, pen and wash, each about 11.5 x 4.5 cm. Verso, fragments of studies for two recumbent nude figures, part of a sketch for the Moses, a sketch of a cornice, pen. The recto, compare Uffizi 1982. Engraved in 1723 by Zanetti (the engraving ill. Copertini I, *tav.* LXX). The recumbent nudes on the verso related to the decorative motives for the spaces between the *rosoni* in British Museum 1918-6-15-3.

London, British Museum, 1905-11-10-50. On the left half of the sheet a study for the Eve, in black chalk; on the right half a study for the Adam, standing, from the rear; pen and brown ink. 13.9 x 8 cm. Fig. 108*b*. A stage in the development of the pose of the Adam probably shortly subsequent to Uffizi 9226.

London, British Museum, 1918-6-15-3, recto and verso. Project for the decorative scheme of the vault. Fig. 111. Pen and wash, 20.3 x 30.4 cm. The elaborate scheme on the recto, in which the spaces between the *rosoni* are filled with oval medallions containing figures, and with nudes in complicated postures who support these medallions, is not a development from the project established in Cracherode Ff.1.86, but rather a separate, alternate design for the whole decoration. This design omits the Maidens altogether, and thus differs essentially from the executed design. However, the way in which the arch faces of the vault are decorated in the finished work is more nearly suggested in this drawing than in the Cracherode design: observe the single large figure of the Moses(?) at the foot of the arch face, of which the remaining area is treated with geometrical rather than (as in the Cracherode drawing) with figure motives. Verso, a smaller sketch of a decorative scheme like that on the recto; a seated figure (the Moses?), a colonnade in perspective, and other architectural motives apparently not related to this project.

London, Victoria and Albert Museum, no. 4898. 13.2 x 8.8 cm. Recto, sketch with lozenges containing figures, according to the scheme of British Museum 1918-6-15-3, and notes for some foliate decoration. Pen and bister, wash, some water color in orange-brown and green. Verso, various sketches not related to the Steccata scheme, including a study of a leg, a portion of a male torso, kneeling, a female figure in profile, an animal. From the Lawrence and Richardson collections. At the top of the verso is the signature *franciscus mausolus,* almost certainly the artist's autograph.

Modena, Galleria e Museo Estense, no. 814. Recto, studies for the framing of the *rosoni;* verso, rough studies for the poses of the Maidens. Pen and red chalk, 22.5 x 18.5 cm. The foliate and animal motives sketched on the recto are much as executed. Both these motives and the poses of the Maidens on the verso are evidently subsequent to the early formulation of the scheme in Cracherode Ff.1.86.

New York, Collection Janos Scholz. Recto, study for the left-hand Maiden (Fig. 106*b*); verso, sketch of a female head. Pen and bister, traces of black chalk, 10.2 x 6.9 cm. The recto related in style particularly to Parma 510/2 and British Museum 1905-11-10-50. It is possible that the head on the verso may have been overdrawn. This head was apparently used as a model for the head of the right-hand Maiden of the south wall: it is the only instance of a preparatory study which may be specifically connected with one of the Maidens of the south wall. This drawing may support the possibility suggested above (p. 193) that Parmigianino may have had a share in the execution of this Maiden.

Paris, Louvre, inv. no. 6466. Study for the center and right-hand Maidens. Fig. 107*a.* Pen and bister, white heightening, 26.4 x 20.4 cm.

Parma, Galleria, no. 510/1. Study for the Moses. Fig. 107*b.* Pen, 18 x 6.5 cm. (torn).

Parma, Galleria, no. 510/2. Study for the Maiden on the right. Fig. 106c. Pen and wash, white heightening, on red-tinted paper, 16.6 x 8.5 cm.

Parma, Galleria, no. 510/13. Study in the nude for the Maiden on the left. Fig. 106a. Black chalk with white heightening on red paper, 19.1 x 10 cm.

Parma, Galleria, deposito del Municipio. Study for the "Coronation of the Virgin" (intended for the decoration of the semidome of the apse). Fig. 105a. Pen and wash, 19.5 x 30 cm. (lunette). Contemporary in style with the early designs for the vault (compare British Museum Cracherode Ff.1.86 and 1918-6-15-3). Probably the original scheme for the decoration of the semidome.

Sacramento (California), Crocker Art Gallery, no. 232. Seated youth, half nude, supporting a plaquette and garlands. Fig. 112d. Pen and wash, white heightening, 7.5 x 5 cm. A variation on the motives for the frieze along the side of the vault suggested in British Museum 1918-6-15-3. Compare Windsor 0549.

Turin, Biblioteca Reale, D.C. 16190. Study for the "Coronation of the Virgin." Fig. 105b. Pen, 7.8 x 11 cm. (lunette). No earlier in style than 1535, and probably somewhat later. This design is much reduced in the number of figures from the Parma "Coronation" drawing, and is altogether a less elaborate conception. The less ambitious scheme of the Turin drawing was, in my opinion, prepared by Parmigianino c.1538, when time was running too short for the execution of his original (Parma Municipio) project.[172]

Windsor, Royal Library, no. 2185. Study for the "Coronation of the Virgin." Pen and wash on blue paper, 18.7 x 18.3 cm. A working up, on larger scale, of the central motive of the late design of Turin Biblioteca D.C. 16190.

Windsor, Royal Library, no. 0547. Two nude youths supporting an octagonal plaquette, drapery, and foliate swags. Fig. 112a. Pen and wash, white heightening, 8.3 x 6.8 cm. An elaboration of the motive in Cracherode Ff.1.86 of pairs of putti holding plaquettes (in the design for the frieze along the edge of the vault).

Windsor, Royal Library, no. 0548. Design for a plaquette, with the figure of a sibyl(?) accompanied by a putto. Fig. 112b. Pen and wash, white heightening, 8.4 x 6.6 cm. Developed from the figures loosely indicated in the plaquettes of Cracherode Ff.1.86 and the medallions of British Museum 1918-6-15-3 recto, and related particularly to the figure in the central oval of the latter design.

Windsor, Royal Library, no. 0549. Nude youth, supporting a plaquette and a garland. Fig. 112c. Pen and wash, 9.5 x 7.3 cm. Developed from the motive sketched at the lower right of the frieze in British Museum 1918-6-15-3 recto.

Windsor, Royal Library, nos. 0575, 0576, 0577. Three studies for the Eve. Fig. 109. Pen and wash, each about 8.5 x 3.5 cm. Compare Uffizi 1984.[173]

[172] Ricci (Parma catalogue, 1896, p. 318), Fröhlich-Bum (p. 66), Testi (*Steccata,* pp. 118 and 266) and others identify as the design for the "Coronation of the Virgin" which was to have adorned the apse only the drawing of that subject preserved in the Parma Gallery. Copertini (I, 146-148) discounts this identification, and prefers to regard the drawing in the Palazzo Reale at Turin as the Steccata apse design. Copertini adduces arguments to prove that the Parma drawing is a design for a "Coronation of the Virgin," the so-called "Incoronata di Piazza," which once decorated the façade of the present Palazzo del Governatore, facing the Piazza. Affò (p. 102, n. 2) had long since made this identification. The design was not executed by Parmigia-

nino, and was put into paint only long after his death, by Jacopo Bertoia in 1566. The lunette is destroyed, but a fragment preserved in the Parma Gallery (which Affò knew and identified) agrees with Parmigianino's drawing. Though the identification of the Parma drawing with the destroyed "Incoronata" painting seems positive, it is by no means thus excluded that the "Incoronata" drawing was among Parmigianino's studies for the Steccata scheme. The Parma drawing for the semidome was probably borrowed by the Commune in 1566 to serve Bertoia in his execution of the fresco on the Palazzo del Governatore. There is no need to accept either the Parma or the Turin drawing as the sole preparatory scheme, to the exclusion of the other.

[173] There are numerous highly doubtful or incorrect attributions of drawings alleged to be preparatory studies for the Steccata. A particularly mislead-

(Copies after lost) preparatory drawings:
F. Rosaspina, in engraving. After a study for the Eve similar to Uffizi 1984. Ill. Copertini I, *tav.* LXXIb.

ing example is Parma 510/3, accepted and illustrated by both Fröhlich-Bum and Copertini. (Fröhlich-Bum, fig. 56, p. 62; Copertini I, *tav.* LXVIII), which is almost certainly, in my estimation, no more than a copy after the finished work. More obviously copies are Parma 510/29 (ill. Fröhlich-Bum, fig. 59, p. 64), the Louvre drawings of the three Maidens (R.F. 582; Archives photo 2545) and of the center Maiden (Archives photo 8114; this last may be by Bedoli). A drawing after the Eve, in the collection of John S. Thacher, New York, may possibly also be a copy after the finished work, though of exceptional quality. Surely a copy is a drawing of the Eve in Modena (Galleria e Museo Estense, no. 837; this opinion kindly communicated to me by the Sovraintendente in Modena, Dr. Roberto Salvini). A drawing for the Aaron in the Uffizi (13626, pen and bister, 35 x 12 cm.), also copied from the painting, is by a less apt imitator. Copertini reproduces (I, *tav.* LXXb) an engraving by Salaino of the Aaron, which may be derived from a lost preparatory drawing, but which is more probably based upon such a copy as this one in the Uffizi. Uffizi 9224, an inept scrawl of a Moses figure, in a summarily indicated landscape, has also been wrongly assigned to Parmigianino. Fröhlich-Bum has published several other drawings as preparatory studies for the Steccata (particularly from the Louvre collection, see her lists p. 190, and her article in *Jahrbuch der Kunsthistorischen Sammlungen in Wien*, 1928), which I do not consider authentic.

An authentic drawing in the Uffizi (no. 1518, pen, 16.5 x 20.4 cm.; fig. 110) probably of the Bologna period, is not a preparatory study for the Steccata, but it should be observed that the figure at the left of this drawing, with arms extended, seems to contain the germ of the *pensiero* later exploited in the center Virgin of the Steccata frieze. Also related to the Steccata in motive, though probably not a preparatory study, is the (authentic) drawing of a female nude in profile toward the right, in the Galleria Corsini (black chalk and wash, heightened with white, 42 x 25 cm.; ill. Fröhlich-Bum, p. 61, pl. 54; photo Anderson 2772). Intimately related in its style of draftsmanship to the preparatory drawings for the Steccata is a small drawing of a nude infant, crouching, who holds a swag of drapery over his right shoulder (Windsor no. 0566, pen and wash, 6.6 x 3.6 cm.), but this drawing cannot be positively related in its motive either to the large preparatory designs or to the executed fresco.

L. Vorstermann, in engraving. After a study for the Moses. Ill. Copertini I, *tav.* LXXIa.
Copy: (formerly) Parma, Collection Farnese. The Moses only; listed in the Farnese inventory of *c.*1680 (Campori, p. 304) as a copy by an unknown after Parmigianino: "alto br. 4 on. 2, largo, br. 1 on. 4 3/4."

HOLY FAMILY WITH THE INFANT ST. JOHN (Naples, Pinacoteca del Museo Nazionale, no. 110), 1535-1539. II. Tempera on canvas, 1.58 x 1.03 m. Fig. 113.

The faces of the children and the mantle of the Virgin have been somewhat damaged; a portion of the landscape to the left rear of the canvas has been obliterated.[174]

The earliest record of the Naples "Holy Family" is in an inventory of the Farnese pictures in Parma in 1662. It is there said to have come to Parma from among the Farnese pictures previously in Rome, and is described as "un quadro in tela con la Madonna Bambino dormiente et S. Giovanni . . ." A fuller description is contained in the Farnese inventory of *c.*1680: "Un quadro alto br. 2 on. 11, largo br. 2 on. 3, a guazzo. Una Madonna in ginocchio che accarezza con la mano sotto il mento S. Giovanni et il Bambino che dorme sopra panno bianco, et un cuscino cremesi alla testa, del Parmigianino." A third mention occurs in the *Cento quadri più famosi* of 1725. In 1734 the "Holy Family" came with the other Farnese pictures to the Capodimonte in Naples, whence finally it arrived in the Naples Gallery.[175]

There is virtually no dispute as to the originality of the Naples "Holy Family,"[176] but since

[174] The latter loss may be completed from the two copies preserved in Parma.

[175] Naples catalogue, 1911, pp. 281-282, and Copertini I, 125, n. 17.

[176] H. Bodmer (*Correggio und die Malerei in Emilia*, p. xxix and fig. 68) is the only dissident in the attribution of this painting. He assigns it to Girolamo Mazzola-Bedoli. Bodmer does not adduce any evidence in his text, but it is apparent that his argument rests upon the confrontation he makes in his illustrations between the Naples "Holy Family" and Bedoli's "Madonna with St. Bruno" (Munich, which he reproduces in his figure 69). There is an unquestioned similarity between the two pictures (as indeed exists in lesser measure between other works

no early authority exists to indicate the period within which this painting was produced there is a considerable disagreement as to its date. De Rinaldis (Naples catalogue, 1928, p. 220) ascribes it to the Roman period, while Venturi (IX/2, p. 640), Fröhlich-Bum (p. 44), and Copertini (I, 105-107) consider it a work of the period in Bologna. We are convinced that these authorities have been too much influenced in their dating of this painting by partly incidental considerations: first, the presence of a landscape admittedly strongly similar (both in detail and in spatial construction) to the landscape in the Uffizi "Madonna with St. Zachary"; and more important, the somewhat unexpected character of surface texture and tonality which result from the unaccustomed medium and ground: this is one of the rare examples of Francesco's painting on canvas. I suggest that the Naples picture is a product of Francesco's later years in Parma, and that it should be associated with the change in style which succeeds the invention of the "Collo Lungo." The painting is, in my opinion, approximately contemporary with the execution of the Steccata frescoes.

Certain morphological considerations first suggest this dating. The type of the Virgin in the Naples painting more closely resembles the Steccata Maidens than any other of Francesco's female types. Her face shows neither the slight evidence of individualizing irregularity that we notice in the "Rosa" and "St. Margaret" Madonnas, nor the fragile and overexquisite oval

of the Uffizi and "Collo Lungo" Virgins. However, when compared with the Steccata Maidens the Naples Virgin shows the same relative heaviness of feature, the same long, straight, classicizing nose, and an identical system of headdress. The drapery of the Naples Madonna has no parallel in the Roman or Bolognese pictures, but it does show a close similarity to the drapery formulas of the Steccata figures. The upper part of the Naples Virgin's dress and the upper part of the garment of the center Steccata Maiden are very like in the pattern of folds, even to the leftward diagonal between the breasts. The curving, earlike fold of the Madonna's mantle has only a distant likeness to the coils of drapery in the background of the "Madonna della Rosa," but it offers a striking similarity to the curve of drapery in the garment of the Saint John in the Dresden altar of 1540.

The type of the Christ child also differs from the infant types of the pictures up through the "Collo Lungo." He has lost the svelte, curvilinear grace of form and the delicacy of feature which characterize, for example, the similarly posed infant of the "Madonna della Rosa," and has assumed a rather massive roundness which again suggests comparison with His representation in the "St. Stephen" altar. This massive roundness appears also in the head of the St. John, and to a less pronounced degree in the head of the Virgin. This strong plastic intention, and the accompanying emphasis on the opposition of modeling light and dark, do not appear in Parmigianino's painting until the stylistic change that is announced in the Steccata.[177]

of Bedoli and of Parmigianino) but it is due to Bedoli's extraordinary expertness in the imitation of his cousin. Bedoli's Munich "Madonna" evidently depends heavily on the Naples picture, and approaches closely the character of some of its motives and details (the attitude of the Virgin, her hair, her hands, the modeling of the Christ child's body, the flowers in the lower foreground, etc.). On the other hand, there are an almost equal number of differences in morphological and technical detail. More important, the whole of Bedoli's picture, in comparison with the Naples work, indicates the critical difference which separates him in quality and kind from Parmigianino: Bedoli's picture is "smaller" in feeling, and conspicuously lacks the sense of a highly artificial, deliberate, and self-conscious organization which emerges from the Naples canvas.

Preparatory drawing: Parma, Galleria, no. 510/5. Study for the Madonna. Fig. 114. Pen, wash, and white heightening, 12.5 x 10 cm. The style of the preparatory drawing also indicates a date late in Parmigianino's *oeuvre.*

[177] Bodmer's observation of the similarity betwen the Munich Bedoli and this painting is an incidental aid in our argument for the late dating of the Naples painting. If it had been painted before Parmigianino's return to Parma it would not ordinarily have been available to Bedoli to serve him as a model for his "Madonna with St. Bruno."

Copies:

Parma, Galleria, no. 172. Oil on canvas, 1.65 x 1.36 m. Acquired from the Rosa-Prati Gallery in 1851.

Parma, Municipio. Indicated by Copertini I, 107.

MADONNA WITH SS. STEPHEN AND JOHN BAPTIST AND A DONOR[178] (Dresden, Gemäldegalerie, no. 160), second half 1539-1540. I. Oil on panel, 2.53 x 1.61 m. Fig. 117.

Vasari (V, 232) describes this work among the paintings done by Parmigianino in Casalmaggiore: ". . . fece per la chiesa di Santo Stefano, in una tavola, la Nostra Donna in aria, e da basso San Giovambatista e Santo Stefano . . ." In 1646, the painting was sold by the church in Casalmaggiore for which it had been commissioned to the Duke of Mantua. It remained in the ducal collection until 1746, when it was sold to the Dresden Gallery.[179]

[178] The donor is identified in a manuscript note of doubtful authority (see Copertini I, 193, n. 43) as Matteo Cavalli.

[179] Compare A. Venturi, *R. Galleria Estense di Modena* (1882), quoted Copertini, *loc. cit.;* and the catalogue of the Dresden Gallery (1929), pp. 78-79.

Preparatory drawing: Windsor, Royal Library, no. 0590. The Saint John and Saint Stephen kneeling on either side of the donor, who is at a lower level between them. A landscape in the middle distance; above, the Madonna seated in a bank of cloud. Fig. 115. Pen, 10.4 x 6.8 cm. Copied in etching by C. M. Metz (the etching ill. Fröhlich-Bum, fig. 51, p. 57).

(Copy after lost) preparatory drawing: A. M. Zanetti, in chiaroscuro (Bartsch XII, p. 169, no. 23; Fig. 116). The two saints stand on a shallow platform before three steps which ascend into a blank background. The Madonna is seated in an oval aureole in the upper center. The donor is seen half-length at the lower left under the Baptist's protecting hand.[180]

Copy: (formerly) Casalmaggiore, Collegiata. According to Affò (p. 104) a copy by Ghisellini had been substituted for the original after its sale to Mantua.

Copertini's entry for the date of sale to Dresden is wrongly given as 1766.

[180] The drawing for a standing "Madonna and Child" (British Museum, Cracherode Ff. 1.94; see note 93, above) associated by Fröhlich-Bum with the National Gallery "Vision of St. Jerome," may perhaps be instead related to this later painting.

THE AUTHENTIC PORTRAITS

PORTRAIT OF A PRIEST (?) (Wrotham Park, Barnet, Herts., Collection Earl of Strafford), 1523. II. Oil (?) on panel, .89 x .64 m. Fig. 120.

The earliest certain record of this portrait occurs in the inventory of the Palazzo del Giardino in Parma of *c.*1680: "un quadro alto br. 1 on. 8, largo br. 1 on 2 1/2. Ritratto con la beretta di prete in capo, con officio alla sinistra et destra sopra una tavola con medaglie et figure antiche et dietro alcune figure antiche di chiaro e scuro del Parmigianino" (Campori, p. 229). What is evidently the same painting was mentioned in 1725 among the *Cento quadri più famosi* of the Farnese collection in Parma (quoted Affò, p. 91). A reference antecedent to both of these, to a "ritratto di prete di mano del Parmigianino"

in the inventory of the pictures of Ranuccio Farnese of 1587 (Campori, p. 52), probably also concerned this same work.

Sometime in the early nineteenth century this picture had found its way from Italy to England, into the collection of the Admiral Lord Radstock. On May 13, 1826, it was sold at Christie's as number 49 among a group of old masters which belonged to Lord Radstock. According to the auction catalogue the portrait had come from Capodimonte; it had presumably been transferred there from the Palazzo del Giardino in Parma by Charles III together with the other Parmigianinos of the present Naples collection. The entry in the Christie catalogue described the picture as a self-portrait, an error that is still perpetuated in the case of two of the known

copies (*q.v.*). The purchaser of the portrait at the Radstock sale was an ancestor of the present owner, Lord Strafford.

Waagen saw the picture at Wrotham Park in the fifties, and described it with some enthusiasm in his supplement:[181] "Parmigianino—A male portrait in a black furred coat, a cap on his head, and a casket [*sic*] in his left hand. A coin lies before him. Half-length. In the landscape background is a very well painted piece of sculpture. This picture displays great energy, uncommon decision of forms, and a masterly modelling in a powerful reddish brown tone."

Singularly, the painting remained unknown to modern students of Parmigianino. It was not mentioned by Fröhlich-Bum in her monograph; while Copertini knew only a partial copy (of miniature size, on slate) in the Uffizi, where it has long been labeled, without reason, as a self-portrait.[182] The first appearance in contemporary literature of the Strafford painting was in a summary mention and illustration in an article of 1940, by Gamba, in *Emporium*.[183] Gamba there rightly described it an original by Parmigianino, but assigned it, in my opinion incorrectly, to Parmigianino's Roman period.

The conspicuous superiority in quality of the Strafford portrait to the three other versions which survive (Uffizi; Minneapolis, Walker Art Center; New York, art market) affords the first evidence that it is the original from which these three versions, all copies, are derived. The second evidence of the originality of the Strafford painting is provided by its exact coincidence not only in description, but in measurements, with the picture cited in the Farnese inventory of *c.*1680: the other versions differ from the record of the inventory in one or the other of these respects.

The correctness of the attribution of this original to Parmigianino in the inventory of *c.*1680, and of what is probably the same painting in the inventory of 1587, must now be established; it emerges with full convincingness from comparison with Parmigianino's unquestioned work. However, except in one respect, this comparison may not be made with Parmigianino's productions of the Roman period, as would be required were Gamba's dating just: the close connection of the Strafford picture is with the work that precedes Francesco's departure from Parma.[184] The only analogy for this portrait among Parmigianino's Roman products is to be found in the two Doria panels (which we believe to postdate only briefly the artist's removal to Rome); the analogy is in the chiaroscuro lighting and in the character of the landscape background. However, the similarity of these elements is more general than specific. The portrait lacks the developed virtuoso fluency in the brushing-in of the landscape, and the subtle variety in lighting, of the Doria pictures. With the one certain work in portraiture from Francesco's time in Rome, the "Lorenzo Cybo" in Copenhagen, the Strafford portrait has but little in common.

This painting appears in fact to be a product of the pre-Roman, less mature phase of Parmigianino's work in portraiture: I believe that it is the earliest among the portraits that survive to us. Its closest correspondences in morphology

[181] 1857, p. 353. (Letter no. VI, "Collection of Pictures Belonging to Lord Enfield, Wrotham Park").

[182] No more positive identification exists for this portrait than the title we have given it. However, a vague suggestion for such an identification lies in the circumstance that the Baiardi family in Parma were among the city's known collectors of coins, antique medals, and cameos (see A. Barilli, *L'Allegoria della Vita,* p. 83); the sitter of the Strafford portrait obviously had similar interests. In Parmigianino's later dealings with the Baiardi, and with Francesco Baiardo in particular (see the history of the Vienna "Amor," and the legal records in the Steccata case), it would seem that their relationship was fairly intimate and of a standing which probably dated back to Parmigianino's early years in Parma. This combination of circumstances permits the suggestion (but no more) that this early portrait commission may have been for and of Francesco Baiardo. A note in an old Uffizi inventory of 1825, made after receipt of a communication from Count Luigi Sanvitale, suggests that the subject may be the sculptor G. A. Fornari. There is no indication of the reason for this notion, which Copertini records (I, 217, n. 1).

[183] XCII (1940) p. 117, ill. p. 118.

[184] Copertini (I, 200) arrived at a similar dating for the (then lost) original on the basis of the evidence offered by the Uffizi copy.

and technique are with the self-portrait in Vienna, definitely dateable in the first half of 1524; it further shows some characteristics in their incipient stage which appear in more developed form in the same Vienna picture, and in the apparently subsequent, but still Parmesan, portrait of Gian Galeazzo Sanvitale. In larger aspects of style the Strafford portrait seems more to be related to a tradition in portraiture that precedes Parmigianino, rather than that which he would imminently develop.

The correspondences with the Vienna self-portrait include: in general, the broad triangular form of the figure and the soft Correggiesque lighting; in particular, the quality of texture in the flesh, and the handling of contours, which still considerably depend on Correggio and yet have not yet achieved the degree of smoothness of the Sanvitale portrait; the soft and sensitive drawing of hair, and the brushing-in of the fur trimming of the garments. The hands of the Priest are still somewhat awkward, but on close examination show a beginning tendency to impart the stylized calligraphic outline that is quite apparent in the self-portrait, as it is also in the "Sanvitale."

In the background of the Strafford portrait is a simulation of an antique relief of Venus, Cupid, and Mars, for which the nearest parallel exists, for the general idea of the motive, in a religious work antecedent to the Vienna portrait by about a year and a half: in the sculptured bases on which St. Lucy and St. Agatha sit in San Giovanni *A* and *B*. However, the manner of drawing the figures in the relief in the Priest's portrait corresponds more exactly to that used at Fontanellato: compare the Mars in the relief with the Actaeon of wall *A* at Fontanellato, and the Venus with the right-hand one of the pair of nymphs on wall *B*.

By the association of the Strafford portrait with San Giovanni and more particularly with Fontanellato, a complement is offered to the evidence of its precedence in date to the Vienna portrait which is suggested by comparison with the latter. It would seem justifiable to advance a date of 1523 for the Strafford portrait of a "Priest."

Copies:[185]

Florence, Uffizi (no. 3971, inv. of 1890). Fig. 121*b*. Oil on slate, .155 x .130 m. A partial copy, in miniature, omitting the table in the lower foreground.

Minneapolis, Walker Art Center. Fig. 121*a*. Oil on canvas, .94 x .71 m. From the collection of the Duke of Sutherland (?). Inscribed on the rear "Lilleshall Catalogue, no. 12." Published as a self-portrait by Parmigianino in a note in *International Studio*, vol. XCIX (August, 1931), p. 54.

New York, art market. Oil on panel, .67 x .57 m. The least satisfactory copy. It has either been cut down, or more probably was never more than a partial copy of the original.

SELF-PORTRAIT IN A CONVEX MIRROR

(Vienna, Kunsthistorisches Museum), first half 1524. I. Tondo panel (segment of a sphere), diameter .244 m. Fig. 122.

Vasari describes this self-portrait (V, 221-222) as one of the paintings done by Francesco in preparation for his journey to Rome: ". . . per investigare le sottigliezze dell'arte, si mise un giorno a ritrarre se stesso, guardandosi in uno specchio da barbieri, di que'mezzotondi: nel che fare vedendo quelle bizzarie che fa la ritondità dello specchio nel girare che fanno le travi de'-palchi, che torcono, e le porte e tutti gli edifizi che sfuggono stranamente, gli venne voglia di contrafare per suo capriccio ogni cosa. Là onde fatta fare una palla di legno al tornio, e quella divisa per farla mezza tonda, e di grandezza simile allo specchio, in quella si mise con grande arte a contrafare tutto quello che vedeva nello specchio, e particolarmente se stesso tanto simile al naturale, che non si potrebbe stimare nè credere: e perchè tutte le cose che s'appressano allo specchio crescono, e quelle che si allontanano diminuiscono; vi fece una mano che disegnava, un poco grande, come mostrava lo specchio, tanto bella, che pareva verissima. E perchè Francesco era di bellissima aria, ed aveva il volto e l'aspetto grazioso molto, e più tosto d'angelo che d'uomo,

[185] The only preparatory drawing for a portrait that I have so far been able to discover is that for the allegorical portrait of Charles V, *q.v.*

pareva la sua effigie in quella palla una cosa divina: anzi gli successe così felicemente tutta quell'opera, che il vero non istava altrimenti che il dipinto; essendo in quella il lustro del vetro, ogni segno di riflessione, l'ombre ed i lumi sì propri e veri, che più non si sarebbe potuto sperare da umano ingegno."

In addition to this precise and enthusiastic description, Vasari informs us (V, 223) of the further history of the self-portrait: ". . . il ritratto dello specchio mi ricordo io, essendo giovinetto, aver veduto in Arezzo nelle case di esso messer Pietro Aretino, dove era veduto dai forestieri che per quella città passavano, come cosa rara: questo capitò poi, non so come, alle mani di Valerio Vicentino intagliatore di cristallo: ed oggi è appresso Alessandro Vittoria, scultore in Vinezia, e creato di Iacopo Sansovino."

According to Vasari (*ibid.*) the portrait was given to Aretino by Clement VII, to whom Parmigianino had presented it together with the other paintings he took with him to Rome. Before the portrait came to Vittoria (1560) it passed through the hands of Elio Belli, Valerio Vicentino's son. Vittoria bequeathed the picture to Rudolf II (1608); the subsequent history of its passage from Prague to the Vienna Museum is identical with that of Francesco's "Amor."[186]

Vasari's dating of the self-portrait is substantiated by its nearly exact coincidence of technique with the Madrid "Holy Family."

PORTRAIT OF GIAN GALEAZZO SANVITALE (Naples, Pinacoteca del Museo Nazionale, no. 111), first half 1524. II. Oil on panel, 1.07 x .80 m. Fig. 123.

Like Francesco's frescoes at Fontanellato, this portrait of the master of Fontanellato is unrecorded by Vasari. However, the first documentary mention of the portrait dates from within the sixteenth century: the inventory of the Guardaroba of Ranuccio Farnese (Parma, 1587) includes "Un ritratto del Conte Galeazzo Sanvitale di mano del Parmigianino con suo ornamento e cortina di cendale cremesino."[187] The

same picture is mentioned in the Farnese inventory of 1680 as "Un quadro alto br. 2 larg. br. 1 on. 8 in tavola. Ritratto d'uomo con barba lunga, beretta in capo di velluto rosso, nella destra una medaglia marcata no. 72, l'altra sopra parte della carega di legno et appresso un elmo e mazza di ferro del Parmigianino."[188] By the date of this inventory the identity of the sitter had apparently been forgotten. The recollection of his identity resulted from the publication in 1857 by Count Luigi Sanvitale[189] of a seventeenth-century copy, which had remained among the family pictures at Fontanellato.[190]

The original painting was transferred from the Farnese Collections in Parma to the Capodimonte in Naples in 1734. Taken by the French in 1799, the portrait was recovered in Rome the following year and returned to Naples. In 1802 it was shown in the Gallery Francavilla as a portrait of Christopher Columbus. In 1806 it was sent to Palermo (as part of the nucleus of an intended public museum) but was returned to Naples the same year.[191]

On the rear of the panel is an old inscription which purports (according to the Naples catalogue) to be *la firma del pittore: OPUS D [?] MAZOLLA,* and the date 1524.[192] Whether or not this inscription is by Francesco himself, the

n. 5. There is no *cortina di cendale cremesino* in the picture. This phrase (which occurs repeatedly in the inventory of 1587) refers to a curtain which protected the picture, and not to any such object in the painting itself.

[188] Campori, p. 229.

[189] *Memorie intorno alla rocca di Fontanellato*, pp. 38 and 44.

[190] Ricci first associated the Naples original with the identified copy at Fontanellato (in *Archivio Storico per le provincie Parmensi*, pp. 11-13); here he also discusses the attempted, but unsuccessful explanation by Ronchini (published in Count Sanvitale's book) of the mysterious medal with the number 72 which the sitter holds.

[191] Naples catalogue (1928), p. 219. The absurd identification as Columbus would seem to have resulted from the medal on the sitter's hat, which represents a ship.

[192] The reading of the *D* is unclear. The script is reproduced in the Naples catalogue, *ibid.* A.O. Quintavalle ("Falsi e veri del Parmigianino giovane," p. 247) reads the signature as *opus de Mazolla, 1524 F,* and regards it as autographic.

[186] See Vienna catalogue (1938), p. 127.

[187] Compare Campori, p. 53, and Copertini, I, 217,

information it contains is correct beyond question, for in morphology and technique this painting is extremely close to the other works of the half-year which precedes Parmigianino's departure for Rome.[193] Copertini (I, 201), Fröhlich-Bum (p. 32), Berenson (*Lists*), as well as Ricci,[194] agree in accepting the authorship and dating stated in the inscription.[195]

Copies:

Providence, R. I., Collection D. N. Brigham. A reduced copy, probably of the nineteenth century.

Rocca di Fontanellato, near Parma. According to Ricci (*Archivio storico per le provincie Parmensi*, p. 11) a work of the seventeenth century.

PORTRAIT OF LORENZO CYBO (Copenhagen, Royal Museum of Fine Arts), second half 1524-1526. II. Oil on panel, 1.23 x 1.02 m. Fig. 124.

In his record of Parmigianino's work in Rome, Vasari (V, 224) thus describes this portrait: "Sentendo la fama di costui il signor Lorenzo Cibo, capitano della guardia del papa e bellissimo uomo, si fece ritrarre da Francesco; il quale si può dire che non lo ritraesse, ma lo facesse di carne e vivo." Milanesi (V, 224, n. 2) had suggested the possible identification of the portrait described by Vasari with Francesco's portrait of a youth, now in Hampton Court; this identity was rejected by Fröhlich-Bum, and in its stead she proposed (p. 32) that the portrait of a youth preserved in the Borghese and containing an inscription reading *in Roma* (which we refuse to Parmigianino, see p. 233) might be that of Cybo.

[193] The fact that the portrait bears the date 1524, in combination with its certain identification as a Parmesan noble, further substantiates our assumption of Parmigianino's presence in his native city through about the first half of that year. Also, the stylistic identity of this work with the works described by Vasari as having been done in preparation for Parmigianino's departure for Rome is additional confirmation for our dating of those paintings in 1524.

[194] *Loc. cit.,* n. 178.

[195] Venturi (IX/2, p. 645) associates the portrait in time with the Fontanellato frescoes, but he dates these last wrongly as late works (see note 47 above).

Baldass corrected both these mistaken suggestions by republishing[196] the Copenhagen portrait, which bears an old inscription in its lower right-hand corner: *Laurentius Cybo Marchio Massae Atque Comes Ferentilis.* This picture had originally been published as a work by Francesco in Madsen's catalogue of the Copenhagen Gallery (1904, no. 203); it had been subsequently illustrated and more fully discussed in the *Italienske Billeder i Danmark* (1910)[197] of Mario Krohn. The portrait had once been owned by the Cardinal Valente, and was acquired in Amsterdam by the Copenhagen Gallery in 1763.[198]

The date of the inscription is uncertain. As Krohn observed, it would not seem contemporary with the picture; yet a combination of circumstances tends to support its identification of the subject. Unless there were a fairly secure tradition of the identity of the sitter there would be no reason to inscribe his name, obscure as it is, on the canvas. The huge ceremonial broadsword supported by the page, and upon which the sitter rests his hand, would seem to be the symbol of some such military office as that of *Capitano della Guardia* assigned to Cybo by Vasari. Finally, upon the sitter's hat are embroidered two *L*'s in reverse; *L* is the initial of Cybo's Christian name.[199]

The inscription also includes a date, but unfortunately its last figures are partly obliterated. It is possible to read the Roman numerals up to MDXXII, but whatever is beyond that is not clearly decipherable.[200] The date of the portrait

[196] In his review of Fröhlich-Bum in *Graphische Künste* (1921), pp. 64-65.

[197] Copenhagen: Nordisk Forlag, 1910; fig. 43, p. 181.

[198] See Copertini I, 218, n. 6.

[199] Even if the Copenhagen picture bore no hint of the sitter's identity there would still be a fair probability of his being Cybo, since this is the sole stylistically certain portrait from the Roman period which survives, and we have no record of a portrait done by Parmigianino during that period other than one of Cybo.

[200] The date has been read as MDXXII-X and as MDXXIII. Even if one of the above readings is correct the date given by the legend is not necessarily true, since it appears to have been painted on at some

must be established from internal evidence. Certainly, the "Cybo" does not bear association with Francesco's mature, post-Roman essays in portraiture. On the other hand, not only the ensemble, but even certain specific features of the Cybo portrait suggest a fairly close association with the 1524 portrait of Sanvitale. The most prominent of these is the retention in the "Cybo" of the foliage screen which closes the background of the Naples portrait; this occurs in these two portraits, but in no others. Further, certain details of morphology (for example, the drawing of the eyes, the metallic linearity of the hair and beard) also display a common formula which is different from that of the later works. There is also a resemblance with the Sanvitale portrait in the excessive consideration given to details of accessories and costume, and in the rather rigid character of pose and expression. Both works have in common an effect of somewhat fussy formality, which disappears from the maturer portraits.

Though the "Cybo" shows so many characteristics in common with the Sanvitale portrait, there are other ways in which it exhibits evidences of a greater maturity: in certain aspects of style and in morphological system the Cybo portrait contains elements which permit comparison with the National Gallery altar, as the "Sanvitale" does not. These are, especially, the decrease in the Correggiesque quality of handling, the increase in the smoothness and roundness of modeling, and the greater monumentality of design as a whole.

Copy: New York, Wildenstein and Company. Oil on canvas, 1.27 x 1.04 m. (Ill. *Italian Paintings,* New York, Wildenstein and Co., 1947, plate 41.) The copy bears an inscription identical with that on the Copenhagen portrait, except that its date is clearly legible, as 1523. From the collections of the Countess Frenfanelli Cybò and the Marquis Strozzi, Florence. Regarded by

Berenson as an authentic replica (letter, 1939, quoted *ibid.*) The picture shows conspicuous weaknesses in drawing, as well as such distortions in the proportions and spatial relationships as are characteristic for the copyist. In my opinion, no earlier in execution than the latest years of the sixteenth century; probably done for the family as a replacement on the sale of the original, as was the frequent custom.

PORTRAIT OF A GENTLEMAN, traditionally called a self-portrait (Florence, Galleria degli Uffizi), second half 1527-1528. II. Oil on panel, .90 x .71 m.[201] Figs. 125-127.

The earliest reference to this portrait is an oblique one, to what was apparently a partial copy of it thus recorded in the inventory of the Palazzo del Giardino in Parma (*c.*1680; Campori, p. 305): "Un quadro alto on. 3 e 3/4, largo on. 3 e 1/4, in tavola. Ritratto del Parmigianino vestito di nero con beretta nera in capo, cadente verso l'orecchio destro, del Parmigianino." To the Uffizi portrait itself there is no certain reference until the third quarter of the eighteenth century, when it was reproduced in engraving (1773) as a self-portrait of Parmigianino, with the indication of its location in that gallery.[202] The collection of *autoritratti* was initiated by Cardinal Leopoldo de' Medici (d. 1675); this painting would have entered that collection, in the guise of a self-portrait, at some time between the mid-seventeenth and the mid-eighteenth century. Its provenance is unknown.

The tradition for the identification of this work as a self-portrait is, according to this record, probably at least as old as 1680, but no evidence exists which enables us to carry it any nearer to the time of the artist. This tradition went without serious question until relatively recently. Copertini, comparing the Uffizi portrait with the positive self-portrait in Vienna, refused to consider the possibility that "due occhi azzurri . . .

time later than the execution of the painting. It is possible that the author of the inscription could have been correctly informed as to the identity of the sitter, while it would have been easier to have recalled the date incorrectly.

[201] An addition of *c.* 6 cm. was made to the top of the original panel, probably during the seventeenth or eighteenth century. This addition appears in most of the older reproductions.
[202] In *Serie degli Uomini i più Illustri nella Pittura* (Florence, 1773), vol. VI, facing p. 49.

diventino neri . . . che l'orbita oculare cambi forma, che l'arco sopraccigliare diventi da arcuato rettilineo, che la base dell'osso frontale si abassi e che il naso di tipo cosidetto romano diventi greco!"[203] Certainly, it seems unlikely that the subject of the self-portrait in Vienna and the bearded sitter in the Uffizi should be the same person, especially (see our dating below) when the two portraits are separated by no more than three or four years.

Copertini's scepticism (which is shared by Berenson, *Lists,* and by W. Friedlaender, verbally) may be justified, and no positive evidence can be adduced against it. Certain indices remain, however, which make one reluctant to dismiss utterly the *possibility* that the traditional interpretation may be correct: all these indices are tentative and inadequate, but their existence should at least be taken into account. The first is the unreliability, as a basis for comparison, of the image in the convex mirror self-portrait of 1524. The image in that painting is admittedly distorted: if it were possible to correct this image in the sense of its original, many of the differences observed by Copertini would become less acute. The nose would become straighter and longer, the face more elongated, the line of the eyebrows more square. But it still could not be argued that this would change the color of the eyes, nor of the hair, of the Uffizi and Vienna subjects so that they would agree.

It should be observed that the person represented in the profile portrait which precedes Parmigianino's "Life" in the 1568 edition of Vasari's *Vite* (Fig. 129)[204] strongly suggests the image which we should expect of the sitter of the Uffizi portrait if he could be turned into profile. I do not know the basis for the likeness in Vasari's engraving, but it is not impossible that it may have been communicated to him

from some reliable source, such as Bedoli. On the other hand, the authority of Vasari's likeness is by no means beyond dispute; in any case one cannot make a conclusive confrontation between Vasari's profile and the Uffizi fullface.

Two further documents exist which suggest a resemblance with the Vasari profile and which, like it, in turn suggest the (only putative) profile of the Uffizi sitter. Both are drawings, certainly from Francesco's own hand: one, the bearded head of a youngish man (Oxford, Ashmolean; Fig. 130),[205] in profile; the other a figure, on a sheet of studies (Uffizi no. 13583; Fig. 128), of an artist sketching, very summarily represented in full-length, and also in profile.[206] The fact that these drawings are autographic, and that the figures they represent are in profile, tends to discount, but not positively exclude, that they may be portraits of the artist himself. These vague items of evidence in drawing, and the related evidence of the Vasari vignette, almost equally insecure as are the drawings in their connection with the Uffizi portrait, should not be made too much of; the traditional identification as a self-portrait of Francesco remains in question.[207]

[203] I, 203 and 218, n. 9. Copertini has somewhat exaggerated the degree of difference in the color of the eyes in the two portraits: they are gray-green rather than *azzurri* in Vienna, and deep brown rather than black in the Uffizi. The fact of the difference remains, and it is apparent also in the color of the hair in the two paintings: light brown in Vienna, chestnut brown in Florence.

[204] Vol. I, part 3, p. 230.

[205] Black chalk, 10.5 x 7.2 cm.

[206] The dating of this latter drawing in the Bologna period is indicated not only on general grounds of style but by the sketch, at the left of the sheet, which relates to the chiaroscuro cut of "La Sorpresa."

[207] Possible further evidence as to Francesco's appearance might have been provided by the drawing which was once in the Raccolta Muselli in Verona, and which was presumed to be a self-portrait from Francesco's hand. See E. Faelli, *Bibliografia Mazzoliana* (Parma: Battei, 1884), p. 53, and Milanesi V, 223, n. 1. This drawing was once in Mariette's collection.

A partial copy after the Uffizi portrait is preserved in the Parma Gallery as no. 313. On the back, it bears the legend *Franciscus Mazola pinxit seipsum. MDXXX.* Ricci (catalogue, 1896, p. 310) regarded the painting as a replica of the Uffizi portrait by Francesco's own hand; according to him the inscription was an old one. Copertini (I, 218, n. 9) informs us that the "signature" is on a relining of the canvas, and cannot therefore be original. Nor, since this painting was acquired only in 1851, from a dealer, is it probable that its inscription antedates the tradition of the identity of the Uffizi portrait.

As in the case of many of Parmigianino's portraits, if we dismiss the traditional identification, we are unable to replace it with another. Vasari gives us no great help: during the Bolognese period within which this portrait was produced, he catalogues (besides the ceremonial portrait of Charles V) only two male portraits by Francesco. One is of "Bonifazio Gozadino il suo ritratto di naturale" (V, 228) and another ". . . non so che conte bolognese" (V, 227); there is no further description of either work.

The date of the Uffizi portrait can be established with fair security from technical and morphological comparison with the religious paintings: the closest relationship is with the "San Rocco." The brushwork in the portrait generally displays a similar interweaving of relatively smooth strokes and there is a similarity in the resultant surface textures (compare, for example, the left hand of the Uffizi sitter and the left leg of the St. Roch; note also the texture of their garments). The handling of light gives a similar variety of illumination in the two paintings; the indication of contours is only a degree sharper and less atmospheric in the Uffizi portrait than in the "San Rocco." The modeling attains a like degree of plasticity in the flesh areas of both pictures, without yet suggesting the scrupulously smoothed and rounded surfaces of flesh which begin to appear in the "St. Margaret" altar.[208]

The usual critical assumption is to date the Uffizi portrait later in the Bologna period, but on the basis of the correspondences with the "San Rocco" altar it appears that the two paintings cannot be far apart in time of execution. The Uffizi portrait almost certainly antedates the "St. Margaret" altar; a dating in the first year or so in Bologna seems justified.

Copies:

Naples, Pinacoteca del Museo Nazionale, no. 201. Canvas, .47 x .42 m. A partial copy. See Naples catalogue, 1911, p. 283, where this copy is identified with a picture cited in the Palazzo del Giardino inventory of c.1680 (Campori, p. 230). This identification is probably incorrect, for the description in the inventory does not accord with this copy in the matter of dress of the sitter or of measurement of width (12 cm. difference).

Parma Gallery, no. 313. Oil on canvas, .44 x .32 m. A partial copy, bust length, with the false signature of Parmigianino on the relining, and the date 1530. See note 207.

(formerly) Parma, Palazzo del Giardino. Panel, c. 16 x 14 cm. Recorded in the inventory of c.1680 (Campori, p. 305). See p. 204 above. A partial copy.

(formerly) Rome, Accademia di San Luca. Recorded by Affò (p. 82, n. 1).

PORTRAIT OF A YOUNG PRELATE
(Rome, Galleria Borghese, no. 85), 1528-1529. III. Oil on panel, .52 x .42 m.[209] Fig. 131.

The attribution of this portrait to Parmigianino is entirely unsupported by external evidence. Its original publication as a work by Parmigianino seems to date only to a notice by Venturi in the Borghese catalogue of 1893. Since then, however, that attribution has been universally accepted. Not only the morphological characteristics (as eyes, lips, ears) but also the technical character and the expression of the painting accord perfectly with Francesco's authentic work. Further, within Francesco's *oeuvre,* it would seem that this portrait could be inserted with considerable certainty into the first half of his period in Bologna. The rendering of the garment and the collar are virtually identical with the corresponding details in the Uffizi portrait. The general system of modeling light and dark in the face would also seem to be close to the latter work.

[208] Compare also the elegant but uncomfortable and artificial position of the left hand of the Uffizi gentleman with the similar position of the right hand of the San Rocco.

It cannot therefore be accepted in evidence for the identification of the subject. In the treatment of the inscription on the Parma copy, Ricci's predecessors (catalogue, 1872) seem to have been more skeptical than he, for they preferred—on what grounds we cannot determine—to call the sitter one Cesare Piacenza, a gentleman of Parma.

[209] Though this is the only portrait of such format in Parmigianino's surviving *oeuvre,* it is not likely that it has been cut down. There are numerous minute pigment losses in the face.

The differences from the Uffizi picture are rather subtle. They take the form of a slightly greater variety of light and shadow on the surface of the skin, and a slightly increased hardness of texture, such as are encountered in the Bologna "St. Margaret." The formula for the drawing of the eyes (the rounded almond shape) found in the Borghese picture also occurs for the first time with such definiteness in the "St. Margaret." It is therefore probable that this portrait is slightly subsequent to the Uffizi portrait, and more nearly approaches the date of the Bologna altar.

ALLEGORICAL PORTRAIT OF CHARLES V (Richmond, Cook Collection, no. 97). Copy of the original of November 1529-March 1530. Oil on canvas, 1.82 x 1.25 m. Figs. 132, 133.

"Quando l'imperadore Carlo Quinto fu a Bologna, perchè l'incoronasse Clemente settimo, Francesco, andando talora a vederlo mangiare, fece senza ritrarlo l'imagine di esso Cesare a olio in un quadro grandissimo; ed in quello dipinse la Fama che lo coronava di lauro, ed un fanciullo in forma d'un Ercole piccolino che gli porgeva il mondo, quasi dandogliene il dominio: la quale opera finita che fu, la fece vedere a papa Clemente, al quale piacque tanto, che mandò quella e Francesco, insieme, accompagnati dal vescovo di Vasona allora datario, all'imperadore: onde essendo molto piaciuta a Sua Maestà, fece intendere che si lasciasse; ma Francesco, come mal consigliato da un suo poco saputo amico, dicendo che non era finita, non la volle lasciare: e così Sua Maestà non l'ebbe, ed egli non fu, come sarebbe stato senza dubbio, premiato. Questo quadro essendo poi capitato alle mani del cardinale Ipolito de' Medici, fu donato da lui al cardinale di Mantoa, ed oggi è in guardaroba di quel duca . . ." (Vasari V, 229)[210]

Vasari's precise account of the circumstances under which the original of this portrait was

[210] A shorter account, differing in that it describes the picture as having been accepted by the Emperor, appears in the first edition (p. 850). Vasari was in Bologna for a time during 1530, the year of the painting of this work. Further, he would certainly have seen the original during his study of the Ducal galleries in Mantua in 1542.

painted permits us to establish its date with considerable exactness. Charles arrived in Bologna November 5, 1529. He was crowned on February 24, 1530, and left the city March 22.[211] His portrait would therefore have been painted during these five months of his Bolognese stay.

No source has been discovered which gives us any intimation of the fate of the original painting after its presence in the Mantuan ducal collection. As for the present copy, it once formed part of the collection of William Angerstein. It was exhibited in Manchester in 1857; in 1883 it was sold to one Mr. Lesser, and soon afterwards arrived in the Cook Collection.[212]

Critical opinion is by no means secure as to the status of the present painting. Venturi (IX/2, p. 641) and Copertini (I, 204) regard it as an original.[213] Fröhlich-Bum[214] considers it a copy by a contemporary close to the master. I feel with Fröhlich-Bum that it is a copy, but do not agree that it need be by an artist close to Parmigianino either in time or school.[215] The morphological and technical characteristics only approach, but do not coincide with those of Francesco in his Bologna period. Certain elements are so rendered

[211] *Cronaca del Soggiorno di Carlo V in Italia. Documento . . . estratto da un codice della Regia Biblioteca Universitaria di Pavia* (ed. G. Romano; Milan, 1892), pp. 113 and 236.

[212] See *A Catalogue of the Paintings at Doughty House*, I, 113.

[213] Copertini (*ibid.*) refers to a "thorough" discussion of the Cook portrait in his article "Il Ritratto di Carlo V di Fr. Mazzola detto il Parmigianino," *Cronache d'Arte*, II (1925), 64-68. This article is in fact only a summary recapitulation of the history of the picture. Copertini adduces no proof therein for his opinion as to the originality of the work.

[214] "Some Unpublished Portraits by Parmigianino," *Burlington Magazine*, vol. XLVI, no. 278 (1925), p. 88; she had made no mention of the existence of the Cook picture in her monograph.

[215] Borenius, in the catalogue of the Cook Collection (note 212, above), felt it "just possible" that the picture might be a copy, but claimed that it should be regarded as the original until a picture with "better right" to that title might be found, a curious logic. In the abridged 1932 catalogue of the collection (*Abridged Catalogue of the Pictures at Doughty House*, ed. M. W. Brockwell; p. 34) the picture is only doubtfully attributed, and it is admitted that it is "possibly a contemporary copy."

as almost to burlesque the character of corresponding elements in Francesco's authentic work. It would be too lengthy to catalogue all these differences from Parmigianino's authentic production; we summarily list only a few of them. The modeling of flesh reduces Francesco's very careful manner of modeling to a schematic abstraction, as in the heads of Charles and of the Fama, in her arms and the arms of the infant Hercules. Similarly schematized is Francesco's customary complex and sensitive representation of surface texture: compare the drapery of the Fama with that of the contemporary "Madonna della Rosa."

The plastic articulation of some forms is painfully uncertain: note the fitting together of the two sides of the heads of Charles and the Fama, and the articulation of the arm of Hercules. The drawing, too, is without the simultaneous authority and sensitivity that Francesco's own drawing shows. Both the larger contours and details within these contours are drawn in a fashion which is either schematically hard and overgeneral, or else very weak: see the arms and fingers, the indication of features, of ears and hair.

The types approximate Francesco's, but are much less refined in appearance and expression: compare the head of the Fama with the "Madonna della Rosa," and the head of the infant Hercules with the infant Christ of that same picture.[216]

In spite of these faults, because it is still a recognizable approximation of one of Parmigianino's important lost works, this copy is an invaluable archaeological, though no longer an aesthetic, document.

Preparatory drawing: New York, Morgan Library, IV, 43. Charles accepting the sphere of earthly dominion from a *putto,* accompanied by other *putti* (bringing leaves of palm?). Fig. 134. Red chalk, 14.3 x 13 cm. Torn vertically, through the length of the sheet, in three places.

[216] Granted the circumstance of the portrait being done "from memory," we might make an allowance for some weakness in Charles's head, but not for as much weakness as appears. Compare detail photograph, Fig. 133.

From the collections of Lawrence, Coningham, E. D. (Lugt 841), Fairfax Murray. Listed in the *J. Pierpont Morgan Collection of Drawings by the Old Masters Formed by C. Fairfax Murray* (London: privately printed, 1912), vol. IV, pl. 43. There assigned to Parmigianino, but improperly described as a "Sketch for the portrait of a General . . . In all probability intended for a portrait of one of the Farnesi." Not hitherto connected with the Cook portrait. The only study for a portrait which I know, though, as we have observed, the work is not a portrait in the normal sense. The drawing is likewise primarily concerned with the exposition of an allegory, and not with the appearance of the sitter.

PORTRAIT OF G. B. CASTALDI (?)

(Naples, Pinacoteca del Museo Nazionale, no. 109), 1529-1530. II. Oil on panel, .98 x .83 m. Fig. 135.

The first detailed reference to this portrait occurs in the 1680 inventory of the Palazzo del Giardino in Parma. It is there described as "un quadro alto br. 1 on. 1, largo on. 9 e 1/2. Ritratto d'uomo con barba, berrettino in capo nero con piuma assentato sopra una carega, al pomo della quale tiene la destra e con la sinistra un libro aperto, mezza figura in schiena vestita di verde e rosso del Parmigianino."[217] The inventory of the *Cento quadri più famosi* of 1725 contains a similar description.[218] In 1734 the portrait was transferred from Parma to the Capodimonte in Naples, from which it was taken by the French in 1799. It was recovered in Rome in 1800, then exhibited (1802) in the Galleria Francavilla as a *ritratto incognito del Parmigianino.*[219]

Sometime during the last century the painting acquired the mythical designation "Portrait of Amerigo Vespucci," a title which it bore until Ricci[220] attempted to identify it instead with a

[217] Campori, p. 232. Note that these measurements do not agree with those of the present picture, but the rest of the description is so specific as to leave little doubt that it applied to the present Naples 109. Possibly the panel has been somewhat cut down.
[218] Quoted in Affò, p. 92.
[219] Naples catalogue (1928), pp. 222-223.
[220] "Di Alcuni Quadri di scuola parmigiana con-

portrait mentioned in the inventory of the wardrobe of Ranuccio Farnese (1587): "Un ritratto di Gio. Batt. Castaldi del Parmigianino con suo ornamento e cendale cremesino."[221] The 1587 inventory contained no more specific description of this portrait, but Ricci tried to justify his identification by a process of elimination.[222] The logic of his process of elimination was satisfactory, but not so his unsupported assumption that the picture of an *uomo con barba* described in detail in the 1680 inventory above was necessarily in the Farnese Collection almost a hundred years before, in 1587, when a portrait of Castaldi was recorded. Though a strong possibility, Ricci's identification of Naples 109 is by no means a certainty.[223]

In this painting the change in technical character compared with the Uffizi portrait is very like that which occurs in the religious paintings between the "San Rocco" and the "Madonna della Rosa." As in the "Madonna della Rosa," this portrait shows an increasing minuteness of brushwork, a harder definition of contours and a somewhat colder and clearer modeling.[224] The morphology of a few details which are comparable in the portrait and the religious painting also suggests a similarity: compare, for example, their common increasingly abstract stylization of the hands. On the basis of the change in tech-

nique from the Uffizi portrait, and the similarity in handling with the "Madonna della Rosa," we should assign the "Castaldi" to approximately the same phase of Parmigianino's development as the latter picture.[225]

[225] Copertini (I, 206) assigns this portrait to the period 1530-1534. Venturi (IX/2, pp. 682-683, fig. 555), like myself, inserts it after the Uffizi portrait. Fröhlich-Bum (p. 33) most erratically considers it earlier than the Sanvitale of 1524. Longhi, in a footnote to his discussion of Girolamo da Carpi in his *Ampliamenti nell' Officina Ferrarese* (Florence: Sansoni, 1940; p. 37, n. 5) makes the revolutionary and, to my mind, untenable suggestion that this portrait (along with the Naples portrait of Vincenti) should be reconsidered from the point of view of its possible reattribution to Girolamo da Carpi. To justify this suggestion would first require the effective dismissal of the intimate correspondences of morphology and technique in both portraits with quite unquestioned portraits by Parmigianino; the visual evidence does not permit such a dismissal. Secondly, it would be necessary to demonstrate that any variations which might be observed in these two works from Parmigianino's other authentic portraits have no parallel in the development of style in his authentic religious and allegorical paintings. I cannot observe any such significant variations in the "Castaldi"; they exist in some measure in the "Vincenti," but there they are reasonably and simply explained in the light of our knowledge of Parmigianino's late development.

As for the attribution of these works to Girolamo da Carpi, there is no way in which a claim for his authorship can be made plausible. It should be expected that his portrait style, especially during his residence in Bologna, should to some extent reflect that of Parmigianino. However, there is no need on this account to confuse the model with the imitator or (to use an ungracious phrase) the influencer with the influenced. To assign to Girolamo these two of Parmigianino's finest portraits is to assume not only that Carpi is dependent on Parmigianino (which we readily admit) but that he is capable of imitation of Parmigianino to the point of counterfeit; worst of all, it assumes a condition contrary to fact; that Girolamo can operate at Parmigianino's qualitative standard. All these assumptions, but especially the last, are in despite of our current knowledge of Carpi as a portraitist. I suggest the comparison of the "Castaldi" with the nearest approach to it among Carpi's certain portraits, the "Archbishop Bartolini-Salimbeni-de' Medici" (Pitti; ill. Venturi IX/6, fig. 399, p. 662; dated by Venturi *c.*1532). The "Archbishop Salimbeni" shows an evident dependence of a general kind upon such Parmigianinesque portraits as the "Castaldi," but the Carpi shows an

servati nel R. Museo Nazionale di Napoli," *Napoli Nobilissima*, III (1894), 150; and *Archivio Storico per le provincie Parmensi*, pp. 9-10.

[221] Campori, p. 52.

[222] See his detailed exposition, cited in note 220. The other portraits listed in the inventory were those of G. G. Sanvitale (now Naples); the portrait of a priest (now Wrotham Park, England); a portrait of a Doctor Berniero (born in 1467 and therefore too old to be the subject of this picture); and finally that of Castaldi.

[223] Copertini (I, 206 and 220, n. 15) agrees in the rejection of Ricci's identity; so also does the Naples catalogue (1928, p. 223). Ricci notes that Castaldi was also painted by Titian and by Paolo Lomazzo, but that their portraits have apparently been lost.

[224] Note, however, how in the figure in the rear background Parmigianino has permitted himself the same loose notation that we observed in the garment of the St. Margaret. In both works some loosely painted passages coexist with the general hardening of surface elsewhere through the picture.

CATALOGUE

PORTRAIT OF A YOUNG MAN (Hampton Court, Collection of H. M. the King), 1530-1531. II. Oil on panel, .97 x .82 m. Fig. 136.

The drapery is somewhat damaged.

The first record of this painting occurs in the MS inventory of Charles II's collection at Whitehall, where it is entered as no. 263.[226] In James II's inventory it appears as no. 482: "a young man in black one hand upon his sword, by Parmigianino."[227] The portrait is again described in an inventory of Queen Anne's time, and recurs in all subsequent inventories of the royal pictures. Since at least 1817 the portrait had been held continuously at Windsor; it was transferred in 1947 to Hampton Court. In most of the later inventories, and in the catalogue by Collins-Baker of the Windsor pictures, the portrait bears the title "An Officer of the Papal Guard."[228]

Milanesi (V, 224, n. 3) had suggested the possible identification of this painting with the (then lost) portrait of Cybo. This identification was refused by Fröhlich-Bum (p. 32), who nevertheless assigned the Hampton Court portrait to the same Roman period as the "Cybo." Copertini (I, 213) considered that the model for the portrait was the same as that for the St. Stephen in the Dresden altar, and that the portrait was thus dateable about 1540.

Examination of the technique in which this portrait is painted reveals no likeness either to Francesco's authentic work of the Roman period or to his last productions. On the other hand there is a strong correspondence in the system of handling with the latest work of the Bologna period: the Uffizi "Madonna with St. Zachary." Comparison of the head of the Hampton Court youth with the heads in the "San Zaccaria" (especially with the two female heads) reveals a very similar character of brushwork, texture, handling of light, and modeling. Particularly, the head of the youth has a similar smooth, ovoid plasticity. Comparison of the present painting with the other portraits suggests that the Hampton Court portrait is a logical subsequent term to the "Castaldi" in the sequence of technical development Uffizi-Castaldi-Hampton Court. Accordingly, this work should be associated with Parmigianino's productions from the end of the Bologna period, or at latest the first year after his return to Parma.

Copies:

Edinburgh, Holyrood House, Coll. H.M. the King.

Knole, ex-Sackville Collection (now National Trust), with an inscription of the seventeenth (?) century: "Florentine nobleman of y^e Strozzi Family."

PORTRAIT OF A YOUNG LADY, called the SCHIAVA TURCA (Parma, Galleria, no. 1147), 1530-1531. II. Oil on panel, .67 x .53 m. Fig. 137.

The first accessible mention of the above portrait occurs in the Uffizi inventory of 1675. It is there described among the pictures collected by the Cardinal Leopoldo de' Medici: "Ritratto di giovane donna, con turbante in capo, con la sinistra tiene un pennacchio, di mano del Parmigianino."[229] The denomination "Schiava Turca" does not appear until the inventory of 1704, and seems there to result only from the turban worn by the sitter.[230] The title is a mere romantic no-

instant contrast in its far less strict and coherent organization of design. The execution gives much more attention to casual details; the forms of hands, head, and body are more accidental and far less highly stylized than in the "Castaldi." The expression imitates the tight control of the "Castaldi" but is utterly without its subtlety or its intense sense of subjective analysis of the sitter. The Carpi portrait, by contrast with the "Castaldi," is deficient in style, in both the colloquial and literal senses. A comparison of the "Vincenti" with (such parallels as it might be possible to find in) Carpi's work would yield similar results.

[226] The entry in the MS inventory of Charles II was kindly communicated to me by Benedict Nicolson (letter of Nov. 9, 1947).

[227] *Catalogue of the Collection of Pictures, etc., Belonging to King James II* (London: Bathoe, 1758).

[228] C. H. Collins-Baker, *Catalogue of the Principal Pictures in the Royal Collection at Windsor Castle* (London: Constable, 1937), p. 250.

[229] Uffizi catalogue (*R. Galleria degli Uffizi, Elenco dei Dipinti,* Florence, 1923), p. 63; Copertini I, 211.

[230] This fashion seems to have become generally

tion, for in addition to all the other obvious evidences to the contrary the subject wears a wedding ring. The portrait remained in the Uffizi collections until 1928, when it was exchanged to the Parma Gallery.

There is a pronounced resemblance in morphology and technique between the "Schiava Turca" and the Hampton Court youth: the lighting and modeling of the head, the drawing of the nose and eyes, and the character of brushwork are sufficiently alike to permit the conclusion that the two portraits are fairly close in time of execution.[231]

PORTRAIT OF THE COUNTESS GOZZADINI (Vienna, Kunsthistorisches Museum, no. 65), 1530-May, 1531. II. Oil on panel, .50 x .46 m. (fragment). Fig. 138. Reduced in the eighteenth century from its original half-length to a bust-length portrait. The head and the curtain to the left are in a virtually completed state, while the dress has been merely underpainted.[232]

The earliest record of the present portrait is in the inventory of the Collection of Archduke Leopold Wilhelm in Brussels (1659), as no. 273.[233] At that time, as may be seen in Teniers' painting of the Archduke's gallery (Vienna, Kunst-

historisches Museum, no. 1101, where this portrait appears in the bottom row between the two larger paintings in the foreground; see Fig. 141), the portrait was presumably[234] in its original dimension, and showed the subject seated three-quarters left, holding a book in her lap.

At the expiration of his governorship in the Netherlands, the Archduke made his collection over to the Emperor Leopold II in Vienna. The pictures were placed on exhibition in the Stallburg; in order to make a more decorative pattern on the wall the curator took extreme liberties with the dimensions of the pictures, cutting some down, and enlarging others to suit his purpose.[235] It was apparently then that the unfinished portions of this painting were cut away, and the whole reduced to the proportion of a bust portrait.

Certain details even in the most nearly completed portions of Countess Gozzadini's portrait have not quite been finished. Her turban has been only very casually indicated on the side nearer us (compare the same headdress in the "Schiava"); her hair has not been rendered in Parmigianino's accustomed detail; her ear requires reworking from its rather clumsy present state; and the eyebrows seem never to have received more than an underpainting.

The relatively finished portions of the Vienna portrait immediately suggest comparison in technique with the "Schiava Turca" and the Hampton Court youth; further, it is the one among these three portraits which offers the most intimate technical parallel to the Uffizi "Madonna di San Zaccaria." Comparison of the brushwork, texture, and modeling in the "Gozzadini" with the head of the Uffizi Madonna indicates that both works must have been executed quite close together in time.

In his account of the works of the Bologna period Vasari (V, 228) tells that Parmigianino "fece a Bonifazio Gozadino il suo ritratto di naturale, e quello della moglie, che rimase

popular in Italy c.1530. See Copertini I, 210, and a rather long, but inconclusive discussion of this type of headdress by Fröhlich-Bum, in *Burlington Magazine*, XLVI (1925), 87.

[231] There is no general agreement about the dating of this picture. Fröhlich-Bum (p. 38) has not assigned a date; Copertini (I, 210, and in his article in the catalogue of the Mostra del Correggio, Parma, 1935, pp. 86-87) considers it somewhat indefinitely a "mature" work.

[232] A radiograph exists at the Fogg Museum. It shows certain minor pentimenti, such as corrections in the drawing of the turban, the eye, etc. The portrait was first ascribed to Parmigianino by F. Wickhoff (Vienna catalogue, 1907, p. 20). It had previously been catalogued as Barbatello (Vienna catalogue, 1882, vol. I, p. 22, no. 24), and in the eighteenth century had been ascribed to Leonardo (*ibid.*). Wickhoff's attribution has been universally accepted: Fröhlich-Bum (p. 30), Copertini (I, 204), Venturi (IX/2, p. 677), Berenson (*Lists*).

[233] Vienna catalogue (1938), p. 127. Leopold acquired many of his paintings, but not this one, from Charles I's collection.

[234] But note the suspicious exact uniformity in dimension of the entire row of portraits!

[235] See J. von Schlosser, *Kunst-und Wunderkammern der Spätrenaissance* (Leipzig: Klinkhardt und Biermann, 1908), p. 125.

imperfetto." The portrait of the husband now seems lost, but we may identify the portrait of the Countess Gozzadini, "che rimase imperfetto," with the Vienna portrait.[236] Two circumstances combine to assure the probability of this identification: first, the unfinished state of the fragment (a unique circumstance in Parmigianino's surviving portrait *oeuvre*); second, the fact that the portrait associates itself so intimately in technique, and thus in date, with the Uffizi "Madonna," a work of the Bolognese period. A further consideration[237] is particularly striking: the Uffizi "Madonna," with which this fragmentary portrait is so closely associated in style, was commissioned for Bonifazio Gozzadini, the husband of the lady represented in the unfinished portrait recorded by Vasari. This connection would seem to lend an even higher degree of credibility to our identification of the Vienna fragment, and also help assure the certainty of our dating of it.

That the portrait of Countess Gozzadini remained unfinished might perhaps be explained by the fact that since its date apparently coincides with, or perhaps even immediately succeeds that of the last religious painting done in Bologna, Francesco might have left the city before its completion. It will be recalled (see above, p. 182) how Francesco had difficulty in collecting payment from Gozzadini for the Madonna di San Zaccaria; this difficulty might have resulted from the fact that he had left part of his work for Gozzadini (the portrait of the Countess) undone.

PORTRAIT OF PIER MARIA II ROSSI, COUNT OF SAN SECONDO (Madrid, Prado, no. 279), 1533-1535. I. Oil on panel, 1.33 x .98 m. Figs. 139, 140.

The identification of the subject of this portrait and of its pendant (Prado, no. 280) as the Count and Countess of San Secondo results from research undertaken by Corrado Ricci, and further developed by Ferdinando Bernini.[238]

Federico Rossi, the son of the Count of San Secondo pictured in Madrid 279, mentioned this portrait in his *Elogia virorum Rosciorum:* "Eius verissima effigies perpolite a Francisco Mazolio eximis pictore delineata Sansecundi inspicitur."[239] Also within the sixteenth century the portrait was noted by Vincenzio Carrari (author of the *Istoria dei Rossi parmigiani*, 1583) as then existing in the Rocca di San Secondo. Carrari's description of the Count Pier Maria[240] is such that it may even have been derived from the present painting: "... di volto veramente heroico, con meravigliosa vivacità d'occhi [*sic!*] co' capelli e la barba bionda. Fu grande di statura; e di fermezza di membra gagliarde, atto a portare e maneggiare l'armi..."[241]

There is no precise information on the circumstances of the transfer of the San Secondo portraits from the family collection to Spain. An inventory of about the second third of the seventeenth century, "Quadri vendibili in ignote località d'Italia,"[242] includes both this portrait and its mate: the first as "Ritratto d'uno de' conti di San Secondo, del Parmigianino"; the second as "Ritratto d'una Contessa di San Secondo con tre suoi figli dal naturale," with an attribution to Correggio. Both paintings were eventually sold to the Spanish royal house. They were then apparently separated: in 1686 the inventory of the Alcazar lists the portrait of a Count of San Secondo by Parmigianino, but does not record the Contessa. In 1772 the portrait of the Count was among the pictures kept at the Retiro, while

[236] Copertini (I, 204) also advances this identity, which has been accepted in the latest Vienna catalogue.

[237] Unremarked by Copertini, to whom we owe the publication of the documents concerning the "Madonna with St. Zachary."

[238] Ricci in *Archivio Storico per le provincie Parmensi*, pp. 19-23; Bernini in "Il Castello dei Rossi di S. Secondo," *Aurea Parma*, Anno III, 1921, *fasc.* 3, pp. 129-139, and in "L'Ambiente Storico del Castello dei Conti Rossi in San Secondo," *Aurea Parma*, Anno XVII (1933), *fasc.* 5-6, pp. 186-201, esp. pp. 192-194. Before the publication of Ricci's article, and the reappearance of the Copenhagen portrait, Madrid 279 bore the favorite appellation of Count Cybo, while Madrid 280 was described as Cybo's wife, Riccarda Malaspina.

[239] Quoted in A. Pezzana, *Storia della Città di Parma* (Parma, 1837-1859), IV (appendix), 51-53.

[240] By this time thirty-six years dead.

[241] p. 199 (quoted Copertini I, 212); noted by Affò (p. 81).

[242] Campori, pp. 453-454.

the portrait of the Countess was in the Royal Palace in Madrid.[243]

The smoothness and minuteness of technique in the portrait of the Count is considerably more than in the latest works of the Bologna period, and seems rather to suggest comparison with the "Amor" and the "Collo Lungo" of the earlier half of the second period in Parma. It is difficult to judge on purely technical grounds which of these two paintings the portrait more closely resembles, but the morphology may help to specify our dating further: the hands and head of the sitter have an extreme refinement and an almost schematic elongation which proceed beyond that of any previous portrait, and which are surpassed, even in the religious works, only in the "Collo Lungo." This would suggest a dating of the portrait rather toward the time of the "Collo Lungo"; that is, toward the middle of the second Parma period rather than at its beginning.[244]

Copies:

Poundisford Park, Collection of A. W. Vivian-Neal. Fig. 142. Panel, 1.32 x .99 m. In the Vivian family since the early nineteenth century. Recorded by Waagen (*Treasures of Art,* III, 176). Recently cleaned, and the brocade (which shows dark in the Madrid picture) is very light in color here (see p. 147, above, n. 32). Falsely considered an original by Parmigianino in the catalogue of the Exhibition of Art Treasures of the West Country Museum and Art Gallery (Bris-

tol, 1937), p. 42. A literal repetition in the size of the original, but by a hand much inferior to Parmigianino.

(formerly) Parma, Collection Rossi. A portrait of a Count San Secondo, attributed to Parmigianino, but apparently a copy after the Madrid painting, was given by a descendant, G. G. Rossi, to Moreau de Saint Mery, French administrator in Parma during the Napoleonic era.[245] Possibly the same as the Vivian-Neal copy.

PORTRAIT OF CAMILLA GONZAGA, COUNTESS OF SAN SECONDO, with three of her sons (Madrid, Prado, no. 280), 1533-1535. II. Oil on panel, 1.28 x .97 m. Fig. 143. See also the previous entry in the catalogue. Portions of this picture apparently finished by another hand.

Certain elements in this portrait are so clearly autographic for Parmigianino that they compel us immediately to recognize his authorship. The head of the boy at the left is strongly like the heads of the children in the "Collo Lungo" altar, not only in form but in its exceptional sensitivity of expression; the head of the Countess has the accustomed authority of Parmigianino's draftsmanship and modeling, and shows the imposition upon the features of certain stylizations which are characteristic for the artist. The execution of detail in certain passages, as in the bodice and turban of the Countess, and of her jewels, reveals the same meticulous skill that is evident in the execution of detail in the portrait of the Count.

However, beyond these passages (and possibly a few others) the rest of this picture visibly deviates from Parmigianino's accustomed standard. There is some old repaint in the passages which I consider suspect, but their faults are not such as are likely to result from restoration alone (unless it should be most radical), but from original defects in form and draftsmanship. For example, the hands of the children are of a remarkable crudity, while the left hand of the Countess resembles an inflated rubber glove. The left sleeve of the Countess, and the garments of the boy on the right and of the youngest child

[243] Prado catalogue (1913), p. 58, and (1933), p. 28. Even though it was forgotten through most of the eighteenth and nineteenth centuries, the association of the name of the Count of San Secondo with the present painting is, from this documentary evidence, perfectly secure (the key document being the Alcazar inventory of 1686). Further visual evidence can be adduced, for a medal exists which bears the image of the Count Pier Maria Rossi (L'Armand, *Les Medailleurs Italiens,* 1883, II, 19, and III, 159) which, according to Ricci, shows the identical face.

[244] Copertini (I, 212-213), working largely from his judgment of the age of the sitter as in his middle thirties, dates this painting and its mate toward 1538. Ricci (cited in note 238) on the other hand, dates the portrait between 1532 and 1534. The beard somewhat obscures the evidence which might be offered by the sitter's age; he was born in 1504.

[245] Ricci, *Archivio Storico per le provincie Parmensi,* pp. 22-23.

are quite without suggestion of rounded form: they seem merely clumsily stuffed rather than disposed around a figure. The execution of the ornamental detail in the dress of the two boys is far less skillful than is normal in Parmigianino. Though probably originally of Parmigianino's design, and begun by him, it would appear that these passages were completed by another hand.

The portrait of the Countess does not have so precise a documentary record as does the portrait of the Count of San Secondo. Its association with the latter painting as its pendant, and the consequent identification of the sitter as the Countess of San Secondo, must be supported by internal evidence. From what does exist from Francesco's own hand in Madrid 280, it is evident that there is in fact a close technical and morphological resemblance with the portrait of the Count. The resemblance to Madrid 279 is stronger than with any other of Francesco's portraits, and implies an approximate community in time of execution. Further arguments for the intimate association of Madrid 280 with Madrid 279 are their near identity in dimension and format, and their connection in subject matter and in design: the pose and direction of gaze of the woman is conceived as if in counterbalance to those of the Count.[246]

In the light of the above evidence, it seems reasonable to regard Madrid 279 and 280 as pendants. If we accept the identification of Madrid 279 as the Count San Secondo, Madrid 280 must be identified as his Countess, Camilla Gonzaga, and three of her sons.[247]

PORTRAIT OF A LADY, CALLED ANTEA

(Naples, Pinacoteca del Museo Nazionale, no. 108), 1535-1537. II. Oil on canvas, 1.39 x .88 m. Figs. 144, 145. An old fold or seam across the canvas is clumsily retouched. Moderate damages also in the lower part of the picture.

The so-called "Antea" is traceable in the documentary sources back only to the third quarter of the seventeenth century. It is first mentioned in 1671 in the *Viaggio pittorico* of Giacomo Barri as "L'innamorata, chiamata l'Antea, del Parmigianino."[248] The Farnese inventory of c. 1680 describes the portrait more fully: "Un quadro alto br. 2 on. 7 largo br. 1 on. 7 1/2. Un ritratto, figura intera sino al ginocchio che rappresenta una Donna detta l'Antea, con guanto ed uno sghiratto nella destra, del Parmigianino." It is similarly cited in the *Cento quadri più famosi* of 1725.[249] From the Farnese collections in Parma the "Antea" was sent to the Capodimonte in Naples. Briefly in Palermo in 1806, it was returned thence to the Naples Gallery.[250]

It should be observed that, though the early

[246] Only two factors suggest a possible flaw in this association: they are the opposite directions of the fall of light in the two portraits, and the difference in the character of their backgrounds. The difference in the fall of light is accounted for by the reversal of the bias of the main figure in the female portrait: the artist obviously prefers to show the part of the face turned toward the spectator in light rather than in shadow. The uniform, opaque background of the Countess' portrait may be accounted for by our judgment of the only partial authenticity of this picture: a background similar to that in the Count's portrait may have been intended by Francesco and not executed, or it may be covered by old repaint. An X-ray photograph of the whole portrait might be of great value.

[247] Copertini (I, 22, n. 25), proceeding from his assumption that the portrait dates c.1538, identifies the three children as Troilo, Ippolito, and Federico, who were three of the six sons of this couple. Ricci (*Archivio Storico per le provincie Parmensi*, p. 22), who dates this painting c.1532-1534, prefers to regard the children as Troilo, Ippolito, and Sigismondo. The Count of San Secondo married Camilla Gonzaga in 1523.

A portrait in the Philadelphia Museum, called a portrait of a lady of the Sciarra family of Rome, and wrongly attributed to Parmigianino by Suida (see below in catalogue of attributed works) is said, also wrongly, to represent the same person who is depicted in Madrid 280.

The latest edition of the catalogue of pictures in the Prado (1945, p. 445) rejects the association of the two portraits, but does not allege any reason therefor.

[248] Or, in the language of the English translation (*The Painters Voyage of Italy*, London, Flesher, 1679, p. 125) "that Amorous Lady, called L. Antea del Parmeggiano, by his own hand."

[249] Campori, p. 212; Copertini I, 207-208; Naples catalogue (1928), p. 221.

[250] Naples catalogue (1928), *loc. cit.*

citations agree in their identification of the sitter, only the earliest might possibly be so construed as to imply a relationship between the sitter and the artist. Such a relationship is first clearly posited by d'Argenville (1745), who describes the lady of the portrait as *La Maitresse du Parmesan apellée Lantea*.[251] There has been much controversy about the identity of the lady in the Naples portrait, and about the nature of her relationship with Parmigianino. D'Argenville's denomination of her as *La Maitresse du Parmesan* would seem to follow reasonably enough upon her identification by the earlier authorities as Antea, for the Antea who has survived in history was a mistress by profession. She was one of the most noted courtesans of sixteenth-century Rome, who attained the distinction of mention by two of Italy's most distinguished connoisseurs in such matters, Aretino and Cellini.[252]

Though Affò (p. 57) was careful to deny the relationship proposed by d'Argenville, he did not question the identity of the lady. The first challenge to the traditional identification came from Count Luigi Sanvitale, in a letter of 1867 directed to the then head of the Naples Museum.[253] Sanvitale insisted that the sitter of the Naples picture was the same as the person represented in a portrait at Fontanellato,[254] which he believed to be of Pellegrina Rossi di San Secondo. In spite of a general resemblance, Count Sanvitale's association of the two portraits was hardly conclusive; further, his identification of the subject of the Fontanellato painting seems to have been pure supposition. However, Count Sanvitale was right at least in his negative thesis: the sitter of the Naples portrait cannot be Antea. This emerges from a clarification of the date of the portrait.

The sitter in this portrait and the Madonna in the "Collo Lungo" altar exhibit strongly similar characteristics in their faces, each of which has been stylized, though to a different degree: in both there is the same cool purity of surface and of contour in the modeling of the face, and a singular likeness in the extreme elongation of the features. Further, among the group at the left of the "Madonna dal Collo Lungo" there is a young girl who bears a resemblance to the so-called Antea which is not merely generic, as is that of the Madonna, but strikingly specific. The girl in the religious picture seems slightly younger than Antea, and her hair is somewhat lighter, but the likeness remains such that it seems impossible that Francesco could have conceived the face in the altar without acquaintance with the sitter of the Naples portrait. These resemblances certainly indicate at least a general community in time of execution between the "Antea" and the "Madonna dal Collo Lungo."

However, in certain larger respects of style in the portrait there appear characteristics (among others a marked increase in gravity of design; see text, above, p. 119) which correspond to tendencies which occur in Francesco's religious works only subsequent to the conception (though not to the long-delayed execution) of the "Collo Lungo." It is therefore possible that the "Antea," though perhaps coeval with the "Madonna dal Collo Lungo," may in fact be slightly later in date: a reasonable dating for the portrait should be 1535-1537.[255]

The fact that the portrait dates from the middle of the second Parma period should in itself tend to discourage its identification as Antea, who (to the best of our knowledge) "flourished" in Rome. Moreover, it is evident from Cellini's mention that Antea was already well established

[251] *Abrégé de la vie des plus fameux Peintres* (1762), I, 224.

[252] Aretino, "Ragionamento del Zoppino," in *Ragionamenti di Messer Pietro Aretino* (ed. "Cosmopoli," 1660), p. 429; Cellini in the *Autobiography* (Florence: Piatti, 1829, ed. Tassi), I, 236.

[253] A. Cutolo, "L'Antea del Parmigianino," *Emporium*, LXXXVI (August 1937), 424ff.

[254] See below, catalogue of attributed works, p. 227.

[255] Copertini (I, 208) positively assumes the identity between the subject of the portrait and the girl in the background of the "Collo Lungo." Considering their apparent difference in age, he prefers to date the portrait a few years after the altarpiece; he thus arrives at a conclusion about like ours. Fröhlich-Bum (p. 29) on the assumption of a relation in style with the Uffizi "Madonna," which she mistakenly places in the Roman period, dates the portrait also in that period. Venturi (IX/2, pp. 674-676) dates the portrait c.1535.

in her profession by 1530. The subject of this portrait, painted in the mid-1530's, can hardly be twenty years old, and is almost surely less; to identify her with Antea, the Roman courtesan, would presume an excessive (though admittedly not impossible) precocity.

In spite, then, of the continuity and the relative antiquity of the tradition that associates Antea's name with this portrait, we must forsake it. It is easy to see how, with such a sitter, some inventive seventeenth-century mind would have conjured up a glamorous name to fit, and invented a romantic relationship between sitter and artist.

We have no positive suggestion for a new identification to replace the traditional one. The only line of reasoning which suggests itself is that which arises out of the resemblance between the girl in the "Collo Lungo" altar and the sitter of the Naples portrait. We have elsewhere suggested (p. 144, n. 26) that the children in the background of the "Collo Lungo" might be from the donor's family. If the girl in the altar and the girl in the portrait are in fact the same, we should then know at least that she may be a Tagliaferri, or possibly a Baiardo; research among the documentary records of the family, if they still exist, might give some further clue.[256]

PORTRAIT OF GIROLAMO DE VINCENTI
(?) (Naples, Pinacoteca del Museo Nazionale, no. 124), 1535-1538. II. Oil on canvas, 1.19 x .88 m. Fig. 146. The background and parts of the dress of the sitter have been damaged by abrasion.

The earliest discoverable mention of this portrait is in the inventory of the Palazzo del Giardino (c.1680), where it is described as "Un quadro alto br. 2 on. 3, largo br. 2. Ritratto d'uomo con robone berettino nero, la destra nel guanto e tiene l'altro guanto impugnato e la sinistra al pomo della spada, del Parmigianino."[257] In 1734 this picture was transported to the Capodimonte in Naples, whence it was later taken by the French. Recovered in Rome, it was exposed in 1802 in the Galleria Francavilla as *Ritratto incognito del Parmigianino, in tela*. It was sent to Palermo in 1806, and subsequently returned to its present place.[258]

The portrait bears a legend of which the evidence must be considered with particular caution. In the last edition of the Naples catalogue (1928),[259] it is given thus:

Jeronimus de Vincenti
Aetatis suae an XXVIII
MDXXXV

However, previous editions of the catalogue (1911 *et al.*) had reported the inscription in different form:

MDXXXV . . . Eronimus de Vincenti
Aetatis suae

I cannot presume to say what the cause of this disagreement may be: whether the inscription had been partially cleaned out, or whether it has been restored and changed.

It is still more singular that none of the mentions of the portrait before 1911 seems to know the inscription, not even to the point of repeating its identification of the sitter. In the 1680 inventory, the sitter is merely *un uomo*, while the Francavilla inventory of 1802 describes him as *incognito*. It would seem to be a possibility that the inscription may be posterior to 1802, or more modern still. At any rate, it would not seem justifiable to make any conclusions on the basis of the inscription, either for the identity of the sitter or the date of the painting.

From the internal evidence it would appear, however, that the date in the inscription (as it is now readable on the canvas) may be fairly close to correct. On comparison with other works this portrait seems to fall, both in style and technique, into the phase of Francesco's reorientation of style subsequent to the "Collo Lungo": probably into the years 1536-1538.

From technical comparison with the "Antea," the "Vincenti" seems perhaps somewhat later.

[256] Ricci in 1930 still supported the old identification. See "Cortigiane del Rinascimento: Antea," in *L'Illustrazione Italiana* (February 23, 1930), pp. 313-316.

[257] Campori, p. 234. The width given in the inventory does not agree with the actual measurement.

[258] Naples catalogue (1928), p. 226.
[259] *Ibid.*

Though the "Vincenti" shows a somewhat greater freedom and openness of brush stroke in most passages, there is a general likeness in the handling of the textures of the garments. On the other hand, the modeling of Vincenti's face and hands shows a marked difference from the "Antea" in the forceful opposition of modeling light and dark. His head and hands do not present the generalized, hollow-seeming surfaces of the Antea, but have instead a very convincing plastic strength.[260]

[260] And, as well, a certain intensity of realistic conviction that proceeds considerably beyond the "Antea." This is aided by the increased particularization of certain details of the surface modeling in

This is the difference we have observed between the technique of the "Collo Lungo" and that of the subsequent Naples "Holy Family" and the Steccata figures: the Vincenti thus suggests a more intimate association with these two works of *c.*1536-1538 than with the paintings which we have assigned to 1535.

the flesh, especially the left hand. See remarks in note 225, above, on Longhi's tentative suggestion for a possible reattribution for the "Vincenti" (to Girolamo da Carpi); Longhi is the only potential dissenter among the critics, who are otherwise unanimous in their attribution of the "Vincenti" to Parmigianino.

B

CATALOGUE OF ATTRIBUTED PAINTINGS

This section of the catalogue lists and briefly discusses pictures which (a) have carried an old attribution to Parmigianino into the present century, or (b) have been attributed to Parmigianino in catalogues or critical literature since 1900.

No consideration is given to the recording of nineteenth-century attributions which have not persisted into our century. Nineteenth-century catalogues and critics assigned a vast number of paintings to Parmigianino without any sound basis; most of these arbitrary attributions have since been changed.

Pictures are listed alphabetically by place.

ATTRIBUTED RELIGIOUS AND MYTHOLOGICAL PAINTINGS

AIX EN PROVENCE, MUSEUM. "Madonna and Child with St. Anne."

Ascribed to Parmigianino in the museum. According to Voss (*Die Malerei der Spätrenaissance in Rom und Florenz,* Berlin, Grote'sche Verlag, 1920; I, 247) and Venturi (IX/6, p. 212) a work of Francesco Salviati.

(*formerly*) AMSTERDAM, GOUDSTIKKER GALLERIES, no. 2512. "Head of a Child." Panel, .455 x .325 m. Fig. 148.

The first reference to this painting dates from 1662, when it was inventoried in the Farnese collections in Rome. In 1680, it was inventoried in the Palazzo del Giardino in Parma. That inventory described the picture as "Un quadro alto on. 9 e 1/4, largo on. 7 e 3/4, in tavola. Una testa di un puttino con capelli annodati, che tiene un dito della sinistra in bocca, e con la destra la Tola [tavola] dell'alfabeto, del Parmigianino." (Campori, p. 229). The *Descrizione di cento quadri de' più famosi* (1725) also describes the painting: "abozzo d'un fanciullo che scherza, avendo l'indice della sinistra alla bocca, ed ha in destra l'abecedario" (quoted Affò, p. 91). Though the Goudstikker panel does not appear in the literature until the late seventeenth century, its earlier origin is indicated by the presence on the rear of the panel of the arms in red wax of Ranuccio Farnese (*c.*1592-1622).

This panel is the companion to a picture, now in the deposit of the museum at Naples, of a head of a child studying a primer (*abbecedário*), with which it is listed together in the inventories of 1662, 1680, and 1725. The Goudstikker panel apparently was abstracted from the Farnese collections some time after 1725, while its companion remained and passed to Naples. The Goudstikker panel was first published, with a revival of the old attribution to Parmigianino, by Fröhlich-Bum in 1930 (*Burlington Magazine,* vol. LVI, 1930, pp. 273-275; the painting was then in the de Frey Collection in Paris). Fröhlich-Bum's attribution has been accepted by Copertini who (though he does not discuss the picture in his text) includes it in his list of authentic works (II, 143). There are, as Fröhlich-Bum points out, many analogies in the Goudstikker panel with Parmigianino's work of the later Parma I, as well as of the Roman periods.[261]

[261] Fröhlich-Bum (*loc. cit.*) advances the suggestion that the Goudstikker panel may be a study from life, done in preparation for the Christ child of Parmigianino's "Vision of St. Jerome." The existence of a pendant would tend to disprove this, since this *putto* was evidently one of a decorative pair. Further, Parmigianino's studies after life, when he made them, were in drawing; no sure example exists in painting. (This panel is not therefore, in the strict sense of being a sketch for a painting, an

However, analogies which are considerably more convincing may be found in the style of Correggio, of which this panel would seem to be a late sixteenth-century pastiche. A. O. Quintavalle ("Falsi e veri del Parmigianino giovane," p. 249) also rejects this painting, and regards it as a work in the same category as has already been established for its companion piece in Naples (see below, p. 222), that is, as a copy after Correggio.

Fröhlich-Bum reports (*loc. cit.*) that a copy of the Goudstikker panel (blue chalk with water color) was auctioned at Boerner's, Leipzig, Nov. 28, 1912.

CERZETO (SORAGNA) CHIESA DI SAN GIOVANNI BATTISTA. "Madonna with SS. John Baptist and Chiara (?)." Panel, 1.33 x 1.06 m.

This painting was restored in 1930; at that time a document of 1717 was discovered which alleged that the picture had been executed in 1541 (*sic*) by Parmigianino. The picture was so published by D. Gallori in *Corriere Emiliano* for April 17, 1931. Sorrentino (*Bollettino d' Arte*, vol. X, ser. 2, 1931, pp. 381-384, ill. pp. 382-383) had already exposed the unreliability of the document, and had assigned the picture tentatively to Antonio Campi. In the catalogue of the Mostra del Correggio (1935) this altar (p. 95, no. 71) is attributed to Anselmi; this attribution would seem to be more nearly acceptable.

CHIARI, PINACOTECA. "Holy Family with St. Catherine." Panel, .45 x .36 m.

The attribution to Parmigianino is indicated in the photographic files of the Frick Art Reference Library. A debased work in a *retardataire* seventeenth-century style.

CITTÀ DI CASTELLO, GALLERIA DEL PALAZZO MANCINI. "Group of Cupids at Play."

Attributed to Parmigianino on the Alinari photo, no. 5365. Only the large figure of Eros at

abozzo, as it is called in the Farnese "Descrizione." The term suits it only as a description of its "sketchy" character of handling.)

the left seems even distantly related to Parmigianino. Perhaps attributable to Bernardino India. See below under Verona, Museo Civico, no. 153.

CREMONA, MUSEO CIVICO ALA-PONZONE. "St. Cecilia with an Angel."

The attribution to Parmigianino is indicated in the photographic files of the Frick Art Reference Library. Neither the types nor the execution bear any resemblance to Parmigianino. By a minor painter of the mid-sixteenth century, perhaps in the Cremonese school.

CREMONA, MUSEO CIVICO ALA-PONZONE. "St. Margaret." Panel, .49 x .35 m. Fig. 149.

The attribution to Parmigianino is indicated in the photographic files of the Frick Art Reference Library, and had previously appeared in the *Guide for Piedmont, etc.,* of the Touring Club Italiano (1926), II, 463. A work from the third quarter of the sixteenth century, in the stylistic tradition of Camillo Boccaccino.

GLASGOW, ART GALLERY AND MUSEUM, no. 129. "Madonna and Child with St. Joseph." On copper, .26 x .215 m.

Attributed to Parmigianino by Fröhlich-Bum (in her article in Thieme-Becker, 1930); recorded in the Glasgow catalogue (1935) with the same attribution. A picture no earlier in style than the third quarter of the sixteenth century; it reflects the strong influence of the Tintoretto school on a minor master. The nature of the support also tends to place the picture later than Parmigianino's time.

LENINGRAD, HERMITAGE, no. 86. "Entombment." Transferred from wood to canvas, .31 x .26 m.

Published by Fröhlich-Bum (*Graphische Künste,* vol. XXXVIII, 1915, "Mitteilungen," p. 3) as an original. Fröhlich-Bum subsequently reconsidered her position, and in her monograph (p. 43) described it as a copy after a lost painting of the Bologna period. In actuality, this is an example of a not infrequent occurrence in the history of Parmigianino's *oeuvre:* the trans-

CATALOGUE

lation into painting by another artist of a print by (or after) Parmigianino. This work is imitated directly from Parmigianino's etching of the same subject. Copertini (II, 104) assigns this painting to Meldolla. The picture is apparently identical with one engraved in 1788 by C. H. Hodges from "the cabinet at Houghton."

(*formerly*) LONDON, COLLECTION WESTMINSTER. Two panels: (a) St. Peter, (b) St. Paul. Each .22 x .076 m.

From the collections of Sir Luke Schaub, 1758; Agar Ellis; Marquess of Westminster. Sold Christie's, July 4, 1924, no. 26. Mentioned in Waagen (*Treasures of Art*, II, 169) as being assigned by the owner to Polidoro, but Waagen remarks that the "execution appears to me to be too finished and elegant." The attribution to Parmigianino is indicated in the photographic files of the Frick Art Reference Library, but is not justifiable on any visible grounds.

LONDON, sold Christie's, March 12, 1926, no. 57. "Holy Family with St. John and Music-making Angels." Attributed in the sale catalogue to Parmigianino, but probably by an artist of the circle of Rudolf II.

MINNEAPOLIS, WALKER ART CENTER. "Madonna and Child with the Infant St. John." .19 x .216 m.

The painting was in the collection of the Marquis de San Vitolia, and subsequently in the collection of Joseph Knowles of London. It was exhibited at Leeds in 1868, and in London in 1886 as Correggio; formerly attributed in the gallery to Correggio. It was reassigned by Mr. LeRoy Davidson to Parmigianino. A copy, with slight variations, from a chiaroscuro print after Parmigianino executed presumably by Antonio da Trento (ill. Copertini II, *tav.* CXXV). On morphological grounds, the copyist may be Alessandro Mazzola-Bedoli.[262]

[262] Compare, for example, his "Madonna and Child with *Putti*," Parma no. 63. The inventory of the Palazzo del Giardino of c.1680 (Campori, p. 268) contains the following notice: "Duoi quadri alti on. 5, larghi on. 6 per chiascheduno e 3/4 . . .

MODENA, PALAZZO CAMPORI. "Marriage of St. Catherine, with St. Stephen." Canvas, .492 x .42 m. Fig. 150.

"Discovered" by Marchese Matteo Campori; published as Parmigianino by Ferruccio Sorgato in the catalogue of the Palazzo Campori, and by Malaguzzi-Valeri in *Cronache d'Arte* (vol. I, 1924, pp. 232-233). The compositional scheme is apparently derived from a common source—seemingly a drawing by, or a print after, Parmigianino—with the Moscow "Marriage of St. Catherine" (see below). In the Campori painting the St. John is replaced by St. Stephen, and the general format of the design is more vertical. Of the two derivations from the Parmigianinesque source, the Campori one seems the less faithful. It is certainly less cleverly executed than the Moscow picture.

MOSCOW, STATE MUSEUM OF FINE ARTS. "Marriage of St. Catherine, with St. John Baptist." Canvas, .20 x .27 m. Transferred 1930 from the Hermitage in Leningrad.

Published as Parmigianino by V. Lazareff in *L'Arte* (vol. XXVII, 1924, pp. 169-171). Accepted by Fröhlich-Bum in Thieme-Becker (1930), and by Berenson. Refused by Copertini (*Archivio Storico per le provincie Parmensi*, NS XXVI, 1926, p. 300). A rather clever, but nevertheless weak pastiche on Parmigianino's style, conceived generally in the manner of his early work, and probably derivative from a drawing by, or print after, Parmigianino. A second work derived from the same source is in the Palazzo Campori, Modena (see above).

NAPLES, PINACOTECA DEL MUSEO NAZIONALE, no. 116. "Madonna and Child with an Angel" (sketch). Panel, .36 x .31 m. (Photo Alinari 34062, Anderson 23503.)

Attributed to Parmigianino in an eighteenth-century inventory; reattributed to him by C. Ricci in *Archivio Storico per le provincie Parmensi* (*op. cit.*) p. 8. It has since been prop-

In uno un paesino; la Madonna Sant^ma in grembo e S. Giuseppe che legge . . . di Alessandro Mazzola." The description, but not the dimensions, might fit the Minneapolis picture.

erly reassigned to G. C. Procaccini (Naples catalogue, 1928, p. 248).

NAPLES, PINACOTECA DEL MUSEO NAZIONALE, no. 118. "Madonna and Child." Tempera on canvas, 1.06 x .90 m. (Photo Alinari 12167.)

In its earliest notice (Palazzo del Giardino inventory, c.1680) attributed to Correggio. In the present catalogue of the Naples Museum (1928, p. 272) given to F. M. Rondani. Only Copertini (I, 35, ill. *tav.* XVb) regards it as by Parmigianino (an early work, c.1522). I find that comparison between this work and Parmigianino's authentic pictures of c.1522, or of any other time, gives only a negative result. The basis of Copertini's attribution is in actuality faulty; it depends in the main on a vague similarity with the late and defective *copy after* Parmigianino's lost "Madonna with St. Jerome and Beato Bernardino da Feltre" (Parma no. 76). A. O. Quintavalle ("Falsi e veri del Parmigianino giovane," pp. 248-249) also rejects Copertini's attribution, and suggests that the painting should be assigned to some minor decorator of the type of Cesare Baglione. A copy is in the Museo Mosca, Pesaro.

NAPLES, PINACOTECA DEL MUSEO NAZIONALE, no. 122. "Santa Chiara." Canvas, .92 x .72 m. (Photo Anderson 5558.)

Accepted as a work of Parmigianino by Fröhlich-Bum (p. 27), Berenson (*Lists*), and Venturi (IX/2, p. 670); so entered in the Naples catalogue (1928, p. 225). Its earliest appearance in the literature is in the Palazzo del Giardino inventory of c.1680 (Campori, p. 236) as a work of Bedoli. Frizzoni (*Arte e Storia,* vol. III, 1884, pp. 213-214), C. Ricci (*Napoli Nobilissima,* vol. IV, 1895, p. 163), and Copertini (II, 97) accept the old attribution to Bedoli, as does L. Testi (*Bollettino d'Arte,* vol. II, 1908, p. 388), though with less certainty. I find that the painting differs from any authentic production of Parmigianino, and conforms with the characteristic manner of Bedoli. Note especially the broad, crinkly folds of thin drapery, the very great breadth of the body, the hard, dark eyes, the modeling of the face, the articulation of the overslender fragile fingers, the exceedingly minute execution of the "still-life" detail.

NAPLES, PINACOTECA DEL MUSEO NAZIONALE, no. 125. "Lucretia." Panel, .67 x .51 m. Fig. 151. See also below under lost works, p. 238.

Accepted as Parmigianino by Fröhlich-Bum (p. 27) and Copertini (I, 186). Not mentioned by either Berenson or Venturi. In the catalogue of the Naples Museum (1928, p. 15) as a certain work of Bedoli. The authorship of this picture was confused at a very early date. Its first record was in the inventory of the wardrobe of Ranuccio Farnese (1587) as a work of Parmigianino, and it bore the same attribution in subsequent old notices. Only modern criticism has presumed to dispute the authority of the tradition.

The work is indeed close to Parmigianino in a general way, but it is impossible to find any exact point of contact with his authentic *oeuvre.* Comparison with the work of Bedoli, however, reveals a complete correspondence. Virtually the same head appears (in reverse direction) on the female saint in Bedoli's altar in San Alessandro in Parma; heads only slightly less similar belong to the seated woman in the right middle plane of Bedoli's "Immaculate Conception" altar, and to the allegorical figure of Parma in the Naples "Parma and Alessandro Farnese." One may observe especially the form of the ear, which is characteristic for Bedoli, but never used by Parmigianino. Other details find a near identity in Bedoli: most striking is the pose and drapery of the Diana in the medallion on Lucretia's shoulder, which compares almost exactly with the bronze figure of Fama in the above-mentioned "Parma and Alessandro Farnese." The handling of detail (the hair especially) reveals that extreme precision of execution at which Bedoli outdoes Parmigianino, but which is accompanied by a hardness and lack of sensitivity of which Parmigianino is not guilty. At the same time, the authority and sensitivity of draftsmanship and modeling of the larger forms (compare the cold relief of the profile, the weakness of drawing of the arm) is considerably less than

221

in Parmigianino. The modeling of the flesh is also more like Bedoli than Parmigianino.

The exchange of this painting for Parmigianino's "Lucretia" was probably due to the early loss of his original. Parmigianino's "Lucretia" was lost by the time of Vasari's second edition, but had left behind it the reputation of having been "cosa divina e delle migliori che mai fusse veduta di sua mano" (V, 233). It is doubtful that such a reputation could have been acquired by as unpretentious a painting as this half-length. More deserving of such a reputation may have been a more elaborate work, such as that of which Enea Vico's engraving may be the pale reflection (Fig. 119). Though not by Parmigianino, the Naples "Lucretia" would seem to have been inspired by him. It seems related to, and perhaps even derived from, Parmigianino's Budapest drawings of the Lucretia theme (Fig. 118; see below under "Lost Works," p. 238). If we may trust the evidence of an entry in the Giardino inventory of c.1680, it would seem that Bedoli treated the Lucretia theme a second time, using a design by Parmigianino related to that preserved in Vico's engraving as a basis for his work. The inventory describes: "Una Lucretia Romana che si uccide con la sinistra presso un piedestallo a base rotta, di chiaro e scuro, in lontananza un poco di paese a mano destra, di Girolamo Mazzola."

NAPLES, PINACOTECA DEL MUSEO NAZIONALE, deposit. "Madonna and Child," called "del Dente." Canvas, oval .84 x .66 m. Fig. 152.

This painting appeared first in the Farnese inventory of 1708 (Campori, p. 470) as a work by Parmigianino. It was engraved as Parmigianino by Robert Strange after its transfer to Naples with the romantic legend *Parmigiani Amica*. Among contemporary critics, it is accepted as a work of Parmigianino only by Fröhlich-Bum (p. 23). This painting is certainly not a work from Parmigianino's hand. The morphology does not bear any but the most superficial comparison with that of Parmigianino (compare especially the drawing of the hands, the hard profile of the Virgin, the quality of the modeling), but

suggests instead the manner of Bertoia, to whom it is indeed assigned without qualification in the Naples catalogue (1928, p. 477). Copertini (II, 99) also considers that it is by Bertoia.

In general, the attitude of the Madonna in this picture, and to a less extent that of the Child, is related to the Madonna and Child figures of Parmigianino's Roman "Marriage of St. Catherine," and even more closely to the figures of Parmigianino's Roman print of the Virgin and Child (Bartsch XVI, p. 7, no. 4; ill. Copertini *tav*. CXVIIIa). It is likely that the Naples picture may be a translation into paint, by another hand than Parmigianino's, of a drawing of his Roman period. Such a drawing, apparently by Parmigianino, did exist; it was engraved by Benigno Bossi in 1784. Compare such parallel instances as that of the translation into painting from a print of the "Adoration of the Shepherds" in the Parma Gallery (no. 33; ill. Venturi IX/6, fig. 408, p. 675; also assigned to Bertoia), the Leningrad "Entombment" (see above, p. 219), the Minneapolis (Walker Collection) "Madonna" (see above, p. 220); and the translations into paint of a drawing, presumably by Parmigianino, or of a print after him, in the Moscow and Modena pictures of the "Marriage of St. Catherine" (see above, pp. 220).

This theme has inspired a number of more or less Parmigianinesque variations thereon. Two are reproduced in engraving in the *Galerie des Peintres les plus Célèbres: Oeuvre du Corrège et choix du Parmesan*, Paris, 1844.

NAPLES, PINACOTECA DEL MUSEO NAZIONALE, deposit (no. 179, catalogue 1911). "Head of Child Studying the *Abbecedário*." Paper, mounted on panel, .29 x .22 m. The companion to the picture formerly in the Goudstikker collection, *q.v.*

Recorded (with its companion) in the Palazzo del Giardino inventory of c.1680 (Campori, p. 228) as "Un quadro alto on. 6 e 1/2 largo on. 5 in tavola. Un puttino in atto di leggere l'abecedario sopra una tavola, a cui fa cenno ad alcune lettere con l'indice della destra, del Parmigianino." Also recorded in the inventory of 1708, and again in the *Descrizione di cento quadri de'*

più famosi of 1725 (quoted Affò, p. 91): "Testa, e sola busto d'un fanciullo applicato a studiare l'abbecedario che tiene in mano." Transferred to Naples, where it appears in the catalogues from 1807 onward, always with the traditional attribution to Parmigianino. The catalogue of 1807 (see V. Spinazzola, *Napoli Nobilissima*, vol. III, 1894, p. 188; note to an article by Ricci in the same periodical, p. 149), unlike the later nineteenth-century catalogues, modified this ascription by indicating that the picture was a copy by Parmigianino after Correggio. The catalogue of 1911 (by A. de Rinaldis, pp. 265-266) has, properly, dropped Parmigianino's name altogether, and describes the picture simply as a copy after Correggio. De Rinaldis points out that the Naples painting is derived from the upper half of the Amorino in Correggio's "Education of Cupid," now in the National Gallery in London. A. O. Quintavalle ("Falsi e veri del Parmigianino giovane," p. 249) confirms de Rinaldis' judgment. Quintavalle illustrates the picture in fig. 10 of his article.

NEW YORK, sold Anderson Galleries, January 17, 1928, no. 98. "Madonna and Child with Angels." Canvas, .565 x .394 m. An imitation by a late sixteenth-century North Italian of Correggio's "Zingarella."

PARIS, LOUVRE. "Holy Family with St. John." Canvas, .419 x .34 m. (Photo Alinari 23563.)

Attributed in the Louvre to Parmigianino, but showing none of his characteristics. Fröhlich-Bum (*Jahrbuch der Allerhochsten Kaiserhauses*, vol. XXXI, *heft* 3, 1913, p. 153), and Venturi (IX/4, p. 742) have assigned it instead to Schiavone. What is apparently another version of this design is described in the Naples catalogue of 1911, p. 283, no. 200.

PARMA, SAN GIOVANNI EVANGELISTA, fourth chapel on the left (Cappella Zangrandi). On the walls: "St. Nicholas of Bari" (Fig. 154); "St. Hilaire of Poitiers." On the faces of the arches, grotesque decoration in white on blue. Fresco.

Attributed to Parmigianino only by A. O. Quintavalle ("Nuovi Affreschi del Parmigianino in San Giovanni Evangelista a Parma," in *Le Arti*, vol. II, *fasc.* 5-6, 1940, pp. 308-313; ill. plate CXXV). Quintavalle (p. 310, n. 7) quotes a document of February 27, 1515 (previously adduced by Copertini in another connection, see above, p. 157, n. 28) for the original commission of the chapel to Parmigianino's uncles, the brothers Mazzola, and alleges that the execution was turned over to Francesco, whose name, Quintavalle further alleges, does not appear in the documents because he was a minor. Francesco was then in fact only twelve years old; he was not only too young to be afforded any legal consideration but also too young to undertake this painting. On the basis of two documents recorded by Affò (Notizie dei vari artefici di Belle Arti che operarono pel Monasterio e per la Chiesa di San Giovanni Evangelista in Parma, MS no. 1599 in the Biblioteca Palatina, Parma) which concern the brothers Mazzola, Quintavalle considers that the execution of the chapel may have been delayed as late as 1522 (thus giving Francesco time to grow up to the job). One of these documents specifically refers to the seventh, and not to the fourth chapel on the left now under discussion; the other document speaks of painting and gilding done in the monastery (and thus not necessarily in the church). Neither document can properly be so construed as to relate to the present chapel.

Quintavalle's conception as to Parmigianino's authorship of this chapel is thus advanced in spite of and not with any sanction from the documents; his conception is equally and entirely in spite of the visual evidence. We are now amply documented on the continuous development of Parmigianino's style from his first surviving work in 1519 through the balance of the first Parma period. The style of this fourth chapel cannot assume any reasonable place in the logic of that development, nor does Quintavalle give any evidence of a serious attempt to make it do so. After alleging this improper attribution to Parmigianino, Quintavalle then asserts an interesting and falsely seductive theory of the influence on the young Parmigianino of Anselmi, in 1521 recently arrived in Parma from Siena; Quintavalle further sees Anselmi's influence as

a medium for the communication to Parmigianino of some elements of the style of Sodoma, and more important, of the style of the relatively precociously Mannerist Sienese, Beccafumi. This construction is a vicious circle: it is not surprising that Quintavalle should feel the style of Anselmi reflected in this fourth chapel, for Anselmi is usually considered, perhaps correctly, to be its author.[263] Copertini (in "Quesiti e precisazioni sul Parmigianino," *Archivio storico per le provincie parmensi,* vol. V, ser. 3, 1940, pp. 17-27) also rejects Quintavalle's attribution to Parmigianino of this chapel. It is his opinion that the figures of Saints Nicholas and Hilary are "di un ignoto imitatore del Rondani, di . . . Bedoli e dello stesso Parmigianino."

PARMA, SAN GIOVANNI EVANGELISTA, sixth chapel on the left (Cappella Bergonzoni). On the walls: "Doctors of the Church" (Fig. 155). On the faces of the arches: "Cardinal Virtues," "Temptation of Adam," "Expulsion from Paradise," etc. Fresco.

Attributed to Parmigianino by Copertini (I, 36-37, ill. *tav.* XVI, XVII, XVIIIa and b), whose attribution is seconded by Quintavalle (*op. cit.*). Copertini's attribution was based entirely on considerations of style and was unsupported by external evidence. Apparently realizing the lack of coincidence with the certainly authentic work of Parmigianino in San Giovanni, Copertini chose to assign this sixth chapel to a phase of style antecedent to Parmigianino's stay in Viadana, about which nothing was known at the time of writing of his book. The discovery since then of two works from the pre-Viadana and Viadana periods, both of which differ completely in style from the frescoes of the present chapel, has quite invalidated Copertini's hypothesis.

Quintavalle (*op. cit.,* p. 311, n. 10) has adduced a document, the will of the donor of the chapel, Melchiorre Bergonzoni, dated March 21, 1522, which lays upon his heirs the obligation

of painting the chapel and providing an altarpiece. This document establishes only the chronological *terminus post* for the decoration; it can in no way of itself be construed as confirming Quintavalle's erroneous assumption of Parmigianino's authorship, or even as remotely applying to it.

These paintings are usually regarded as the work of Anselmi; though only uncertainly so attributed they demonstrate the style of a Correggio follower who, like Anselmi, approaches considerably nearer that master than Parmigianino ever does.

RICHMOND, COOK COLLECTION, no. 99. "Pietà." Panel, .78 x .219 m.

Listed as by Parmigianino in the catalogue of the pictures at Doughty House (1913, p. 114), with the remark that the attribution is the "traditional one." Fröhlich-Bum (*Burlington Magazine,* vol. XLVI, 1925, p. 88) insists that to maintain the attribution to Parmigianino would be impossible. A work of *c.*1550-1560; possibly by a Bolognese artist.

ROME, COLLECTION OF CANON FILIPPO PIRRI. "La Madonna di Casa Armano."

Attributed very tentatively to Parmigianino's early period by Copertini (I, 40, ill. *tav.* XXV). It has been engraved by Rosaspina, with an attribution to Parmigianino.[264] Copertini does not risk more than the mere suggestion that this may be an early work by Parmigianino. To my mind, even this suggestion is unwarranted. This is also the opinion of A. O. Quintavalle ("Falsi e veri del Parmigianino giovane," p. 248), who regards the Pirri picture as a "copia imbarrochita da un originale correggesco." Quintavalle also illustrates, in the same article (fig. 11), a second version of this painting in the magazine of the Naples Museum.

ROME, GALLERIA SPADA. Three Heads. Fresco fragment. Fig. 153.

Accepted for Parmigianino by Fröhlich-Bum (in Thieme-Becker, 1930) and by Venturi (ill. IX/2, fig. 533, without discussion). Not men-

[263] The tradition of Anselmi's authorship is traceable at least to the late seventeenth century (*Inventario degli oggetti d'arte,* 1934, p. 40: "Nota della pittura di Parma" by A. Santangelo and M. Oddi).

[264] See Copertini II, 71, n. 33.

tioned by Berenson; rejected by Copertini (I, 79). By an imitator of Parmigianino's manner, but with conspicuous differences from his morphology and quality both. Compare especially: the weak drawing of the face of the man, the flatness of modeling in the female head and neck, the form of her ear, the overquick, rather schematic imitation of Parmigianino's calligraphy of hair and drapery.

ROME, MUSEO SAN PAOLO FUORI LE MURA. "Holy Family with St. Catherine." Panel (?). (Photo Alinari 32739).

The attribution to Parmigianino is indicated on the Alinari photograph and in the files of the Frick Art Reference Library. By a Roman (?) master of the mid-century.

ROME, PINACOTECA CAPITOLINA, no. 31. "St. John in the Wilderness." Copper, .49 x .39 m.

Attributed with a question to Parmigianino in the catalogue of the gallery (*Musei Capitolini*, 1925, p. 270). The fact of its being on copper would make the attribution improbable, even if the style should at all permit it. Copertini (II, *tav.* CLXIII) and others have reassigned the work to Mastellata.

SESTRI LEVANTE, COLLECTION FERDINANDO RIZZI. "Holy Family." Panel, .546 x .42 m.

Attributed to Parmigianino in the photograph files of the Frick Art Reference Library. A seventeenth-century painting of the lowest quality.

SESTRI LEVANTE, COLLECTION FERDINANDO RIZZI. "Holy Family with St. John." Panel, .197 x .254 m.

Attributed to Parmigianino in the photograph files of the Frick Art Reference Library. A debased North Italian work of the seventeenth century.

SOMERLEY, RINGWOOD (HANTS), COLLECTION EARL OF NORMANTON. "Marriage of St. Catherine, with St. Joseph." Panel, .76 x .61 m. (Photo Cooper 154098.)

Purchased in 1864 from G. Raphael Ward by the great-grandfather of the present Earl. A work of very late sixteenth, or more probably seventeenth-century, date.

VENICE, PINACOTECA MANFREDIANA. "Marriage of St. Catherine."

The attribution to Parmigianino is hesitantly suggested by Copertini (in "Quesiti e precisazioni sul Parmigianino," *op. cit.;* ill. fig. 3). A compilation by a Bolognese master of the mid-sixteenth century (very close to Pellegrino Tibaldi) of motives from Parmigianino's Roman "Marriage of St. Catherine" and his Bolognese "Madonna with St. Margaret."

VERONA, MUSEO CIVICO, no. 153. "Madonna and Child with Saints." Canvas, .72 x .58 m.

Attributed to Parmigianino by Berenson in his 1907 *Lists*, but omitted in the revised edition. The catalogue of the gallery (1912, p. 64) assigns the painting to Bernardino India, as does Venturi (IX/7, fig. 21, p. 41).

VIADANA, MUSEO COMMUNALE. Two fragments with women's heads. Oil on panel, each .54 x .45 m.

The gallery considers these as works done by Parmigianino during his stay in Viadana. The *Inventario degli oggetti d'arte d'Italia* (vol. VI, Mantova, 1935, p. 181) makes the comment: *. . . probabilmente da ascrivere al secolo XVIII.*

VIENNA, AKADEMIE DER BILDENDEN KÜNSTE. "Virgin and Child with Four Saints."

Considered a painting of Parmigianino's Roman period by Venturi (IX/2, p. 633). The catalogue of the Academy (1927, p. 274) rejects this impossible suggestion, and prefers to enter the work merely as that of a North Italian painter of the second third of the sixteenth century. It further (justly) considers the painting as the work of a *recht unpersonlichen und wenig bedeutenden Maler.*

VIENNA, COLLECTION A. VEITSCHBERGER. "Holy Family with St. John."

Assigned to Parmigianino by Fröhlich-Bum (p. 28). In all probability a German painting. There is not the slightest possible community with Parmigianino's work.

VIENNA, PRIVATE COLLECTION. "Marriage of St. Catherine."

Attributed to Parmigianino by Alex Hajdecki (*Wiener Dilettanten-Scholien*, vol. I, 1909, with illustration). Entirely unrelated to Parmigianino. Also so judged by C. W. Stern in a review of Hajdecki's article (*Cicerone*, vol. VI, 1914, p. 603).

WINDSOR CASTLE, COLLECTION H. M. THE KING. "Minerva" (?) Canvas, .635 x .456 m. Fig. 156.

Assigned to Parmigianino by Berenson (*Lists*) and by the keepers of the collection (Cust, Collins-Baker; see *Catalogue of the Principal Pictures in the Royal Collection at Windsor Castle*, p. 250). Copertini (II, 118, ill. *tav*. CLVIIIa) regards it as the production of an imitator. Neither Fröhlich-Bum nor Venturi mentions the picture. It has been engraved by Cornelis Vischer.

Probably identifiable with the painting of a *Pallade armata* attributed to Parmigianino in the 1662 inventory of the Studio Muselli in Verona (Campori, p. 186): "Una Pallade Armata, nell' armatura v'ha una figurina che rappresenta la Vittoria, mostra una mano ignuda, di grandezza come quel di sopra [i.e., alt. di cinque quarti] del Parmigianino." The first record of the picture in England is in a MS inventory of the collection of Charles II in Whitehall, as no. 315. The earliest reattribution to Parmigianino was apparently by W. Hazlitt in his 1843 edition of the *Sketches of the Principal Picture Galleries*.

A refined and sensitive imitation of Parmigianino, but the expression of the whole, as well as certain elements in the technique and morphology (for example, the overrefinement in the execution of detail, the excessive uniform smoothness of the surfaces, the drawing of the eyes) betray the difference from Parmigianino's own style. This picture may be one of the not infrequent instances of derivation from a drawing by Parmigianino. The Morgan Library owns a drawing (no. IV, 41A; 11.3 x 8.2 cm.), very probably authentic to Parmigianino, of the same figure; the drawing shows more of the bust downward toward the waist, and is generally less constricted by its frame than is the painting.[265]

[265] Fröhlich-Bum, in *Old Master Drawings*, IX (1935), 56, and pl. 57 and 58, published two drawings which she describes as probable designs for an overdoor or lunette decoration. They are in fact studies for the medallion on the breast of the Minerva. Fröhlich-Bum attributes these drawings to Parmigianino. I consider the attribution doubtful, but in any case Parmigianino's authorship of the drawings would not necessarily require his authorship of the existing painting.

ATTRIBUTED PORTRAITS

BERLIN, KAISER FRIEDRICH MUSEUM, no. 259a. "Noble of the Order of St. James." 1.11 x .91 m. Acquired 1875 from the Marchese Patrizi, Rome.

Occasionally assigned to Parmigianino. At present, generally regarded as a work of Sebastiano del Piombo or of his school, to which it is not much closer than to Parmigianino. See the Kaiser Friedrich catalogue (1906), and P. d'Achiardi, *Sebastiano del Piombo* (Rome, 1908), pp. 215 ff. Copertini (I, 224, n. 27) feels there is some connection with the school of Parmigianino.

(*formerly*) BERLIN, COLLECTION DR. BENEDIKT (*dealer*). "Portrait of a Lady in White." Panel, .52 x .392 m.

Accepted as Parmigianino by Fröhlich-Bum in her article in Thieme-Becker (1930). A weak picture by a North Italian master, c.1530-1540; it seems to have been heavily repainted.

BOLOGNA, PINACOTECA, no. 763. So-called "Self-Portrait of Parmigianino as a Youth." Panel, .40 x .26 m.

Attributed to Parmigianino in the catalogue of 1899 (p. 114) with the comment that it is

Parmigianino's self-portrait, *viene creduto*. Probably a work from the last years of the sixteenth or the beginning of the seventeenth century.

BOSTON, MUSEUM OF FINE ARTS. "Portrait of a Man."

Formerly assigned to Parmigianino by the museum; at present reattributed to Girolamo da Carpi (see article on Carpi in Thieme-Becker).

DRESDEN, GEMÄLDEGALERIE, no. 162. "Portrait of a Young Man," with the attributes of a saint-martyr. Canvas, 1.02 x .68 m.

Accepted by Fröhlich-Bum (p. 38) and by Berenson (*Lists*); regarded as a Parmigianino by the gallery. Copertini (I, 222, n. 27) rejects the work without question and suggests that it may be by Alonso Cano. This idea is as improbable as is the attribution to Parmigianino.

FLORENCE, UFFIZI, no. 1377. "Portrait of a Young Man." Oil on panel, .48 x .40 m.

Accepted for Parmigianino by Fröhlich-Bum (p. 38) and by Berenson (*Lists*). Rejected by Copertini (I, 223, n. 27). Only the drawing of the eyes suggests Parmigianino; the rest of the picture is entirely uncharacteristic.

FONTANELLATO, PALAZZO SANVITALE. "Portrait of a Young Lady."

Accepted by Fröhlich-Bum in Thieme-Becker (1930), and by Venturi (IX/2, p. 645). Not mentioned by Berenson; rejected by Copertini (I, 223, n. 27) who considers it a Lombard work of the late sixteenth or early seventeenth century. It certainly postdates Parmigianino by at least a half century. The subject was identified by Count Luigi Sanvitale (letter to Fiorelli, Director of the Naples Museum, 1867) as Pellegrina Rossi di San Secondo. A slight resemblance between this lady and the "Antea" of Naples has resulted in an attempt to identify the two. (See A. Cutolo, in *Emporium*, vol. LXXXVI, 1937, pp. 424-428). Cutolo regards this painting as a copy of a lost Parmigianino; so also does Antonio Sorrentino (*Emporium*, vol. LXXIV, July 1931, p. 34). Sorrentino chooses to identify the subject as one Paola Sanvitale, and also suggests her identify with the sitter for the "Antea."

FRANKFORT, STÄDELSCHES KUNST-INSTITUT, no. 42. "Portrait of a Lady with Gloves and Fan." Panel, .99 x .66 m. (Photo Bruckmann 405.) From the Collection of William II of Holland, 1850.

Wrongly attributed to Sebastiano del Piombo in the catalogue of 1893 (?); occasionally (as in the Bruckmann photograph) reproduced as by Parmigianino. Venturi (IX/6, p. 604, fig. 360) considers it a work of Niccolo dell'Abbate. In any case, quite unrelated to Parmigianino: it is probably the work of a Central Italian artist of the mid-sixteenth century.

(THE) HAGUE, COLLECTION K. W. BACHSTITZ. "Portrait of a Lady." Panel, .49 x .36 m.

Formerly in the collection of Stefan von Auspitz in Vienna. Attributed to Parmigianino by Fröhlich-Bum (Thieme-Becker, 1930) and (according to the dealer's statement) by Fiocco. Not mentioned by Venturi; called Cavazzola by Berenson (*Lists*). Much inferior to Parmigianino's authentic work; Berenson's attribution would seem to be correct.

HAMPTON COURT, no. 168. "Portrait of a Lady with a Dog and an Orrery."

Assigned to Parmigianino in the catalogue (1914) with a question mark. Not discussed by Fröhlich-Bum, Copertini, or Venturi; regarded by Berenson (*Lists*) as possibly a copy after Parmigianino. An Emilian (?) painting of c. 1540.

HAMPTON COURT, no. 306. "Portrait of a Lady," called Isabella d'Este. Panel, 1.14 x .91 m. Fig. 157.

According to Lionel Cust (*Burlington Magazine*, vol. XXV, August 1914, p. 290) acquired by Charles I from the collections in Mantua. Not in the catalogue of the sale of Charles's pictures. Acquired by the Dutch merchant van Reynst, and repurchased from him for Charles II by the States General. In the catalogue of Charles II's pictures in Whitehall as a "Venetian Woman in Antick habit, sitting in a chayre, said to be Raphaels." In the Windsor inventory of 1776 as

Raphael; in the Kensington inventory of 1818 as Sebastiano del Piombo. The subject has been identified (on grounds not fully convincing) as Isabella d'Este, an identity for which Fröhlich-Bum (*Burlington Magazine,* vol. XLVI, 1925, p. 87) adduces further but yet not sufficient evidence.

Considered a work of Parmigianino by Cust (*op. cit.*); assigned to Parmigianino with a question mark in the catalogue of 1914 and in the catalogue of 1929 (by Collins-Baker, pp. 114-115). Fröhlich-Bum accepts this attribution (*Burlington Magazine,* 1925). Questioned by Berenson, while Venturi (according to a note in the catalogue of 1914) has suggested the name of Callisto da Lodi. Copertini (I, 223, n. 27) assigns it to the Florentine school.

L. Venturi (*L'Arte,* vol. XXIX, 1926, p. 244) assigns it to Romano, as does Benedict Nicolson who in a letter of November 9, 1947, volunteers the following: "in my opinion by Giulio Romano (see the drawing, Braun 286, in the Louvre, for or of the servant in the background . . . from the studio of Giulio)." Mr. Nicolson has an illustrious predecessor in this observation: as noted by J. Hess ("On Raphael and Giulio Romano," *Gazette des Beaux-Arts,* ser. 6, vol. XXXII, no. 967-968, p. 99, n. 71) Mariette, in his "Abecedario" (*Archives de l'Art Français,* vol. VIII, Paris, Dumoulin, 1857-1858, p. 167), had connected an engraving after the Hampton Court painting with the same Louvre drawing, in his time in M. Crozat's collection; Mariette had also proposed Romano's authorship of both. F. Hartt (*Art Bulletin,* vol. XXVI, no. 2, 1944, pp. 92-93) advances the same attribution, which I also believe to be nearest the truth of the matter.

HAMPTON COURT, no. 964 (?). "Portrait of Louis Gonzaga and a Companion." Fig. 158.

Traditionally attributed to Parmigianino in the gallery, but not so published in any catalogue; regarded by the then Assistant Keeper, Benedict Nicolson (letter June 9, 1939) as a "doubtful affair." A mediocre portrait of the mid-century or later.

ITALY, COLLECTION ELEANOR MA-

RION CRAWFORD-ROCCA. "Portrait of a Gentleman with a Letter." Panel, .89 x .724 m. Inscribed *Aetatis sue* [*sic*] *Anno XXXVI.* The sitter carries a letter with an illegible inscription.

Described by the editors of *Connoisseur* (vol. CIII, February, 1939, "Notes and Queries, no. 1019, p. 711) as "not unlikely . . . school of Parma. Francesco Mazzola . . . has left portraits precisely in this manner. The type, too, is somewhat reminiscent of his self-portrait." Related not to Parmigianino, but to certain portraits by Girolamo da Carpi. Compare, for example, Carpi's "Archbishop Bartolini-Salimbeni" (Florence, Galleria Pitti).

LONDON, NATIONAL GALLERY, no. 649. "Portrait of a Boy." Panel, 1.28 x .61 m.

Occasionally attributed to Parmigianino; formerly also to Bronzino and Pontormo. It has long been recognized as a characteristic work of Salviati. See National Gallery catalogue (1936), p. 316.

LONDON, COLLECTION THOMAS AGNEW & SONS. "Portrait of a Lady."

Attributed by the owners to Parmigianino. Venturi (*L'Arte,* vol. XXXI, 1928, p. 204, with illustration, and IX/7, p. 665, fig. 365) has reassigned it definitively to Empoli.

LONDON, sold Christie's, July 7, 1922, no. 115. "Portrait of a Gentleman," called Alfonso d'Este, Duke of Ferrara. Canvas, 1.04 x .80 m.

Acquired in Florence by Sir Coutts Lindsay; then in the collections of Sir George Donaldson and Sir J. C. Robinson; sold from the collection of Ralph Brocklebank. An extremely dubious painting, which only generally reflects the style of a North Italian portrait of c.1530-1540.

LOVERE, GALLERIA TADINI, no. 59. "Portrait of a Knight of Calatrava." .86 x .68 m. (Photo Anderson 30125.)

Once attributed in the gallery to Titian; reassigned to Parmigianino by Frizzoni (*Emporium,* vol. XVII, 1903, p. 348). Accepted as Parmigianino by Fröhlich-Bum in Thieme-

Becker (1930), and by Berenson (*Lists*). Not mentioned by Venturi. Copertini (I, 224, n. 27, and in the catalogue of the Mostra del Correggio, 1935, p. 87) prefers to reject it. By a more prosaic and literal-minded artist than Parmigianino, but one influenced by his manner. Probably in the circle of Verona-Venice, *c.*1530-1540.

MADRID, PRADO, no. 55. "Portrait of a Youth with a Viola." Panel, .77 x .59 m. (Photo Anderson 16034.)

In 1746 in the collection of Isabel Farnese at La Granja. Formerly attributed to Bronzino in the gallery. According to the catalogue of 1933 (p. 34) Berenson considers it the work of a Parmesan master. The picture is entered in his *Lists* as a possible copy after Parmigianino. According to Voss (see Madrid catalogue, *loc. cit.*) in the school of Parma, Emilia, or Modena, *c.* 1540. I can see no evidence even of reflection of a Parmigianinesque original.

MADRID, PRADO, no. 416. "Lady with a Green Turban." Canvas, .64 x .50 m. (Photo Anderson 16401.)

A much disputed picture. Only Suida regards it as by Parmigianino. Berenson considers it by Dosso Dossi; Gamba and Venturi (IX/6, p. 603, fig. 359) by Niccolo dell'Abbate. In any case, the picture bears no relation to Parmigianino.

MILAN, AMBROSIANA. "Portrait of a Sculptor."

Attributed to Parmigianino in Berenson's original list for North Italy, again in the revised *Lists,* and in the latest (Italian) edition. The picture is not entered in any of the official catalogues of the Ambrosiana, nor in the *Itinerario* (1932). The Prefect of the Ambrosiana states (letter, February 1948) that he can find no record of the existence of such a picture in the gallery.

MILAN, private collection. Portrait of an armed youth, attended by a female deity (?).

Attributed to Parmigianino by E. Arslan ("Contributi a Ercole di Roberti, Parmigianino, Primaticcio," *Emporium,* vol. CV, no. 626, 1947,

pp. 65-66; ill. p. 67) on the basis of a supposed resemblance to the Richmond copy of Parmigianino's Charles V. The Milan portrait is related to the latter work for the most part only through its use of a similar allegorical figure. The reflection of Parmigianino's style is a distant one, and appears to have passed through some Ferrarese intermediary. A resemblance, perhaps fortuitous, exists between the sitter of this portrait and the oldest of three sitters in a painting described as of the "Dukes of Ferrara" at Castle Howard (there attributed to Tintoretto, but very probably by Bedoli).

MINNEAPOLIS, INSTITUTE OF ARTS. "Portrait of a Nobleman."

Published as Parmigianino in the *Bulletin* of the Institute (vol. XXII, January 1933, p. 3). There is no basis for this attribution; the style is a much more soft and painterly one than Parmigianino's. Perhaps in the school of Bergamo, *c.* 1540.

NAPLES, PALAZZO REALE. "Portrait of a Man," called Gian Martino Sanvitale. .93 x .80 m. Dated (on the lintel above the door in the background) 1536. Fig. 159.

Attributed to Parmigianino in the inventory of the Palazzo del Giardino (*c.*1680, Campori, p. 236). By 1752 the attribution had been changed by Ruta (Inventario dei quadri di Parma, 1752, preserved in the State Archives, Naples) to Bedoli. A later inventory of 1816 (also in the Naples Archives) reassigned it to Hans Holbein, and the work bore this uncomfortable designation until well into the present century. First reattributed to Parmigianino by Hadeln, in his review of Fröhlich-Bum's monograph (*Kunstchronik und Kunstmarkt*, vol. 32/2, 1921, p. 745); formally published as by Parmigianino by Antonio Sorrentino (*Bollettino d'Arte*, vol. XXVII, ser. 3, 1933, p. 82ff.) who identifies the subject (on extremely dubious grounds) as a posthumous portrait of Gian Martino Sanvitale. Berenson assigns the painting to Lotto; Copertini makes no definite attribution, but will not permit it to be given to Parmigianino (I, 224, n. 27). To my mind, a work of Giro-

lamo da Carpi during his "Titianesque" phase, 1535-1537.

NAPLES, PINACOTECA DEL MUSEO NA-ZIONALE, no. 112. Portrait of a youth with hand on hip. Canvas, 1.02 x .86 m. Fig. 160. The painting is in a very damaged condition. A coat of arms in the upper right corner has been almost entirely obliterated.

Listed in the inventory of the Palazzo del Giardino (c.1680) as Parmigianino (Campori, p. 232). Accepted by Fröhlich-Bum (p. 38), by Venturi (IX/2, p. 654), by Berenson (*Lists*), and Copertini (I, 203) as a work of the Roman period. The damaged condition of this work makes definite judgment difficult. I do not, however, share the opinion which assigns this portrait to Parmigianino. The figure shows a developed extreme of elongated proportion that does not occur in Parmigianino except during the period 1530-1535; yet what is visible of the technique of the painting (and enough is visible to permit sure observation of this element, especially in the handling of the drapery) does not at all conform to the clear, sharp, antitextural handling of the mature phase of Parmigianino's style. It is this unaccustomed combination of elements that at first arouses serious doubt of Parmigianino's authorship. Then, certain details do not correspond to those in Parmigianino's authentic work: the fingers especially (note the space between the fingers of the left hand, and the drawing of the forefinger of the right hand) do not correspond with Parmigianino's hands, though they suggest them; the drawing and modeling of the face, as well as its expression, are cruder than in Parmigianino.[266]

NAPLES, PINACOTECA DEL MUSEO NA-ZIONALE, no. 119. "Portrait of a Man," called Giovanni Bernardo da Castelbolognese. Panel, .63 x .50 m. (Photo Anderson 5562.)

[266] Longhi (*Ampliamenti nell' Officina Ferrarese,* p. 37, n. 5) suggests (not altogether improbably) that this picture is related to Rosso Fiorentino; Pittaluga (*Manieristi Toscani,* Bergamo: Istituto Italiano d'Arti Grafiche, 1944; p. 28) accepts the portrait as a work of Rosso and proposes a tentative dating c.1523.

To the Galleria Francavilla from San Luigi dei Francesi (1802) as a portrait of Baldassare Peruzzi. An inventory of 1806 lists it as a portrait of Giovanni Bernardo da Castelbolognese, by Baldassare Peruzzi. Attributed to Parmigianino in the catalogue of the museum (1928, p. 224). Accepted by Fröhlich-Bum (p. 37), and by Berenson (*Lists*). Not discussed by Venturi; rejected by Copertini (I, 223, n. 27).

Only the character of the textures bears any resemblance to Parmigianino. The drawing and modeling are quite weak (see especially the contour of the right side of the face, the drawing of the eyes and lips, the modeling of the nose and left cheek); the expression has an intimacy and pathos unknown in Parmigianino; the composition as a whole is more simple and direct than any of Parmigianino's designs. In spite of its evident technical weaknesses, this is a work of considerable interest. Having removed it from Parmigianino's *oeuvre,* it should be possible to find a place for it more definite than merely North Italian, c.1530-1540. A suggestive stylistic connection seems to exist between this painting and the portrait of a man attributed (uncertainly) to Sebastiano in the Berenson Collection (ill. G. Bernardini, *Sebastiano del Piombo,* Bergamo, 1908, p. 49).

NAPLES, PINACOTECA DEL MUSEO NA-ZIONALE, no. 120. "Portrait of a Tailor." Canvas, .88 x .71 m. (Photo Anderson 5557.)

Described in the inventory of the Palazzo del Giardino (c.1680) as the tailor of Paul III Farnese, but without ascription to any author. The attribution to Parmigianino is defended in the catalogue of the museum (1928, p. 226), and accepted by Berenson (*Lists*). Fröhlich-Bum (p. 104) considers it a work by Bedoli, as do Frizzoni (*Arte e Storia,* vol. III, 1884, pp. 213-214), Ricci (*Napoli Nobilissima, op. cit.,* p. 166), and Testi (*Bollettino d'Arte,* vol. II, 1908, p. 379). The manner of modeling of the flesh, and the hard, infinitely meticulous execution of detail are completely characteristic for Bedoli.

NAPLES, PINACOTECA DEL MUSEO NA-ZIONALE, (no. 19, catalogue 1911). Portrait

of a youth with the initials *L. V.* Oil on panel, .74 x .60 m. (Photo Anderson 5497.)

Assigned doubtfully to Bronzino in the 1911 catalogue; it appears to have been omitted from the catalogue of 1928. According to Antonio Sorrentino (*Bollettino d'Arte,* vol. XXVII, ser. 3, 1933, p. 82) the painting appeared in the inventory of the Palazzo Farnese in Rome for 1653, and in subsequent inventories of the Farnese collections (1662, 1697, etc.), but without indication of the identity either of the subject or the author. Only Sorrentino assigns this work to Parmigianino; no other authority has considered the possibility of Parmigianino's authorship. Certainly, the painting cannot pretend to come any nearer to Parmigianino than the general circle of Emilian portraiture of the second third of the sixteenth century. A strong stylistic connection exists between this portrait and the portrait of a youth with a dog (Rome, Corsini, *q.v.*) attributed by Bodmer to Niccolo dell'Abbate; an affinity (though not a positive coincidence) of style may be observed between these two works and a portrait of a young man with a parrot (Vienna, Kunsthistorisches Museum), also attributed by Bodmer, as well as by Venturi and the Vienna catalogue, to Niccolo dell'Abbate.[267]

NAPLES, PINACOTECA DEL MUSEO NAZIONALE, no. 752. "Portrait of a Youth." Oil on panel; unfinished. (Photo Alinari 44805.)

Not listed in the catalogue of 1928, but now attributed in the Museum to Parmigianino. A very weak picture by a minor Emilian master, *c.*1540.

NEW YORK, COLLECTION FREDERICK BROWN. "Portrait of a Man Writing." Panel, .72 x .57 m.

Acquired from John Levy Co., New York; previously in the hands of the Drey Galleries in Munich. Accepted by Fröhlich-Bum (*Burlington Magazine,* vol. XLVI, 1925, p. 88), and by Venturi (IX/2, p. 631). Berenson omits the picture from his *Lists,* and Copertini (I, 222, n. 27)

refuses it categorically to Parmigianino. Longhi (*Ampliamenti;* see above, note 266) suggests that it should be considered from the point of view of its relationship to Girolamo da Carpi. A work which comes close to the early Parmigianino in its general character, but not in its details (the hands, the lack of clarity of contour, the oversteep perspective of the table, the strong spatial emphasis in the perspective of the shoulders). We advance as a speculation that this work may possibly represent an early aspect of the style of Girolamo Mazzola-Bedoli. The Vienna "Portrait of a Reading Man" (*q.v.*) may be by the same hand.

NEW YORK, COLLECTION NEWHOUSE GALLERIES. Portrait called "The Queen of Cyprus and her Dog." From the Edward Brandegee and Fairfax Murray Collections. Reproduced in the dealer's advertisement in *Art Digest* (vol. XIX, April 1, 1945, p. 17).

An almost certain work by Callisto Piazza. Compare that artist's "Music" (Johnson Collection, Philadelphia), and the figures of contemporary ladies at the left of his scene of the "Preaching of St. John Baptist" in the Chiesa dell'Incoronata at Lodi (Photo Anderson 11425).

NEW YORK, COLLECTION C. F. ZOYLNER. "Portrait of a Man with a Black Beret." Panel, .635 x .508 m. From the Anderson Galleries, November 12, 1924.

An extremely dubious painting, imitative of the North Italian style of *c.*1510-1520.

PARIS, LOUVRE. "Portrait of a Young Man." Oil on canvas, .59 x .44 m. Fig. 161. The picture has been enlarged and restored.[268]

Assigned to Parmigianino by Carlo Gamba (*Bollettino d'Arte,* vol. IV, ser. 2, 1925, pp. 213ff.) as a work of his early period. Accepted as an early self-portrait by Fröhlich-Bum in Thieme-Becker (1930). Copertini (I, 200) also accepts it as a work by Parmigianino, as does W. Suida ("Opere sconosciute di pittori parmensi,"

[267] Bodmer, in *Correggio und die Malerei in Emilia* (1942), p. xxxvi and figs. 93 and 94; Venturi IX/6, p. 596; Vienna catalogue (1938), p. 1.

[268] Our reproduction is of the original area of the canvas.

Crisopoli, vol. III, 1935, pp. 105-113). Berenson does not mention the painting; Venturi (quoted by Gamba, *loc. cit.*) regards it as a work of the Correggio school. Morelli and Perkins were in agreement on yet another ascription, to Bacchiaccha. The portrait is still assigned in the Louvre to Raphael. The drawing of the hand, eyes, and hair, as well as the drapery and flesh surfaces, differ from authentic early works of Parmigianino, but a pronounced resemblance in general to his Roman style remains. I am not positive in my rejection of this painting.

PARIS, COLLECTION ROTHSCHILD. "Portrait of a Man," called Valentino.

Formerly in the Borghese Gallery, Rome. The picture has been somewhat enlarged in all directions, with a consequent considerable alteration in its original effect. Attributed during the last century often to Raphael; by Morelli to Bronzino; by Burckhardt (with a question) to Georg Pencz; by O. Muendler to Parmigianino (see Copertini I, 206). Copertini reaffirms Muendler's attribution, without any indication of his reasons. Though the portrait is Parmigianinesque in many respects, there are an equal number of differences: especially the weak articulation of the left hand, the oversharp contrast of light and dark modeling in the face, the relaxed expression (so different from Parmigianino's customary fixed intensity of gaze), the excessively nervous effect of the sharp body contours. Probably an Emilian painting, and in the neighborhood of 1530; I cannot assign it any more specifically.

PARMA, GALLERIA, no. 333. "Portrait of a Man with an Hourglass." Canvas, 1.10 x .90 m. (Photo Anderson 10633.)

Attributed to Parmigianino by Fröhlich-Bum in her article in Thieme-Becker (1930), and by Venturi (IX/2, p. 668). Not mentioned by Berenson. Ricci in his Parma catalogue (1896, p. 240) considered the painting a certain work of Bedoli, and tentatively identified the sitter as Enea Irpino, a Parmesan poet of the first half of the sixteenth century. Copertini (II, p. 97, and catalogue of the Mostra del Correggio, 1935, pp. 103-104) attributes the picture to Bedoli. To

my mind practically a paradigm of the critical differences which distinguish many of the most Parmigianinesque Bedoli portraits from a true Parmigianino. Certain of these differences are: the lesser formality and rigidity of pose and composition; the multiplication of accessories, painted with a thin and most meticulous brushstroke; the thinner, weaker handling of textures; the fragile, overdelicate articulation of the fingers; the very precise, but rather hard and automatic drawing of the hair and beard; the weakish draftsmanship of the eyes; the indirection of the sitter's gaze, and the lack of intensity in his expression.

PHILADELPHIA, PENNSYLVANIA MUSEUM OF ART, no. 48. "Portrait of a Lady." Panel, .99 x .86 m. Fig. 162.

Published as a work of Parmigianino's Roman period by Siren (*Burlington Magazine,* vol. L, 1927, p. 3), and accepted as such by Fröhlich-Bum (Thieme-Becker, 1930). Originally acquired by the museum (1896) as a Bronzino, and titled "Princess of the Sciarra Family"; subsequently catalogued as by Giulio Campi. Neither Berenson nor Venturi mentions the portrait in their consideration of Parmigianino's works. The Farnese inventory of 1680 describes this picture as by Bedoli, and Copertini (I, 224, n. 27) is willing to regard the ascription of the inventory as correct. Certainly not by Parmigianino; but neither do I consider the Farnese attribution the proper one.

RICHMOND, COOK COLLECTION, no. 98. "Head of a Young Man" (fragment). Oil on slate, .33 x .19 m. Fig. 163.

Assigned by Borenius in the catalogue of the collection (1913, p. 114) to Parmigianino. Fröhlich-Bum (*Burlington Magazine,* vol. XLVI, 1925, p. 88) reaffirms this attribution. Neither Berenson nor Venturi mentions the work. Copertini (I, 223, n. 27) considers it a work of the mid-sixteenth century or later, and notes that the sitter appears in the collection of miniatures (now in the Parma Gallery), which belonged to the Farnese family; the Farnese did not appear in Parma till 1545. Aside from the possible

identity of the sitter as one of the Parmesan Farnesi and the consequent likelihood that the portrait is subsequent to 1545, the style of the work more positively requires its rejection to Parmigianino. The drawing of the right contour of the face and of the left side of the jaw lacks both Parmigianino's sensitivity and his power of describing form; the eyes are also drawn in uncharacteristic fashion. The modeling, especially of the left side of the face, is excessively abrupt; it does not convey the sense of smoothed roundness of form that Parmigianino's modeling invariably does. The expression is much less precise in the sitter's control over it (and in the artist's definition of it) than in any of Parmigianino's authentic portraits. So vague and gentle a melancholy does not occur in any of Parmigianino's other subjects. The slate support of the painting, while not a conclusive argument against Parmigianino's authorship, does not occur in any of his authentic works. Except by Sebastiano del Piombo (who used it rarely), slate was only most infrequently employed as a support until later in the sixteenth century.

ROME, GALLERIA BORGHESE, no. 86. "Young Man with a Letter." Canvas, .72 x .58 m. Fig. 164. The letter on the table bears the legend *in Roma*.

The catalogue of the gallery (1893, p. 77) indicates that the portrait, there assigned to the school of Raphael, was once considered by Raphael himself, and goes on to remark that *Certa ricercata eleganza dell'atteggiamento farebbe pensare al Parmigianino.* Fröhlich-Bum (p. 32) assigns it definitely to Parmigianino, as does Venturi (IX/2, p. 684). De Rinaldis (itinerary of the gallery, 1931, p. 38) prefers to assign it to Bedoli. Copertini includes it among his list of authentic pictures, but is less categorical in his text (I, 202), where he says *forse lo iniziò, ma non potè finirlo, lo stesso Parmigianino.* Longhi (*Ampliamenti;* see above, note 266) suggests that it is *cosa toscana, forse del Vasari.* As the picture stands today no part of it permits an association with Parmigianino. Certain of its morphological characteristics much resemble those of the "Youth with a Hand on his Hip" (Naples, no. 112), but

the damaged condition of both works prevents any positive statement as to their relationship.

ROME, GALLERIA D'ARTE ANTICA (PALAZZO CORSINI). "Portrait of a Young Man with a Dog." Fig. 165. Inscribed on the table *An XX.*

Ascribed in the catalogue of the gallery (vol. I, no. 23) to Parmigianino; accepted as such by Fröhlich-Bum in Thieme-Becker (1930). Neither Berenson nor Venturi mentions the painting; Copertini (I, 223, n. 27) considers that it is *lontano della personalità di Francesco.* A very sympathetic portrait, strongly connected in style with the portrait in Naples of a youth with the initials *L.V.* (*q.v.*). Bodmer (*Correggio und die Malerei in Emilia,* p. xxxvi and fig. 93) has attributed the present painting to Niccolo dell'Abbate.

SIENA, ACCADEMIA DELLE BELLE ARTI. "Man with a Blond Beard."

The photographic files of the Frick Art Reference Library, where this work is catalogued under Parmigianino, say that it is not identified in the Siena catalogue of 1924, but that it is perhaps identical with no. 522 in the catalogue of 1903, which is described merely as a portrait of an unknown, unattributed. The source of the attribution to Parmigianino is unknown. In any case, positively not by Parmigianino, but by a minor Tuscan painter of the later sixteenth century.

VIENNA, KUNSTHISTORISCHES MUSEUM, no. 61. "Portrait of a Gentleman of the Santacroce Family." Panel, .98 x .67 m. In the background, the classical "Amazone Patrizi."

Attributed to Parmigianino in the early years of this century (see Vienna catalogue, 1907.) Reassigned correctly to Salviati by Voss, and now universally accepted as such (see Fröhlich-Bum, p. 38, and Vienna catalogue, 1938, p. 149).

VIENNA, KUNSTHISTORISCHES MUSEUM, no. 66. "Portrait of a Reading Man." Panel, .67 x .52 m. Fig. 166. The original surface of the panel has been much damaged.

This work first appeared in the Prague inventory of 1718, no. 224, with an attribution to the

school of Correggio. Transferred to Vienna in 1723 as a work of Correggio; first exposed in the galleries in 1816. The original ascription to Parmigianino was made by A. Krafft (1837).[269] Fröhlich-Bum (p. 31), Berenson (*Lists*), Venturi (IX/2, p. 660), Gamba (*Emporium,* vol. XCII, no. 549, 1940, p. 110) and Arslan (*Emporium,* vol. CV, no. 626, 1947, p. 66) accept this attribution; Copertini (I, 222, n. 27) regards it as *molto dubbia.* There are a number of close similarities in certain details between this portrait and certain paintings of Parmigianino's first Parma period. There is also a general similarity, in type and expression of the person represented, to the Strafford "Portrait of a Priest." Nevertheless, it is my opinion that the present work must be refused to Parmigianino. None of the similarities to the authentic work, if pressed, carries genuine conviction; particularly, they are not strong enough to override the evidence of a greater number of patent dissimilarities to anything in our experience of Parmigianino's work. Some of these are: the badly drawn, claw-like hand (a parallel to this detail cannot be found except in the retouched copy, Parma 192, after the lost "Marriage of St. Catherine"); the particular weakness of the modeling of the right side of the sitter's face; weakness of draftsmanship in execution of the details of the costume (the costume is itself[270] rather curious; though it is generally in the mode of the 1520's, I can remember no exact parallel to it); the informality of the pose, which is unlike anything in Parmigianino's authentic work.

The deciding factor in our refusal of this painting to Parmigianino is the effect of the ensemble: this is dominated by a particularly disturbing lack of organic coherence in the relationship among the parts of the body. Such a lack of organic character is perfectly possible to Parmigianino, but never to the degree evident in this picture; further, Parmigianino's violations of anatomical logic in the construction of the human figure always result in an increased rhythmic coherence of design. In the Vienna "Reading Man," the sacrifice of anatomical logic has not been so

[269] See Vienna catalogue (1938), p. 128.
[270] As Copertini has also noted (I, 222, n. 27).

compensated, but the design reflects instead all the incoherence of the bodily construction out of which it is composed. Compare "Portrait of a Man Writing," New York, Collection Frederick Brown, above.

VIENNA, KUNSTHISTORISCHES MUSEUM, no. 67. Portrait, called "Malatesta Baglione." Panel, 1.17 x .98 m. Fig. 167.

This painting has borne an attribution to Parmigianino at least since Mechel's catalogue of the Vienna gallery (1784, p. 62, no. 16) where it is described, without specification of source or reason, as a portrait of Malatesta Baglione. It has since been almost universally regarded as an authentic work by Parmigianino. Fröhlich-Bum (p. 34), Berenson (*Lists*), Venturi (IX/2, p. 684), and Gamba (*Emporium, op. cit.,* 1940, p. 116) accept it as such without thought of question. Copertini (I, 223, n. 27) was the first seriously to challenge the traditional ascription; he assigned it instead to the school of Sebastiano del Piombo. After the most serious consideration, I have been compelled to agree with Copertini's refusal of Parmigianino's authorship, though I doubt his suggestion that the work may have originated in Sebastiano's milieu.

The rejection of so important and widely accepted a painting is a serious matter, and must be justified in some detail. In a general way, this portrait is of a quality which one should be pleased to accept for Parmigianino himself. Moreover, the character of the picture as a whole is quite Parmigianinesque. However, intimate investigation of the painting reveals a number of serious differences from the style of Parmigianino's authentic work. The figure is constructed in a way which is without parallel in Parmigianino's portraits. It is a hollow surface of bell-like shape, and of considerable flatness (in spite of its being posed on a bias). The forward surface of the body inclines outward and downward towards the edge of the picture, so that the lower part of the figure "bells out" toward the spectator. The drawing of the garments which enclose the body (note the fur collar, the sash across the waist) is such as to increase the effect of flatness of the body rather than modify it. Behind this

flat, hollow surface of the figure there is represented a background more specific in its construction than in any portrait by Parmigianino; this background is related to the figure according to a system of perspective and scale even more arbitrary and irrational than we observe in Parmigianino's most extreme distortions in the representation of space. The handling of all the surface textures is markedly colder and thinner than in Parmigianino, and more scrupulously literal. Then, the drawing lacks the calligraphic interest and (in details) the naturalness of Parmigianino. See, for example, the beret; the automatic-seeming pattern of folds on the drapery of the arms of the figure; the stiff, brittle, meticulous drawing of the hairs of the fur, and the hard drawing of the hair of the beard (compare against the beard of the Count San Secondo); the rather weak drawing of the eyes, with their slight suggestion of disharmony in direction. Finally, the expression of the sitter has a rather romanticizing and mysterious overtone that does not appear in Parmigianino's interpretations of his sitters.

This painting, though thus clearly separable from Parmigianino's style, is not far distant from it. It must be the work of a painter who knew Parmigianino's formulas intimately, and who as an executant performed equally skillfully, though not at so high a level of inspiration. It is difficult to find an artist who fits these specifications as well as does Bedoli. Yet, when we investigate Bedoli's *oeuvre* for positive comparisons, it is difficult to find any so exact as would justify our assigning this portrait to him without question. However, a reasonable confrontation can be made with the "Portrait of a Man with an Hourglass" in the Parma Gallery (no. 333); a comparison even more exact may be made with the male heads in the left foreground of the "Allegory of the Virgin" in the same gallery.

A photograph (Mansell) exists in the files of Dr. W. Suida, New York, of a good, old, copy of this portrait in which the figure is represented in the guise of King David, with a crown on his head, and a harp in the middle distance to the right.

WASHINGTON, NATIONAL GALLERY OF ART (KRESS COLLECTION), no. 189. "Portrait of a Lady" with the initials *M.M.V.A.* Panel, .66 x .53 m.

The original attribution to Parmigianino results from a certificate given by Van Marle. The picture was reproduced as Parmigianino in the dealer's advertisement in *Art News,* vol. XXVIII, April 26, 1930, and in *Parnassus,* vol. III, no. 3, March 1931. Fröhlich-Bum has listed it as by Parmigianino in her article in Thieme-Becker (1930). The picture is now considered in the collection to be a work of Salviati.

WASHINGTON, NATIONAL GALLERY OF ART (KRESS COLLECTION), no. 866. Female head, called "Portrait of a Lady." Oil on panel, .42 x .32 m. Much rubbed and restored.

Probably originally not a portrait, but an allegorical figure of some kind; perhaps a fragment from a larger painting. Attributed to Parmigianino in written opinions from Perkins, Suida, Fiocco, and A. Venturi (though the latter does not record the picture in his *Storia dell'Arte*). Longhi considers it by a "strict follower" of Parmigianino, Berenson has suggested the possibility of Bedoli's authorship. (Opinions on file in the Gallery.) Certainly not by Parmigianino; probably the work of a Parmesan or Bolognese painter of the decade 1540-1550.

WINDSOR CASTLE, COLLECTION H. M. THE KING. "Man with a Cleft Chin." Canvas, .66 x .495 m.

Assigned to Parmigianino in the catalogue of the collection (1937, p. 251). Attributed to Giulio Campi by Berenson. Benedict Nicolson (letter of November 9, 1947) suggests that the portrait is "very close to, and perhaps by, Niccolo dell' Abbate." This ascription is much more nearly just than would be any attribution to Parmigianino. A version (with slashed sleeves) exists at Kedleston (Nicolson, *ibid.*).

C

CATALOGUE OF LOST PAINTINGS

This section of the catalogue is titled a catalogue of "lost" paintings only for convenience of nomenclature. It in fact includes all paintings assigned to Parmigianino by sources up to 1800, and which cannot be definitely identified with a surviving work of Parmigianino or of another artist. The interest of these early attributions rests mainly on the assumption that they may depend in some measure on a historical tradition. It is obvious that the authority of such traditional attributions varies greatly, and that they become less dependable as they grow later. However, because we have no means of discriminating among these old attributions for their reliability, it has been thought wiser to record all that appear in the available sources. The arbitrary stopping point for this record is the end of the eighteenth century: by that time the tradition is in most cases already too tenuous to merit serious attention. The entries in this section are arranged in chronological sequence by date of the earliest reference to the painting.

WORKS ASSIGNED TO PARMIGIANINO BY SIXTEENTH-CENTURY SOURCES BUT SINCE LOST.

In the following quoted material, the spelling of "Parmigianino" has been modernized throughout.

1549: Michelangelo Biondo, *Della Nobilissima Pittura e della Dottrina, di conseguirla agevolmente et presto,* Venice (in *Quellenschriften für Kunstgeschichte,* vol. VI, Vienna, 1873; tr. A. Ilg), p. 38: ". . . a picture of the Saint Catherine, that is splendidly painted, in the Church of San Petronio, and the *Sponsalitio.*" Probably a confused reference to the "Saint Margaret" altar now in the Bologna Gallery. It was in Biondo's time in the church of St. Margaret and not in San Petronio; its subject is also easily confusable with a *Sposalizio.*

1550: Vasari, *Vite* (1st ed.), pp. 846-847: "Or essendo Francesco in Roma, fece un bellissimo quadro d'una circuncisione, et lo donò al Papa: et fu tenuta una garbatissima invenzione per le tre lumi fantastiche ch'a detta pitture servivano. Per ciò che le prime figure erano illuminate dalla vampa del volto di Christo, le seconde ricevevano lume da certi che portavano i doni al sacrificio per certe scale con torce accese in mano: et l'ultime erano scoperte, et illuminate dall' aurora, che mostrava un leggiadrissimo paese, con infinità di casamenti." Substantially the same description appears in the second edition (V, 222-223) which adds the supposition: "si stima che poi col tempo l'avesse l'imperatore." The original painting was alleged by d'Argenville (*Abrégé de la Vie des Plus Fameux Peintres,* ed. 1762, II, 30) to be in the Vatican.

A drawing in the British Museum (1910-2-12-34; 18.7 x 28.6 cm., lunette; engraved by Vorstermann with the inscription *Fran: Parm: Del:;* the engraving ill. Copertini II, *tav.* CXLVa) is sometimes adduced as evidence for the appearance of this lost Roman "Circumcision." This drawing (fig. 44; possibly a copy) agrees in one respect only with Vasari's description: his reference to "certi che portavano i doni al sacrificio per certe scale con torce accese in mano"; it differs in every other circumstance. Conspicu-

ously, this drawing does not show a landscape background, but an architectural interior, probably inspired, as we have observed elsewhere, from the Pantheon. Further, the subject of this drawing is almost certainly a "Presentation in the Temple" rather than a "Circumcision"; the action of the priest is that of receiving the Child, not that of circumcising. Finally, the shape of the drawing does not suggest a design for what would normally be understood by the term *quadro;* it is a lunette which would, in this period, ordinarily occur only as a subordinate part of an altar, or in an architectural decoration. That this British Museum drawing was in fact intended as a design for part of an architectural decoration (and not for an independent portable painting, such as would have been given as a separate gift, as the "Circumcision" was given to the Pope) is confirmed by another drawing, now in the Victoria and Albert Museum. This drawing (no. B. 2693-20; 23.5 x 19.7 cm.; from the collection of Charles Sackville Beale; hitherto unphotographed and unpublished; Fig. 45), an original in Parmigianino's style of the Roman period, is a design for the whole decorative scheme of what appears to be a small chapel: in the miniature semidome of the chapel, above the altar, is the same composition as in the British Museum drawing, here more roughly sketched, and projected in perspective to accord with the curving shape of the semidome. We have no evidence to tell us for what specific chapel this decoration was intended, nor is there evidence to indicate that it was ever in fact executed. That this scheme was at least considerably developed is suggested by the (for Parmigianino) relatively careful working out of the British Museum "Presentation" drawing.[271]

Vasari (1st ed.), p. 846 (in Rome): "ancora alcuni quadretti piccoli, ch'erano venuti poi in mano del Cardinale Ippolito de' Medici." Also 2nd ed. (V, 224.)

[271] In addition to the sketch for the "Presentation" in the lunette of the chapel, the Victoria and Albert drawing contains what appear to be two (sculptured?) figures in niches flanking the altar; at the lower left is a group of angels(?) with books, and on the wall at the lower right an illusionistic motive of a balustrade and a praying female figure.

1st ed., p. 848 (in Bologna): "ad un sellaio suo amico . . . una Madonna dipinto, volta per fianco con bella attitudine, e parecchie altre figure." Also 2nd ed. (V, 227). The text in the second edition permits, if one stretches a point, the assumption that the Madonna and accompanying figures were set in a landscape. Copertini (I, 122) suggests this interpretation. Affò (p. 67) says "mi fa risovvenire quella nel Palazzo del Signore Principe Borghese, Roma," which is in fact a "Marriage of Saint Catherine," engraved by Tinti, now in Lord Normanton's collection.

Vasari (1st ed.), p. 848 (in Bologna): "due tele a guazzo per . . . Luca dai Leuti, con certe figurette di bellissima maniera." Also 2nd ed. (V, 227).

1st ed., p. 849 (in Bologna): "un ritratto d'un Conte bolognese . . ." Also 2nd ed. (V, 227).

1st ed., p. 849 (in Bologna): "sparsi per Bologna alcuni altri quadri di Madonne et quadri piccoli; colorati et bozzati . . ."

1st ed., p. 850 (in Bologna): "Fece a Bonifazio Gozadini il suo ritratto di naturale." Also 2nd ed. (V, 228). Copertini (I, 219, n. 2) notes the following: *"Il Litta,* sotto la voce Gozzadini, riproduce il ritratto di un Gozzadino, il quale appare in terza e mostra il solo busto . . . notiamo che in esso esistono riflessi parmigianineschi." The original from which the *Litta* portrait was derived is unknown.

Vasari (1st ed.), p. 850 (in Bologna): "Abozzo il quadro d'un altra Madonna, il quale in Bologna fu venduto a Giorgio Vasari Aretino, che in Arezzo nelle sue case nuove et da lui fabricate onoratemente lo serba." Also 2nd ed. (V, 228-229).

1st ed., p. 851 (in Casalmaggiore): "fece per quei signori [the Baiardi] due bellissime tavole."

1560: Lamo, *Graticola di Bologna, ossia Descrizione delle pitture, sculture e architetture di detta città* (MS of 1560; published Bologna, Guidi, 1844), pp. 11-12 (in the house of Bartolommeo Passerotto): "un quadro di una Maddalena nel deserto di mano del Parmigianino." Affò (p. 75) says that it is "probabilmente lo stesso conservato oggidi nella stessa città dal Sig. Alfonso Arnoaldi." An entry under Parmigi-

anino's name in the catalogue of the Crozat Collection (Paris, 1755, p. 11; quoted Affò, pp. 88-89) describes a female saint kneeling in the desert, contemplating a skull and crucifix, on a small panel. DuFresnoy (*L'arte della Pittura,* 1755; quoted Affò, p. 58) also mentions a Magdalen by Parmigianino. An authentic drawing of the Magdalen subject is in the Louvre, 6423 bis; probably Roman period.

Lamo, p. 27: "un bel quadro in tela di un ritratto di Messer Rinaldo dalli panni d'arazzo dipinto per mano del Parmigianino."

1568: Vasari, *Vite* (2nd ed.):

V, 220 (in Viadana): "S. Francesco che riceve le stimate e Sta. Chiara, fu posta nella chiesa de' frati de Zoccoli."

V, 221 (first Parma period): "Fece tre quadri, due piccoli ed uno assai grande" (the last being the Madrid "Holy Family"). The *due piccoli* possibly identifiable with the two small pictures now in the Doria Gallery, which, however, I have assigned to early in the Roman period; see above, catalogue of authentic works.

V, 224 (in Rome): "un tondo d'un bellissima Nunziata che egli fece a messer Agnolo Cesis, il quale è oggi nelle case loro, come cosa rara stimato." Three drawings, all *c.*1525 in their style of draftsmanship, survive from Parmigianino's studies for this painting: Louvre 6380, 6432, and British Museum Cracherode Ff. 1.89. Louvre 6380 has been cut so that only the right two-thirds of the sheet remain, but the *tondo* form intended for the painting is clearly indicated. All three drawings show the Madonna (in various attitudes) accompanied by an *angioletto* who supports a book for her. In Louvre 6432 the Madonna and the *angioletto* are arranged in a manner strongly reminiscent of the Sybils of the Sistine. That Parmigianino had this same source in mind is confirmed by the verso of the same sheet, which shows a literal copy of one of the *ignudi* from Michelangelo's ceiling.

V, 224 (in Rome): "in un quadro la Madonna con Christo, alcuni angioletti, ed un S. Giuseppo . . . la quale opera era gia appresso Luigi Gaddi, ed oggi dee essere appresso gli eredi." In the first edition (p. 847) this had been confused with the "Holy Family" now in Madrid. Vasari had then thought that the latter painting, and not the one described above, was the "Holy Family" in the possession of the Gaddi. Insecurely identified by Voss (*Kunstchronik und Kunstmarkt,* 1923, p. 637) with the Doria "Adoration."

V, 233 (in Casalmaggiore): "fece (e questo fu l'ultima pittura che facesse) un quadro d'una Lucrezia Romana . . . ma come si sia, è stato trafugato, che non si sa dove sia." Note that as early as 1568 Vasari considered the painting lost. A drawing in Budapest (E IV 21, recto and verso, pen and wash, 18 x 8.8 cm.; Fig. 118) is the only surviving record of the Lucretia subject which is certainly from Parmigianino's own hand. The drawing is close in style to the later Steccata drawings, and may thus in fact have been related to the work executed by Parmigianino at Casalmaggiore. The study of the draped Lucretia on the recto would seem to have been inspired by the Marcantonio print of the same subject (Bartsch XV, p. 29, no. 1). A print by Van der Borcht from a drawing then ascribed to Parmigianino in the Arundel Collection (ill. Denys Sutton, "Thomas Howard, Earl of Arundel and Surrey as a Collector of Drawings," part I, *Burlington Magazine,* vol. XXXIX, no. 89, 1947, pl. IIa) may reflect another *pensiero* of Parmigianino for the Lucretia theme. This print shows Lucretia (on a funeral pyre?) lying on a sword which transfixes her; in the background is an antique breastplate and a shield. A copy in drawing, perhaps after the lost Arundel drawing, but possibly after the print, exists in the Louvre (no. 4995).[272]

Affò (p. 87), quoting Erba's MS ("Compendio dell' origine, antichità, successi e nobilità della città di Parma," 1572), names as the patron of the "Lucretia" Giannantonio de'Vezzani, and suggests a possible identification with the full-length seated figure of which there exists an engraving by Vico with the legend FRAN. PAR. INVENTOR. (Fig. 119). It is of course impossible to determine whether Vico's engraving is after a

[272] Other copies after drawings, presumably by Parmigianino, of the Lucretia theme are: Uffizi 13160, Paris, Ecole des Beaux Arts 34931*a* and *b*, Windsor 0562, and (formerly) collection K. E. Marion, Berlin.

drawing by Parmigianino or after the lost painting. Copertini (I, 186), and others previously, have attempted to identify the bust-length painting of Lucrezia in Naples with the painting mentioned by Vasari. For judgment of this picture, which I consider by Bedoli, see the catalogue of attributed works, above, p. 221.

A "Lucrezia Romana" is given to Parmigianino in the Farnese inventory of 1587 (Campori, p. 53) but with only a summary description: "un ritratto di Lucretia romana con il suo ornamento et cortina di cendale di mano del Parmigianino." This may be the same work which is described more fully in the Farnese inventory of c.1680, and there also given to Parmigianino: "una Lucrezia romana con la destra si ferisce al petto col coltello, nuda dalla destra e coperata la spalla sinistra di un panno cangiante, sopra cui una medaglia di Diana del Parmigianino"; this description is that of the painting in Naples which we ascribe to Bedoli. It should be observed that Giacomo Barri, in his Viaggio pittoresco of 1671, mentions two pictures of the Lucretia subject in the Palazzo del Giardino, both of which he assigns to Parmigianino (English ed., 1679, pp. 128 and 130). The catalogue of King James II's collection (168-; publ. London: Bathoe, 1758) mentions (p. 69, no. 779) a Lucretia stabbing herself, which is there attributed to Correggio. It is possible that this work may have had some relation with Parmigianino's lost painting.

V, 233 (in Casalmaggiore): "un quadro di certi ninfe, che oggi è in casa di messer Niccolò Buffolini a Citta di Castello." Ricci (Disegni della R. Galleria Uffizi, Serie seconda, fasc. 3, Florence, 1914, introduction) has suggested that the famous drawing of bathing nymphs (Uffizi, no. 751) is a preparatory study for this lost work. I consider that the Uffizi drawing is considerably earlier than Parmigianino's residence in Casalmaggiore, and dates in fact from the Bolognese period; Copertini (II, 146) agrees with this dating of the drawing.

V, 233 (in Casalmaggiore): "una culla di putti che fu fatta per la signora Angiola de' Rossi da Parma; la quale è similmente in Città di Castello." (Affò (p. 58) citing the Libro del Titi

(Descrizione delle Pitture, Sculture, etc. esposte al pubblico in Roma, 1763) intimates that in Titi's time the picture was in Rome.

1572: A. M. da Erba, "Compendio dell'origine, antichità, successi e nobiltà della città di Parma" (MS no. 419 in the Parma Library): "Una tavola di molto valore nella chiesa di S. Francesco" (at Casalmaggiore). Probably a confused reference to the "St. Stephen" altar.

1587: Inventory of the wardrobe of Prince Ranuccio Farnese (Campori, p. 53): "Un ritratto del Dr. Berniero di mano del Parmigianino con suo ornamento et cortina di cendale verde." As Ricci notes (Archivio storico per le provincie Parmensi, p. 10) Berniero was born in 1467; this portrait would therefore represent a person of fairly advanced age.

1597: MS diary of Smeraldo Smeraldi of Parma, quoted Affò (p. 92), records that in 1597 Alessandro Orso of Parma owned five pictures by Parmigianino, and "che usava tutte le diligenze per acquistare un Davide dipinto dal medesimo, che stava in potere di un certo Giammaria scultore."

2nd half 16th century (undated): "Inuentario delle Pitture del q. s. Cauaglier Bayardo," publ. by A. Rapetti, "Un inventario di opere del Parmigianino," in Archivio storico per le provincie parmensi, vol. V, ser. 3 (1940), pp. 39-53. Rapetti suggests that the Cav. Bayardo here referred to is the Francesco Baiardo who was the friend and patron of Parmigianino. This inventory would seem certainly to be of a Parmesan collection formed apparently before c.1560. As such it should be of great importance. Unhappily, however, it is extremely vague in its descriptions and measurements. This vagueness makes it impossible to check the few items in the inventory which may perhaps be identifiable with surviving works; there is thus no way of determining the extent of the credibility of the other attributions in the inventory. It should be noted that attributions to Parmigianino have been made with what would seem to be an excessive generosity. Because this inventory seems undepend-

able I have thought it wiser not to attempt to use it in establishing the history or identity of any of the pictures discussed in the catalogue. Reproduced herewith are the entries for paintings assigned to Parmigianino with tentative comments.

"1. Un' Cupido colorito finito di mano del Parmigianino alto B. 2 e più. [The Amor?]

"2. Una Palas di chiaro, e scuro finita di mano del Parmigianino alta B. 2.

"3. Un'Mercurio di chiaro, e scuro finito di mano del Parmigianino alta B. 2.

"4. Un'ritrato colorito e finito d'una donna in piedi di mano del Parmigianino alta B. 2 1/2. [The Antea? The single given measurement agrees with that of the Antea.]

"5. Un'Presepio colorito è finito di man di M. Gironimo Mazollo ritrato da un'*disegno* del Parmigianino. Longo B. 1 alto B. 10.

"10. Una Madona colorita è finita in quadretto largo B. 8 alta B. 6 col putino, S.ta Caterina, e san Gioani di mano dil Parmigianino.

"12. Una testa col petto d'una Minerua colorita finita alta B. 16 larga 10 di mano del Parmigianino. [Compare the (attributed) Windsor Minerva. Assuming that the "B." is in error for "on.," the horizontal measurement, but not the vertical measurement, agrees.]

"13. Una Lucretia bozzata benissimo di colore alta B. 16 larga B. 12 di mano del Parmigianino. [Assuming that "B." is in error for "on.," the measurements are approximately those of the (attributed) Naples "Lucretia"; however, the Baiardo picture is only "bozzata."]

"14. Un'ritratto del Vescouo Rangone in piedi, colorito finito alto B. 2 o. 4 di mano dil Parmigianino.

"16. Una testa d'una mad. na colorita finita alta B. 16 larga 12 co' il petto ritratta da una dil Parmigianino, dal Mazollo.

"17. Un'quadretto colorito con una donna, doi puttini alto B. 7 largo B. 5 di mano del Parmigianino. [Related to the Frankfort "St. Catherine"? The dimensions of the picture here listed (again assuming the substitution of "on." for "B.") are larger, but in the same proportion, as the existing variants of the St. Catherine with two *putti*.]

"18. Uno quadro colorito finito co' due teste di donne et tre d'Agnelli ritratte da uno dil Par-

migianino p. il mazollo alto B 16 largo B 12.

"19. Un'ritratto d'una donna sin'a mezzo colorito finito alto B 10 largo B 12 di mano dil Parmigianino.

"20. Un'quadro d'una donna ignuda ch'incorona un'Cauallo con'un puttino appresso bozzata di colore finito alto B 20 largo B 12 di mano del Parmigianino. [Compare the drawing in the Louvre (ill. Fröhlich-Bum, fig. 105, p. 88; Copertini II, *tav.*, 13b).]

"21. Un'ritratto picolo colorito finito alto B 5 largo B 4 di mano del Parmigianino.

"23. Uno quadretto co' una testa d'una donna, sono di stile bozzato alto B 8 largo B 5 dil Parmigianino.

"34. Un'quadretto co'uno san Rocco bozzato di colore alto o. 7 largo o. 5 di mano del Parmigianino.

"37. Un'quadretto co' uno presepio in disegno di chiaro è scuro finito alto B 1 largo o. 10 di mano dil Parmigianino dal quale il Mazollo ha tolto il colorito. [Compare no. 5 of this inventory.]

"39. Un'quadretto co' una testa d'uno giouine finita, è colorita alto o. 4 largo o. 3 sotto il quale sono due figure maschio e femmina che si godono, colorite di mano del Parmigianino.

"40. Un'quadro co' due donne è duoi puttini colorito, finito alto o. 18 largo o. 14 ritratto da uno del Parmigianino.

"41. Un'Ritratto sopra il rame colorito finito alto o. 6 largo 4 di man dil Parmigianino. [On copper, an abnormal practice for Parmigianino's own time.]

"45. Un'quadro in Carta fatto di stilo colorito finito con una testa col petto di donna col balzo in testa alto o. 15 largo 9 di mano dil Parmigianino.

"46. Uno quadretto colorito finito è di lapis nel qual'è ritratto il Parmigianino di sua mano alto o. 5 largo 4.

"49. Un'ritratto colorito finito d'un huomo alto o. 4 largo B 3 di mano dil Parmigianino.

"51. Un'quadro con un'ritratto d'un huomo con una veste di pelle alto B 16 largo B 12 colorito finito di mano del Parmigianino.

"54. Un'quadro con una testa di donna col petto colorito finito alto o. 12 largo B 8 di man del Parmigianino."

WORKS ATTRIBUTED TO PARMIGIANINO BY SEVENTEENTH- AND EIGHTEENTH-
CENTURY SOURCES, BUT NOT NOW DEFINITELY IDENTIFIABLE WITH ANY
SURVIVING WORK EITHER OF PARMIGIANINO
OR OF ANOTHER ARTIST

1624: Inventory of pictures of Cardinal Alessandro d'Este, bequeathed to the Princess Giulia d'Este (Campori, Inv. no. X):

p. 65: "Una testa del mano del Parmigianino . . ."

p. 68: "Un ritratto d'una femina antica del Parmigianino."

162–: Catalogue of the pictures bought by Angelo Garimberti, and kept in the house of his sons in Parma (quoted Affò, p. 94): "Una bozza d'un S. Girollamo di mano del Parmigianino originale . . ."; "Un ritratto . . . di mano del Parmigianino."

1630: G. B. Marino, *La Galleria distinta in Pitture e Sculture* (Venice, 1630), lists a "Virgin Beside the Cross" by Parmigianino (see A. Barilli, in *Aurea Parma, Anno XIV, fasc.* 1, 1930, pp. 37-38). The third edition (according to Faelli, *Bibliografia Mazzoliana*) lists a "Virgin and Child" by Parmigianino.

1632: Pictures in the palace of the Duke of Savoy in Turin (Campori, Inv. no. XI), p. 77: "Altro [quadro] della Madonna del Parmigianino larg. on. 8, alt. 12"; p. 99: "Natività di Christo, ovato, maniera del Parmigianino, long. on. 8, alt. 12"; p. 102: "Madonnina del Parmigianino con Christo et un angelo sotto una palma; long. on. 6, al. 8." The last not impossibly identifiable with the St. Catherine subject (Frankfort, etc.) of the first Parma period, *q.v.*

1632: Inventory of the chattels of Roberto Canonici (Campori, Inv. no. XII):

p. 107: "Judit di Francesco Parmigianino dal mezo in su un quadro a otto facie, ha gli capelli per spalla, con la mano dritta appogiata a un spadone, e la stanca sopra alla testa d'Oloferne . . ."

p. 110: "Un Christo, e S. Gioanni Bambini, di Francesco Parmigianino, ambidue sono nudi e si bacciano stando a sedere su una barca in un bosco. N.S. ha la mano drita su al volto di S. Gioanni, e lui ha parimenti l'istessa mano sopra il corpo di N.S. et la stanca su il colo: gl'e un angelo che va pascolando et ha una mosca sopra della schiena, e in un arbore lì vicino sono tortore . . ."

p. 122: "Un Christo di Francesco Parmigianino, che stando in una barchetta, S. Pietro gli sta con le mane giunte inginochiato avanti, dietro del quale gl'e S. Andrea, che in atto di dolersi parla con Christo in un altra barchetta li vicina gli sono duoi altri apostoli, che con gran fatica tirano su una rete piena di pesce, gli n'e un altro che con il ramo tiene ferma la barca, sopra alla testa del quale gl'e un castello . . ." This description would seem certainly to be of a copy after Raphael's "Miraculous Draft of Fishes."

1640: Pictures for sale in Genoa (Campori, Inv. no. XIV), p. 141: "Testa del Parmigianino."

c.1640: Pictures in the Studio Coccapani, Reggio (Campori, Inv. no. XV), p. 151, no. 162: "Una Madonna col puttino et S. Giovanni di mano del Parmigianino"; no. 165: "Un Christo morto con la Madonna tramortita et altri santi et sante, opera fornita del Parmigianino."

16– (before *1649*): Vanderdoort, *A Catalogue and Description of King Charles the First Capital Collection of Pictures . . .* (MS in the Ashmolean Library, Oxford; publ. London: Bathoe, 1757), p. 7, no. 26: "Said to be done by Parmigianino . . . A piece of two naked children embracing one another, signifying Christ and Saint John in the desert . . . 1 ft. 4 1/2 in. x 1 ft. 6 in." Compare entry under 1632 (chattels of Roberto Canonici, p. 110). This picture, as well as a copy thereof "from the Mantua collections" which was owned by Charles II, came to the collection of James II at Whitehall. Compare the catalogue of the collection of James II, p. 34, no.

386 ("Our Saviour and Saint John small figures when children"), and p. 49, no. 561 (". . . our Saviour and Saint John, naked figures"). Both are given in that catalogue as originals.

Vanderdoort, p. 84, no. 2: "Said to be done by Parmigianino . . . a little side-faced woman's picture in reddish drapery bought by the King of Varseline, 1 ft. 2 in. x 10 in." Suggests the Prado "St. Barbara" in description (as well as color), but does not agree in size.

p. 105, no. 6: "Done by Parmigianino . . . Another Italian woman's picture, with her arm naked, dressing herself, and a man holding a looking glass to her; . . . half a figure as big as the life, painted upon cloth . . . 3 ft. 5 in. x 2 ft. 9 in." Compare the motive in the Louvre Titian, the so-called "Alfonso of Ferrara with Laura de' Dianti."

p. 124, no. 6: "Done by Parmigianino, being the eighth piece of Fressley . . . the picture of our Lady and Christ, and Saint John, little intire figures and Joseph a half figure . . ." Possibly a copy of the "Madonna di San Zaccaria"? A description of a similar work appears in James II's catalogue (p. 61, no. 688), but cannot refer to this painting since the picture in James's collection is described as having been given to him by Sir John Shaw.

p. 131, no. 5: "Done by Parmigianino . . . a black complexioned gentleman with a black beard holding in his right hand a red book, being some scholar, painted upon a board. 2 ft. 1 in. x 1 ft. 5 in." Also in the collection of James II (see James II's catalogue, p. 12, no. 134).

1651: Pictures of Signora Eleanora Marchi Cremonesi (Campori, Inv. no. XVIII), p. 167: "un quadretto piccolo su l'assa sopra il quale vi e dipinto un papagallo del Parmigianino."

1660: Marco Boschini, *Carta del Navegar Pitoresco* (Venice), Vento quinto, a description of the collection of the Baron Tassis in Venice:

"De quella venerabile maria [by Parmigianino]
Vorave dir gran cose se savesse,
E vorria far che ognuno la credesse
el più bel fior di quella Galleria."

1662: Pictures in the Studio Muselli, Verona (Campori, Inv. no. XX), p. 183: "una Madonna con un Puttino e S. Gioseffo mezze figure di mezzo naturale, del Parmigianino"; p. 188: "una testa della Madalena cala poco del naturale, del Parmigianino"; p. 189: "Un modelletto del tavola del Parmigianino di Bologna di grandezza di mezzo foglio, del Parmigianino" (perhaps a small copy of Parmigianino's "St. Margaret" such as that now in the Louvre; see above, p. 181); p. 192: "Il ritratto . . . del Parmigianino; diversi ritratti e figurini del Parmigianino" (the *ritratto del Parmigianino* possibly a drawing; see Vasari, V, 223, n. 1, and p. 205, n. 207).

1662: Pictures (?) in the Studio Curtoni, Verona (Campori, Inv. no. XXI), p. 199: "il Salvatore deposto, la Madalena et altre figure." Perhaps a version in painting after the etching by Parmigianino. Possibly identifiable with the small copy in oils in Leningrad (see above, p. 219).

Some if not all of the following were probably prints rather than paintings; the wording of the inventory is unclear: "Il Presipio con il Signore, la Vergine e Pastori"; "L'Annonciata"; "La Vergine con altre figure"; "La Vergine col Bambino"; "La Vergine, Gesù e S. Giovanni."

1671: Giacomo Barri, *Viaggio pittoresco* (Venice, 1671); citations from the English translation, "The Painters Voyage of Italy" (London: Flesher, 1679):

p. 126 (Parma, Palazzo del Giardino): "two *Ladies,* by the hand of Parmigianino . . . A Picture of a Shagged Spaniel, by Parmigianino."

p. 128 (*ibid.*): "a *Ritratto* . . . by Parmigianino."

p. 129 (*ibid.*): "a *Madonna* with her *Son,* by the hand of Parmigianino."

p. 138 (Modena, in the Ducal Gallery): "a Picture, and a *Ritratto,* by Parmigianino."

c.1680: Inventory of the Palazzo del Giardino in Parma (Campori, Inv. no. XXIV):

p. 208: "Un quadro alto 8, largo on. 6 1/2, in tavola. Una testa di uomo con barba nera e collarino lavorato, del Parmigianino."

p. 224: "Un quadro alto on. 2 e 1/2, largo on. 6, in guazzo. Un S. Girolamo a sedere in un paese che con la destra fa cenno ad un raggio di gloria e con la sinistra al fiume, con diadema, del Parmigianino."

p. 230: "Un quadro alto br. 1 on. 3 e 1/2, largo on. 11 e 3/4. Ritratto di un prete con beretta in capo, officio alle mani et anello alla destra, del Parmigianino."

p. 230: "Un quadro alto on. 10 e 1/2, largo on. 6 e 1/2. Una testa d'uomo con beretta nera e barba nera longa e un robone rivolto davanti dove si vede certa parte di panno bianco, del Parmigianino." Improperly identified by de Rinaldis (Naples catalogue, 1911, p. 283) with a copy after the so-called self-portrait in the Uffizi (see above, p. 206).

p. 230: "Un quadro alto 7 largo on. 4 e 1/2. Una testa di uomo con vesta rossa e pellizza bianca sopra le spalle, del Parmigianino."

p. 260: "Duoi quadri alti br. 2 on. 1 e 1/2; larghi br. 2 on. 6 e 1/2 per chiascheduno. Una Madonna con le mani giunte, riguarda il Bambino che li sta alla sinistra, Ambi di chiaroscuro, del Parmigianino, *copiate* dal Gatti."

p. 289: "un quadro alto br. 1 on. 7, largo br. 1 on. 5. Un abozzo di Madonna a sedere con bambino in grembo vestita di rosso, del Parmigianino."

p. 296: "Un quadro alto br. 1 on. 1, largo on. 11. Cinque teste di giovani, del Parmigianino. *Copia* del Gatti."

p. 306: "Un quadro alto on. 6, largo on. 9 e 1/2. Marte e Venere abbracciati sopra di un letto con sotto lenzuoli, et da piedi drappo rosso, et il zoppo Vulcano che li cuopre con una rete di ferro, et un amoretto che esce di sotto del letto, del Parmigianino." Parmigianino had treated this theme in drawing, though not in such a design as is described here. At least one of these drawings survives (Parma Gallery, ill. Copertini II, *tav.* 8). One of the Venus-Vulcan-Mars designs may have been reproduced in engraving by Vico (ill. Copertini II, *tav.* 14; also see Copertini II, 57-58).

1680: W. Chiffinch, *A Catalogue of the Collection of Pictures . . . Belonging to King James the Second . . .* (publ. London: Bathoe, 1758):

p. 29, no. 326: "By Parmigianino: Our Lady, Christ, Saint John, and Saint Jerome, with a crucifix."

p. 48, no. 556: "A Madonna with Saint Catherine and Saint Joseph, unfinished."

p. 61, no. 688: ". . . Our Lady with Christ, Saint John and Saint Joseph. Given to the King by Sir John Shaw." Apparently not the same picture as that in Charles I's collection (see above, p. 242).

p. 69, nos. 777-778: ". . . Two pictures at length."

1685: Pictures of Prince Cesare Ignazio d'Este (in Reggio?) (Campori, Inv. no. XXVI), p. 313: "Testa di un puttino picciolo, dicono del Parmigianino . . . (con cornice) larga on. 7 1/2 et alta on. 8 1/2 circa"; p. 321: "Un ritratto di un vecchio con barba biforcuta, chi ha una mano sopra un libro, dicono del Parmigianino, senza cornice alto on. 7 largo on. 5 1/2."

1689: Pictures of Christina of Sweden, in Rome (Campori, Inv. no. XXVIII), p. 346: "Un quadro in tavola con la Vergine a sedere, S. Giuseppe in piedi, il Bambanino in piedi ignudo avanti, più a basso S. Francesco con una croce ed un libro in mano, in bel paese del Parmigianino, alto pmi. 3 e 3/4, largo 2 e 3/4 . . ."

1690: Pictures in the Casa Boscoli, Parma (Campori, Inv. no. XXIX):

p. 381: "Un quadretto su l'assa con cornice indorata qual è una Cingarina, originale di mano del Parmigianino, fatto pero molto tozza per contrafare quella del Correggio." Perhaps identifiable with the picture shown in the Sezione Iconografica of the Mostra del Correggio in 1935 (see above, p. 136, n. 50).

p. 384: "Una testa di pastello, di mano del Parmigianino . . . una beretta in capo, vestito aperto davanti, mostra la camisia."

p. 390: "Ritratti di alt. br. 1 incirca, [fra] uno del Parmigianino, con barba longa . . ."

p. 403: "Un ritratto con barba nera di altezza on. 3 sul rame vestito all' antica, di mano del Parmigianino." On copper, and therefore probably later than Parmigianino.

p. 404: "Un ritratto d'una dama vedova con frappe e velo nero in fronte d'altezza br. 1, del Parmigianino."

1695: Description by Gian Paolo Melilupi of the reception at the Rocca dei Marchesi Melilupi di Soragna (near Fontanellato) of the Duchess Dorothea Sophie de Neuborg; document preserved in the archives of the family at Soragna and quoted in Charles Nisard, *Correspondance inédite du Comte de Caylus avec le Père Paciaudi Theatin* (Paris, 1877), II, 364, n. 3:
"Mais la Duchesse applaudit avec transports la vue des peintures du Parmigianino dans deux chambres, l'une dite dei Zingari, l'autre della Suzanna . . . [representant] une troupe de Zingaris et Suzanne au bain . . ."
Nisard states in the same note that these works were destroyed in the seventeenth century by time and damp. Apparently therefore the visit of which Melilupi speaks must have occurred considerably before the date of his description, and the paintings possibly did not exist in his time. Affò (p. 81) repeats a tradition that Parmigianino had worked for the Melilupi: "Pretendesi ancora che i Marchesi di Soragna . . . lo facessero travagliare nelle loro terre."

16—: Pictures for sale at *Ignote Località d'Italia* (Campori, Inv. nos. LX-LXVIII), p. 443: "Parmigianino: Ritratto d'una gentildonna giovane . . . dicono esser del detto mano . . ."

1708: Inventory of pictures and *objets d'art* in the Gallery of the Duke of Parma (Campori, Inv. no. XLIX):
p. 461: "Quadro alto on. 10 largo on. 7 1/2 . . . una fanciulla martire con coltello nel petto, vestita di rosso, con corona in capo, ed officio nelle mani, del Parmigianino."
p. 461: "Quadro in tavola, alto on 9 e 1/2, largo on. 8. Una Madonna a sedere col Bambino sul ginocchio, che scherza con S. Giovanni che tiene nelle mani una colomba, ed a' piedi un agnello, ed alla destra tre angeli con S. Giuseppe dietro della medesima, con capanna in paese, del Parmigianino."
p. 462: "Quadro alto on. 11, largo on. 8 . . . Una Madonna a sedere con Bambino nella brac-

cia, che accarezza S. Giovanni Battista, S. Giuseppe alla sinistra della medesima con mani una sopra l'altra, in paese, del Parmigianino."

1720: Letter of Paolo Zimengoli (Bottari, *Lettere Pittoriche,* IV, 23; quoted Affò, pp. 92-93), mentions a Venus by Parmigianino discovered by Zimengoli in Verona in that year.

c.1720: Pictures in possession of Monsignor Giammaria Lancisi (Campori, Inv. no. LII), p. 514: "Due quadretti ovali consimili ai sudetti [i.e., di tre palmi] con due ritratti in tela, del Parmigianino."

1722: Pictures of the Casa Sampieri in Bologna (Campori, Inv. no. LVI), p. 599: "Uno in assa, S. Catterina, mezza figura, di Francesco Parmigianino."

1722: Zanella, *Vita del Cignani* (Bologna; reported in Faelli, *Bibliografia Mazzoliana*) mentions a work by Parmigianino in the Collection Tadini, Bologna.

1755: Catalogue des Tableaux du Cabinet de M. Crozat (Paris), p. 33 (quoted Affò, p. 89) mentions "Una Sacra Famiglia sopra un fondo di Achitettura a foggia di anfiteatro colorito su la pietra lavagna." On slate, and therefore unlikely to be by Parmigianino.

1757: Pictures of Mauro Dolay (Campori, Inv. no. LIX), p. 626: "Altra quadro piccolo in tela, con cornice velata, che rappresenta una figura, di mano del Parmigianino."

1762: J. A. d'Argenville, *Abrégé de la Vie des Plus Fameux Peintres,* Paris, vol. II (1st ed. 1745):
p. 29 (in Parma): ". . . au saint sépulchre, la Vierge, l'enfant Jésus, saint Jean avec trois anges dans un fond de paysage . . ."
p. 30 (in Rome): ". . . une autre Vierge avec l'enfant Jésus dormant . . ."; (in the Ducal Gallery, Parma): ". . . une grande annonciation . . . Une autre Vierge avec saint Jean-Baptiste et saint Christophe . . . le portrait d'une fille appellée la *Ricolina* . . ." The last perhaps identifiable with a bust-length portrait in the Fontainebleau style,

nude and in profile, which bears on the back the inscription "Portrait de la Ricolina." This is now in the collection of the Comte de Demandolx-Dedons in Marseilles. (Ill. H. Baderou, *L'Ecole de Fontainebleau*, Geneva, Skira, 1944.)

p. 31 (in the Palatine Gallery at Dusseldorf): "une Vierge allaitant son fils, et à ses côtés saint Joseph et saint Jean-Baptiste; sainte Lucie; une sainte famille"; (in the French Royal Collection): ". . . une Vierge et sainte Elizabeth; une autre Vierge . . ."; (in the Palais Royal, Paris) ". . . une sainte famille peinte sur toile; la Vierge avec son fils, saint Joseph et saint François peints sur bois . . . une autre sainte famille, de grandeur naturelle."

1763: Filippo Titi, *Descrizione delle Pitture, sculture . . . esposte al pubblico in Roma* (Rome: Pagliarini) p. 482: (in the Palazzo Colonna, Rome) ". . . del Parmigianino una gran tavola."

1771: Letter of Luigi Canonico Crespi (quoted Bottari, *Lettere Artistiche,* VII, 85): ". . . il ritratto della celebre contessa Matilde, dipinto in profilo in un quadretto dal Parmigianino, si conserva entro la clausura del Monastero delle Monache di S. Orsola [in Mantua]."

1773: Serie degli Uomini i più Illustri nella Pittura, Scultura, e Architettura, Florence, VI, 54: ". . . vedesi nello stesso Real Palazzo [Pitti] un altro [ritratto] in tavola rappresentante una Fanciuletta con un piccolo Gatto in braccio."

1775: L'arte della pittura di Carlo Alfonso du Fresnoy, accresciuta . . . ed arrichita (Rome) p. 296: (in Rome) a "St. Francis" in the church of S. Paolo alla Regola; in the Palazzo Giustiniani "La Maddalena, il Cieco nato ed il figliuolo della Vedova risanato."

1777: Inventory of the Quadreria Boschi in Bologna (Campori, Inv. no. LX), p. 631: "Figure istoriate, di . . . Parmigianino"; p. 633: "La S. Famiglia di . . . Parmigianino . . ."

1778: Temanza, *Vite dei più celebri architetti e scoltori Veneziani . . . nel secolo XVI* (Venice, reported in Faelli, *Bibliografia Mazzoliana*) mentions a "Madonna che sarebbe stata posseduta da Alessandro Vittoria, che ora e a Vienna."

1784: Affò, *Vita del . . . Parmigianino:*

p. 57: Among the *quadretti* mentioned by Vasari as having been done in Rome, and which fell into the hands of the Cardinal Ippolito de' Medici, may be "la vaga testa di Maria Vergine dipinta in tavola largo un palmo in circa che vedesi in Roma tra le pitture possedute dall'Eminentissimo Sig. Cardinale Valenti Gonzaga . . ."

p. 75 (Sig. Alfonso Arnoaldi in Bologna): "presso di cui trovasi del nostro Pittore anche mezza figura di donna grande al naturale . . ."

p. 82: ". . . nel Palazzo del Sig. Marchese Pier-Luigi dalla Rosa-Prati [Parma] . . . un ritratto di un giovane vestito alla spagnuola, che tiene fra le mani un libretto, dipinto dal nostro Mazzola." In a note, Affò explains that this is not, as has been supposed, a self-portrait of Parmigianino.

17—: Pictures of the Cardinal Gonzaga di Novellara (Campori, Inv. no. LXI):

p. 640: "Un ritratto in rame di forma sferica piccola, del Parmigianino." Possibly a copy after the Vienna self-portrait.

p. 641: "Un quadretto con quattro puttini in piedi ed uno in terra esprimenti il trionfo d'Amore, alto on. 6, largo 6, del Parmigianino"; "Una Visitazione di S. Elisabetta con altre diverse figure alto on. 17, larga 10, del suddetto [i.e., Parmigianino]"; "Una S. Maria Maddalena con un angelo, alto on. 24, largo 11, del Parmigianino"; "Una Catterina Vergine e Martire, alto on. 24, largo 11, del Parmigianino"; "Un quadretto con una Santa, alto on. 7, largo 4, del Parmigianino."

1787: Luigi Lanzi, *Storia Pittorica della Italia* (citations from ed. of Milan, 1825, vol. III):

p. 417: ". . . una Sacra Famiglia presso il sig. presidente Bertioli, e un S. Bernardino a' PP. Osservanti in Parma." Lanzi observes that these are early, "Correggiesque" works.

p. 420: "Rare sono in lui le copiose composizioni, com'è la Predicazione di Cristo alle turbe, collocata in una camera del R. Sovrano a Colorno . . ."

BIBLIOGRAPHY

The following types of bibliographical item are not included in this listing: biographical dictionaries and other compilations in dictionary form; documentary sources which remain in manuscript; catalogues and descriptions of museum collections and of exhibitions; guide books of the nineteenth century and later. Further, in accord with the limitation implied in the title of this book, items which refer mostly to Parmigianino's activity in the graphic arts are omitted, except where they include references to Parmigianino's preparatory studies for paintings.

Full references to all bibliographical items, whether they appear in this listing or not, may be found with their first citation in the text.

Items are listed in chronological order. Authors' names are listed in the Index.

M. Biondo, *Della nobilissima pittura e della dottrina, di conseguirla agevolmente et presto* (Venice: Alla Insegna di Appollina, 1549; publ. in *Quellenschriften für Kunstgeschichte*, V [1873], A. Ilg, ed. and trans.), chap. xix, "Della memoria di Fr di Parma pittore, e de le sue opere et dove."

G. Vasari, *Le vite de' più eccelenti architetti, pittori et scoltori italiani da Cimabue insino a' tempi nostri: descritte in lingua toscana da Giorgio Vasari pittore aretino* (Florence: Torrentino, 1550).

L. Dolce, *Aretino, ovvero dialogo della pittura* (Venice: Giolito, 1557).

P. Lamo, *Graticola di Bologna, ossia descrizione delle pitture, sculture e architetture di detta città, fatta l'anno 1560 dal pittore Pietro Lamo* (Bologna: Guidi, 1844).

G. Vasari, *Le vite de' più eccellenti pittori, scultori ed architettori. Di nuovo dal medesimo riviste et ampliate . . .* (Florence: Giunti, 1568).

R. Borghini, *Il riposo di Raffaello Borghini, in cui della pittura, e della scultura si favella, de' più illustri pittori, e scultori, et delle più famose opere loro si fa mentione . . .* (Florence: Marescotti, 1584).

G. P. Lomazzo, *Trattato dell'arte de la pittura* (Milan: Pontio, 1584).

G. B. Armenini, *De' veri precetti della pittura* (Ravenna: Tebaldini, 1587).

Ranuccio Pico, *Appendice dei vari soggetti parmigiani che o per bontà di vita o per dignità o per dottrina sono stati in diversi tempi molto celebri et illustri . . .* (Parma: Vigna, 1642).

F. Scanelli, *Il microcosmo della pittura* (Cesena, 1657).

M. Boschini, *La carta del navegar pitoresco* (Venice, 1660).

C. A. Du Fresnoy, *De arte graphica* [Paris, 1667] . . . *translated into English . . . by Mr. Dryden* (London: Rogers, 1695).

G. Barri, *Viaggio pittoresco* (Venice, 1671); in English transl. as *The Painters Voyage of Italy* (London: Flesher, 1679).

L. Scaramuccia, *Le finezze de' penelli italiani* (Pavia, 1674).

Francesco Albani, *Trattato di pittura* (fragment), publ. in Malvasia, *Felsina pittrice* (Bologna: Barbieri, 1678).

C. C. Malvasia, *Felsina pittrice* (Bologna: Barbieri, 1678).

R. De Piles, *Abrégé de la vie des peintres, avec des reflexions sur leurs ouvrages* (Paris: de Sercy, 1699).

C. Ruta, *Guida ed esatta notizia a' forestieri delle più eccellenti pitture che sono in molte chiese della città di Parma* (Parma, 1739).

M. —— de l'Académie Royale des Sciences de Montpellier [A. J. D. d'Argenville], *Abrégé de la vie des plus fameux peintres . . .* (Paris: de Bure l'Ainé, 1745-1752), I, 220-224.

A. M. Zanetti, *Raccolta di varie stampe a chiaroscuro dai disegni originali di Francesco Mazzuola, detto il Parmigianino, e di altri isigni*

BIBLIOGRAPHY

autori da Antonio Maria Zanetti Q.m Gir. che gli stessi disegni possiede, 1749.

Anon., *Serie degli uomini i piu illustri nella pittura, scultura e architettura con i loro elogi, e ritratti* . . . (Florence: Marsi, 1769-1773), VI (1773) 49-56.

I. Affò, "Vita del graziosissimo pittore Francesco Mazzola detto il Parmigianino," in *Raccolta ferrarese di opuscoli scientifici e letterari*, XIII (Venice: Coleti, 1783).

Anon., "Appunti critici alla vita ecc. scritta dall' Affò," in *Memorie enciclopediche di Bologna per l'anno 1783*.

Anon., *Disegni originali di Francesco Mazzola, parte della famosa raccolta del sig. Có d'Arondell, ora presso M.ur de Non, incisi da Francesco Rosaspina* (Bologna: Lodovico Inig, n.d. [c.1783]).

I. Affò, *Vita del graziosissimo pittore Francesco Mazzola, detto Il Parmigianino* (Parma: Carmignani, 1784).

Anon., *Celeberrimi Francisci Mazzola parmensis graphides per Ludovicum Inig Bononiae collectae editaeque anno MDCCLXXXVIII*.

C. M. Metz, *Imitations of drawings by Parmigianino in the collection of His Majesty* (London: engr. and publ. by C.M.M., 1790).

I. Affò, *Il Parmigiano servitor di Piazza: ovvero dialoghi di Frambola nei quali, dopo varie notizie interessanti sulle pitture di Parma, si porge il catalogo delle principali* (Parma: Carmignani, 1794).

L. Lanzi, *Storia pittorica della Italia* (Bassano: Remondini, 1795-1796).

C. P. Landon, *Vies et oeuvres des peintres les plus célèbres de toutes les écoles* (Paris, 1803-1817), IX (1813), "Le Parmesan."

Anon., *Le più insigni pitture parmensi indicate agli amatori delle belle arti* (Parma: Bodoni, 1819).

G. Bottari and S. Ticozzi, *Raccolta di lettere sulla pittura, scultura ed architettura scritte da' più celebri personaggi dei secoli XV, XVI e XVII* (Milan: Silvestri, 1822-1825).

W. Coxe, *Sketches of the Lives of Correggio and Parmigianino* (London: Longman, Hurst, 1823).

M. Leoni, *La plejade parmense* (Parma: Bodoni, 1826).

F. Bellini, *Cenni intorno alla vita e alle opere di Francesco Mazzola denominato il Parmigianino* (Parma: Ferrari, 1844).

M. A. Gualandi, *Nuova raccolta di lettere sulla pittura, scultura ed architettura, scritte da' più*

celebri personaggi dei secoli XV a XIX . . . in aggiunta a quella data in luce da Mons. Bottari e dal Ticozzi (Bologna, 1844-1856).

P. Giordani, *Tutti gli affreschi del Correggio in Parma e quattro del Parmigianino disegnati ed intagliati in rame da Paolo Toschi e dalla sua scuola* (Parma: Carmignani, 1846).

M. Gualandi, *Memorie originali di belle arti* (Bologna: Sassi, 1846), series IV, pp. 76 and 80, no. 191.

A. E. Mortara, *Della vita e dei lavori di Francesco Mazzola detto il Parmigianino* (Casalmaggiore: Bizzarri, 1846).

L. S. [L. Sanvitale], *Memorie intorno alla rocca di Fontanellato ed alle pitture che vi fece Francesco Mazzola detto il Parmigianino* (Parma: Grazioli, 1857).

C. Blanc, "Francesco Mazzuoli ou Mazzola dit 'Il Parmegianino,'" in *Histoire des peintres de toutes les écoles depuis la renaissance jusqu'à nos jours* (Paris: Renouard, 1861-1876).

A. Ronchini, "La steccata di Parma, memorie storico-artistiche," in *Atti e memorie delle deputazioni di storia patria per le provincie modensi e parmensi, anno 1863*, pp. 169ff.

G. Campori, *Lettere artistiche inedite* (Modena: Soliani, 1866).

G. Campori, *Raccolta di cataloghi ed inventari inediti di quadri, statue, bronzi, dorerie, smalti, medaglie, avorii . . . dal sec. XV al sec XIX* (Modena: Vincenzi, 1870).

G. Milanesi, ed., *Le vite de' più eccellenti pittori scultori ed architettori scritte da Giorgio Vasari pittore aretino* (Florence: Sansoni, 1878-1885), esp. V (1880-1881), 217-242.

G. Campori, "Un dipinto del Parmigianino," in *Atti e memorie della R. deputazione di storia patria per le provincie dell'Emilia*, N.S. IV, no. 1 (1879), 189-191.

P. Grazioli, *Cenni biografici di Francesco Mazzola detto il Parmigianino e descrizione del monumento erettogli in Parma* (Parma: Grazioli, 1879).

E. Faelli, *Bibliografia Mazzoliana* (Parma: Battei, 1884).

G. Frizzoni, "La pinacoteca del museo nazionale di Napoli—II," *Arte e storia*, III, no. 27 (1884), 213-214.

Anon., *Le gallerie nazionali italiane* (Rome: Ministero della pubblica istruzione, 1894), I, 25-30.

C. Ricci, *Di alcuni quadri di scuola parmigiana conservati nel R. Museo Nazionale di Napoli* (Trani: Vecchi, 1894).

BIBLIOGRAPHY

C. Ricci, "Di alcuni quadri di scuola parmigiana conservati nel R. Museo Nazionale di Napoli," *Napoli nobilissima,* III (1894), 129-131, 148-152, 163-167.

V. Spinazzola, "Ancora dei quadri del Parmigianino nel Museo Nazionale (nota all'articolo di C. Ricci)," *Napoli nobilissima,* III (1894), 187-189.

C. Ricci, "Ancora dei quadri parmensi del Museo di Napoli," *Napoli nobilissima,* IV (1895), 13-14.

C. Ricci, "Di alcuni quadri conservati nel R. Museo di Napoli," *Napoli nobilissima,* IV (1895), 182-183.

C. Ricci, *La Madonna dal collo lungo* (Parma: Battei, 1895).

C. Ricci, "Di alcuni quadri del Parmigianino già esistenti in Parma," *Archivio storico per le provincie parmensi,* IV, 1895 (publ. 1903), 1-25.

N. Pellicelli, *L'Arte nella Chiesa della Steccata* (Parma, 1901).

G. Frizzoni, "Arte retrospettiva. La Galleria Tadini in Lovere," *Emporium,* XVII (1903), 348.

G. Robiony, "La Madonna dal collo lungo del Parmigianino," *Rivista d'arte,* II (1904), 19-22.

L. Testi, *Parma* (*Italia artistica*), (Bergamo: Istituto italiano d'arti grafiche, 1905), esp. pp. 46-47.

L. Testi, "Una grande pala di Girolamo Mazzola alias Bedoli detto anche Mazzolino," *Bollettino d'arte,* II (1908), 369-395.

A. Hajdecki, "Ein neu aufgetauchter Parmigianino," *Kunstkritischen Wiener Dilettanten-Scholien,* vol. I (Vienna: Stern, 1909).

Reviewed in *Der Cicerone,* VI (1914), 603-604.

L. Cust, "Notes on pictures in the royal collections —XXIX," *Burlington Magazine,* XXV (1914), 290.

G. Nilsson, *Quelques remarques sur un tableau retrouvé de Corrège et sur le tableau célèbre de Parmigianino de la Galerie Impériale de Vienne, "L'Amour taillant son arc"* (Copenhagen, 1914).

L. Fröhlich-Bum, "Handzeichnungen des Parmigianino zu einigen seiner bekanntesten Gemälde," *Die graphischen Künste,* XXXVIII (1915), "Mitteilungen," 1-12.

L. Fröhlich-Bum, *Parmigianino und der Manierismus* (Vienna: Schroll, 1921).

Reviewed: L. Baldass in *Die graphischen Künste,* XLIV (1921), "Mitteilungen," 63-66; G. Biermann in *Der Cicerone,* XIII (1921), 564; T. Borenius in *Burlington Magazine,* XXXIX

(1921), 149; D. von Hadeln in *Kunstchronik und Kunstmark,* N.F. 32/2 (1921), 745-748; G. Ring in *Die Bildhauer-Künste,* IV (1921), 108-112; G. Copertini in *Archivio storico per le provincie parmensi,* N.S. XXII (1922), 287-299; W. Weisbach in *Deutsche Literaturzeitung,* XLIII, no. 26 (1922), 566-567.

F. Bernini, "Il castello dei Rossi di S. Secondo," *Aurea Parma,* V, fasc. 3 (1921), 129-138.

U. Beseghi, "La 'Steccata' e il Parmigianino in un libro di critica," *Aurea Parma,* VI, fasc. 1 (1922), 23-27.

L. Testi, *Santa Maria della Steccata in Parma* (Florence: Battistelli, 1922), esp. pp. 117-142.

M. Tinti, "Il Parmigianino," *Dedalo,* Anno IV (1923-1924), I, 208-301; II, 304-327.

Reviewed by G. Copertini in *Archivio storico per le provincie parmensi,* N.S. XXIII (1923), 486-489.

H. Voss, " 'Verschollene' Werke des Parmigianino," *Kunstchronik und Kunstmarkt,* N.F. 34/2 (1923), pp. 635-638.

V. Lazareff, "Un quadro del Parmigianino a Pietroburgo," *L'Arte,* XXVII (1924), 169-171.

Reviewed by G. Copertini in *Archivio storico per le provincie parmensi,* N.S. XXVI (1926), 300.

F. Malaguzzi-Valeri, "La Galleria Campori," *Cronache d'arte,* I (1924), 232-233, 241.

G. Copertini, "Il ritratto di Carlo V di Fr. Mazzola detto il Parmigianino," *Cronache d'arte,* II, fasc. 2 (1925), 64-67.

W. Friedländer, "Die Enstehung des Antiklassischen Stiles in der Italienischen Malerei um 1520," *Repertorium für Kunstwissenschaft,* XLVI (1925), 49-86.

L. Fröhlich-Bum, "Some Unpublished Portraits by Parmigianino," *Burlington Magazine,* XLVI (1925), 87-89.

C. Gamba, "Nuove attribuzioni di ritratti," *Bollettino d'arte,* series 2, IV (1925), 211-217.

A. Venturi, "Il Parmigianino e la scuola di Parma," in *Storia dell'arte italiana,* vol. IX, part 2 (Milan: Hoepli, 1926), pp. 623-729.

L. Venturi, "Un ritratto d' Isabella d'Este dipinto da Giulio Romano," in *L'Arte,* XXIX (1926), 244-245.

G. Copertini, "Il capolavoro del Parmigianino, 'La Madonna di S. Zaccaria,'" *Aurea Parma,* XI, fasc. 6 (1927), 261-269.

M. Pittaluga, "Tre disegni del Parmigianino," *L'Arte,* XXX (1927), 263-266.

C. Ricci, ed. *Le vite del Vasari nell' edizione del*

BIBLIOGRAPHY

MDL (Milan-Rome: Bestetti e Tumminelli, 1927).

O. Sirén, "Three Italian Pictures in the Pennsylvania Museum," *Burlington Magazine,* L (1927), 3ff.

F. Antal, "Un capolavoro inedito del Parmigianino," *Pinacoteca,* I (1928), 49-56.

G. Copertini, "Disegni sconosciuti ed altri inediti del Parmigianino," *Aemilia,* I (1928), 39-51.

G. Copertini, "La visione di S. Girolamo del Parmigianino," *Aurea Parma,* XII, *fasc.* 5 (1928), 147-155.

G. Copertini, "Il nuovo quadro del Parmigianino nella R. Galleria di Parma," *Corriere Emiliano,* August 31, 1928.

L. Fröhlich-Bum, "Studien zu Handzeichnungen der Italienischen Renaissance," *Jahrbuch der Kunsthistorischen Sammlungen in Wien,* N.F. II (1928), 173-183.

N. Pevsner, (and O. Grautoff), *Barockmalerei in den romanischen Ländern, Handbuch der Kunstwissenschaft,* (Wildpark-Potsdam: Akademische Verlagsgesellschaft Athenaion m.b.h., 1928), 49-53.

A. Sorrentino, "I recenti acquisti della R. Galleria," *Aurea Parma,* XII, *fasc.* 5 (1928), 136-140.

A. Venturi "La schiava turca del Parmigianino," *Aemilia,* I (1928), 11-12.

A. Barilli, "La Vergine presso la croce del Parmigianino," *Aurea Parma,* XIV, *fasc.* 1 (1930), 37-38.

L. Fröhlich-Bum, "A rediscovered work by Parmigianino," *Burlington Magazine,* LVI (1930), 273-274.

W. Heil, "A painting by Parmigianino," *Bulletin of the Detroit Institute of Arts,* XI, no. 8 (1930), 109-112.

C. Ricci, "Cortigiane del rinascimento: Antea," *L'Illustrazione italiana,* vol. LVII (1930), part 1, no. 8, pp. 313-315.

A. Sorrentino, *Il Parmigianino,* Piccola collezione d'arte, no. 43 (Florence: Alinari, 1930).

D. Gallosi, "La pala d'altare dipinto dal Parmigianino conservata nella chiesa parrocchiale di Cerzeto," *Corriere Emiliano,* April 17, 1931.

C. Ricci, *Figure e fantasmi* (Milan: Hoepli, 1931), pp. 179-189.

A. Sorrentino, "Parma: restauro della pala d'altare della chiesa parrocchiale di Cerzeto (Soragna)," *Bollettino d'arte,* series 2, X (1931), 381-384.

A. Sorrentino, "Parma: restauro di affreschi e di quadri," *Bollettino d'arte,* series 3, XXV (1931), 182-183.

A. Sorrentino, "La rocca di Fontanellato," *Emporium,* LXXIV (1931), 22-35.

G. Battelli, "Il Parmigianino," *Corriere Emiliano,* Sept. 2, 1932.

G. Copertini, *Il Parmigianino* (Parma: Fresching, 1932).

Reviewed: D. Cavaliere in *Aurea Parma,* XVII, *fasc.* 2 (1933), 70-72; L. Pettorelli in *Archivio storico per le provincie parmensi,* N.S. XXXIII (1933), 319-328.

K. Wehlte, "Röntgenologische Gemäldeuntersuchungen im Städelschen Kunstinstitut," *Städel-Jahrbuch,* VII-VIII (1932), 220-223.

Anon., "Portrait of a nobleman by Parmigianino," *Bulletin of the Minneapolis Institute of Arts,* XXII (1933), 3-6.

G. Copertini, "Un'opera poco nota del Parmigianino: il Battesimo di Gesù," *Parma, Rivista bimestrale del commune* (January, 1933), p. 26.

A. Sorrentino, "Ritratti inediti del Parmigianino," *Bollettino d'arte,* series 3, XXVII (1933), 82-86.

H. Voss, "Ein Wiedergefundenes Gemälde von Parmigianino: Taufe Christi," *Jahrbuch der Preussischen Kunstsammlungen,* LIV, *heft* 1 (1933), 33-37.

H. Manz, *Die Farbgebung in der italienischen Malerei des Protobarock und Manierismus,* Munich Inaugural-Dissertation (Berlin: Brandel, 1934), esp. pp. 110-116.

G. Copertini, "Un opera sconosciuta del Parmigianino: 'lo sposalizio di Sta. Caterina' in Bardi," *Aurea Parma,* XIX, *fasc.* 2 (1935), 58-60.

L. Fröhlich-Bum, "Unpublished Drawings by Parmigianino," *Old Master Drawings,* IX (1935), 55-57.

A. O. Quintavalle and others, compilers, *Mostra del Correggio, catalogo* (Parma: Fresching, 1935), esp. pp. 81-88, 139-153.

A. O. Quintavalle, "Problemi e spunti critici alla mostra del Correggio," *Emporium,* LXXXI (1935), 358-359.

W. Suida, "Opere sconosciute di pittori parmensi," *Crisopoli,* III (1935), 105-113.

Anon. ("a cura della Federazione dei Fasci . . . di Parma"), *Manifestazioni parmensi nel IV centenario della morte del Correggio* (Parma: Bodoni, 1936), esp. 211-231.

A. Cutolo, "L'Antea del Parmigianino," *Emporium,* LXXXVI (1937), 424-428.

G. Copertini, "Quesiti e precisazioni sul Parmigianino," *Archivio storico per le provincie parmensi,* V (1940), 17-27.

BIBLIOGRAPHY

C. Gamba, "Centenari: il Parmigianino," *Emporium,* XCII (1940), 108-120.

A. O. Quintavalle, "Nuovi affreschi del Parmigianino in San Giovanni Evangelista a Parma," *Le Arti,* II (1940), 308-313.

A. Rapetti, "Un inventario delle opere del Parmigianino," *Archivio storico per le provincie parmensi,* V (1940), 39-53.

H. Bodmer, *Correggio und die Malerei der Emilia* (Vienna: Deuticke, 1942), esp. pp. xxiii-xxviii (Italian ed.: *Il Correggio e gli Emiliani,* Novara, de Agostini, 1942).

A. O. Quintavalle, "Falsi e veri del Parmigianino giovane," *Le Arti,* V (1943), 237-249.

A. O. Quintavalle, "Disegni romani del Parmigianino," *Pro Arte* (July-August, 1943), pp. 177-185.

J. Isaacs, "The Collector of Drawings," in *Apropos* (London: Pilot Press, n. d. [1945?]), p. 4.

E. Arslan, "Contributi a Ercole de Roberti, Parmigianino, Primaticcio," *Emporium,* CV (1947), 65-69.

251

ADDENDA

Since the completion of this book I have had an opportunity to devote further study to the problem of Parmigianino's work in the field of drawing. This study is by no means yet complete, but it has so far included the reëxamination of the Parmigianino material in several major European collections, among them the British Museum, Windsor, Chatsworth, the Louvre, Chantilly, and the Uffizi. This research has already yielded considerable further information about Parmigianino's preparatory drawings, including some cases of real importance in relation to the study of the paintings. I present these addenda to the lists of preparatory drawings with the understanding that, though these addenda help to complete the material already included in the catalogue, our full knowledge of Parmigianino's preparatory studies must still wait on the completion of a study of his drawings as a whole. The order in which the addenda are given is that in which the paintings to which they relate appear in the catalogue.

MARRIAGE OF ST. CATHERINE, BARDI

Florence, Uffizi, 1461. "Marriage of St. Catherine" with three saints. Pen and bister, 18.8 x 14.2 cm. (photo Braun 711).

Paris, Louvre 6401. "Marriage of St. Catherine" with four saints. Pen and bister, 22.4 x 15.7 cm.

Both drawings accord with the earliest drawing style of Parmigianino. Each study differs in important respects from the finished picture, but there can be little doubt of the connection of both drawings with it. Of the two drawings, that in the Uffizi, much less fluid in its arrangement of the figures, represents the earlier stage in the development of the composition.

A compositional study for an altarpiece in the Fogg Museum at Harvard, which I refused to Parmigianino some years ago (quoted in the catalogue of drawings of the Fogg Museum), I now consider to be an authentic drawing of the same period as the Bardi altar, and possibly connected with it.

FRESCO DECORATION, PARMA, S. GIOVANNI EVANGELISTA

Four drawings exist in the British Museum and the Louvre of which the style and general subject are related to the two preparatory studies for S. Giovanni Evangelista which have already been cited. It is not impossible that these drawings may have had to do with other chapels decorated by Parmi-

gianino in S. Giovanni (as was alleged by Vasari), but now lost. These drawings are: Louvre 6422, "John on Patmos" (?); Louvre 6404, two seated saints; British Museum 1874-8-8-2267, an Evangelist; Louvre 6425, two foreshortened *putti*. All these drawings are in an extremely bold style, and in composition are very strongly dependent on Correggio.

The Uffizi cabinet contains two drawings, 739 verso and 741 verso, both of which show studies of various figures of bishop saints, in half-length. These drawings may also relate to the decoration of a chapel, now lost, in S. Giovanni. Their style differs somewhat from that of the British Museum and the Louvre drawings described above; the Uffizi studies seem more nearly to approach the manner of the preparatory studies for Fontanellato. The subject matter, and to some extent the attitudes of the figures on the Uffizi sheets suggests the Church Fathers of the sixth chapel at S. Giovanni, which I have refused to Parmigianino. Another drawing, at Chatsworth (785, Vasari Society reproduction, second series, part VI, no. 10), there attributed to Parmigianino, specifically relates to a minor figure in the sixth chapel: to one of the Virtues on the decoration of the arch faces. I have reviewed my rejection of Parmigianino's authorship of the sixth chapel with this additional evidence in mind, but I have not seen fit to alter the opinion previously expressed in the catalogue. In the case of the Chatsworth draw-

ing, the one indisputably connected with the decoration of the sixth chapel, I am not convinced of Parmigianino's authorship of the drawing; its manner certainly differs from that of the Uffizi sheets. In the case of the two Uffizi drawings, it becomes evident, even on a quick comparison, that their relationship to the Church Fathers of the sixth chapel is one of subject matter, but not of style. The figures in the drawings show a rhythmic ease of attitude, and a grace of *contrapposto,* that the Church Fathers do not share. It finally remains true, as we have observed in the catalogue, that in terms of their *painting* these frescoes do not compare to any authentic work of Parmigianino. Rather than deduce his authorship of the sixth chapel from such resemblance as may exist between it and the Uffizi drawings, it is more reasonable to assume that this resemblance may result from the eminently likely influence of Parmigianino upon the designer of the sixth chapel, or from a possible influence in the opposite sense.

CIRCUMCISION, DETROIT, INSTITUTE OF ART

The drawing in the Louvre (6390) is certainly an original by Parmigianino. The version of the same drawing attributed to him in the Uffizi (9279) is, however, nothing more than a mechanical reproduction, in a simulated sanguine technique, of the Louvre original.

FRESCO DECORATION, FONTANELLATO, ROCCA

Chatsworth, Collection the Duke of Devonshire, 787B recto and 787E verso. Studies for the *putti,* one each on the recto and verso. Pen and bister, 11 x 4.8 cm.

Paris, Louvre, 6439. A pergola with *putti* playing against it and around its top opening. Pen and bister, wash, 15.4 x 14.6 cm.

HOLY FAMILY, MADRID, PRADO

Paris, Louvre, 6417 recto. Final study for the composition, squared for enlargement. Red chalk, 18.7 x 12.2 cm. In this drawing a second head of an old man appears at the upper left beside that of the Joseph.

Windsor, Royal Library, 0345 verso. The Madonna and Child, with a *putto* to the right. Red chalk, 12.5 x 8.3 cm. Lightly sketched. An early stage in the development of the picture.

A drawing in the Albertina (photo Braun 319), which is alleged to be a study for the Prado "Holy Family," is not from Parmigianino's hand.

ORGAN WING WITH ST. CECILIA, PARMA, STECCATA

Paris, Louvre, 6456. St. Cecilia moving toward the right, accompanied by a *putto.* Pen and bister, wash 20.8 x 15.8 cm., enlarged at top and bottom to 26.9 cm. The drawing style of this study confirms beyond question our dating of the picture toward the end of the first period in Parma.

VISION OF ST. JEROME, LONDON, NATIONAL GALLERY

Chantilly, Musée Condé, LV 132. Recto, two alternative poses for the Madonna and Child. On the left half of the sheet the Madonna holds the Child high on one side to the right, and is seated on a pedestal supported by three *putti.* Verso, two studies of the St. John, and one of a St. Jerome in the attitude of reading. Pen and bister, wash, white heightening, 20.5 x 13 cm.

Various motives from this sheet have been engraved by Rosaspina. In the Uffizi (1521) there is a copy after a larger separate study by Parmigianino of the motive of the Madonna holding the Child up to one side.

Chantilly, Musée Condé, LV 134 *primo.* The Madonna and Child only. Pen and bister, wash, 10 x 5.5 cm.

Paris, Ecole des Beaux-Arts, 34786 recto. The Christ Child against the legs of the Madonna. Red chalk, 23.8 x 16.7 cm. The drawing on the verso, which shows the Child leaning down from the Madonna's lap to take some flowers(?) from a *putto* below, may be yet another variant idea for the composition.

Paris, Louvre, 6423. Study for the St. Jerome. Red chalk, 13.6 x 9.8 cm. The same, or a similar drawing engraved by Rosaspina from the collection Armano, Venice.

Sale, Sotheby's 1947, from the collection of Richard Ford. Study of the Madonna and Child. Engraved by Rosaspina from Armano's collection.

The damaged drawing for the Madonna and Child in the Louvre (6397), on which I suspended judgment in my original citation, I now feel is certainly authentic. British Museum, Cracherode Ff. 1.94, also for the Madonna and Child, which I earlier thought might possibly be connected with the Dresden Madonna rather than with the "Vision of St. Jerome," I now associate definitely with the former.

ADDENDA

An authentic drawing in the Louvre (6402) and three copies at Windsor (0587, 0588, 0593), all of a St. Jerome motive, would seem to be for an independent composition of this subject rather than for the London picture.

ST. ROCH AND DONOR, BOLOGNA, S. PETRONIO

Chatsworth, Collection the Duke of Devonshire, 793B. Study for the entire composition. Black chalk, 14.3 x 9.2 cm.

Paris, Louvre, 6397 recto and verso. Studies for the St. Roch, kneeling. The drawing on the recto is in part a tracing from that on the verso. Pen and bister, wash, 20 x 14.8 cm.

MADONNA DAL COLLO LUNGO, FLORENCE, PITTI

Budapest, National Gallery. The two angels kneeling beside the Madonna and Christ Child. Pen. (Reproduction in the British Museum, 1906-4-19-224). Attributed in the collection to Filippino Lippi.

Paris, Louvre, 0584. Angel with an urn. Pen and bister, 6.2 x 2.1 cm. (One of five small drawings on this same amount.)

Paris, Louvre, 6403. Two angels, one with an urn. Red chalk, 10.5 x 5.4 cm. A figure (of the Madonna) has been cut away from the right of the sheet.

Paris, Louvre, 6453. The Christ Child. Pen and bister on orange-tinted paper, 10 x 6.5 cm.

Paris, Louvre, 6470. Study for the entire composition. Pen and bister, wash, 12.9 x 8.2 cm.

Windsor, Royal Library, 0541. Head of the Madonna. Pen and bister on pink-tinted paper, oval (cut out), 5 cm. high.

I wish to revise my earlier assessment of certain of the chalk drawings in the Louvre related to the "Madonna dal Collo Lungo." Louvre 6387, "Madonna and Child with the Young St. John," I now consider to be an authentic preparatory study, which stands probably toward the beginning of the generation of the picture. Louvre 6381, of the same subject, but with a second study for the head of the Madonna at the upper left, I now also consider authentic; it would seem to represent a second stage in the development of the picture. Louvre 6378 reflects a still subsequent stage, but is fairly certainly a copy rather than Parmigianino's original drawing. A definite copy, probably after a drawing next in sequence, is Louvre 6483, which reflects the same composition as that shown in the print by Zanetti

which I have mentioned earlier in the catalogue. Louvre 0577, the drawing in this series which most nearly resembles the finished painting, remains for me a very doubtful case.

On the basis of comparison especially with Louvre 6381 I am now prepared to admit the possible originality of the Morgan drawing of the Madonna. Further evidence which relates to this drawing exists in the form of two eighteenth-century prints after two very similar drawings. One print, by Rosaspina, shows a figure very like that of the Morgan drawing: Rosaspina's original was in the Armano collection in Venice. The second print, by Faldoni, again shows a similar figure, but with the breasts exposed; this drawing was in Zanetti's collection.

There are certain authentic drawings which are related in theme to the "Madonna dal Collo Lungo," but which are not, in my opinion, preparatory studies for the picture. These are: Uffizi 1525 verso, a large seated draped female figure, suggesting especially the Madonna of Louvre 6384; Windsor 0589, an aged man reading and facing right, related to the "prophet" theme; a similar drawing in the Louvre, 6464 bis.

Louvre 6375, with the prophet and his companion on its left half, and on its right a figure related to the Steccata Moses, is a copy.

FRESCO DECORATION, PARMA, STECCATA, DRAWINGS FOR THE FIRST (REJECTED) PROJECT

Paris, Louvre, 6418. Daniel(?) among lions, with a child and angel. Pen and black ink, bister, wash, 6.3 x 10.3 cm.; lozenge-shaped.

Paris, Louvre, 6454. An aged male nude and an angel. Red chalk, 7.2 x 10.3 cm.; indication of an intended oval shape.

Paris, Louvre, 6460. A soldier with a scimitar raised above the body of a child (Judgment of Solomon?). Pen and bister, wash, 7.7 x 4.5 cm.; indication of a narrow, pilaster-like shape, and the bottom of a lozenge-shaped panel evident above.

Parma, Gallery, 510/21. Daniel(?) and a second male figure, with a lion. Red chalk, lozenge-shaped. The heads drawn on a piece of paper pasted on the sheet; the addition perhaps by Parmigianino.

Windsor, Royal Library, 0550. A winged female figure, holding garlands, in a vertical pilaster between indications of two "lozenges" above and below. Pen and bister, wash, white heightening, 9.5 x 6.4 cm.

All the drawings above were for the various panels

meant, according to the first scheme, to fill the spaces between and beside the rosettes.

Bayonne, Musée Bonnat LB 1255 (three studies for a figure of St. Paul[?] standing) and Paris, Ecole des Beaux-Arts 34931 *secondo,* verso (copy; a seated older male in a niche) suggest the larger figures shown on the arch faces in the design for the rejected scheme (compare British Museum 1918-6-15-3), and may thus also be part of the complex of rejected preparatory drawings.

PARMA, STECCATA, FURTHER AUTHENTIC DRAWINGS FOR THE EXECUTED SCHEME

Chatsworth, Collection the Duke of Devonshire, 788A. The three Maidens. Pen and ink, brush and water color, 23.3 x 17 cm. Damaged.

Chatsworth, 790A. On the upper half of the sheet, the left and center Maidens. On the lower half of the sheet, partly intersecting the female figures, a self-portrait. Pen and bister, 10.5 x 7.3 cm.; lower corners cut. Perhaps rather a reminiscence of the decoration than a preparation for it. For the self-portrait portion of this drawing, see below.

Paris, Louvre, 6463 bis. Study for the Eve, standing. Pen and black ink, washed with grey and touched with water color, 12 x 3.6 cm.; remounted on a larger sheet.

Paris, Louvre, 6467. Center and right Maidens, with parts of the foliate decoration of the vault. Pen and bister, wash, on pink-tinted paper, 13.8 x 9.6 cm.

Parma Gallery, 510/23. Center Maiden, with outlines of the rosettes which surround her. Lead(?) point on blue prepared paper; faint traces of gold and white heightening; faded.

Vienna, Albertina. Study for the Eve(Braun photo 329). On the right side of the sheet Eve is posed by a male model.

Windsor, Royal Library, 0565. Center and right Maidens. Pen and bister, gray wash, 8.1 x 8.1 cm.

I am unable to arrive at a positive judgment of originality for the following drawings related to the executed project: Chatsworth 789A, for the left and center Maidens; Louvre 6465 and 6468, for the left Maiden; Louvre 6501, the Aaron(?); Louvre 6463, the Adam. Louvre 6477, for the Aaron, is badly damaged and seems to be redrawn. If this sheet should be authentic, it is the source for the definite copy in the Uffizi (13626, already mentioned in the catalogue).

The following drawings, related to the Steccata figures, are in my opinion copies or imitations of Parmigianino's designs. For the Maidens: Uffizi 1458; British Museum Cracherode Ff. 1.85, 1948-10-9-127; Louvre 0581, 6448, 6457, 6464, 6471 *ter;* Albertina 23757 and Braun photos 334, 335. For the Moses: Louvre 6374. Windsor has a series of copies after studies for the Moses, the Madonna of the Coronation design, and the Eve. These copies are numbered 0569 through 0577; they include three studies for the Eve (0575, 6, 7) which I have earlier catalogued wrongly as originals. Windsor 0554 is a copy of the later design for the "Coronation of the Virgin," derived from the authentic drawing in Turin.

HOLY FAMILY WITH THE INFANT ST. JOHN, NAPLES, MUSEUM

Louvre 5911 contains motives which appear to relate to the Naples painting: the recto of this drawing shows an aged draped male walking to the right, reading a book (red chalk); along the right side of the sheet are anatomical studies of male figures, in profile (pen). On the verso the same older male figure appears in variant pose, and there are also two studies of a woman's sleeve. The old man would seem to be a study for the Joseph in the middle background of the Naples picture; the studies of a sleeve recall the left arm of the Virgin of the same painting. The date of the drawing, as is suggested especially by the attenuated male anatomical studies which share the recto of the sheet, would be in the second Parma period, to which we have assigned the painting. I now believe that Chatsworth 790B, with studies for an old draped male figure striding forward (which I have catalogued under the preparatory drawings for the "Madonna dal Collo Lungo") may also in fact be a study for the Joseph of the Naples "Holy Family." The fact that this study is on the verso of a drawing connected with the Steccata would also tend to support my late dating of the painting.

ALTAR WITH SS. STEPHEN AND JOHN BAPTIST, DRESDEN, GALLERY

Florence, Uffizi, 13622. St. John kneeling on the left, St. Stephen(?) to the right, the Madonna on a throne, an architectural background to the right rear. Pen and bister, 6.5 x 4 cm.

Madrid, Biblioteca Naçional, 7728. SS. Stephen and John seated, three-quarter length, the Virgin seated in an aureole above. Pen and bister, 6.2 x 4 cm.

Madrid, Biblioteca Naçional, 7729. SS. Stephen and John kneeling, the Virgin standing in an aureole

above. Pen and bister, 6.2 x 4 cm. The verso has a fragment of an autograph by Parmigianino: *primo pregato più volte anzi* . . . All three above drawings cut out, probably from a single large sheet.

A drawing related to the Madonna of the Stephen altar (Uffizi 13639, red chalk, 12.5 x 7.5 cm.) is so rubbed that final judgment of its originality is impossible, but I incline strongly to consider it an authentic preparatory study. A drawing in the Albertina (photo Braun 320) is a copy, apparently from the print by Zanetti after a lost drawing, already cited in the catalogue.

SELF-PORTRAIT IN A CONVEX MIRROR, VIENNA, MUSEUM

Paris, Louvre, 6452. The head thrown slightly back and toward the left. Red chalk, 7.2 x 5.2 cm. Rubbed and torn, remounted.

Another youthful self-portrait drawing at Windsor (0529) is not directly connected with the Vienna portrait, and is in my opinion a copy after a lost drawing rather than an original.

PORTRAIT OF GALEAZZO SANVITALE, NAPLES, MUSEUM

Paris, Louvre, 6472. Recto, the subject seated, but in a pose more diagonal than in the painting. Verso, a sketch of the sitter's head only. Pen and bister, 14 x 11.9 cm.

PORTRAIT OF A GENTLEMAN, FLORENCE, UFFIZI

The sheet at Chatsworth, 790A, already cited under the addenda to the preparatory drawings for the Steccata, bears on its lower half a full-face head, unmistakably a self-portrait, of which the subject (in spite of a visible difference in age and idealization) is identical with the sitter of the portrait in the Uffizi. The Chatsworth drawing thus affords our long-sought confirmation for the traditional identification of the Uffizi picture as a self-portrait of Parmigianino.

Certain observations are suggested by the face in the remarkable Chatsworth drawing. The expression is strangely weary and distant, almost sick, a revelation of the state of spirit of the artist in the long course of his execution of the Steccata frescoes (to which the upper half of the drawing refers), or even afterwards; as we have observed, the drawing seems as if it might be a reminiscence of this difficult commission rather than a preparation for it. There is a conspicuous difference from the commanding elegance with which Parmigianino had invested himself in the earlier painted portrait. The drawing and the painting (now that we are certain of its identity as Parmigianino) together become interesting evidence of the contrast, of which we have spoken, between the public and the private face of a man of this time. The painting is also evidence of Parmigianino's conception of himself as not an artist-artisan, but a gentleman artist, and of the place he would, on this account, arrogate to himself in the society of his time. In the Uffizi portrait the artist has assumed, with entire convincingness, the qualities that we have come to associate with the Mannerist conception of aristocracy.

Some further evidence of Parmigianino's appearance is provided by a drawing in profile in the Albertina, on a so-called Vasari mount (photo Braun 314). This drawing probably served as the basis for the vignette in Vasari's second edition. The drawing is in a careful crosshatched style, almost as if it were intended for engraving, but it seems certainly to be from Parmigianino's own hand. A less formal document is a late drawing in the British Museum (1858-7-24-6, also in a thin, crosshatched style) which shows Parmigianino seated, holding up on her hind legs an enormous bitch, which appears also in other late drawings by him. In spite of the singular pose of the sitter this drawing would also seem to be an authentic self-portrait. An old legend on it says: *Il ritratto di Parmigiano di sua mano.*

PORTRAIT OF COUNT SAN SECONDO, MADRID, PRADO

A drawing in Parma (510/18, lightly sketched in pen and bister) of an armed figure in antique costume, may be for the statuette in the right background of the portrait.

INDEX

257

INDEX

INDEX

INDEX

INDEX

PLATES

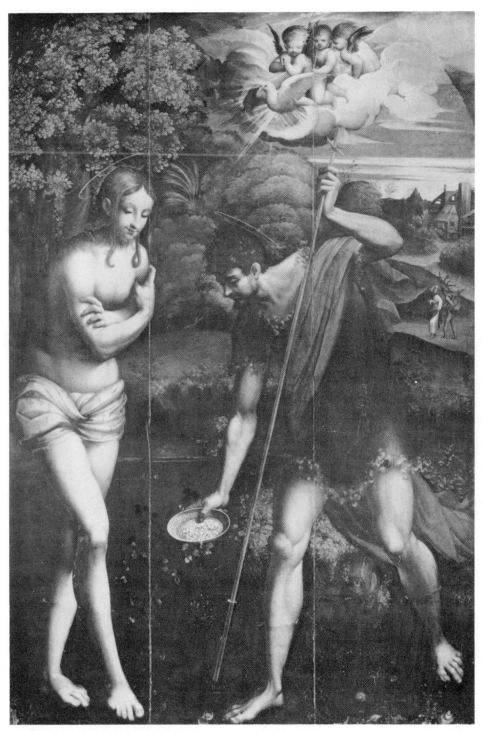

1. BAPTISM OF CHRIST. Berlin, Kaiser Friedrich Museum.

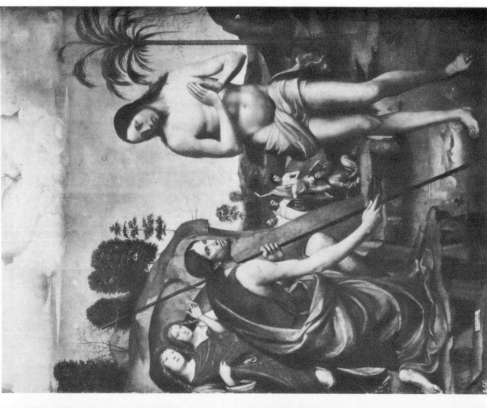

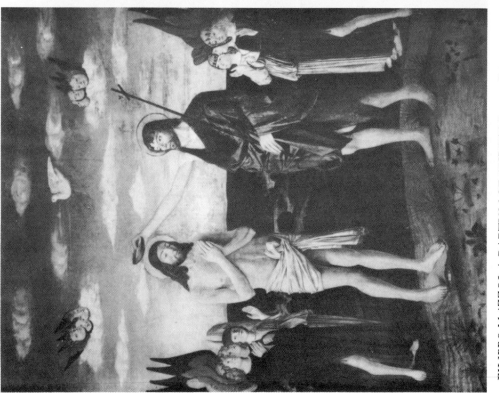

2. *FILIPPO MAZZOLA*: BAPTISM OF CHRIST. Parma, Duomo.

3. *FRANCIA*: BAPTISM OF CHRIST. Hampton Court.

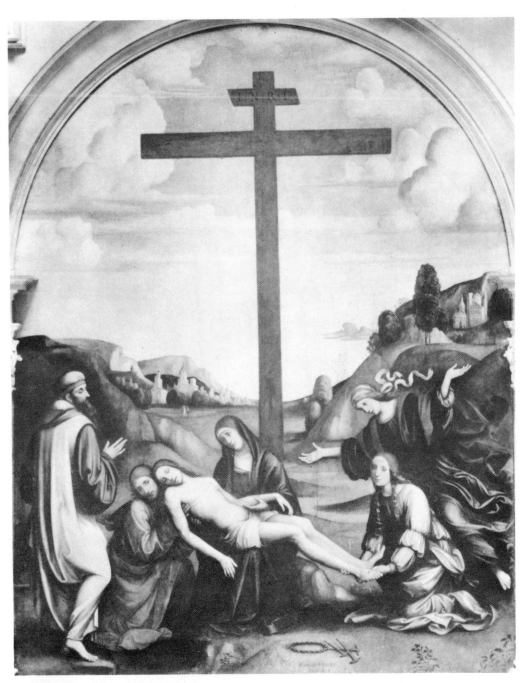

4. *FRANCIA:* DEPOSITION. Parma, Galleria.

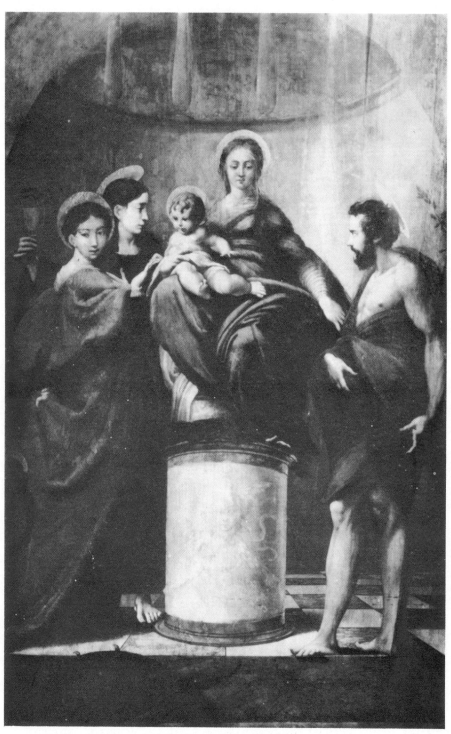

5. MARRIAGE OF ST. CATHERINE. Bardi, S. Maria.

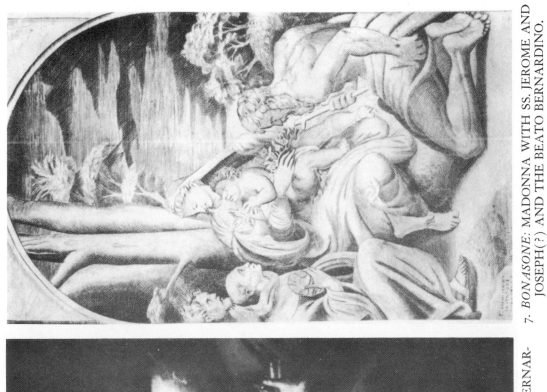

7. *BONASONE*: MADONNA WITH SS. JEROME AND JOSEPH(?) AND THE BEATO BERNARDINO.

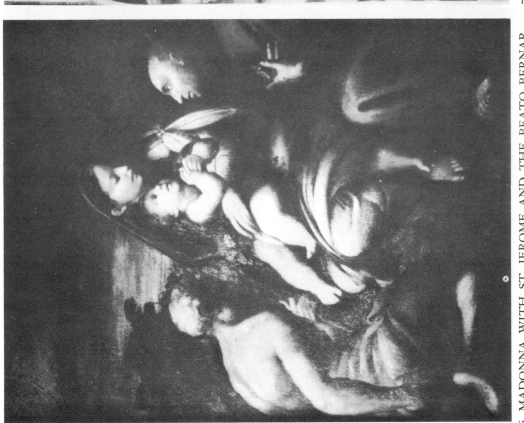

6. MADONNA WITH ST. JEROME AND THE BEATO BERNARDINO DA FELTRE. *Copy.* Parma, Galleria.

8. SS. LUCY AND APOLLONIA(?). Parma, S. Giovanni Evangelista, first chapel on left.

9. EXECUTION OF ST. AGATHA. Parma, S. Giovanni Evangelista, first chapel on left.

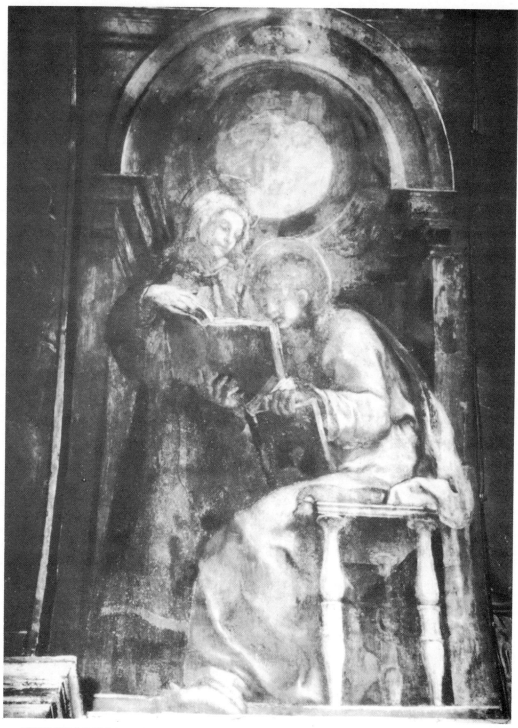

10. TWO DEACON SAINTS. Parma, S. Giovanni Evangelista, second chapel on left.

11. ST. ISIDORE MARTYR (ST. SECUNDUS?). Parma, S. Giovanni Evangelista,
second chapel on left.

(a) (b)

12. PUTTI. Parma, S. Giovanni Evangelista, first chapel on left, arch faces.

13. STUDY FOR S. GIOVANNI EVAN-
GELISTA: SS. Lucy and Apollonia.
Berlin, Print Room.

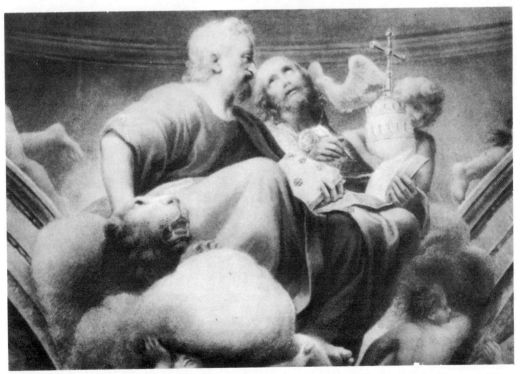

14. *TOSCHI* (Copy after Correggio): SS. MARK AND GREGORY. Parma, S. Giovanni Evan-
gelista, pendentive.

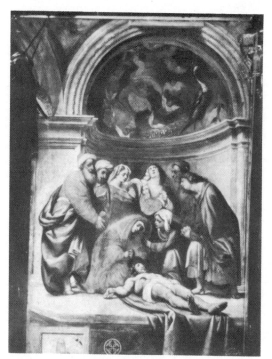

15. *PORDENONE:* DEPOSITION. Cremona,
Duomo.

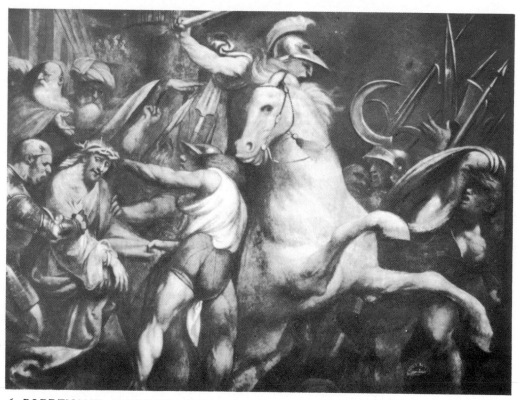

16. *PORDENONE:* CROWNING WITH THORNS, *detail*. Cremona, Duomo.

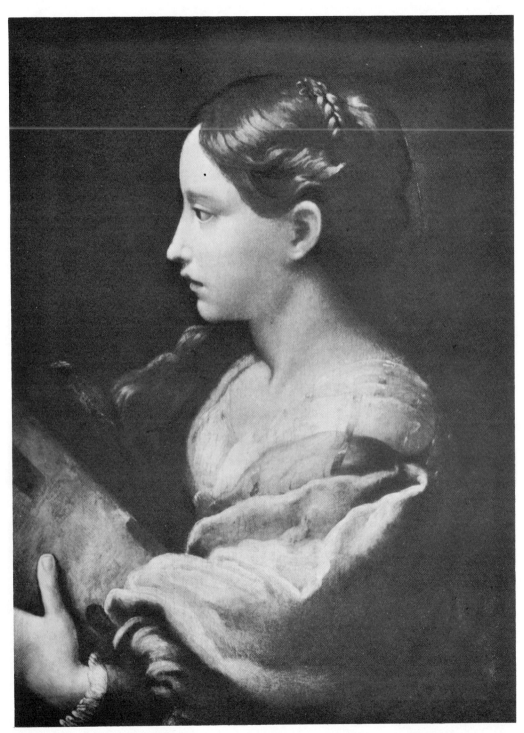

17. ST. BARBARA. Madrid, Prado.

19. STUDY FOR A CIRCUMCISION. *Copy(?)*. Paris, Louvre.

18. CIRCUMCISION. *Copy*. Detroit, Institute of Arts.

20. MARRIAGE OF ST. CATHERINE. *Copy.* Parma, Galleria.

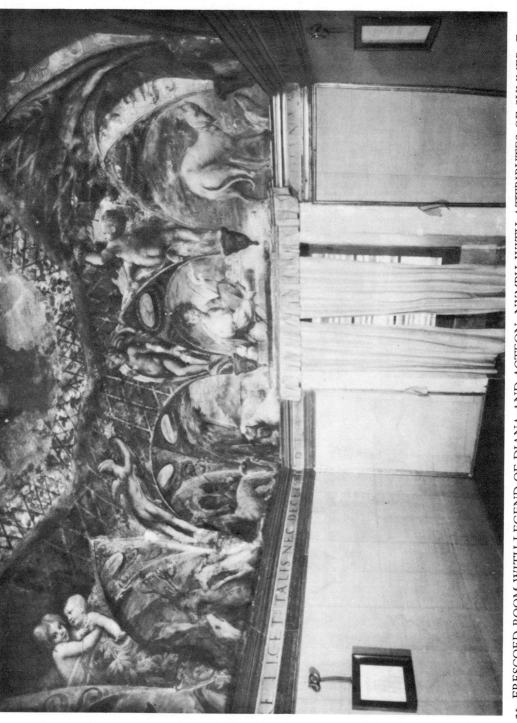

21. FRESCOED ROOM WITH LEGEND OF DIANA AND ACTEON. NYMPH WITH ATTRIBUTES OF SUMMER. Fontanellato, Rocca.

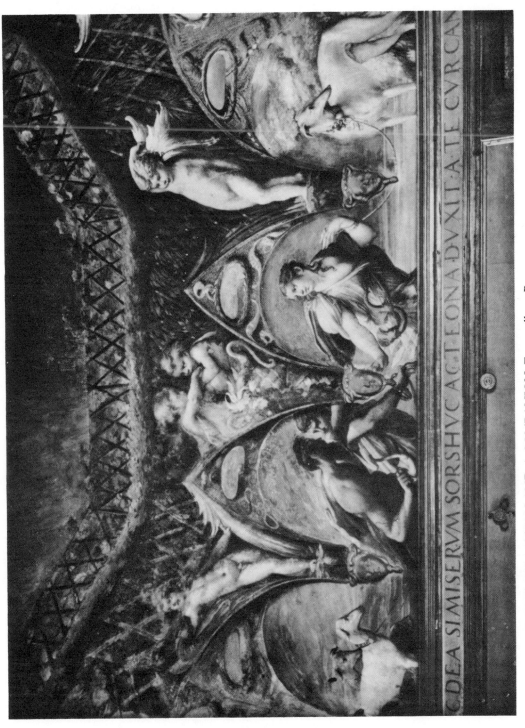

22. NYMPH PURSUED BY ACTEON AND A COMPANION. Fontanellato, Rocca.

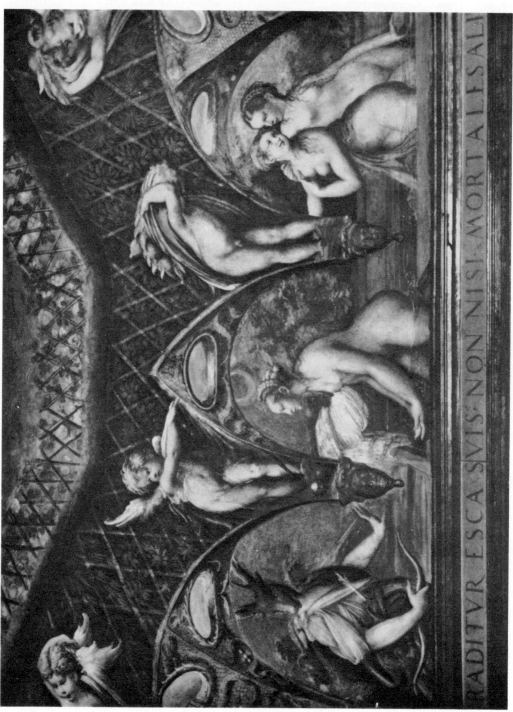

23. ACTEON CHANGED INTO A STAG. Fontanellato, Rocca,

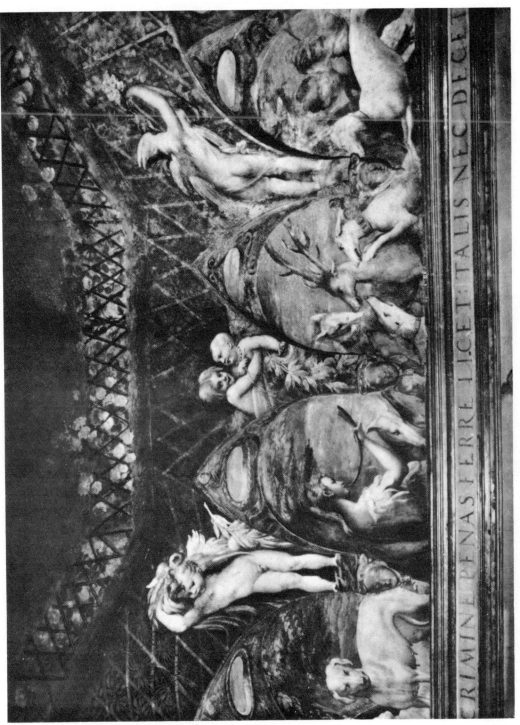

24. ACTEON DEVOURED BY HIS DOGS. Fontanellato, Rocca.

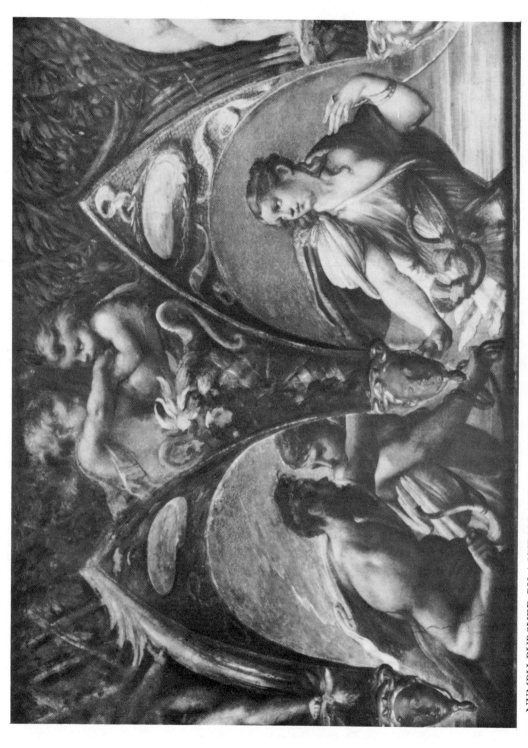

25. NYMPH PURSUED BY ACTEON AND A COMPANION, *detail*. Fontanellato, Rocca.

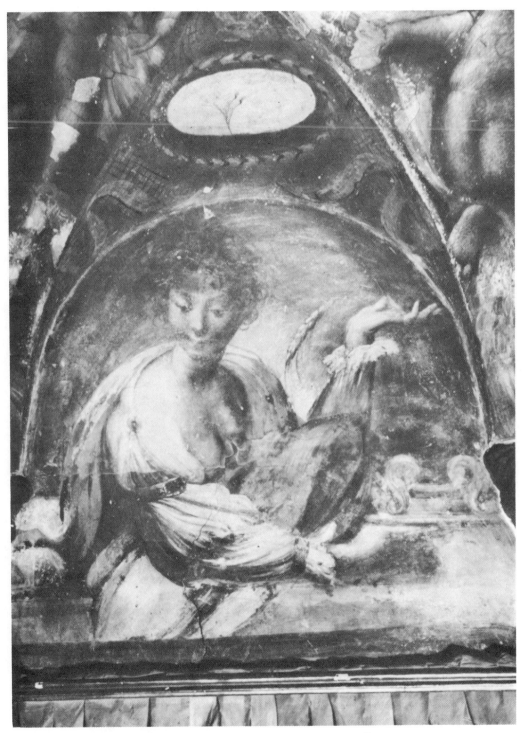

26. NYMPH WITH ATTRIBUTES OF SUMMER, *detail*. Fontanellato, Rocca.

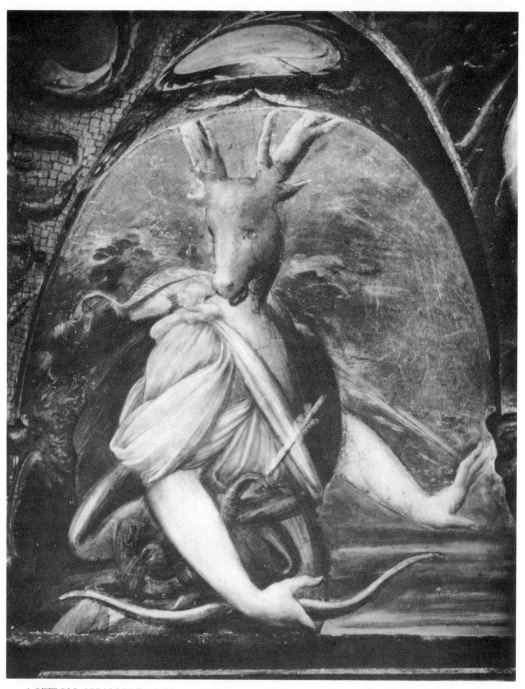

27. ACTEON CHANGED INTO A STAG, *detail,* Acteon. Fontanellato, Rocca.

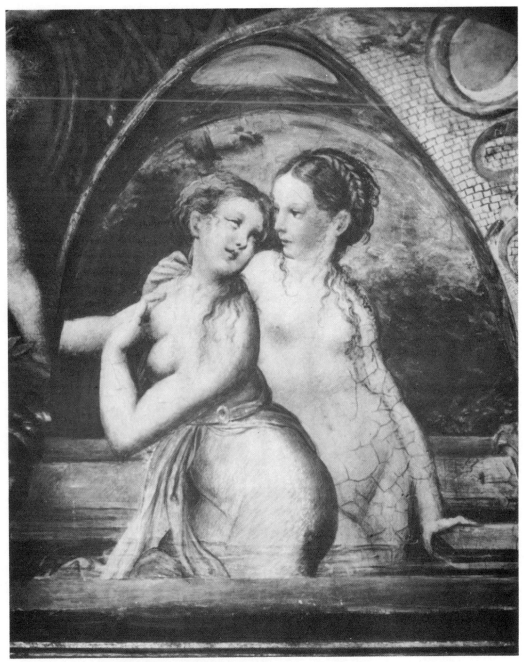

28. ACTEON CHANGED INTO A STAG, *detail*, Two Nymphs. Fontanellato, Rocca.

(a)

(b)

29. STUDY FOR FONTANELLATO: (a) *Putti.* (b) Diana Splashing Acteon. New York, Pierpont Morgan Library.

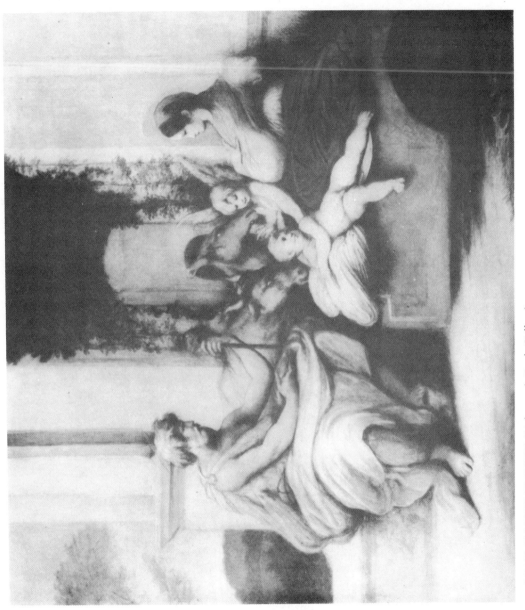

30. REST ON THE FLIGHT. Richmond, Cook Collection.

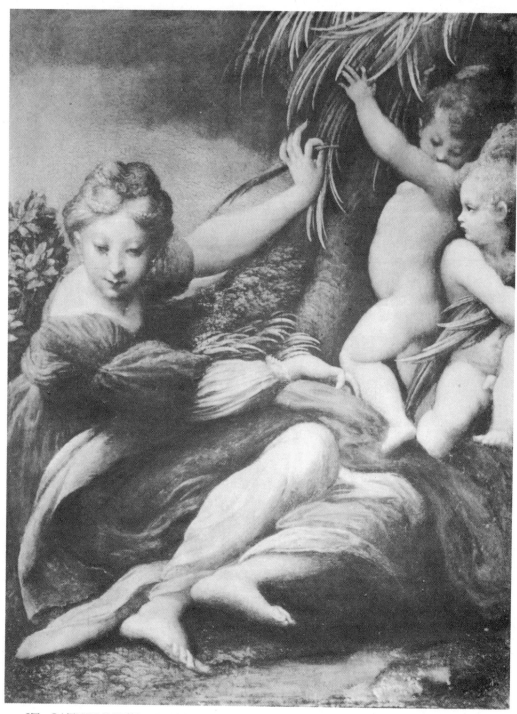

31. ST. CATHERINE(?). Frankfort, Staedelsches-Kunstinstitut.

32. ST. CATHERINE(?). *Radiograph*. Frankfort, Staedelsches-Kunstinstitut.

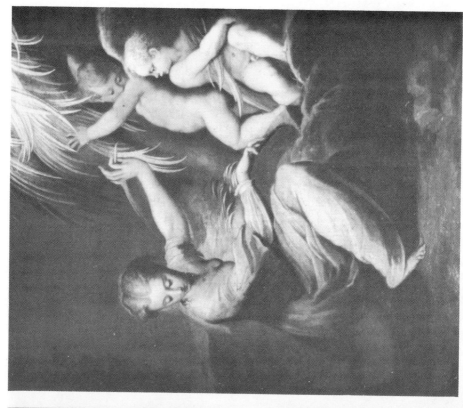

34. ST. CATHERINE. *Copy.* Vienna, Kunsthistoriches Museum.

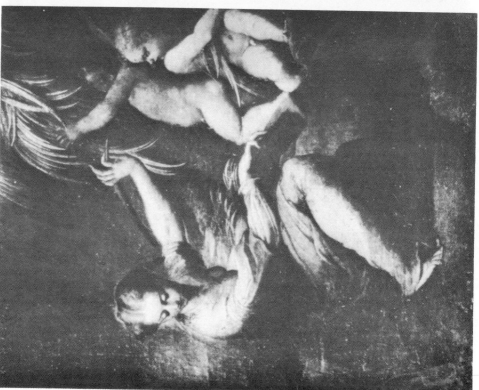

33. ST. CATHERINE. *Copy.* Parma, Galleria.

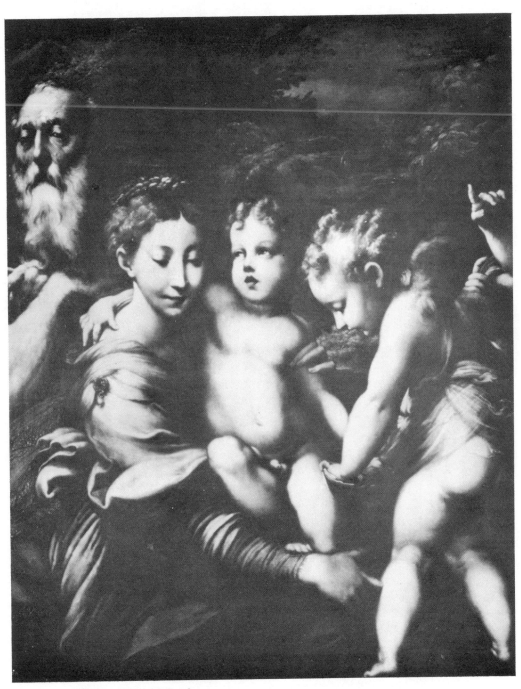

35. HOLY FAMILY. Madrid, Prado.

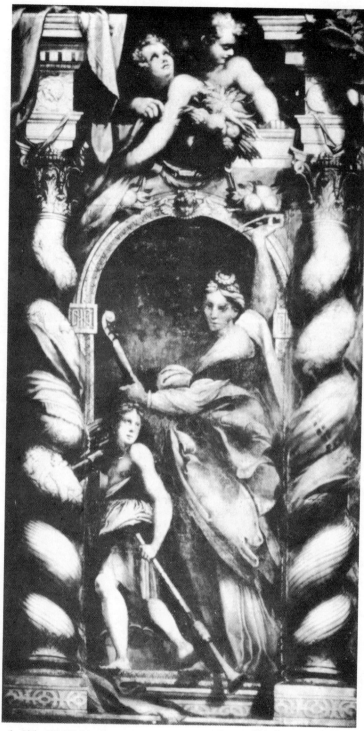

36. ST. CECILIA. Parma, S.M. della Steccata.

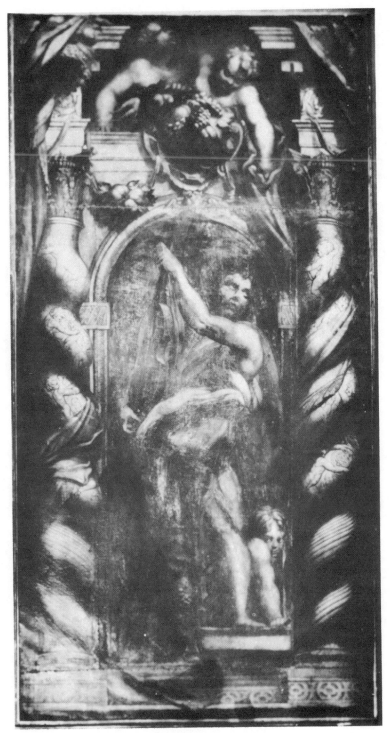

37. DAVID. Parma, S.M. della Steccata.

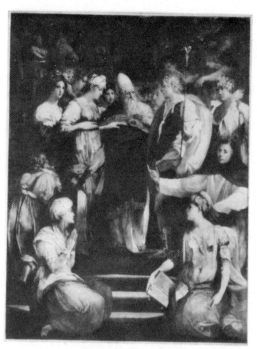

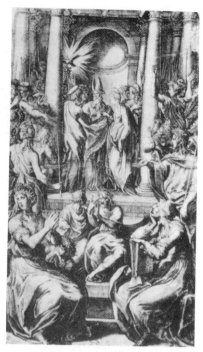

38. *ROSSO:* MARRIAGE OF THE VIRGIN.
Florence, S. Lorenzo.

39. *CARAGLIO:* MARRIAGE OF
THE VIRGIN.

40. STUDY FOR A MARRIAGE OF THE VIRGIN. New York, Pierpont Morgan
Library.

41. CREATION OF EVE. London,
British Museum.

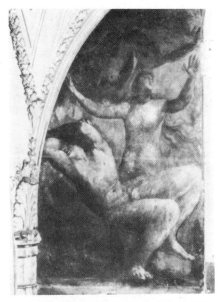

42. *ROSSO:* CREATION OF EVE.
Rome, S.M. della Pace.

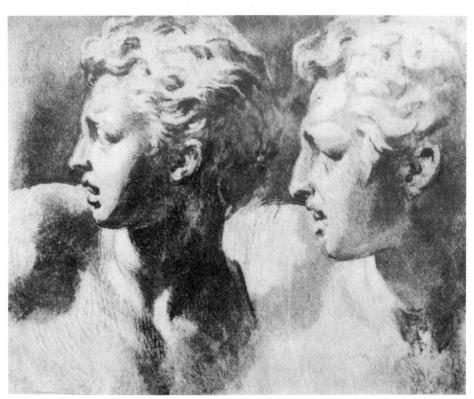

43. STUDY FROM THE LAOCOON GROUP. Florence, Uffizi.

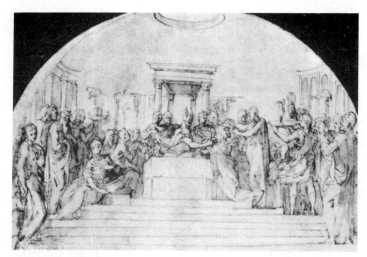

44. PRESENTATION IN THE TEMPLE. *Copy(?)*. London, British Museum.

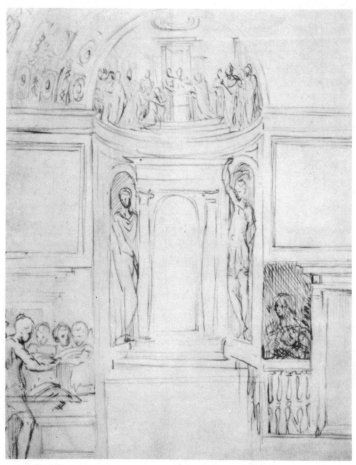

45. PROJECT FOR DECORATION OF A CHAPEL. London, Victoria and Albert Museum.

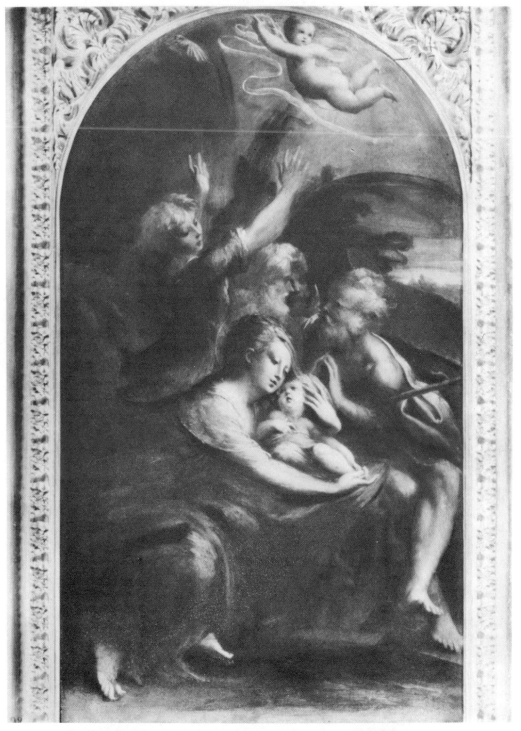

46. ADORATION OF THE SHEPHERDS. Rome, Galleria Doria-Pamphili.

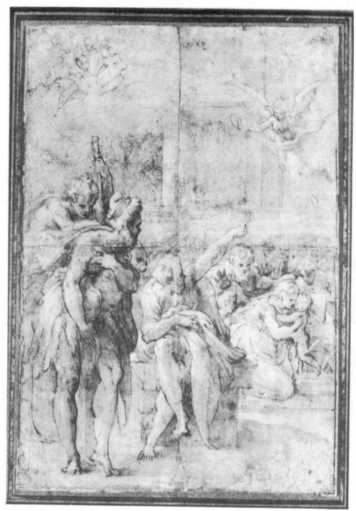

47. ADORATION OF THE SHEPHERDS. New York, Metropolitan Museum.

48. ADORATION OF THE SHEPHERDS. Florence, Uffizi.

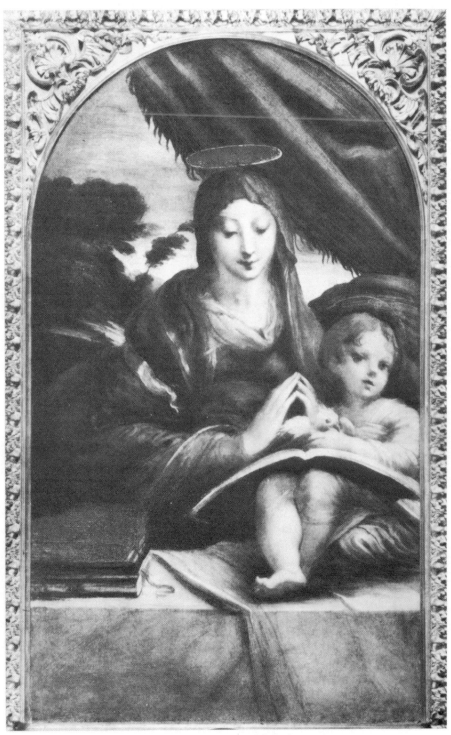

49. MADONNA AND CHILD. Rome, Galleria Doria-Pamphili.

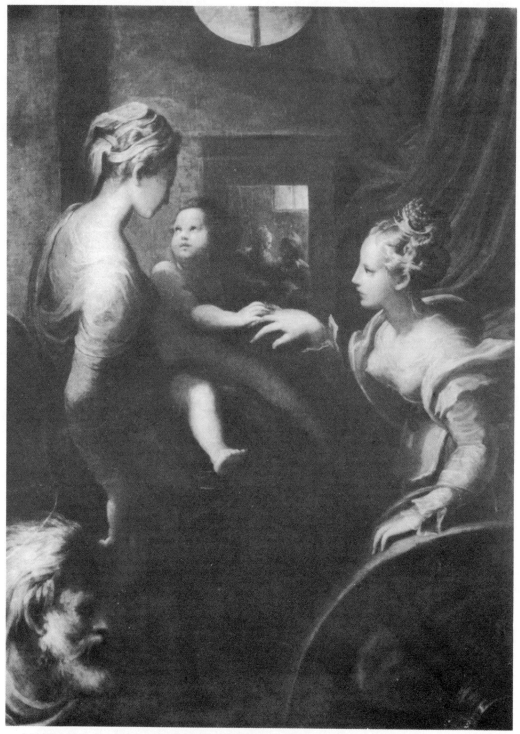

50. MARRIAGE OF ST. CATHERINE. Somerley, Collection Earl of Normanton.

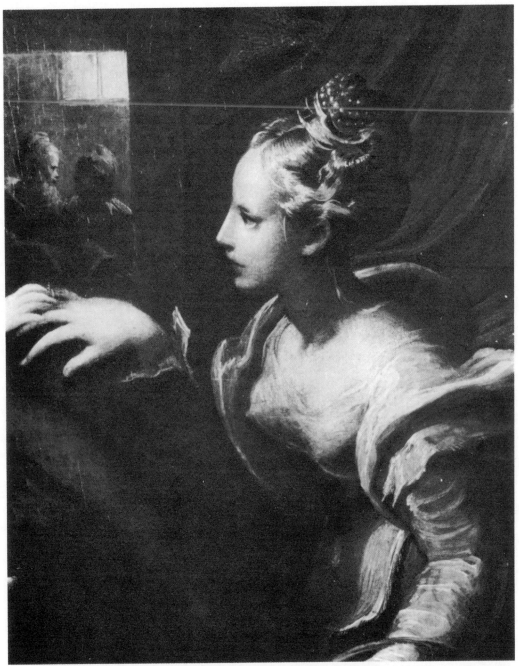

51. MARRIAGE OF ST. CATHERINE, *detail,* St. Catherine. Somerley, Collection Earl of Normanton.

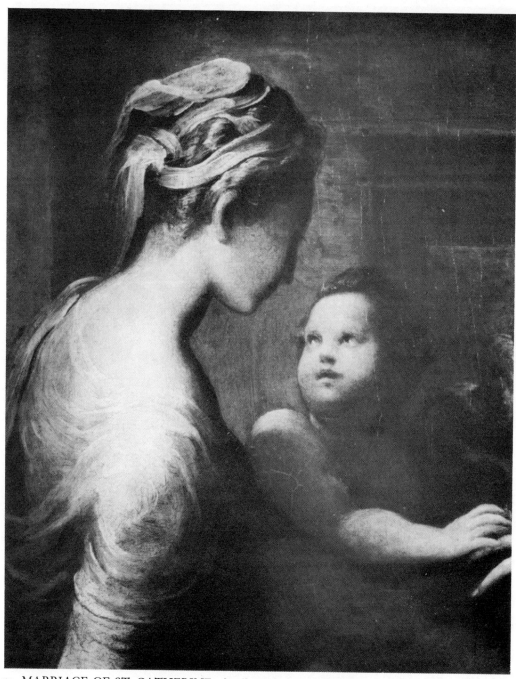

52. MARRIAGE OF ST. CATHERINE, *detail,* Madonna and Child. Somerley, Collection Earl of Normanton.

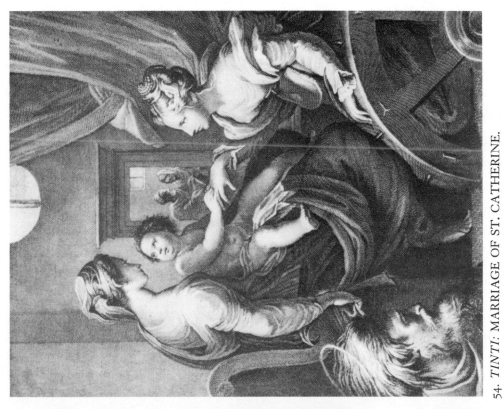

54. *TINTI*: MARRIAGE OF ST. CATHERINE.

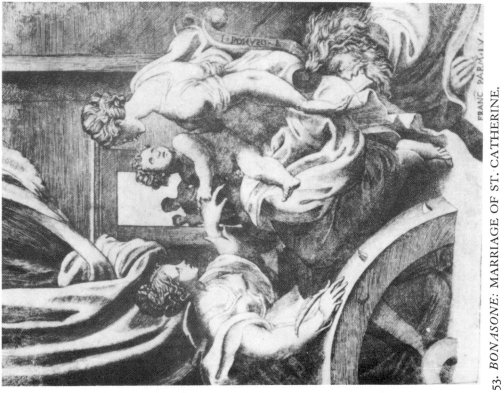

53. *BONASONE*: MARRIAGE OF ST. CATHERINE.

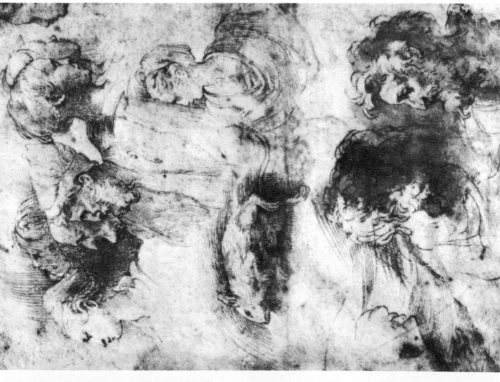

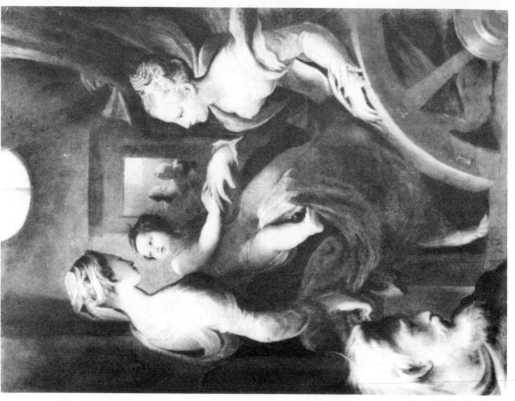

55. MARRIAGE OF ST. CATHERINE. *Copy.* London, Collection
Duke of Wellington.

56. SHEET OF STUDIES (THE "DISEGNO DEL TOPO
MORTO"). Parma, Galleria

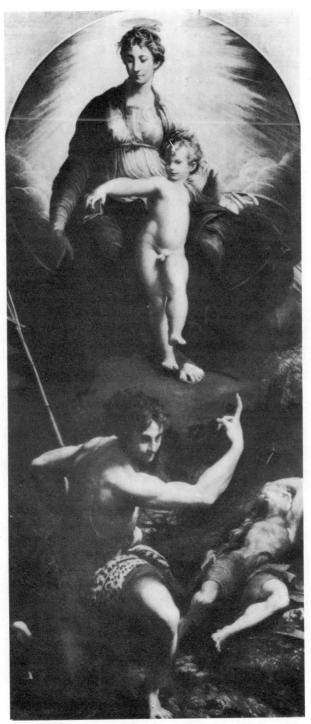

57. VISION OF ST. JEROME. London, National Gallery.

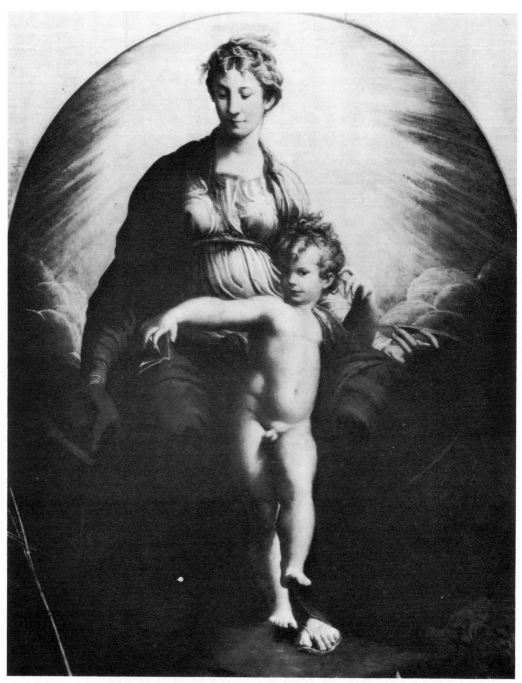

58. VISION OF ST. JEROME, *detail*, Madonna and Child. London, National Gallery.

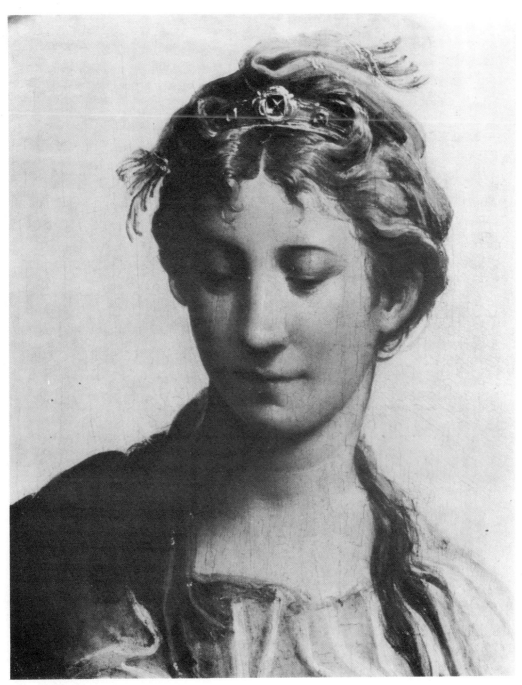

59. VISION OF ST. JEROME, *detail,* Madonna. London, National Gallery.

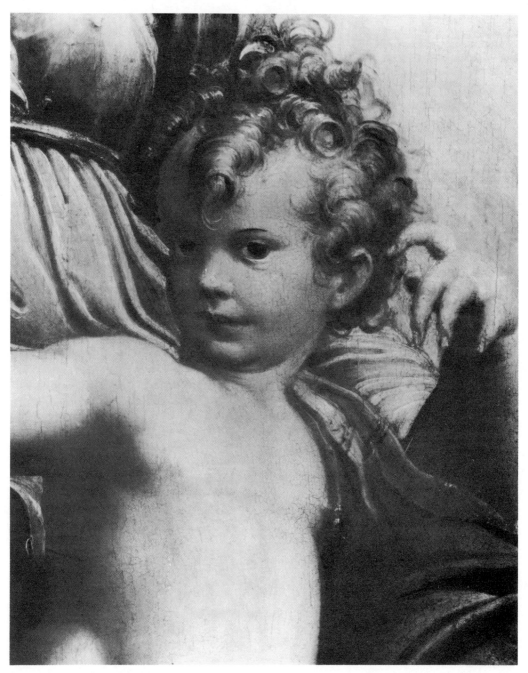

60. VISION OF ST. JEROME, *detail,* Christ Child. London, National Gallery.

61. STUDY FOR VISION OF ST. JEROME. London, British Museum.

62. STUDY FOR VISION OF ST. JEROME. Parma, Galleria.

63. STUDY FOR VISION OF ST. JEROME: St. Jerome. London, British Museum.

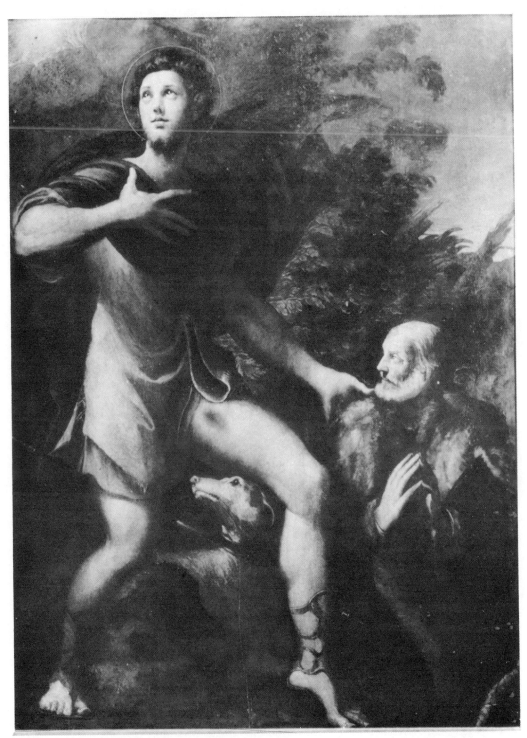

64. ST. ROCH AND A DONOR. Bologna, S. Petronio.

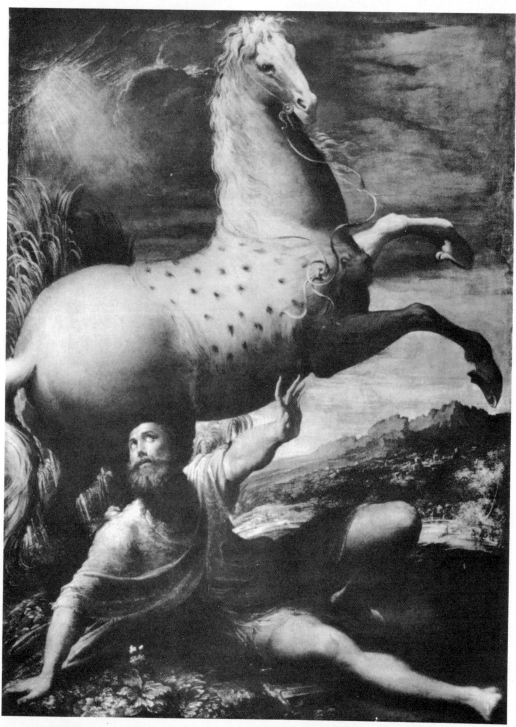

65. CONVERSION OF ST. PAUL. Vienna, Kunsthistorisches Museum.

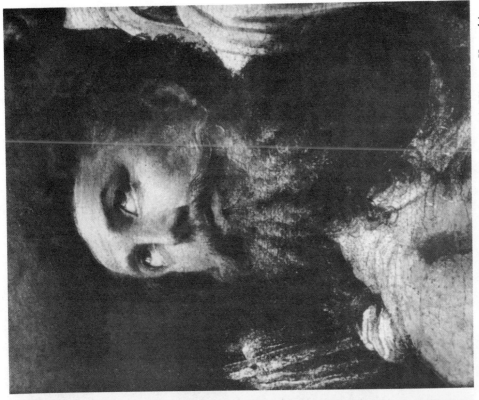

67. CONVERSION OF ST. PAUL, *detail*, St. Paul. Vienna, Kunsthistorisches Museum.

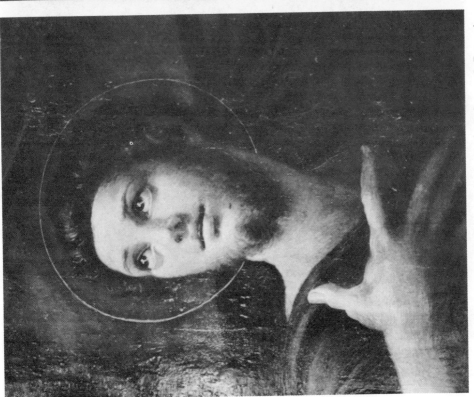

66. ST. ROCH AND A DONOR, *detail*, St. Roch. Bologna, S. Petronio.

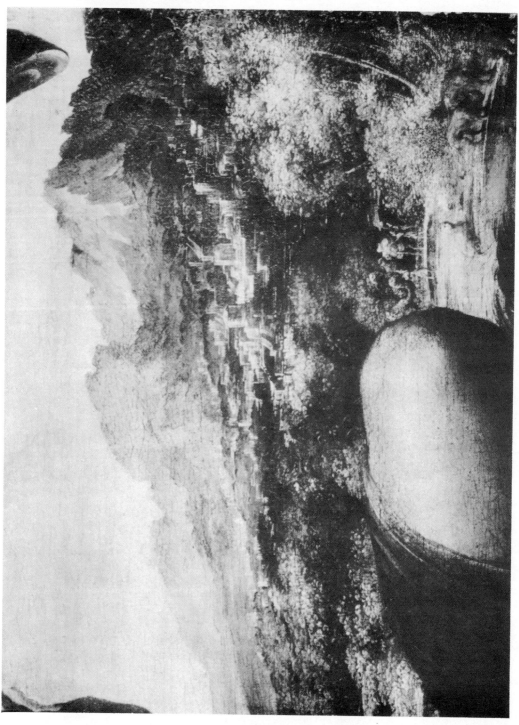

68. CONVERSION OF ST. PAUL, *detail*, landscape. Vienna, Kunsthistorisches Museum.

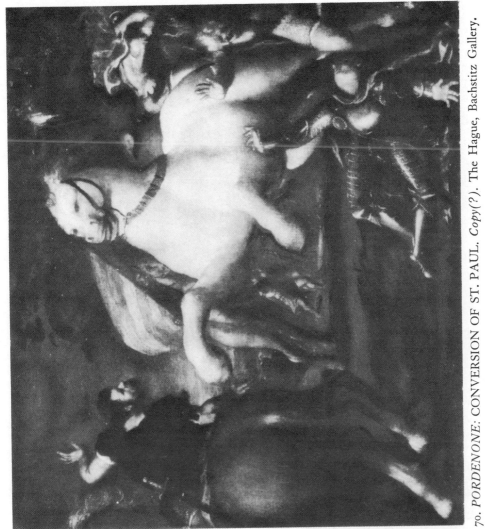

70. *PORDENONE:* CONVERSION OF ST. PAUL. *Copy(?).* The Hague, Bachstitz Gallery.

69. *MORETTO:* CONVERSION OF ST. PAUL, *detail.* Milan, S.M. presso S. Celso.

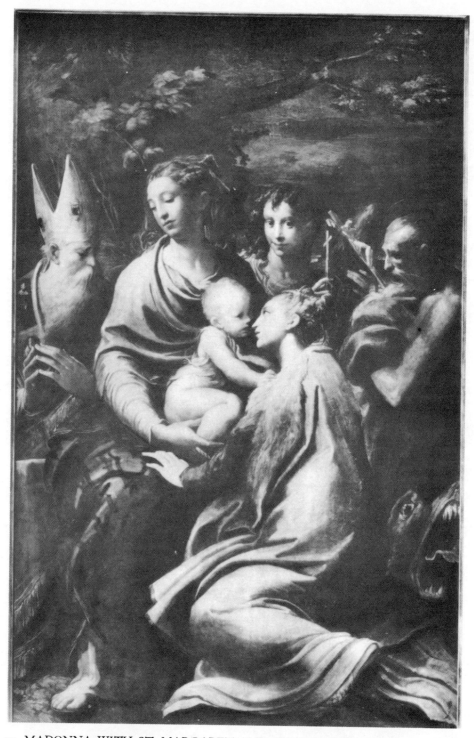

71. MADONNA WITH ST. MARGARET AND OTHER SAINTS. Bologna, Pina-
coteca.

72. MADONNA WITH ST. MARGARET, *detail*, St. Margaret and the Christ Child. Bologna, Pinacoteca.

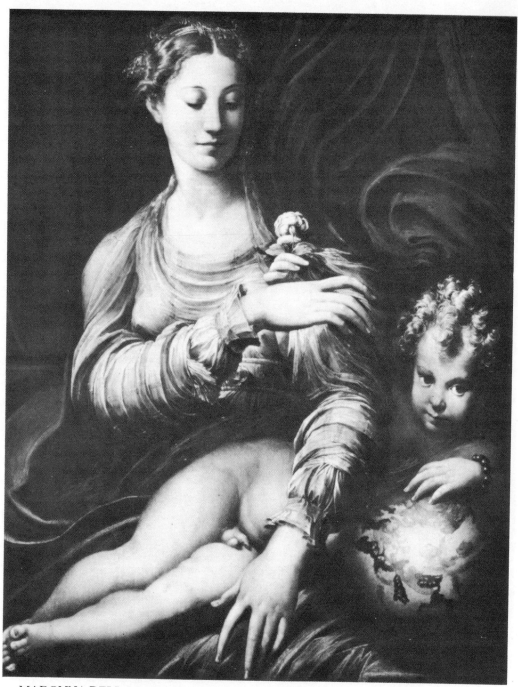

73. MADONNA DELLA ROSA. Dresden, Gemaeldegalerie.

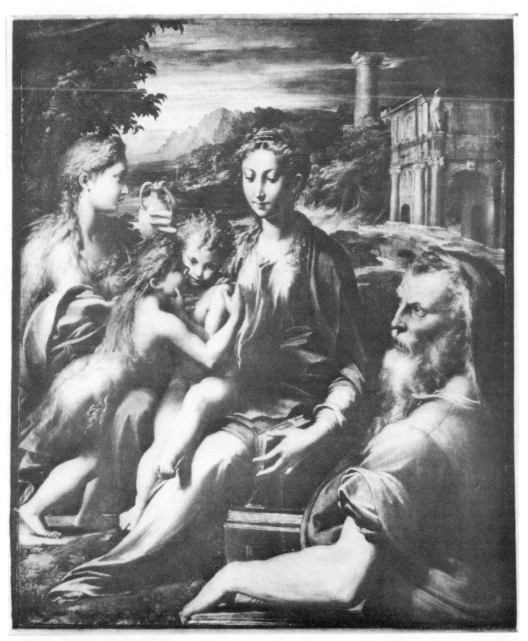

74. MADONNA WITH ST. ZACHARY, THE MAGDALEN, AND INFANT ST. JOHN. Florence, Uffizi.

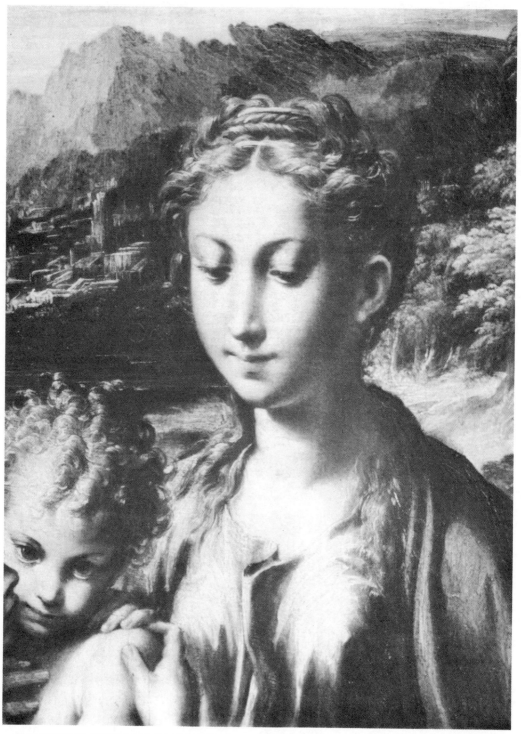

75. MADONNA WITH ST. ZACHARY, *detail,* the Madonna. Florence, Uffizi.

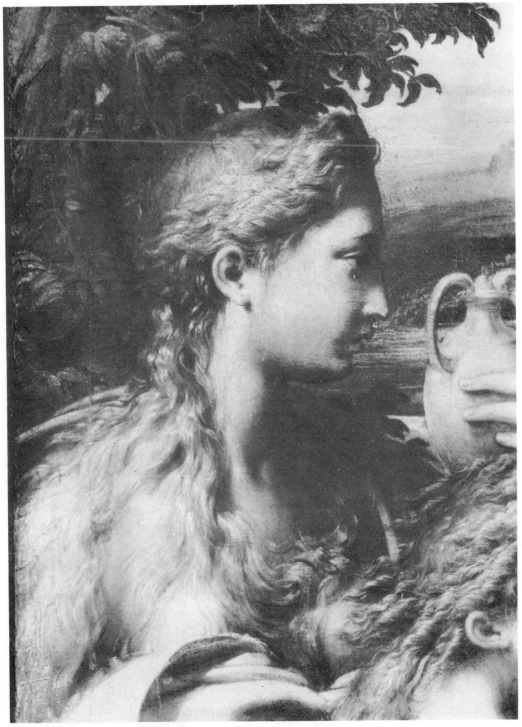

76. MADONNA WITH ST. ZACHARY, *detail,* the Magdalen. Florence, Uffizi.

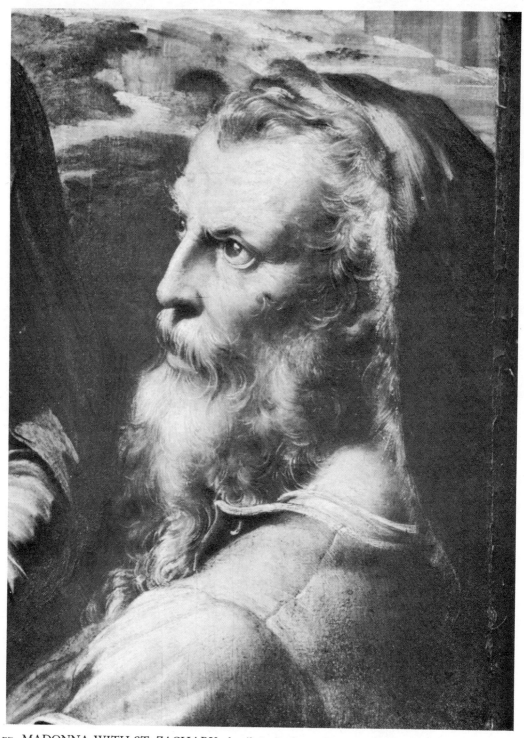

77. MADONNA WITH ST. ZACHARY, *detail,* St. Zachary. Florence, Uffizi.

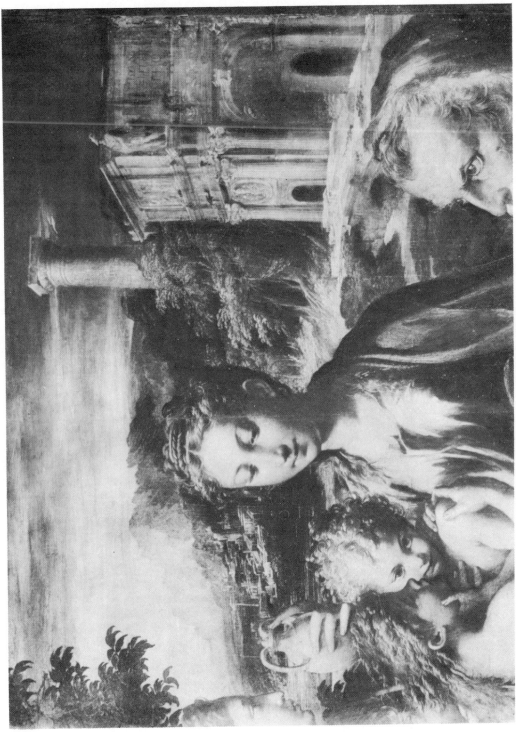

78. MADONNA WITH ST. ZACHARY, *detail*, landscape. Florence, Uffizi.

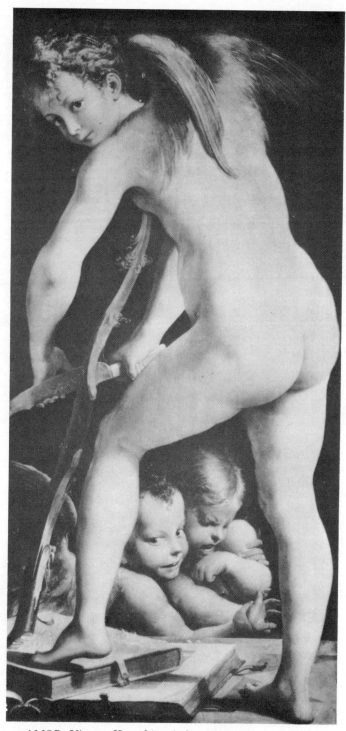

79. AMOR. Vienna, Kunsthistorisches Museum.

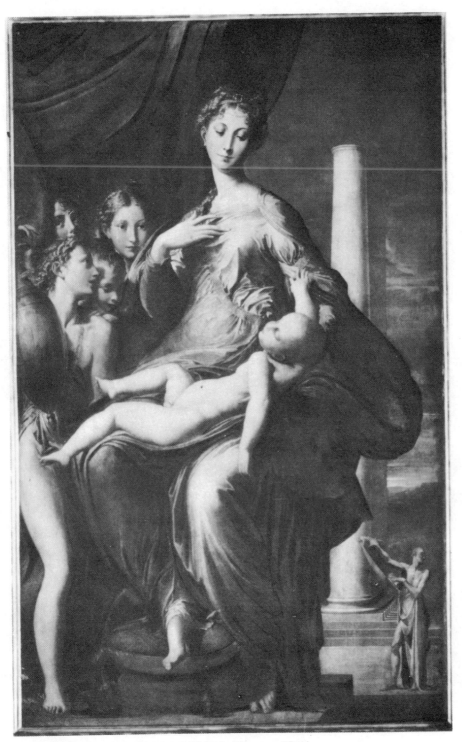

80. MADONNA DAL COLLO LUNGO. Florence, Pitti.

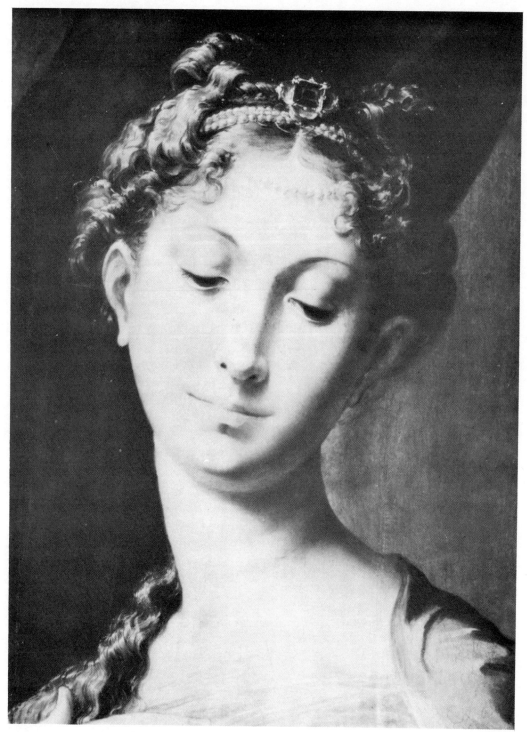

81. MADONNA DAL COLLO LUNGO, *detail,* the Madonna. Florence, Pitti.

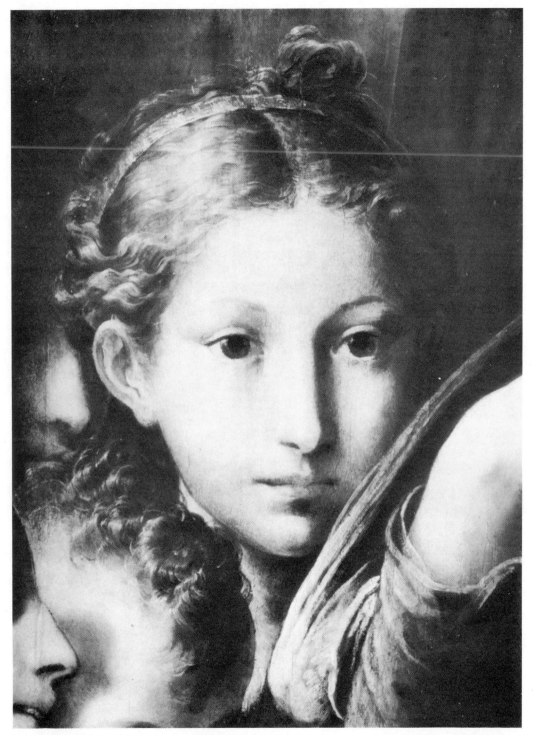

82. MADONNA DAL COLLO LUNGO, *detail,* Head of Attendant Girl. Florence, Pitti.

83. MADONNA DAL COLLO LUNGO, *detail,* the "Prophet." Florence, Pitti.

(a)

(b)

(c)

84. STUDIES FOR THE MADONNA DAL COLLO LUNGO.

(a) Drapery of the Madonna. London, British Museum. (b) The "Prophet" and His Companion. Florence, Uffizi. (c) The "Prophet." London, British Museum.

(b)

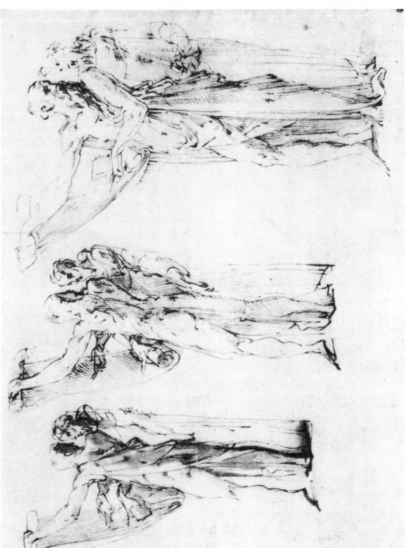

(a)

85. STUDIES FOR THE MADONNA DAL COLLO LUNGO.

(a) The "Prophet" and His Companion. Oxford, Ashmolean Museum. (b) The "Prophet." Parma, Galleria.

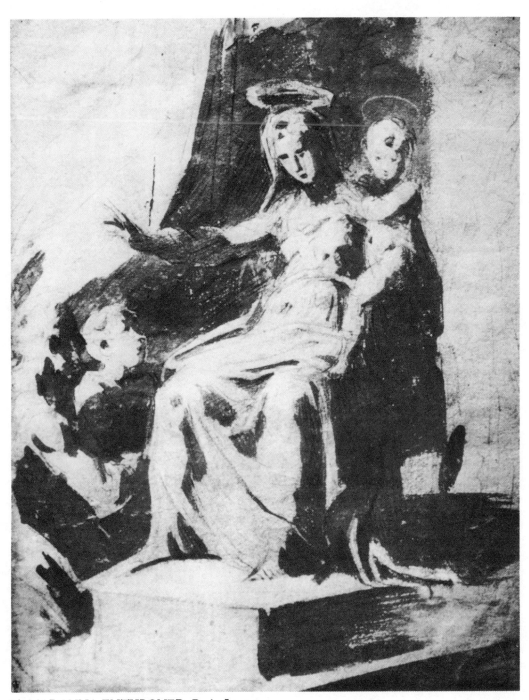

86. MADONNA ENTHRONED. Paris, Louvre.

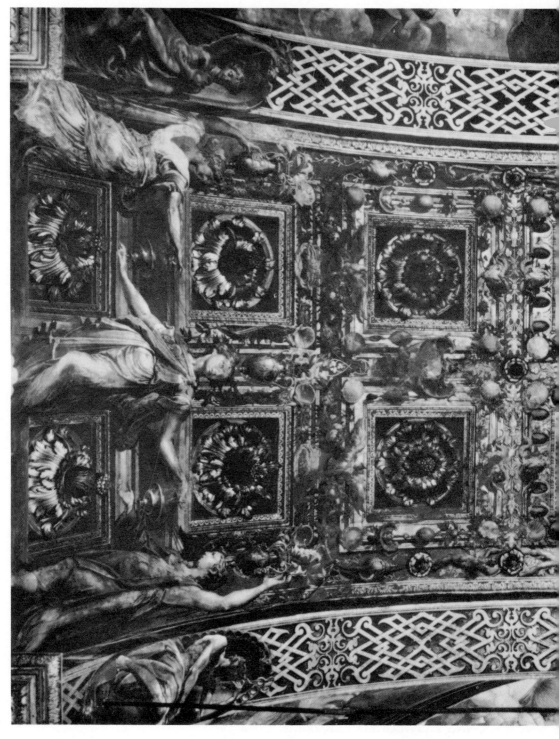

87. FRESCO DECORATION. Par

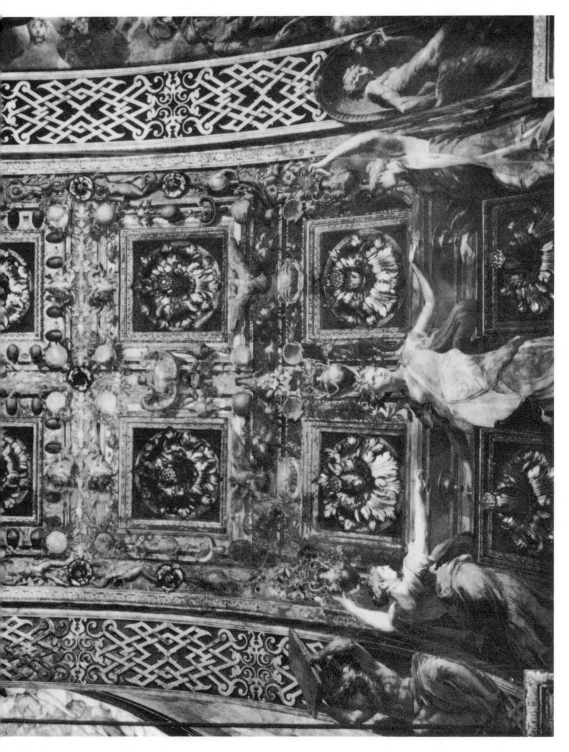

M. della Steccata, east vault.

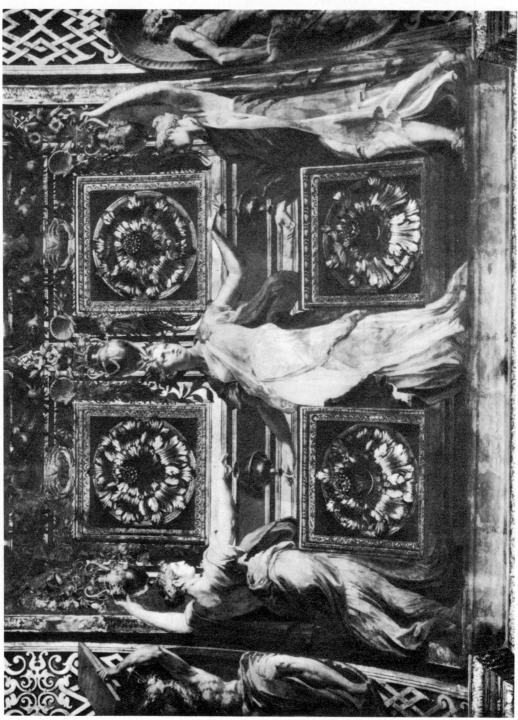

88. STECCATA DECORATION: north wall.

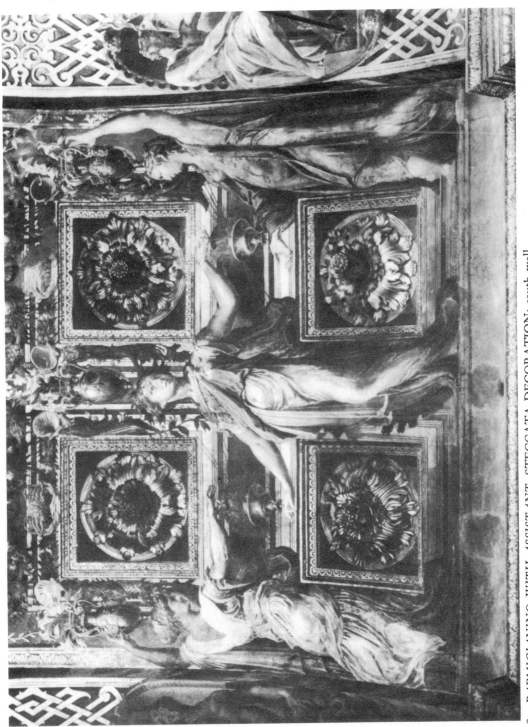

89. *PARMIGIANINO WITH ASSISTANT. STECCATA DECORATION: south wall.*

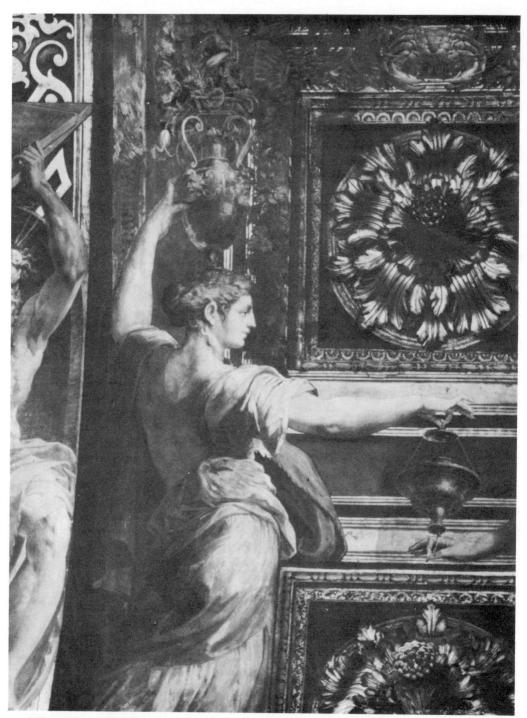

90. STECCATA DECORATION: north wall, *detail,* Maiden on left.

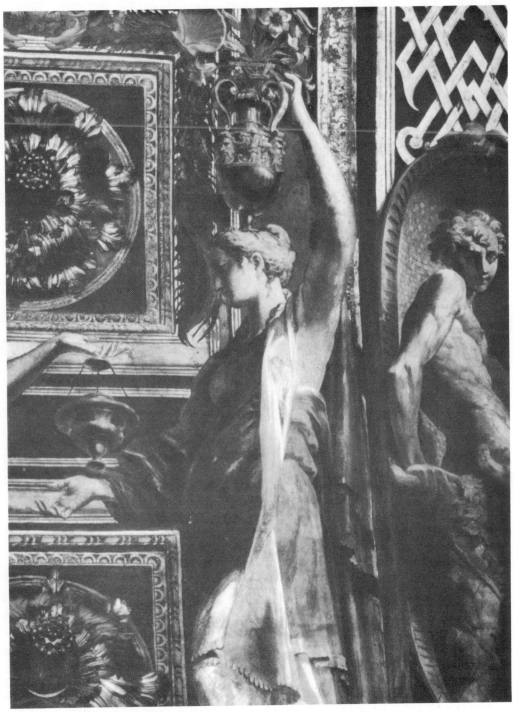

91. STECCATA DECORATION: north wall, *detail*, Maiden on right.

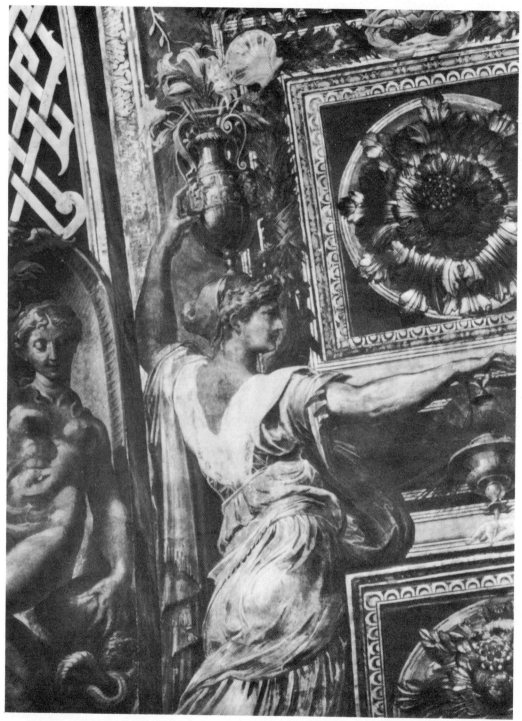

92. *ASSISTANT OF PARMIGIANINO*. STECCATA DECORATION: south wall, *detail*, Maiden on left.

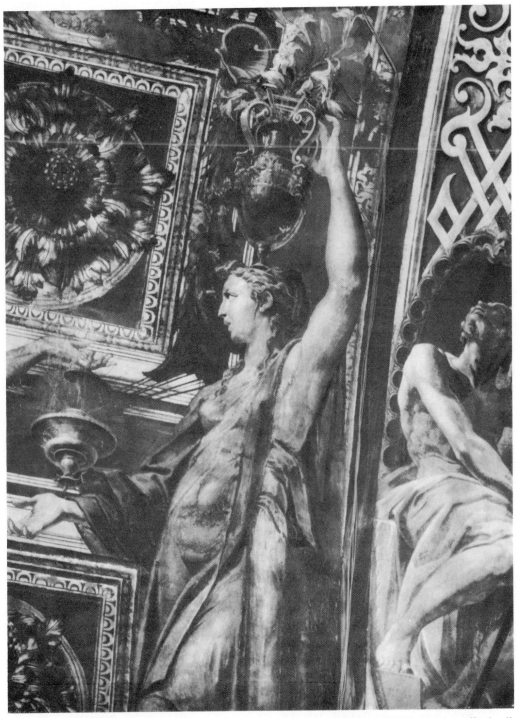

93. *PARMIGIANINO(?) AND ASSISTANT*. STECCATA DECORATION: south wall, *detail*, Maiden on right.

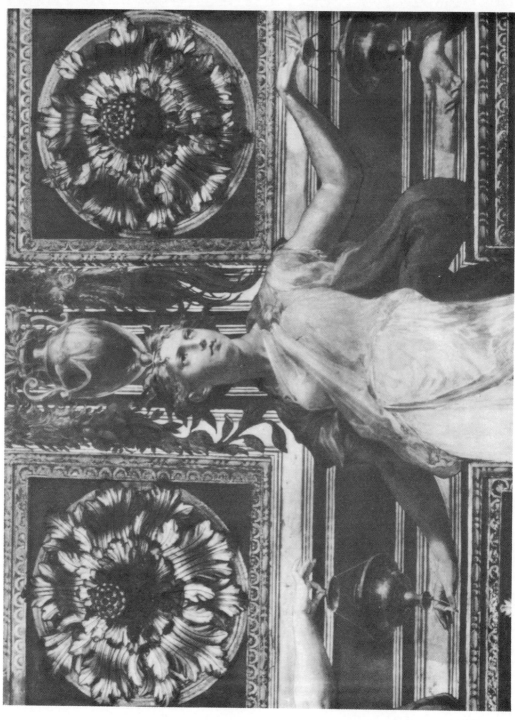

94. STECCATA DECORATION: north wall, *detail*, Maiden in center.

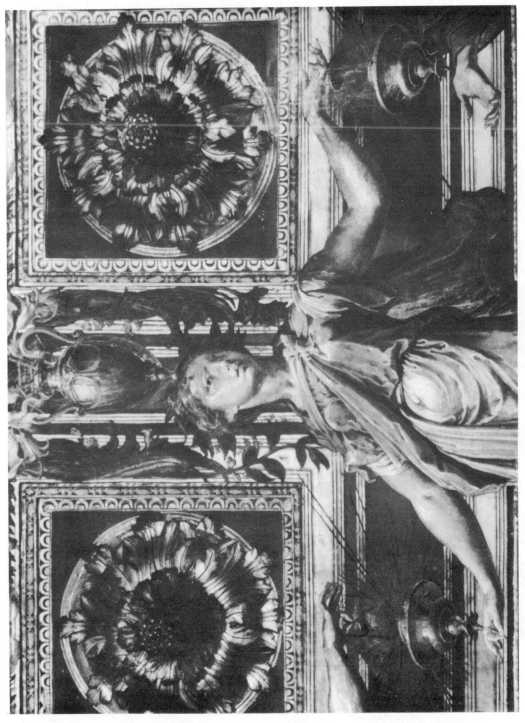

95. *ASSISTANT OF PARMIGIANINO. STECCATA DECORATION:* south wall, *detail*, Maiden in center.

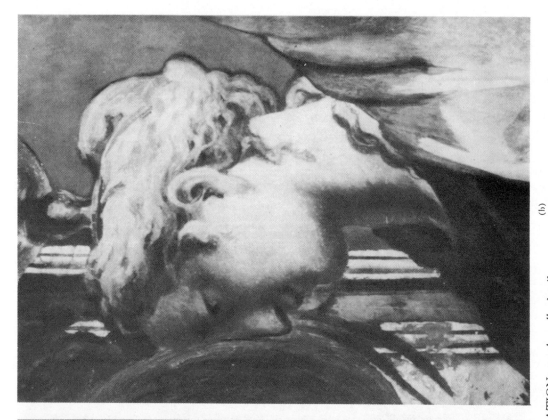

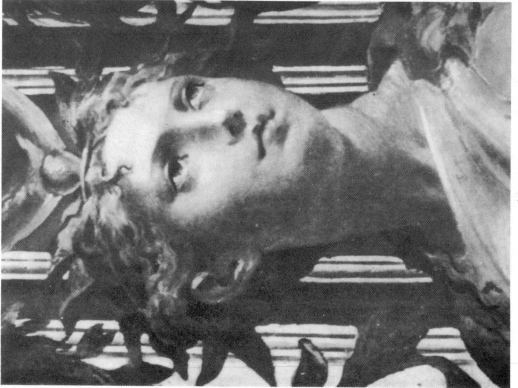

(a)

(b)

96. STECCATA DECORATION: north wall, *details*.
(a) Head of Maiden in center. (b) Head of Maiden on right.

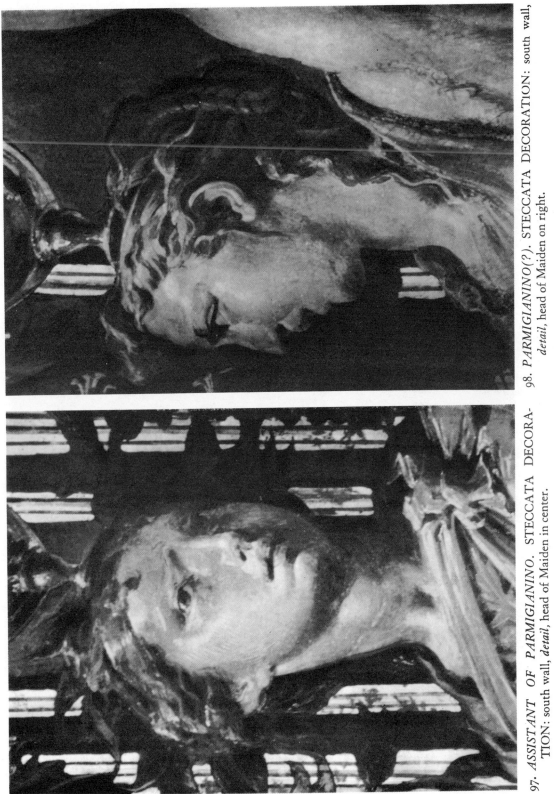

97. *ASSISTANT OF PARMIGIANINO.* STECCATA DECORA-
TION: south wall, *detail*, head of Maiden in center.

98. *PARMIGIANINO(?).* STECCATA DECORATION: south wall,
detail, head of Maiden on right.

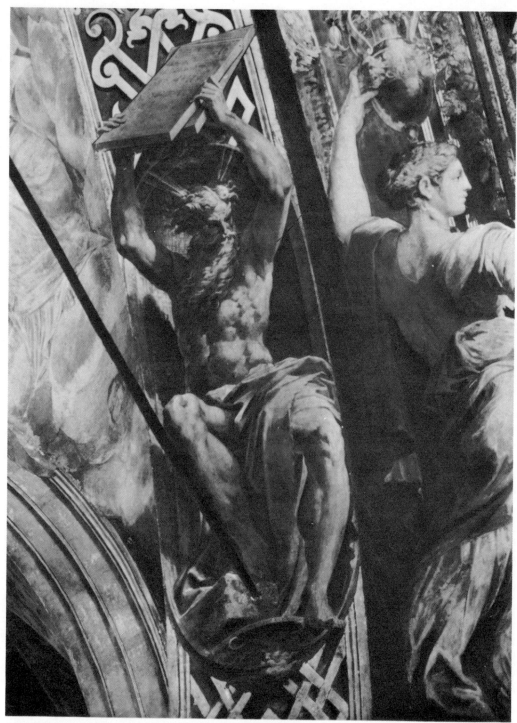

99. STECCATA DECORATION: north wall, *detail*, Moses.

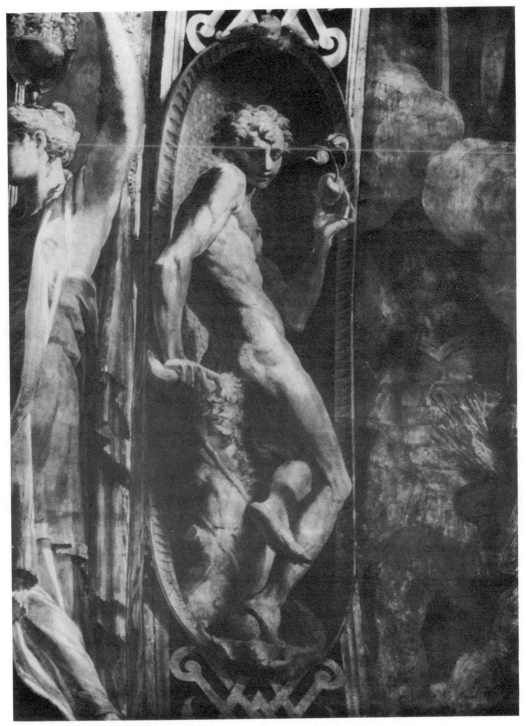

100. STECCATA DECORATION: north wall, *detail*, Adam.

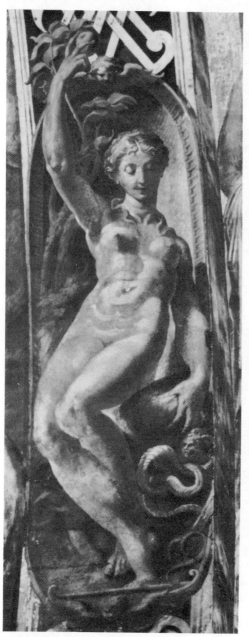

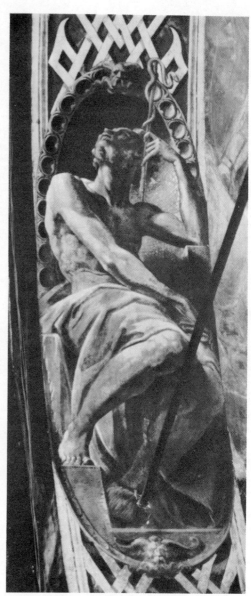

102. *PARMIGIANINO(?)*. STECCATA
DECORATION: south wall, *detail*,
Aaron.

101. STECCATA DECORATION: south
wall, *detail*, Eve.

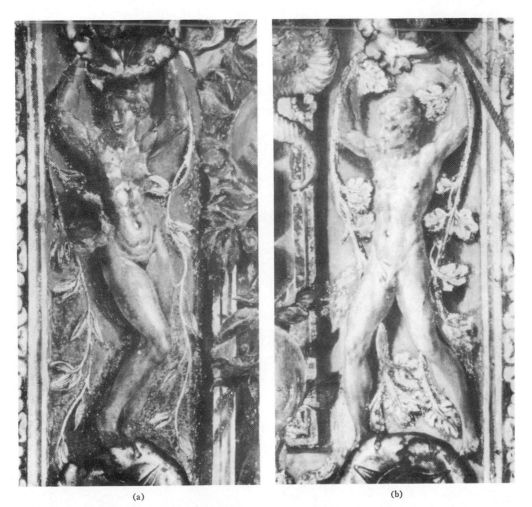

(a) (b)

103. STECCATA DECORATION: west band of the vault, accessory figures.

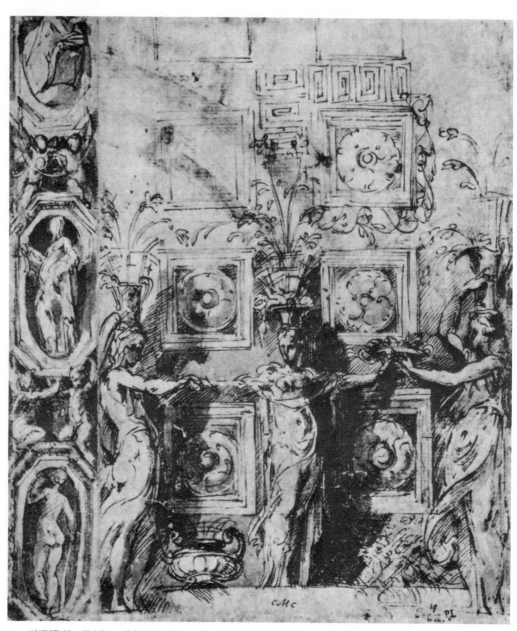

104. STUDY FOR STECCATA DECORATION. London, British Museum.

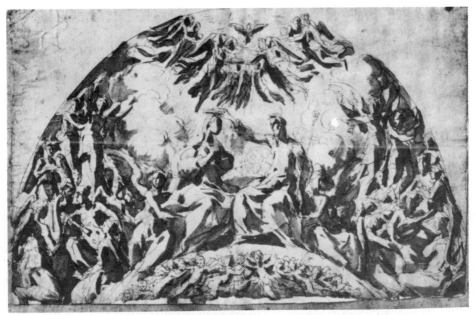

(a)

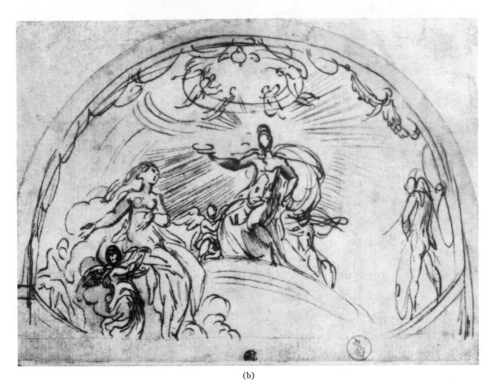

(b)

105. PROJECTS FOR STECCATA DECORATION.

(a) Coronation of the Virgin. Parma, Galleria (deposita del Municipio). (b) Coronation of the Virgin. Turin, Biblioteca Reale.

106. STUDIES FOR STECCATA DECORATION.

(a) Maiden on left. Parma, Galleria. (b) Maiden on left. New York, Collection Scholz. (c) Maiden on right. Parma, Galleria.

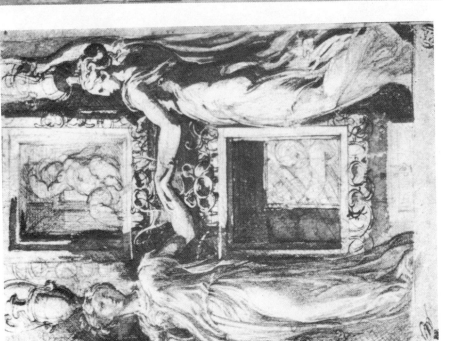

(a)

(b)

107. STUDIES FOR STECCATA DECORATION.

(a) Center and right-hand Maidens. Paris, Louvre. (b) Moses. Parma, Galleria.

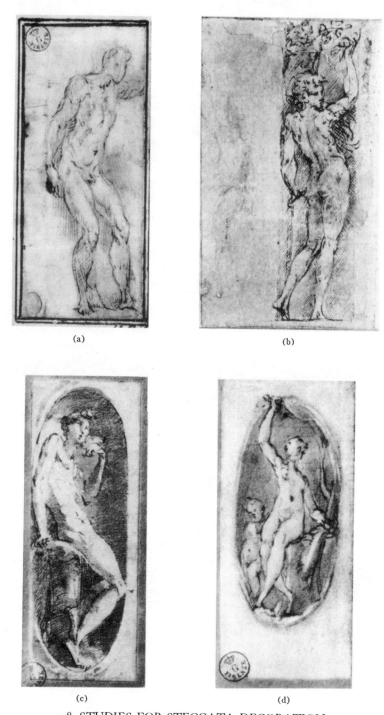

(a)

(b)

(c)

(d)

108. STUDIES FOR STECCATA DECORATION.

(a) Adam. Florence, Uffizi. (b) Adam and Eve. London, British Museum.
(c) Adam. Florence, Uffizi. (d) Eve. Florence, Uffizi.

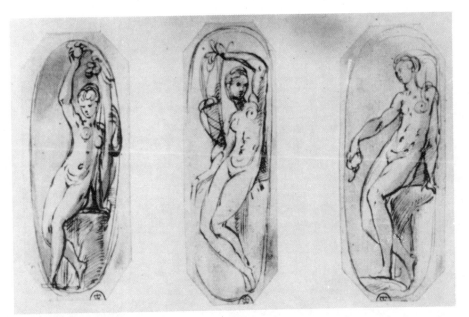

109. STUDIES FOR STECCATA DECORATION: Eve. Windsor, Royal Library.

110. SHEET OF STUDIES OF FEMALE FIG-
URES, *detail*. Florence, Uffizi.

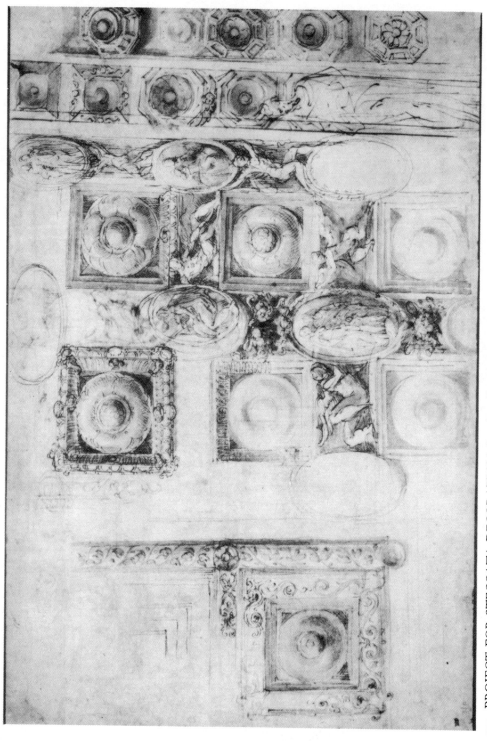

111. PROJECT FOR STECCATA DECORATION. London, British Museum.

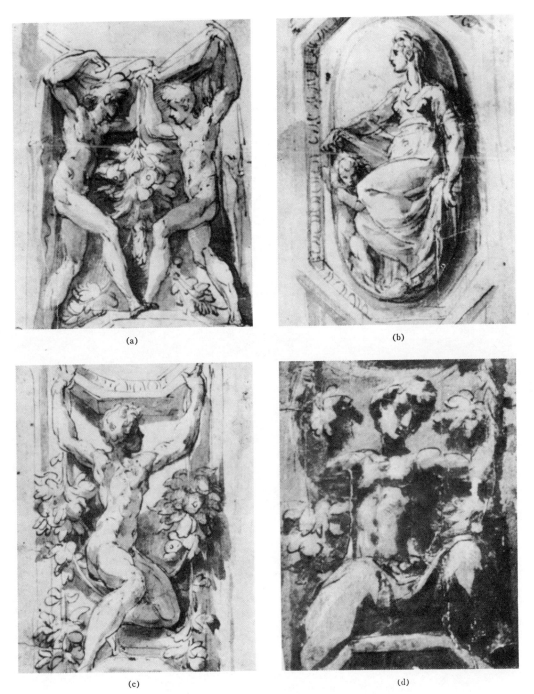

(a) (b)

(c) (d)

112. PROJECTS FOR STECCATA DECORATION.

(a) Youths with Garlands. Windsor, Royal Library. (b) Sybil(?) and *Putto*. Windsor, Royal Library. (c) Nude Youth. Windsor, Royal Library. (d) Seated Youth. Sacramento, Crocker Art Gallery.

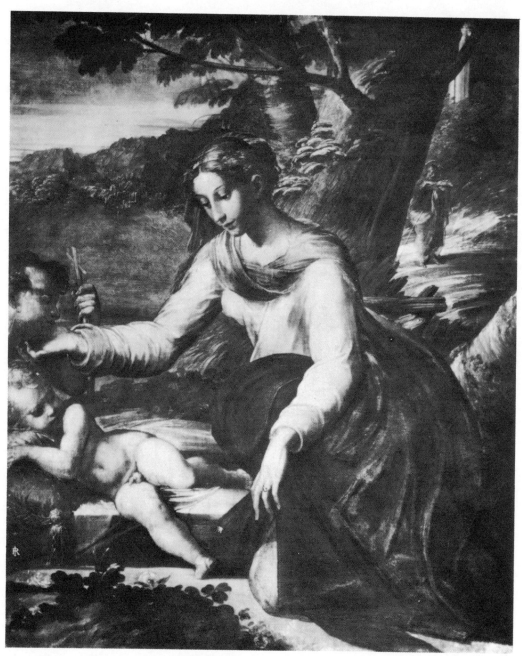

113. HOLY FAMILY WITH INFANT ST. JOHN. Naples, Pinacoteca del Museo Nazionale.

114. STUDY FOR HOLY FAMILY WITH INFANT
ST. JOHN. Parma, Galleria.

115. STUDY FOR MADONNA
WITH ST. STEPHEN.
Windsor, Royal Library.

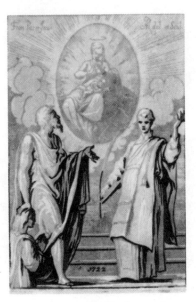

116. *A. M. ZANETTI (copy after
Parmigianino)*: STUDY
FOR MADONNA
WITH ST. STEPHEN.

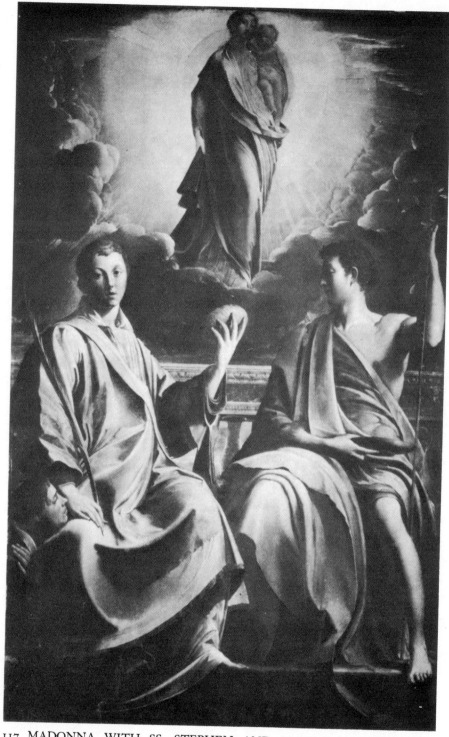

117. MADONNA WITH SS. STEPHEN AND JOHN BAPTIST. Dresden, Gemaeldegalerie.

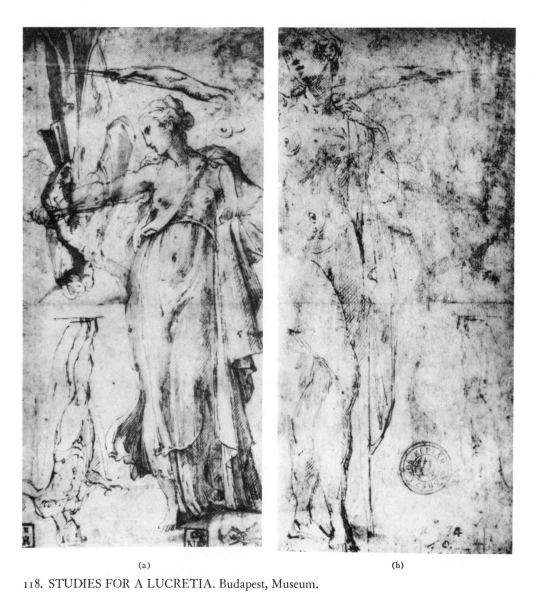

(a) (b)

118. STUDIES FOR A LUCRETIA. Budapest, Museum.

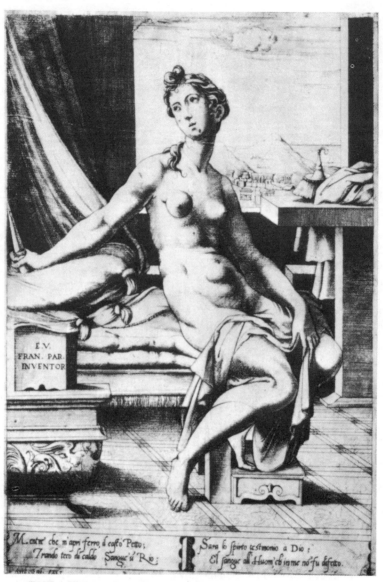

119. *ENEA VICO:* LUCRETIA.

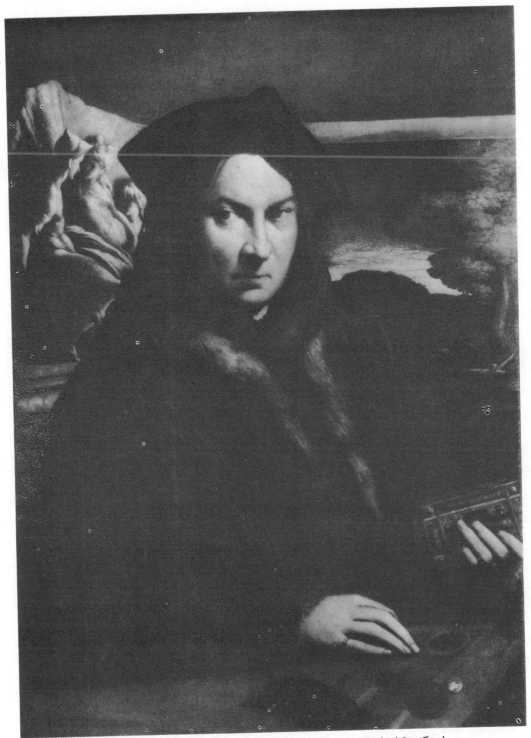

120. PORTRAIT OF A PRIEST(?). Wrotham Park, Collection Earl of Strafford.

121. PORTRAIT OF A PRIEST(?). *Copies.*
(a) Minneapolis, Walker Art Center. (b) Florence, Uffizi.

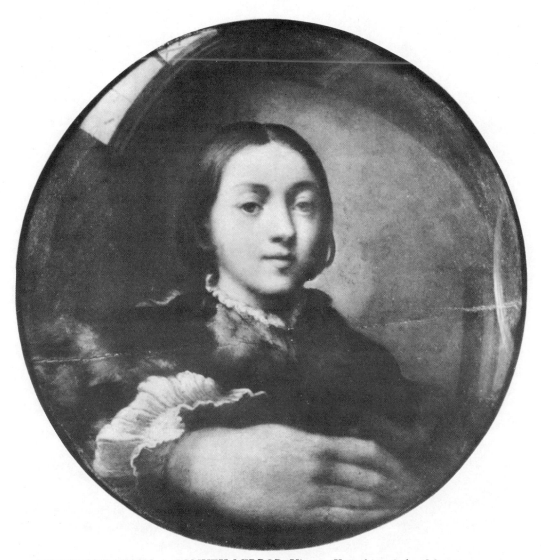

122. SELF-PORTRAIT IN A CONVEX MIRROR. Vienna, Kunsthistorisches Museum.

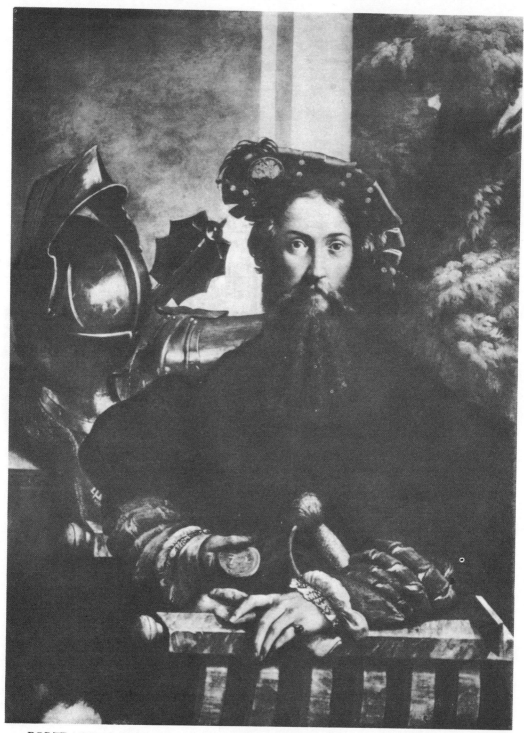

123. PORTRAIT OF GIAN GALEAZZO SANVITALE. Naples, Pinacoteca del Museo Nazionale.

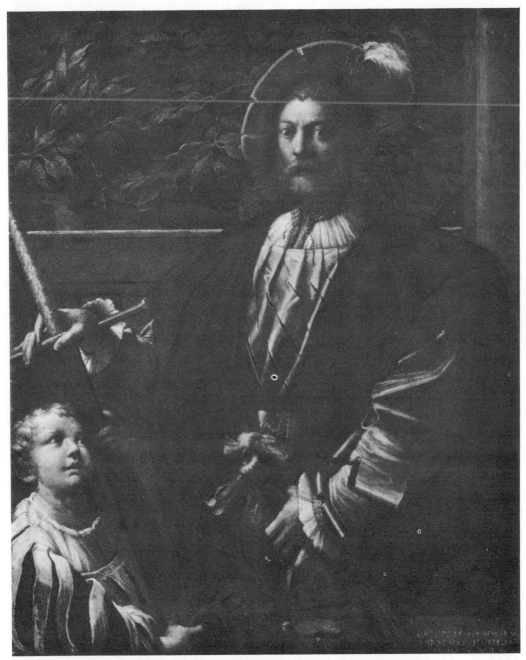

124. PORTRAIT OF LORENZO CYBO. Copenhagen, Royal Museum of Fine Arts.

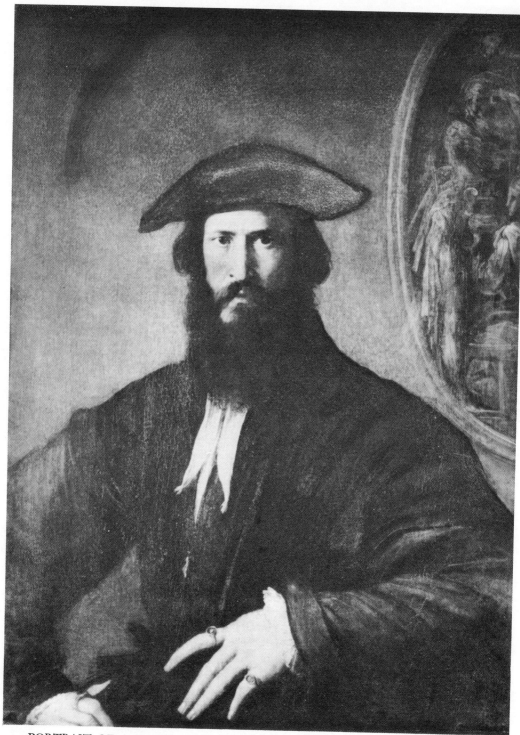

125. PORTRAIT OF A GENTLEMAN (traditionally called a self-portrait). Florence, Uffizi.

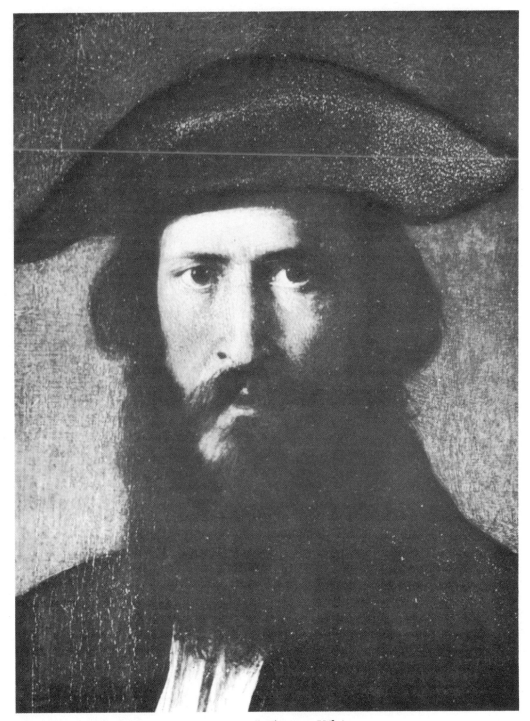

126. PORTRAIT OF A GENTLEMAN, *detail*. Florence, Uffizi.

127. PORTRAIT OF A GENTLEMAN, *detail*. Florence, Uffizi.

128. SHEET OF STUDIES with Artist Sketching. Florence, Uffizi.

129. *VASARI*: VIGNETTE TO THE LIFE OF PARMIGIANINO IN THE EDITION OF 1568.

130. HEAD OF A YOUNG MAN. Oxford, Ashmolean Museum.

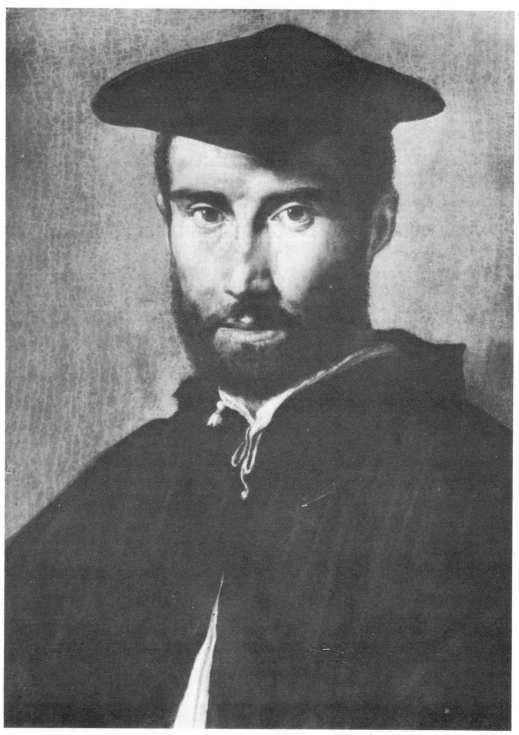

131. PORTRAIT OF A YOUNG PRELATE. Rome, Galleria Borghese.

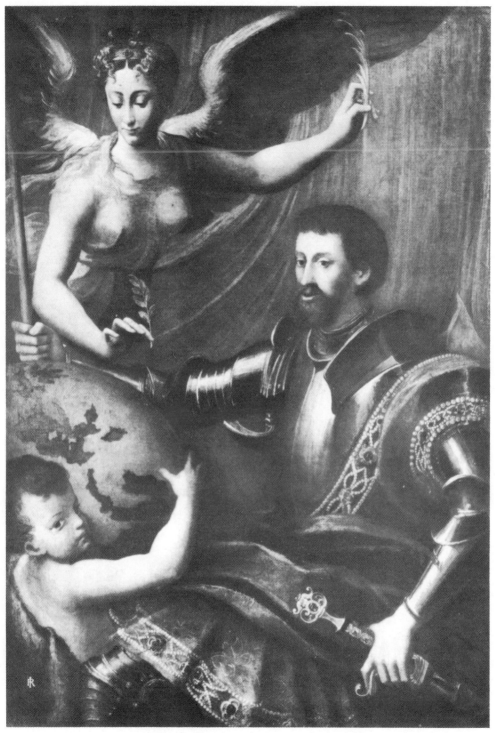

132. ALLEGORICAL PORTRAIT OF CHARLES V. *Copy*. Richmond, Cook Collection.

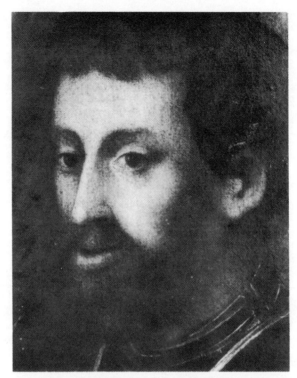

133. ALLEGORICAL PORTRAIT OF CHARLES V.
Copy, detail. Richmond, Cook Collection.

134. STUDY FOR THE ALLEGORICAL POR-
TRAIT OF CHARLES V. New York, Pier-
pont Morgan Library.

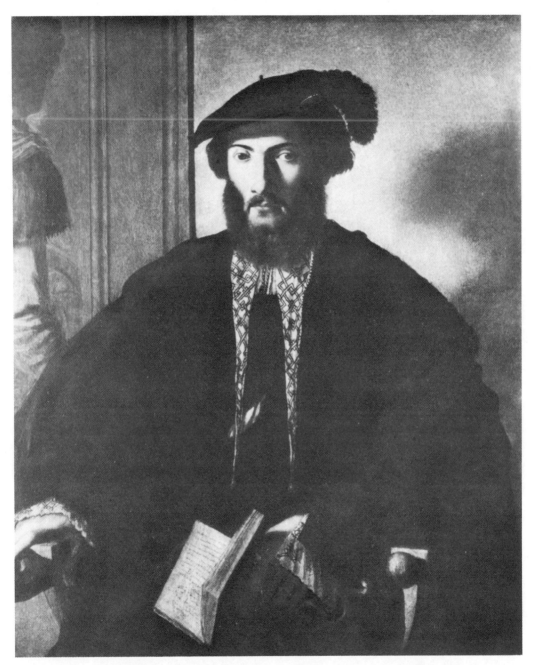

135. PORTRAIT OF G. B. CASTALDI(?). Naples, Pinacoteca del Museo Nazionale.

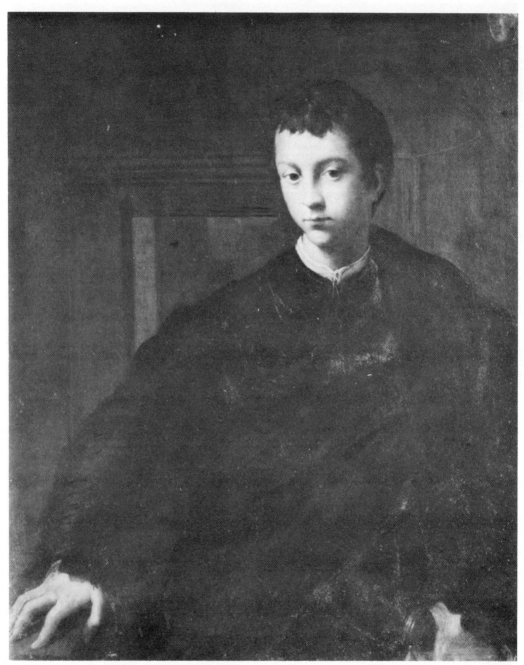

136. PORTRAIT OF A YOUNG MAN. Hampton Court.

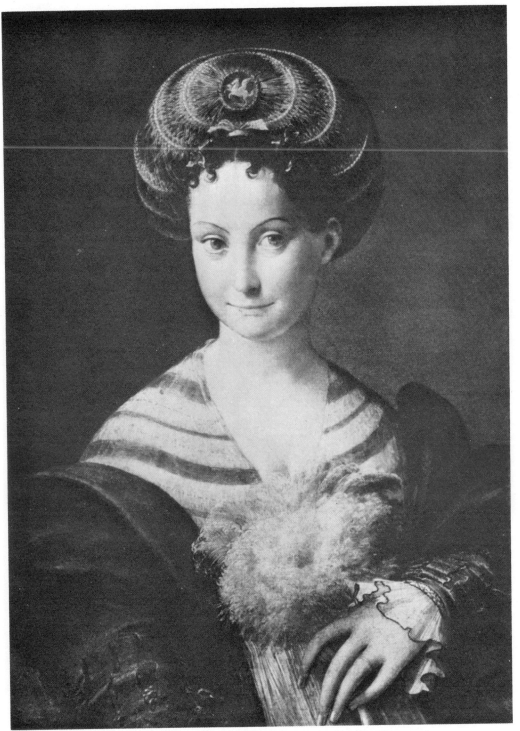

137. PORTRAIT OF A YOUNG LADY (THE "SCHIAVA TURCA"). Parma, Galleria.

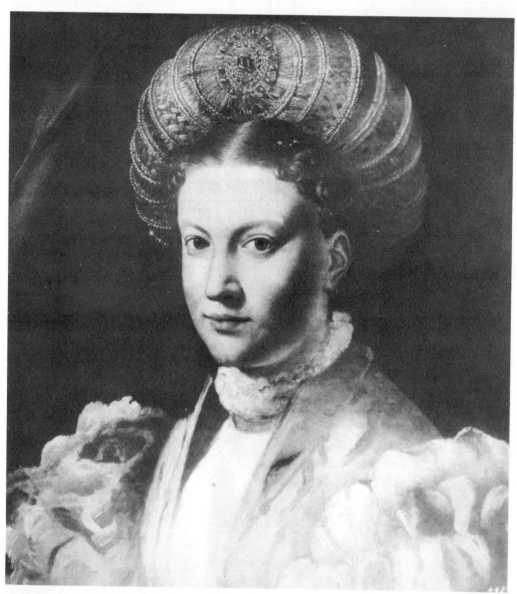

138. PORTRAIT OF COUNTESS GOZZADINI. Vienna, Kunsthistorisches Museum.

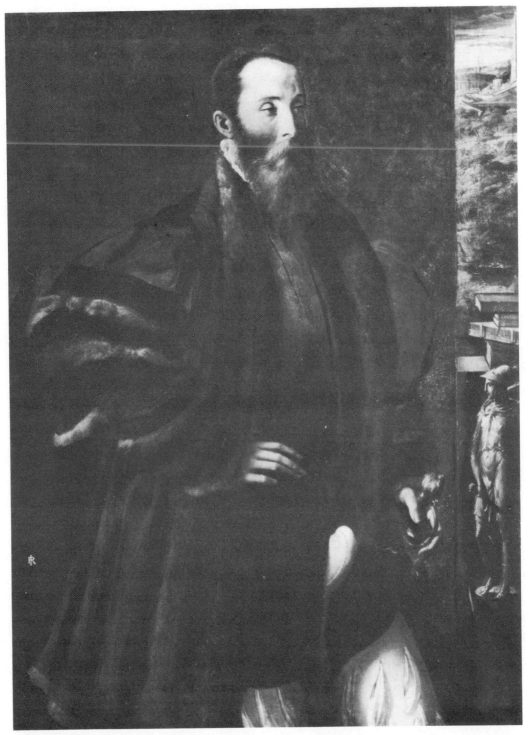

139. PORTRAIT OF COUNT SAN SECONDO. Madrid, Prado.

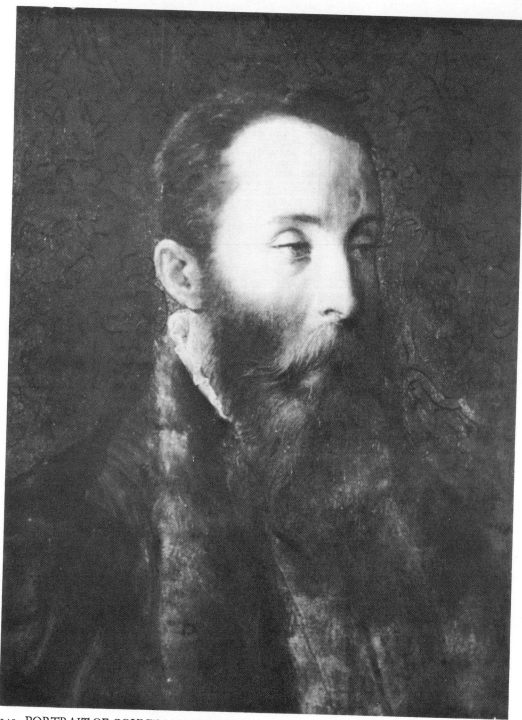

140. PORTRAIT OF COUNT SAN SECONDO, *detail*. Madrid, Prado.

141. *TENIERS*: GALLERY OF ARCHDUKE LEOPOLD WILHELM,
detail, showing portrait of Countess Gozzadini. Vienna, Kunsthis-
torisches Museum.

142. PORTRAIT OF COUNT SAN SECONDO. *Copy.*
Poundisford Park, Collection A. W. Vivian-Neal.

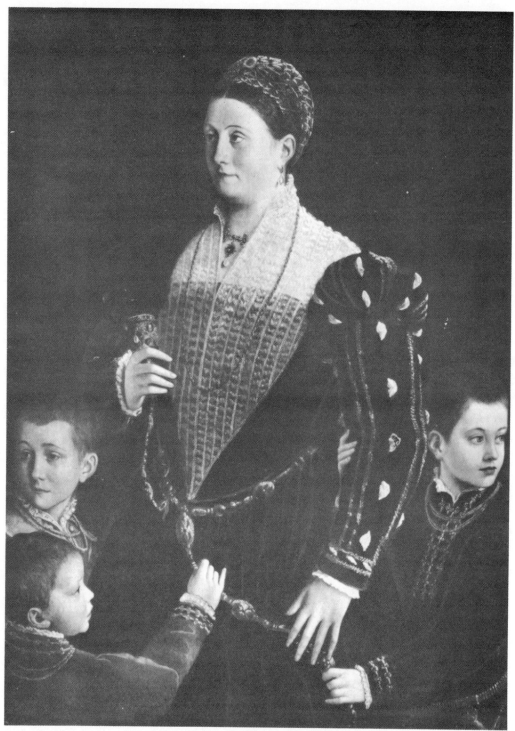

143. PORTRAIT OF COUNTESS SAN SECONDO. Madrid, Prado.

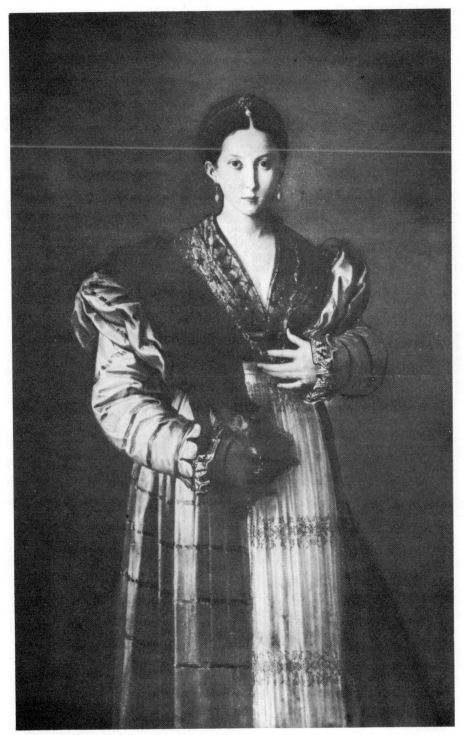

144. PORTRAIT OF A LADY, called "ANTEA." Naples, Pinacoteca del Museo Nazionale.

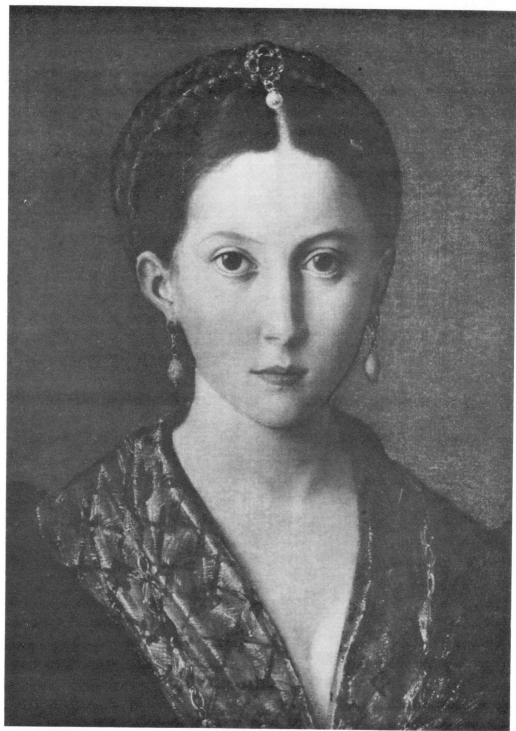

145. PORTRAIT OF "ANTEA," *detail*. Naples, Pinacoteca del Museo Nazionale.

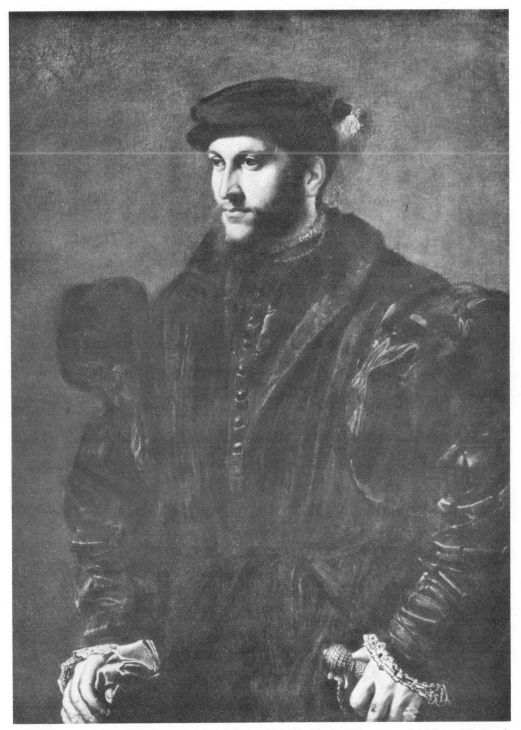

146. PORTRAIT OF GIROLAMO DE VINCENTI(?). Naples, Pinacoteca del Museo Nazionale.

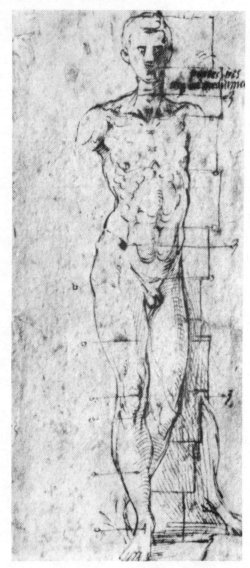

147. STUDY FOR PROPORTIONS OF
MALE FIGURE. Parma, Galleria.

148. HEAD OF A CHILD. Formerly Amsterdam, Goudstikker Gal-
leries.

149. ST. MARGARET. Cremona, Museo Civico Ala Ponzone.

151. LUCRETIA. Naples, Pinacoteca del Museo Nazionale.

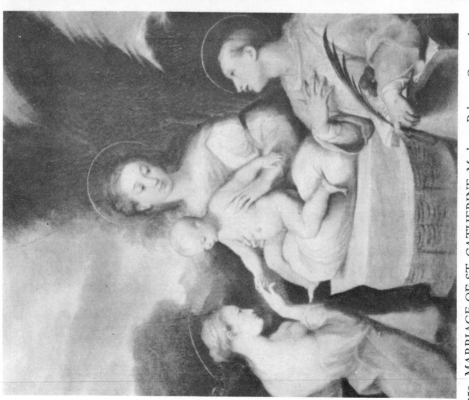

150. MARRIAGE OF ST. CATHERINE. Modena, Palazzo Campori.

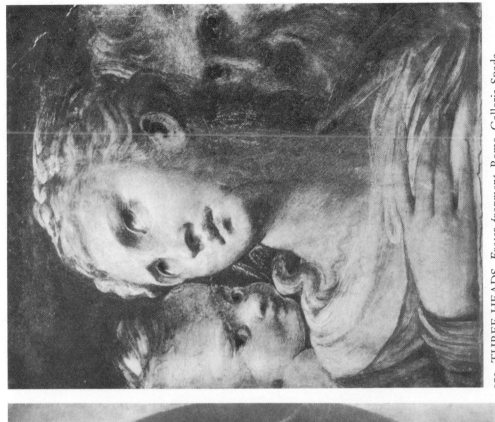

153. THREE HEADS. *Fresco fragment.* Rome, Galleria Spada.

152. MADONNA DEL DENTE. Naples, Pinacoteca del Museo Nazionale.

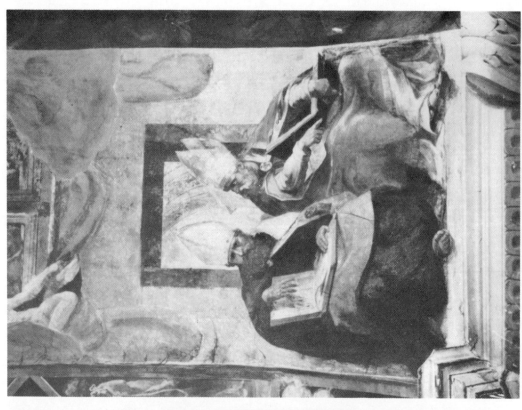

155. TWO DOCTORS OF THE CHURCH. Parma, S. Giovanni Evangelista, sixth chapel on left.

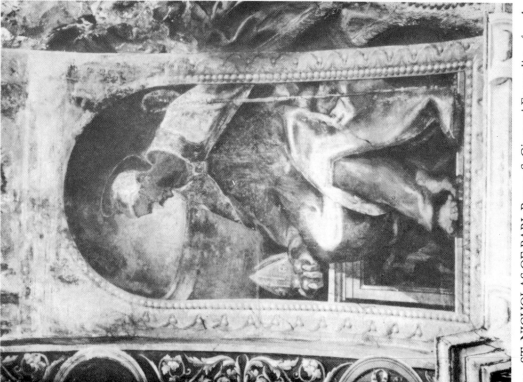

154. ST. NICHOLAS OF BARI. Parma, S. Giovanni Evangelista, fourth chapel on left.

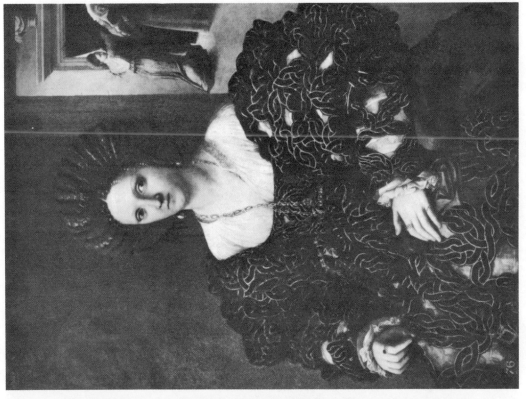

157. PORTRAIT OF ISABELLA D'ESTE(?). Hampton Court.

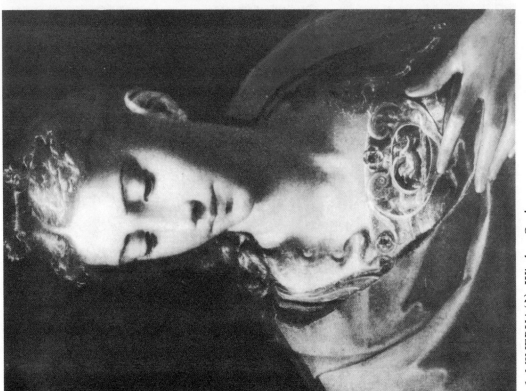

156. MINERVA(?). Windsor Castle.

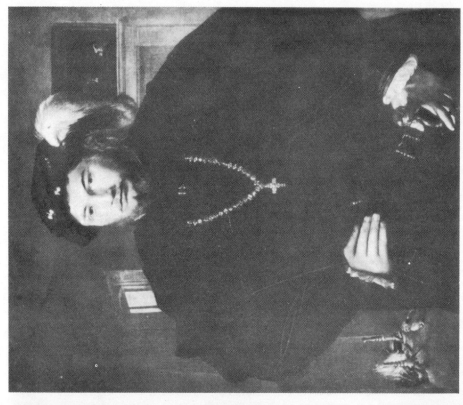

159. PORTRAIT OF A MAN, called GIAN MARTINO SANVITALE,
Naples, Palazzo Reale.

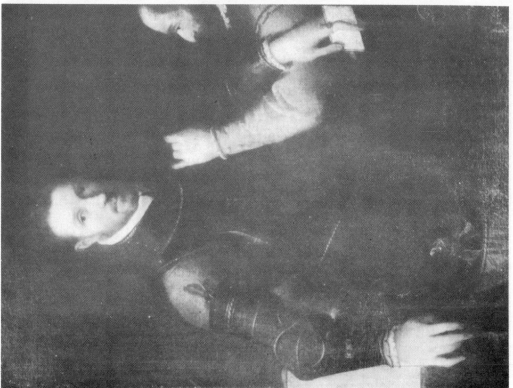

158. PORTRAIT OF LOUIS GONZAGA AND A COMPANION
Hampton Court.

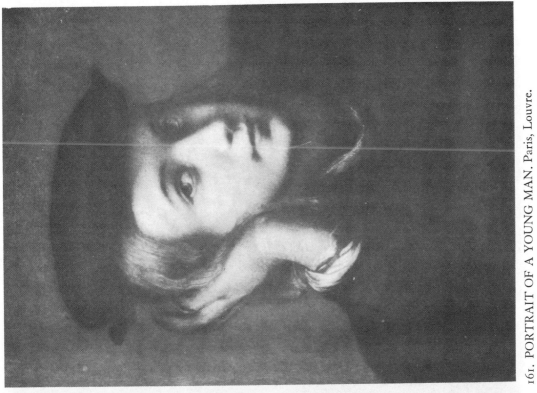

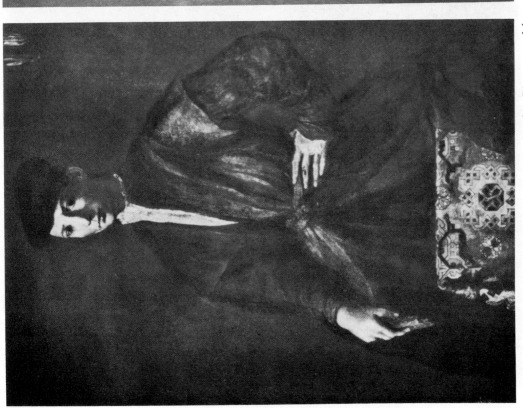

160. YOUTH WITH A HAND ON HIS HIP. Naples, Pinacoteca del Museo Nazionale.

161. PORTRAIT OF A YOUNG MAN. Paris, Louvre.

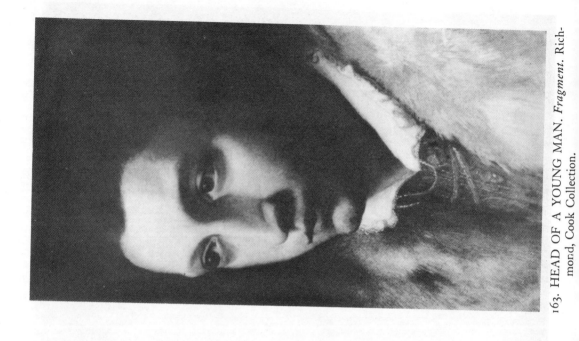

163. HEAD OF A YOUNG MAN. *Fragment.* Richmond, Cook Collection.

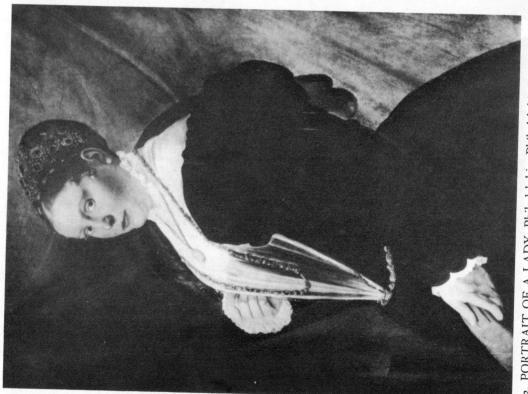

162. PORTRAIT OF A LADY. Philadelphia, Philadelphia Museum of Art.

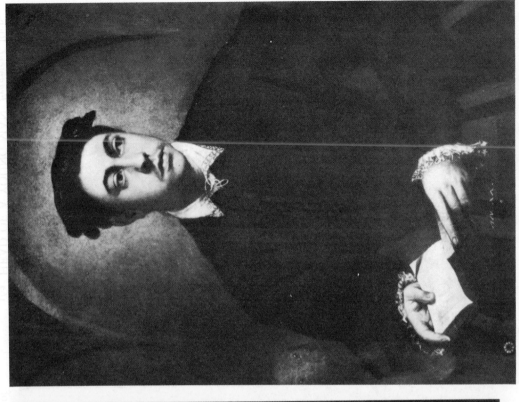

165. YOUNG MAN WITH A DOG. Rome, Palazzo Corsini.

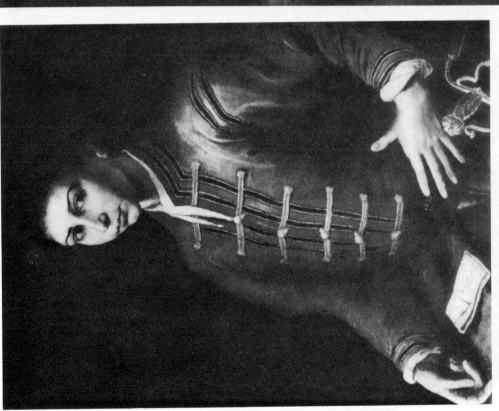

164. YOUNG MAN WITH A LETTER. Rome, Galleria Borghese.

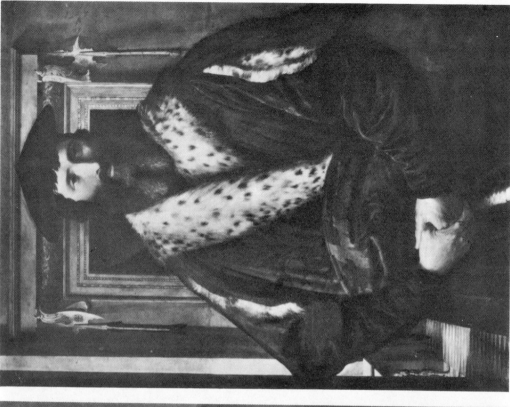

167. PORTRAIT, called MALATESTA BAGLIONE. Vienna, Kunst-
historisches Museum.

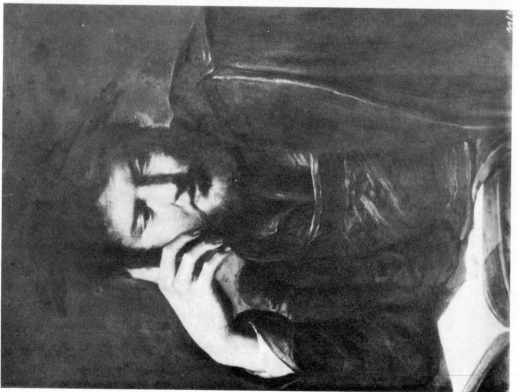

166. PORTRAIT OF A READING MAN. Vienna, Kunsthistorisches
Museum.